PIETER BRUEGEL

PIETER BRUEGEL

LARRY SILVER

ABBEVILLE PRESS PUBLISHERS

NEW YORK LONDON

FOR THE ORIGINAL EDITION
Editorial Director: Agnès de Gorter
Photo Researcher: Béatrice Coti
Graphic Design: Marc Walter/Studio Chine
Editor: Suzanne Madon

FOR THE ENGLISH–LANGUAGE EDITION
Editors: Mary Christian and Susan Costello
Production Manager: Louise Kurtz
Design and Typography: Misha Beletsky
Composition: Angela Taormina

First published in the United States of America in 2011 by Abbeville Press, 137 Varick Street, New York, NY 10013.

First published in France in 2011 by Éditio-Éditions Citadelles & Mazenod, 8, rue Gaston de Saint-Paul, 75116, Paris

First published in the United States of America in 2011 by Abbeville Press, 137 Varick Street, New York, NY 10013.

First edition
10 9 8 7 6 5 4 3 2 1

Library of Congress Cataloging-in-Publication Data

Silver, Larry, 1947–
 Pieter Bruegel / Larry Silver. — 1st ed.
 p. cm.
 Simultaneously published in Paris, France in 2011 by Editio-Editions Citadelles & Mazenod.
 Includes bibliographical references and index.
 ISBN 978-0-7892-1104-0 (hardcover : alk. paper)
 1. Bruegel, Pieter, ca. 1525–1569—Criticism and interpretation.
 2. Bruegel, Pieter, ca. 1525–1569—Catalogues raisonnis. I. Bruegel, Pieter, ca. 1525–1569. II. Title.
 ND673.B73S53 2011
 759.9493—dc23
 2011024612

For bulk and premium sales and for text adoption procedures, write to Customer Service Manager, Abbeville Press, 137 Varick Street, New York, NY 10013, or call 1-800-ARTBOOK.

Visit Abbeville Press online at www.abbeville.com.

Front Cover:
Pieter Bruegel
The Grain Harvest
Detail of plate 278

Back Cover:
Pieter Bruegel
Netherlandish Proverbs
Detail of plate 191

1 *(page 2)*
Pieter Bruegel
Peasant Kermis
Detail of plate 291

2 *(pages 4–5)*
Pieter Bruegel
Hunters in the Snow
Detail of plate 275

3 *(pages 8–9)*
Pieter Bruegel
Wedding Dance
Detail of plate 288

4 *(page 10)*
Pieter Bruegel
Wedding Dance
Detail of plate 288

CONTENTS

Preface

1 GOD IN THE DETAILS: *CHRIST CARRYING THE CROSS* (1564) 15

2 BRUEGEL IN ANTWERP

3 HIERONYMUS COCK, BRUEGEL'S PRINTMAKER 67

4 BRUEGEL AS LANDSCAPE ARCHITECT 93

5 THE "SECOND BOSCH": BRUEGEL ADAPTS A TRADITION 137

6 PARABLES, PROVERBS, PASTIMES 181

7 RELIGION AND TRADITION: ANTWERP, EARLY 1560s 239

8 RELIGIOUS IMAGERY IN A TIME OF TROUBLES 263

9 PEASANT LABOR AND LEISURE 307

10 SOCIAL STRESSES AND STRAINS 361

11 BRUEGEL'S LEGACY

Conclusion

Notes

Index of Names

Index of Works

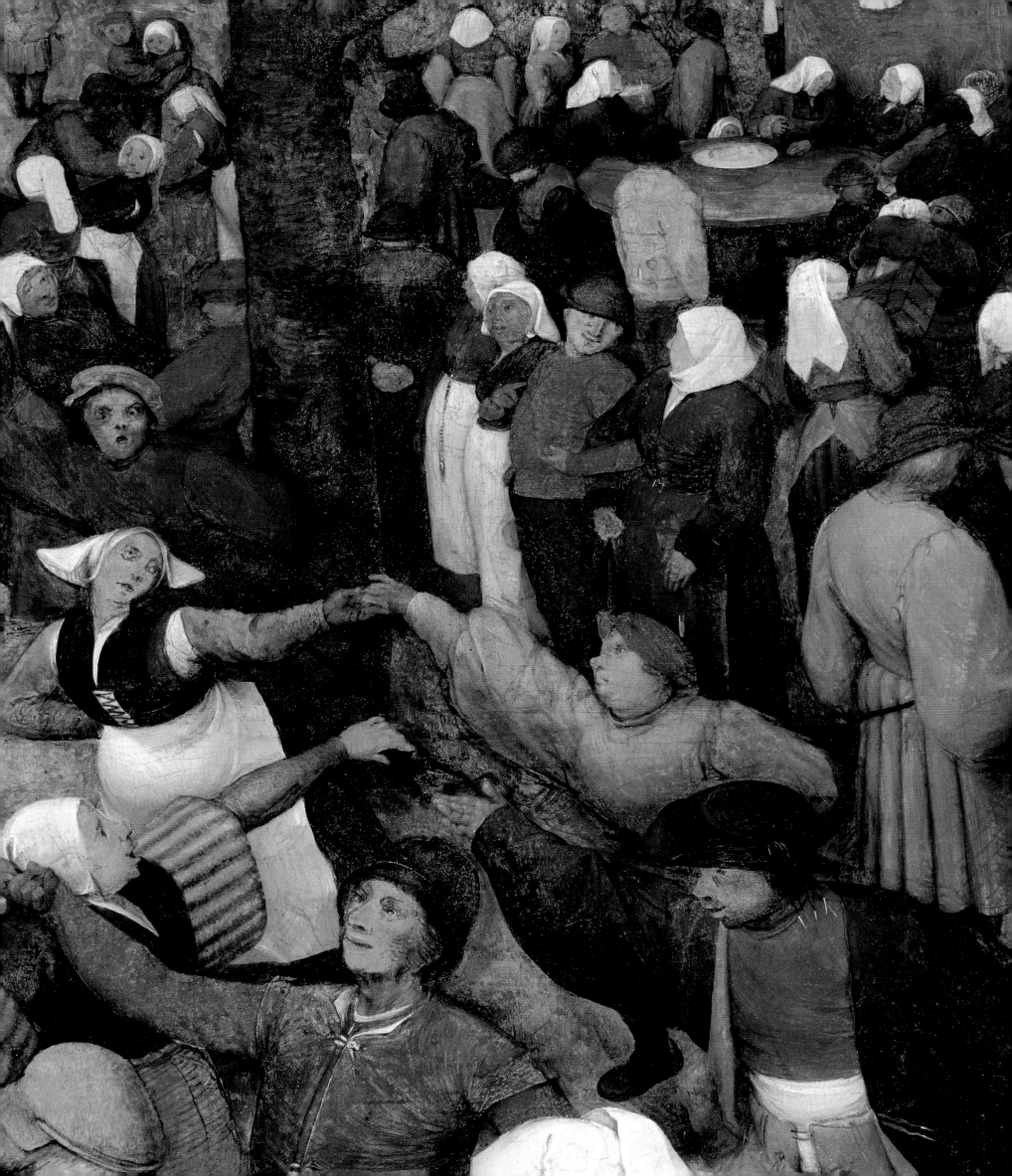

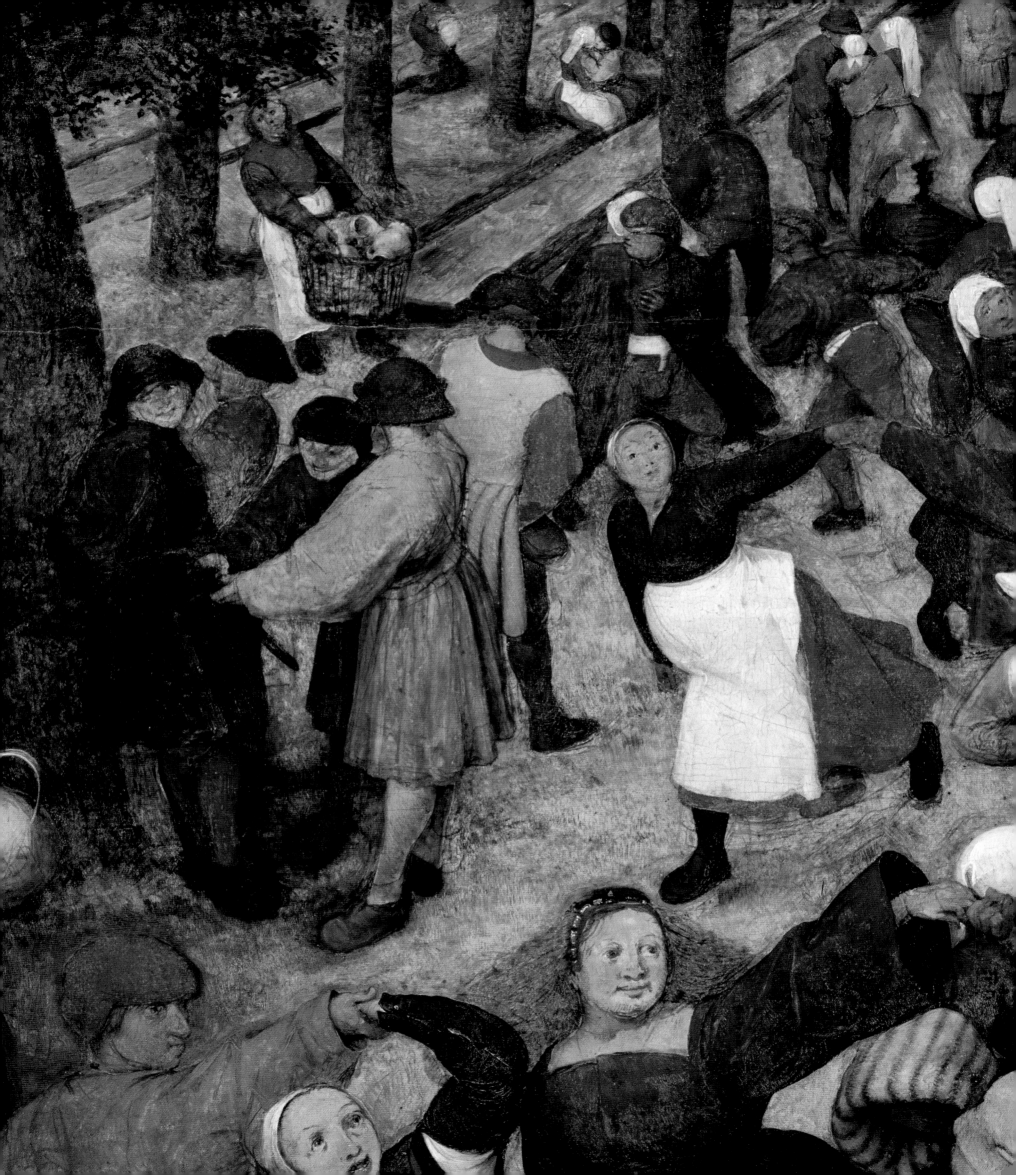

PREFACE

This study is meant to be a complem[ent] book *Hieronymus Bosch* (2006). Take[n] these two volumes allow the intereste[d] see major trends of visual culture in the Nether[lands over] a span of more than a century: painting, dra[wing and] (to a more limited extent) prints from the lat[e fifteenth] century to the end of the sixteenth century. [Moreover] because in his own day (chapter 2) Pieter Br[uegel was] known in Antwerp as a "second Bosch," nume[rous con]- tinuities (and contrasts) link these two domina[nt figures] (a topic expressly explored in chapter 5). The l[egacy of] Bruegel (chapter 11), begun through his litera[l legacy in] his own two painter sons, Pieter the Younge[r and Jan] Brueghel, extends well into the seventeenth c[entury;] also continued through the popularity of his [favor]- ite subjects—landscapes and peasant scenes—[with a host] of imitators and innovators.

The personal situation of Bruegel differs [consider]- ably from Bosch's financial and artistic inde[pendence.] Antwerp, his main center of activity, was the c[ommercial] capital of Europe, if not of the emerging w[orld econ]- omy (chapter 2), and it became the home o[f] first permanent art market. Print production [in which] Bruegel was an active participant, particula[rly in his] early career, actually became a production li[ne opera]- tion run as a private enterprise by entrepre[neur and] Hieronymus Cock at his own publishing ho[use. The] firm was appropriately named Aux Quatre [Vents (at] the Sign of the Four Winds), since Cock's p[rints had]

[internat]ional circulation and even involved the exchange [of profe]ssional printmakers with Italy (chapter 3). The [diversit]y of print styles and subjects in Cock's portfolio [also atte]sts to the range of options available in Antwerp [to Brue]gel and other artists, so we can situate his own [achieve]ment in relation to the works of other artists, [such as] his contrast to the epic Italianate formulations [of his r]ival Frans Floris or his competition with other [scenes] of peasants and kitchens by Pieter Aertsen and [Joachim] Beuckelaer (chapter 9).

[Brue]gel's historical moment also includes the begin- [ning of] a tumultuous chapter in the history of the Neth- [erlands,] the onset of the Dutch Revolt in the later 1560s [chapter]s 8, 10), which eventually would split apart the [Lower] Netherlands into the modern nation-states of [Belgium] and the Netherlands. Bruegel's art shows sen- [sitivity t]o the growing instability of his society, which [would] have had an immediate impact (of an almost lit- [eral kin]d) on the life of artists, beginning with systematic [iconocla]sm of religious images during late summer of [1566 in] the churches of Antwerp and elsewhere. In some [respects], because of his private commissions, Bruegel [was mo]re impervious to depredations of his master- [works,] unlike Aertsen and Floris, who lost important [church]-based altarpieces to the forces of destruction. [When w]e look closely at his works, we can see early [unease] with military force (*Suicide of Saul*, 1562; plate [...] climaxing with an image of "secular apocalypse" [in the] words of Walter Gibson, the dean of Bosch

and Bruegel studies), *The Triumph of Death* (undated, but situated here around 1566; plate 244). Already in his lone etching of 1560, *Rabbit Hunt*, Bruegel shows a hunter hunted, a man with a crossbow stalked in turn by an armed soldier (plate 107).

Thus this book faces two directions. On one level, it is unapologetically old-fashioned: it focuses on a single artist, including several lost works preserved in faithful and consistent copies by his sons. It also attends carefully to his works in all media, prints and drawings as well as paintings, utilizing the latest research and systematic catalogues, especially by Hans Mielke on the drawings and Nadine Orenstein on the prints as well as by Roger Marijnissen and Manfred Sellink on the entire oeuvre. Its purpose is to examine with care all of the surviving works and to look for patterns, changes, and dominant interests, without forcing Pieter Bruegel into what Mark Twain called "a foolish consistency."

But this book also aims for a wider, more contingent, and contextual viewpoint, already suggested above—the historical and social circumstances occasioned by the art market, including the wider issues raised by urbanism and material wealth, epitomized by Antwerp. The artist's own responses later in his career to both political and religious turbulence in the Low Countries would be continued in the next generation by followers, particularly in such new themes as the Peasants' Distress (*Boerenverdriet*; plate 312).

When these two viewpoints are combined, it is possible to see how visual forms change over time, almost like the life forms on an evolutionary trajectory—not inevitably, to be sure, since with individual artists invention is always a component, but with recognizable extensions and variations from inherited models and even earlier examples by the same artist. For example, we can see how the brand name of "Bosch" was used by Cock and by Bruegel as an inspiration, only to be replaced by the new brand of "Bruegel" for his sons and successors in the next generations. We also see how individual, artistic innovation navigates between the personal demands of private commissions and the pressures of the art market to repeat successful formulas, particularly in emerging genres, such as peasant scenes and landscapes, the subject of my own earlier study (Philadelphia, 2006).

Bruegel scholarship began in earnest at the end of the nineteenth century, when the newborn nation of Belgium began to seek a flagship native artist. For Belgian scholars, led by Georges Hulin de Loo and René Bastelaer, Bruegel made a perfect alternative to the arch-internationalist Rubens, in part because he seemed fixated on recording the authentic local village life of peasants. This outlook was extended by later folklorists of the Low Countries (Grauls, Lebeer, Vandenbroeck, emphasizing Bosch), especially for Bruegel's use of folk sayings and customs. Most major European scholars of the first half of the twentieth century, led appropriately out of the great Bruegel museum collection in Vienna by Max Dvořák, Gustav Glück, and Charles de Tolnay, strove to make the artist into a philosopher of universal principles, using such cosmic concepts as "the soul and mechanism of the universe," to use the phrase of Otto Benesch. Bruegel scholarship after midcentury, led by Fritz Grossmann and Carl Gustav Stridbeck, focused on the artist's relationship to sophisticated patrons and cultural leaders, aligning him with their values of religious liberalism in a period of parochial contests, even positing his membership in the secret sect, the Family of Love (a claim that has not received any additional subsequent evidence). Inevitably, the seriousness of the academic enterprise sought an artist with the same intellectual subtlety, so their version of Bruegel has became an ironist and moralizing social critic, now using peasant subjects to castigate general human sinfulness through the use of this lowest common existence.

The most recent generation of scholarship, headed by Walter Gibson, has begun to situate Bruegel amid fellow artists, sometime rivals in prints as well as paintings, as well as within other cultural movements, such as the civic rhetoricians (*rederijkers*) with whom he shared guild membership in Antwerp. Heated debates have ensued about which visual and verbal sources provide the most appropriate indices of his own attitude, not to mention whether Bruegel is to be singled out as distinct and exceptional or else seen as characteristic and engaged closely with others in contemporary issues of culture and society.

Many of those controversies will be addressed in the pages that follow, but it is equally clear that even to define a shared culture amid varying classes and audiences remains problematic. Not only do the diverse modern agendas of scholars—sometimes resulting from their own nationality and training—shape what views they impute to the artist, but additionally the variety of potential sources and parallels from the sixteenth century shape each interpretation of Bruegel's art. At present no scholarly consensus has emerged for Bruegel, and much attention has focused on re-examining his oeuvre in all media or studying the rhetoric of his presentation through individual works.

The two most recent comprehensive monographs on

Bruegel—by Roger Marijnissen in 1988 (reissue...
and by Manfred Sellink in 2007—concentra...
most part on individual works in chronolog...
Both have provided essential foundations for...
Because of their existence, this book has tak...
topical approach, considering Bruegel's prin...
ects and themes, without necessarily trying...
size the traditional coherent development as...
"life and works" monographs. While striving a...
Bruegel's formative role and historical positi...
Netherlandish art, prints as well as painting,...
will also spend some time showing works b...
contemporaries and his successors. A comp...
study of sixteenth-century Netherlandish art...
be written, but this study should be able to...
some suggestions of how Pieter Bruegel woul...
ten into that account.

Fellow scholars of Bruegel impel all of us...
his work to see him with continually fresh...
rethink our inherited wisdom. Because of thei...
ful, welcome contributions, this book is gratef...
cated to current Bruegel scholars, led by Walte...
in the hope that, while "standing on the sho...
giants" (as always in scholarship), its insight...
make some fresh contributions to our collectiv...
and thinking. Its analyses are also addressed t...
colleagues and students, especially of recent y...
have revived research about the artist and his e...

In America the study of Bruegel remained...
time in the able hands of Fritz Grossmann, bu...
fectionist streak meant that his brilliance wa...
passed on through short articles and mentori...
than the catalogue raisonné that remained hi...
Sisyphean struggle. I had the unforgettable...
tune to meet Grossmann in his retirement, an...
cuss the artist as well as those prior European s...
Bruegel mentioned above. But for a student o...
eration, indispensable current colleagues who...
also made this book possible need to be ackno...
Gibson foremost, but also Nadine Orenstein,...
Sellink, Ethan Matt Kaveler, Mark Meadow,...
Falkenburg, Todd Richardson, Walter Melion,...
man, Timothy Riggs, David Freedberg, Rob...
win, Nina Serebrennikov, Elizabeth Honig,...

...Leopoldine Prosperetti, Dan Ewing, Lynn
...Bret Rothstein, Alison Stewart, Keith Moxey,
...ndenbroeck, Carl van de Velde, Arnout Balis,
...der Stock, Konrad Renger, Jürgen Müller, Philip
...len, Joaneath Spicer, Margaret Sullivan, Svetlana
...Edward Snow, plus the late greats, Hans Mielke
...drawing catalogue numbers are used in this
...Fritz Grossmann, and Wolfgang Stechow. Their
...contributions and other important scholarship
...cited in the notes below, although for the most
...ent works containing bibliography will be cited
...nterested reader rather than trying to be exhaus-
...an artist with such a full, rich literature.

...other dedication of this work takes me back to
...version of country roots, to life within the
...culture (in many respects) of Waco, Texas.
...years ago I promised this book to my lifelong
...Morrie Fred, and I am happy to deliver it at long
...other Wacoans, "deep in my heart," are my sib-
...bye and Susan Silver, Raylene Silver, and Allyn
...old Schmucker, Texans all, but with a twist. On
...vel, as Bruegel scholarship exemplifies, every-
...study has a personal, even autobiographical
...I am sure that the best way to pay tribute to my
...ious heritage, shared with them, is to offer this
...my beloved family. Last but not least among
...the one surviving sibling of my parents, trea-
...ncle Harris Sprecher, out in the "country life" of
...rbara.

...want to offer special and cordial thanks to Agnès
...r, who has supported this book at every stage
...ncept to completion, after first commissioning
...n Bosch for the same series. In today's publish-
...onment, to produce an art book worthy of its
...with sumptuous reproductions that do justice in
...whole and in details to the works themselves,
...with a respect for serious scholarly analysis, is
...and altogether too rare. I salute with profound
...Madame de Gorter and the house of Citadelles
...ot, a "Phare des Arts," as well as my esteemed
...shers, Abbeville Press in America.

Larry Silver
Philadelphia, 2009

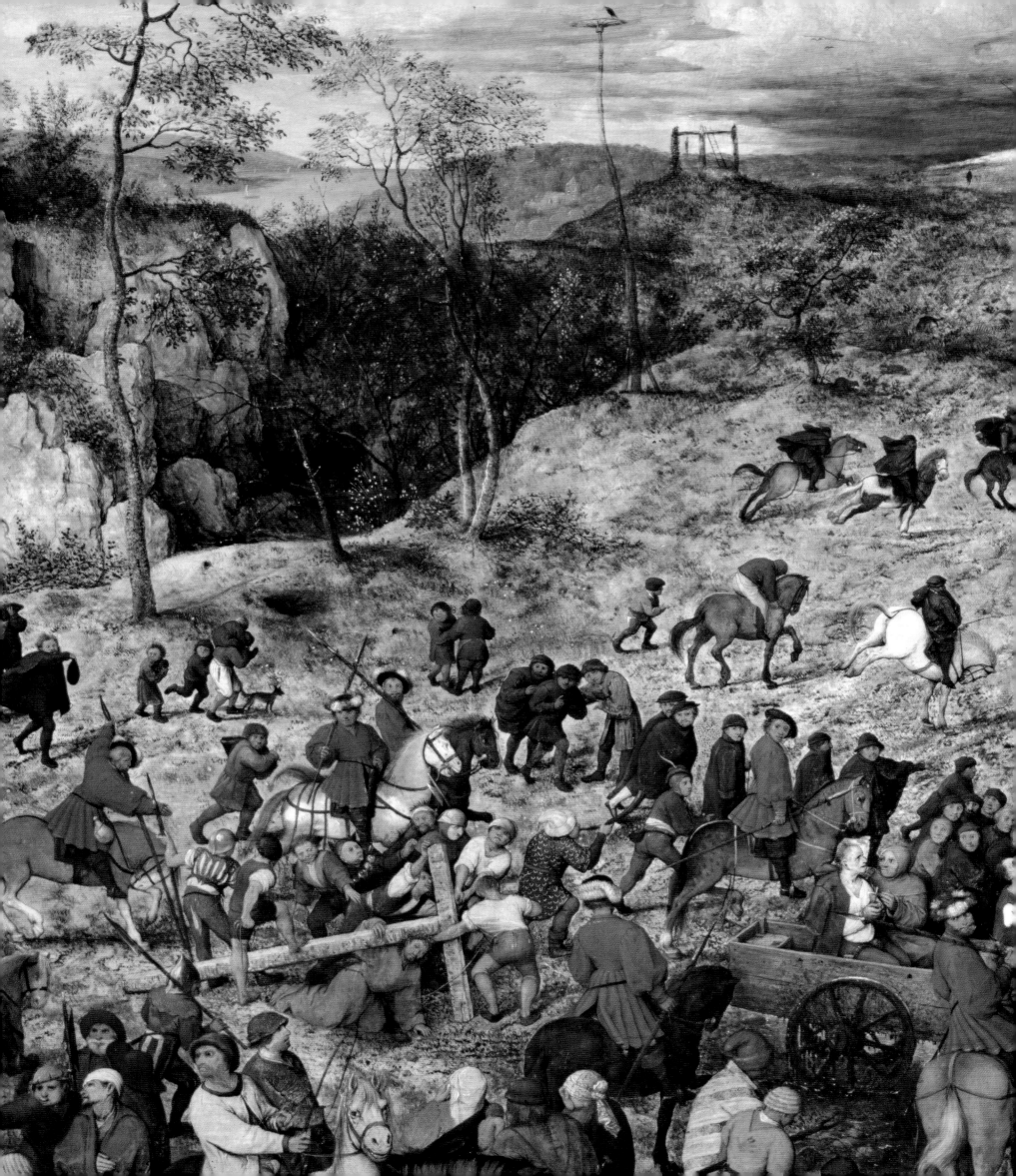

I

GOD IN THE

DETAILS:

CHRIST CARRYING

THE CROSS (1564)

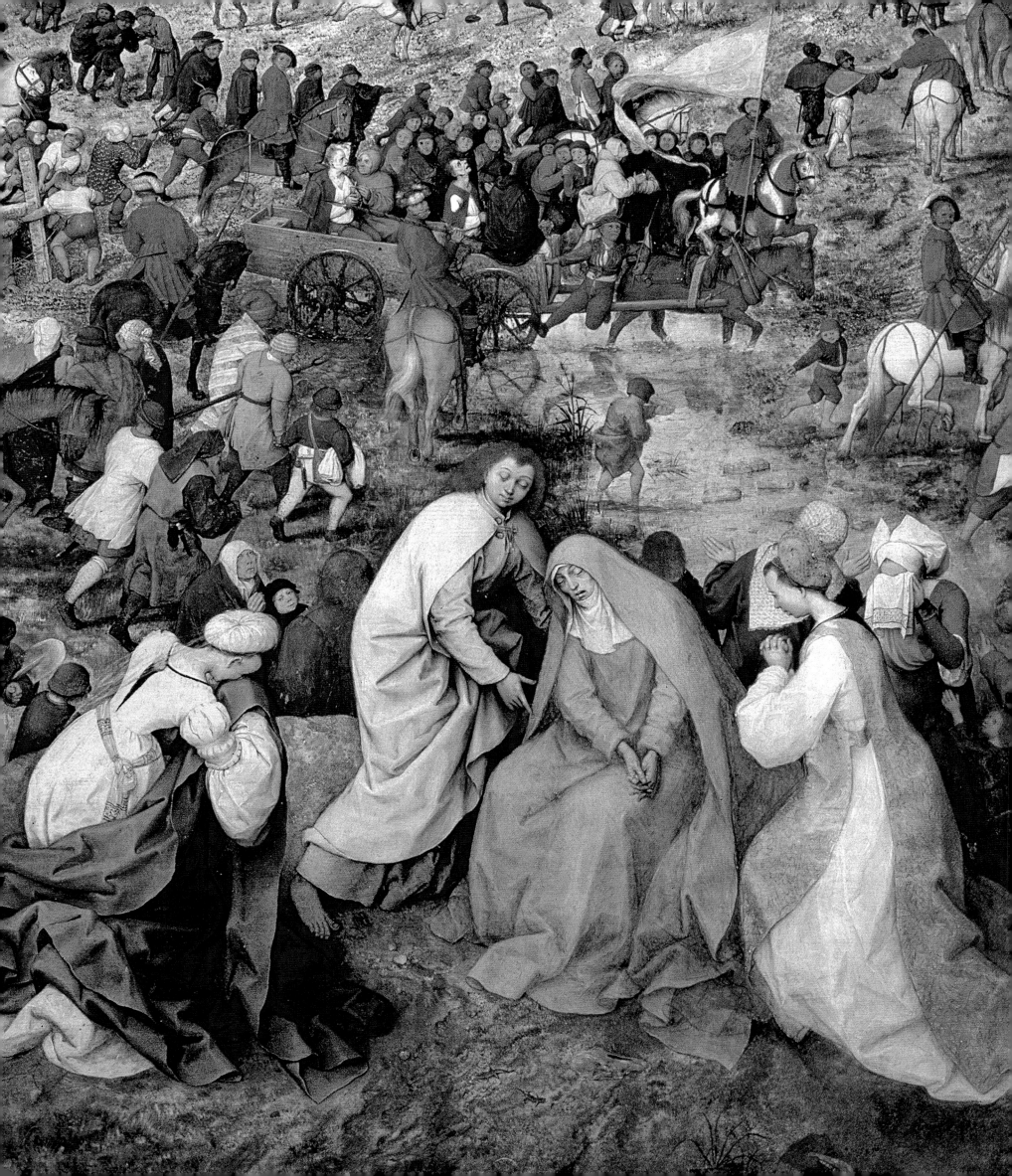

Pieter Bruegel's largest painting, *Chris[t Carrying] the Cross* (signed and dated 1564; plat[e ...] [pres]ents over a hundred tiny figures swarm[ing across] a vast landscape panorama. Its rich yet bewilde[ring detail] envelops the observer in a host of vignettes tha[t ...] to overwhelm any sense of the true subject o[f the pic]ture, even making it difficult to distinguish [at first] that it presents a religious subject: *Christ Ca[rrying the] Cross*. The reason for all this confusion is the [...] short, thick, active figures, all dressed in cont[emporary] costume—whether the redcoat soldiers of the [mounted] horse guard, whose brightness flickers throu[ghout the] surface of the image, or else the humbler, dra[b-colored] villagers scurrying along in all directions.[1] In[deed, only] upon closer inspection does the attentive vie[wer note] that the small figure of Christ, who has fallen [under the] cross, appears in distinctive gray-blue robes a[t the geo]metrical center of the vast composition, fram[ed by the] wooden beams of his burden.

Lone exceptions to the squat contempor[ary figures] that dominate the scene, several tall, slender fig[ures with] small heads (plate 8, detail) stand on a ridge in [the upper] right corner; their contrasting archaic dress rev[eals them] to be different in kind from the ants' nest of an[imated] characters behind them. To a viewer familiar [with the] history of Flemish painting, these exception[al figures] in the corner are revealed as the heirs to typ[es invented] more than a century earlier in the panels of su[ch artists] as Rogier van der Weyden (active 1432–64). Sp[ecifically] they compare closely to his swooning Virgin in [the arms] of John the Evangelist beneath the cross in Rog[ier's small] panel *Crucifixion* (c. 1460; plate 7).[2] There th[e ...] colors of their mantles—blue for Mary, ros[e for] John—derive from their original position as th[e ...] everyday wings of an altarpiece—the humbler [...] whose colors are often muted grisailles—in [contrast] to a more splendid colored interior, perhaps o[riginally] comprised of painted sculptures. Indeed, thes[e holy] figures alongside Rogier's Crucifix, with Chri[st on the] Cross at the right half of this diptych, also [resemble] carved and painted wooden sculptures, redu[ced here] to these main figures around the cross, carvin[gs seem]ingly animated into life through the faith of t[he devout] beholder.[3] Indeed, van der Weyden played v[ariations] on this fundamental theme in a number of h[is works,] notably his renowned Prado *Deposition* (befor[e 1443).4] However, in both of these important precedent[s the ear]lier Flemish painter had isolated his holy figure[s against] a gold background (Madrid) or a red cloth o[f honor] (Philadelphia), whereas in Bruegel's image [these fig]

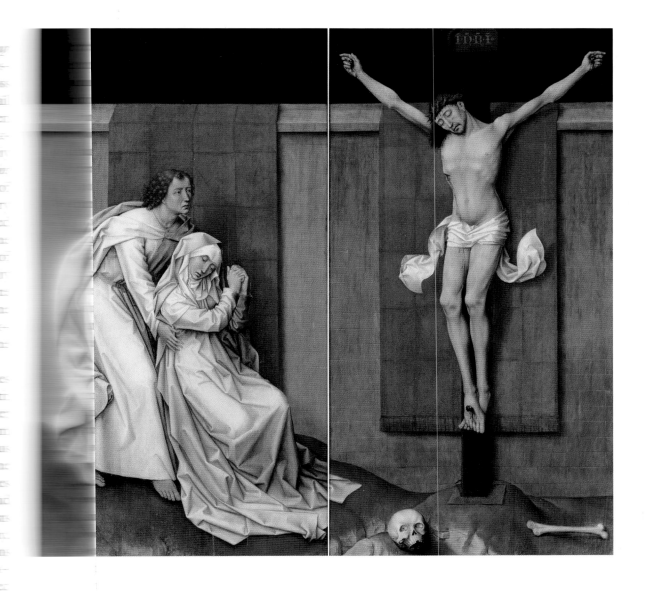

[fig]ures are only distinguished by their elevated location, [remote fr]om the viewer and overlooking the vast panorama [from a f]oreground ledge in the lower right corner. Yet [Bruegel] also shows Mary in a pale mantle, whose color [echoes th]e robes of her son, as she too sinks to the earth [in angui]sh and exhaustion, supported gently by the [youthful] St. John the Evangelist, as in van der Weyden's [panel frag]ment. Bruegel's holy figures, including the other [mournin]g women, are extracted from the usual clus[ter depic]ted underneath the cross and now presented [instead b]efore this wider panorama.[5]

[Of c]ourse, the mournful conduct by these holy fig[ures still] offers the proper model of response to the [quie]t saving sacrifice of Jesus for humanity.[6] Yet [these figu]res expressly turn their backs to the unfolding [scene of] the way to Calvary, which unfolds behind them, [immers]ed in the midst of the teeming crowd.[7] Upon [closer in]spection, other figures within the crowd also

5 and 6 *(pages 14–15 and opposite)*
Pieter Bruegel (c. 1525/30–1569)
Christ Carrying the Cross, 1564
Details of plate 8

7 *(above right)*
Rogier van der Weyden
(act. 1432–64)
Crucifixion, c. 1460
Oil on panel, left panel 70⅜ ×
36⅝ in. (180.3 × 93.8 cm), right panel
70⅜ × 36⅛ in. (180.3 × 92.6 cm)
Philadelphia Museum of Art,
John G. Johnson Collection

8 *(pages 18–19)*
Pieter Bruegel
Christ Carrying the Cross, 1564
Oil on panel, 48⅜ × 66¼ in.
(124 × 170 cm)
Kunsthistorisches Museum, Vienna

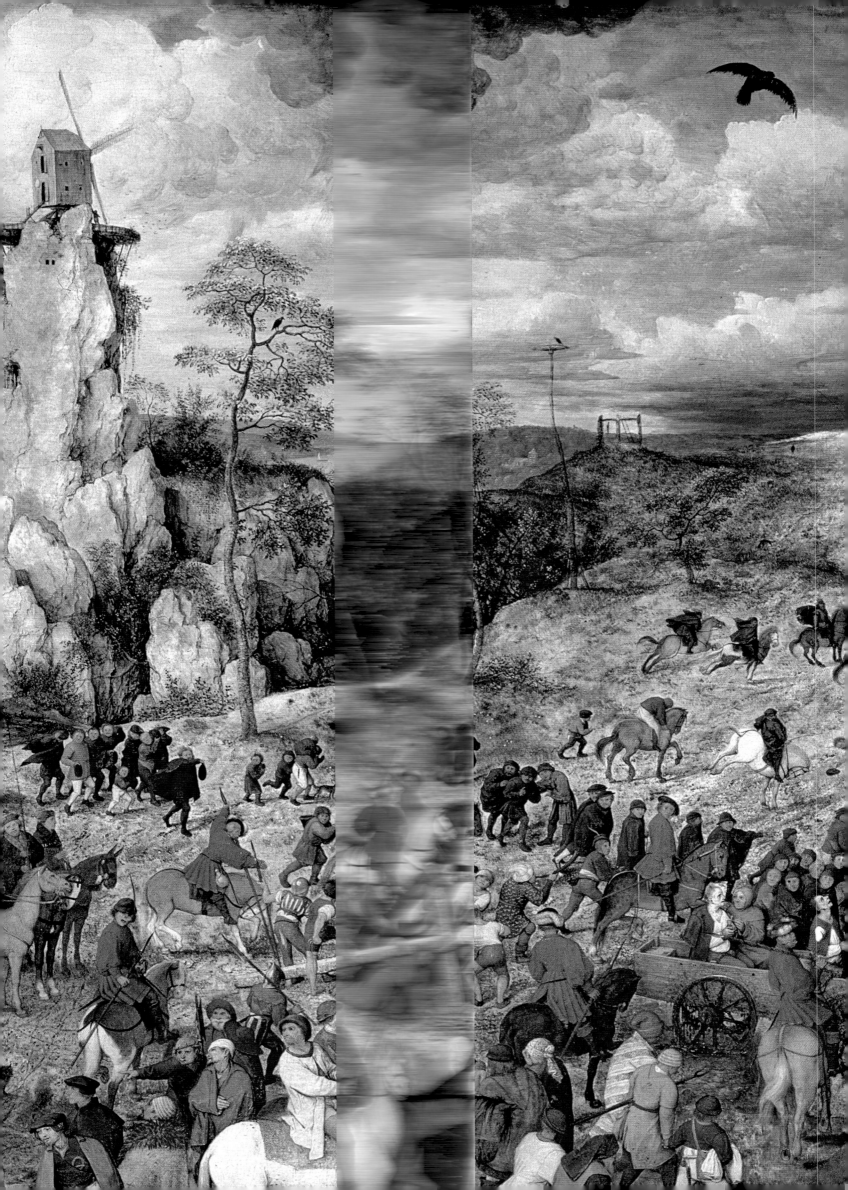

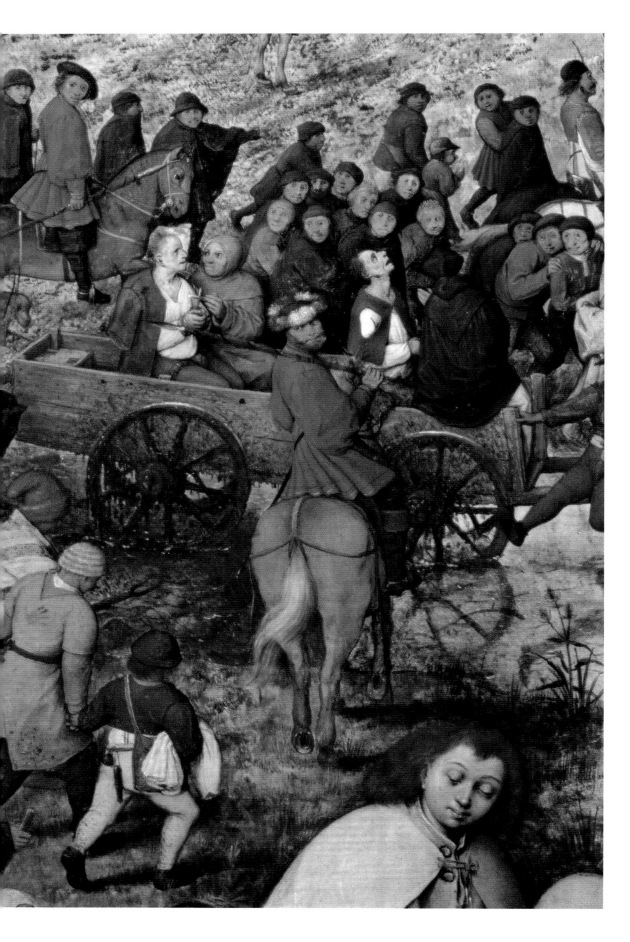

act out the fuller narrative of Christ's Way to Calvary. In particular, the pair of thieves who will flank Christ on the cross are making their own way to Golgotha (plate 9).[8] They appear directly above the holy figures at the right side of the composition, as both of them ride in a cart with accompanying figures. Holding a small cross in his bound hands as a sign, however anachronistic, of his nascent conversion, the good thief sits behind and offers his confession to a Franciscan friar.[9] Later, when all three men are on the cross, the good thief will implore, "Jesus, remember me when you come in your kingly power" (Luke 23:39–43). Meanwhile at the front of the cart the other thief, despite a similar small cross in his own hand, still cries out in despair and seems impervious to the ministrations of a black-robed Dominican beside him; this obvious lack of faith shows him to be the "bad thief," who will soon refuse even the comfort of Christ himself. Indeed, their relative positions in the cart anticipate their later placement atop the crosses, with the good thief to Christ's right (i.e., the viewer's left) and the bad thief on the unfavorable viewer's right (*sinister* side of Christ), the usual location of Hell in Last Judgment scenes.[10] Redcoats on horseback guard this wagon of prisoners, while pedestrians behind the cart gape at the condemned. For them this scene of impending execution seems no different from any other public punishment of the day (such as those myriad tortures recorded by Bruegel in his image of *Justice* from his print designs for a series of the Seven Virtues (see plates 170, 171).

This inclusion of the condemned thieves appeared in other images of Christ *Carrying the Cross*, including images by Bruegel's principal influence (chapter 5), Hieronymus Bosch (active c. 1475–1516). For example, Bosch painted a wing of Christ Carrying the Cross (plate 11), filled with tormentors around Jesus with the cross, in which the two thieves appear at the bottom of the panel. There the good thief—in the lower right corner like the Bruegel holy figures—actively confesses to another Franciscan friar beneath a tree. Meanwhile, on the opposite side, the viewer's left, the bad thief is accompanied by a mysterious individual with a red cloak and dark head covering as well as a colorful blue shield with pendant bells (dots on both the shield and the head covering suggest stars, indicating that the figure could be an astrologer or magician). This kind of exotic costume reappears throughout Bosch's panel, where turbans and other unusual millinery denote the tormentors of Christ, presumably Jews, as the evil nemesis of true Christians, equivalent to contemporary Turks in some circles. One

of them, wearing a turban and dressed in ye[llow, the]
false color of Jews, carries another blue shield[, this one]
with the poisonous figure of a toad.[11]

Bruegel's figures, by contrast, are not so clear[ly marked]
as aliens by their costumes; rather they are dr[essed for]
the most part like ordinary Flemish villagers. Bu[t Bruegel]
does place the cart with the thieves at a poin[t where it]
crosses a small stream. Reindert Falkenburg [interprets]
this body of water as a reference to a New Testa[ment site]
(John 18:1), the brook of Kidron, where Kin[g Asa (II]
Chronicles 15:16; I Kings 15:13) had earlier des[troyed an]
idol.[12] But other, more general biblical referen[ces point]
to danger by drowning, such as Psalm 69: "S[ave me O]
God; For the waters are come in even unto [the soul."]
And of course, crossing water would also allu[de to the]
sacrament of baptism, the ultimate moment o[f conver-]
sion, the choice placed before each of the thie[ves in the]
presence of Jesus. Bruegel's allegory of Hope [from the]
Seven Virtues series (plate 163) also include[s, among]
prisoners confined in the foreground, hopin[g for lib-]
eration, among its many other would-be bene[ficiaries of]
that specific virtue; shackled, they too are thre[atened by]
rising waters.[13]

Whether this stream in the picture should be [read alle-]
gorically, either as the passage of conversion [or else as]
the bog of sinfulness that requires avoidance o[r extrica-]
tion, the cart is still about to cross it, and the [man, or fig-]
ure, who rides behind the horses as they draw[s the cart]
deliberately lifts his feet to avoid getting them [wet, thus]
avoiding any encounter with the water. In fr[ont of the]
cart a pair of children have hiked up their pan[ts to cross]
the brook on foot, while the guards cross ea[sily, unaf-]
fected, on horseback. Right next to one of t[he horses,]
a father has put his child on his back and eme[rges from]
the stream with his own pants drawn up.[14] Pe[rhaps they]
all embody the simplicity of childish faith, as [enjoined]
by Jesus (Matthew 19:13–14; Mark 10:13–15; L[uke 18:15–]
17), "for to such belongs the kingdom of hea[ven. Truly,]
I say to you, whoever does not receive the ki[ngdom of]
God like a child shall not enter it." Thus, [within this]
procession to Calvary, not all of the charact[ers can be]
condemned for their indifference to the pligh[t of Jesus]
or for their hostility in the traditional role of t[he tormen-]
tors of Christ.

Yet the other most explicit element of reli[gious nar-]
rative in Bruegel's *Christ Carrying the Cross* [appears in his]
inclusion of a vignette concerning the assis[tance—or]
lack of it—accorded to Jesus with his heav[y burden.]
Specifically, just above the site on the left h[alf of the]
painting, he features a couple engaged in a st[ruggle that]

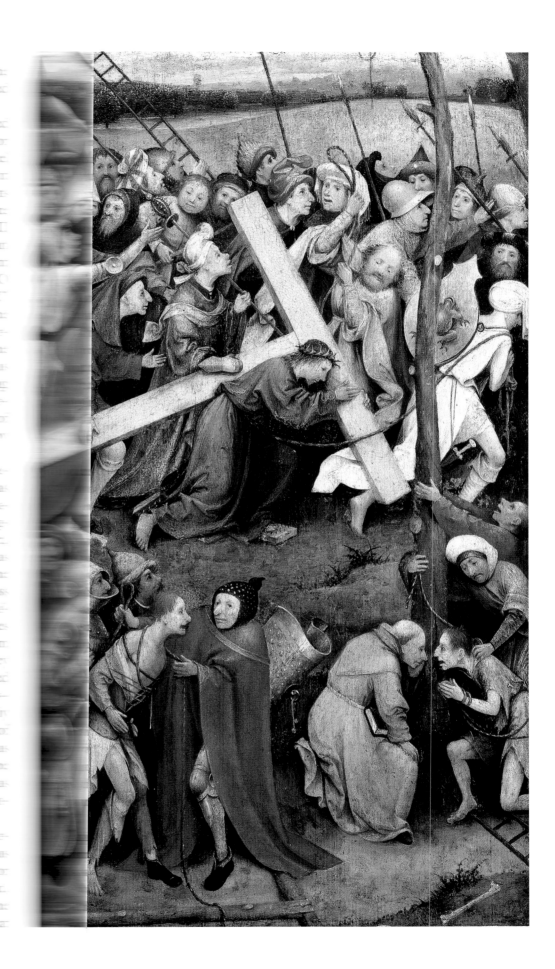

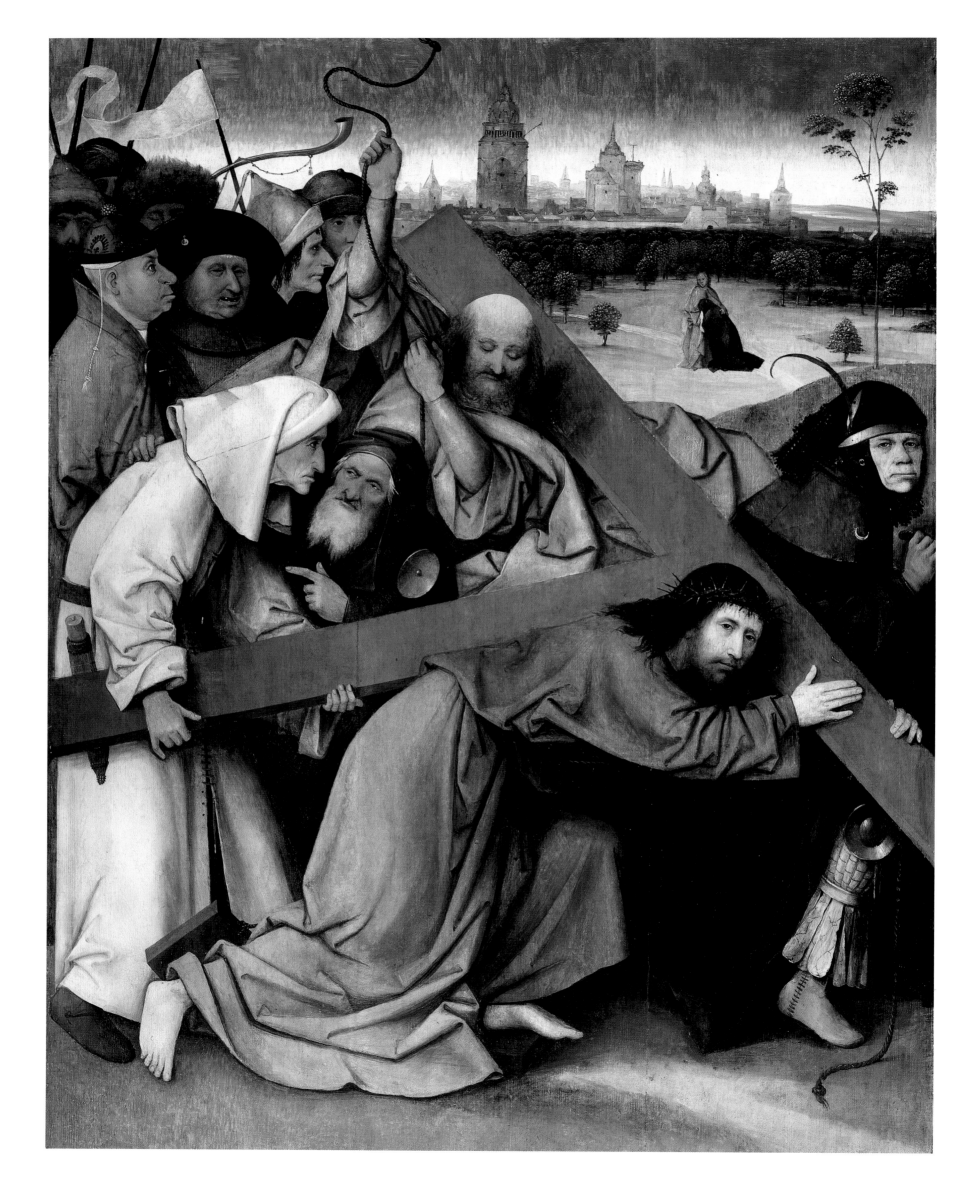

corresponds to the upraised heads of the ho[...] A soldier in striped pants accosts the husband [...] pointed end of his halberd weapon, as ano[...] him forward forcibly to come and assist Jesu[...] heavy burden of the cross. Nevertheless he re[...] tugs and drags his feet as he turns to implor[...] for help. She in turn struggles to restrain him [...] his shoulder to pull back against his involunta[...] ment. Ironically, despite the effort visible on [...] ered old face, the wife has an (anachronistic [...] her belt, so her resistance to providing aid [...] revealed to be a most un-Christian form of [...] observing the letter but not the spirit of true [...] compassion.[15] Scholars have long recognize[...] scene stages a nontextual prelude to a well-kno[...] connected to the Passion and repeated in the [...] Stations of the Cross in the late Middle Ages [...] of Simon of Cyrene, "coming from the cou[...] was "compelled" to carry the cross along w[...] (Luke 23:26; Mark 15:21; Matthew 27:32).[16] [...] resents an elderly Simon as a helper amid the [...] who follow and harass Jesus in a mature w[...] *Carrying the Cross* (plate 11). By contrast, Br[...] tradicts this traditional model of pious and co[...] ate behavior by Simon and shows instead the [...] of both of these country folk, drafted agains[...] to participate in the actual face of real need. [...] dropped a bound lamb—sacrificial animal s[...] Christ himself—that he was carrying to mark[...] has dropped and spilled a huge jug of milk. [...] a crowd gathers to gape at those unfortuna[...] up in the process of punishment, just like th[...] alongside the cart carrying the two thieves.

This attentive spectatorship to access[...] makes the corresponding lack of attention b[...] to Christ's own plight all the more striking— [...] spiritual inattention that can only be char[...] spiritual blindness.[17] It also contrasts wit[...] sight and spiritual enlightenment of the [...] on the foreground hillside; they do not e[...] turn toward the cross in order to know—i[...] its deep spiritual significance as a salvific [...] humanity. Of course, we viewers, too, fail [...] presence of Christ on casual first inspection [...] crowded panel. Closer examination, howeve[...] ure of Christ, fallen under the cross (plate 8) [...] tormentors above and beside him. Some o[...] down, adding to the weight of the cross; a[...] faces stands a fool, dressed in the distincti[...] and oversized bells (Bruegel would desig[...]

[...]graving; see plate 76). Before the cross a strangely [...] figure wearing a dark coat with crescent moons [...] a horn to announce the progress of the cross. At [...] ne time, some of the mounted or walking figures [...] and just below Christ and the cross manifestly [...] away from him and present their backs as they stare [...] direction of Simon of Cyrene.

[...] the one foreground figure next to the holy fig-[...] the lower center, who has the best vantage point [...] entire painting, turns leftward and only notes [...]ing thief with a bag over his shoulder, perhaps [...]ed from the same goods left behind by Simon of [...]. That foreground figure is a peddler with a back-[...] bearing catskins and oversized wooden spoons, [...]d in a subsistence and materialist way of life. He [...]bles two Bosch peddlers, figures who traverse a [...]ng and dangerous landscape, either on the exte-[...] of the *Haywain* triptych (Prado, Madrid) or on a [...]le tondo that once also formed the exterior of a [...]mbered altarpiece (plate 12).[18] Moreover, Bruegel's [...]rer remains seated and passive at the very moment [...] Simon of Cyrene is dragooned into service to assist [...] he cross.

[...]us the vast crowd of ordinary peasants, squat and [...] and scattered across the expanse of this setting, suc-[...]s to the varied array of distractions—whether the [...]es in the cart, the tussle around Simon of Cyrene, [...]t the process of going to market or to a public exe-[...]n. Their masklike faces are simple and caricatured. [...] as Joseph Gregory cogently reminds us, they are

9 *(page 20)*
Pieter Bruegel
Christ Carrying the Cross, 1564
Detail of plate 8

10 *(page 21)*
Hieronymus Bosch (c. 1450–1516)
Christ Carrying the Cross
Oil on panel, 22¼ × 12½ in.
(57.2 × 32 cm)
Kunsthistorisches Museum, Vienna

11 *(page 22)*
Hieronymus Bosch
Christ Carrying the Cross
Oil on panel, 58½ × 36⅝ in.
(150 × 94 cm)
Monastery of San Lorenzo de
El Escorial, Madrid

12 *(above)*
Hieronymus Bosch
Peddler
Oil on panel, 27¾ × 27½ in.
(71 × 70.6 cm)
Museum Boijmans Van Beuningen,
Rotterdam

all dressed as contemporaries, conveying the message of their spiritual blindness in a quotidian world and revealing their distance from the holy figures and the true significance of the *Carrying of the Cross*.[19]

Seeing truly, therefore, becomes the theme of this entire panel, as the vast sweep of the procession, punctuated by the bright red coats of the mounted soldiers, curves around from the left center to recede to the right distance, where a crowd is forming in a circle at Golgotha, marking the precinct of the destined punishment upon the crosses. One pious figure, bearded and in profile—even interpreted by Jürgen Müller and Joseph Gregory as a self-portrait of Bruegel—does see clearly.[20] He stands modestly at the right edge of the painting, beside the trunk that forms the base of a torture wheel above in echo of the circle of Golgotha at the upper right. A second man in dark clothing clasps the trunk; he has a distressed look in his large and pensive eyes, and he seems not to look in the direction of the cross, though his grief seems profound (Gregory even identifies him with despairing Judas, though he lacks the yellow clothing and red hair often used to designate that character). A few nuns, turning toward Jesus with dramatically mournful gestures, link these observers at right to the group of the holy figures on the right foreground rise.

If the Vienna picture combines the contemporary with the biblical in its figures, it also freely mixes different kinds of spaces to devise a composite landscape. Bruegel has long been admired for his encompassing landscape spaces, which he had begun in the form of drawings as his earliest images (chapter 4). In this respect, his painting culminates half a century of landscape painting in his hometown of Antwerp, going back to the innovations of Joachim Patinir (active 1515–24).[21] On one level, the layout of the setting presents a Flemish plain, punctuated arbitrarily by a towering rock in the center, atop which stands a characteristically Netherlandish windmill. Yet at the same time in the hazy left distance appears the walled city of Jerusalem, marked by the centrally planned, domed Temple structure at its heart.[22] While the dominant flow of the movement emerges out of Jerusalem, several peasants on the left side appear headed into the city with their wares.

Bruegel's composed landscape also contains calculated contrasts, particularly between the two sides. At the left edge, balancing the dead tree with torture wheel at the right, rises another tree, sporting leafy foliage. Similar contrasts color the skies across the expanse of the painting: a sunny left side gives way over the span of the procession to an increasingly lowering dark sky, with thick clouds and flying dark carrion crows above the Golgotha mount at the upper right.

In the center the high hill with the windmill contrasts vertically with the dominant horizontal format of the panel in general. Moreover, this steep hill presents a formidable climb in contrast to the seated comfort of the peddler directly below it; close inspection shows that a tiny figure atop the rock peers down and faces the viewer, providing an inverse to the peddler's back in the foreground. This contrast suggests the arduous upward path of virtue compared to the easy, wide path of pleasure and worldliness.[23] The broad plain of worldliness in the horizontal expanse is where the peasants and soldiers carry on life as usual.

Several scholars have interpreted the windmill atop the rock symbolically.[24] It can be seen in its role as the grinder of grain, source of life and of the Christian Eucharist, and thus a clear link to the sacrifice of Christ as the bread of life (John 6:51). Walter Gibson also evokes the poetry of Bruegel's contemporary, Jan van den Berghe, *Leenhof der gilden* (1564), which uses the windmill as an image to symbolize frequent and easy change, blowing with every change of wind.[25] The turning of the wheel also suggests the cyclical passage of time and the recurrence of the everyday. In Christian terms this raises the late medieval notion of the "perpetual Passion," which holds that the sins of humanity continually torment Christ and that meditation on the Passion in the present provides a proper mood of pious penitence.[26] In this respect, as Gibson first noted, the shape of the windmill's intersecting vanes evokes both the recurrence and the shape of meditation on the cross. Importantly, Bruegel turns the windmill so that its cruciform blades face toward Golgotha, where two crosses already stand in place, awaiting the arrival of Jesus with his own cross.

Bruegel has been justly celebrated for his mastery of landscape and for his coordination of such a vast crowd of simple, ordinary, contemporary figures of peasants and soldiers. Yet for all of his originality, Bruegel already has shown sensitive utilization of both figures and types from important predecessors, chiefly Rogier van der Weyden and Hieronymus Bosch. Moreover, for this subject of the *Christ Carrying the Cross*, his imagery depended upon a long pictorial tradition in Flemish painting, extending all the way back to the founding master, Jan van Eyck (active 1425–41).

The earliest of the major, influential images of *Christ Carrying the Cross* was a work painted by Jan van Eyck, preserved only in painted copies (the best version is in

Budapest; plate 13) but also in a drawing vari[...] 14).[27] This work, set within an expansive la[...] already sets the compositional schema later em[...] Bruegel: a curving path with spectators along [...] Christ in the center foreground, marked in pl[...] large intersecting beams of the cross; the tw[...] bound and in front (on foot); Jerusalem in th[...] one side (right) and the destination of Golgo[...] opposite side (left) in the distance as a destina[...] where the two crosses of the thieves are alrea[...] Even the squat figure types are already pres[...]

[...]odel, perhaps captured more sensitively by the [...]rawing. Much of this same Eyckian vitality and [...]ic scope for the procession to Calvary is cap-[...] a widely circulated engraving (c. 1475) by the [...] painter-printmaker Martin Schongauer (active [...]91; plate 15).[28] That work retains the same direc-[...]r the horizontal procession as Van Eyck's orig-[...]ugh it crowds the figures more closely to the [...] the composition, even as it retains the curving [...] of the masses toward Golgotha in the back left. [...]auer's print also captures some of the additional

13
After Jan van Eyck (act. 1425–41)
Christ Carrying the Cross
Oil on wood, 38 × 50½ in.
(97.5 × 129.5 cm)
Szépmüvészeti Múzeum, Budapest

14 *(top)*
After Jan van Eyck
Christ Carrying the Cross
Drawing, 8 × 10⅞ in. (20.5 × 27.9 cm)
Albertina, Vienna

15 *(bottom)*
Martin Schongauer (act. c. 1470–90)
Christ Carrying the Cross
Engraving, 11¼ × 16⅝ in. (28.7 × 42.5 cm)
Kupferstichkabinett, Berlin

elements of Bruegel's Vienna painting: the lowering sky of dark clouds above the place of execution as well as the isolated cluster of holy figures, here quite miniaturized within a valley pocket just before the cross in the central distance, rather than featured in the corner foreground as with Bruegel.

But Bruegel's *Way to Calvary* does not simply concoct a recipe of ingredients from fifteenth-century masterpieces, whether van Eyck's painting or Schongauer's engraving. Instead, Bruegel built upon a plentiful series of more recent renditions of this subject by his Flemish sixteenth-century antecedents, all of whom situated this theme in panoramic landscapes.[29] This active pictorial tradition, including paintings by the Master of the Brunswick Monogram, Herri met de Bles, and Pieter Aertsen, must be reckoned as the solid foundation upon which Bruegel constructed his own variation upon an inherited theme.

Falkenburg has called attention in these landscapes with the *Christ Carrying the Cross* to the antithetical imagery, which Bruegel heightened in its contrast for the Vienna painting by setting the massive uplift of the central rock and windmill against the broad expanse of the procession.[30] Once more, the touchstone for this metaphor is Christ's own parable (Matthew 7:13–14) about the narrow gate and steep path to eternal life versus the "broad way that leads to destruction, and there are many who go in by it." Bruegel counters the left-to-right movement of Jesus and the cross with a countervailing movement by peasants on their way to the city (Jerusalem) for market, especially at the left edge of the panel, where their backs are turned to the viewer as they make their way. This is the same purpose that Simon of Cyrene and his wife were also pursuing when they were rudely interrupted in their everyday, material existence by the intrusion of history in the form of Roman soldiers accompanying the cross.

The Way to Calvary was a favorite subject during the second quarter of the sixteenth century in the art of Bruegel's Antwerp. More of these works were painted by Herri met de Bles than by any other artist. Bles, usually identified with "Herri de Patinir," a registrant in the Antwerp St. Luke's guild in 1535, is assumed to have been the nephew of pioneer landscape painter Joachim Patinir.[31] While Bles's large workshop production means that there is considerable variability in his paintings concerning their fineness of execution, atmosphere, or repetition of motifs, a number of basic types, formative for Bruegel's conception in Vienna, emerged from that studio.

Close to the Van Eyck/Schongauer model i[s a Christ] *Carrying the Cross* by Bles (plate 16), where [the richly] detailed figures in orientalist costumes, some o[f them on] horseback, proceed with the two bound thie[ves across] the landscape from right to left: Jerusalem's ga[te] is their point of origin, its centrally planne[d] Temple stands in the center behind the wa[lls] Christ and the cross, and Calvary is a raised [...] mount at the left. The tiny holy figures appear [...] in the middle distance in front of the centra[l gate and] Temple. More extraordinary are the still more [...] figures within the Temple precinct in the ba[ckground]

[who en]ct earlier scenes from Holy Week and the Pas-[sion, be]ginning with the Entry into Jerusalem.[32] On a [th]e left corner stands a peddler figure with a large [...] his back; he observes the procession along with [some ch]ildren who have climbed up a dead tree to view [the spec]tacle. In this work there are no peasants going [the othe]r way, only spectators along the side of the road. [As a sug]gestion of the universal significance of the scene, [several] blacks even appear within the crowd alongside [the peas]ants.

[In va]rious related but differing versions, Bles's work-[shop ge]nerated well over a dozen versions of this subject

16
Herri met de Bles (c. 1510–c. 1555–60)
Christ Carrying the Cross, c. 1536
Oil on panel, 32 × 44⅝ in.
(82.2 × 114.3 cm)
Princeton University Art Museum,
New Jersey

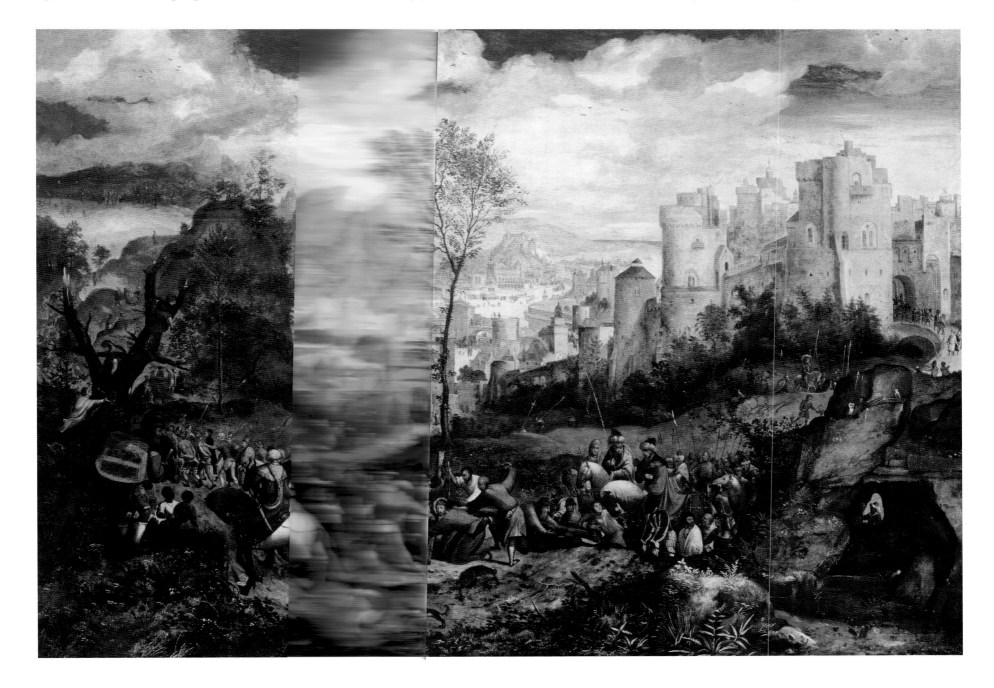

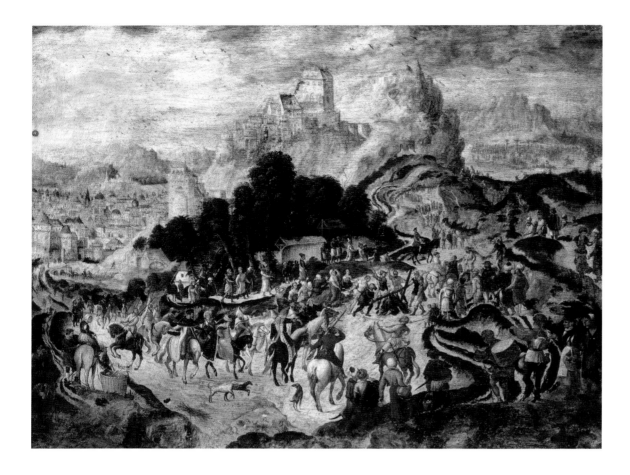

in a vast landscape. One compositional type features a massive mountain rising over the center of the composition at a distance with Jerusalem at the left and the procession turning around a foreground pivot that now places Jesus and the cross already a certain distance down the road toward a distant Golgotha, lost in the haze at right, where all three crosses are visibly upright (the best version is in Palazzo Doria-Pamphilij, Rome; plate 17; a close second version, including some of the same figures, is in Akademie, Vienna). Like the Bruegel Vienna panel, this image features some eighty small figures as part of an even larger crowd of spectators. Their costumes vary from the exotic turbans of the Near East to the contemporary garb of peasants and mounted redcoat soldiers. In this case, at the edge of the curving road a number of peasants with large baskets, many seen from behind in the foreground, clearly have paused on their way to market and watch the procession like us viewers.

The closest model for Bruegel from the previous generation was the anonymous Master of the Brunswick Monogram, often identified as Jan van Amstel, an artist recorded in the Antwerp guild in 1527–28.[33] Two key works situate Christ in procession within a large landscape panorama, filled with hosts of tiny figures: *Christ's Entry into Jerusalem* (probably 1537, with traces of date; plate 18) and *Christ Carrying the Cross* (plate 19). In the Stuttgart *Entry* the procession advances down from a hill at the left rear across to right distance, but in this case the city of Jerusalem, shrouded in bluish haze, becomes the destination, not the starting point.[34] A spindly tree at the right edge frames the composition with verdant foliage. Already in this work Christ appears as a small figure on his donkey, near the center of the composition but surrounded by crowds of small, stout figures, mostly in contemporary dress, punctuated with bright colors of red and yellow. A small group of them gathers in the immediate foreground; one of them even bears a bound lamb upon his shoulders, and a woman at left carries a large jug on her head, the same kind of vessel that fell and spilled when Simon of Cyrene's wife intervened against the soldiers in Bruegel's Vienna painting. Some behavior in the Stuttgart crowd is anything but exemplary: for example, one man kicks the colt behind Christ; several men farther back are fighting over a garment; meanwhile, near the back another figure in yellow (visible at left above a dog) deftly picks the purse of a distracted follower in blue.

The Louvre *Way to Calvary* more fully integrates the parts of the landscape by placing an expansive view of Jerusalem at left immediately next to Golgotha on the right, which is distinguished largely by its elevation and the dense crowd of spectators in a circle at the horizon under ominous skies. Once more the figure of Jesus stumbles under the weight of the cross just below the center of the picture. Many figures on horseback are in the procession; some of them farther ahead carry imperial banners that feature the double-headed eagle of the Holy Roman Empire, the contemporary vestige of ancient Rome. Numerous onlookers occupy favorable vantage points, chiefly in the left corner foreground and on a rise with trees above the right corner. Coming from the opposite direction is a hay wagon, a symbol of useless materialism and greed in the works of Bosch (for example, his Madrid and Escorial *Haywain* triptychs).[35] As in the Stuttgart *Entry*, a stretch of ground between the lower edge and the first spectators, seen from behind, suggests continuity with the viewer space and strongly implicates the viewer as another observer of the procession. This powerful appeal to the vision and the insight of the beholder was readily adopted by Bruegel for his Vienna picture.

A final, major, near-contemporary influence on Bruegel's Vienna painting comes from Pieter Aertsen (active in Antwerp 1553–57, but born in Amsterdam, where he

completed his career).[36] In a lost painting of *C... rying the Cross* (1552, Berlin) Aertsen inserte... vignettes that were adopted by Bruegel for th... painting. In the right corner appears the sce... Simon of Cyrene is unwillingly conscripted to... his wife struggles to pull him away from the... Their goods are left behind: the spilled mil... the ground below the wife's feet, and the pan... the foodstuffs for market is left behind, to be...

...ditionally, the materialism and indifference of ...ants to Jesus's plight is further underscored by ...nce of a large cart with wares and baskets in the ...eground, which manifestly is proceeding in the ... direction of the way of the cross above it. In ...iddle ground one of the two thieves, stripped, ... a cart, accompanied by a monk to hear his ...on; the other, also nude, rides slumped over a ...orse ... the lower left. Opposite him, a peasant rides

18

Master of the Brunswick Monogram
(Jan van Amstel?)
Christ's Entry into Jerusalem,
traces of date 153[7] (?)
Oil on panel, 32½ × 40 in.
(83.3 × 102.5 cm)
Staatsgalerie, Stuttgart

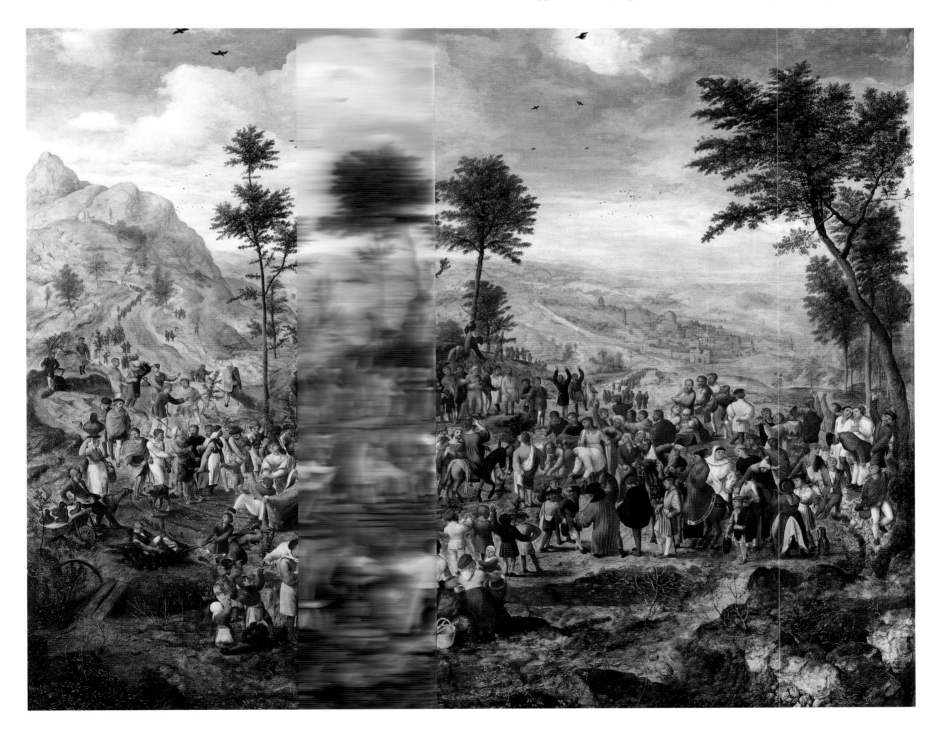

19
Master of the Brunswick Monogram
(Jan van Amstel?)
Christ Carrying the Cross
27¼ × 32¾ in. (70 × 84 cm)
Musée du Louvre, Paris

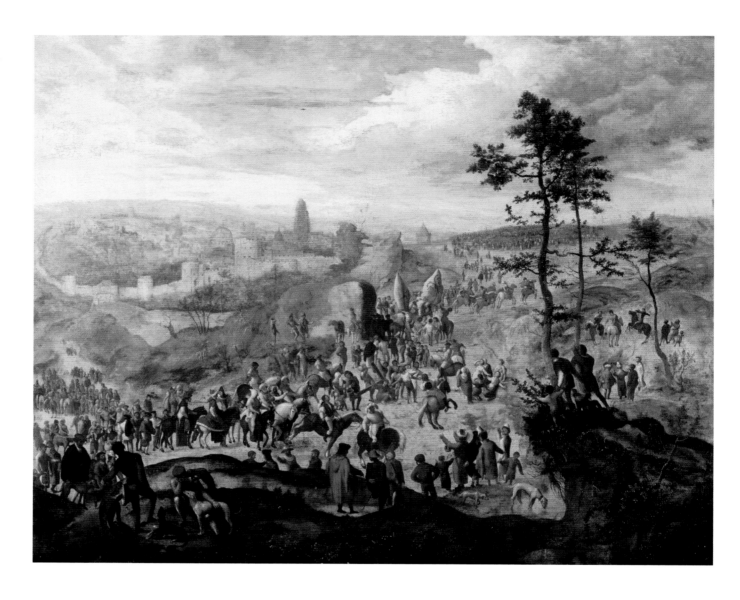

backward on the horse that draws the cart, and facing backward he fails to see either the thief or Jesus, but rather seems to be distracted by the Simon of Cyrene fracas. In Aertsen's Berlin formulation, Jesus falls amid his tormentors, but now he appears off-center in the upper right, already ascending the steep hillside of Calvary. Moreover, the scene is now presented like Bruegel's, much more as a site of public executions—with torture wheels, an enormous gallows, and other instruments of punishment. Aertsen strives more than Bruegel to show historical costumes, for example, the short tunics and armor for Roman soldiers, but he also retains the contemporary representation of peasant observers. Indeed, without Christ at the center of the composition, the viewer is even more prone to be distracted by the details of the scenes. Although the Virgin swoons in the company of holy figures, here her elevated viewing place is situated well within the picture space, on line with the

cross and in the middle distance, and thus easily overlooked amid all the other activities.

A second, larger version of the subject by Aertsen (plate 20) vividly contrasts the sky above Golgotha on the right and Jerusalem on the left. In this image a variety of events in the sequence of the Crucifixion are represented; for example, in the right distance on high, the second of the three crosses is being erected. Meanwhile, Jesus appears just entering the foreground area near the left edge, already assisted by Simon of Cyrene with the heavy burden of the cross. On the flank of the hill in the left middle distance before Jerusalem the holy figures remain isolated and obscure, albeit in brighter light. The foreground plane is entirely dominated by peasants looking in all directions.

Just before Bruegel's own 1564 Vienna staging of the subject, Aertsen's nephew, Joachim Beuckelaer (active 1560–c. 1573), produced a pair of related images: in

Hamburg (1563), which essentially repeats the [...] les and Pieter Aertsen. His interpretation of this
Aertsen in reverse; and in Tokyo (1562; plate 2 [...] subject included busy peasants trudging to mar-
latter picture offers a vertical format to emph [...] ing the Crucifixion as a contemporary form of
steep ascent to Golgotha, where instruments o [...] ecution, and two thieves riding with monk con-
especially the large gallows, are very much in [...] carts en route to their demise. Bruegel offered a
under threatening skies. Christ appears clos [...] onal representation of Jerusalem as a historic city
viewer in the lower center, assisted by Simon [...] ntrally planned domed Temple on its skyline. His
but persecuted by numerous figures in historic [...] rominence for the historically distinct holy fig-
What Beuckelaer added to the equation is his p [...] red costumes and types derived ultimately from
placement of the swooning Virgin surrounded [...] an der Weyden but also based upon a recent pre-
figures in the lower right corner. Just as with [...] n in this scenic context by Joachim Beuckelaer.
these figures turn away from the procession.

 For his own *Christ Carrying the Cross* i [...] [...] rse, like all artists, Bruegel responded to exist-
(plate 8), Bruegel thus incorporated innovative [...] ite local formulations with his own creative syn-
ideas about representing that popular theme in a [...] owever, sometimes the request for a particular
sive landscape, which had been developing for a [...] subject could come from its owner—in the case
of a century in Antwerp paintings, particularly [...] enna *Christ Carrying the Cross* we are in the for-
[...] unusual, situation of knowing precisely who

20

Pieter Aertsen (1507/8–1575)
Christ Carrying the Cross, 1552
Oil on panel, 42⅛ × 65½ in.
(108 × 168 cm)
Koninklijk Museum voor Schone
Kunsten, Antwerp

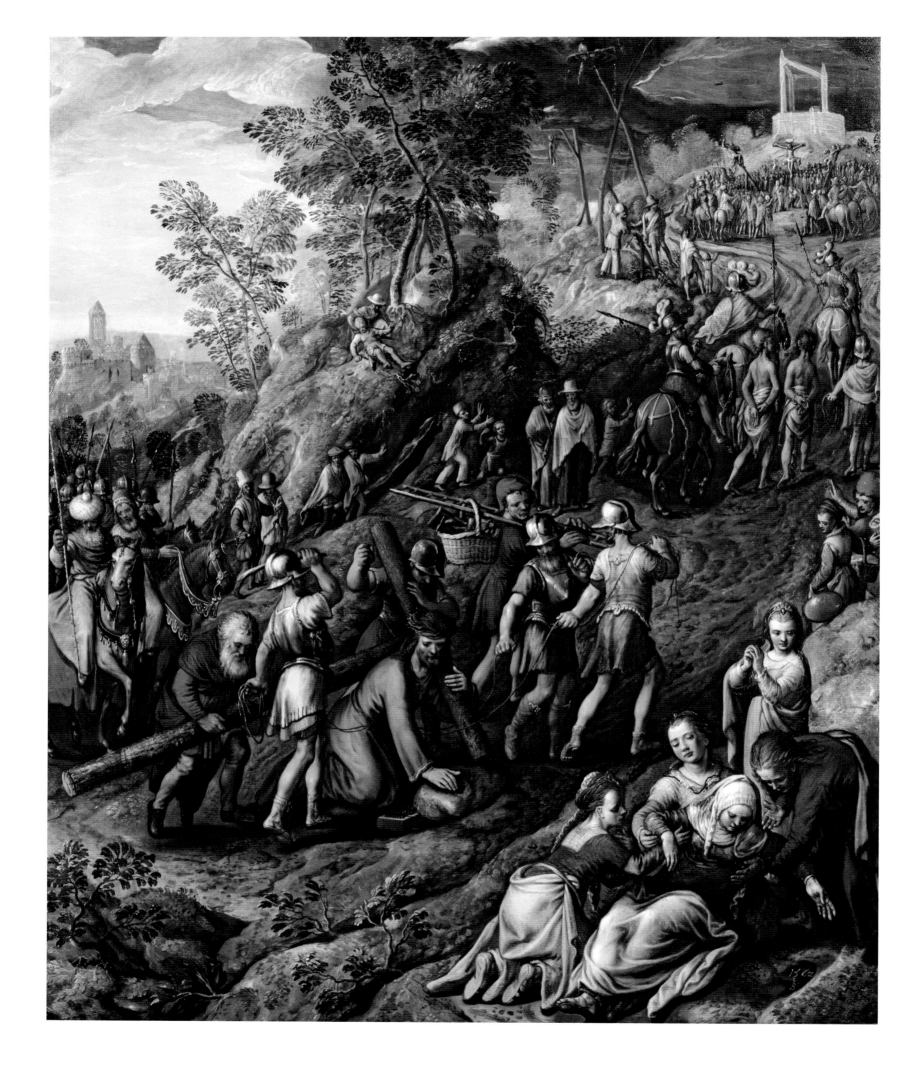

owned the work. That same owner, Nicolaes Jo[ngelinck] also either purchased or commissioned Brueg[el's set] of *The Months* (chapter 9).[38] Brother of a me[dalist and] sculptor, Jacques Jongelinck, Nicolaes was a ma[n of con]siderable wealth and political connections as re[ceiver of] the Zeeland toll on shipping.[39] A sophisticate[d col]lector, Nicolaes Jongelinck owned no fewer tha[n sixteen] paintings by Bruegel, and his other rooms c[ontained] one painting by Albrecht Dürer and two large [sets by] Bruegel's contemporary rival in Antwerp, Fra[ns Floris] (chapter 2): one set of the Liberal Arts, the ot[her of the] Labors of Hercules. All these works were locate[d at Jon]gelinck's suburban residence near Antwerp's c[ity walls,] and they were recorded in an inventory of h[is goods] when he forfeited them as security in payment f[or a debt.] At the time of his death in 1570 Nicolaes Jo[ngelinck] owed money to a number of creditors, inclu[ding even] King Philip II of Spain, who had seen the Fl[emish Her]cules pictures during his earlier residence in [the Low] Countries, 1556–58.[40]

We can imagine that Jongelinck, document[ed owner] of so many other Bruegels, appreciated *Christ [Carrying] the Cross* as one of those pictures that summar[izes all of] the achievements of Pieter Bruegel. It feature[s a superbly] rendered, expansive landscape setting. Its ros[ter of fig]ures includes contemporary peasants and sol[diers, but] also closely studied allusions to traditional Fle[mish art] figures, chiefly based on Rogier van der Wey[den. For] his basic pictorial ideas, Bruegel readily adopt[s both the] subject and the representational strategy of th[e Way to] Calvary in his Vienna picture, incorporating [crowded] scenes of small figures that extends back to Jan [van Eyck,] Martin Schongauer, and Hieronymus Bosch. [Addition]ally, he also picks up on the more recent em[phasis on] landscape settings for this Passion event with[...work] from the previous generation, principally fr[om Herri] met de Bles as well as his near contemporari[es Pieter] Aertsen and Joachim Beuckelaer.

Yet Bruegel still realizes his image with an i[mportant] novelty. His holy figures in the corner assu[me a new]

[promine]nce, and both their proportions and costumes [contrast] utterly with the crowded scene of peasants [and soldi]ers. But most significant is the very process of [viewing] this Vienna painting. Amid all of the distrac-[tions of] figures and settings, Bruegel forces the viewer [to seek] out and discover the figure of Jesus fallen under [the cross]. From a position like the elevated foreground [position] of the holy figures, juxtaposed with the elevated [setting] of the central hill and its windmill, the viewer [surveys] all these details and must discern the principal [figures a]nd their significance within this picture, includ-[ing the] distance points of Jerusalem at the left and the [execution] site of Golgotha at the right.

[Follo]wing the visual sequence of scenes is like a verbal [meditati]onal sequence, so popular in late medieval devo-[tional li]terature, that amplifies the narrative through [added] moments in Christ's lifetime events, especially his [Passion] as recounted in such perennial works from the [fourteen]th century as Ludolph of Saxony's *Vita Christi* [or the an]onymous *Meditations on the Life of Christ*.[41] Yet [Bruegel'] s deliberate use of contemporary figures and sit-[uations] especially the torture instruments and execution [scene enc]ourages added viewer empathy for the biblical [situation] and poses a moral choice akin to that of Simon [of Cyre]ne or other indifferent witnesses to this particu-[lar mom]ent of human suffering.

[At the] time that he painted *Christ Carrying the Cross* in [1562 Piet]er Bruegel had been making images in Antwerp [for about] a decade after a documented trip to Rome. He [had beg]un his career as a designer for engraved prints, [particula]rly of landscapes and of religious subjects, then [moved] into a career chiefly as a painter. This picture [exemplif]ies the range of his earlier achievements, even as [it points] the way to his distinctive final paintings—both [of unconve]ntionally staged religious subjects and of [peasants] in crucial moments of moral decision-making. [Just as w]e viewers can survey the expanse of Calvary in [this pain]ting, so can we get a sense of the artist's entire [career fr]om this decisive moment and this individual [accomp]lishment.

21

Joachim Beuckelaer (c. 1533–1574)
Christ Carrying the Cross, 1562
Oil on panel, 37⅝ × 30¾ in.
(96.5 × 79 cm)
National Museum of Western Art,
Tokyo

2

BRUEGEL IN
ANTWERP

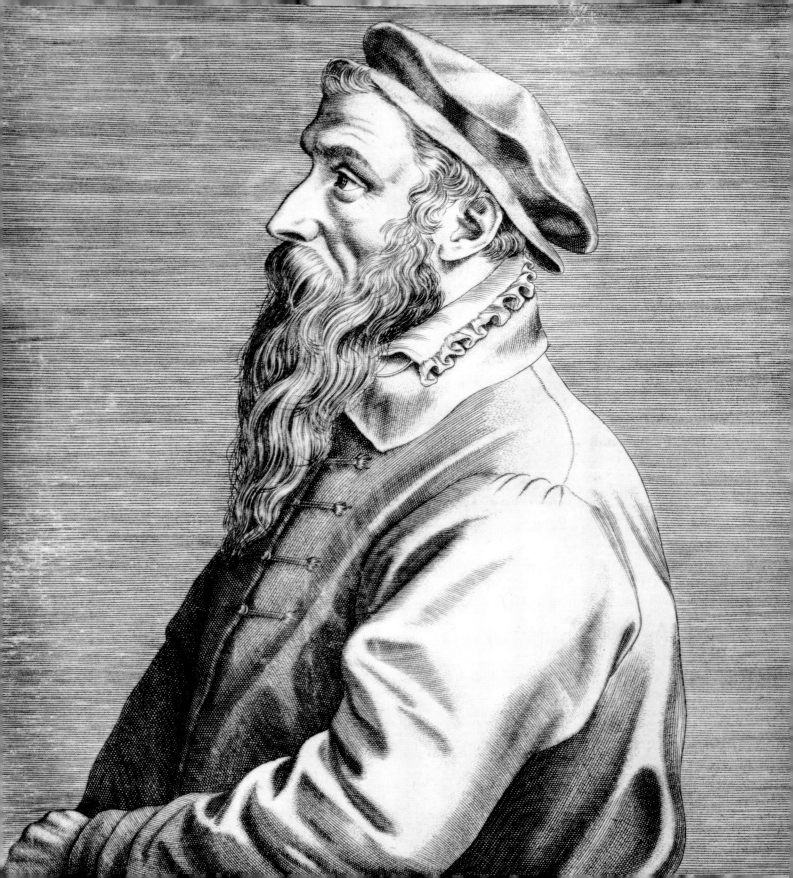

Any consideration of Bruegel's life and ⸺ ⸺ begin with his home town, Antwer⸺ ⸺ shaped the issues and circumstance⸺ ⸺ art-making. At the time of Bruegel's admissio⸺ ⸺ Antwerp painter's guild of Saint Luke in 1551⸺ ⸺ had enjoyed half a century of unparalleled gr⸺ prosperity, making it the "capital of capitalism⸺ ⸺ height of its early sixteenth-century economic⸺ Antwerp served as the crossing point for exc⸺ commodity imports: Portuguese spices, Gern⸺ als, Baltic timber and grain, Spanish and Engli⸺ These exchanges were facilitated by financial flo⸺ merchant "colonies" from various corners of ⸺ including the English Merchant Adventurer⸺ ish, French, South Germans, the Hanseatic ⸺ ("Easterlings"), as well as various Italian cent⸺ as the Lombards and Genoese.[2] The city's p⸺ was severely hampered in 1557 by Spain's declar⸺ ruptcy—soon rippling out to Portugal and Fran⸺ lowed by the Dutch Revolt, beginning in the la⸺ (chapter 8).

Within that economic boom—and occasion⸺ turns—art also prospered.[3] The first permanent⸺ ket was established in the city in an artists' gal⸺ the newly built financial exchange, the Bourse (⸺ replaced the two-week art market within the te⸺ Brabant trade fairs that had predominated du⸺ fifteenth century.[4] Moreover, importantly for ⸺ one major Antwerp innovation in art produc⸺ the development of print publishers, led by ⸺ own publisher, Hieronymus Cock, whose s⸺ aptly named At the Sign of the Four Winds (Au⸺ Vents; chapter 3).[5] As Karel van Mander declar⸺ 1604 *Schilderboek* (Book of Painting):

> The renowned and splendid city of Antwerp, ⸺
> owes its bloom to trade, has succeeded in attr⸺
> to itself from all over the most important rep⸺
> tatives of our art, who have also taken them⸺
> there in great numbers, because art stops gla⸺
> the vicinity of riches. . . . In the same meas⸺
> Florence earlier in Italy, so does Antwerp now⸺
> to be a mother of artists in the Netherlands.[6]

Certainly Pieter Bruegel was one of those art⸺ ⸺ migrated to Antwerp to make his name and fo⸺ ⸺ the new art market conditions.

⸺ tist as celebrated as Pieter Bruegel, documenta-
⸺ ains surprisingly scarce. Even his birthplace is
⸺ n. The principal early two-page biography from
⸺ *derboek* by Van Mander (Haarlem, 1604) post-
⸺ y credits a namesake city, Brueghel, near Breda
⸺ ovince of Noord-Brabant, though the reliability
⸺ formation has been questioned. For example,
⸺ o Guicciardini, an Italian visitor to Antwerp and
⸺ Countries, declares in his published account
⸺ t Bruegel was born in Breda itself, and he goes
⸺ ise him as such a great imitator of Hieronymus
⸺ his own day that he was known as a "second
⸺ nus Bosch."[7]

⸺ Van Mander's sketch remains the starting point
⸺ iography sketch of the painter, the most plau-
⸺ ness of Bruegel is a profile engraving (plate 24),
⸺ to the Antwerp printmaker Jan or Johannes
⸺ nd issued by the same print publishing house,
⸺ tre Vents, where Bruegel had worked in his
⸺ er in Antwerp. This portrait appears within a
⸺ images of the celebrated Netherlandish paint-
⸺ comprised the local tradition. Each portrait was
⸺ nied by Latin verses, penned by Domenicus
⸺ ius in praise of the individual.[8] The panegyric
⸺ out Bruegel read, in translation:

> ⸺ s this new Hieronymus Bosch, reborn to the
> ⸺ who brings his master's ingenious flights
> ⸺ y to life once more so skillfully with brush
> ⸺ yle that he even surpasses him? Honor to
> ⸺ eter, as your work is honorable, since for the
> ⸺ ous inventions of your art, full of wit, in the
> ⸺ r of the old master, you are no less worth of
> ⸺ nd praise than any other artist.[9]

⸺ s painters guild contains an entry admitting the
⸺ s "Peeter Brueghels painter") in 1551, which sug-
⸺ t he was born about a quarter-century earlier.[10]
⸺ der is the only source for Bruegel's training,
⸺ scribes the apprenticeship to Pieter Coecke van
⸺ 550), a leading painter in Antwerp and tapestry
⸺ based in Brussels; his wife, Mayken Verhulst,
⸺ ed watercolor specialist and miniaturist.[11] This
⸺ iod establishes a link between Bruegel and the
⸺ y of the Spanish Netherlands, to which he later
⸺ 1563. According to Van Mander, Bruegel went
⸺ ry the daughter of Coecke. Bruegel's admission
⸺ twerp guild might have been occasioned by the

PETRO BRVEGEL. PICTORI.

22 (pages 34–35)
Pieter Bruegel
Two Monkeys, 1562
Detail of plate 51

23 (opposite)
Theodore Galle
Portrait of Pieter Bruegel
Engraving
Private collection

24 (above)
Jan Wierix
Portrait of Peter Bruegel
from Domenicus Lampsonius,
Pictorum aliquot celebrium
Germaniae Inferiores effigies, 1572
Private collection

23

recent death of his former master, so he might have been
older than some of the other new painters in the city.
Certainly Coecke's grand style, shaped by Italy, seems to
have made little impression on Bruegel's work.

Other documents, discovered only a generation ago,
reveal that the young Bruegel was already busy in 1550–
51. Together with a slightly older artist (admitted to the
Antwerp guild in 1540), Pieter Baltens, he served as the
minor collaborator on an altarpiece for St. Rombouts in
nearby Mechelen (the home town of Mayken Verhulst)
for the glovemakers guild.[12] Baltens produced the main,
central panel of the altarpiece, devoted to legends of the
local saint, Gommarius (Gomer); Bruegel added the
wings, showing local patron saints, Rombout and Gom-
marius, on their grisaille exterior.

Van Mander claims that the artist next left his native
land for Italy by way of France. Later images by the
painter in all media show his personal familiarity with
Sicily (see below). Certainly indirect evidence in the
early landscape drawings of Bruegel suggests that he
studied works by Italian masters, particularly Titian and
his circle in Venice. His *Southern Cloister in a Valley* (plate
81) shows firsthand observation of Italian hillside topog-
raphy and is executed on French paper. One of Bruegel's
early designs for engravings, *Prospectus Tyburtinus* (*View
of Tivoli*; plate 26), part of the Large Landscapes pro-
duced by Cock around 1555 (chapter 3), features a water-
fall setting on the Tiber near Rome. Another drawing
shows the principal dock region of the Tiber River, the
Ripa Grande (plate 25), duly labeled "a ripa" by the artist
himself in the same ink.[13] Additionally, a later letter from
an Italian doctor to Bruegel's distinguished Antwerp
patron, Abraham Ortelius, passes greetings along to the
artist as well as his younger Antwerp associate (inscribed
in the Antwerp guild in 1558), Marten de Vos.[14]

One of the leading artists in Rome, Croatian minia-
turist Giulio Clovio, who produced the luxury manu-
script Farnese Hours (New York, Morgan Library; plate
252) for Cardinal Alessandro Farnese, mentions several
lost Bruegel works in his 1578 inventory.[15] These cited
works are plausible products of Bruegel's hand, even if
executed in media that appear nowhere else in his later
work. For example, a *Tower of Babel*, one of his favor-
ite subjects later (plates 215, 240), was painted on ivory.
Additionally, a pair of landscapes includes a gouache
View of Lyons (*Lion di Francia*)—doubtless the product
of the artist's trip down to Italy.[16] Thus Bruegel's time
in Rome included some kind of affiliation (like the link
two decades later between Giulio Clovio and the young
El Greco) of the novice with a leading older artist who

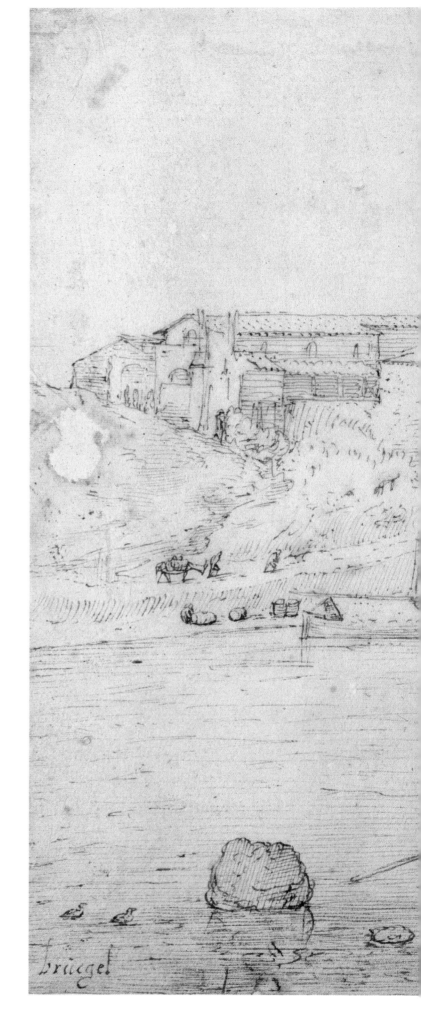

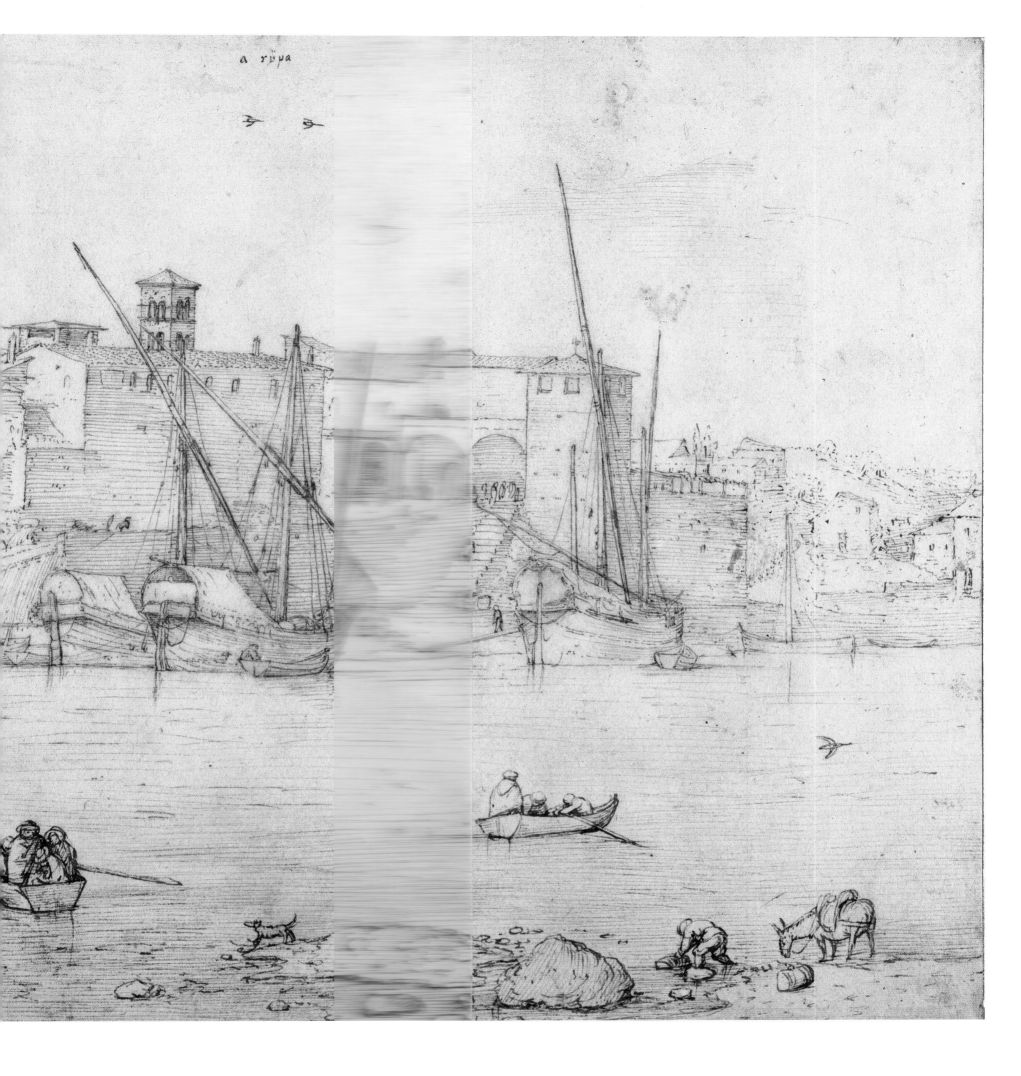

a rÿpa

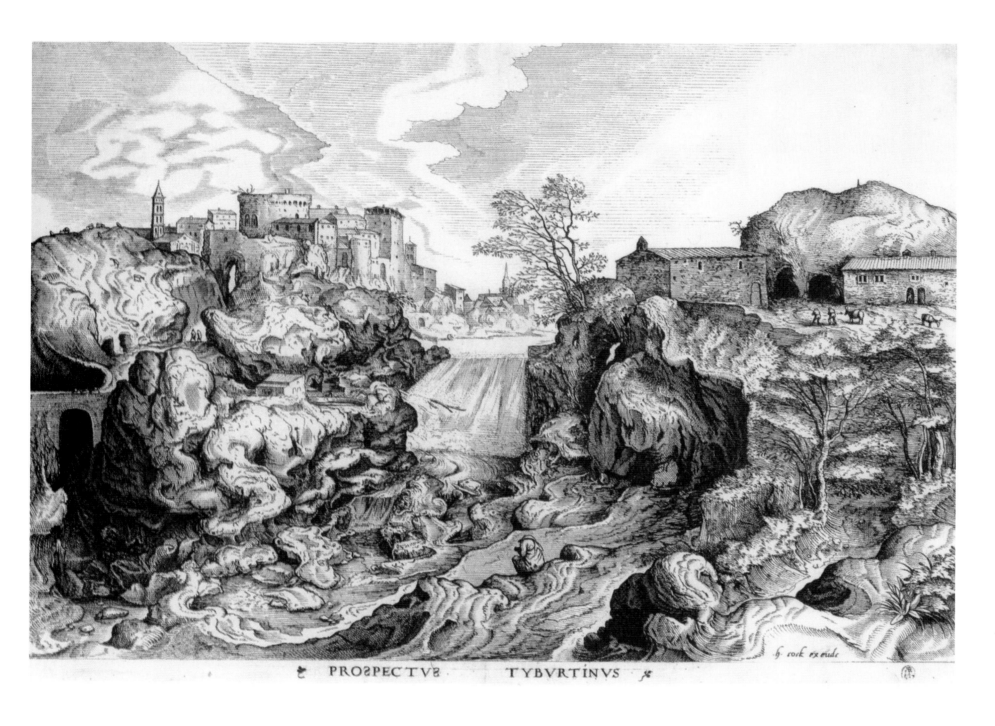

PROSPECTVS TYBVRTINVS

26

Jan and Lucas Duetecum,
after Pieter Bruegel
View of Tivoli, c. 1555
Etching from Large Landscapes
12⅝ × 16½ in. (32.7 × 42.7 cm)
Private collection

had immigrated there earlier in his own right. Moreover, landscape art as a category of production emerged early in Bruegel's career, and the documentation supports the surviving landscape drawings, dated as early as 1552–54.

When Bruegel returned to Antwerp around 1554, he began to work for Hieronymus Cock, an etcher-turned-print publisher, who became a leading entrepreneur from his publishing house Aux Quatre Vents.[17] Cock himself had been in Rome and returned with drawings that he used as the basis of his own etchings of views of ruins (1550–51), featuring the Colosseum (plate 54).

He coordinated the efforts of print designers—among whom Bruegel—with professional engravers to produce a wide variety of print subjects and categories (chapter 3). One of his first engravers was an Italian, Giorgio Ghisi, who also worked between 1550 and 1555 to replicate a number of previously executed compositions by the likes of Raphael and Bronzino before returning to Italy for the rest of his career. Cock also featured (and Ghisi sometimes engraved) the Italianate forms of a Netherlander from Liège who had also visited Rome himself: Lambert Lombard.[18] Thus the Italianate interests

in style and historical subjects that characteriz... som...
midcentury Flemish art production was well s...
Hieronymus Cock, if not by Bruegel himself, d...
trip to Rome. Cock would later enlist the tal...
variety of professional engravers, some of whom...
closely with Bruegel, especially Peter van der...
but also Philips Galle (who would succeed...
Antwerp's principal publisher).

The earliest of the Bruegel contributions t...
print output was a landscape setting with a ba...
river and harbor, dated 1554 (plate 65), which...
bears in its forest area; when Cock adapted thi...
sition for his print, he added the biblical figure...
and Satan to the lower left corner in order to...
a *Temptation of Christ* (plate 66). Thereafter...
made designs almost exclusively for Cock pr...
the mid-1550s until his death in 1569; his im...
even perpetuated posthumously by Cock's wi...
cxken Diericx (the publisher himself died in 15...
most intense period of print designs for Cock...
through 1562, after which the artist moved t...
and married. In addition to the Large Land...
1555–56; chapter 4), Bruegel designed individ...
as well as series in the style of Bosch, beginnin...
Fish Eat Little Fish, a drawing of 1556 (plate ...
was engraved by van der Heyden with a false a...
to Bosch as "inventor" (1557, plate 69. Next Bru...
on to design print series for Cock—of the Sev...
Sins (1556–58), followed by a series of the Sev...
(1559–60; chapters 5–6). It was chiefly for s...
as the Vices that he came to be characterize...
ond Bosch" by both Guicciardini and Lam...
In 1560 Bruegel produced his lone etching, ...
Hunt (plate 107). In 1559 he changed the orth...
his name from Brueghel to Bruegel on his dr...
paintings.

Early paintings are never easy to discover a...
The first secure signed and dated work is Brue...
scape with Parable of the Sower (1557; plate 109), ...
work but an image that builds upon the st...
the Large Landscapes for Cock with high ho...
small-scale figures. At the end of the decade B...
began to paint large-scale works that resemb...
positions of the Seven Virtues, as they encom...
of social practices—children's games, custom...
ior around the complementary holidays o...
and Lent—as well as a visual collection of...
a hundred Netherlandish proverbs (chapte...
ously, although these are among the largest...
paintings, we have no information about th...

The year 1562 brought considerable new activity
..., with at least five dated works, several of them
... n the idiom of Hieronymus Bosch (*Fall of the
... gels, Dulle Griet*; plates 146–48, 143).
...3 Bruegel moved to Brussels, away from the
... capital of the Netherlands, to join its political
... There he married Mayken Coecke in the church
... Dame de la Chapelle, and at the end of 1564
..., Pieter the Younger, was born; he would even-
... ecome a painter of numerous adaptations of
...r's paintings and prints (chapter 11).[21] But the
... rior connections to Antwerp did not end, and
... continued to enjoy the support of patrons such
... nam Ortelius, the publisher in 1570 of the first
... *Theatrum orbis terrarum*, who owned a small
..., *Death of the Virgin* (plate 260).[22] Elaborate
... have been made for Bruegel's intellectual circles
... this contact with Ortelius, who is celebrated
... wn panegyric on the artist in a friendship album
... ow); however, their personal contact need not
... wider shared circle of interests or associates.[23]
... ersely, even before he moved to Brussels, Brue-
... rks were avidly collected by Antoine Perrenot
... velle, cardinal at Mechelen, who also served as
... councilor and eventually as governor for King
... II in Brussels—until he was deposed in 1564
... to surrender his palace and collections to exile
... rement (chapter 8).[24] Granvelle owned several
... pictures and wrote anxiously from his exile to
... about their safety; however, the only likely sur-
... work that was once in his possession is the 1563
... *to Egypt* (plate 207).
... ng the later, Brussels period one other promi-
... tron back in Antwerp was Nicolaes Jongelinck,
... l-connected court figure who was granted the
... enues from nearby Zeeland shipping and built a
... tial suburban town house just outside Antwerp,
... he filled with an extensive art collection (includ-
... Vienna *Christ Carrying the Cross*, plate 8).[25] From
... l Jongelinck had acquired a quite diverse range
... mes, fully sixteen pictures, including three specifi-
... named works: a *Tower of Babel* (probably the larger,
... rsion of the subject, now in Vienna; plate 215),
... nna *Christ Carrying the Cross* (1564), and the six
... of The Months (1565; chapter 9). Additionally,
... ned numerous earlier pictures in a pair of sets on
... (c. 1555), painted by Bruegel's principal rival in
... rp, Frans Floris. These were of learned themes:
... ven Liberal Arts (engraved by Cornelis Cort for
... series issued by Hieronymus Cock, for example,

plate 57) and the Labors of Hercules (twelve deeds on ten canvases).[26]

Moreover, the brother of Nicolaes, Jacques Jongelinck, was a noted sculptor who not only made life-sized bronze figures on commissions from the court but also designed portrait medals, including several for Cardinal Granvelle.[27] Jacques might also have accompanied Bruegel on his initial trip to Italy, though the evidence is slim. Additionally, the master of the mint, Jean Noirot, also owned at least five paintings by Bruegel, featuring peasant subjects.[28] Bruegel thus seems to have been much admired and seriously collected by a prestigious circle of wealthy individuals, several of them closely associated with the Antwerp mint.[29] And the artist maintained strong ties back in Antwerp even while he resided in Brussels; significantly, we note that his images of humble peasant subjects were collected by a prosperous clientele.

Bruegel's signature peasant subjects for the most part were painted in his later years, though only the 1566 *Peasant Wedding Dance* (plate 288) is dated. These works in turn remained wildly popular and were copied by Pieter the Younger as well as imitated by a host of epigones (chapter 11). The artist began his representation of peasant festivities with a pair of earlier engravings, *The St. George Kermis*, issued by Cock (plate 263), and the *Kermis at Hoboken* (drawing 1559; plate 264), the only print produced by another Antwerp publisher, Bartholomeus de Mompere.[30] Van Mander in 1604 claimed that Bruegel and a friend, Hans Franckert, "a noble and upright man . . . often went out into the country to see the peasants at their fairs and weddings." Thus did the artist "delight in observing the droll behavior of the peasants, how they ate, drank, danced, capered, or made love, all of which he was well able to reproduce cleverly and pleasantly in watercolor or oils, being equally skilled in both processes." Certainly documentary elements of folk practices are contained within Bruegel peasant pictures.[31] Additionally, Bruegel in this later period situated a number of religious themes from the Infancy of Jesus within the snowy setting of a contemporary Flemish village: *Adoration of the Magi* (1563; plate 348), *Census at Bethlehem* (1566; plate 230), and *Massacre of the Innocents* (plate 235). He also stages his *Blind Leading the Blind* (1568; plate 305), based on a parable of Christ, before a rural parish church.

With the onset of the Dutch Revolt in the late 1560s (chapter 8), Bruegel might have felt threatened in terms of personal safety or political views. Once more, Van Mander provides testimony, albeit posthumously, about several controversial, captioned drawings: "But as

some of them were too biting and sharp, he had them burned by his wife when he was on his deathbed, from remorse or fear that he might get into trouble and might have to answer for them." In this connection the biography expressly mentions one extant panel: *The Magpie on the Gallows* (1568; plate 317) but also another work, *Time Breaking Through*, which might refer to a posthumously produced print (for which no drawing survives), *Triumph of Time* (1574; plate 319); however, Fritz Grossmann suggests that this theme might allude to another allegory of discovery, a recovered Bruegel drawing of a classical subject, *The Calumny of Apelles* (1565; plate 318).[32] Throughout his career, the ominous presence of armed soldiers had shadowed Bruegel pictures of both religious subjects as well as rural landscapes, climaxing in the army of skeletons overrunning a scorched earth in his *Triumph of Death* (plate 244). Thus a number of works in his later days (chapters 8, 10) do lend support to Van Mander's contention about the artist's political controversy.

Pieter Bruegel died in 1569 and was buried—as a loyal Catholic—in Brussels at the church of his marriage, Notre Dame de la Chapelle, where a commemorative tombstone was erected by his second son, the renowned painter Jan Brueghel, born in 1568 (chapter 11).[33] His fame was considerable and enduring. We noted above the inclusion of his portrait in the Cock series (1572; plate 24) of twenty-three celebrated Netherlandish artists, engraved chiefly by Johannes Wierix but also by Cornelis Cort, and accompanied by verses penned by Lampsonius that praise Bruegel as a "second Bosch."[34] Two years later the highly learned and sophisticated praise of the painter was inserted by Abraham Ortelius into his own friendship book, or *album amicorum* (Cambridge, Pembroke College).[35] In translation, it reads:

That Pieter Bruegel was the most perfect painter of his age, no one—unless jealous or envious or ignorant of his art—could ever deny. He was snatched away from us in the flower of his life—but whether I should attribute it to Death, who thought him more advanced in age when he observed the distinguished skill of his art, or rather to Nature who feared that his genius for dexterous imitation would bring her into contempt, I cannot say.

Abraham Ortelius dedicated this in grief to the memory of his friend. The painter Eupompos, it is reported, when asked which of his predecessors he followed, pointed to a crowd of people and said it was Nature herself, not an artist, whom one ought

to imitate. This applies also to our friend Bru
of whose works I used to speak as hardly wo
art but as works of Nature. Nor should I ca
the best of painters, but rather the very natu
painters. He is thus worthy, I claim, of being
tated by them.

Bruegel depicted many things that cann
depicted, as Pliny says of Apelles. In all his
more is always implied than is depicted. Th
also said of Timanthes. Eunapius writes in h
of Iamblichus: Painters who are painting hand
youths in their bloom and wish to add to the
ing some ornament and charm of their own th
destroy the whole character of the likeness, s
they fail to achieve the resemblance at which
aim, as well as true beauty. Of such a blemis
friend Bruegel was completely free.

This encomium has been well studied by previo
ars, who help to unravel its thick, learned re
to ancient texts.[36] Imitation of nature is praise
any use of artists as models, a frequent *topos*
in ancient texts, as is the envy of Nature herse
the erudite Ortelius also compares Bruegel to
known from the descriptions of antique artis
Natural History by Pliny the Elder. Eupompos
pointed to people, i.e. Nature, as his model for
with this reference Ortelius is praising Bruege
own naturalness of depicting ordinary people, i
the celebrated peasants, "true beauty" rather th
artificiosa prettiness to enhance his pictures w
tional charm. Indeed, Ortelius asserts that Bru
so completely replaces nature that it is equally
of imitation to Nature herself. And Apelles, c
as the greatest of painters and as the exclusive p
of Alexander the Great, is cited here for represe
undepictable or ephemeral, such as the famous
of a lightning storm.[38] A good example in
oeuvre would be his *Dark Day* (1565; plate 274)
series of the Months for Jongelinck, which repr
atmosphere of sudden storms that arise in ear
In similar fashion, Timanthes is celebrated by
what he implies rather than explicitly displays
Life of Iamblichus by Eunapius offers a call for
thus subtly criticizing the heroizing or idealizi
ures (in all likelihood by artists like Floris) for
of improving nature.[39] In short, Bruegel a
the emerging canon of naturalism as the foun
Netherlandish painting, confirmed at just this
by Lampsonius verses along with portrait engr

27
Aegidius Sadeler
Portrait of Bruegel, 1606
Engraving, 12⅛ × 8¼ in.
(30.6 × 21 cm)
Private collection

30

Frans Floris

Archangel Michael with the Dragon
of the Apocalypse, 1554

Oil on panel, 118⅛ × 85¾ in.

(303 × 220 cm)

Koninklijk Museum voor Schone

Kunsten, Antwerp

destroyed during the iconoclastic image destruction in August of 1566 (chapter 8), a time when Floris's main altar of the cathedral, an *Assumption of the Virgin*, was also destroyed entirely.[47] While there are no literal copies of individual figures, clearly the overall inspiration for Floris's crowded scene of beautiful angels against muscular falling demons was Michelangelo's *Last Judgment* fresco in the Sistine Chapel, visible to Floris during his own trip to Rome (1541–46), right after he joined the Antwerp painters guild in 1540/41. The seven-headed dragon dictated by the text of Revelation (chapter 12) is derived from the woodcut illustration of *Apocalypse* by Albrecht Dürer (1498). The subject of armed conflict by the forces of good against evil, led by the guild's patron saint, the archangel Michael, was certainly an appropriate choice for the local fencers, and a number of the weapons are meticulously rendered; however, the angels carry the swords of fencing, whereas the monsters wield a hatchet, torch and bow and arrow.

This epic struggle as depicted by Floris differs utterly from the Boschian forms, placing full emphasis on hybrid monsters, which Bruegel would produce for this same subject nearly a decade later (1562). That contrast between them on a shared theme further underscores the aesthetic rivalry between the two main Antwerp schools of painting. Ironically, the defenders of the two painters took opposite and unexpected paths: de Heere's verses in praise of Floris and the Italian manner are in Dutch, whereas the emphasis on Bruegel's naturalism by Ortelius makes reference to ancient painters and classical texts while using the learned language of antiquity, Latin.

Some rare older contemporaries of Bruegel painted successfully in both styles. A prime example is Jan Massys (active 1530–73), brother of Cornelis Matsys (compare plate 31) and son of renowned painter Quinten Massys (active 1491–1530), often considered the father of the Antwerp painting tradition.[48] One work by Jan Massys that stands quite close to Frans Floris—and may represent a belated influence of the younger artist upon the older one, who returned to Antwerp in 1558—is his depiction of a languorous half-nude, *Flora*, essentially topless within a transparent drapery and situated before a skyline of Antwerp (1559; plate 31).[49] As befits her name, Flora holds a small bouquet aloft and a larger bunch of flowers in her lap. Her ready return of the viewer's glance suggests that this is Flora in her guise as the arch-courtesan, epitome of beauty yet sexually available. Even her role as the goddess of spring still attaches the goddess Flora to the season of love and pleasure. Jan Massys also underscores here the importance of Antwerp, not

only through the ready identification of the c[...] on the horizon, especially through the distinctive to[...] of the cathedral of Our Lady, but also by the small f[...] at the left, part of the luxurious garden behind the fi[...]. In[...] work shows sculpture with the founding my[...] of the city, where the legendary hero Brabo (eponym[...] name sake of the province of Brabant) has cut off th[...] hand of the giant Antigon and prepares to hurl it (*han[...]* or "hand throw": Antwerpen) into the local [...]. But what should a viewer conclude about the rel[...] between beauty and sensual sinfulness and t[...] artist's home town? In all likelihood, Jan Massys is s[...] both the beauty and the temptations, not to [...] the possibilities for erotic sinfulness, endem[...] to the metropolis, the queen city on the River Schel[...].

Yet this more subtle, if alluring vision of te[...] is complemented in Jan Massys's work by mo[...] and vulgar amorous imagery. Sometimes he fe[...] so-called "Ill-Matched Pair," in which an old [...] is seduced for his money by one or more cunni[...] wenches, often in a tavern setting.[50] But such [...] matches also unfold within the framework of [...] Massys biblical scenes with beautiful unclad sire[...] older men, such as *Lot and His Daughters* (1563[...]), *David and Bathsheba* (1562, Paris), or *Susann[...] Elders* (1564, Pasadena; 1567, Brussels).[51]

Most often, however, Jan Massys features [...] pleasures between peasants or other lower-cla[...] grouped under such modern generic names [...] Company." These images usually feature figur[...] sexes, old and ugly as well as vulgar, who ar[...] together in a tavern setting.[52] A good examp[...] kind of half-length presentation, the *Merry* [...] (plate 32) features an old man together with a[...] ant woman, standing behind a table and in [...] chimney in what clearly is a humble tavern. O[...] before them sits a large crock of beer. The c[...] accosted by a bagpiper, carrying his instru[...] his arms, as well as by a woman with a long f[...] mouth. In this case, the artist uses vulgar pea[...] to convey an ironic inversion of figures who [...] monly are young and beautiful, certainly mor[...] themes of love. Such inappropriately lustful [...] also form the targets of verbal irony in such [...] Erasmus's *Praise of Folly* (1511) or in painting[...] father, Quinten Massys, especially his *Grot[...] Woman* (c. 1520; London, National Galler[...] companion is a pendant panel, *Grotesque Old [...] York, private collection).[53]

A similar pictorial tradition, a variation on [...]

of Massys's Ill-Matched Pair, was carried on in the next generation by Jan van Hemessen, as in his 1543 *Tavern Scene* (plate 33), featuring large, close-up figures. There an old man is accosted by two assertive young women, clearly prostitutes after his money, an interaction echoed by the cat beside them in the center that is slyly stealing roast fowl from the table. While one of them proffers wine in a glass as well as herself, at the right side an old bawd with her own pewter can of wine abets the situation and watches, while providing for a hidden dog in the lower right corner. In the background denouement the same old man in his hat is napping by a fire, an image of either sloth or of postcoital exhaustion, beside the same two young women.

In the Vienna example by Jan Massys, the bagpipe and flute are both rustic and peasant musical instruments, while also obviously suggesting sexuality through their phallic shapes.[54] Renger cites a possible association with an old Dutch folk saying, *met het trommeltje gewonnen, met het fluitje verteerd* (won with the drumroll, dissolved with the flute), a military metaphor that suggests that in issues of courtship "size matters."[55] Perhaps the round opening of the crock should be taken as its antipode, a vaginal suggestion, in this case grasped uneasily by the old man in the center. Moreover, the crock is large enough to be passed around and shared across an entire table. Thus, in contrast to his suggestion of learning and international sophistication with images of Flora/Venus, Jan's alternate theme of laughable old peasant amours uses a pictorial idiom that remains both truly local and vernacular.

Between these two choices, out of which Jan Massys seems to have practiced both equally well and often, Bruegel opted in his pictorial style for a presentation both simpler and humbler than that of Floris, as suggested by the poetic invective against a "certain painter" so close to him. We have already seen in chapter 1 how much of what Bruegel put into his composition of *Christ Carrying the Cross* was anticipated not only by his distant predecessors in the Netherlandish tradition but also by more recent contemporaries, such as the Master of the Brunswick Monogram or the pair of Pieter Aertsen and Joachim Beuckelaer.

The Master of the Brunswick Monogram, who has been identified with Jan van Amstel, a mysterious landscape painter described by Karel van Mander, seems to have been active in the generation just before Bruegel, during the second quarter of the sixteenth century.[56] Besides expansive landscapes for religious events, as seen in chapter 1, several tavern scenes have also been

frequently assigned to the Master of the B░░░░░
Monogram. Representative of this imagery ░░░░░░
panel (plate 34), which shows a dense popu░░░░░
both sexes seated around the table of an interi░░░
fireplace. That this locality also doubles as a b░░░░░
evident from one couple heading upstairs to ░░░░░
the top center, while in the upper left on the s░░░░░
a woman welcomes a man into her bed. Pewt░░░░
beer are omnipresent to lubricate the social lif░░░░░
the couples around the table have begun to pa░░░░
men are dressed in the flashy slashed garmen░░░░░
temporary infantry soldiers, usually an unsav░░░░
peacetime.[57]

Another contemporary Antwerp artist (ad░░░░░
the painters guild in 1553, although he ended hi░░░░
Amsterdam after 1559), Pieter Aertsen (1507/8–1░░░
ipated several of Pieter Bruegel's own interes░░░░░
eral years and also achieved his own distinctiv░░░░
formulas sooner.[58] Aertsen's distinctive com░░░░
innovation in painting consisted of his jux░░░░░
of prosaic elements, especially well-stocked ░░░░░
kitchens in the foreground with religious s░░░░░░
the background.[59] A good example is his pr░░░░░

░░░░░ *and the Adulterous Woman* (1559; plate 35), the
░░░░░ scene (John 8:3–11) that Bruegel would paint in
░░░░░ in 1565 (see plate 255). Aertsen, however, features
░░░░░ with their market wares across the entire fore-
░░░░░ of the image, so that the viewer has to be alert
░░░░░ the scene of Jesus writing on the ground in the
░░░░░ und, adjuring whoever is without sin to cast the
░░░░░ e. In Bruegel's hands, this image becomes a par-
░░░░░ religious toleration and individual conscience,
░░░░░ Aertsen the pictorial emphasis on worldly goods
░░░░░ a sensory indulgence, a desire akin to the sin of
░░░░░ of which the woman stands accused. In fact,
░░░░░ woman, a viewer must consider his own falli-
░░░░░ susceptible to temptations and immersed in self-
░░░░░ ce.[60] In a city like Antwerp, the entrepôt for the
░░░░░ f the globe, Aertsen's presentation of the market
░░░░░ challenge concerning the proper relationship
░░░░░ body and spirit, with a need for deeper discern-
░░░░░ pick out the Gospel message.

░░░░░ same kind of message was embedded in the
░░░░░ s of Aertsen's nephew, Joachim Beuckelaer (c.
░░░░░ 4), such as his large *Fish Market with Ecce Homo*
░░░░░ late 36), where the standard Catholic practice of

eating fish on Fridays, not to mention the bounty of the sea, so readily available in Antwerp, is undermined by the pressing need to act as witness and judge before the presentation of Christ to the people by Pilate in the distant background.[61] Beuckelaer produced seven pictures of markets with Ecce Homo in the period between 1561 and 1570, and they are often punctuated by imagery with stage-set architecture, such as obelisks, derived from Italian publications by the theorist Sebastiano Serlio.[62] These locations, artificial and foreign spatial imports, suggest the kinds of allegories acted out in public places during festive events, whether state progresses of entering princes or outdoor theater performances, such as rhetorical competitions among cities. Their stagelike presence in these pictures thus poses a dilemma about public behavior, raising questions of morality, both as personal and social decisions, even as they link the Gospel past to an Antwerp urban present.

Beuckelaer's own response to the maritime port world of Antwerp manifested itself in a scene of the *Miraculous Draft of Fishes* (1563; plate 37), which features a foreground expanse of fishermen with their wares in front of a more atmospheric distance with the maritime miracles on the Sea of Galilee, including Peter's attempts to walk on water (Matthew 14:28–33) and the miraculous catch (John 21:1–11), a final manifestation of Jesus after the Resurrection.[63] Both of these events serve as tests of faith as well as confirmation of the presence of its power.

Compared to the *Sea Gods* by Floris (1561; plate 28) and the *Miraculous Draft of Fishes* by Beuckelaer (1563; plate 37), Bruegel responded in his own way to the international shipping that provided the foundation of Antwerp's prosperity. For Cock he produced a series of ten prints, engraved by Frans Huys (d. 1562), which appeared in the early 1560s (the one bearing the latest date reads 1565; plates 38, 39).[64] Commercial ships are freely mixed with warships, though clearly some vessels served both functions. Bruegel's first image of a ship probably was the ocean-going galleon in his *Fall of Icarus* (see plate 111), which established his ability to render an almost portraitlike accuracy for details about such craft.[65] For the most part these engravings feature a single vessel or a pair, sometimes accompanied by smaller, more local, coastal craft, or else accompanied by foreign ships, such as the oared galleys characteristic of Mediterranean shipping. Several of the images situate ships before a port, occasionally a foreign port. Such sites serve as reminders that these ships represented a new form of transportation as well as the promise of both economic and military supremacy around the globe.

36 *(top)*
Joachim Beuckelaer
Fish Market with Ecce Homo,
1570
Oil on panel, 57 × 57¾ in.
(146 × 148 cm)
Nationalmuseum, Stockholm

37 *(above)*
Joachim Beuckelaer
Miraculous Draft of Fishes, 1563
Oil on panel, 43⅛ × 82¼ in.
(110.5 × 210.8 cm)
Getty Museum, Los Angeles

That supremacy is acted out through juxta[...]
of Atlantic and Mediterranean ships, sometime[...]
flict. The largest print ever produced by Brue[...]
Cock comprised two sheets: *Naval Battle in t[...]*
of Messina (1561; plate 40), a contest that pits E[...]
Christians against Islamic Turks, as if in antici[...]
the climactic Battle of Lepanto (1571).[66] In this[...]
too, the artist collaborated with Frans Huys[...]
engraved plates, signed with the names of eac[...]
represent the breadth of the panorama of R[...]
Calabria, also the subject of an undated Brueg[...]
ing (plate 41).[67] The drawing reverses the local[...]
phy, accurately depicted from the south in the p[...]
was also probably penned as a preparatory stud[...]
print, intended to be reversed, along with lost[...]
tory drawings of the ships themselves. Even th[...]
the drawing reappears on the left sheet of the p[...]
featured on the right in the engraving is the[...]
volcano of Mt. Etna, and the harbor at the left,[...]
closely resembles the rounded haven already in[...]
a destination in the *Fall of Icarus*. We must ass[...]
lost drawings by Bruegel also shaped Huys's[...]
Messina, and the galleons in the lower left cor[...]
engraving also stand close to several of the ind[...]
ships prints by Huys after Bruegel.

An undated painting, ascribed to Bruegel b[...]
times doubted as authentic (plate 42), shows[...]
naval battle between galleons and smaller Arab[...]
with either oars or lateen sails.[68] It has been c[...]
Bay of Naples, even though it closely resemble[...]
posite of the two halves of the 1561 print, as i[...]
both a rounded harbor with a high volcano[...]
(presumably Vesuvius, close to Naples). Of cou[...]
battle scenes do not directly address the qu[...]
international trade, but they provide sure evide[...]
prowess—well beyond the Mediterranean—th[...]
girded eventual Netherlandish supremacy at se[...]
the following century the Dutch East India C[...]
would establish an overseas commercial netwo[...]
the Indian Ocean around the Dutch colonial c[...]
Batavia (modern Jakarta).[69]

Bruegel certainly acknowledged the impo[...]
ships in another work from this same period of[...]
1560s: his 1563 large *Tower of Babel* (plate 215)[...]
that symbol of human hubris and self-indul[...]
an enormous material prosperity, abetted by[...]
that dock at the foot of the enormous structu[...]
ing trade goods as well as the materials, pa[...]
bricks, for its construction. Among the other[...]
advanced technology that complement shipbui[...]

38 (left)
Frans Huys (1522–1562),
after Pieter Bruegel
Dutch Hulk and a Boeier, 1564–65
Engraving, 9½ × 7½ in.
(24.4 × 19.3 cm)
Museum Boijmans Van Beuningen,
Rotterdam

39 (below)
Frans Huys, after Pieter Bruegel
Armed Three-Master Anchored
near a City, c. 1561–62
Engraving, 9 × 11⅜ in.
(23.2 × 29.2 cm)
The Metropolitan Museum of Art,
New York; Dick Fund 1928 28.4(4)

40
Frans Huys, after Pieter Bruegel
Naval Battle in the Straits of Messina,
1561
Engraving and etching in two plates,
16⅞ × 27¾ in. (43.4 × 71.1 cm)
Museum Boijmans Van Beuningen,
Rotterdam

41 *(right)*
Pieter Bruegel
View of Reggio Calabria, c. 1560
Pen and brown ink, with gray
by another hand, 6 × 9⅜ in.
(15.4 × 24.1 cm)
Museum Boijmans Van Beuningen,
Rotterdam (Mielke 54)

42 *(pages 54–55)*
Pieter Bruegel (?)
View of Bay of Naples
Oil on panel, 16⅜ × 18⅜ in.
(42 × 47 cm)
Palazzo Doria Pamphilij, Rome

citizens could either be viewed as benignly pro[...]
the imperial and Spanish royal presence, emb[...]
the walls themselves and the Imperial Gate, o[...]
burdened with costs and corruption in their at[...]
retain political and economic independence as[...]

The problematic quest for wealth in Antw[erp...]
gerated by the land speculation by Gilbert va[n Schoo-]
nebeke in the early 1550s, formed a recurrent [...]
Bruegel's art, chiefly in the form of prints, beg[...]
the very same moment as the *Ice-Skating befor*[...]
of St. George, 1558. His ultimate subject of vain [...]
for happiness amid material goods appears i[...]
drawing (plate 45) and engraving (plate 46) [...]
of *Everyman* (*Elck*).[82] The eponymous figure [...]
man appears throughout the image, a grayb[eard with]
glasses—here doubtless an indication of mora[l as well as]
physical short-sightedness—constantly seeking[...]
ing, even pulling a strip of cloth against himse[...]
the full purse of gold at his waist, most of [...]
go into scrutinizing the varied contents of bal[...]
and boxes, most of them stamped with mercha[...]
(one of them on the box beneath the tugging [...]
the mark of Cock himself).[83] Strewn across t[...]
are useless items: discarded tools, a broken m[...]
games (cards, dice, chess board). Everyman's [...]
dent in carrying a lighted lantern during day[...]
the larger allegorical significance of the imag[...]
suggested by his very name (labeled in the p[...]
hem of his garment) is underlined by a larg[...]
globe of the world at his feet.[84] The wider [...]
appears in the background, as Everyman not [...]
a military encampment (perhaps a symbol o[...]
and its preoccupations with territory) but al[...]
up a hill from there to visit a village church [...]
background site in Bruegel's later village s[...]
one does not imagine that the church visit wi[...]
more enlightenment than the fruitless searche[...]
out the rest of the image.

The accompanying text, in Latin as well as [...]
Dutch, makes the point explicit: "No one do[...]
his own advantage everywhere, no one do[...]
himself in all that he does, no one does not [...]
where for private gain. This one pulls, that o[...]
have the same love of possession." Bruegel [...]
castigates the search for self-knowledge th[...]
sessions. In the process *Everyman* thematiz[...]
problems, moral judgment and the true val[...]
rialism, which preoccupied Aertsen and B[...]
their kitchen and market scenes.

Yet there is a built-in paradox in the ima[...]

[Every]man's antithesis, No Man, represented in a
[i]mage-within-an-image (next to an extinguished
[candle] as a figure dressed in fool's garb amid a cluster
[of discar]ded and broken items. He holds a mirror for
[introspe]ction, but as the lines in Dutch below the image
[reveal, th]at self-knowledge reveals "No Man" to himself,
[no] man knows himself."[85] Such paradox subverts
[any easy] attempt to draw any positive moral message
[from Bru]egel's print, and it casts doubt on the very pro-
[cess of s]eeing and knowing.

[Anoth]er Bruegel print from the same time engages
[the larger] issue of materialism as well as knowledge: the
[Alchemist] (drawing, 1558; plate 48; engraving, attributed
[to Philip]s Galle, plate 47).[86] By this time the author-
[ity of al]chemy, particularly its claim to transmute baser
[metals i]nto gold successfully, was being contested as a
[delusion]al form of greed. This print certainly seems to
[su]vert criticism of its claims; however, alchemy
[rem]ained a goal of imperial science at the court of
[Rudolf] II in Prague in the late sixteenth century and
[inf]ormed the science of Isaac Newton at the end of
[the seve]nteenth.[87] Bruegel's critical attitudes were shared

45 *(opposite)*
Pieter Bruegel
Everyman (*Elck*) 1558
Drawing, 8⅛ × 11⅜ in. (20.9 × 29.2 cm)
British Museum, London, (Mielke 41)

46 *(below)*
Pieter van der Heyden (c. 1530–after 1572),
after Pieter Bruegel
Everyman
Engraving, 9 × 11¾ in. (23.2 × 30 cm)
Private collection

by later Netherlandish artists, such as David Teniers and Cornelis Bega (for example, his 1663 panel, J. Paul Getty Museum, Los Angeles).[88] In the finely textured drawing, the scholar sits, dressed in old-fashioned robes, and gestures as he offers instructions for the procedures from a book captioned disparagingly with the pun "alghe-mist," meaning "all shit" or "all fog." In this messy laboratory a motley trio of accomplices assist in the actual execution. One, clearly dressed in the asses' ears of a fool, squeezes bellows over a brazier in a smelting process next to a makeshift table made out of a shutter. In the center of the image an older woman in dowdy clothes turns over a coin purse only to find it empty, her gold coins sacrificed in previous "experiments." Finally, the alchemist proper, her husband, a scrawny man with scraggly hair and tattered clothes, bends over his work at the hearth, seemingly on the verge of dropping a few last coins into his crucible for refining. In the meantime, their three unsupervised children clamber up into the pantry, where one of them has his head stuck into a pot. The outcome of this wastefulness and vanity is evident through the background window, showing the subsequent scene, where the entire family has almost immediately become reduced to beggary and heads to the poorhouse (labeled "hospital"); the poor child has not yet even been able to get the pot off of his head. In the Latin text appended to the print, the warning against such vain striving is expressly sounded: "The ignorant ought to put up with things and afterward labor diligently."

Bruegel could satirize the quest for riches explicitly. A print produced posthumously (after 1570) by Cock's widow depicts a comic clash between animated *Money-Boxes and Piggy-Banks* (plate 50).[89] As Matt Kaveler has observed, this allegory stages a mock tournament—an inappropriately archaic knightly event, staged with lances, swords, and banners as well as the trappings of armor. Yet here the tournament depicts capitalist competition in its fullest embodiment, motivated by pure greed. This print follows from the representation of Avarice in the demon-filled, Boschian world of the earlier Seven Deadly Sins series, made for Cock (1556–58; plate 124). The added Latin verses proclaim: "Booty makes the thief, the assault that serves all evil helps him, and so does the pillage good for fierce spoils." The Dutch translation is even more explicit: "Forward, you piggy banks, barrels, and chests. / It's all for money and goods, this fighting and quarreling . . . but there would be no battle if there were nothing to steal." Chaos ensues in this print, more like a mêlée or a free-for-all than a tournament proper and an absurd indictment of universal greed.

On a more modest level, Bruegel also parodies the foolish pursuit of trinkets with a dated 1562 engraving, executed by Pieter van der Heyden for Cock, *Peddler Robbed by Monkeys* (plate 49).[90] The itinerant merchant with a pack on his back traditionally was represented as a short step from beggary, as in the cases of Hieronymus Bosch's *Peddlers* on the outsides of two of his triptychs (plate 12).[91] Moreover, the large, strong sleeping figure of the peddler, dressed like a peasant himself, epitomizes sloth and the avoidance of honest labor, even though he takes his rest before a well-ordered rural farmyard (another favorite Bruegel background image), more appropriate to a true peasant. His deep sleep and hidden hand gesture exemplify idleness.[92] And he will be punished for his lack of industry in the loss of his goods and a gain of only a hatful of monkey shit.

Bruegel borrowed this subject from earlier art, including a landscape of the previous generation by Herri met de Bles (Dresden). Apes embody a subhuman baseness and foolishness as well as irrational desire.[93] The monkeys easily fall prey to their own cupidity; they are tempted by his dazzling baubles: spectacles (moral short-

47 *(below)*
Philips Galle, after Pieter Bruegel
The Alchemist, c. 1558
Engraving, 13⅛ × 17⅜ in.
(33.7 × 44.5 cm)
Bibliothèque du Musée des
Arts Decoratifs, Paris

48 *(opposite)*
Pieter Bruegel
The Alchemist, 1558
Pen and brown ink, 12 × 17⅝ in.
(30.8 × 45.3 cm)
Staatliche Museen,
Kupferstichkabinett, Berlin
(Mielke 42)

49 *(above)*
Pieter van der Heyden, after Pieter Bruegel
Peddler Robbed by Monkeys, 1562
Engraving, 8⅞ × 11½ in. (22.7 × 29.5 cm)
Rijksmuseum, Amsterdam

50 *(right)*
Pieter van der Heyden, after Pieter Bruegel
Combat between Money-Boxes and Piggy-Banks, after 1570
Engraving, 12 × 17⅝ in. (30.8 × 45.3 cm)
The Metropolitan Museum of Art, New York; Dick Fund 26.72.40

sightedness; cf. *Everyman*), mirrors, gloves, purses—all items associated with vanity and pretense.[94] The hobby-horse that they ride and the simple instruments—toy drum, flute, and Jew's harps—that they play link their activities to the useless games of children (cf. Bruegel's own painting, *Children's Games*, 1560; plate 195). While humorous, their very imitation of human activities and desires points out the absurdity of such indulgences.

Distilled to its essence, Bruegel conveys this same outlook in a tiny panel, *Two Monkeys* (1562; plate 51).[95] These animals themselves indicate the vast reach of Antwerp trade; they are red colobus monkeys from Africa. Here, however, the two creatures are chained, robbed of their mobility and joyfulness as if in a prison and limited just to the husks of nuts left for them. Their hunched postures convey misery. Behind them, bathed in misty atmosphere, stands the skyline of Antwerp, recognizable from its tall church spire of Our Lady's. Large ships and small fill the river, and great birds (possibly storks) fill the sky, as if to defy the confinement and isolation of the monkeys.[96] Of course, the association of monkeys with sinfulness and animal nature could still be read into their limited existence, but it is also possible to see the metropolis and its pursuit of the goods of the world as

Illecebres inter tantas, atq̃,
Inditium cunctis efferus

Al ſeetmen v ooc anders, will
Daerom vuere wÿ den hae

Aux quatre Vents.

P. Bruegel Inue

Preda facit furem, feruens mala cuncta miniſtrat
Impetus, et ſpolijs apta rapina feris.

Men ſoeckt wel actie om ons te verdooven,
Maer men ſouwer niet krÿgen, waerder niet te roouen.

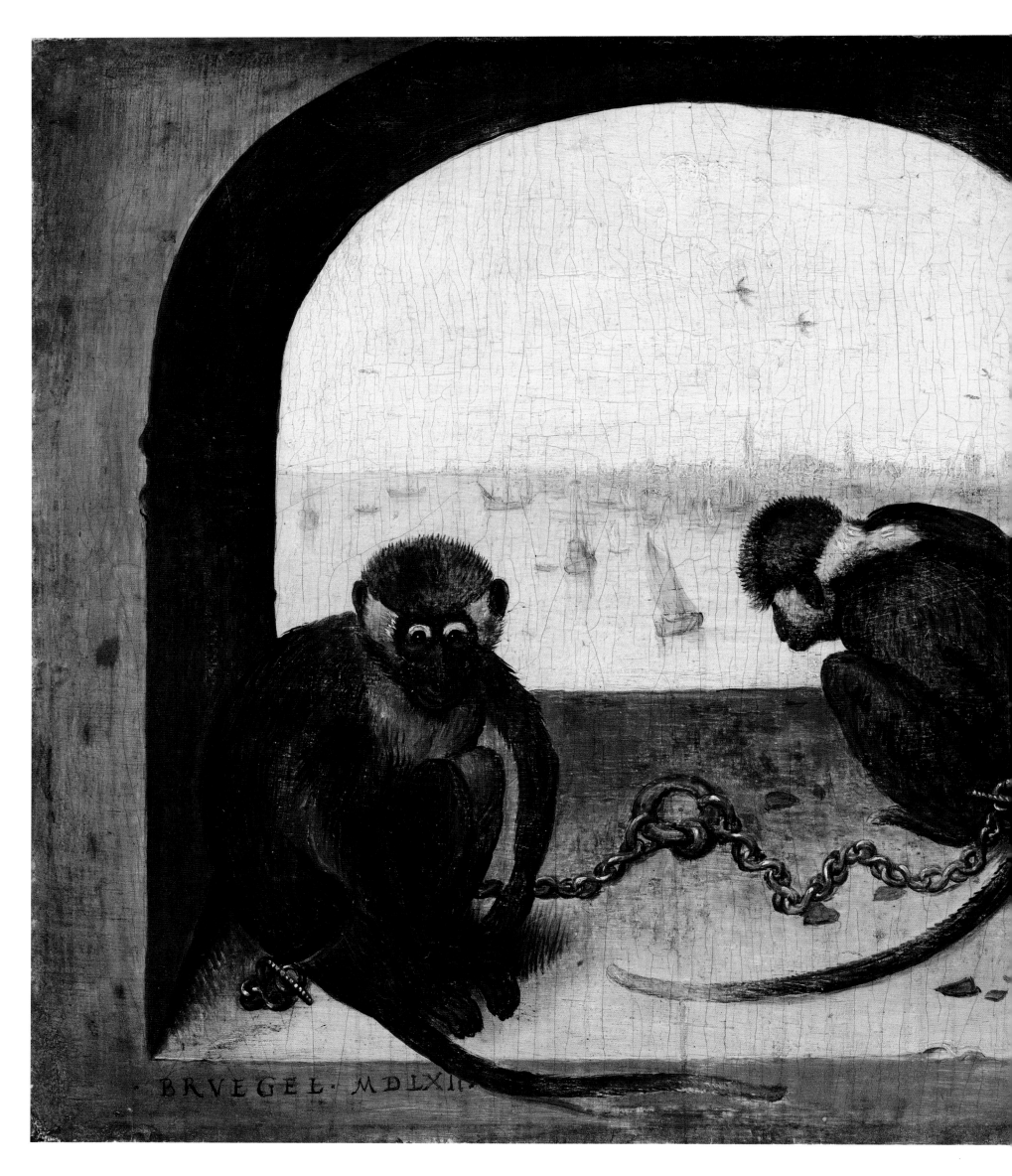

...anaogous to the materialist enslavement of the monkeys. In this respect, then, the picture as a whole replicates the ...avour of the 1563 *Tower of Babel* (plate 215), where the ...foreground hubris of a grasping emperor motivates and ...coordinates the desires of an entire population within its ...own landscape. Ultimately this tiny work claims that the ...canvas in thrall to material desires, despite all of its appar-...ent freedom and prosperity. Perhaps this image can be ...seen as a valedictory to Antwerp and an indictment of its ...empty values. The very next year Pieter Bruegel moved ...to the capital city and court center in Brussels.

51
Pieter Bruegel
Two Monkeys, 1562
7⅞ × 9 in. (20 × 23 cm)
Staatliche Museen, Berlin

S·MARTINI

3

HIERONYMUS COCK, BRUEGEL'S PRINTMAKER

When Bruegel returned to Antwerp [...] 1555, he went to work for a pub[...] prints, Hieronymus Cock (151[...] Admitted to the Antwerp painters' guild in 154[...] began as an etcher of his own works, particula[...] views of Rome, and he also made prints aft[...] scape designs by his painter brother Matthijs [...] 1509–1548). Around 1548 he began to establish [...] ing house in Antwerp, Aux Quatre Vents (At th[...] the Four Winds), which he ran for two decad[...] it was run after his death by his widow. Coc[...] formula closely resembled the later mass pr[...] of the Industrial Revolution of the nineteenth [...] division of labor. First, Bruegel as well as oth[...] served as designers for professional engravers, [...] executed the images onto copper plates. Ove[...] decades of production, Hieronymus Cock u[...] thirty designers and a dozen engravers to pr[...] prints. Cock himself was the entrepreneur and [...] of the process, akin to a book publisher, esp[...] Antwerp contemporary, Christopher Plantin ([...] offel Plantijn; c. 1520–1589), a former bookbin[...] press in Antwerp, the Golden Compass, be[...] leading book producer of the century.[2]

Cock learned from his experience in Rome [...] 1540s about new possibilities for print publish[...] Marcantonio Raimondi (c. 1480–before 153[...] a specialist engraver after the designs of R[...] 1520) and other Roman artists, and some of [...] were acquired by bookseller Antonio Salama[...] c. 1562). Before midcentury a pair of Roman [...] lishers in the Piazza Navona—Francesco Sala[...] of Antonio) and Antonio Lafreri (1512–1577)[...] rivals and then partners who provided for [...] range of engraved images, including maps.[3] I[...] a real and substantial exchange of personnel[...] between Antwerp and Italy: first Giorgio [...] north, briefly (1550–55) bringing a numbe[...] Renaissance compositions (Raphael, Michel[...] Cock before he returned to Italy; then a C[...] engraver, Cornelis Cort, went south (1565–78[...] as the specialist engraver after designs and [...] by such artists in Venice and Rome as Titia[...] Muziano, and Zuccaro.[4]

At the outset of his publishing venture, C[...] the protection of patronage, so he dedicate[...] of his early prints to Antoine Perrenot, Car[...] velle (1517–1586), then a minister to Emper[...] later a major political adviser to the regent i[...] erlands and an avid collector of Bruegel pa[...]

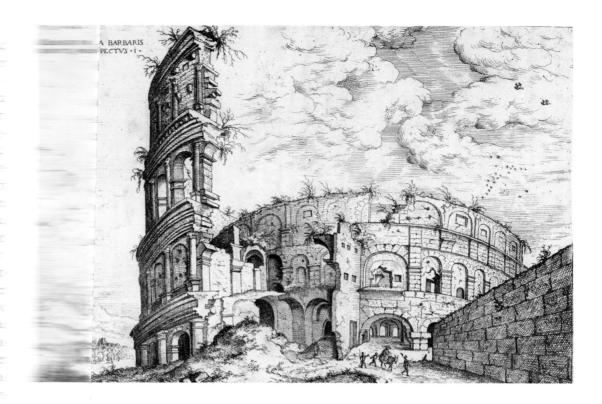

[...]de an effort to secure what is known as a "privi[...] [...]at is a protection against copying within a given [...] granted by the local ruler.[6]

[...]an get a sense for what kinds of art were available [...] Antwerp of Bruegel's own beginning career by [...]ng what engravings Cock produced in the early [...] irst of all, Cock generated images on his own: [...] *Roman Ruins*, an etchings series, chiefly of the [...]um, formed the first published visual record of [...]tes and a worthy printed successor to the reper[...] drawings after Roman sites in the earlier genera[...] Maarten van Heemskerck, documented in Rome [...]6).[7] The 1551 series was already dedicated to Gran[...] Cock's views of the Colosseum (plate 54; drawing [...]burgh) show varied, wiry lines built up to show [...]tures of the rough stones and the contrasting deep [...]ws of the vaults. Bruegel himself went to Rome [...] afterward and might have made his own drawings [...]rd the experience of the Colosseum, for this mas[...] d iconic building became the model for his own [...]truction of the Tower of Babel in a pair of painted [...]entations during the 1560s (plates 215, 240).

[...] other early enterprise by Cock himself as an [...] featured images of small figures in landscapes after [...]ng designs by his painter brother, Matthijs Cock [...]47). Surely some of them were issued during the [...]tive years of the Quatre Vents enterprise, 1550–51.

52 (*pages 66–67*)
Jan (1554–1595) and Lucas Duetecum,
after "Hieronymus Bosch"
St. Martin in a Boat
Detail of plate 63

53 (*opposite*)
Matthijs Cock (c. 1509–1548)
Apollo and Daphne
Detail of plate 55

54 (*above*)
Hieronymus Cock (1518–1570)
View of Colosseum, 1551
Etching, 9⅛ × 12½ in.
(23.2 × 32.2 cm)
Museum Boijmans Van Beuningen,
Rotterdam

65
Pieter Bruegel
Landscape with Bears, 1554
Drawing, 10⅝ × 16 in. (27.3 × 41 cm)
Národní Galerie, Prague (Mielke 22)

66
Hieronymus Cock,
after Pieter Bruegel
Temptation of Christ, c. 1554
Etching, 12½ × 17⅛ in.
(31.9 × 43.9 cm)
Private collection

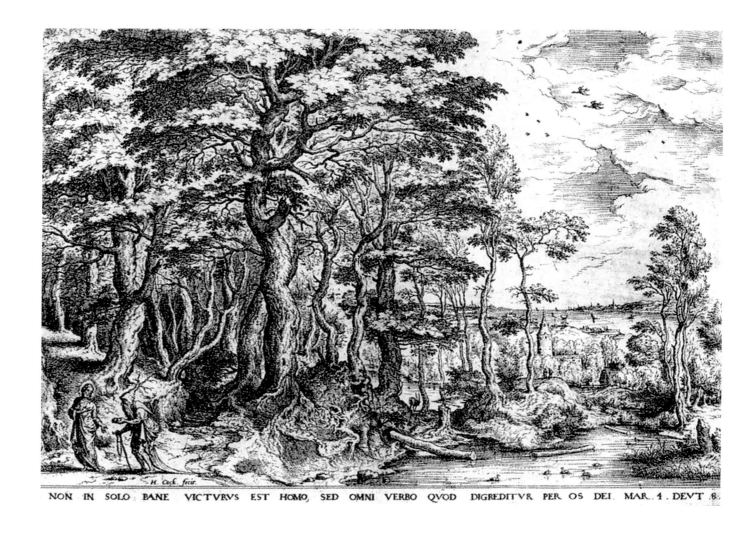

NON IN SOLO PANE VICTVRVS EST HOMO, SED OMNI VERBO QVOD DIGREDITVR PER OS DEI. MAR. 4. DEVT. 8.

in Flanders featured biblical figures in the foreground of what were otherwise composite "world landscape" panoramas in the tradition of Joachim Patinir (see chapter 4).[57] Indeed, the series had a renewed influence after it was reissued by Claes Jansz Visscher at Amsterdam in 1612.[58] Cock's 1559 Dutch inscription makes the local character of the images clear and makes claims for their naturalism in depiction: "Many and very attractive places of various cottages, farms, fields, roads, and the like, ornamented with animals of all sorts. All portrayed from life and mostly situated in the country near Antwerp." Thatched roofed cottages, punctuated by squat plane trees and a few taller, more slender boughs are viewed across quiet, open public spaces with a low horizon. These qualities can be seen, for example, in the New York ink drawing by the (still anonymous) Master of the Small Landscapes. A few other prints show villas in the form of larger stone, castlelike structures in their role as country retreats. Not all of the drawings receive corresponding replication as prints. The entire series conveys

the suggestion of a country walk, a local weekend excursion to the nearby countryside by a city-dweller like Cock and his presumed clients.[59]

Bruegel's earliest print for Cock shows the striking difference between the Small Landscapes and the earlier landscape series produced for Aux Quatre Vents, closer to the settings after Matthijs Cock. The drawing study, considerably worn, has no human figures and is usually known as the *Landscape with Bears* (dated 1554; plate 65), although it has a verso with a distant view of a city across open water with boats.[60] Instead of an open view of a local village, it shows a thick forest—something that did not exist in the Netherlands—of impossibly stylized and curving trees. As we shall see in the next chapter on Bruegel's early landscape drawings, some of this formulation derives from Italian models, particularly from the circle of Titian. Colorful shadows fill the depths and accent the trunks as well as the boughs of the trees. At the left distance the horizon opens up to reveal a large river with a city on the far bank. Since the drawing contains only

bears and no human figures, it is doubtful w[hether it] was devised with a print in mind.

When Cock did take this drawing and etche[d it] ("... Cock fecit") for commercial distribution, [...] the entire composition was reversed in the [printing] process. However, he added a pair of tiny b[...] figures, Jesus and Satan, in what became the [...] corner of the print, making the image into a *T[emptation] of Christ* (plate 66), with the inscription "Ma[n shall not] live by bread alone, but by every word that p[roceeds] out of the mouth of God, Mark 4 [*recte* Matt[hew 4] and Deuteronomy 8 [8:3]." Satan appears wi[th a small] branching barren tree atop his head, like a Bos[chian demon]; his cloak train ends in a lizardlike tail, and hi[s feet] suggest claws. In one hand Satan holds a ros[ary and a] cross, a test of faith through the trappings of f[aith...]; in his other hand he holds a stone, suggestin[g the first] challenge to Jesus: to turn such rocks into br[ead (Mat-] thew 4:3).

The modest scale of these principals ca[n be com-] pared to the etched figures in wider lands[capes that] Hieronymus Cock made after the drawing de[signs of his] brother Matthijs, particularly the transformi[ng figure of] Daphne-as-laurel (plate 56). Thus it is quite u[nlikely that] Bruegel himself designed these figures. Ulti[mately the] image offers the same kind of moral instructi[on through] its protagonists that Cock also offered in his f[irst image] in the manner of Bosch. The explicit mora[l is drawn] through the inscription, and it remains muc[h the same:] possessions and consumption merely distrac[t from true] spirituality.

[Th]is image also offers an extended landscape, one [of the ea]rliest made by Cock and surely one of Brue[gel's earli]est designs for a Cock print of any kind. Cock [...] has used finely etched striations to emphasize [the range] of shadows in the forest as well as the marshy [...] the right foreground and the minute city skyline [at the h]orizon. Due to the damaged condition of the [...] drawing, it is not possible to tell how much of [...]ial subtlety and modeling was present in Brue[gel's des]ign. Clearly the etching is already a translation [of the d]elicate and varied brown ink strokes of *Land[scape with] Bears*. The minute details of Cock's own added [figures] also are delineated crisply and precisely, includ[ing the] radiant halo of Christ. *The Temptation of Christ*, [... a] collaboration with Cock himself in the role of [...] combines the moral instruction that shapes the [Bosch]ian images within a dominant landscape. Shortly [after]ward, the artist would design the Large Landscapes [...]d; etched by the Duetecums rather than by Cock [himself;] chapter 4), as he also began to make a series of [...] in the manner of Bosch to serve that particular [...] market for the Quatre Vents (chapter 5).

[The] Boschian strain in Bruegel print designs soon [appear]s in *Big Fish Eat Little Fish*, after a drawing that [he sign]ed and dated (1556; plate 68). This drawing, too, [is in po]or condition, doubtless in part because of its use [in the] production of an engraved copy by Pieter van der [Heyde]n (plate 69). In this case, however, the Cock prac[tice of] ascribing images to "Hieronymus Bos inventor" [contin]ues on the print, which also carries the name of [Cock an]d the monogram, one of his earliest, of van der

67
Master of the Small Landscapes
Village Scene, c. 1560
Pen and brown ink, 5 × 15⅝ in.
(12.7 × 39.7 cm)
The Metropolitan Museum of Art,
New York; Rogers Fund 1906

68 *(Page 84)*
Pieter Bruegel
Big Fish Eat Little Fish, 1556
Pen and brush with gray and brown
inks, contours indented for transfer,
8⅜ × 12 in. (21.6 × 30.7 cm)
Albertina, Vienna (Mielke 31)

69 *(Page 85)*
Peter van der Heyden,
after Pieter Bruegel
Big Fish Eat Little Fish, 1557
Engraving, 8 7/8 × 11⅝ in.
(22.9 × 29.8 cm)
The Metropolitan Museum
of Art, New York; Dick Fund

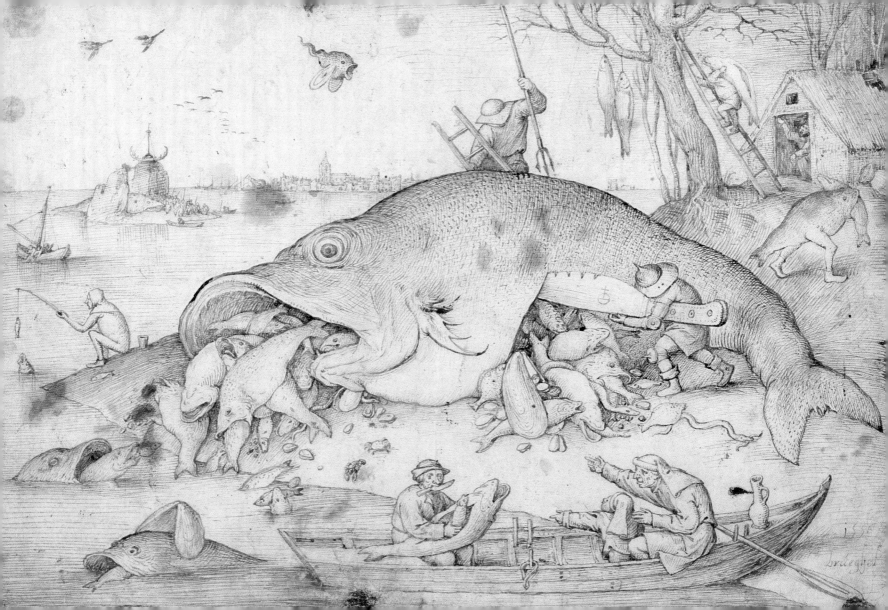

GRANDIBVS E VNT PISCES PISCIBVS ESCA.
Siet fone dit hebbe ghe eten / dat die groote villen de cleine eten

Hieronÿmus Bos.
inuentor

COCK EXCV 1557

Heyden (PAME, for Petrus à Merica). While we can be certain that the drawing is by Bruegel rather than Bosch, the publisher chose instead to credit the much more familiar and marketable name of Bosch on the print itself. In this case, the message is proverbial, and Bruegel would reuse this image within more than a hundred like it in his 1560 painting *Netherlandish Proverbs* (plates 186, 187). The message is inscribed below in Latin and Dutch, and to show its validity from generation to generation, a father is pointing to the scene for his son to observe (*Ecce*, "behold").

Many Bosch-derived elements fill this print: flying fish in the sky, a fish with legs in the left background, and a giant fish in the right background seems to be the object of a visit from a crowd of humans. Gigantism appears in the form of birds in the center image of Bosch's renowned *Garden of Earthly Delights* (Prado, Madrid), where a large fish is carried; fish fly in the *Garden* as well as in Bosch's *St. Anthony* (Lisbon), where on the left wing one large fish eats a smaller; a fish with legs leads the procession to Hell in the *Haywain* triptych (Prado, Madrid). Moreover, the man with a helmet who wields an enormous knife, inscribed with the orb of the world, and slices open the largest fish seems to derive from a Boschian image in the *Hell* wing of the *Garden of Earthly Delights*, where an army is led by a giant knife between a pair of enormous ears.[61] However, it is worth stressing here that this image is not a Hell scene, nor are the figures demons; instead, this print intends to show "the way of the world" through its imagery of a Netherlandish proverb, however preternatural its figures.[62] It should be noted in a chapter on designs for prints that Bruegel has begun in this drawing to make regular, even, repeated pen strokes to model the various surfaces of his image for van der Heyden's burin.

The two collaborators, Bruegel and van der Heyden, would soon team up again for Cock's Bosch-related series of the Seven Deadly Sins (1556–58; chapter 5), which once more seems to present a Hell-on-earth. They also soon collaborated on another folly print like the ones ascribed to "Bos," but this one comes with the label "Bruegel inventor": *The Ass at School* (plates 70, 71). The original drawing, followed very closely in the print, as with *Big Fish Eat Little Fish*, is dated 1556; it bears an added Dutch inscription (the print also has a Latin inscription) in a different ink, fashioned in a careful calligraphic hand.[63] Once more the content is proverbial: if you send a stupid ass to Paris, it will not return as a horse. The ass in question appears in the upper right of the drawing, accompanied by spectacles as the marker

of his shortsightedness and attempting to read a sheet of music. He looks in on an overcrowded schoolroom of unruly children (who resemble miniature adults), presided over by a teacher who is about to spank the exposed bottom of one of them, presumably with a switch that he wears in his hat. The teacher also wears fifteenth-century costume from the era of Jan van Eyck, seemingly to suggest that he too is old-fashioned and will not be able to impart any more to them than to the donkey.

Close in form to the *Ass in School* are a couple of further collaborations on folly prints of Bruegel with Pieter van der Heyden: *The Stone Operation* (1559, no extant drawing; plate 72) and *The Festival of Fools* (plate 76), probably from around the same date but not issued until after Bruegel's death, since it bears the Quatre Vents designation but without the name of Cock himself, so it corresponds to other posthumous publications by his widow after 1570.[64] *The Stone Operation* takes on the literal premise of foolishness, which according to contemporary folklore, exemplified in contemporary satires in Dutch by the local rhetorician guild (*rederijkers*), claimed that foolishness was simply a product of a stone on the brain, which could be cut out by a surgeon (like the subject of the shaving of the fool, another popular delusion about ridding the body of its folly). Bosch had made this topic the theme of one of his small pictures (Prado, Madrid), and a more dramatic enactment of this subject was painted a decade before Bruegel's print by Jan van Hemessen (c. 1550, plate 73).[65] While an original inscription is also lacking, the meaning of the engraving seems clear. Bosch also showed a quack doctor with an exotic costume and a tabletop signboard as one of the deceivers in the foreground of his *Haywain*. Additionally, Lucas van Leyden produced his own 1523 engraving (plate 75) of an outdoor quack dentist, whose assistant picks the pocket of a gullible peasant while he is in pain from oral surgery, as all three figures are standing up like the Bruegel *Stone Operation*.

In this print, which seems to have translated its design less effectively than most van der Heyden engravings,[66] a crowd of grotesque figures fills a village square, squeezing around a makeshift table where the "operation" will be performed by the quack surgeon, an old woman whose belt holds a pouch full of surgical scissors. She is already holding up one large globe to the crowd as she yanks around the head of a poor peasant who suffers from a highly visible stone at his forehead. Next to her in the center foreground her assistant is pouring soothing water onto a seated man, whose open head wound

brueghel · 1·5·5·6

Al reyst den esele ter

Est eenen esele by en sal gheen peert weder keeren

Brugel · Inuentor ·

COCK · EX · 1557

PARISIOS STOLIDVM ... AT ASELLVM · SI HIC EST ASINVS NON ERIT ILLIC EQVVS ·

Al reyst den ... leeren / ist eenen esele hy en sal gheen peert weder keeren

4

BRUEGEL

AS LANDSCAPE

ARCHITECT

Landscapes comprised Pieter Bruege[l's earliest] designs for Hieronymus Cock's engr[aving] series, probably issued around 1555, kn[own as the] Large Landscapes.[1] But Bruegel had been [making] drawings of landscapes as his earliest docume[nted work] as early as 1552, and no other aspect of his art ha[s been more] thoroughly re-examined by scholars in recen[t...]

As we have already seen (chapter 2), by [the time of] Bruegel's midcentury entry into the local guil[d...] painting had already developed an establish[ed category] of painting known as landscapes. Indeed, dur[ing his visit] to the city in 1520–21 the German artist Alb[recht Dürer] already described the pioneer of landscap[e imagery] Joachim Patinir (active 1515–24) as "the goo[d landscape] painter."[3] In the following generation, land[scape draw]ings as signed, independent works of art wer[e produced] notably by one of the two artist sons of Qu[entin Mat]sys (act. 1491–1530), Cornelis Matsys (act. 153[...]. Not only did Cornelis monogram (C ME [...) landscape] his horizontal ink drawings, but he gave th[em a signa]ture style that would considerably shape the [early draw]ings of Pieter Bruegel: short repeated ha[tching to] land surfaces and scratchy, shaping strokes fo[r flickering] effects of foliage (plate 80). His layout of th[e landscape]

[...] follows the model of Patinir, beginning with an [elevate]d foreground ledge, in this case punctuated by a [sturdy], curving tree trunk that rises above the horizon, [then] moving to a lower, hill-lined valley in the middle [groun]d, and finally to a glimpse of a distant horizon, [...] with open water. Unlike Patinir, no major reli[gious] [f]igures are visible to define the content of the pic[ture. F]rom the foreground; instead, amid their cottages [and tr]ees tiny anonymous figures and animals inhabit [the sp]ace and move within it without drawing atten[tion. T]he exposed paper conveys an overall brightness [and un]ity to this delicate drawing.

[Bru]egel clearly was already making landscape draw[ings a]s part of his Italy itinerary. No fewer than five [extan]t drawings date from 1552, and it is significant as [well th]at Bruegel signed and dated them, with a self-[consci]ousness and confidence in their status as finished [art wo]rks comparable to Cornelis Matsys. The standard [wisdom] by scholars holds that Bruegel did not bring [back It]alian forms and figure types like those of his mas[ter Pi]eter Coeck van Aelst, or other artists who were [profou]ndly shaped by their own trips to Italy (Lam[bert L]ombard, Frans Floris, Maarten van Heemskerck; [chapte]r 3). However, his landscapes do reveal a dialogue

78 (pages 92–93)
Pieter Bruegel
Landscape with Parable of the Sower,
1557
Detail of plate 109

79 (opposite)
Pieter Bruegel
Stream with Angler, c. 1554
Detail of plate 92

80 (below)
Cornelis Matsys
Landscape, 1540
drawing, 7¾ × 12⅛ in.
(19.9 × 31.2 cm)
Musées Royaux des Beaux-Arts
de Belgique, Brussels

81

Pieter Bruegel
Southern Cloister in a Valley,
drawing, 1552
Signed "Brueghel"
Brown ink with watercolor
highlights by another hand,
7¼ × 12¾ in. (18.5 × 32.6 cm)
Staatliche Museen,
Kupferstichkabinett, Berlin
(Mielke 2)

with recent works from Italy, especially from the circle of Titian in Venice, which had its own connections to Northern Europe, albeit more toward Germany, directly across the Alps.[5] In *Southern Cloister in a Valley* (signed "Brueghel" and dated 1552; plate 81) Bruegel already displays the range of penwork, with darker and thicker parallel strokes in the foreground, dotted and delicate flecks in the distance; unfortunately the visual effects have been compromised and exaggerated by the addition of washes by a later hand. The setting looks Italian, with gentle hills and a monastery with tiled roof. This attention to plausible topography immediately raises the question of whether Bruegel created this image on site or adapted it from a site; however, comparison to the model of Cornelis Matsys both for compositional layout and for technique suggests that Bruegel already was conscious of how constructed even convincing landscape had to be. In this case, he used the model of a Flemish landscape drawing to evoke the Italian campagna.

From the same year Bruegel's *Wooded Landscape with Mills* (plate 82) presents a strikingly different composition. It is organized—like met de Bles's landscapes (chapter 2) and like so many Bruegel landscapes to follow—from a diagonal vantage point at the lower left, and it is viewed in a highly directed fashion, off to a low horizon just above the lower right corner. This viewpoint is dominated by a tall, sharply curving tree that reaches to the very top of the sheet and counters the horizontality of the format with dramatic, more heavily modeled verticality. Unlike the Berlin drawing, however, this setting is not markedly specific, yet like Bruegel's later design of 1554 for the Cock *Temptation of Christ* etching, *Landscape with Bears* (see plates 66, 65), it places a thickly forested zone at one side opposite a view that opens up to the distance. A similar twisting trunk, available in a Venetian colored woodcut of the early 1530s, was probably designed by Domenico Campagnola (for example, *Two Goats beneath a Tree*).[6] The

hillside clustered with a thick forest derives ▓▓▓ ▓▓▓ ▓▓▓▓▓▓▓ to Giovanni Britto after Titian) of *Landscape*
els by Titian himself, as preserved in anothe▓ ▓▓▓▓▓▓ *▓▓ Milkmaid* (c. 1520–25).[8] Bruegel tried his hand at the
ico Campagnola drawing, *Landscape with W▓▓▓▓ ▓▓▓* ▓▓▓▓▓▓ ▓▓ as well in a signed *Pastoral Landscape* (plate 85).
(plate 83).[7] Thus in his Milan drawing Brueg▓▓ ▓▓▓ ▓▓▓ ▓▓▓▓, small-scale anonymous figures ply their rural
not Italian settings, but rather Italian motifs, ▓▓▓▓▓ ▓▓▓▓ ▓▓ tending flocks of sheep and cows; the nearest
several models, as his subject. ▓▓▓▓▓ moves into the setting on horseback. Following

 The pastoral tradition of imagery, whic▓ ▓▓▓▓▓▓▓ ▓▓▓ ▓▓▓ck, here the gentle diagonal movement from the
shepherds immersed in the hills and tend▓▓▓ ▓▓▓▓▓ ▓▓▓ ▓eft corner to the low horizon at the right distance
was also a Venetian specialty, such as in th▓ ▓▓▓▓▓▓ ▓▓▓▓ues Bruegel's experiments in spatial layout. In

82
Pieter Bruegel
Wooded Landscape with Mills, 1552
Pen and brown ink, 8¼ × 11 in.
(21.3 × 28.1 cm)
Biblioteca Ambrosiana, Milan
(Mielke 3)

83
Domenico Campagnola
(after Titian?)
Landscape with Wooded Slope
Pen and brown ink
Galleria degli Uffizi,
Gabinetto Disegni et Stampi,
Florence

84 (above)
Pieter Bruegel
Ripa Grande, n.d.
Pen, brown and sepia inks,
8⅛ × 11 in. (20.7 × 28.3 cm)
Devonshire Collection, Chatsworth
(Mielke 14)

85
Pieter Bruegel (right)
Pastoral Landscape, 1552
Signed "[B]rueghel"
Pen and brown ink, 8⅜ × 12⅛ in.
(21.5 × 31 cm)
Nasjonalgalleriet, Oslo (Mielke 7)

86 (opposite)
Pieter Bruegel
Landscape with St. Jerome, 1553
Pen and brown ink on laid paper,
9 × 13⅛ in. (23.2 × 33.6 cm)
National Gallery of Art, Washington;
Ailsa Mellon Bruce Fund (Mielke 17)

this case, the spindly trees follow the course of recession (as if anticipating the movement into depth of the 1565 *Hunters in the Snow*; plate 275). In this work the darker ink is applied more boldly and broadly but with the same distinctive handling, particularly noteworthy after a drop-off at the lower right corner, where a lower valley extends into depth. Some of this boldness might result from the artist's study of Venetian woodcuts and their linear graphics.

In the following year, 1553, Bruegel signed and dated a landscape drawing with St. Jerome (plate 86). This work readily aligns with the structure of the 1552 Berlin drawing: strong shadings in the foreground and finer structure in the distance like Cornelis Matsys. Like Netherlandish painted landscapes, this image features a small but prominent foreground saint: St. Jerome in retreat, beneath another tall, spreading tree in the lower left corner, kneeling beside a crucifix and beating his breast with a stone to dispel lascivious thoughts.[9] Compositionally, this image moves from the dominant elevated ledge with trees at the left foreground, across a valley in the middle distance, to a fortified town (a motif that also appears in a drawing by Titian, Musée Bayonne, Bonnat).[10] This arrangement provides a synthesis of the two previous works, using the curving trees and diagonality of the Milan drawing along with the plausible site of hills, trees, and settlements across the background.

The artist left tangible evidence of his time in Rome (1552–54) with one of his few truly topographical drawings: *Ripa Grande* (undated but signed; plate 84), the main river harbor on the Tiber. Constructed from two different inks, suggesting two different campaigns of creation, this image uses a darker brown for its closer bank with small anonymous figures in boats, whereas the clustered horizontal background buildings and ships are rendered in a lighter reddish-brown. This drawing is noteworthy for its disciplined use of parallel strokes, which define the water surface as well as the solid shaded walls of the buildings opposite. At the far right a view into distance utilizes the same delicacy of touch (clearly the work of the same artist, though his son Jan Brueghel has sometimes been credited with this work). While this

is the only surviving drawing by Bruegel of ▓▓▓ ▓▓
later used the Colosseum for the basic struc▓▓▓ ▓▓ ▓▓
Tower of Babel in his paintings of the 1560s ▓▓▓▓ ▓▓
240), and one of his Large Landscapes, mac▓▓ ▓▓ ▓▓▓
after his return to Antwerp, shows a *View of* ▓▓▓ ▓▓▓
an impressive waterfall.

Bruegel, however, also created Alpine sce▓▓ ▓▓ ▓▓
eral of his early landscape drawings. Here ▓▓ ▓▓▓ ▓▓
advantage over Patinir and earlier landsca▓▓ ▓▓▓▓▓
from the flat country of the Netherlands by ▓▓▓▓ ▓▓ ▓▓
direct experience of the Alps on his trips t▓ ▓▓▓ ▓▓▓
Italy. As Karel van Mander, his first biogr▓▓▓▓ ▓▓▓
with astonishment in the *Schilderboek* (1604 ▓▓▓ ▓▓
journeys Bruegel did many views from nat▓▓▓ ▓▓ ▓▓▓
it was said of him, when he traveled throug▓ ▓▓▓ ▓▓▓
that he had swallowed all the mountains and ▓▓▓▓▓ ▓▓
spat them out again, after his return, on to ▓ ▓▓▓▓▓▓
and panels." A first example, *Mule Caravan* ▓▓▓ ▓▓▓
side (traces only of signature and date; plate 8▓ ▓▓▓▓
towering pine trees at the right edge, growi▓▓ ▓▓▓ ▓▓
corner ledge that is closest to the viewer. T▓▓ ▓▓▓▓
delineated forms resemble the 1552 *Pastoral L*▓▓▓▓ ▓

plate 85), but the river valley in the left distance
▓▓ered in the finest of regular strokes, where a city
▓▓▓ its surrounding hills seems to dissolve in atmo-
▓▓▓▓. In 1553 the *Mountain Landscape with River and*
▓▓▓*rs* (plate 88) shows full mastery of both Alpine
▓▓▓▓s and spatial disposition from lower left to upper
▓▓▓ Small travelers occupy the left corner ledge; they
▓▓▓ ▓eneath another of Bruegel's spindly framing trees,
▓▓▓ ▓eir vista follows the flow of a stream. Like the
▓▓ *Grande*, this drawing offers a commanding object
▓▓▓ from the viewer, in this case a promontory with
▓▓▓ss at its crest, matched by a tall hill at the right.
▓▓▓ ▓▓ver bends behind them, and at the high horizon
▓▓▓▓rms its destination a tiny glimpse of open water is
▓▓▓▓. Echoes of the swelling landscape reappear above
▓▓▓▓▓y fashioned clouds.

▓▓nother signed and dated 1553 drawing (plate 89)
▓▓▓▓s a carefully constructed, minutely executed moun-
▓▓▓▓us setting that towers even more forbiddingly
▓▓▓ ▓ts tiny human wayfarers. Its entire environment
▓▓ ▓▓▓y enclosed by the peaks, which seem to confront
▓▓▓ ▓▓wer and to rise well above him with no obvious

87 *(opposite)*
Pieter Bruegel
Mule Caravan on a Hillside
Drawing, traces of signature and date,
8½ × 16¾ in. (21.8 × 30.1 cm)
Museum Boijmans Van Beuningen,
Rotterdam (Mielke 5)

88 *(below)*
Pieter Bruegel
Mountain Landscape with River and
Travelers, 1553
Pen and brown ink, 8⅞ × 13⅛ in.
(22.8 × 33.8 cm)
British Museum, London
(Mielke 10)

89
Pieter Bruegel
Alpine Landscape, 1553
Pen and brown ink, 11¼ × 16¾ in.
(29 × 43 cm)
Musée du Louvre, Paris (Mielke 16)

pathway except downward from the curving road at the lower left to the valley at lower right. This crowded composition offers no open spaces, including the cloud-filled sky above. From such Alpine experiences emerged the *Large Landscapes*, etched and published for Cock (see below), though this drawing is smaller in size than those prints.

Most fully worked of Bruegel's early mountain land-scape drawings is *Landscape with Fortified City* (1553, signed "p.brueghel"; plate 90). This work, too, displays a *horror vacui*, with such dark clouds above that the mountains at the right distance almost look silhouetted. Like the fortress behind *St. Jerome* from the same year (plate 86), this construction extends across the breadth of the image, and it is as fully detailed as the trees and animals, a vestige of pastoral, which stand before it. The gathering clouds and the fortified city will reappear in the background of Bruegel's 1564 *Christ Carrying the Cross* (plate 8).

For all of these works, Bruegel carefully constructed the spatial arrangements and meticulously applied his fine pen strokes to works that necessarily were created in the studio rather than on site. He made contrasting images appropriate to the pictorial traditions of Venice, especially pastoral, or else he included authentic Alpine experiences in the spaces, using ink drawing techniques of his Flemish predecessors. What these drawings share in common is their use of the horizontal format of the paper to suggest panoramic breadth, which the artist adapts to show strong recession into depth, often steeply from a corner foreground ledge that provides a viewing-point.

However, among the early drawings a pair of anomalous landscapes turn the paper ninety degrees and operate within a vertical format that follows the curving contours of boldly delineated trees. *Forest with Bears* (c. 1554; plate 91) is undated and is close to a number of drawing copies, many associated with Jan Brueghel.[11] As Mielke noted, the copies point to some lost drawings that were reused in the workshop of Bruegel's heirs, but the London drawing has the strongest claim to authenticity, although unsigned.[12] It has the same combination

92 (left)
Pieter Bruegel
Stream with Angler, c. 1554
Pen and brown ink on paper,
13½ × 9¼ in. (34.5 × 23 cm)
Bibliothèque Royale, Brussels
(Mielke 19)

93
Pieter Bruegel
River Valley in a Hilly Landscape, 1552
Pen and brown ink on blue paper,
6⅞ × 10¼ in. (17.6 × 26.4 cm)
Musée du Louvre, Paris (Mielke 1)

94 (pages 110–11)
Pieter Bruegel
Forest Landscape with View of Ocean,
1554
Pen and brown ink, brush and
brown ink, white gouache,
and black chalk on laid blue paper,
10⅛ × 13⅜ in. (26 × 34.4 cm)
Fogg Art Museum, Harvard
University Art Museums,
Cambridge, Mass.;
The Maida and George Abrams
Collection (Mielke 7a)

of Titian-inspired forest, now populated with [...] animals—seven bears in the London drawing—r[...] the cows and sheep of the pastoral settings. [...] horizontally, this same setting was used by B[...] his 1554 Prague drawing, which Cock used as [...] ground for his first Bruegel print, the etched *T[...] of Christ* (plates 65, 66).

A similar vertical drawing, *Stream with [...]* (1554; plate 92), also replicated in copies, is d[...] by a boldly drawn, craggy tree, which not only [...] beyond the top of the paper but also reaches i[...] out to the limits on either side. Dwarfed by t[...] able wood and its overhanging roots, a pair [...] men, one in a boat and the other on the ban[...] upstream by a distant figure on a horse, pu[...] living in harmony with nature. To the right [...] an old mill nestles within the thick woods and [...] nesses nature's force for human benefit.

Just before going to work for Cock, Bruegel [...] one final "colored" drawing on blue paper (1[...] 94). This recently discovered work has only [...] edent: an abraded, early *River Valley in a Hilly* [...] (plate 93), also on blue paper but in only black[...]

[...]self is a Venetian trademark, which had already [...] formative for Albrecht Dürer during his visit to [...]n 1505–7; he used blue paper to formulate a new, [...] modeling from this middle tone toward white [...]ts and dark shadings.[13] In this later drawing, [...]ently, rather than using only hatching, as in the [...] monochrome drawings as well as in the early [...]age, Bruegel now uses white highlights on the [...] and brown wash for the shadows, especially for [...]s and slope in the near left foreground. Careful [...]tion (and infrared study) reveal that the work is [...] over a black chalk sketch, reinforced with ink of [...]trokes.[14] Technical inspection also reveals that [...]e white highlights were applied as part of the draw-[...] process rather than being added later. In this work [...] already begins to structure landscape akin to his [...]ndscapes for Cock (see below): a viewing point [...] foreground left edge that recedes from heavily [...]d heights down to flatter, open ground and an [...] to an open water horizon.

[...]rms of the contents of this setting, the colored [...]ing offers a new synthesis, combining the Vene-[...] forests with a new appreciation of local Flemish

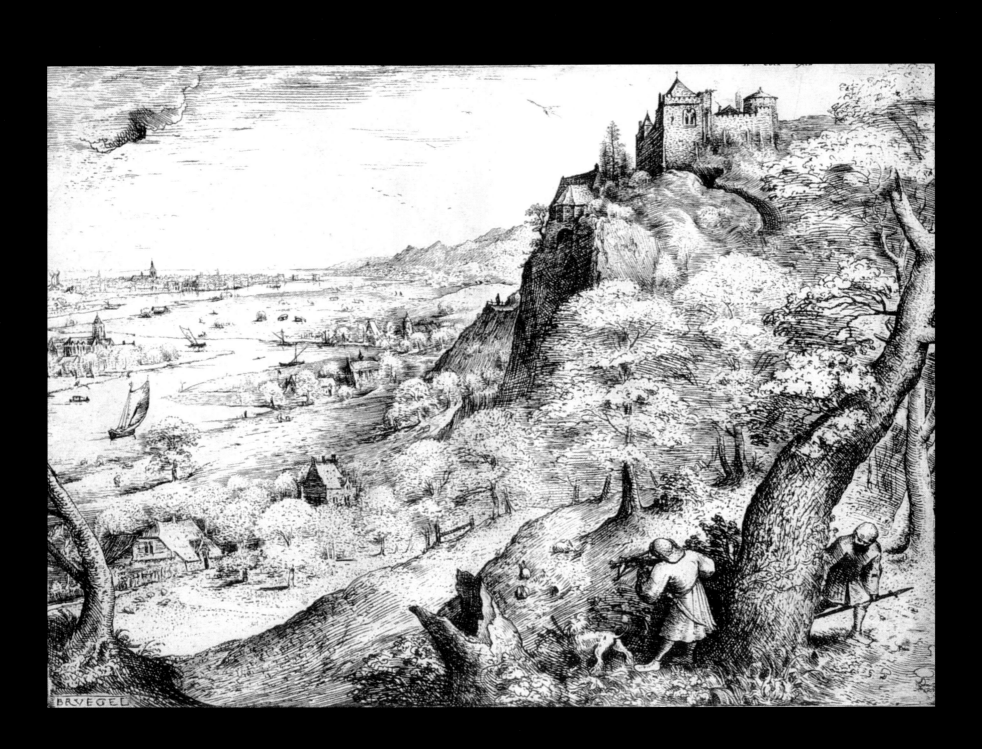

interrupt the otherwise unbroken white of
This riverside imagery also gave rise to an en
egory of Flemish landscape, fully exploited as
formula by his son, Jan Brueghel, for exam
River Landscape (plate 105).[24] One can also co
recession of this riverside imagery to the dyn
sion of Bruegel's *Ice Skating before the Gate o*
(plate 44).

This stronger infusion of local Flemish m
bined with greater spatial clarity and cohesio
a dramatic turn in Bruegel's landscape ar an
for later Flemish and Dutch renderings, inc
Small Landscapes of Cock. However, wher
tried his own hand at a solo effort in printma
lone etching, *Landscape with Rabbit Hunt* (
he returned to the formulas of his Large
designs. By eliminating his usual collaboratio
Duetecums, the artist was able to preserve the
ety of linework of his design, emphasizing dif
texture between the rough surface of the tre
the soft shimmer of foliage as well as the pre
sturdy hillside fortress. More delicate render
atmospheric distance is also preserved throug
cess. Compositionally, Bruegel's landscape b
Rustic Solitude (plate 102) in the lower right
elevated ledge that drops off in stages to a fl
valley but also gives way to the tall hill with th
in the upper right, which extends virtually t
of the print—where Cock places his mark.
own signature appears in block letters in the b
along with the date "1506"; scholars used to u
this as 1566 until it was revised by Christopher
be understood as a slip by the artist, who got
tion right in reversing the numbers but still
the 0 and 6 of the date.[25]

Recent re-examination of a drawing in reve
print, formerly thought to be a copy (plate
persuaded most scholars that it is the authenti
compositional design for the *Rabbit Hunt* etc
has black chalk preparatory drawing, reinforc
curiously the farther features are rendered in m
especially the hillside, and the nearer figures
are portrayed chiefly in outline. The drawing is
size as the print and might well have been tra
the plate somehow. Since the *Rabbit Hunt* was
only individual print, we should not be surpris
a compositional drawing that is less finished, be
artist himself would fill out the details, especiall
icate flecks and dots that could not be replicat
Duetecums during the process of working on

Mielke acutely observed, the refinement of the
details is consistent with a Bruegel original.
the majority of the Large Landscapes, this print
religious subject to animate its landscape, but
is it devoid of apparent content. In this case the
figures include a hunter with a crossbow who
the eponymous rabbits with his dog. Yet he fails
that on the other side of the corner tree lurks a
with a spear, a potential weapon used in warfare
a weapon expressly for hunting a dangerous,
animal, especially a bear.[27] In short, this image
ominous cast, despite the beautiful landscape
beyond the foreground ledge. Previously this
was associated with a benign and instructive
Netherlandish proverb (compare Bruegel's *Netherland-
erbs;* plate 187): "He who pursues two rabbits at
will lose both" (the English equivalent is "a bird
and is worth two in the bush"). However, more
this etching certainly conveys the mood of "the
hunted," and was so identified by Margaret Sul-
who cited an adage collected by Erasmus, "A hare
you hunt for prey."[28] The rabbit hunter focuses
on his activity and fails to notice his own danger
vulnerability, stalked by an armed soldier.

107 *(opposite)*
Pieter Bruegel
Landscape with Rabbit Hunt, 1560
Etching, 8¾ × 11⅜ in.
(22.3 × 29.2 cm)
Private collection

108 *(above)*
Pieter Bruegel
Landscape with Rabbit Hunt
Pen and brown ink with black chalk,
8¼ × 11½ in. (21.3 × 29.6 cm)
Institut Néerlandais, Collection Frits
Lugt, Paris (Mielke 53)

Had Bruegel not gone on to make paintings, at this point in his career he would still have been acclaimed as a master of landscape through his works in the graphic arts, but he might still not be celebrated any more than such draftsmen as Cornelis Matsys and Domenico Campagnola, both of whom provided powerful models that influenced his own drawings. Using such models does not mean that Pieter Bruegel did not have his own distinctive manner of composing the spaces and delineating the details of his landscapes. We remember his characteristic handling of strokes and flecks, his delicate rendering of details like animals and figures in transit or fortress walls and flickering foliage. In addition, we can celebrate his diversity of settings, ranging from thick forests and open pastorals derived from Titian and Venice to Alpine passes with almost no habitation. Increasingly in his designs for the prints, Bruegel incorporates distinctly local Flemish details into his highly artificial constructions, which derive from the "world landscape" models by Patinir and his followers in Antwerp. At a time when most of the landscape drawings made in the Netherlands were sketchbook compositions rather than independent works, Bruegel was unusual in following the example of Matsys to produce drawings as completed, independent works, to be collected and contemplated in their own right.[29] But it was his turn to painting in the late 1550s that marks the beginning of Bruegel's lasting reputation as an artist. Not surprisingly he began with works that primarily consisted of landscape.

Seemingly the first of Bruegel's paintings—today, unfortunately, in damaged condition and blurry in its details, which has caused uncertainty about its attribution—his *Parable of the Sower* is signed and dated 1557 (plate 109). This layout closely accords with the earlier *Rustic Solitude* and can readily be compared to the drawing in the same orientation in London (see plates 102, 103). Like the print, the high foreground is closed with a pair of slender trees that extend upward to the top of the composition; the main figure is located beneath them. Unlike the resting peasants of the print, this particular farmer is busy with his occupation, casting seeds widely ("broadcasting") across the left foreground of the image. A large tree stump occupies the center foreground, where stones are clearly visible in the soil. The main angle of viewing runs from the sower at the lower left corner to high Alpine crests in the upper right background, even as a wide river flows across that vista from lower right to a large bay at the horizon near the upper left. Once more the intermediate landscape is a Flemish village environment, albeit distributed along an uncharacteristic hillside topography. Near the center of the image stands another church steeple with a blue top. Perhaps the most unusual detail is the visible but indistinct crowd scene on the far side of the river.

That crowd in conjunction with the sower holds the key to the meaning of this image. Although possibly due in part to the painting's condition, the figure of Jesus is not recognizable on the riverbank—compare the tiny scene of Baptism in the Jordan River in Bruegel's 1566 *Preaching of St. John the Baptist* (see plate 224)—the fact that a speech is being delivered beside a boat suggests that this is an interpretation of the Sea of Galilee. The occasion is the first of Jesus's parables, this one (Matthew 13:1–23) delivered "beside the sea" to great crowds, so that Jesus "got into a boat and sat there, and the whole crowd stood on the beach" (13:2). The lesson is conveyed through homely metaphors, and this first parable uses the example of a sower, whose seeds were in part devoured by birds from the path, in part fruitless upon stony soil or choked by thorns, and in part successful because they found fertile soil. The moral of the story is that sermons and the word of God more generally are sometimes lost on unperceptive listeners (13:13) but effective with anyone "who hears the word and understands it" (13:23). Thus a parable itself is likely to be understood by only some of its audience, so again the task of the viewer is to discern the subject and its significance behind its seemingly everyday appearance.

Like the episode of the Ecstasy of the Magdalene, the gathering around Christ at the Sea of Galilee in the background is the key to understanding that this image is another (quasi-) religious subject, not a landscape with incidental figures. This Sower (rather than a mere sower) conveys deeper meaning and further suggests that the artist might also have hidden significance in some of his other works, just as he employs an adage in his *Rabbit Hunt*, then uses *Netherlandish Proverbs* shortly afterward for a 1559 painting (plate 187), and still was painting parables when he produced *The Blind Leading the Blind* (1568; plate 305) at the end of his career. As will be the case in many later Bruegel images (chapter 8), a perceptive viewer's recognition—perhaps even with the force of a revelation—of the religious content in a work that at first sight seems more like a local Flemish village or landscape will be a necessary pictorial skill for understanding much in the artist's oeuvre.

One of the artist's most celebrated paintings—and one of the most controversial—is his nonreligious canvas (rather than panel) of *The Fall of Icarus* (plate 110).[30] Its very authenticity has been challenged, though no one

from Crete on wax-fused wings by Daedalus and his son Icarus, the poet expressly mentions three witnesses to their seemingly miraculous flight—shepherd, fisherman, and farmer, the very occupants of Bruegel's landscape—who exclaim in wonder that these fliers might be gods. Of course, despite the warnings by his father not to fly too close to the sun, Icarus's pride took him up to greater heights, from which he tumbled to his death in the sea when the heat of the sun melted the wax and disintegrated his wings. Even though the painting does not show the three witnesses directly observing the flight above them, their presence in the image shows Bruegel's familiarity with Ovid's Latin verses and his cast of characters.

Because of his misjudgment Icarus was taken to be the epitome of foolish haughtiness, appearing in one (near-) contemporary emblem book from Antwerp (Johann Sambucus, 1564), which declares that it is better to know one's proper place and accept one's own fate.[32] Even a century later, the sculpted marble relief image of a falling Icarus will appear outside the Bankruptcy Chamber of the elaborate Amsterdam Town Hall.[33] This same moral message was provided in the interpretation given by Karel van Mander in his *Wtleggingh* (Explanation) of the *Metamorphoses*, published with his *Schilderboek* for the use of artists in 1604.[34] The most vivid representation of the falling youth is provided by Peter Paul Rubens in his oil sketch (plate 112) for the painting cycle of myths sent to King Philip IV of Spain in 1636–38 for his hunting lodge, the Torre de la Parada.[35] Like most illustrated mythographies of the sixteenth century, such as the volume by Bernard Salomon (Lyons, 1557), Rubens shows the tumbling Icarus beside his father, Daedalus, in the climactic moment of his sudden fall.

In contrast to this more conventional emphasis on the tragic hero, Bruegel has reduced his presence in the composition to a pair of legs crashing into the sea in the lower right corner as a shower of feathers gradually cascades downward behind him, mostly visible in front of the sailing ship. Yet Bruegel's Musées Royaux version does not even represent Daedalus at all (unlike the Van Buuren copy) and focuses instead on that group of anonymous individuals who expressly do work with natural forces. In addition to the farmer, the shepherd, and the fisherman, the anonymous sailors on the ship are humbly harnessing wind and weather, land and sea, to achieve their appropriate goals. Instead of representing self-transformation and clever defiance of natural limits, Daedalus's plan to soar through the air like a bird is doomed to fail rather than destined to provide

113
Pieter Bruegel
Fall of Icarus, 1590
Detail of plate 110

everlasting, godlike glory. His name is remembered, and theirs are not, yet he loses his son to ever greater striving. That this underlying message was pertinent for Bruegel—and that he knew and used Ovid's own text—is revealed by the plump green bird that hovers upon a branch between the angler and the ship. That bird depicts the very next figure in Ovid's verses, Perdix, once an apprentice to Daedalus but hurled by him from a tower, only to be transformed by Minerva into a partridge. That bird, observes Ovid, "Never flies high, nor nests in trees, but flutters / Close to the ground . . . The bird, it seems, remembers, and is fearful of all high places."[36] Just as the viewer might easily overlook Icarus as the true subject of this composition, so too might the opposite lesson—the quieter caution of the partridge—remain unnoticed. Indeed, closest to the ship one of the white sheep in the flock ventures dangerously close to the edge of the shore, neglecting its safety.

Directly in front of the plowman, barely visible in the bushes, lies a corpse, an old man on his back, whose balding white head lies face up. The very anonymity of this nameless character and his uneventful death contrast utterly with the renowned figure of Icarus (seen ignominiously only from his other end), the victim of a catastrophic accident in the bloom of his youth. Charles de Tolnay was the first of many commentators to observe this detail, which he tied to an assertion that it constituted a symbolic miniature of the entire image, claiming that it is the emblematic representation of a Dutch proverb, "The plow does not stop on account of the wish of a dying man."[37] Also possible as a commentary are the words of Jesus's parable: "No one, having put his hand to the plow, and looking back, is fit for the kingdom of God" (Luke 9:62).[38]

One last, small detail of the foreground accessories adds poignancy to the plowman's labors: a coin purse and dagger lie in the foreground. Most observers who note this detail associate it with the peasant himself, although Matt Kaveler is quick to note that it provides a discordant note to his peaceful toil on the land, so he reads it instead as being set aside by the farmer himself to provide an image of peace rather than peasant violence.[39] Instead, we should rather assign these attributes to someone else, or least to an inhabitant of the very environment not visible in the *Icarus*—the distant world of the city, where such tools of force and finance are much more useful within an urban and capitalist setting (see chapter 2).

The *Parable of the Sower* (plate 109) provides an example in Bruegel's recent painted oeuvre of a work whose larger significance, like a parable itself, emerges from

humble actors, whose very humility and closeness to the earth makes the lesson hold more universal significance. As Kaveler and Robert Baldwin pointed out, Bruegel includes the farmer as an emblem of Diligence, one of several epitomes in the background of his 1559 drawing design for *Hope*, a print in the Seven Virtues series for Hieronymus Cock (plate 163); the allegory of Hope herself holds a sickle in one hand and a spade in the other.[40] The farmer's practiced patience and acceptance of his station in life provide the antithesis to the boldness of the soaring youth, just as the well-trimmed sails and teamwork of the ship, hugging close to the shore, assure its eventual attainment of its harbor destination. In the background of *Hope,* however, dangers threaten: the farmer is sowing perilously close to the swelling stream, and Bruegel also includes ships on the verge of sinking in stormy waters, while the allegory herself stands upon an anchor.[41]

Thus the ultimate imagery of Bruegel's *Fall of Icarus* makes nature and harmony with nature into the subject of the painting. Even while it presents the defiance of nature in the vertical axis used by the two fliers, it asserts the harmony with nature through figures organized in the landscape along the horizontal axis. Reading from left to right across the foreground and following the background coastline, one sees the plowman placed prominently near the center and on line with the ship at the right, descending to the fisherman (and partridge) at the lower right corner, closest to the water level.

Claims that Bruegel did not devise the *Icarus* composition fall short when one sees the wider influence of this uncommon subject among his contemporaries. Hans Bol of Mechelen, an artist who on one occasion completed Bruegel's print designs for the Four Seasons by the Cock workshop (see chapter 9), made a particularly striking adaptation in a small gouache on paper (signed and dated 1590; plate 114).[42] In that miniature the Ovid text is more literally re-enacted, as the plowman, shepherd, and angler all look up in amazement at both figures flying overhead, before the fall of Icarus.

Whether the Brussels picture is the damaged Bruegel original or else the truest version of the lost *Icarus* composition, its layout provides a culmination of the artist's early landscapes in his graphic works. It also signals his ongoing considerations of those anonymous, ordinary figures who inhabit and work within Bruegel's composite landscape settings. In Bruegel's mature paintings of the 1560s (chapter 9) such productive peasant labors on the land would eventually become his signature pictorial formula and recurrent favorite theme.

114

Hans Bol

Fall of Icarus, 1590

Gouache on paper, 5⅛ × 8 in.

(13.3 × 20.6 cm)

Museum Mayer van den Bergh,

Antwerp

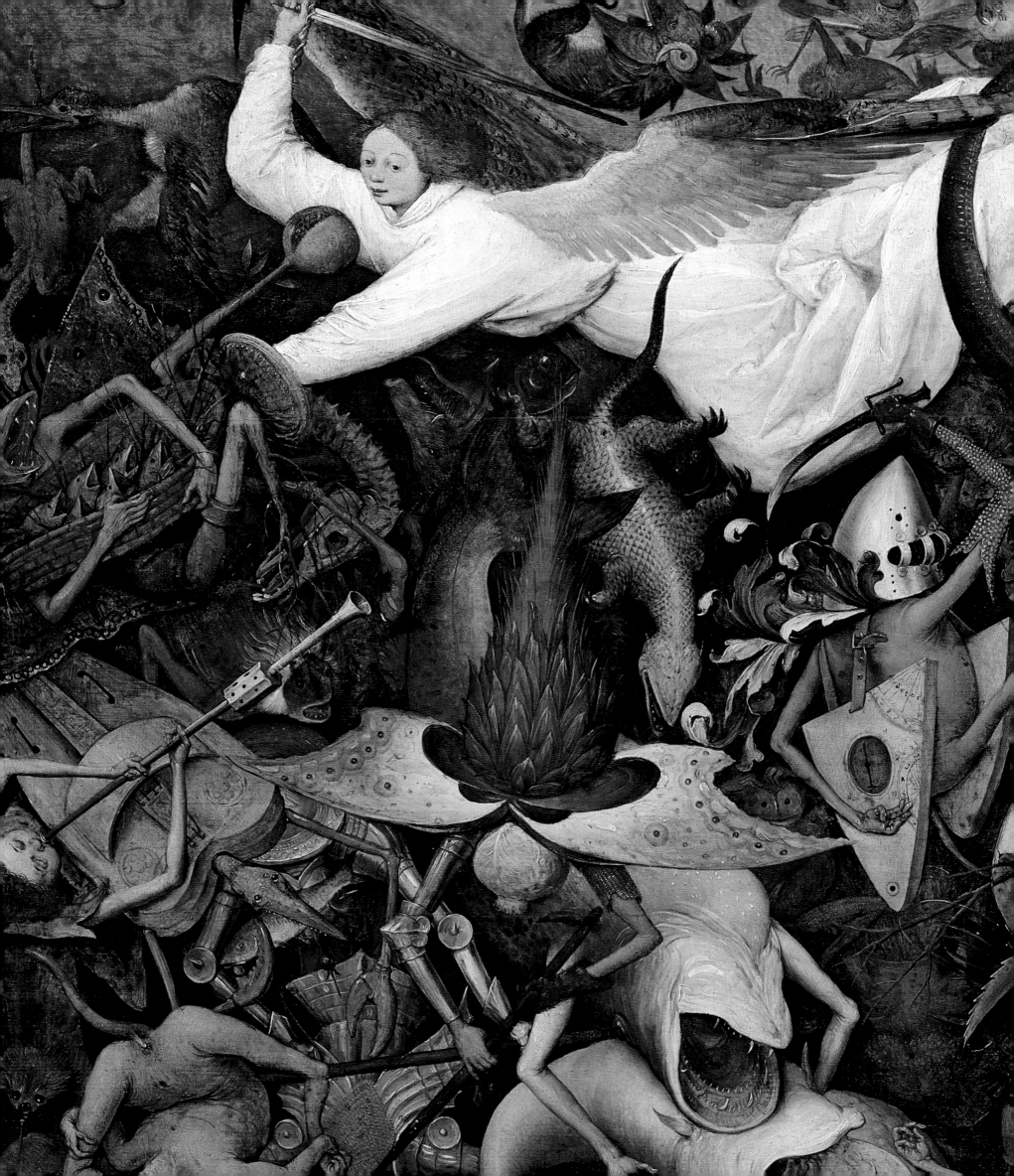

5

THE "SECOND
BOSCH":
BRUEGEL ADAPTS
A TRADITION

When the engraved profile [plate 24) of Pieter Bruegel [...] humously within a series o[...] celebrated painters of the Netherlands, *quot celebrium Germaniae inferioris effig*[...] by the Hieronymus Cock firm Aux Quat[...] run by Cock's widow), it was accompa[...] verses penned by Domenicus Lampsoni[...] catory verses to the entire volume by La[...] claim that artists of the region no longer h[...] upon workshop training; instead, they b[...] numerous and widespread printed rep[...] renowned compositions produced and [...] Cock (chapter 3), particularly by artists[...] Floris and Pieter Bruegel, from the curre[...] The poet also calls for the imitation of [...] extending back to Jan van Eyck (d. 1441[...] Bruegel as exemplary in his attention to [...] ter 1). The verses beneath the Bruegel po[...] underscore his links to Hieronymus Bosc[...]

> Who is this new Jerome Bosch reborn t[...]
> who brings his master's ingenious fligh[...]
> life once more so skillfully with brush a[...]
> he even surpasses him? . . . Honor to[...]
> as your work is honorable, since for th[...]
> inventions of your art, full of wit, in th[...]
> the old master, you are no less worthy[...]
> praise than any other artist.[2]

Very similar sentiments were penned by [...] ciardini in his *Descrittione di tutti Paesi B*[...] ing Bruegel's lifetime: "Pieter Bruegel [...] imitator of the knowledge and fantas[...] Bosch, whereby he has also acquired th[...] 'second Jerome Bosch.'"[3]

Much of this reputation came from th[...] by Bruegel, produced as designs for engr[...] Antwerp printmaking firm, Aux Quatre[...] 3). We have already seen a number of pu[...] originals—almost certainly imitations, [...] right forgeries—engraved for the firm b[...] fessional specialist, Pieter van der Heyd[...] go on to engrave works by Bruegel in[...] Indeed, alongside the strong offering[...] works, and landscape prints (chapter 4)[...] a large roster of Bosch-influenced works[...] Indeed, Bruegel's own early foray into [...] Cock, *Big Fish Eat Little Fish* (plate 68) b[...] lent attribution to Bosch, "Hieronymus [...]

[Ev]en though Bruegel soon would go on to produce [ima]gery under his own name with Cock, many of his [ear]ly compositions, some of them in series, would con-[tinu]e to feature the basic, popular pictorial vocabulary of [Bos]ch, particularly his hybrid monsters.

[O]ne of the earliest of the Boschian images by Bruegel, [alth]ough it appeared with no name other than Cock's, [dep]icts one of Bosch's favorite themes: *Temptation of [St] Anthony* (1556; the undated drawing survives, plate [...].[4] Certainly Bruegel's adoption of Bosch's forms and [...]ne echoed the imitation of Bosch by a variety of mid-[cen]tury painters in Antwerp, such as Jan Mandyn, *Temp-[tati]on of St. Anthony* (c. 1550; plate 119).[5] Unlike *Big Fish [Eat] Little Fish*, which reversed the design in the process [of] printing, this engraving shares the same orientation [as t]he drawing, even while adding a few eye-catching [det]ails, such as a discarded bag of coins, along the bot-[tom] edge of the print. However, Bruegel is already [atte]mpting to accommodate to his task, using graphic [mea]ns suitable for reproduction to convey shading, par-[ticu]larly through dense networks of linear hatchings. [Ma]ny expressly Bosch elements reappear in this ren-[diti]on: the oversized human head in the center, redo-[len]t of the celebrated Tree-Man in his *Garden of Earthly*

115 (pages 136–37)
Pieter Bruegel
The Fall of the Rebel Angels, 1562
Detail of plate 146

116 (opposite)
Pieter Bruegel
Dulle Griet ("Mad Meg"), 1562
Detail of plate 143

117 (below)
Pieter van der Heyden,
after Pieter Bruegel
The Temptation of St. Anthony, 1556
Engraving, 9⅝ × 12¾ in.
(24.7 × 32.8 cm)
The Israel Museum, Jerusalem

MVLTÆ TRIBVLATIONES IVSTORVM, DE OMNIBVS IIS LIBERABIT EOS DOMINVS · PSAL · 33 ·

118
Pieter Bruegel
The Temptation of St. Anthony,
c. 1556
Pen and brush with brown and
gray-brown inks, 8⅜ × 12¾ in.
(21.6 × 32.6 cm)
Ashmolean Museum, Oxford
(Mielke 30)

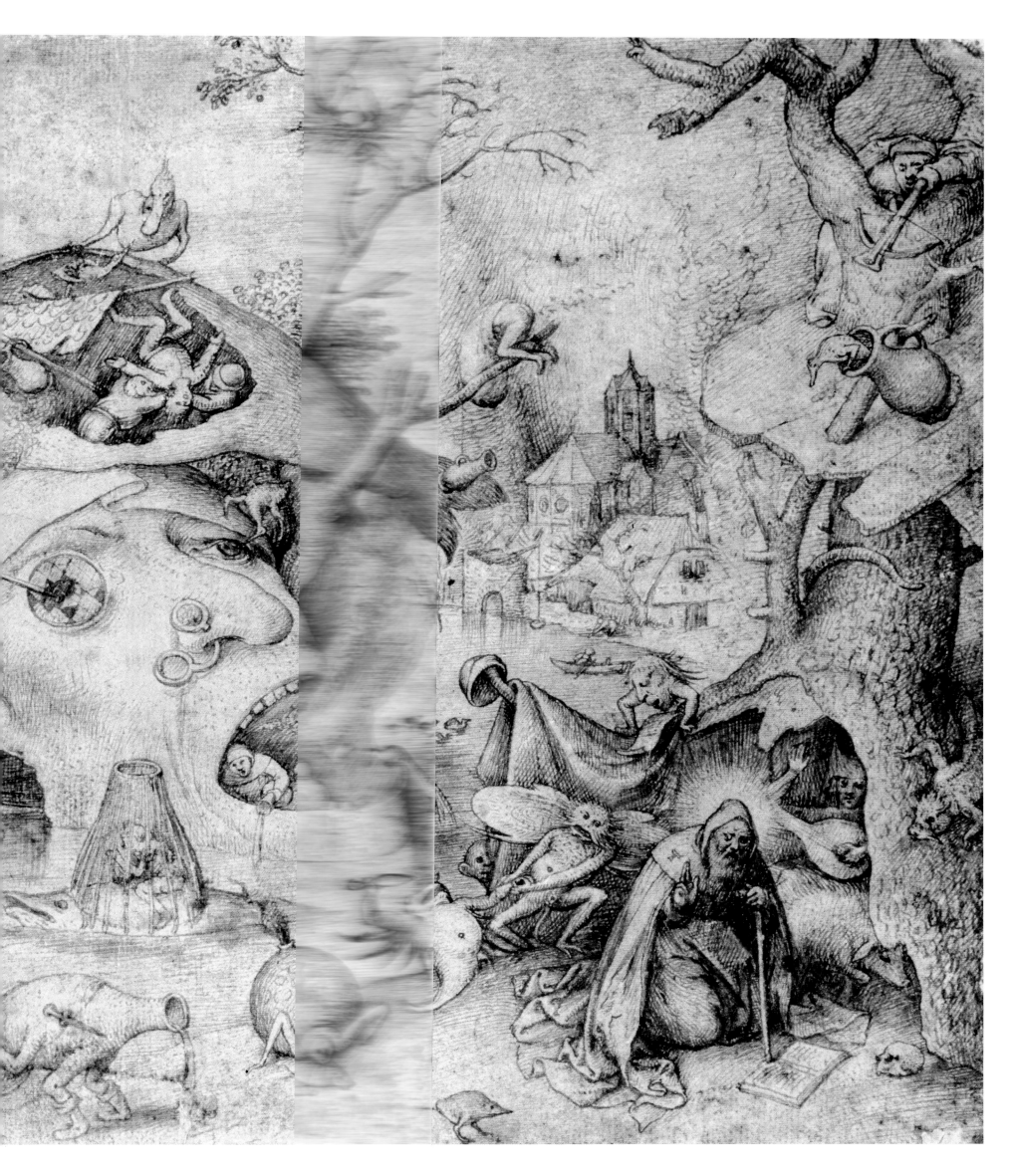

Delights;[6] the giant hollow fish above that head, as in *Big Fish Eat Little Fish*; the fat man riding a barrel as in the *Allegory of Intemperance* (Yale University Art Gallery, New Haven); the flames engulfing a background village and its parish church; and the general use of hybrid monsters, such as heads on legs or curious mixtures of bird, insect, and other animal parts. In both the drawing and the print, the saint is positioned in the lower right corner, kneeling in meditation before an open prayer book and a human skull at the foot of a hollow tree. Marked by a bright halo, he wears his distinctive dark monk's robes with a tau cross and is accompanied by his standard attribute, a pig. The scene depicts a moment from the saint's life in his wilderness retreat as a hermit when he is beset by demons, principally in the guise of the hybrid monsters but also disguised as seductive females, such as the woman with a lute beside the saint within the hollow tree.[7] The Latin inscription on the print points out how this stoic resistance by the saint to suffering as well as temptation can serve as inspiration and a model of behavior; such fortitude served as an inspiration to assist sufferers from diseases, especially in the hospital network operated by the Antonite Order.[8] But it is also apparent that the fascination of this print

derives from its fullness of details across the composition and from its inventive variation on Boschian elements, particularly the strange, oversized head, which doubles as a shelter with a broken window for one eye and giant spectacles for a nose ring.

Another favorite Bosch subject, the *Last Judgment*, was represented by Bruegel for Cock two years later (plate 120).[9] In this case, the artist shows awareness of his engraver, designing the all-important left-right division to be reversed and properly oriented with the Hell mouth on the viewer right (but on the judging Christ's left, the *sinister* side of the Last Judgment). Many traditional medieval components define this Last Judgment. The scene shows a Christ enthroned on a rainbow in the top center, his feet on a globe as he blesses with his right hand, curses with a downward gesture of his left. The blessed side is signaled beside Christ's head with a lily, balanced opposite by a sword of damnation. Traditionally, the resurrection of the dead occurs at the Last Judgment and is pictured in the foreground of the print; additionally, in accord with medieval visual conventions, Hell is represented by a giant open mouth.[10] The juxtaposition between Heaven and Hell is one of altitude: while the saved ascend up a hillside, the damned descend into the Mouth of Hell. But Bruegel imitates Bosch in details, especially the monsters, such as the owl on webbed feet or the fish with a pair of arms, both placed beside his signature. Even small details are telling, such as the angels with insect wings beside the sword and the condemning left hand of Christ. While some commentators have attempted to read this image within the emerging controversies between Catholics and Calvinists in the Netherlands, this religious tension had not yet definitively surfaced in 1558, so this *Last Judgment* most probably appealed for its very conventionality as well as for as its Boschian details.

The importance of sin in the Last Judgment context had already been treated by Cock recently, when he commissioned from Bruegel a series of designs for the Seven Deadly Sins, something akin to other series that were emerging from Cock's workshop in an Italianate idiom by Frans Floris for such allegorical topics as the Seven Liberal Arts, the Five Senses, and both the Vices and Virtues.[11] Produced between 1556 and 1558, for which the 1558 *Last Judgment* might even serve as a culminating eighth image,[12] these Bruegel prints of the Seven Deadly Sins were also composed in the idiom of Bosch: tiny monsters cavort within a landscape before a high horizon to convey the thorough pervasiveness of sinfulness in the world. In each image a female personification

Compt ghy gebenedyd

En gaet ghy vermaledyde in dat eeuwighe vier

Brueghel 1558

Brueghel inuet

VENITE. BENEDICT
ITE. MALEDICTI.

NVM. ÆTERNVM. Compt ghy ghebenedyde myns vaders hier.
SEMPITERNVM. En ghaet ghy vermaledyde in dat eewighe vier.

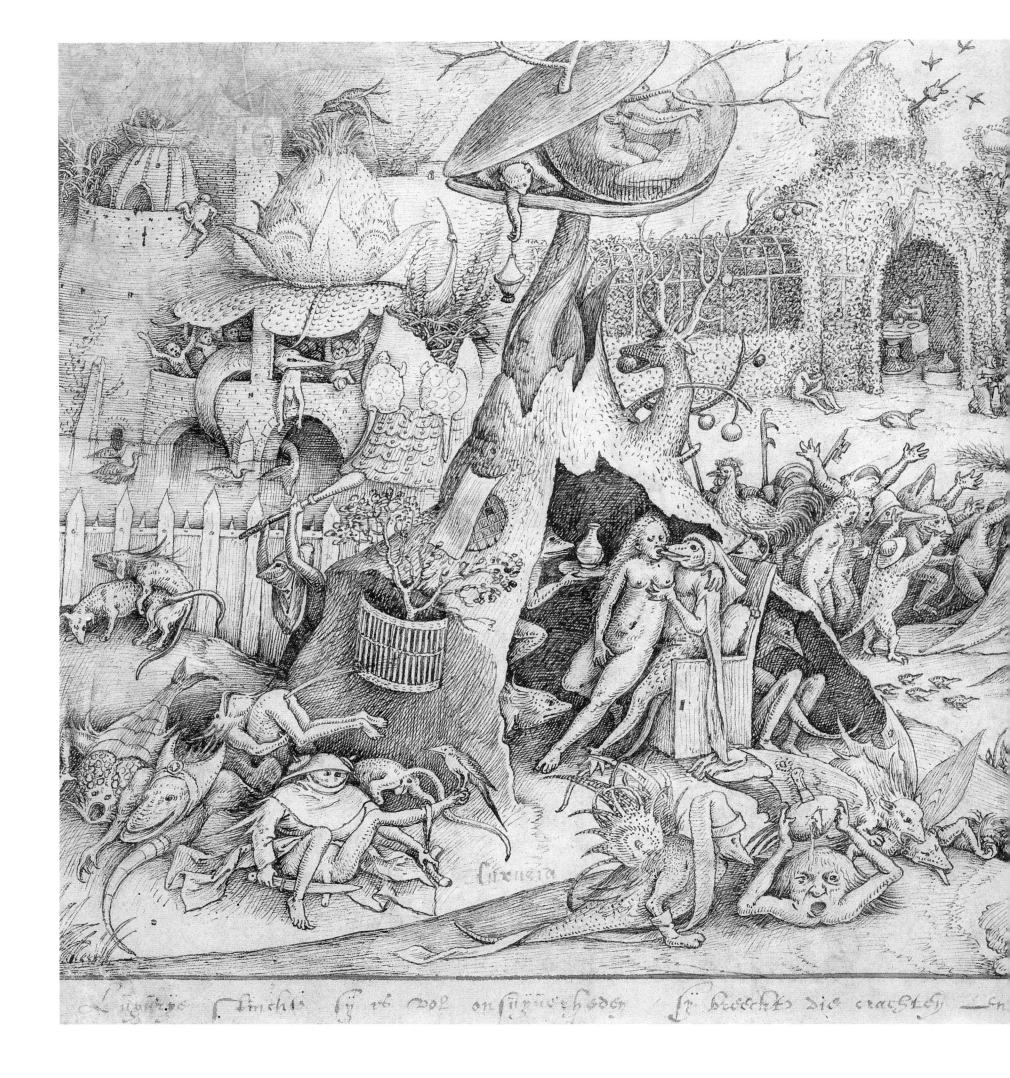

the Vice sits front and center, acting out the sin in question while accompanied by her symbolic animal companion. The setting, filled with demons, suggests Hell on earth.

For example, *Lust* (*Luxuria;* original drawing, plates 123) shows a nude female seated on the lap of a web-footed demon in a hollow tree; as they kiss intimately, above their heads sits the cock that symbolizes lustfulness.[13] Above the cock the tree itself morphs into the head of a stag, another animal frequently associated with lust.[14] Numerous elements after Bosch are distributed throughout the image: above the hollow tree a giant mussel shell, symbol of lust because of its alleged aphrodisiac properties, houses an amorous couple in a crystal globe, much like the erotic pairs in Bosch's celebrated triptych, *The Garden of Earthly Delights* (Prado, Madrid).[15] Distinctive Boschian exotic architecture, in this case resembling an organic flower shape, appears above the bridge in the upper right, like the water in Bosch's *St. Anthony*. Also in the background of Bruegel's design, courtly settings, notably a fountain and a garden bower, provide occasions for amorous encounters.

In fact, very few humans are actors in these images; for the most part, they are acted upon, beset like Saint Anthony by depredations from demons. For example,

122 *(left)*
Pieter Bruegel
Lust (Luxuria), 1557
Pen and gray-brown ink,
contours indented for transfer,
8¾ × 11½ in. (22.5 × 29.6 cm)
Bibliothèque Royale de Belgique,
Cabinet des Estampes, Brussels
(Mielke 36)

123 *(below)*
Pieter van der Heyden,
after Pieter Bruegel
Lust, 1558
Engraving, 8⅞ × 11½ in.
(22.6 × 29.6 cm)
Bibliothèque Nationale de France,
Paris

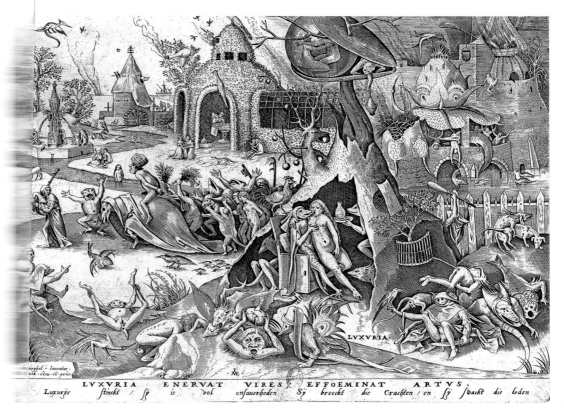

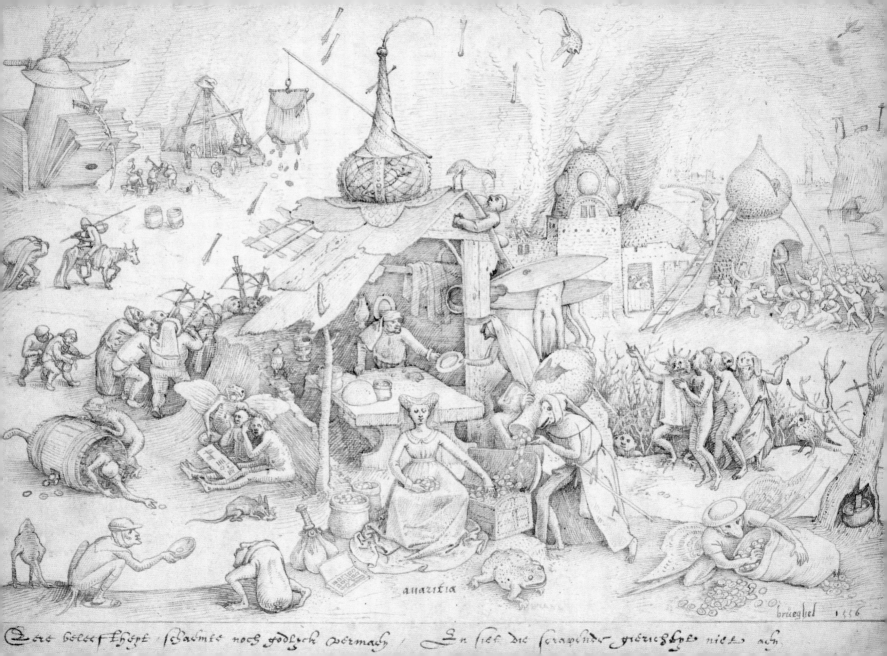

auaritia

bruegnel 1556

in the left middle ground of *Lust* a small g[roup of] naked figures, led by a costumed fool w[ith the instru]ment of folly, a bagpipe, is pushed along b[...] of them, wearing a hat (changed from a [...] form of an ecclesiastical miter in the orig[inal drawing] with an insulting label on it, rides a ske[leton ...] to a mount of Bosch in the left foregroun[d ...] of his *St. Anthony* triptych, where another [...] figure plays a harp at the head of a proces[sion. This] procession, albeit run by demons, rese[mbles the fol-] custom of charivari, a village condemna[tion of ...] matched couples (usually because of age)[...] for *Lust*, like many of the other caption[s ...] Deadly Sins series, is a learned citation, [...] shed much insight on the message of th[...] case, there is no reason why Bruegel sh[ould ...] associated with this choice. The Latin [...] rather than directly quoted from Senec[a ...] "On Care of Health and Peace of Mind: [...] the strength, weakens the limbs" (*Luxu[ria] effoeminat artus*).[17] The accompanying, [...] distich says, in translation: "Lechery stin[ks ...] breaks [man's] powers and weakens limb[s ...]"

Earliest drawing in the series was *Ava[rice* (origi]nal drawing plate 124), although it app[eared ...] in 1558 with the rest of the series. This [...] fication is dressed in the archaic, faintly [...] wimple that Antwerp artists of the prev[ious generation] had featured in images of greedy mon[ey ...] example Marinus van Reymerswaele's 153[9 *Moneychanger and His Wife*] (plate 126).[18] Of course, a[s ...] in the prosperous economy of Antwer[p, avarice is the] most immediate and frightening of tem[ptations (chap-]ter 2).[19] Before the figure of Avarice sit t[...] and scales for testing and measuring coi[ns ...] her accompanying animal attribute, th[e ...] sits between a strongbox, being filled [with coins by a] demon, and jars full of coins. Behind he[r ...] a metal plate to a pawnbroker. A thief h[as ...] the top of the shed. In this image one [...] the left edge based assumes both the sh[ape ...] of clay piggy banks, just like the perso[nifica...]ers of Bruegel's later allegorical print o[...] (plate 50).

Once more demons fully infest the [...] vide much of the action in the print, a[...] of humans at right (who in turn are b[...] their purses) are shooting with a cro[ssbow ...] purse hanging above the shed of the f[...] Above the demon bearing coins and c[...]

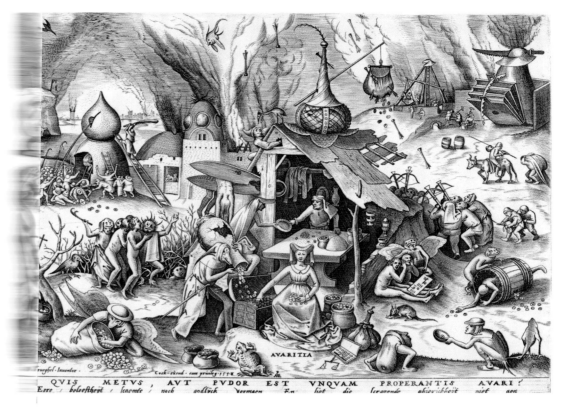

124 *(opposite)*
Pieter Bruegel
Avarice, 1556
Pen and gray-brown ink,
contours indented for transfer,
... × 11⅝ in. (22.8 × 29.8 cm)
British Museum, London
(Mielke 33)

125 *(above)*
Pieter van der Heyden,
after Pieter Bruegel
Avarice, 1558
Engraving, 8¾ × 11½ in.
(22.5 × 29.6 cm)
The Metropolitan Museum
of Art, New York; Harris
Brisbane Dick Fund

126 *(below)*
Marinus van Reymerswaele
(act. 1535–45)
Moneychanger and His Wife,
1539
Oil on panel, 32⅜ × 37⅞ in.
(83 × 97 cm)
Museo Nacional del Prado,
Madrid

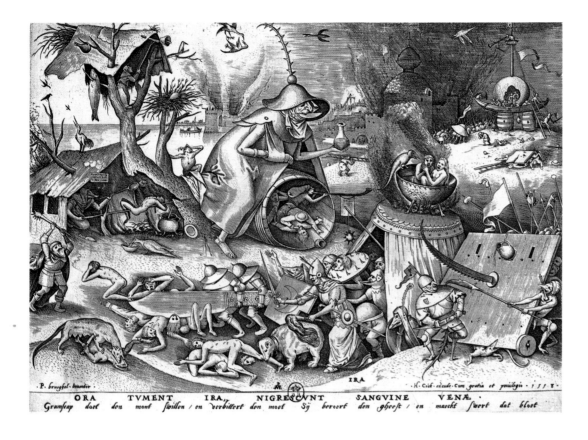

IRA

ORA TVMENT IRA, NIGRESCVNT SANGVINE VENA.
Gramſcap doet den mont ſwillen / en verbittert den moet Sij beroert den gheeſt / en maeckt ſwert dat bloet

127 (above)

Pieter van der Heyden,

after Pieter Bruegel

Anger, 1558

Engraving, 8¾ × 11½ in.

(22.5 × 29.4 cm)

Bibliothèque Nationale de France,

Paris

128 (opposite)

Pieter Bruegel

Anger, 1557

Pen and brown ink,

contours indented for transfer,

8⅞ × 11¾ in. (22.8 × 30.1 cm)

Galleria degli Uffizi, Florence

(Mielke 37)

office a naked human figure is being snipped in two by a giant pair of scissors, like the giant knives that Bosch employed in his Hell scenes (*Garden of Delights*; *Last Judgment*). Flames and smoke fill the sky, along with flying fish like Bosch's. The Latin caption of the print derives from Juvenal's fourteenth satire, "No Teaching like that of Example": "What respect for laws, what fear, what sense of shame is to be found in a miser hurrying to be rich?" This phrase bemoans, "Does the greedy miser ever possess fear or shame?"[20] The Flemish phrase echoes, "Scraping Avarice sees neither honor nor courtesy, shame nor divine admonition."

Bruegel's design and print of *Anger* dates from 1557 (plates 127, 128).[21] In this case the personification is an armored virago instead of a seated figure. She wields a sword in one hand and a flaming torch in the other as she emerges from a tent into battle at the head of an army of demons, fighting under the crescent moon emblem, redolent of Islam. Her accompanying animal, a bear, is actively biting a naked figure; above them, anonymous helmeted soldiers wield a giant knife against naked foes in echo of Bosch's Hell armies but also of the blade in Bruegel's own recent print, *Big Fish Eat Little Fish* (plate 68).

This world stands closer to the infernal torments

invented by Bosch, such as the demon in the left center, who adds sauce from a spoon as he roasts a naked figure on a spit. Atop the war tent another pot boils a pair of naked human victims. Just as with the distinctive couple in a globe within *Lust*, these images strongly suggest that Bruegel had been looking at Bosch originals rather than the host of epigones and imitators. Other, more general elements of Bosch's inversions of nature are incorporated in *Anger*, such as the flying fish in the sky above a ship on barrels and out of the water in the upper right corner of the print. But Bruegel also took advantage of more recent Boschian compositions, including some of the prints falsely ascribed to Bosch by Cock. For *Anger* he adapted an engraving of a *War Elephant*.[22] In particular, he transfers some of the siege engines, composed of boards on wheels with projecting blades. Moreover, some exotic building types used in Bruegel's *Pride* engraving (plates 129, 130) provide nearly direct transcriptions of the constructions on the back of this same elephant.

The inscription for *Anger* comes from the third book of Ovid's *Ars amatoria*, advising women to keep their mad moods under control, for fierce anger is more becoming to beasts: "Anger makes the face swell up and the veins grow black with blood."[23] Dominating this image at the top center and riding upon a huge barrel filled with figures in conflict, a giant cloaked figure in a helmet with a knife in her (?) teeth looms over the entire landscape. With one broken arm in a sling and the other holding up a flask, like the contemporary medical tests of urine, this figure strongly suggests an overall illness, a broken condition in the world. Indeed, in the original drawing, but not in the print, the banner above the siege machine in the corner shows an orb of the world, like the blade in *Big Fish Eat Little Fish*. As we shall see, especially for paintings in his later career (chapters 8, 10), Bruegel consistently showed war and conflict in a negative light, so it is not surprising that for him in this series of the Vices *Anger* potentially proves to be the most disturbing of the Seven Deadly Sins, precisely because it can lead to such death and destruction.

Pride (plates 129, 130) features a fashionably dressed woman, a personification of personal vanity gazing at her face in a hand glass.[24] Her proud animal companion is a peacock. Mirrors abound in the image, and at the right corner of the print a man is being shaved and a woman has her long hair washed by a demon. Above them, a lute and sheet music appear, suggesting that such activity is frivolous. In the immediate foreground a pair of demons gazes at mirrors, one of them bent over

brueghel · 1557 ·

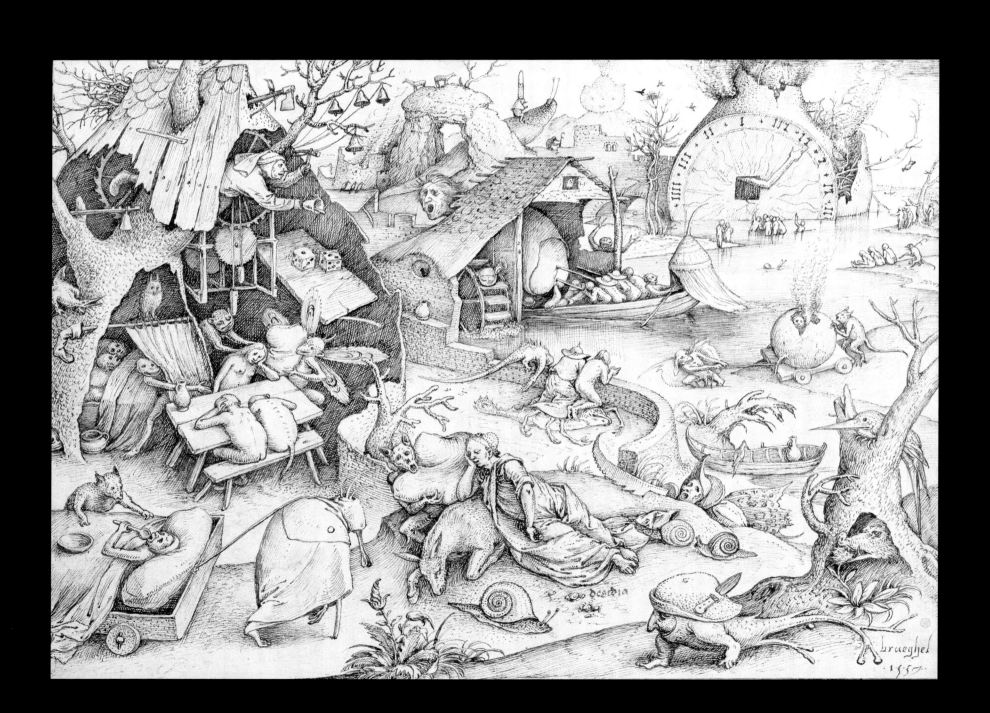

brueghel . Inuentor .

H . Cock . excud . cum priuileg . 1558

SEGNITIES FRANGIT, LONGA OCIA NERVOS .

Traecheyt maeckt machtel Die senuwen dat de mensch niewers toe en doocht .

Toblite ô porte capita vestea attollimure fores sempiterne et ingredietur Rex ille gloriosus

TOBLITE Ô PORTE, CAPITA VESTEA ATTOLLIMINI FORES SEMPITERNE ET INGREDIETVR REX ILLE GLORIOSV

Hell. The Dürer image also made sense w
prints, the Large Woodcut Passion, devot
cal sequence, whereas Bruegel's image ap
tion and surely held interest much more
hybrid monsters than for its theological s

The figure of Christ is tall and lean i
and royal cloak, resembling the figure i
urrection, a painting on paper (plate 21c
Philips Galle, plate 211), usually dated
later.[45] Carrying a cross staff with the b
rection, he appears within a crystal globe
nine smaller angels with musical instru
of his halo forms the visual focus in the
the image, in contrast to the dominant
surrounding infernal regions. Large-scale
familiar, fill the entire foreground and
scene. Perhaps in response to the pres
of Christ, their torsions and physical
note of comedy and excess to the scene.
tesque but unthreatening, the Mouth o
its grateful captive souls with little thr
suffering; indeed, that giant tonsured
open at its brow to reveal small, grinni
of them crowned, presumably Satan hi
crously diminished powers. On its s
truly ludicrous hairy demon with arms.
corner a giant helmet on a treetop op
other tiny humans inside. However, tor
place upon a wheel, upon which other
impaled and then disgorged into a lar
flames below it at the right center of t
the strangest element in the composi
rate crested jousting helmet with an
pied by a sword-wielding demon and
but hanging in the air. This emblem o
its ethos of conflict provides an iron
humility of Christ himself.

As noted, Bruegel's first priority
emphasized his emerging painting ca
1561, he produced his first important pa
ner of Bosch, keyed in the vivid color
Dulle Griet ("*Mad Meg*"; plates 142,
Deadly Sins had already presented a s
straddled both sides of the modern sac
and *Dulle Griet* mixes those categori
this case an army of housewives atta
very mouth of Hell. Their leader is
virago, armored like the personificati
who strides with her battle sword a
the direction of the Mouth of Hell.

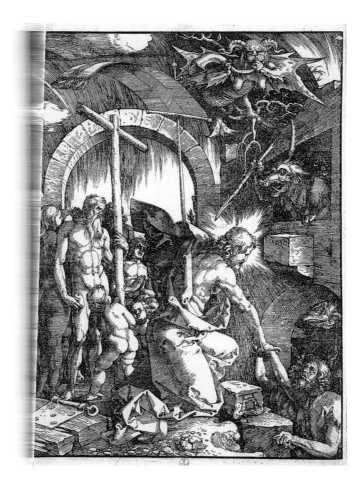

who successfully plunder and battle with the demons, she carries a strongbox as well as baskets and a sack filled with plunder, chiefly household wares. The image was already known to Karel van Mander, whose biography of Bruegel in his 1604 *Schilderboek* (Book of Painting) names the picture, then already in the collection of avid enthusiast Emperor Rudolf II in Prague: "Dulle Griet who loots in front of Hell."[47]

Once more Hell is portrayed as a giant open mouth, doubling as a fortress tower whose eye is combined with a window. The usual cast of animal demons, flying and climbing against the sky, reappears here. One unusual element in the Hell scene is a giant above Dulle Griet, who perches on top of a building with a boat on his back; he uses a large spoon to ladle a stream of silver coins out of his rear end, a broken egg. By way of explanation for this unusual detail of a spoon, Walter Gibson evokes an English proverb, already present in Chaucer, that "it takes a long spoon to sup with the devil."[48] But this particular image seems more connected to a hellish inversion of avarice itself, the master temptation in prosperous Antwerp. As if to confirm the local association,

139 *(opposite, top)*
Pieter Bruegel
Christ in Limbo, 1561
Pen and brown ink,
contours indented for transfer,
8¾ × 11½ in. (22.3 × 29.4 cm)
Albertina, Vienna (Mielke 55)

140 *(opposite, bottom)*
Pieter van der Heyden,
after Pieter Bruegel
Christ in Limbo
Engraving, 9⅛ × 11½ in.
(23.5 × 29.5 cm)
Bibliothèque Royale, Brussels,
Cabinet des Estampes

141 *(left)*
Albrecht Dürer (1471–1528)
Christ in Limbo, 1510
Woodcut, 15⅝ × 11³⁄₁₆ in.
(39.6 × 28.4 cm)
Galleria degli Uffizi, Gabinetto
Disegni et Stampi, Florence

142 *(pages 164–165)*
Pieter Bruegel
Dulle Griet ("*Mad Meg*"), 1561
Detail of plate 143

left the Apocalyptic Woman of Revelation 12 appears, so clearly this work represents the later conflict. Regardless, this altarpiece was commissioned for the Antwerp Church of Our Lady by the guild of swordsmen, which would have regarded the military prowess of the angels as an appropriate skill, especially since the guild also adopted St. Michael as their patron saint.[58]

The contrast with Bruegel's version could not be greater. His more diminutive, central St. Michael, clad in golden armor like Bosch's tiny figure in the clouds, has the same tall, slender physique and small head as Bruegel's Christ figures in *Christ in Limbo* and *Resurrection* (plates 139, 211), two works from the same period, the early 1560s. He wields a battle sword, and his shield shows the red cross of the Resurrection. The same figure type reappears in the angel figures, whose flowing liturgical robes are accented with the stoles of celebrants at the mass, a long-standing Netherlandish visual tradition for angels (for example, Rogier van der Weyden's Beaune *Last Judgment*).[59]

In spatial terms, too, Bruegel adopts several elements from Bosch's representations of the same subject. His image of highest Heaven is a sphere of pure, brilliant white light, so blinding that it does not permit viewing of God the Father, whereas in Bosch the godhead is a giant rosy mirage, surrounded by a dazzling brightness that resolves on its edges to the bodies of glowing angelic choirs, presumably seraphim. Bosch did once employ a figureless image of Heaven as a white sphere, surrounded by lesser spheres with more color, the ultimate destination in a shutter depicting ascending souls of the blessed, naked figures accompanied by angels (plate 151). In effect, Bruegel's offers a reversal to that wing panel by Bosch, depicting descent with gravity of the angels cast out of Heaven rather than ascent. This fall of the satanic forces out of the realm of pure spirit—only to see them taking on bestial, hybrid demonic shape as they fall—is Bruegel's fullest echo of Bosch's imagery, and it confirms the identity of the Brussels picture as the same theme of the Fall of Lucifer and his minions rather than the final conflict of Apocalypse.

Another Boschian element adopted by Bruegel is the basic concept of a range of material substance that progressively increases the closer one gets to the surface of the earth. Thus the heavenly area is filled with white light at the central and highest point, then blue sky, and it remains almost empty of visible or palpable matter. But below the middle of the picture the background darkens into earth tones, and the world of demons begins— a seemingly impenetrable welter of tangled bodies and

146, 147, 148 (*left, pages 170, 171*)
Pieter Bruegel
Various details of
The Fall of the Rebel Angels, 1562
Oil on panel, 46¼ × 63⅜ in.
(118.5 × 162.5 cm)
Musées Royaux des Beaux-Arts
de Belgique, Brussels

witches begins with a broom-riding female who rises up the chimney on vapors from the boiling pot; below her a cat faces a toad, and a small group of monkeys on chairs look on.[64] Indeed, in the upper left corner of the print, directly above Hermogenes, a pair of naked witches are flying on their demonic familiars, a pig with wings and a dragon, in a clash that resembles a joust. Below them fall the hailstorms blamed on the powers of black magic. Behind them a third figure approaches on a goat that flies on the fumes emerging from the top of the chimney. In the lower right corner, another naked woman, who wears the stole of a priest, stands in a large circle with a sword across it to make the sign of the cross; she is in the process of slicing into a snake to extract venom or blood for her spells. All around the magician in his chair stands a crowd of demons (with even an elephant added), composed from the same hybrid traits we have seen already in earlier Bruegel prints, most recently *Christ in Limbo* (plate 139).[65] Another spell is being enacted before a silhouetted horned figure, read out by a sorcerer from an open book in a basement space, visible through a hole in the floor.

The satanic implication of that horned figure casts a more disturbing mood over the lively activity in this print. On axis above that basement crater in the dark center of the print a series of worldly disasters is visible behind the saint and between the flying witches. Within a darkened background great floods fill the land and ships are sinking with their passengers in danger of drowning, perhaps from the storms raised by the flying witches. Bruegel shows this same kind of disaster at the horizon of his catastrophic *Triumph of Death* (plates 155, 243, 244). Perhaps most disturbing is the collapse of a church steeple, losing its cross and breaking off, just when one of the endangered figures had climbed it to cling for safely above the waters. In the presence of so much foreground evil, this looks like the result of black magic, *maleficia*, by the witches and demons. The Latin inscription is explicit in identifying the subject as well as assigning it satanic powers: "St. James by devilish deception is placed before the magician."

Bruegel provides the denouement of this story with his next print: *The Fall of the Magician Hermogenes* (plates 153, 154).[66] Here the magician is undone by his own powers, which are redirected by the saint, as the Latin inscription proclaims, "[The saint] obtained from God that the magician should be torn to pieces by demons." According to the Golden Legend, Hermogenes converts when he sees the superior power of the Christian saint; however, in this case Bruegel conflates

this story with the tale of Simon Magus, a magician who falls to his death when his demons are countermanded by St. Peter.[67] This scene represents pride punished as well as true faith vanquishing sorcery, much like Bruegel's *Fortitude* (plate 138). In Bruegel's version, Hermogenes is upside down, and his demons turn on him, one of them wielding a spiked club. St. James stands with his followers before a church-like portal, blessing the scene and seemingly causing this turn of events.

This image, however, also presents a festive carnival atmosphere, where, accompanied by figures dressed as fools, other demons gyrate like gymnasts and balance like acrobats under a picture banner like a circus poster. Other figures perform puppetry or enact shell games at the table or floor. In this sequel, the background is benign rather than sinister: a quartet of smiling observers peer through a background window in the upper left corner and enjoy the performance. In effect, the blessing by the saint has revealed the actions of demons as nothing more than harmless stunts and tricks.

During this period of the St. James prints new challenges arose through conflicts in the religious sphere, as Calvinism increasingly opposed the authority of the Catholic Church and gained adherents in the Netherlands (see chapter 8), thereby provoking countermeasures from the Inquisition.[68] For Bruegel, who produced religious images in both paint and print, this was a time when using the popular idiom of Bosch in his work not only made good sense commercially; in addition, it provided a kind of religious neutrality that stood apart from emerging doctrinal controversies. From the *Temptation of St. Anthony* to *St. James and the Magician Hermogenes*, the trials of virtuous, saintly figures by demonic tormentors never seems in doubt.

Most of the images, particularly the Seven Deadly Sins, are filled with demons in unnatural, hellish fire landscapes of Bosch, featuring fantasy structures as well as giants immured in buildings. One could posit that these places, like the Hell-on-earth centerpiece of Bosch's Vienna *Last Judgment* triptych, could depict Purgatory, the place of purgation and punishment for sinfulness in the afterlife that became part of Church doctrine after the late twelfth century.[69] What characterized Purgatory was its adaptation to each individual sin and sinner and its finite punishment, in contrast to the everlasting fires of Hell. What makes the Seven Deadly Sins resemble Purgatory in practice is the presence of naked human figures, that is, the resurrected souls normally emerging from their tombs only on the final Judgment Day. However, there is no visual tradition for showing Purgatory,

DIVVS IACOBVS DIABOLICIS PRAESTIGIIS ANTE MAGVM SISTITVR

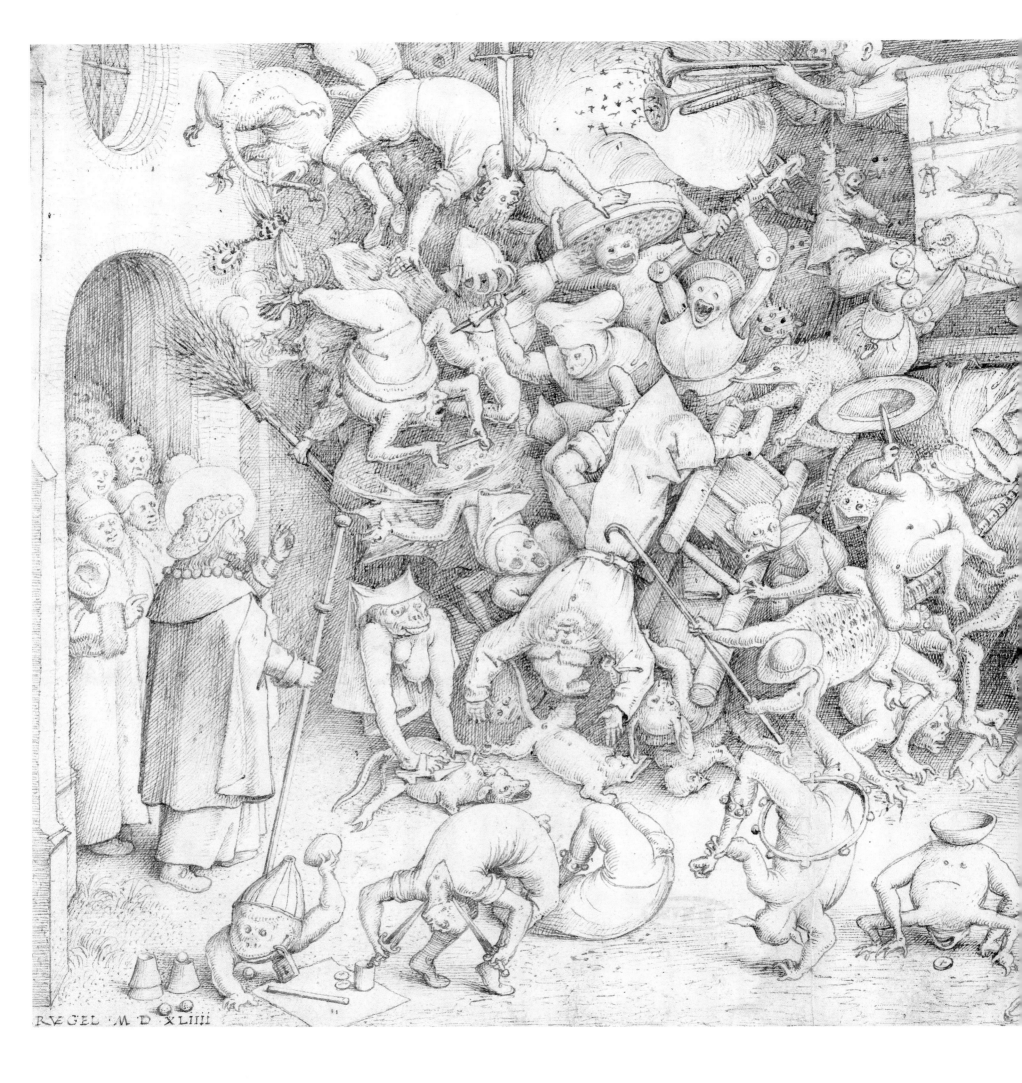

RVEGEL · M · D · XLIIII

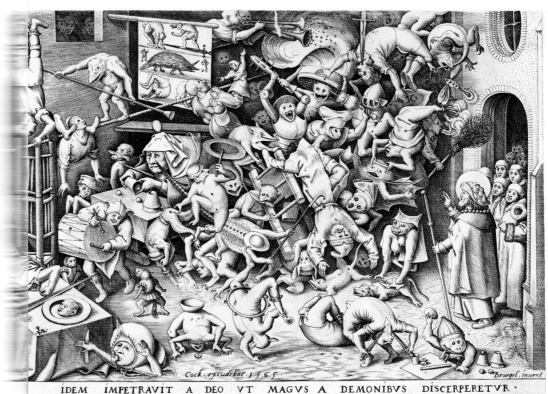

IDEM IMPETRAVIT A DEO VT MAGVS A DEMONIBVS DISCERPERETVR.

cept as a few souls being plucked out of cleansing flames, so these images of the Vices also could continue Bosch's earlier imagery of Hell on earth.

Yet in contrast to Bosch's viscerally cruel torments, early Bruegel's more lively and amusing demonic inventions add a layer of drollery to his compositions, even here, as noted by his contemporaries. Even more in the allegory of *Patience* (plate 137), both stoicism and strength potentially provide a personal antidote to the besieging torments. This victory over sin itself is all the more evident in *Fortitude*, where all Seven Deadly Sins and their animal attributes are vanquished seemingly without effort. The specific triumph over Hell itself in *Christ in Limbo* (plate 139) shows the power of the true Christian faith.

Certainly the layer of comic presentation is stronger still in a painted work such as *Dulle Griet* (plate 143), where the religious dimension of the setting is completely missing in the midst of disorder and total conflict between womankind and the demonic realm, a visual parody and reversal of *Christ in Limbo*. Even in another panel with explicitly religious content and a closer derivation form Bosch himself, *The Fall of the Rebel Angels*, Bruegel adds a spirit of invention and discovery that mitigates the ultimate tragedy of evil entering the world.

153 *(left)*
Pieter Bruegel
The Fall of the Magician Hermogenes,
1565
Pen and brown ink, contours
indented for transfer, 9⅛ × 11½ in.
(23.3 × 29.6 cm)
Rijksmuseum, Amsterdam
(Mielke 61)

154 *(above)*
Pieter van der Heyden,
after Pieter Bruegel
The Fall of the Magician Hermogenes,
1565
Engraving, 8¾ × 11⅜ in.
(22.4 × 29.2 cm)
The Metropolitan Museum of Art,
New York; Dick Fund

Indeed, the heavenly forces, led by archangel Michael, clearly have the upper hand, literally, over the rebel angels led by Lucifer with the outcome assured, seemingly as inevitably as gravity itself.

Bruegel does suggest Church corruption (*Patience*) and represents the evil effects of witchcraft (*St. James and the Magician Hermogenes*); in both works he shows a real world beset by disasters of fire or flood. But for the most part, his use of Bosch came after more than a half century of intervening imitations, so the power of the originals had come to be dulled by familiarity and frequent repetition. Bruegel used Bosch as both a model and as a basic theme from which to devise variations, increasingly original and inventive, distanced from the conventional Bosch subjects of Saint Anthony or the Last Judgment. In contrast, Bruegel's last remaining large-scale work about issues of life and death, *The Triumph of Death*, would largely abandon and fully delimit the presence of Boschian demons, while also introducing a real world filled with violence, sudden death, and widespread disasters. That image belongs not to this period, but instead to a much more troubled and unsettled moment of religion and politics in the Netherlands, which will be taken up later, in chapter 8.

155
Pieter Bruegel the Elder
Triumph of Death
Detail of plate 244

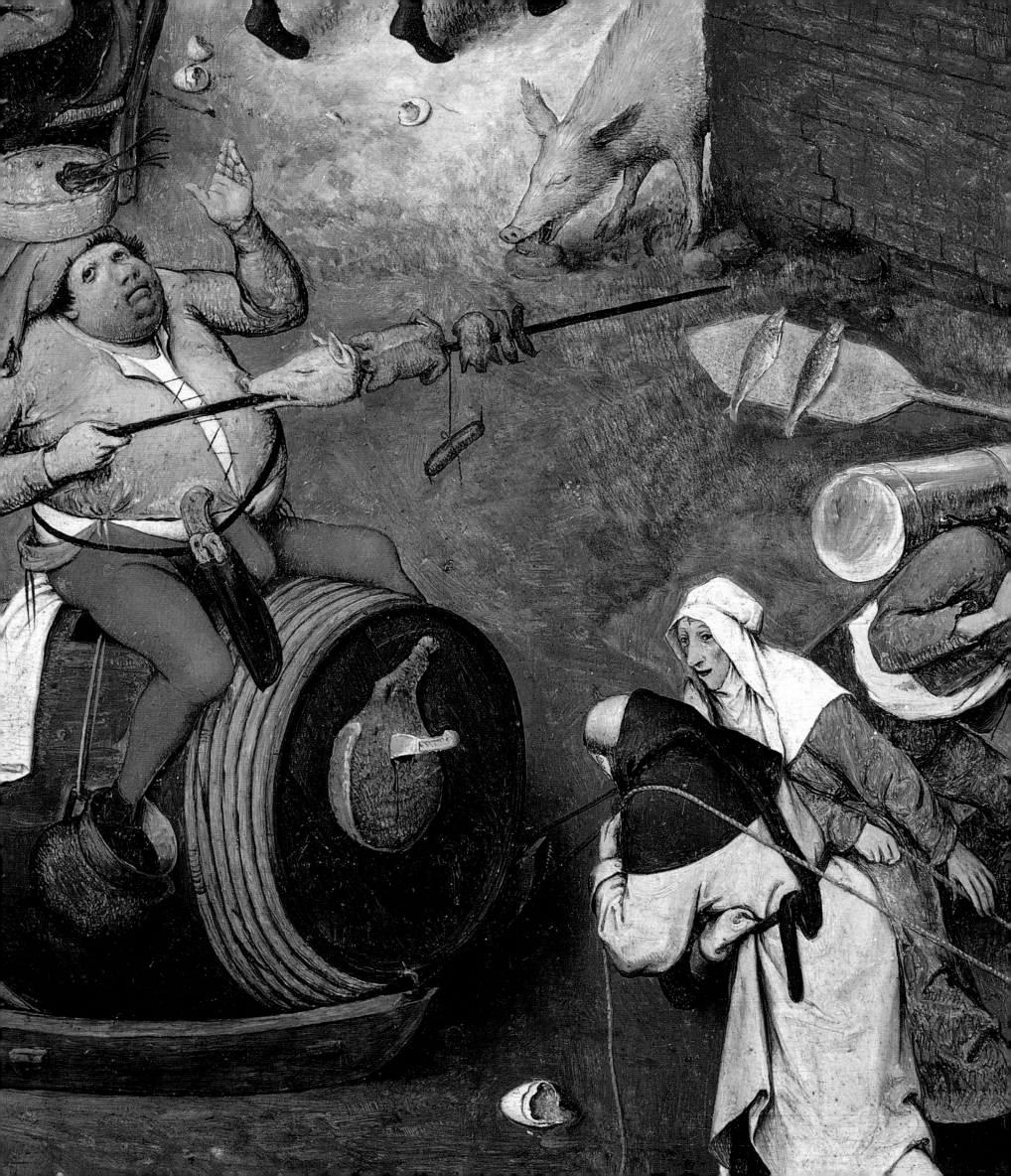

6

PARABLES,

PROVERBS,

PASTIMES

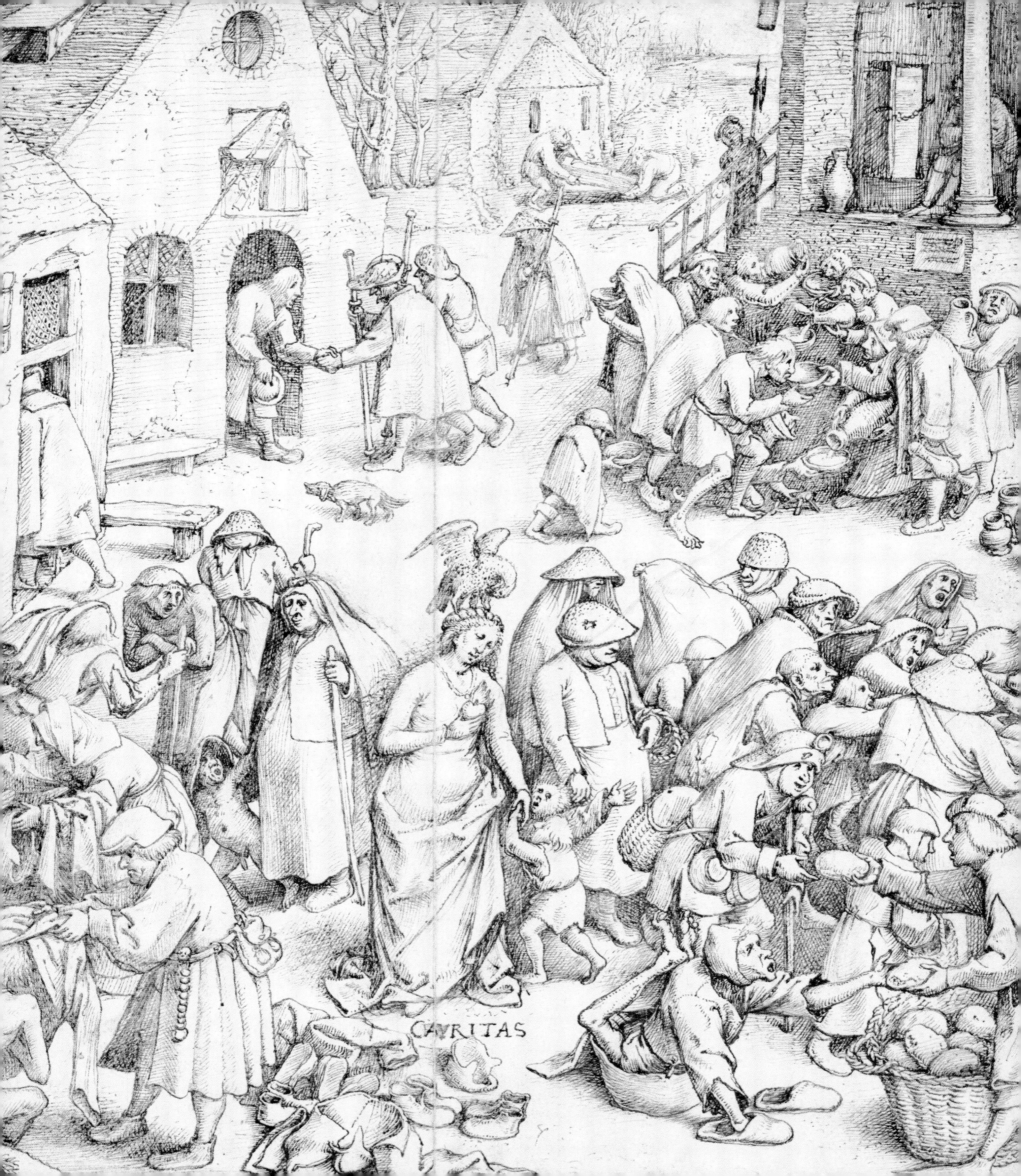

CARITAS

Right after Pieter Bruegel [...] print series of the Seven [...] Hieronymus Cock in 1558, he [...] a corresponding set of the Seven Vir[...] recent work, including the engraving *P[...]* (ter 5), this new series did not employ t[...] Bosch and his demonic world of saint[...] temptations. Instead, following the e[...] nary behavior begun at this exact mom[...] for the engraving *Everyman (Elck's;* p[...] incorporates a series of spaces from t[...] we see a shortsighted old man with spe[...] hunts vainly for fulfillment amid a foreg[...] material goods and a background with[...] activities of a military camp and a parish[...] the images in Bruegel's Virtues engrav[...] lar effort at enacting good deeds, but[...] ambiguous outcome. Indeed, many[...] chiefly Charles de Tolnay and Irving[...] viewed these prints as ironic, represen[...] guise of virtuous behavior but eithe[...] intent or ineffective in results.[1]

Essentially the Seven Deadly Sins is a[...] ations, a hellish landscape with demon[...] a central female personification an[...]

[...]nimal attribute, and the same formula was employed [...]r *Patience* (plate 137) and even for *Fortitude* (plate 138). [...]et each of the remaining Virtues has its own distinctive [...]tting and activities, albeit once more surrounding a cen[...]al female personification. One grouping—Faith, Hope, [...]nd Charity—suggests itself from the three theological [...]rtues, articulated by St. Paul (1 Corinthians 13:13).

The image of Charity (plates 157, 159), engraved, as [...]as the rest of the series, by Philips Galle, is the most [...]raightforward of all the Virtue images.[2] It represents [...]e Seven Works of Mercy, as outlined in Christ's ser[...]on on the coming Last Judgment (Matthew 25:35–45).[3] [...] similar image of the Seven Works of Mercy appeared [...]n Bernard van Orley's *Last Judgment* triptych (plate 158), [...]n altarpiece commissioned for the cathedral in 1518/19 [...]y the Antwerp almoners' guild.[4] Underneath the Judg[...]ent itself is the final act of kindness, burying the dead— [...]uriously performed in the center of the composition [...]t the very moment when the rest of the graves of the [...]orld are opening up to resurrected nude figures. In the [...]talianate structures of the two shutters appear the other [...]ctivities of the Seven Works of Mercy, here practiced by [...]e darkly-clad almoners themselves: feeding the hun[...]ry, watering the thirsty, taking in the stranger, clothing [...]e naked, tending the sick, and visiting prisoners. The

156 (*pages 180–81*)
Pieter Bruegel
The Combat between Carnival and Lent, 1559
Detail of plate 176

157 (*opposite*)
Pieter Bruegel
Charity, 1559
Detail of plate 159

158 (*below*)
Bernart van Orley
Last Judgment triptych, 1525
Oil on panel, central panel,
96¾ × 85 in. (248 × 218 cm), wings
96¾ × 36⅝ in. (248 × 94 cm)
Koninklijk Museum voor Schone
Kunsten, Antwerp

159 (*page 184*)
Pieter Bruegel
Charity, 1559
Pen and dark brown ink, contours
indented for transfer, 8¾ × 11⅝ in.
(22.4 × 29.9 cm)
Museum Boijmans Van Beuningen,
Rotterdam (Mielke 46)

160 (*page 185*)
Philips Galle, after Pieter Bruegel
Charity, c. 1559
Engraving, 8¾ × 11½ in.
(22.5 × 29.5 cm)
Museum Boijmans Van Beuningen,
Rotterdam

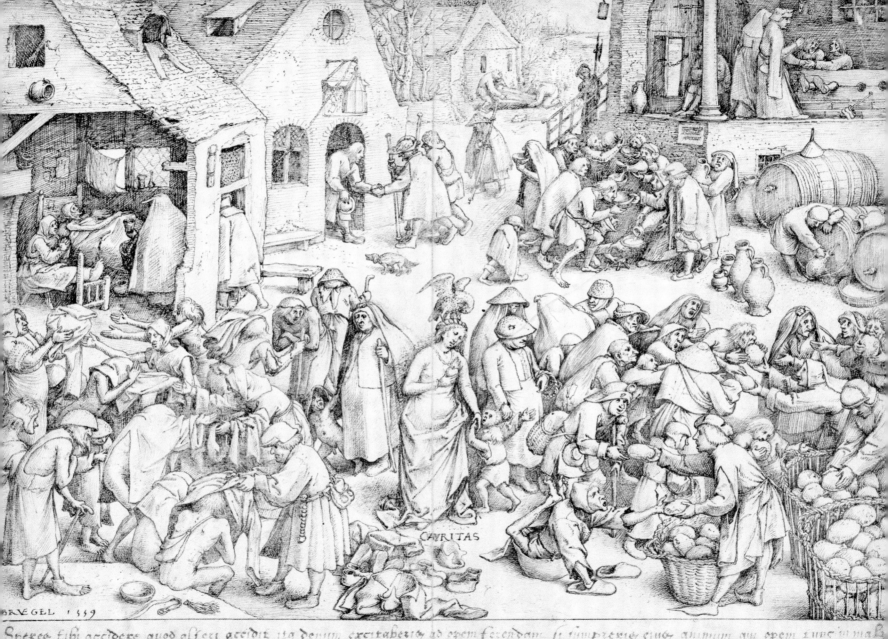

CARITAS

BRVEGEL · 1559

Spece tibi accidere quod alteri accidit ita demum excitaberis ad opem ferendam si sumpreries eius animum qui opem tunc in malis constitutus implorat

CHARITAS

BRVEGEL. 1559

SPERES TIBI ACCIDERE QVOD ALTERI ACCIDIT, ITA DEMVM EXCITABERIS AD OPEM FERENDAM
SI SVMPSERIS EIVS ANIMVM QVI OPEM TVNC IN MALIS CONSTITVTVS IMPLORAT

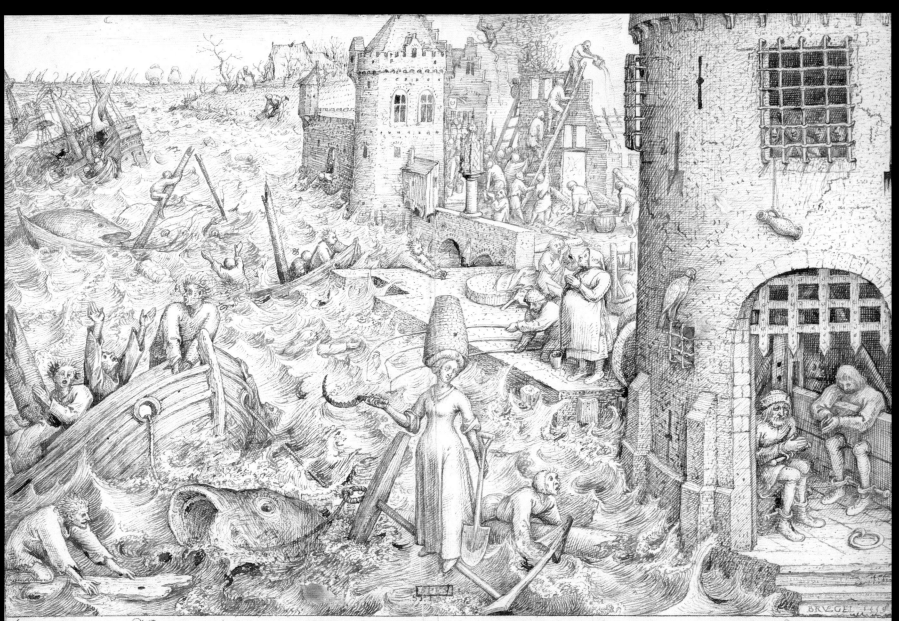

Iucundissima est spei persuasio et vitæ imprimis — Necessaria inter tot ærumnas penecz intolerabilis —

BREGEL

difference in Bruegel's version is readi[...] [...]
eliminates the Last Judgment entirely[...] [...]
judging Christ with angels and the tw[...] [...]
in heaven above, as well as the full-bodi[...] [...]
ing from their tombs. Instead he shows[...] [...]
taking place in an artificial city square [...] [...]
buildings. The recipients of charity inclu[...] [...]
grims, and emaciated beggars—all gat[...] [...]
central personification.

That female personification figure hol[...] [...]
on her head: the pelican, described in [...] [...]
ies as a bird that will prick its own brea[...] [...]
young with parental blood.[5] She display[...] [...]
in her left hand (in some images she h[...] [...]
a sign of love but stands upon a stove)[...] [...]
to a pair of ragged and dependent ch[...] [...]
right hand. These latter identify one asp[...] [...]
mercy or serving one's neighbor, Miseri[...] [...]
also suggest an overlap between the [...] [...]
surroundings, echoed in the women wi[...] [...]
her. The Latin inscription reads in tr[...] [...]
of expanded version of the empathy d[...] [...]
Golden Rule: "Expect what happens t[...] [...]
pen to you; you will then and not until[...] [...]
to offer help only if you make your ow[...] [...]
the man who appeals for help in the mi[...] [...]

Similarly straightforward in its prese[...] [...]
ties, Bruegel's *Prudence* (original draw[...] [...]
161, 162) employs the same high hori[...] [...]
nation of interior and exterior settings[...] [...]
actions shows careful attention to pre-p[...] [...]
corner foreground scene, a woman care[...] [...]
on twigs to prevent their catching fire [...] [...]
she has back-up buckets and a large syri[...] [...]
in case of need. Behind her a very sicl[...] [...]
panied by both kinds of doctors who[...] [...]
needs: a physician, who examines his[...] [...]
and a priest, who is poised to administe[...] [...]
worst-case scenario. Behind the perso[...] [...]
center a pair of men are depositing c[...] [...]
box, saving for a rainy day, as the Engl[...] [...]
have it. Behind them at the center distan[...] [...]
repairs update a facade with fresh tim[...] [...]
horizon Bruegel's bucolic rural life u[...] [...]
church gets roof and tower repairs; [...] [...]
ing sailboat steers a central course; an[...] [...]
farmers prepares the soil for planting [...] [...]
bank against floods. Across the remai[...] [...]
a cluster of figures prepare for winter. [...] [...]
a house, a pair of figures hauls up mor[...] [...]

[...]res in the hearth. Meanwhile, in the foreground, sev-
[...]al women are butchering and salting meat at a table, as
[...]veral men carry inside a storehouse of harvested root
[...]getables in large sacks. The giant hollow carcass of a
[...]g hanging indoors serves as both a source of food and
[...] a memento mori, later to be imitated by painters and
[...]intmakers.[7] Its meaning is even reinforced by a man
[...]anding next to it in the darkness with a lighted candle,
[...]other marker of the transience of time. Awareness of
[...]e's own mortality is a hallmark quality of prudence.

[...]Indeed, the personification figure holds her own cof-
[...]n as a reminder of her mortality. In her right hand she
[...]olds a mirror before her face, not as an act of vanity but
[...]ther as an emblem of self-knowledge. On her head sits
[...] sieve, a practical image of wisdom that can separate
[...]heat from chaff. She stands upon a variety of tools used
[...]or repairs behind her: a ladder for home repairs, spade
[...]or soil preparation, bucket for fire control, and basket
[...]ith pig's heads for food storage. Once more the Latin
[...]scription is conventional, even banal: "If you wish to
[...]e prudent, think always of the future and keep every-
[...]ing in the forefront of your mind."

[...]The figure of Hope (plates 163, 164) stands amid a
[...]uster of seeming catastrophes.[8] In contrast to the calm

163 (opposite)
Pieter Bruegel
Hope, 1559
Pen and dark brown ink,
contours indented for transfer,
8¾ × 11½ in. (22.4 × 29.5 cm)
Staatliche Museen,
Kupferstichkabinett, Berlin
(Mielke 48)

164 (below)
Philips Galle, after Pieter Bruegel
Hope, c. 1559
Engraving, 8¾ × 11¼ in.
(22.3 × 28.8 cm)
Museum Boijmans Van Beuningen,
Rotterdam

IVCVNDISSIMA EST SPEI PERSVASIO, ET VITAE IMPRIMIS
NECESSARIA, INTER TOT AERVMNAS PENEQ INTOLERABILES.

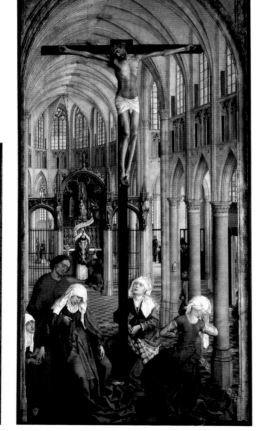

river of *Prudence*, here stormy waters are filled with sinking ships, and even the fortunate survivors are attacked by giant fish. In the corner tower a pair of shackled prisoners sit in quiet prayer. Perched on the bars of the tower sits a falcon, free of any cage but still immobile because of a hood over his eyes (A caged bird is a frequent component of Hope, an animal analogous to the prisoners). Behind the tower, along the edge of the river, a standing pregnant woman gazes heavenward, while a fisherman with several poles aims for a catch. At the top center of the image a burning building brings out firefighters with buckets and ladders. Beside them another man prays at a roadside shrine and turns his back on the fire. At the far horizon a pair of farmers are laboring; one of them behind a plow, plants seeds, as the other shores up the river edge of the field against encroaching floods. Each of these individuals faces danger, suffering, or at best future uncertainty (the pregnant woman and the farmer); each one hopes for a better outcome or delivery from distress, often through the effectiveness of prayer. As Bergström indicated, German prints accord well with Bruegel's surrounding situations; he cites a Heinrich Vogtherr woodcut (1545), which includes a German verse, "Hope is fortunately at hand / In water's and fire's adversity."[9]

The personification of Hope requires more explanation (plate 163). She carries a spade and a sickle in her two hands and a beehive on her hand, as she stands upon an anchor that seems to float atop the waves. The spade, sickle, and beehive are farming equipment, used in the process of cultivation and as instruments of hope for increase and eventual harvest. Other images of Hope show her with a ship on her head or a bird in a cage, but these elements are included among the vignettes of the scene. The anchor suggests the eventual safe harbor of the ship, or hope fulfilled. Possibly it also holds a larger spiritual sense, related to a biblical passage: "This hope we have as an anchor of the soul, both sure and steadfast. . . . Where the forerunner has entered for us, even Jesus" (Hebrews 6: 19–20). Hope is one of the three theological virtues, after all, and its essential ingredient remains prayer and the prospect of eventual salvation: "But if we hope for what we do not see, we eagerly wait for it with perseverance. Likewise the Spirit also helps in our weaknesses" (Romans 8:25–26).

The Latin inscription is less obviously religious, but it shows the sustaining strength of hope in the midst of adversities: "Very pleasant is the conviction of hope and most necessary for life, amid many and almost unbearable hardships." Once more, then, Bruegel's representation conforms relatively well with visual traditions of the

FIDES

FIDES MAXIME CONSERVANDA EST PRAECIPVE IN RELIGIONEM,
QVIA POTENTIOR EST QVAM HOMO·

ock exc

Brugel Inu

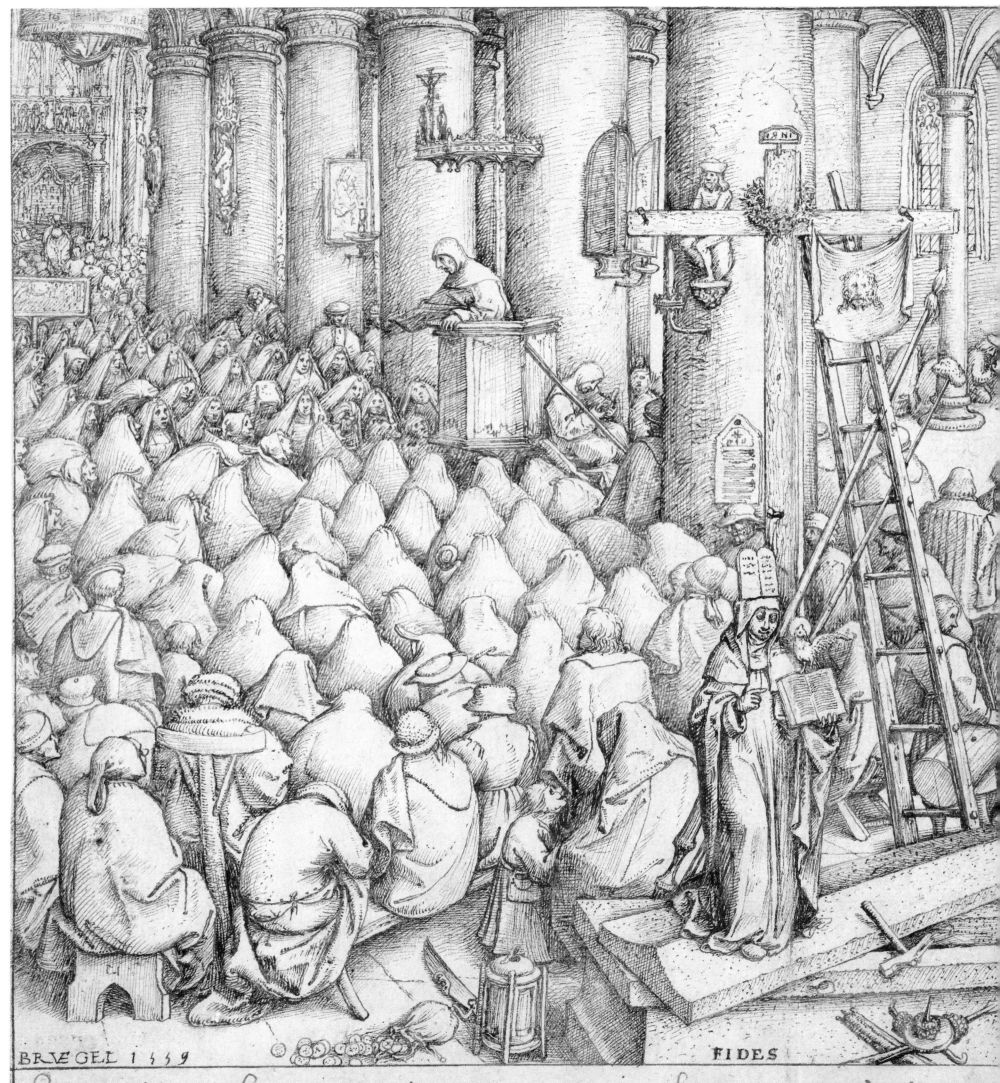

BRVEGEL 1559 FIDES

fides maxime a nobis conseruanda est, praecipue in religionem, quia deus prior

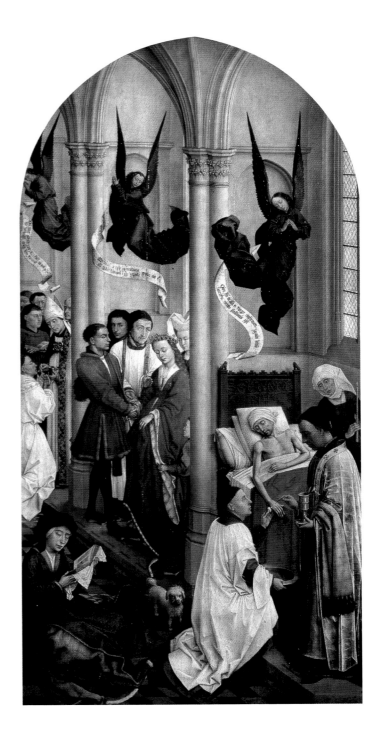

167 *(left)*
Pieter Bruegel
Faith, 1559
Pen and brown ink,
contours indented for transfer,
8¾ × 11½ in. (22.5 × 29.5 cm)
Rijksmuseum, Amsterdam
(Mielke 45)

168 *(below)*
Rogier van der Weyden
Chevrot Altarpiece
(*Seven Sacraments* triptych), c. 1450
Detail of plate 165

193

JUSTICIA

BRVEGEL

Scopus legis est ut aut eum quem punit emendet aut poena eius ceteros meliores reddat aut sublatis malis ceteri

precedent here.) Behind this scene a beh⬚⬚⬚ sword occurs on the same elevated plat⬚⬚⬚ intones prayers opposite. On the oppo⬚⬚⬚ allegory another seated judge passes ser⬚⬚⬚ of prisoners in the dock, presented by a ⬚⬚⬚ sword as learned counsel and civic mag⬚⬚⬚ Behind this foreground group in a pair⬚⬚⬚ condemned man is about to lose his ha⬚⬚⬚ is being dragged forward behind him. ⬚⬚⬚ the building hangs a prisoner in strapp⬚⬚⬚ by both feet and hands. The perspectiv⬚⬚⬚ variety of tortures: flogging, burning a⬚⬚⬚ hanging as well as the wheel on which pr⬚⬚⬚ ken. Each of these punishments has draw⬚⬚⬚ of spectators.

This spectatorship holds the key to un⬚⬚⬚ contemporary views of public punishm⬚⬚⬚ day.[17] Mitchell Merback has observed ⬚⬚⬚ fixion itself is a form of capital punishm⬚⬚⬚ ter 1), suitable for public audiences, an⬚⬚⬚ the representations of the tortures of the⬚⬚⬚ the cross in art (and, by extension, also⬚⬚⬚ of the martyrdoms of saints) responde⬚⬚⬚ punishments exacted in late medieval ju⬚⬚⬚ spectacle thus became intrinsic to the p⬚⬚⬚ of justice in the sixteenth century. As ⬚⬚⬚ clear, the purposes of punishment inclu⬚⬚⬚ deterrence, and the "desire to see both ⬚⬚⬚ perish absolutely" in order to extirpat⬚⬚⬚

⬚vine punishment from the land.[19] The "good death" or ⬚cceptance of punishment by the accused was also taken ⬚o be a signal mark of a properly purged soul, a process ⬚f Christian repentance, purification, and ultimate salva-⬚on, akin to Purgatory itself.[20]

Bruegel's drawing does not make very specific con-⬚mporary reference to local justice, but in Galle's ⬚ngraving the eight shields above the balcony judg-⬚ent area are clearly marked with arms representing the ⬚rovinces of the Netherlands, indicating that this space ⬚ould be seen as "the high tribunal of the counts of Bra-⬚nt."[21] The Vierschaar, a small enclosed courtyard, now ⬚estroyed, was constructed in 1539 along the Antwerp ⬚verbank; punishment was administered at the Steen, a ⬚rge stone prison along the river, still extant, or at des-⬚nated areas outside the city walls, for example, for gal-⬚ws (compare plate 42 or even Bruegel's visualization of ⬚e Crucifixion outside of Jerusalem, plate 9). The accu-⬚cy of the punishments can be confirmed by consulting ⬚e principal contemporary legal compendium, Josse ⬚e Damhouder, *Praxis rerum crminalium* (1551).[22] There ⬚rture is permitted to obtain evidence, and the rack is ⬚e favored mechanism. Thus one has very good reason ⬚ think that Bruegel's representations in *Justice* plausi-⬚y reproduced actual conditions in Antwerp's judicial ⬚unishments. This accuracy, of course, need not imply a ⬚ecific attitude on the part of the artist, but it strongly ⬚ggests that he did not exaggerate either the spectacle ⬚r the punishments, or even the characters of judges

171 *(opposite)*
Pieter Bruegel
Justice, 1559
Pen and gray-brown ink, contours
indented for transfer, 8¾ × 11½ in.
(22.4 × 29.5 cm)
Bibliothèque Royale, Brussels,
Cabinet des Estampes (Mielke 49)

172 *(above)*
Ambrogio Lorenzetti
(c. 1290–c. 1348)
Good Government, 1337–40
Fresco
Palazzo Pubblico, Sala dei Nove,
Siena

173
Pieter Bruegel
Temperance, 1560
Pen and brown ink,
contours indented for transfer,
8¾ × 11½ in. (22.5 × 29.5 cm)
Museum Boijmans Van Beuningen,
Rotterdam (Mielke 51)

and magistrates, in order to score easy points through excessive punishment. As usual, the Latin inscription is not particularly revealing: "The aim of law is either to correct him who is punished, or to improve the others by his example, or to provide that the population live more securely by removing wrongdoers." The question remains for interpreters of Bruegel whether justice is served on behalf of the judge and his society or for those who are judged and punished.

That the values of Bruegel's Virtues series, particularly Justice, were widely held can be ascertained from early fourteenth-century Siena, shown in the personifications of *Good Government* in frescoes for the ruling patriciate (the Nove, or Nine) by Ambrogio Lorenzetti (plate 172).[23] There the figure of Justice balances scales under the guidance of Wisdom (Sapientia); from her right hand an angel shows Distributive [*sic*] Justice as the combined activity of beheading a kneeling figure while crowning another figure with a palm in his right hand. Justice sits to the far right of the enthroned male personification of the city, and other personifications, including virtues, accompany him in triads on either side.[24] Above his head hover the three theological virtues of Faith, Hope, and Charity, and a second figure of Justice appears at the far left of the male Commune above a group of prisoners with their armed guard. In her left hand sits a crown, and beneath the sword in her right hand sits a decapitated head. From these personifications we can readily infer that for civic order Justice is essential, and harsh punishment, including beheading, remains a basic form of justice. Further confirmation emerges from the allegories on the opposite wall, where in the allegory of Bad Government, Tyranny, with a demonic appearance of pointed teeth and horns, sits enthroned beneath three allegories of vices: Pride, Avarice and Vainglory. Justice appears once more, but now humiliated and bound at his feet, her scales broken on the ground beside her. The importance of Justice is made evident through the Italian inscription below the Good Government fresco: "This holy Virtue [Justice], where she rules, induces to unity the many souls, and they, gathered together for such a purpose, make the Common Good their Lord, and he, in order to govern his state, chooses never to turn his eyes from the resplendent faces of the Virtues who sit around him." Guided by (divine) Wisdom and by the theological virtues that inform the Commune, Justice thus receives heavenly instruction, at least in Siena's visual ideals.

Along with *Fortitude*, produced with a Boschian vocabulary as a struggle of good versus evil, the image

igi et Luxuriosi appare...... ...ra Tenacitati sordidi aut obscuri existim..

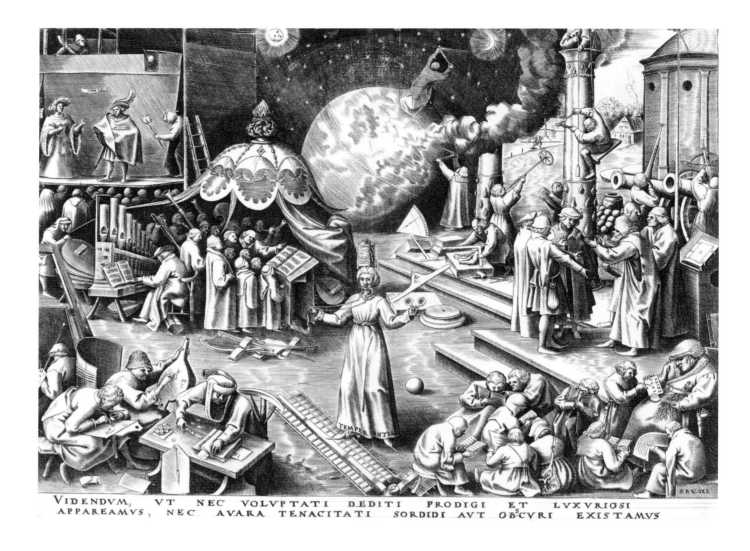

174
Philips Galle, after Pieter Bruegel
Temperance, c. 1560
engraving, 8¾ × 11½ in.
(22.4 × 29.4 cm)
Museum Boijmans Van Beuningen,
Rotterdam

VIDENDVM, VT NEC VOLVPTATI DEDITI PRODIGI ET LVXVRIOSI
APPAREAMVS, NEC AVARA TENACITATI SORDIDI AVT OBSCVRI EXISTAMVS

of *Temperance*, drawn in the same year (plates 173, 174) is the most conceptual of Bruegel's Virtues.[25] Diverse activities, most of them mental or intellectual, are scattered around the allegory like spokes around a wheel. In some respect the strange attributes of the personification provide the clue to understanding the overall composition. Temperance has a clock on her head, which refers to the shared root of *tempo*—time as well as regular rhythm—which governs the well-ordered life. Spectacles in her hand point here to clear-sightedness (though often elsewhere they indicate short-sightedness). She stands upon a windmill blade, whose regularity of turning reaffirms rhythm and measure and also contributes to an association with the technology of the mechanical arts. In her mouth is a bridle, signifying restraint and mastery, particularly of one's words; on her feet are spurs, further discipline for a horse. Traditionally, temperance is understood as self-restraint, in the sense of

moderation, such as consumption of food or alcohol. Some Temperance figures, such as an engraving by Lucas van Leyden (1530), are shown adding water to their wine to exemplify this kind of discipline; however, Bruegel's dramatic departure from this ideal nude figure for his personification shows the distinctive form of his Virtues series even more clearly.

The other key to the Temperance figure is that she uses a snake for her belt. Such an entwined serpent was the symbol of Mercury in the form of his serpent-staff, or caduceus, and the activities around Temperance conform well to those associated with the planet Mercury in a late medieval visual series, the Children of the Planets.[26] In a Ptolemaic cosmos of concentric planetary circular orbits this doctrine held that astrological influences from each planet dominated particular earthly temperaments and activities.[27] Mercury, god of both commerce and eloquence, was the sponsoring influence over the liberal

and mechanical arts, arrayed here across[...]
position. A good comparison to Bruege[...]
the Children of the Planets is Maarten v[...]
Children of Mercury, engraved by Herm[...]
and published by Cock (1568).[28] Its in[...]
the links between the activities: "Mercu[...]
gent, shrewd, ambitious, and generous [...]
skilled in mathematics and whose wishe[...]
They are visionaries." In this image w[...]
writers, scholars, astronomers, a doctor[...]
counting coins, but additionally—and [...]
the right edge of the print both a stone[...]
and a painter at his easel in back. A woo[...]
edent of the Children of the Planets d[...]
Nuremberg artist Georg Pencz.[29]

Elements of measure tend to define t[...]
the foreground corner of Bruegel's *Te*[...]
matics dominates through the figure of [...]
eychanger (in conventional archaic c[...]
counts coins and keeps accounts, secon[...]
Importantly, behind these figures sits a[...]
a palette with his back to the viewer, [...]
large canvas with the aid of a maulstick[...]
importance for painting of measure an[...]
proportion more than geometry). In t[...]
ner sits a teacher of grammar (armed [...]
punishment), who checks the alphabet[...]
others work in their copybooks.

The activities crowded in the remain[...]
are often more symbolic. At the top ce[...]
mer on a world globe uses a compas[...]
moon; behind him appear sun and star[...]
a second man measures the earth itse[...]
group of geometers take measurement[...]
sures a field, an architect inspects a reli[...]
and a trio of inspectors aligns and mea[...]
related skill of trajectory for cannon an[...]
firing stands at the edge of the backgrou[...]
are mechanical arts rather than liberal a[...]
children of Mercury also included so[...]
arts, such as architecture and medicine[...]

Just in front of the weapons stand[...]
men, some of them clerics in learned c[...]
spirited debate; they represent dialec[...]
sees a continuation of verbal skills in[...]
in the form of a drama. As Mak first[...]
distinctly Dutch form of allegory featu[...]
(a male "Hope" and an illegible fema[...]
on stage, accompanied by a costum[...]
"watcher," or guardian, above to driv[...]

point.[32] This drama of urban rhetoricians, *rederijkers*, represents the discipline of rhetoric in the overall scheme of activities in the print.[33] In front of the drama several musical performances are staged: a portable organ, backed by singers reading from a characteristically single oversized choir book; other instruments sit on the ground beside the choir, brasses and woodwinds are in use behind them.[34]

Taken together, these are the seven liberal arts, traditional within medieval education and stemming from antiquity: grammar, dialectic rhetoric, music, arithmetic, geometry, and astronomy.[35] Significantly, Pencz, followed by Bruegel and Heemskerck, included painting among the liberal arts, associated with arithmetic and geometry. Bruegel's inscription, added to the composition, stresses, however, the more typical aspect of Temperance, moderation: "We must look to it that, in the devotion to sensual pleasures, we do not become wasteful and luxuriant, but also that we do not, because of miserly greed, live in filth and ignorance."

Bruegel's composition is loosely based upon the celebrated Raphael composition in the Vatican library (Stanza della Segnatura), *Philosophy*, often known today as *The School of Athens*.[36] This image was also one of Hieronymus Cock's earliest and largest prints, an engraving on two sheets produced by Italian engraver Giorgio Ghisi as *St. Paul Preaching in Athens* (1550), so while Bruegel might well have seen the original in Rome during his visit at the outset of his career, he could just as easily have seen the Cock print upon his return. It shows a variety of figures clustered around celebrated teachers and located on several layers of steps. Closest in both form and subject is the corner group in the lower left of Bruegel's drawing and in the same position in Ghisi's print after Raphael; there a youth with a tablet responds to an elderly teacher as a number of other scholars of all ages crowd around. This repetition suggests that Bruegel might well have used the print as his stimulus, or at least as a memory aid, and that the overlap between intellectual training in both works made for a meaningful connection with the liberal arts. We also recall that Cock also would issue a later series of Seven Liberal Arts, engraved by Cornelis Cort after paintings by Frans Floris for Nicolaes Jongelinck (1565).[37]

Both *Fortitude* and *Temperance* are dated 1560 on the original drawings, and their constructed and arbitrary spaces mark the furthest departure from the worldly actions in the remaining Virtues by Bruegel. Yet there is no reason in either work to read the conception as ironic, any more than in the most straightforwardly worldly of

175 (pages 204–5)
Pieter Bruegel
The Combat between Carnival and Lent, 1559
Detail of plate 176

the compositions, *Charity* and *Prudence* (plates 159, 162). Irony is in the eye of the beholder and implies a strong act of interpretation, reversing the basic sense of a depiction. As Wayne Booth says about literature: "there is no limit to the number of deciphering pleasures that can be packed into a book. And clearly the challenge to the cryptographer is greatest when the explicit helps from the author, speaking in his own voice, are least."[38] It can certainly be claimed that Bruegel's inscriptions, a series of quotes collected from standard references as "commonplaces" (see below on proverbs), appear oddly banal in comparison to the complexity of some of his compositions.[39] Yet, in the case of *Temperance*, as Lynn White first noted, that virtue, newly understood as measure, became the leading element of early modern knowledge, a key to understanding bourgeois self-regulation and practicality.[40] Thus it would be difficult to view Bruegel's unusual presentation of *Temperance* as ironic, or as some Erasmian attack on schoolmen, especially at a time when the medieval criticisms of curiosity were shifting toward a more positive view of such an interest.[41] Nor can his *Fortitude* be seen as anything other than a reduction of ethics to good-versus-evil, perhaps comically simplified but hardly to be construed negatively or in the opposite sense. Bruegel does not require

a collaborative interpreter to make moral sense of his Virtues. Neither are his personifications negated by the actions around them, nor are they caricatures, vices in the guise of virtues.

What Bruegel does seem to do with these images (and perhaps with their added verbal commonplaces) is to pose situations that call for judgment on the part of the viewer.[42] The relationships—like those of a contemporary emblem—between allegory, text, and actions do pose interpretive challenges.[43] Nowhere is this dilemma for viewer response more pressing than for the images of *Faith* and *Justice*, the two works most frequently used as a focus for ironic readings (plates 167, 171). Many interpreters see these works as undermining the very virtue whose identity they profess to enact. Whether through the more limited efficacy ascribed to the sacraments (not even all seven of them present) or the excesses of public punishment meted out to judicial offenders, Bruegel's views are read out as more "progressive" or "liberal" or "modern" than the seemingly neutral presentations of activities included in his designs would seem to indicate.

Such a reading cannot be excluded; as noted, irony's power derives precisely from its deadpan delivery but also from the viewer's knowing "collusion" (to use the word of Wayne Booth) with the artist. Bruegel's cleverness lies precisely in his presentation of the everyday, the conventional, the traditional, but with the barest suggestion of his personal touch (though this might have had commercial benefits as a recognizable "brand") and thoughtful intervention. As noted in the introduction and chapter 2, the documentary evidence remains thin for considering Bruegel as a critical mind or an intellectual; however, scholars are often guilty of seeing what they want in the artists they study, so it would be inevitable that many of them would seek and find a colleague—critical, modern, and liberal—in the Bruegel they see. If the problems are more complex in the artist's later career a decade later (chapters 8 to 10), then they should at least still be simpler during the artist's first half decade back in Antwerp, when he is not even working on his own, but collaborating (as in the case of the added inscriptions) for a wider, more general audience with his print publisher Hieronymus Cock (see chapter 3) at the firm Aux Quatre Vents. If there is learning on display here, it conforms to a classical ethos as extended into medieval culture—pursuing the virtuous life and wisdom through religion combined with learning.[44]

Gibson also notes that one of the public allegorical dramas (*spel van sinne*), staged at the Antwerp 1561

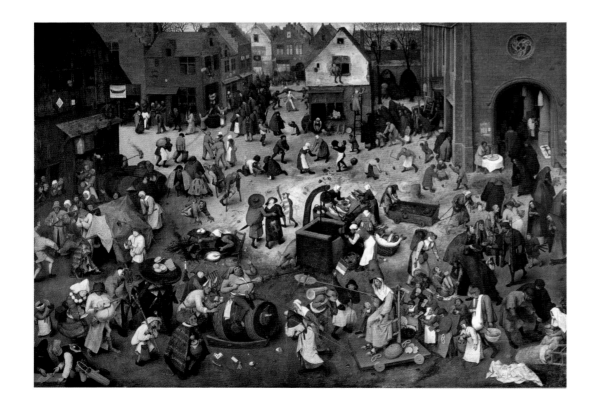

rederijker competition, or *landjuweel*, fea▨
cations of the Seven Liberal Arts accom▨
sentatives of painting, sculpture, ethics, ▨
other trades or professions that "bring w▨
to the practitioner."[45] Indeed, the the▨
competition (somewhat innocuous, to ▨
controversy) used the leading question, ▨
most awakens men to art [i.e., the libera▨
of this public topic a couple of years late▨
see Bruegel's *Temperance* as ironic in any▨

But religious interpretations of Br▨
necessarily inform another allegory, his ▨
painting *The Combat of Carnival and ▨*
176–78, 180–81, 183).[46] We do not know ▨
for this large work, but it marks the a▨
from being primarily a designer for pri▨
primarily a painter of big images with ▨
bright colors. It was quickly followed by▨
ish Proverbs and *Children's Games* (plate▨
discussed below).

The *Combat* is set in a market area, ▨
beside the main church, though it take▨
that is manifestly not a market day. Be▨
zon, bounded by houses, shops, and t▨
the church, crowds of figures fill the sp▨
comically opposite figures in mock co▨
in bright colors a fat man sits on top ▨
carrying a lance comprised of a spit wi▨
and wearing a meat pie on his head. H▨
gaunt female in a nun's habit, wearing ▨
bol of the church, on her head and bea▨
bakery plank with a pair of fish on it; ▨
and mussels ring her feet (plate 177). ▨
personify Lent, the forty-day period b▨
begins with Ash Wednesday, and Car▨
of feasting before Lent, culminating in▨
Tuesday. Of course, the Catholic religio▨
Easter as climax, defines these two cont▨
but Carnival constitutes a period of fest▨
only marginally inflected by religiou▨
contrast, Lent is somber, a period fo▨
spiritual reflection.

We find the same opposition amon▨
retine and their foods as well as the ▨
ures in the middle distance. Carnival's▨
masks and costumes with party hats. ▨
in civic youth groups performing chari▨
use noisemakers, such as clanging kitch▨
the *rommelpot*, a squealing jar covered▨
pig's bladder and manipulated with ▨

▨d gambling mark the Carnival half: in the lower left
▨rner a pair of masked figures—one of them wearing
▨affles on his hat—are casting dice, and below the main
▨er barrel, playing cards are visible. Carnival foods
▨e rich and fatty, precious indulgence before the fast-
▨g and abstinence during Lent. Empty eggshells below
▨e barrel form part of the batter for waffles and pan-
▨kes, which are being prepared over a fire by a seated
▨oman above the barrel (plate 180). Most of these ele-
▨ents—waffles, eggs, improvised kitchen instruments,
▨d general folly—can be found (albeit without a spe-
▨fic allegory of Carnival) in another, slightly later Cock
▨ngraving, by Pieter van der Heyden after "Hieronymus
▨osch," *Carnival Tavern Scene*.

▨The Carnival side also features outdoor plays. Outside
▨e inn at left a spirited costume farce, "The Dirty Bride"
▨*De vuile bruid*), features a disheveled female, crowned
▨ith twigs, who stands before a nuptial tent as she is
▨d by a prancing groom (plate 179); they are serenaded
▨n improvised instruments by more costumed follow-
▨s of Carnival as a small audience looks on from inside
▨e tavern. This play provides another mismatch, akin to
▨e unequal ages mocked in a charivari. Here the bride
▨ understood as dissolute as well as poor and slovenly;
▨e groom perforce must be a fool. More broadly, the
▨n itself bears a signboard, decorated with a holiday
▨reath, with the name "Blue Ship" (*Blauwe Schuit*), a

178 *(opposite)*
Pieter Bruegel
The Combat between Carnival and Lent, 1559
Detail of plate 176

179 *(below)*
Pieter Bruegel
The Dirty Bride, c. 1566
Pen and black-brown ink on white-prepared partially cut block of applewood, 10⅜ × 16⅜ in. (26.4 × 41.6 cm)
The Metropolitan Museum of Art, New York; Harris Brisbane Dick Fund

180, 181 *(pages 210, 211)*
Pieter Bruegel
The Combat between Carnival and Lent, 1559
Details of plate 176

ship of fools and miscreants associated with the carnival season and its excesses.[49] Bruegel would later produce a separate print of the *Dirty Bride*. First he put a design on a woodblock for cutting and printing as a woodcut, but that remained unexecuted despite initial carving in the upper left corner. Shortly afterward, a dated engraving of the same in reverse subject was issued by Cock in 1570.[50] In both scenes a figure with a coin bank (a child in the engraving, but an adult in the painting) stands by the side of the tent, presumably to solicit contributions for the performers.

The Lent side offers contrasting kinds of costumes and foodstuffs. The allegory of Lent is pulled by a monk and a nun, and children follow behind with crosses on their foreheads made out of ashes. They carry wooden clappers, noisemakers normally used by crippled beggars to announce their coming to seek alms. Alms are bestowed outside the church to blind and crippled beggars by well-dressed burghers and pious women in dark clothes. Foods found beside the allegory of Lent are also carried by her followers: simple baked goods and fish rather than meat and water rather than beer or wine. At the same level as the waffle-maker women with white linen head coverings are drawing water from a well and cutting up fish.

Besides these basic contrasts of the two principals (and the two principles, which are in fact complementary),

many other folk customs tied to the calendar are laid out by Bruegel across the background of the image.[51] If there were any inclination to consider this artificially constructed setting and its crowded figures as unified in either space or time, closer inspection dispels that notion. Above the rooftops on the left a tree bare of leaves shows a wintry silhouette, but in the churchyard early springtime buds sprout. At the farthest street near the top center a bonfire marks a seasonal change, in this case perhaps between winter and spring, and a procession led by fife and drum issues from a doorway. Proceeding down the street a parade of a religious confraternity, all dressed in brown mantles and carrying wooden clappers like lepers, follows a tall staff with sprigs of new growth, the sawmiller's emblem and another symbol of the fertile end of winter. They follow a bagpiper, who turns in the direction of the church; some of them pause at doorways to collect donations of food or drink (a child is offering bread to one of them at the head of the line). Beside them a circle of dancers fills the remainder of the street. Here the complementary principles of Lent and Carnival, respectively, are acted out on foot. Another part of this same group of alms-seeker stands close to the tavern of the Blue Ship—lepers and cripples, clearly marked by their crutches but also by the distinctive foxtails on their traveling cloaks. Their once-a-year day is Copper Monday, which follows Epiphany or Twelfth Night (6 January).[52] Bruegel would also isolate this group in a small painting (see plate 309) that also included the housemother, dressed in a cape and a conical hat while collecting alms. The child at the corner of the inn who stands on a barrel and drinks from a tankard—as the younger children cheer "the king drinks!"—is also celebrating Twelfth Night (plate 183).[53] Two couples in the street behind the cripples show men dressed in gray and carrying torches, celebrants of the *Lichtmis*, or "festival of lights," in early February (transmuted in modern America into Groundhog Day, another festival about lengthening days and the end of winter).

Related to other customs of welcoming spring is the "hunt of the wild man," a play staged before the farther inn, at the head of the same street.[54] A man carrying a club and covered with fur plays the role of a wild man, the figure of ultimate primitive strength. He is confronted by a masked woman with a ring and is followed by a figure with a crossbow and an "emperor," wearing the crown and carrying a sword of office, who carry him off for a mock execution. Bruegel repeated this same imagery in his lone woodcut (plate 182), presumably once intended to be paired with its fellow Shrovetide

play, *The Dirty Bride* (plate 179).[55] As in the earlier play, attendants stand ready to collect donations for the players from the spectators.

On the side of Lent there are fewer season-specific activities or markers, although inside the church the statuary on piers is covered up, just as altarpieces remain shuttered during Lent. As noted above, the women are dressed in somber black mantles, which they pull over their heads, but one of them carries greenery, suggesting the celebration of Palm Sunday a week before Easter itself. Beside the church a house receives spring cleaning on the outside from a woman on a ladder and on the inside from another in the doorway. Gaignebet has identified the figure upstairs in the window as an effigy burned midway during the Lenten period along with the breaking of crockery by children in the foreground (an anticipation of Bruegel's contemporary painting of *Children's Games,* see below and plate 195).

Importantly, the Lent side of the picture showed unpleasant truths about poverty, sickness, and death, but these were expurgated by an early owner, painted over and only revealed by technical examination in the conservation laboratory.[56] The white cloth in the lower right corner covers a half-nude cadaver with a swollen belly. Another skeletal corpse was painted out in the flatbed on wheels to the right of the fishmongers and made to look like ashes. Finally, the round table next to the church doorway beneath the current round table covers a pair of sick children.

For the most part, Lutherans and other Protestant sects abolished Carnival festivities and downplayed Lent itself, emphasizing instead salvation through faith alone rather than the good works of fasting and almsgiving, featured on the church side in the Vienna painting. This has led some interpreters, notably Stridbeck, to assign a religious significance to the opposition between these two camps, seeing Lent as a traditionally Catholic practice and, by default, seeing Carnival as a Lutheran rival, or else inferring some kind of satirical anticlericalism to Bruegel across the entire image. Instead, *The Combat between Carnival and Lent* seems more interested in recording customary seasonal practices, often with folkloric elements of verdant fertility and the change of seasons or of wildness mocked or tamed (the "dirty bride" and the "hunt for the wild man").

Moreover, Carnival excess, itself clearly limited, is defined by Lent, which in turn is limited, a specific, ascetic moment in the Church calendar. Their mutuality remains reciprocal and inverse; Carnival exists as both the precondition and antithesis of Lent, and vice versa. Thus, as recent scholars such as Kaveler and Carroll have observed, one cannot choose nor endorse one period or lifestyle over the other. Both sides have distinctive food, alms, even games, and in Bruegel's painting other times and post-Christmas moments in the new year also play a role in the active religious life of a contemporary Christian.

The balance built in to the painting is epitomized in its very center by a trio of figures, seen from behind, precisely between the waffle maker and the fishmongers at the well.[57] One character is clearly marked as a fool in his motley; he carries a torch like the gray figures celebrating *Lichtmis* on the left side, and he seems to be turned to head in their direction. But behind the fool stands a couple dressed in the dark costume of pilgrims with cloaks and hats, though they do not follow him. Indeed, in contrast to the torch of the fool, the woman carries an unlit lamp on her back. Their feet show that they are slightly inclined to go to the right side, where the same somber clothing and religious goals dominate. His revelry contrasts with their sobriety and propriety as a couple, as if to underscore the essential contrasts between the sides of the painting and its two seasons. Yet all three figures are poised at a moment and a place of transition; each seems perfectly capable of going either way, as if to reinforce the swift transition yet total contrast between the poles of Carnival and Lent, both of them removed from everyday commerce and occupations.

Moreover, in this respect Bruegel was again following the lead of Bosch and a close contemporary printmaker. His was not a culturally charged moment conditioned

184
Anonymous follower of
Hieronymus Bosch
Combat between Carnival and Lent
Oil on panel, 23 × 46¼ in.
(59 × 118.5 cm)
Noordbrabants Museum,
's-Hertogenbosch

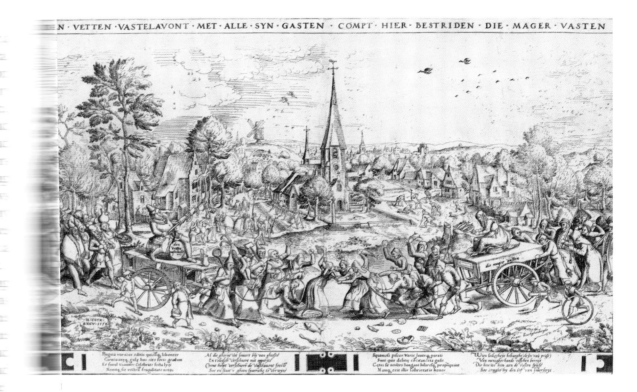

by Lutheranism, and it was not a persona...
form of anticlericalism, but rather part of...
understanding. Indeed, Bosch compos...
this same theme, now lost but preserve...
connected versions (for example, 's-H...
plate 184).[58] In this image the main figure...
excess plays the bagpipe, rustic instrumen...
carries the *marot,* or fool's bauble; one ...
who carries him on a tabletop is able to...
from his spilled pitcher. On the opposite...
only a tabletop with a fish, supported ...
headless female, and in general Carniva...
the upper hand in an unequal competiti...
man in the very center with a drinking-p...

Only the year before Bruegel's paint...
of the same subject appeared from the...
Hogenberg (plate 185) and issued by...
Hieronymus Cock.[59] Here the conflict ...
figures, entitled "fat Carnival" (*vetten V...*
"thin Lent" (*mager Vasten*), is situated...
before a country village. Like Bruegel,...
appear here on carts: male Carnival at lef...
rel with a sausage-filled spit, female Ler...
her grill filled with fish. The idea of a mo...
later used by Bruegel for his image of the ...
Money-Boxes and Piggy-Banks (plate 50)....
individual features of the allegories and th...
including background dancers and crippl...
from Hogenberg's print for the Cock wo...
would be a mistake to personalize Brueg...
to try to draw pointed spiritual conclusio...

In that same year, 1559, Bruegel painte...
work of nearly identical dimensions, a c...
Netherlandish Proverbs (plate 186, 187).[60] ...
to the more integrated space of *Carnival...*
image assembles different shelters, rangin...
poor and from city to country, in seemin...
or incongruous juxtapositions; it also cr...
ures close together, yet each group actio...
independent, often an absurd performan...
as numerous scholars have noted, anothe...
berg etching in Antwerp, a large two-sh...
captions for the proverbs or images sho...
Bruegel's own picture and prompted nu...
in the Berlin painting.[61] The etching is t...
Cloak with the explanatory subtitle, "but ...
called the errors [or foibles] of the worl...
image in an even more schematic layout ...
actions, is the blue cloak of deceit, norm...
with an adulterous woman.[62] This image ...

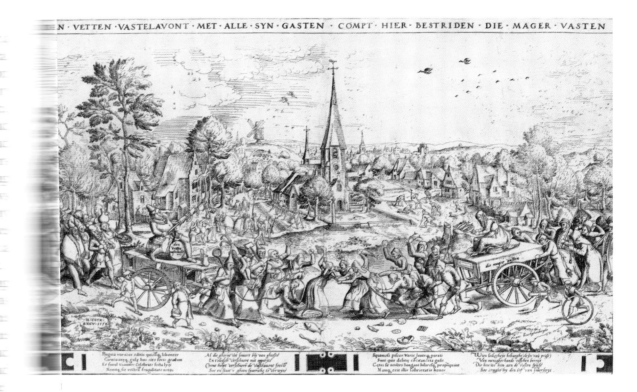

lower left corner of the print, but it receives strik-
...ng prominence from Bruegel, who places this pair of
...ures in the bottom center of his painting, showing
...he cuckolded husband as old, with a bent posture and a
...e, backed by a young upright wife in a brilliant, low-
...red dress. This juxtaposition of ages epitomizes the
...matched pair or unequal couple, the target of abusive
...an charivari (see above) and artistic satire in Germany
...d the Netherlands since the late fifteenth century.[63] Yet
...Meadow points out, this particular deceit is unlikely
...be the overriding subject of the entire ensemble, and
...re probably both works survey the *abvisen* (liter-
..."abuses," but more properly understood as foibles
...errors, oddities or weaknesses of the world, viewed
...mprehensively through examples by both Hogenberg
...d Bruegel).

This subject had a long literary sixteenth-century
...igree in Netherlandish literature, highlighted by
...smus's *Praise of Folly* (1511) and a host of verbal and
...al offshoots, including local urban *rederijker* litera-
...re, especially verses.[64] Certainly many, indeed most,
...the scenes by Hogenberg and Bruegel enact follies,
...etimes striving for the impossible, sometimes mis-
...derstanding how the world truly works. Despite the
...st array of images—the tally varies from 85 to over
...—we must look closely in order to assess what hap-
...s in these vignettes.

185 *(above)*
Frans Hogenberg
Combat between Carnival and Lent,
1558
Etching, 12⁷⁄₈ × 20³⁄₈ in.
(32.7 × 51.8 cm)
Rijksmuseum, Riksprentenkabinet,
Amsterdam

186 *(pages 216–17)*
Pieter Bruegel
Netherlandish Proverbs, 1559
Oil on panel, 46 × 62³⁄₄ in.
(118 × 161 cm)
Staatliche Museen, Berlin

188, 189, 190

(opposite and pages 222–23)
Pieter Bruegel
Netherlandish Proverbs, 1559
Details of plates 186, 187

In the lower left corner of the image (plates 186, 187, 189), we find one figure we have already met before: the shrew who "can tie the devil to a cushion" (see no. 1 in plate 187, also the key to figures on page 219), which in its fullest fashion forms the later subject of *Mad Meg* (1561; see plates 116, 143); above her (also in Hogenberg) appears a "pillar-biter," someone who literally acts out a folly, understood to be religious zealotry or excess (no. 3).[65] Obvious folly is displayed by the woman who "carries fire in one hand and water in the other," (no. 2) but even more by the man next to her, who beats his head against a brick wall, the ultimate image of frustration (no. 22).[66] Behind him "the sow pulls the tap out" from a beer keg (no. 21), meaning that a wastrel can ruin a supply, especially if unsupervised. In the shadows above the pigs a dog is raiding the larder with the same greedy animal instinct (no. 6). Leaning out onto the brick wall we meet another familiar figure, the hen-pecked husband, or "hen-feeler" (no. 18, plate 145), as well as the folktale figure, already included in Aesop's Fables, who "bells the cat" (nos. 19, 20). In Bruegel's image this figure is fully decked out in armor, suggesting that he is a false hero, over-prepared for risk. In Aesop's telling, helpless mice arm for this dangerous mission, but Bruegel has rendered the danger as absurdly overestimated to call for armor (Hogenberg also shows the scene with a human in the center at the lower edge). Indeed, with the knife in his mouth, this soldier is quite literally "armed to the teeth." In front of the wall more images display frustrating activities. One man attempts to shear a pig as his neighbor gets wool from a sheep (no. 23), and a man in the doorway attempts vainly to "carry daylight out in a basket" (no. 25, also labeled helpfully at the left edge of Hogenberg). The significance of the two women busy at their spinning is not obvious, but they are clearly collaborating: "the one winds what the other spins," suggesting that they are gossips (no. 24), sharing tales, possibly even about the woman with the blue cloak right before them (no. 46).[67] To complete our survey of the lower left corner of the Berlin picture, we should note more vain activities in the shadow of the tavern-like space. A man on his knees with a grill is grilling herring to get the roe (no. 4), and the man on the ground beside him literally falls between stools (no. 5). Finally, the scissors on the window refer to what is still called in English a "clip joint," or an overpriced business (no. 16).

Most of these figures are comically absurd, though there are also some misogynist themes here about shrews and gossips as well as normative gender roles that belittle hen-pecked or effeminate husbands. Animals as well as humans fill this world; often their ties are misguided, such as shearing a pig or belling a cat, but the animals will cause problems if they are not supervised (pig at tap, dog at larder). In this segment of the image, negative examples display what happens when the bourgeois values of hard work, common sense, and social order (including male dominance and animal husbandry) are not vigilantly observed.

This picture does show quite a number of foolish religious behaviors. Next to the doorway of the tavern we see several images about hypocrisy. A small open window shows a man literally speaking with two mouths, in short a hypocrite (no. 26). Under a blue-roofed (more deceit?) shelter beside the door, one man lights candles to the devil, a false faith from either hypocrisy or misplaced esteem in hopes for favor (no. 45); next to him another man kneels to confess to a devil (no. 44).[68] A third figure in the shadows uses a bellows to blow into the ear of that same devil (no. 43); this activity normally constitutes arousal or enticement and is usually performed by the devil himself, as in Albrecht Dürer's engraving *The Dream of the Doctor*.[69] All three figures appear in Hogenberg as well (candles in the lower right corner; confession in the top center), but not clustered together as in Bruegel. Elsewhere in the image before a thatched hovel in the right foreground, Christ sits outdoors on a chair, with his orb and a cruciform halo, but despite his blessing gesture he is being given a "flaxen beard" by a monk who kneels at his feet—another image of pious hypocrisy (no. 85). Above the thatching and beyond the water one other monk in the painting is resigning his holy office, when he "hangs his cowl on a fence," a gesture understood as changing one's profession but also abandoning one's calling (no. 69).

Bruegel also presents images of class difference as part of the ways of the world, and again he juxtaposes images with one another to make their message greater than the sum of their individual parts (no. 48). At the right front of the picture a poor beggar, one of his feet crippled and the other unshod, has to stoop and bend to make his way into an oversized, transparent globe of the world (this same image appears above the devil with his candles in the right corner of Hogenberg). Yet next to him, dressed in a resplendent cape and wearing a fashionable feathered caps stands a rich nobleman, who nonchalantly balances a tiny globe on the tip of his thumb ("he has the whole world in his hands," no. 49), though he shows neither the solidity nor the authority of Christ's orb of dominion. Moreover, just between the nobleman and Christ, another class conflict ensues, as two peasants are pulling

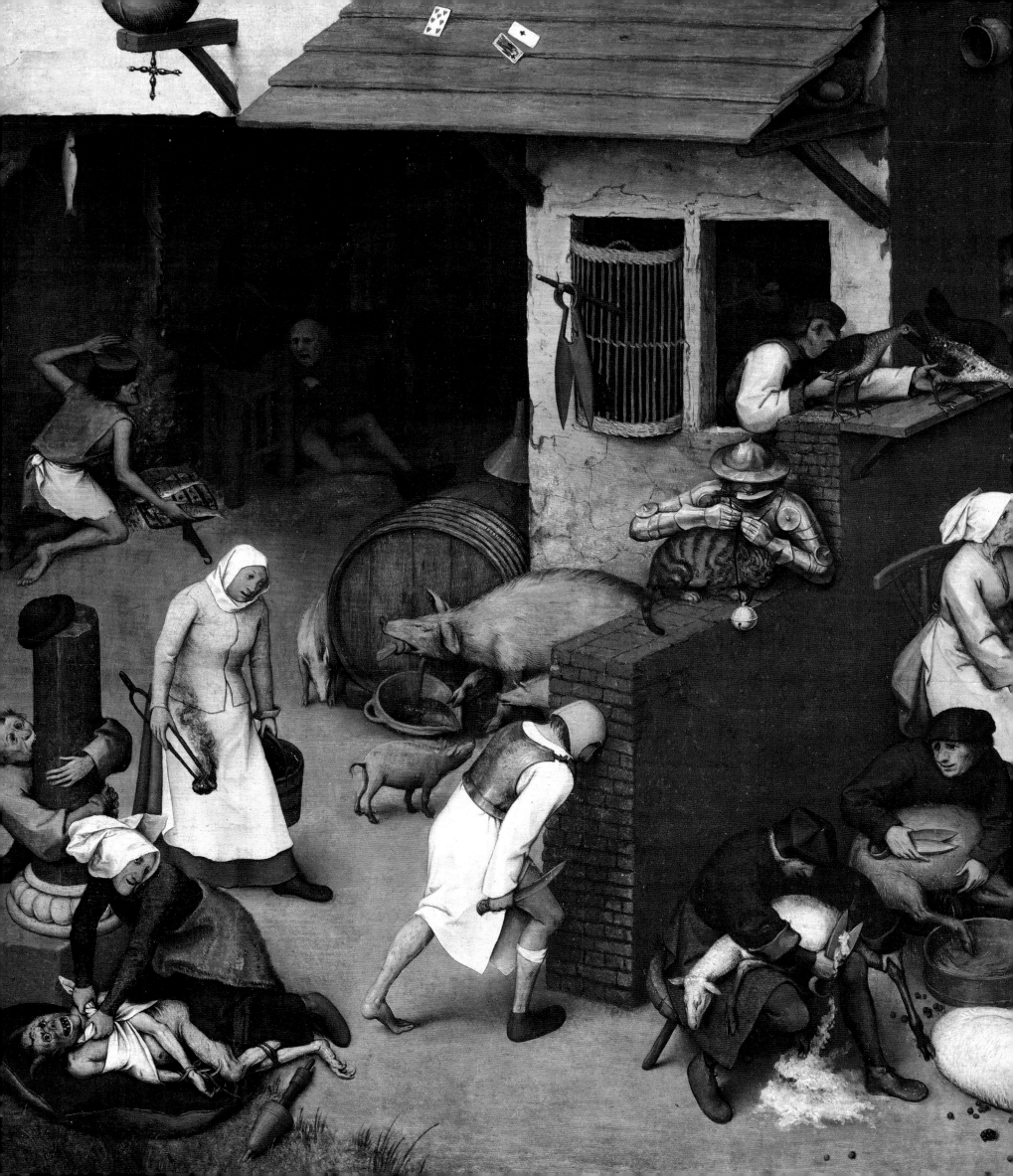

at a single pretzel, like the two identi[cal fig]ures in Bruegel's *Everyman (Elck)* (no. 8...) Along the right edge, falling from the ... another poor man with a bandaged ri[ght ...] uncertainly in a basket whose bottom ... "between heaven and earth" (no. 76). ... cannot be used, but this man has also ma... that is ending badly.[70]

Another orb sits upside down, its cr[oss ...] the inn at the left (no. 7). Some scholars ... the entire picture from this key imag... upside down, though its obscure locatio... such a sweeping interpretation.[71] In fact... found in Hogenberg as the target of a fi... on the world." His trousers are pulled ... leans precariously out of a window to p... brous act (no. 8). His costume is also dist... colored conical hat with an egg on top, s... folly and instability. Below him, and equa... a deck of cards falls with random results, ... unpredictability of chance and the luck... fools (no. 9). Behind him, in the shadow... men "take [lead] each other by the nose ... is as *Fools* (plate 76). Out of the front of t... who wears a bandage is also using a si... crescent moon to perform (like a figure ... the ultimately futile act of pissing at the ... And directly above him a crossbow arc... bring down one of many pies on the r... "pie in the sky" in modern English; see ... *Luscious Land*; plate 302), shoots one a... other, making the same mistake repeated...

Several other rich men are similarly c... behavior, like the foreground nobleman. ... the staircase above the water, another fa... acter with striped hose and a bright re... his money into the water (going throu... water, no. 59). His wasted riches are aki... gesture of another well-dressed man in th... directly above the beggar in the globe, w... before swine" (rather than the biblical p... 7:6; no. 50).

Many other images of frustration do... landscape. Some of them involve anima... man near the middle right edge, who at... ture an eel in his bare hands (no. 75), ... lone monk swims against the stream (n... image we have already met: the two dogs ... ure of Christ strive over a bone of conten... image of *Envy* (no. 51; plate 135). Another ...

...appears above the man casting roses: in the fable a fox [an]d a crane dine together, but the crane offers a narrow-[ne]cked jug from which only he can drink (no. 42).

Humans, too, are often frustrated. In the top center, "[p]igs are in the wheat," ruining hard work (no. 32).[72] [I]n the upper right across a fence a peasant with a stick "watches bears dance," (no. 70) an unexplained prov-[er]b that seems to refer to hunger. Another man stoops [co]ming out of the central castle, since he "walks with a [bu]rden" on his back across the bridge (no. 40). Even [the] nobleman with the globe has a wheel beside him [wi]th "spanner in the works" (modern British), a "stick [in] the wheel" (no. 82). In the lower right corner one fig-[ure] "cries over spilt milk" (no. 81). while beside him a [ch]aracter "cannot reach from one bread to the next" (no. [70]), even though he attempts to stretch across a single [lun]cheon for both items. Above him a figure "gapes at [the] oven" (no. 78) that is, he stares at something that [can]not respond at all, akin to beating one's head against [a w]all. The fuller sense of this proverb is that "one does [no]t look for another in the oven, unless one has been in [it] oneself" (no. 84). Above the oven a woman takes a [chi]cken egg but lets a goose egg walk (no. 77).

Underneath in the right corner a man is looking for [a h]atchet with a lantern, ultimately failing to under-[sta]nd what acts work, as "he seeks an axe to send for the [hat]chet" (no. 80).[73] But his lantern also does not work [we]ll (in contrast to a bright lantern in the hovel behind [the] seated Christ, where another man "sits in his own [lig]ht"), so this is a "lantern without light." This signifi-[can]t detail becomes all the more poignant when we real-[ize] that it appears just above the artist's own signature [on] the panel, suggesting that his imagery is unlikely to [en]lighten the viewer very much, despite his best efforts [in t]he shadows of this complicated world.

[B]ruegel sometimes cleverly combines various ele-[me]nts through juxtaposition. In the central waterway, [wh]ere we have already seen a slippery eel and a swim-[me]r against the stream, we see another strange use of [sun]light, as a man holds up a fan to shade his eyes even [tho]ugh he is still standing in the stream; envious of the [suc]cess of others, he cannot bear to see the sun shine [on] water (no. 56). Behind him a floating hat suggests [fail]ure, not being able to keep one's head above water. [Im]mediately afterward we are reminded that "big fish [eat] little fish" (no. 57), just as Bruegel proclaimed in his [earl]y engraving design (plate 68). Beneath them a man [thr]ows out a haddock to catch a cod," gaining nothing. [Nor] does the angler under the bridge fare any better, for [fo]olishly he "fishes behind the net" (no. 41).

191 (*opposite*)
Pieter Bruegel
Netherlandish Proverbs, 1559
Detail of plates 186, 187

Some themes pervade the image, albeit in scattered locations. Various individuals express their contempt through excrement: we have already met the fool who shits on the world (no. 8), and in the upper right corner at the horizon a man shits on the gallows in defiance of death itself (no. 66). Yet above the river two rear ends protrude from a single outhouse (no. 58), showing that they are utterly inseparable. Beside them, the man with the burden on the bridge wipes his rear against the door in an act of insouciance (no. 40). A woman below the sun in the upper right must discover that "horse droppings are not figs" (no. 68) to avoid either self-deceit or deceitfulness.

Such misapprehension or stupidity also informs some of these images, as we have already seen, such as shooting arrows one after the other (no. 31). Perhaps the most obvious image is the man below the blue cloak at the lower center of the entire image, who is filling in the ditch after his calf has already drowned (no. 47). Atop the castle tower in the top center several more fools reside. One man is changeable, i.e., "his coat blows with the wind" (no. 35). A man beside him "throws feathers to the wind," a wasted effort (no. 36). Inside the tower a woman "sees a stork flying," or wastes her time daydreaming (no. 38). On the bridge a man "falls from the ox onto the ass," a social decline but also a foolish change. In front of him above the bridge in a small tower (also with a blue roof) sits a cramped violinist who "plays on a pillory," which amounts to run a dishonest risk with the same contempt for punishment as to shit on the gallows (no. 33).[74] In the window of the tavern a group of people make the Carnival mistake of "shaving the fool" (no. 29). The ultimate act of foolishness derives from a parable of Christ himself: at the right horizon beneath the sun, three tiny silhouetted figures of blind men follow one another, only to fall inevitably into a ditch (no. 64; Matthew 15:14; also the subject of a full-sized Bruegel canvas, plates 305, 306)

Yet Bruegel's image is not entirely filled with mistakes, stupidity, or folly. Some of its proverbial advice is useful common sense. For example, next to the eel several images suggest that (a) it is easy to cut straps out of other people's leather (i.e., to spend other people's money. no. 74); and (b) that you can take a pitcher to the water once too often (no. 72). Some people will be selfish, such as the man—again dressed in armor, casting further aspersions on military figures—to the right of the tower who will warm himself even at the burning house of a neighbor (no. 61). Just before the blind men, an old woman flees from wolves, since "fear and terror make even the old run" (no. 63). Next to her a peasant drags a burdensome large stool or table, as if he has no other furniture (no. 62).[75] Other signs call for sensible, sharp-sighted vision: the boat next to the gallows "sails before the wind" (no. 67), but it also shows an eye on its sail, which would translate into modern English as "keeping one's eyes on the prize." A similar eye between scissors, drawn on the side of the tavern, means to be sharp-sighted, as either a wink or a snip (no. 15).[76] Sometimes even knowing what one does not know can be a form of wisdom: the puzzled man sitting beside the boat and the gallows in the upper right is posing a question that cannot be answered, "why do geese go barefoot?" (no. 71). Indeed, as Meadow notes, the sun itself can pose a final proverbial observation, "there is nothing spun so fine that the sun does not show it" (no. 65).[77]

The large Berlin painting was not the first effort by Bruegel to realize individual activities as images of proverbial wisdom. The previous year he produced an ensemble of a dozen proverbs, most of which turn up in the larger Berlin work. Painted as twelve separate medallions and mounted into a composite work, with inscriptions added at the time of assembly, they primarily display the images of ultimate frustration as single-figure works against a red background. Although surely not penned by Bruegel, these inscriptions on the roundels offer an additional benefit compared to *Netherlandish Proverbs*, with individual scenes described in Dutch, plus a Latin phrase above that points to an overall message: "These everyday scenes give advice in a humorous way and cleverly criticize human behavior."[78] Most of the images are close to identical with their counterparts in the Berlin painting. In the top row three out of four images are common: a man whose cloak blows with the wind ("a flatterer am I"); a woman carrying fire coals in one hand and water in the other (with the added explanation "I show one face to some, another to others"); as well as a man on the ground between chairs ("In indulging I remained unsurpassed; having lost all I land in the ashes between two stools"). In the center all four images overlap. A man fills in the ditch after the calf has drowned. Another casts roses before swine. An armored soldier bells the cat ("emboldened by the shield"). And that curious figure in the water with a sunshade reappears at center right ("My neighbor's riches grieve me"). Below all four figures are also shared with the Berlin picture. To beat one's head against a brick wall (but without any armor) means that "ill-tempered and surly am I." The next man fishes behind the net ("lean falls to me, fat to another"). A figure with the blue cloak lacks

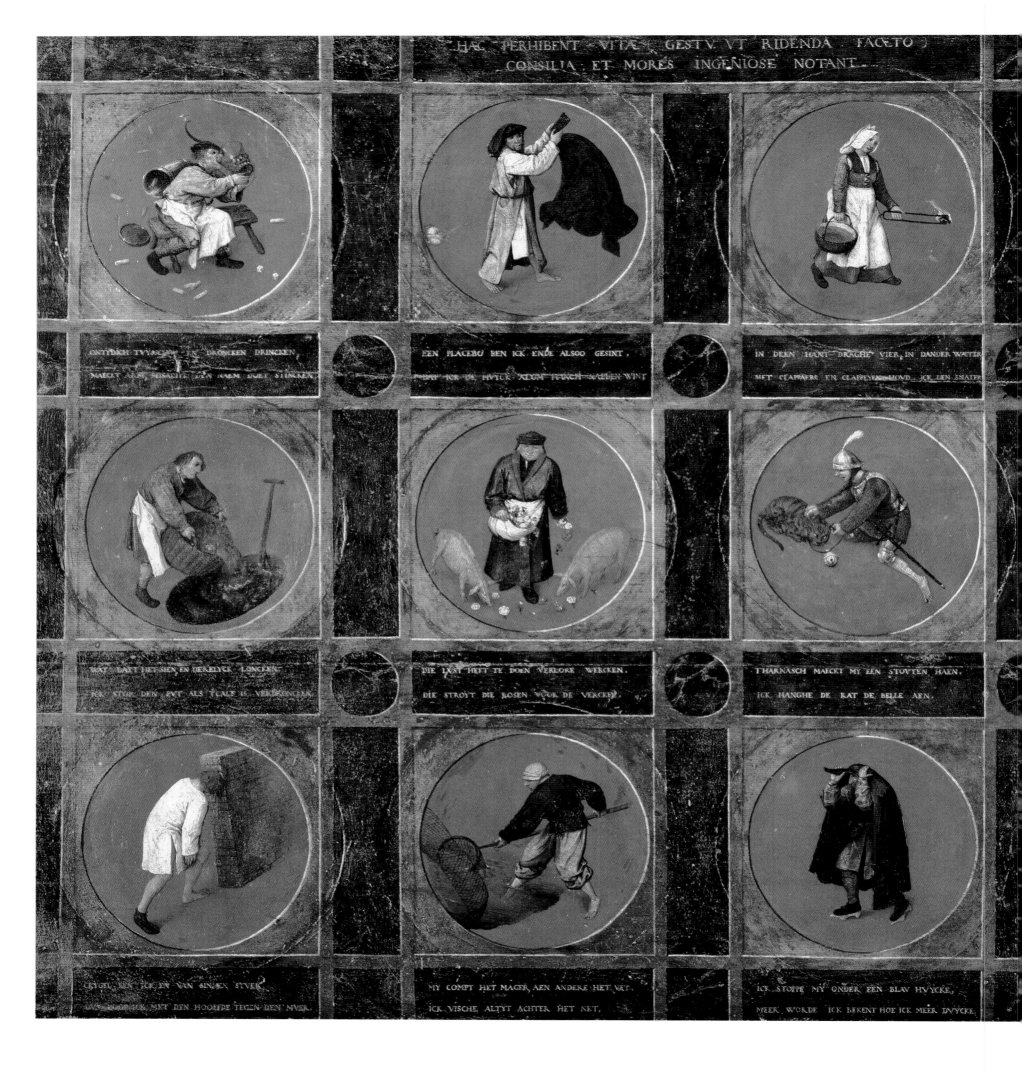

HÆC PERHIBENT VITÆ GESTV VT RIDENDA FACETO
CONSILIA ET MORES INGENIOSE NOTANT

ONTYDICH TVSSCHEN EEN DRONCKEN DRINCKEN
MAECT ALSO MISAKOE EEN NAEM DVET STINCKEN

EEN PLACEBO BEN ICK ENDE ALSOO GESINT
DAT ICK DE HVYCK ALOM NAECH WAEIEN WINT

IN DEEN HANT DRAGHE VIER IN DANDER WAETER
MET CLAPPERS EN CLAPPEN HOVD ICK DEN SNATER

WAT BAET HET SIEN EN DEELYCK LONCKEN
EK STOP DEN PVT ALS TCALF IS VERDRONGEN

DIE LVST HEFT TE DOEN VERLORE WERCKEN
DIE STROYT DIE ROSEN VOOR DE VERCKEN

THARNASCH MAECKT MY EEN STOVTEN HAEN
ICK HANGHE DE KAT DE BELLE AEN

CRYGEL BEN ICK EN VAN SINNEN STVER
DVS LOOP ICK MET DEN HOOFDE TEGEN DEN MVER

MY COMPT HET MAGER AEN ANDERE HET VAT
ICK VISCHE ALTYT ACHTER HET NET

ICK STOPPE MY ONDER EEN BLAV HVYCKE
MEER WORDE ICK BEKENT HOE ICK MEER DVYCKE

228 PIETER BRUEGEL

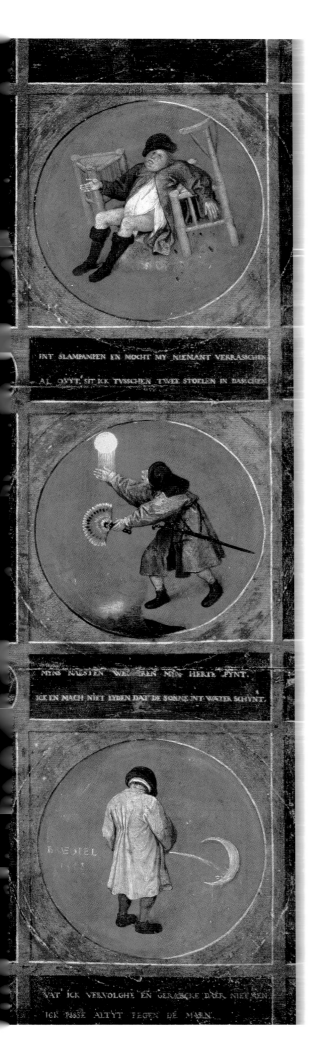

his deceitful bride, yet "the more I conceal, the more I reveal." Finally a man pisses directly at a crescent moon itself, not a signboard.

The only figure not replicated in *Netherlandish Proverbs* is the wastrel at top left of *Twelve Proverbs*, who sits on a bench, guzzling drink from a huge glass, with dice around his feet; he declares, "The fruits of ill-timed dicing and drunkenness are poverty, scorn, and ill-repute" (plate 194). Thus in this case the man does not act out a proverb, but instead serves as a negative example of profligacy, a frequent theme in sixteenth-century Flemish art.[79] Indeed a recently rediscovered small roundel—same size and format—by the young Bruegel shows a *Drunk Cast into a Pigsty* like the Prodigal Son of parable, mocked and derided by his fellow peasants.[80] Bruegel clearly was working in both his *Twelve Proverbs* and *Netherlandish Proverbs* with moral instruction through negative examples.

The inscriptions on *Twelve Proverbs* again pose questions about Bruegel's own contributions and learning, for the inscriptions were added when the roundels were assembled into a single ensemble, probably a few decades after the production of the images.[81] As we saw above, inscriptions on the Virtues were likely added after the drawing designs for inclusion in the prints, and Nina Serebrennikov was able to identify classical literary sources for those rather neutral commonplaces. In his study of *Netherlandish Proverbs*, Mark Meadow has expanded those insights concerning Bruegel's use of commonplaces and notebook compilations, both for vernacular Dutch proverbs and for Latin equivalents, adages.[82] After all, proverbs have biblical roots as well as classical equivalents, and a vast array of popular sayings, particularly in Dutch but also in English, supplements this store.[83] Regardless of their sources, proverbs had to be collected, and the sixteenth century saw a major effort by humanists and vernacular compilers alike to assemble adages and proverbs for their distilled wisdom.

On a scholarly level, Erasmus assembled the most famous collection of adages, which were first published in 1500 but continued over the span of his entire career for more than three more decades.[84] Eventually, they totaled 4,151 ancient proverbs, each one accompanied by a commentary, history, and some suggested uses. These most often take the form of full phrases or dicta, such as "know thyself" or "war is sweet to those who have not tried it," but also classical phrases (labors of Hercules, Pandora's box). A way station between classical languages and contemporary French is provided in the compendium by Rabelais in his *Gargantua*, a work of great

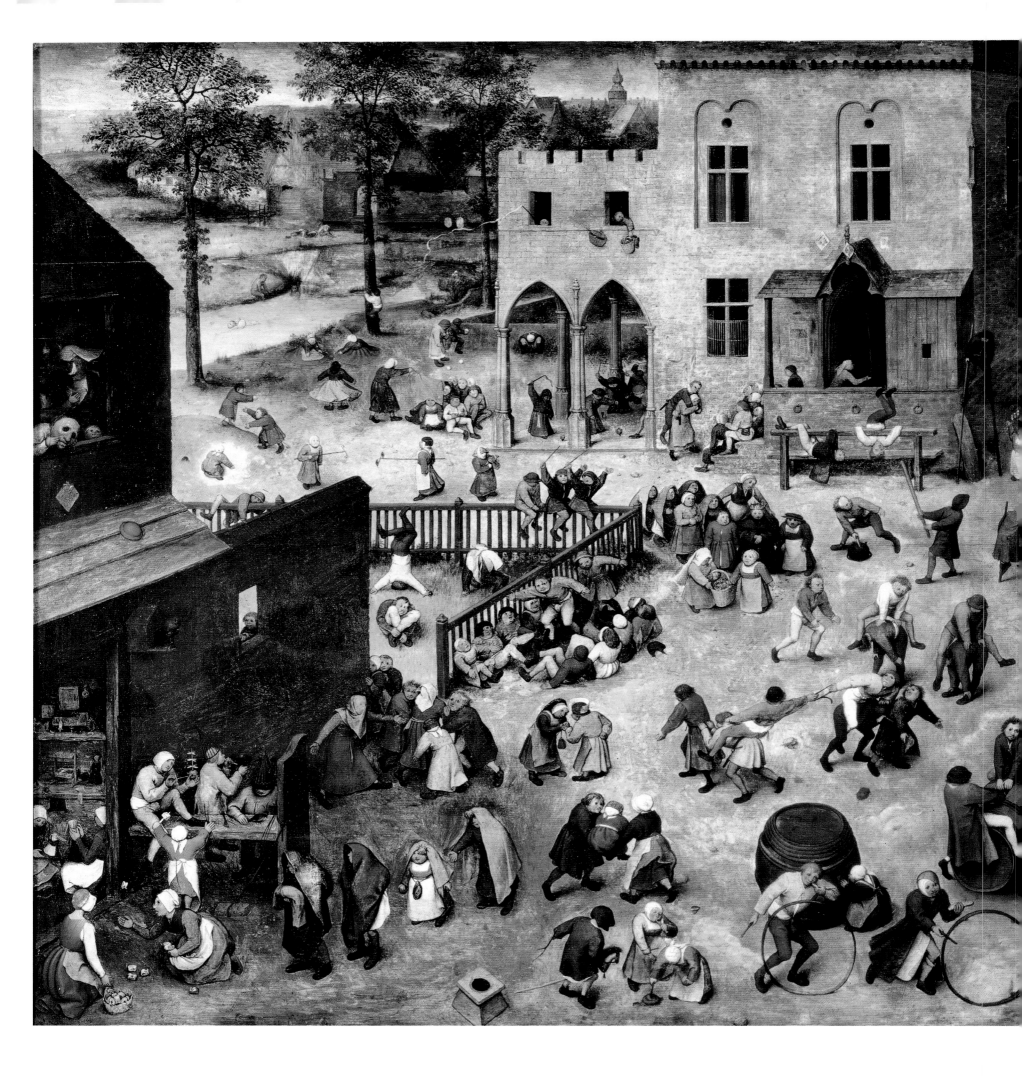

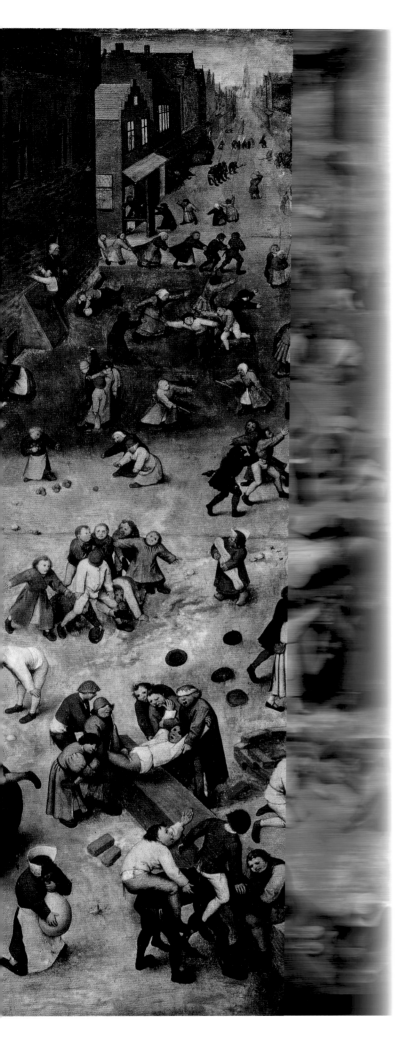

The knucklebones game in the left corner inserts an element of chance, even gambling. As noted, the baptism procession comes next, followed by a child's training stool or toilet, possibly a commentary on the lasting value of children's activities. Near the center, a child on a stick-horse embodies the power of imagination as well as imitation imbedded in all of these games: on the one hand, to animate a lifeless object and make it a source of pleasure and action; on the other, to imitate a necessary adult skill, riding a horse.[99] This game—and other children's play—had already captured the attention of an early printmaker, Israhel van Meckenem (d. 1503), in his own engraving on the theme. Right beside the rider a little girl plays the fife and drum, the basic battlefield instruments of contemporary war (and the subject of a small late Bruegel grisaille, see plate 315).[100] Bruegel also includes homely metaphors across the foreground: at the bottom center another girl with the drummer probes an animal dropping with a stick, and farther to the right another child (wearing a Shrovetide crown of Carnival) blows up a pig's bladder, the memento mori discussed earlier in this chapter. The prominent central activity of hoops, gendered between a boy and a girl, echoes the hollow barrel just behind and suggests both emptiness and cyclical movement. In the lower right corner a group game, identified by all commentators as "how many horns does the goat have?," features dominance and submission. And in the rightmost corner, right above the artist's signature (as significant as the lightless lamp in *Netherlandish Proverbs*), Bruegel has placed a young girl who is scraping red color from bricks to make an artist's pigment.[101] Here the activity of the artist fuses with the children's games in a form of serious play.

Beyond the question of documentary for its own sake, *Children's Games* poses questions of significance, for this is an almost unprecedented visual theme, closely examined. As Hindman pointed out, Bruegel did draw upon one tradition: calendar pages of manuscript illumination, the same source that he would later utilize for his images of the changing seasons in The Months (see chapter 9).[102] He made particularly good use of the Ghent-Bruges tradition, such as the Mayer van den Bergh Breviary and the miniatures of Simon Bening (1483/84–after 1558).[103] Additionally the games of children served as the subject of later, sixteenth-century prints, though these, while aware of Bruegel's painting, need not be ascribed to his own thinking about the subject. Cock himself published a series on the Ages of Man in 1570, designed by Stradanus and engraved by Pieter Furnius, which included an initial print of *Infancy*

195 *(left)*
Pieter Bruegel
Children's Games, 1560
Oil on panel, 46 × 62¾ in.
(118 × 161 cm)
Kunsthistorisches Museum,
Vienna

followed by *Youth* and *Adolescence*.[104] A similar design by Marten de Vos, engraved by Nicolas de Bruyn, *The Age of Ten*, also appears within a series of ten prints of the Ages of Man, published by Gerard de Jode in Antwerp; it looks like a condensed version of Bruegel's *Children's Games*, with a market square and a dozen games under way.[105] The Latin inscription speaks of how "the child leaps around impetuously."

But these images within a larger classification of the Ages of Man were replaced within the seventeenth-century emblem tradition by readings that stressed their futility or impermanence, particularly the image of boys blowing bubbles, as Stridbeck noted.[106] Roemer Visscher's popular *Sinnepoppen* exemplifies such emblems, but also emphatically verbalizes its critical, moral censure of play with pointed examples that simply do not stand out in Bruegel's rich ensemble. Another often-cited later version with a structure like Bruegel's city hall (based on the main square, Abdijplein, in nearby Middelburg) is Adriaen van de Venne's design for *Children's Games*, an image from another popular seventeenth-century Dutch moral tract, Jacob Cats's *Silenus Alcibiades* (1618).[107] It bears the Dutch caption "Children's games used for symbols and teaching of customs," as well as a Latin epigraph, "out of trifles serious things" (*ex nugis seria*), and its accompanying verse offers commentary:

> Play, even if it appears without sense,
> Contains a whole world therein;
> The world and its complete structure,
> Is nothing but a children's game;
> Thus, after the frost thaws . . .
> You will find . . .
> Your own folly in children's games.[108]

From this later imagery and verbal commentary, many of Bruegel's interpreters have concluded that *Children's Games* embodies a comprehensive study of human folly.

While the participants seemingly are all children, some commentators have remarked that they often look like miniature adults and that they often seem to be joyless in the pursuit of their games. Just as Jacob Cats's Latin phrase suggests that "out of trifles come serious things," many seventeenth-century artists, notably Jacob Jordaens and Jan Steen, depicted images of misguided examples in disorderly homes, where training for young children takes place across a raucous table of revelry, as three generations embody the proverb, "As the old pipe, so the young sing."[109] But very few of these games simulate real adult activities or provide a contribution to the civilizing process, the cultivation of manners in children, advocated by Erasmus in his treatise *De civilitate morum puerilium libellus* ("On Civility in Boys," 1530).[110]

Considerable scholarly argument has engaged the question of how the sixteenth and seventeenth centuries evaluated the nature of children and their relationship to adults.[111] The modern debate began with the publication by Philippe Ariès in 1962 of a controversial thesis that early modern childhood was not regarded as a separate age with its own character, but rather that children were treated in Bruegel's day as miniature adults, to be molded into model citizens. Since then, however, substantial evidence has been marshaled to show the importance of children, particularly in the Netherlands, where portraits of children and families begin at precisely the same moment as Bruegel's *Children's Games*.[112] Of course, these need not undermine the assumption that the main interest in having such images was to assert the continuity and lineage of a family, but Ozment argues that evidence of parental sentiment appears in the forms of mourning for children who died in infancy.

Yet even if these children in Bruegel's painting are not to be regarded solely as miniature adults, their formation as adults does not seem to be particularly significant as a goal or purpose of play. As noted, no single adult activity stands out, neither the wedding procession (albeit placed close to the exact center of the image) nor the baptismal procession, nor even follow-the-leader. However, some real skills are being developed, such as walking on stilts, swimming, climbing, marbles, even headstands, not to mention rule-based or board games, but these also have no lasting adult consequences. Some other games, such as riding the fence or tilting at a mock tournament with pinwheels (both in the left rear by the fence) simulate or imitate chivalric adult skills, while some youthful activities are gendered, such as the girls playing with dolls inside at the lower left edge. But none of these serious enterprises clearly display folly itself in nearly the same degree as the *Netherlandish Proverbs*.

What *Children's Games* does present is a rich accumulation of carefully observed activities, making it an equivalent in its persuasive space and its elevated viewpoint to the *Combat between Carnival and Lent* from the previous year. Moreover, this image presents its figures with a kind of neutrality of composition, distributing the small figures at regular and tight intervals throughout the space and up to the high horizon. Those figures themselves are presented with simplified shapes and basic colors, with

minimal facial expressions that have de[...] [...] readings, but suggest a comical distance [...] from individuals on the part of the pain[...] fact regards the totality of these game[...] in the aggregate, as a crowd. He insp[...] full range of their basic activities, not [...] judgment or deliver a clear moral mess[...] study their behavior. These children ar[...] or adults-in-training. Instead, they p[...] kind of creature, following instincts tha[...] lized or fully trained into adult activi[...] them the lessons of *Netherlandish Pro[...]* been learned, and they are far more [...] eral in acting out those metaphors as [...] characters. For them the daily cares o[...] have not yet arisen, and they can read[...]

enjoy on either the side of Carnival or of Lent, though Carnival surely offers more fun and includes more children among its merrymakers.

At the same moment, 1559, Bruegel began his lasting engagement with peasants in their festivities (chapter 9), in effect combining the overview and integrated space of his large paintings with simplified images of beings who are not easily regarded as his true peers, the urban bourgeoisie. In both form and content, then, those peasants should also be regarded as connected to their own customary activities and primal impulses like these children. We shall see that Bruegel's presentation—and presumably also his attitudes—concerning peasants would change over the ensuing decade. But he began to represent his celebrated rural festivities at just the moment when he also was examining *Children's Games*.

197
Pieter Bruegel
Children's Games, 1560
Detail of plate 195

7

RELIGION
AND TRADITION:
ANTWERP,
EARLY 1560s

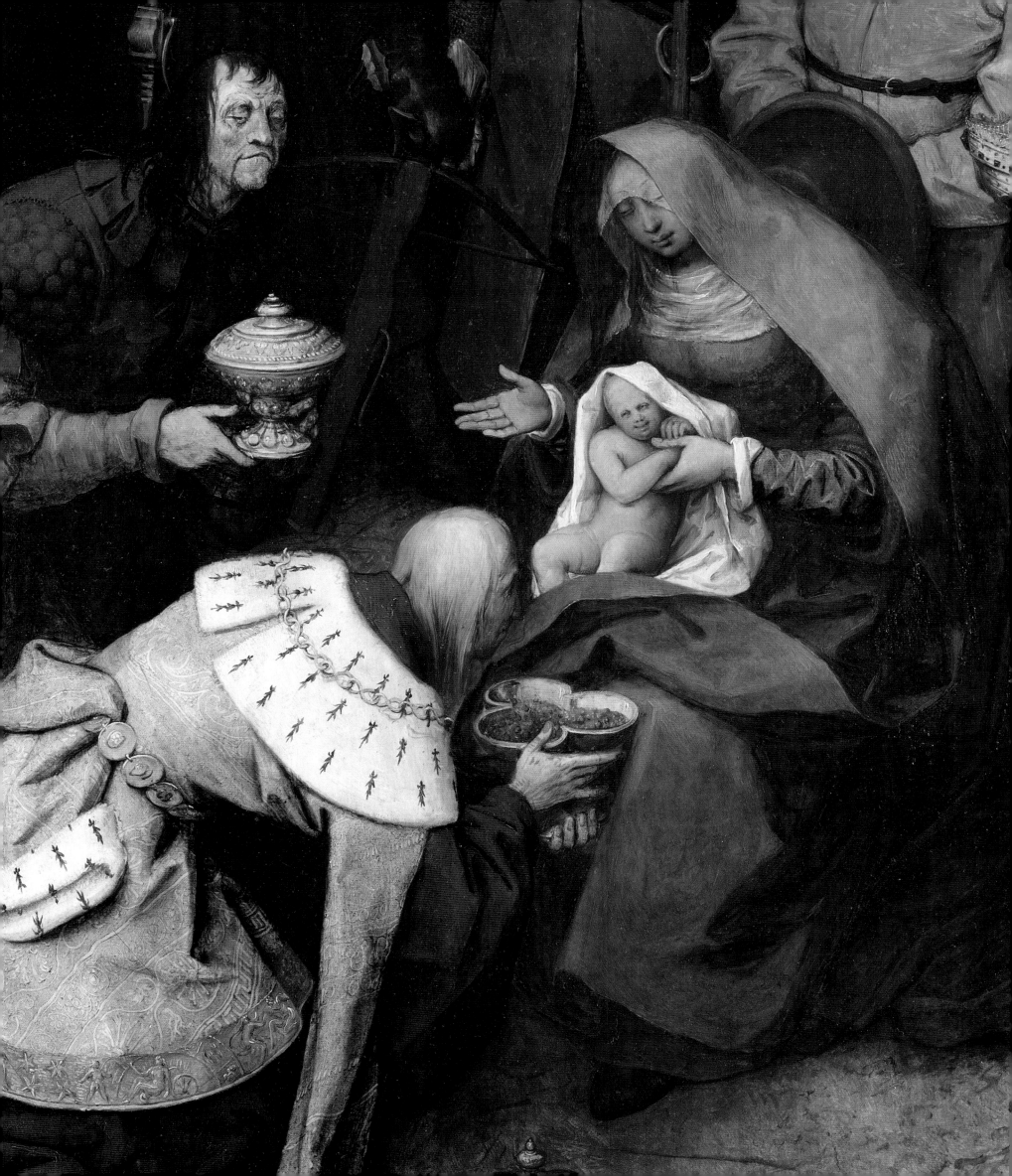

Bruegel's largest religious pain*rying the Cross* (1564; plate 8)conscious vision upon the es
of Way to Calvary compositions that f
Netherlandish painting, especially dur
generation. Close viewer attention and
formed the *raison d'être* of that vast p
very subject remains obscure until the
the tiny figure of Christ in the center.

During that same year Bruegel broug
sionist formulation to an even more s
subject in his *Adoration of the Magi* (
1564; plates 199, 200). This work, his
gious narrative, in contrast to the h
of the *Christ Carrying the Cross,* also
famous models of the late fifteenth cer
by Hugo van der Goes of Ghent and
mulation of Hieronymus Bosch aroun
sixteenth century, as well as other An
from the sixteenth century. But like *C
Cross,* it, too, forces an attentive viewe
very act of seeing and believing.

Many of the features of this paintin
ventional. Attention focuses on the
Madonna and Child. Her face at the
ter is framed in a bright blue mant
very color of heaven but also sugges
mourning.[1] Sitting on her lap, the o
the Christ Child, is surrounded by th
white sheet. Yet this child is manife
he squirms awkwardly, as if in fright
visitors who near him.[2] Here, too, Br
a regionally famous model: the r
Madonna and Child by Michelangelo
in nearby Bruges in the namesake Ch
(plate 201).[3] That sculpture also featur
ing his mother with his left hand and
albeit more as if standing and desce
turning to seek maternal shelter. Bru
has emphatically altered the Child, re
and gracefulness with a shrinking def

Even while referring to handso
model, Bruegel deliberately makes h
pretty and distinctly more human. M
presents the Madonna and Child dire
of the viewer, who stands at a low v
the main objects of adoration from a
gap and level with the chest of the M
if kneeling or genuflecting. Mary tu
direction of the visiting magi and exte

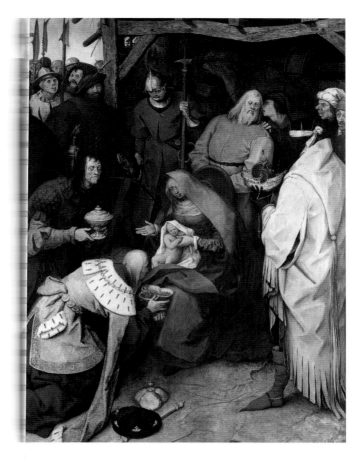

to them, but the Christ Child's torsion actually presents his body more directly to the viewer.

Following the conventions of the Adoration subject in art, Bruegel features the three magi, the "wise men of the East" (Matthew 2:1–11), who brought presents and tribute of gold, frankincense, and myrrh. By pictorial tradition, these three kings were associated with the three ages of mankind and with the three known continents—Europe, Asia, and Africa. European moral superiority due to the adherence to the Christian faith was signaled in Adoration pictures, particularly in fifteenth-century Flanders, by the placement of the European figure as the oldest of the magi and the one with white skin and features in the position physically closest to Christ. This old, white-haired king wears an ermine-trimmed mantle with an exquisitely embroidered hem with pagan symbols, possibly signs of the zodiac. He kneels with his offering of gold coins in a trilobed basin at the feet of Mary; his scepter and coronet are placed directly before the viewer in an open spot strewn with bits of straw at the bottom center of the picture.[4]

A close comparison to this very figure can be found

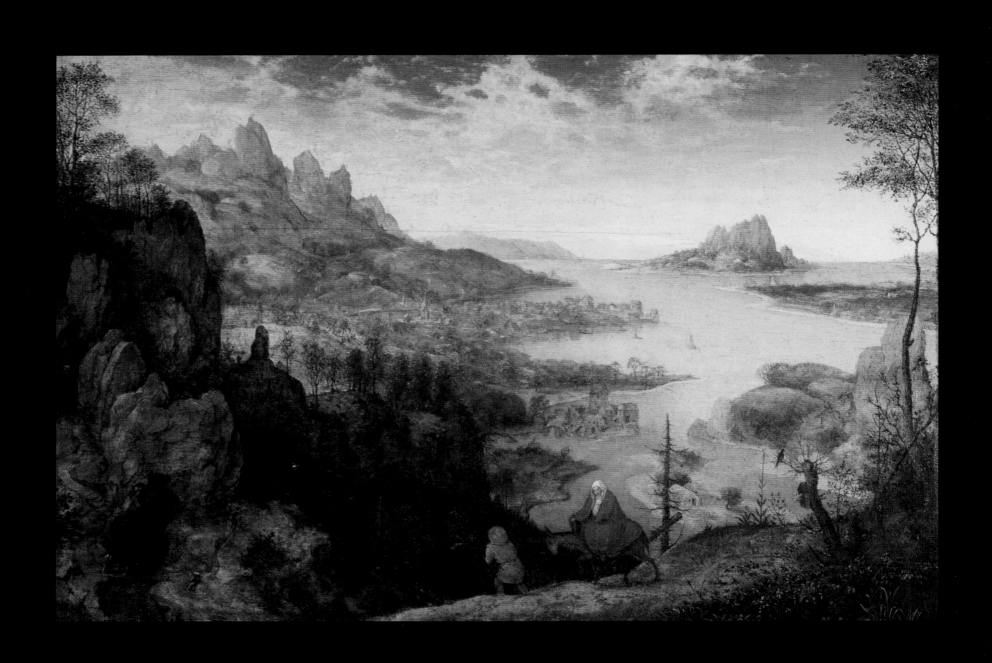

In effect, Bruegel has collapsed the [illegible] between the biblical period and his o[illegible] the shrines set aside for pagan idols w[illegible] the advent of the true religion, first th[illegible] presence of the Holy Family, but in [illegible] world through the statues of Mado[nna and Child] sur- rogates for the actual figures in flight [illegible] might even see here an early manifes[illegible] own emerging sympathy for peasants [illegible] deep, if simple faith. By contrast, in [illegible] *Egypt*, the idol—on the hillside at t[illegible] Antwerp panel—clearly is pagan and [illegible] on a column.[24] Indeed, the replace[illegible] idols with Christian cult images is e[illegible] a fifteenth-century illustration of the [illegible] from the typological manuscript [illegible] *salvationis* (plate 209).[25] Bruegel al[illegible] shrine within the country village se[illegible] *Peasant Kermis*, where a colored M[illegible] image (probably a painted woodcut[illegible] a shelter upon the tree at the top rig[illegible] overlooking the village square wher[illegible] place and still the site of flower offer[illegible]

The forms of the holy figures the[illegible] reprises of the same two characters [illegible] *of the Magi*. Joseph, seen from beh[illegible] wide-brimmed straw hat and simp[illegible] tume with vest. Mary still wears a [illegible] head covering, although she has sub[illegible] for the blue she wears in the Lond[illegible] figures will reappear with much the [illegible] again in blue) and donkey transpo[illegible] figures in Bruegel's 1566 *Census at [illegible] Their travels are reinforced by the [illegible] characters visible in the image: wan[illegible] around the mountain cave in the l[illegible] the association that we have seen [illegible] landscape prints pertains here—th[illegible] spiritual retreat, in this case a refug[illegible]

This charming, luminous pan[illegible] session of a leading political and r[illegible] Netherlands: Antoine Perrenot d[illegible] nal and also adviser to the regent [illegible] Brussels, Margaret of Parma.[26] B[illegible] to Brussels sometime around 156[illegible] such court patronage might have [illegible] tion; however, Granvelle was for[illegible] try under political pressure in 156[illegible] surviving letter his pictures had a[illegible] market by December 1572.

Bruegel seldom portrayed the adult Christ promi- nently in his work, preferring to have the viewer seek him out, as in the *Christ Carrying the Cross*. An excep- tion to this pattern is a finished drawing of the Resur- rection (plate 210), later engraved for Cock at nearly the same size, presumably by Philips Galle (plate 211). A quick glance at the wakening soldiers, lanky figures with small heads, who wear broad-brimmed hats like the figure of St. Joseph in the *Flight into Egypt*, suffices to show a shared authorship and approximate date. Additionally, the figure of the angel that announces the miracle in the center closely echoes the proportions of the archangel Michael in the *Fall of the Rebel Angels*, also 1562. In all likelihood, this drawing, considerably abraded, was formulated as an independent work rather than as a design for an engraving, since the blessing hand of Christ is his traditional right hand, reversed in the print to a left-handed gesture. Yet the concept of the independent drawing was still a considerable novelty

207 (*opposite*)
Pieter Bruegel
Flight into Egypt, 1563
Oil on panel, 14½ × 21⅝ in.
(37.1 × 55.6 cm)
Courtauld Institute, London

208 (*below*)
Joachim Patinir (c. 1480–1524)
Flight into Egypt, 1516–17
Oil on panel, 11⅜ × 13 in.
(29.3 × 33.3 cm)
Koninklijk Museum voor Schone
Kunsten, Antwerp

FVGA DEIPARAE IN AEGYPTVM.

209 (above)
Jan and Lucas Doetecum after
Imitator of Pieter Bruegel
Rest on Flight into Egypt, c. 1555
Etching, 12¼ × 16⅝ in.
(31.5 × 42 cm)
Private collection

210 (opposite)
Pieter Bruegel
Resurrection, c. 1562–63
Pen and brown ink, brush with
blue-gray and dark blue inks
(added partly by another hand?),
pasted on oak panel, contours
indented for transfer, 16¾ × 12 in.
(43.1 × 30.7 cm)
Museum Boijmans Van Beuningen,
Rotterdam

in Netherlandish art, seemingly established by Bosch, and this work on paper is the lone surviving example in Bruegel's oeuvre; moreover, it is enhanced with wash, something unique to this drawn narrative.[27] Notably, the near future would find the artist making small-scale, multi-figure religious scenes—*The Death of the Virgin* and *Christ and the Woman Caught in Adultery*, 1565 (plates 260, 255)—in grisaille on panel. But he seems to have anticipated that combination of Gospel figure subject and format with the Rotterdam *Resurrection*.[28]

Bruegel's choice of subject once more engages the issues of seeing and believing. The Maries (five in number in this print rather than the traditional three) have come to the tomb (Matthew 28:1–7) at the very moment of another earthquake, in echo of the earlier moment of Christ's demise upon the cross (Matthew 27:51–52), when graves also were opened. According to the Gospel text, the soldiers quake with fear at the sight of the angel, who informs the Maries that Christ was risen and "not here." They will only see him later in Galilee after bearing witness to the apostles about the resurrection, yet Bruegel shows him at the top center of the drawing in the midst of clouds (and with the suggestion of a halo, accentuated by sharp illumination in Galle's

engraving). The more prosaic and literal-minded soldiers are inspecting the empty tomb or shielding their eyes from the sudden light of the angel (a "countenance like lightning" 28:3). In contrast to most earlier Netherlandish images of the Resurrection (for example, Dieric Bouts's canvas, plate 212), which show the figure of Christ standing upon the open slab cover of a stone tomb, Bruegel returns to the text to show the cave setting with a stone rolled away from it. Light against the nocturnal darkness also plays a major role: the Galle engraving emphasizes the rising sun of Easter, symbol of the new era of grace, at the horizon behind the Maries. While this glow has been abraded in the drawing, it underscores the existing visual rhyme between the haloes of both angel and resurrected Christ, even as it contrasts with the lantern hanging above the sleeping soldiers. Bruegel's *Resurrection* presents as a theme this fundamental contrast between light/enlightenment—the sunrise in the distance, but especially the figure of Christ above—available to the viewer of the drawing or print, versus the limited understanding of the soldiers when confronted with the angel.

Bruegel's *Resurrection* shows the artist's ongoing, sometimes obsessive, preoccupation with soldiers, in this case with their weapons: the halberds and axes carried by the helmeted figures at the mouth of the cave plus the crossbow and winch in the lower center of the image. In the *Adoration of the Magi* the figures of soldiers and their weapons occupy the upper left of the composition (see plate 200). But the artist's fullest exposition of armies in conflict is another smaller panel, *The Suicide of Saul*, signed and dated 1562 (plate 213). The event depicted is an episode from the Old Testament (1 Samuel 31:1–6; inscribed on the panel itself "Saul xxxi. Capit"), in which the army of the Israelites, led by King Saul, battles the Philistines at Mount Gilboa and stands on the verge of being conquered. According to the Bible, the sons of Saul were slain by the foe, and the archers approached to threaten King Saul himself, who falls upon his own sword to avoid being humiliated in defeat. Bruegel's image places the suicide alone with his armor-bearer in the lower left corner of the composition, while below them across the remainder of the panel teems the conflict of miniature armies in the Jezreel Valley. In the distance, crossing the river (31:7), the Israelites retreat along with their animals, including visible camels.

While Bruegel constructs this landscape setting after his own formulas from the Large Landscape prints for Cock (for example, *Rustic Care*), for his visual model of the battle, he almost certainly relied upon south

214 (below)
Cornelis Anthonisz. (c. 1505–1553)
Tower of Babel, 1547
Etching, 12½ × 14⅜ in.
(32.2 × 37 cm)
Staatliche Museen,
Kupferstichkabinett, Berlin

215 (right)
Pieter Bruegel
Tower of Babel (large version), 1563
Oil on panel, 44½ × 60½ in.
(114 × 155 cm)
Kunsthistorisches Museum, Vienna

subject of this etching, rather than its construction, which dominates previous Netherlandish depictions. Indeed, Anthonisz. shows angels from heaven accompanying a thunderclap that undermines the structure, which fragments and falls. Below, a crowd of people reacts with gestures of distress, while at the left edge ships flee to safer harbors and turbaned soldiers (like those of Bruegel's *Suicide of Saul*) escape across a crumbling bridge. A figure in antique armor, who might be Nimrod, has fallen to the earth in the center foreground.

One earlier representation of the structure—featuring cranes and construction technology as well as the commanding figure of Nimrod with a kneeling figure in the foreground—appears in the *Grimani Breviary*, the luxury manuscript exported to Cardinal Domenico Grimani of Venice and ascribed to either Gerard Horenbout or the anonymous Master of James IV of Scotland (plate 216).[38] There it forms an Old Testament

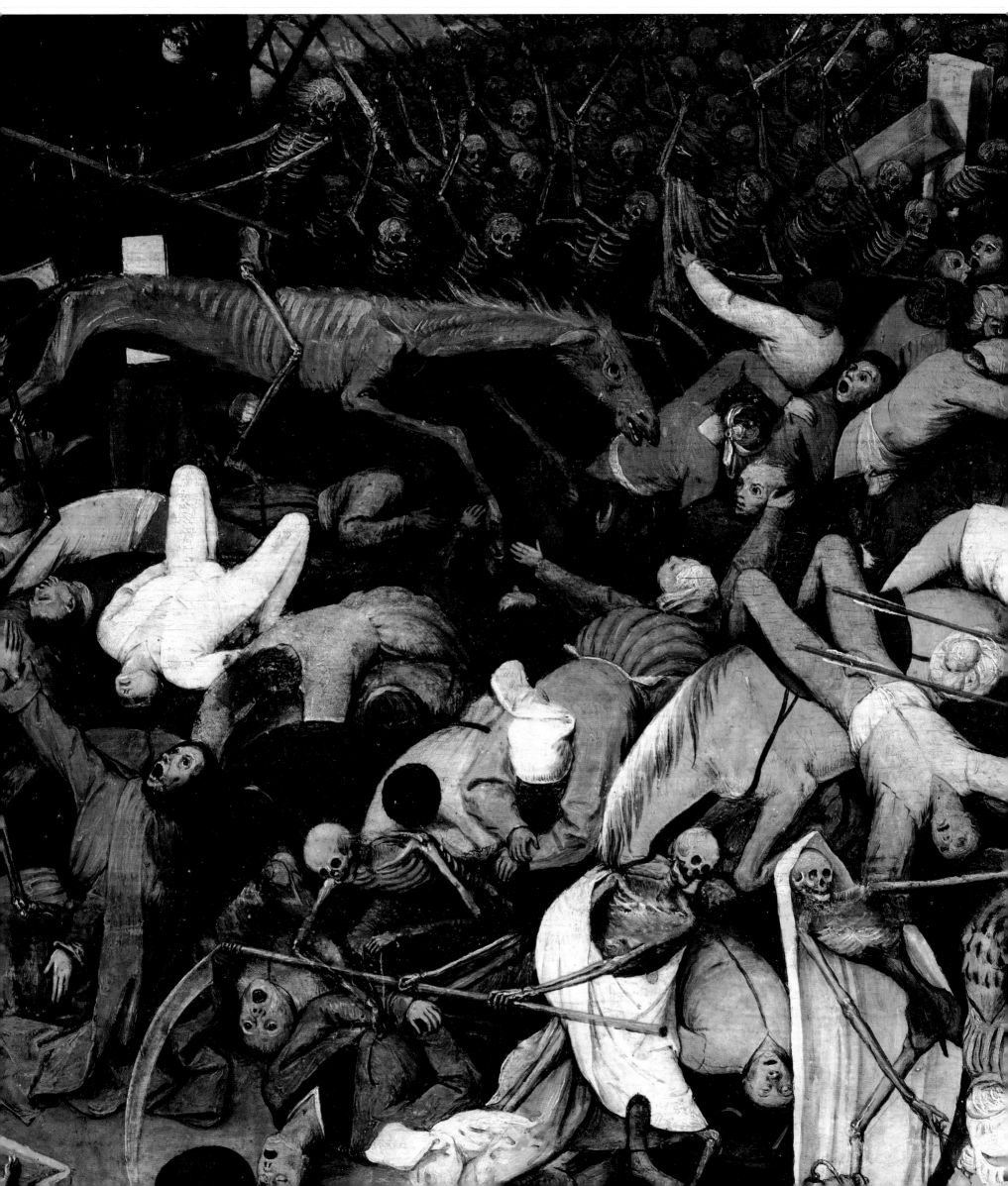

8

RELIGIOUS IMAGERY IN A TIME OF TROUBLES

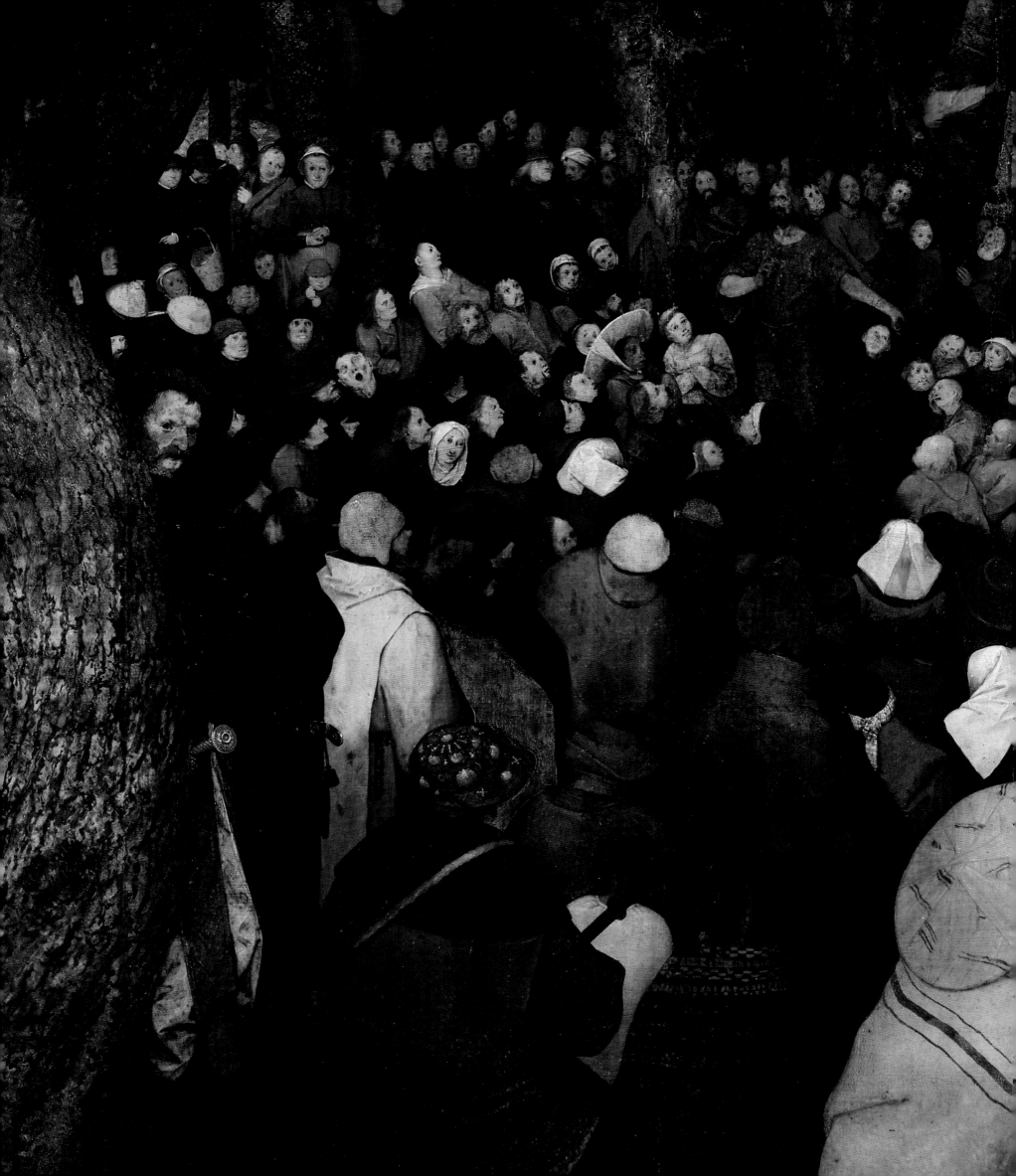

The venerable old America[n] ... O'Neill used to declare th[at] ... local." In Bruegel's Netherlan[ds] ... 1560s, political events, in the form of ... Spanish authority, accelerated rapidl[y] ... spark what history knows as the Du[tch Revolt]. Additionally, that homegrown polit[ical activism soon] became intricately intertwined wit[h] ... grassroots popularity of Calvinism ... weight to the assertive dominant rel[igion, Catholicism] of the ruling Spanish monarch. We [have already seen] Bruegel offering an implied criticis[m] ... unchecked authority in his 1563 *Tow[er of Babel]* (plate 215); thus it will not be surprising tha[t the painter would] have reacted to the events unfoldin[g around him], per- haps the more so during his later c[areer] ... Brussels, site of the court.

The Netherlands was ruled since ... half-sister of King Philip II, Marga[ret of Parma] (plate 222) and by her aristocratic adviso[r, Antoine Perrenot,] called Granvelle (plate 223), who w[as an avid collector] of Bruegel pictures (for example, ...) ... ouster of Granvelle in early 1564, p[artly in response to] the remonstration to the king duri[ng the previous year] by William of Orange and the cou[nts of Egmont and] Hornes, forms in retrospect one o[f the opening salvos] of protest in the nascent Dutch Re[volt].

One of the markers of increasin[g religious dissent in] the region of Antwerp was the sudd[en immense popular-] ity in summer, 1566, of "hedge prea[chers," who held large] outdoor sermons (*hagenpreken*) at [Calvinist gatherings] beyond the city limits. Calvinism [had first taken root] in France, radiating outward alon[g linguistic channels] from John Calvin's home center i[n Geneva to the Wal-] loon cities in the Low Countries, b[ut it also had inroads] in Holland, especially Amsterda[m] ... 1564 a Calvinist preacher had been ... Antwerp civic authorities against ... even as Philip II insisted on enfo[rcement of anti-heresy] laws. But by mid-1566 Margare[t of Parma had been] compelled by pressure from the le[ading Dutch nobles to] suspend those strictures, leading [to the return of exiled] Calvinists and the summer rise of [the hedge preachers].

Against these events Bruegel ... *The Preaching of St. John the Bapt[ist]* ... a crowded human vista of a div[erse population at the] edge of a forest clearing listenin[g to the sermon of the] saint, the "voice crying in the w[ilderness"] ... Matthew 3:1–6). This image hel[d enduring popularity] and was copied by both of the ...

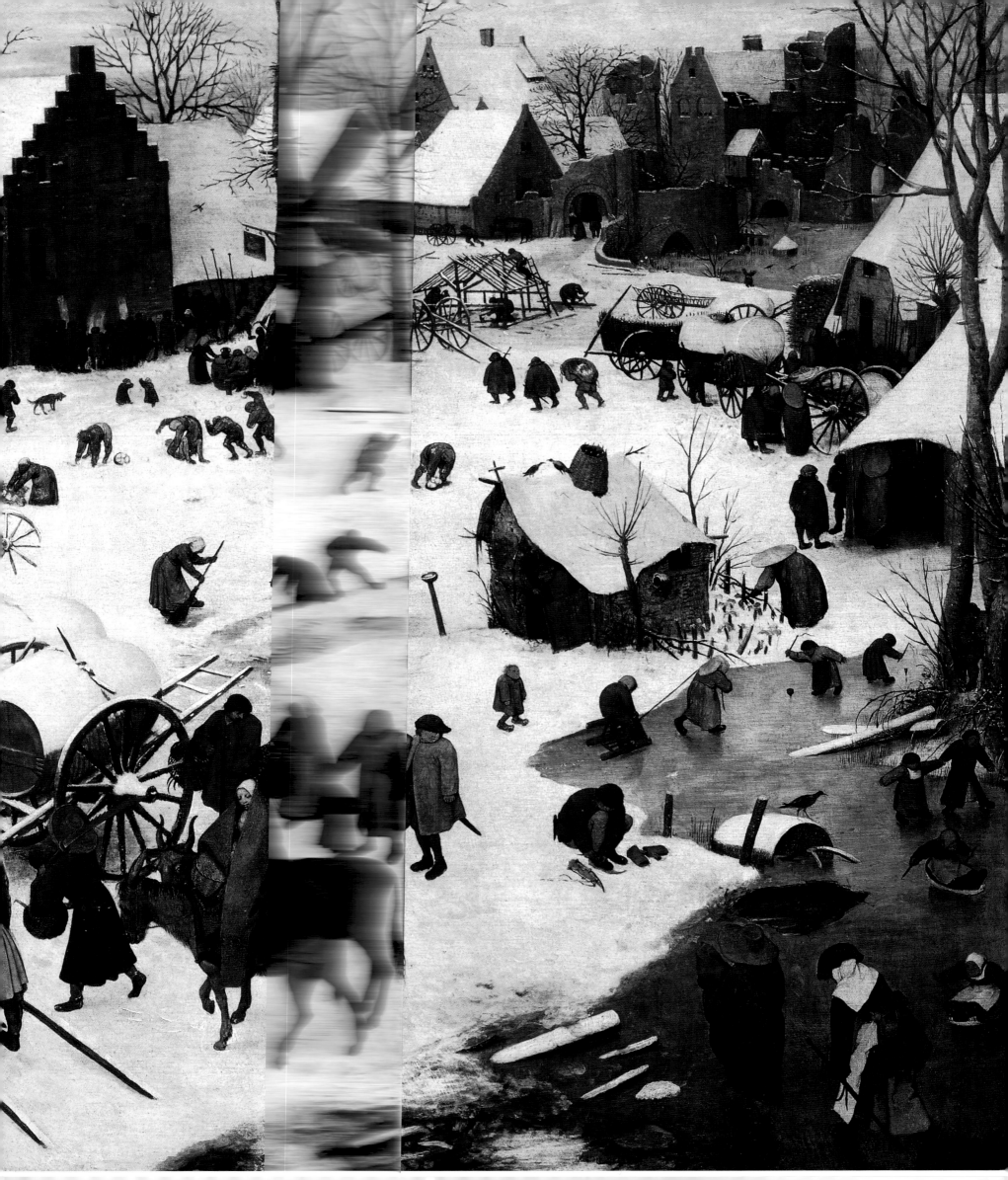

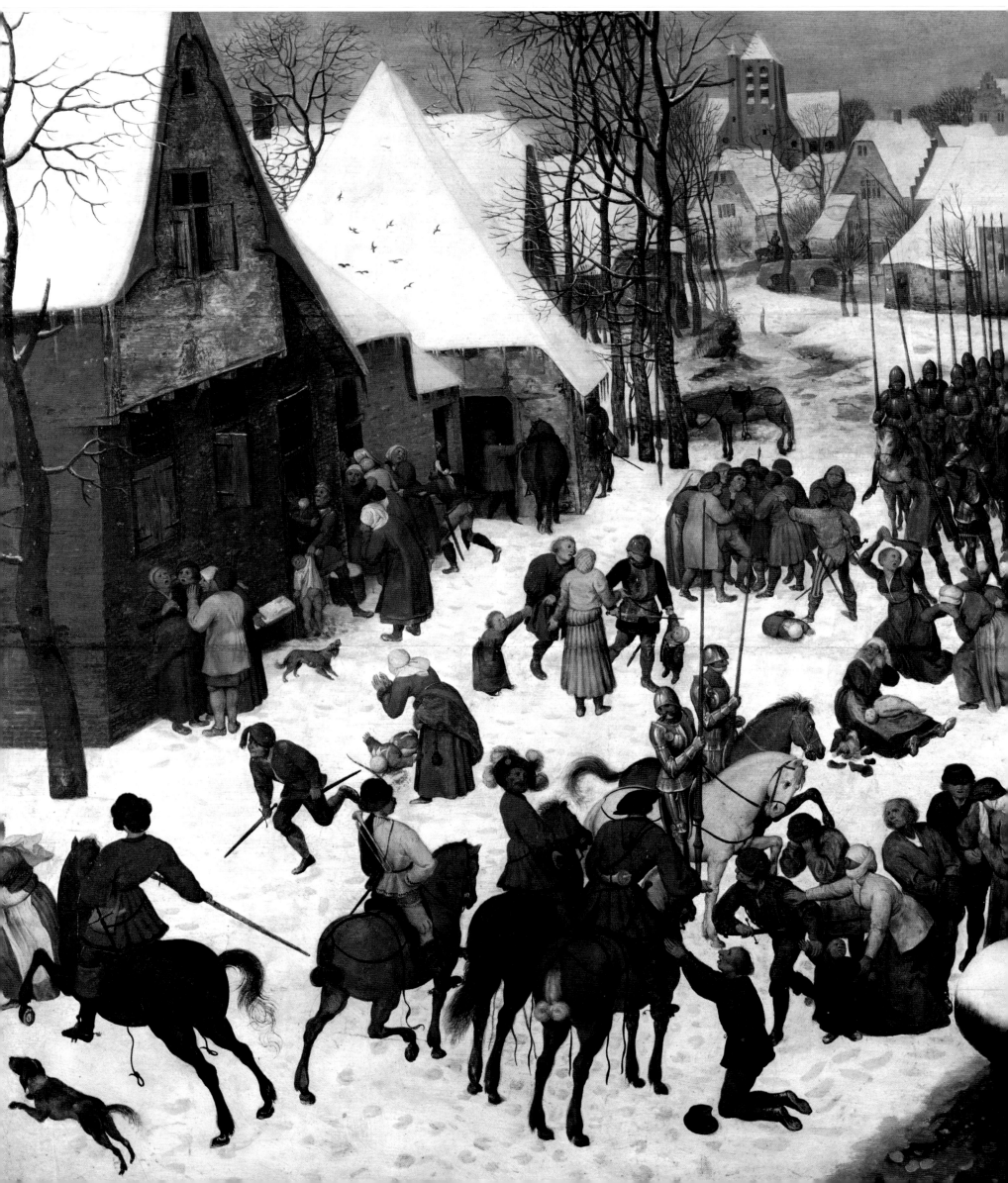

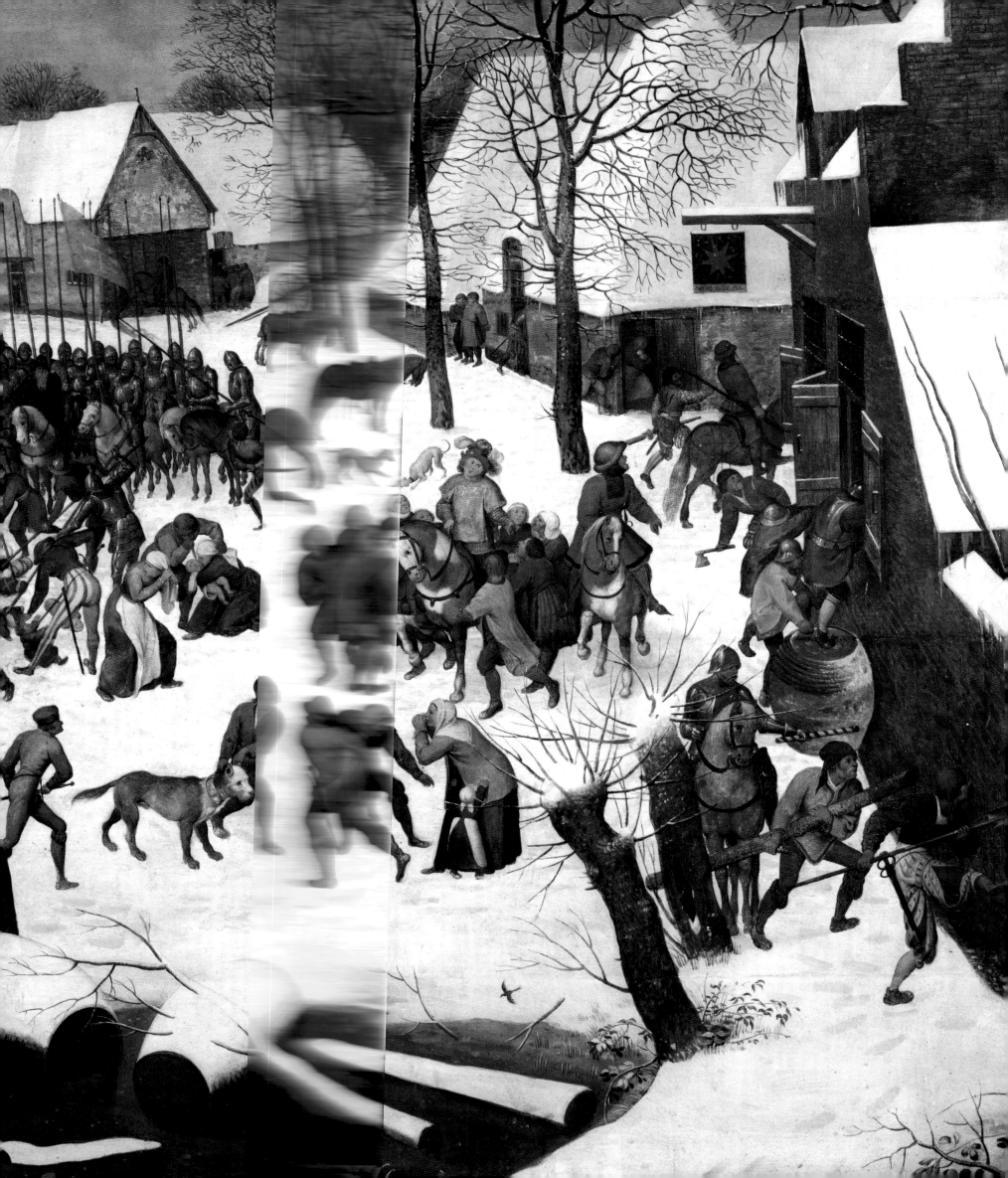

Massys, and others. Whether or not Bruegel explicitly signaled any form of political protest to his contemporaries, their response was to replicate the image through copies (including the Vienna version, plate 236; many others by Pieter the Younger) as well as variants, part of a larger, late-sixteenth-century theme of "peasants' distress" (*boerenverdriet*; see chapter 11).[21]

The original appearance of the Bruegel composition can be gleaned from its copies, which show the very real dangers to children: one dead child lies on the lap of his mother near the center of the composition, while in the foreground, behind the kneeling and pleading man, another toddler is being pulled away from his more active, resisting mother by a soldier with a sword. Yet the horror of the scene was too much for some later owner of the Hampton Court original. The child on the lap was transformed into a wrapped package, and the other children in distress metamorphosed into various animals, including a goat for the foreground boy, whose feet still remain visible. Other children were repainted into geese, and those who are stabbed by the soldiers' lances in the top center of the composition reappeared as turkeys.[22]

As in the case of the *Census at Bethlehem* any references to the Holy Roman Empire can be understood as updated versions of the original Roman Empire; however, a later owner (probably Emperor Rudolf II in Vienna in the early sixteenth century, when Karel van Mander saw the painting there) has painted out the direct references to imperial identity and culpability for these terrible actions. For example, the mounted horseman, probably a herald, surrounded by pleading parents at the right center once had an imperial double-headed (i.e. Habsburg) eagle painted on his tabard, but it has been removed from the Hampton Court version. In similar fashion, the red banner above the cluster of armored horsemen in the top center once showed the five golden crosses of Jerusalem, both the marker for the territory of the Holy Land but also an extended territorial claim of the emperors. In similar fashion, the signboard for the tavern in the town bears the title "The Star" (*dit is inde ster*), alluding to the star of Bethlehem. Thus Bruegel established "plausible deniability" (to use modern political speech), should he have been confronted with any charges that he was attacking the authority of the current Empire, the Habsburg cousins of Philip II himself.

Unfortunately the Hampton Court picture no longer shows the original appearance of the leader of the armored horsemen, who stand watch in the top center over the atrocities that unfold before them across the village square. That figure was also altered, but he reappears in the good copies, such as the one in Vienna. In the Hampton Court version the figure is simply shown in dark distinguishing armor, but in the Vienna version he appears in black robes with a stringy long gray beard. Some scholars have attempted to identify that feature with the bearded figure of Alba (compare plate 234).[23] Yet not only are the comparisons inconclusive, but Bruegel could hardly dare to be so explicit in identifying Alba directly with such a massacre, at the risk of his own freedom in Brussels. It seems safest to assume that the artist's criticism of tyranny was meant to be kept at an indirect level, akin to his prior display of the ancient giant Nimrod, commanding the construction of the *Tower of Babel* (plate 215) or the contested kingship of Saul in the *Suicide of Saul* (plate 213). Or he could use suggestive implications of relevance for contemporary viewers through his use of current red uniformed or armored soldiers for those who persecute Jesus in the Passion, especially in the *Christ Carrying the Cross* (plate 8) or in the contemporary costumes in the lost *Crucifixion* (plate 219).[24]

Military force also defines the men on horseback in Bruegel's 1567 *Conversion of Paul* (plate 237). Here, even more than in the *Census at Bethlehem* (plate 230) of the previous year, the subject remains obscure upon first glance. A first impression consists of an imposing setting of a high mountain pass with a distant view down to a verdant seacoast and small figures making their way through it, from sunlight at the left horizon to dark storm clouds in the upper right. What the viewer then notices, anchoring a viewpoint into the distances at both left and right, are several large equestrian figures in the lower right corner of the picture, including the prominent rump ends of horses. These mounted figures are cavalry officers, dressed in bright and ostentatious costumes and bearing the banner of their forces. Behind them a fuller cavalry squadron appears in contemporary armor before the dark clouds. Traditionally such cavalry positions were the prerogative of nobles, who had the means for both horses and full field armor (foot soldiers often had partial armor, either helmets or breastplates), and they had served as field leaders in medieval warfare.[25] But this is also an army of foot soldiers as well as cavalry. Closer inspection of the left corner of the image shows infantry making its way up the steep hillside. This combination of military units was still characteristic of sixteenth-century armies, although artillery in the form of cannon (not shown) increasingly played a role.[26]

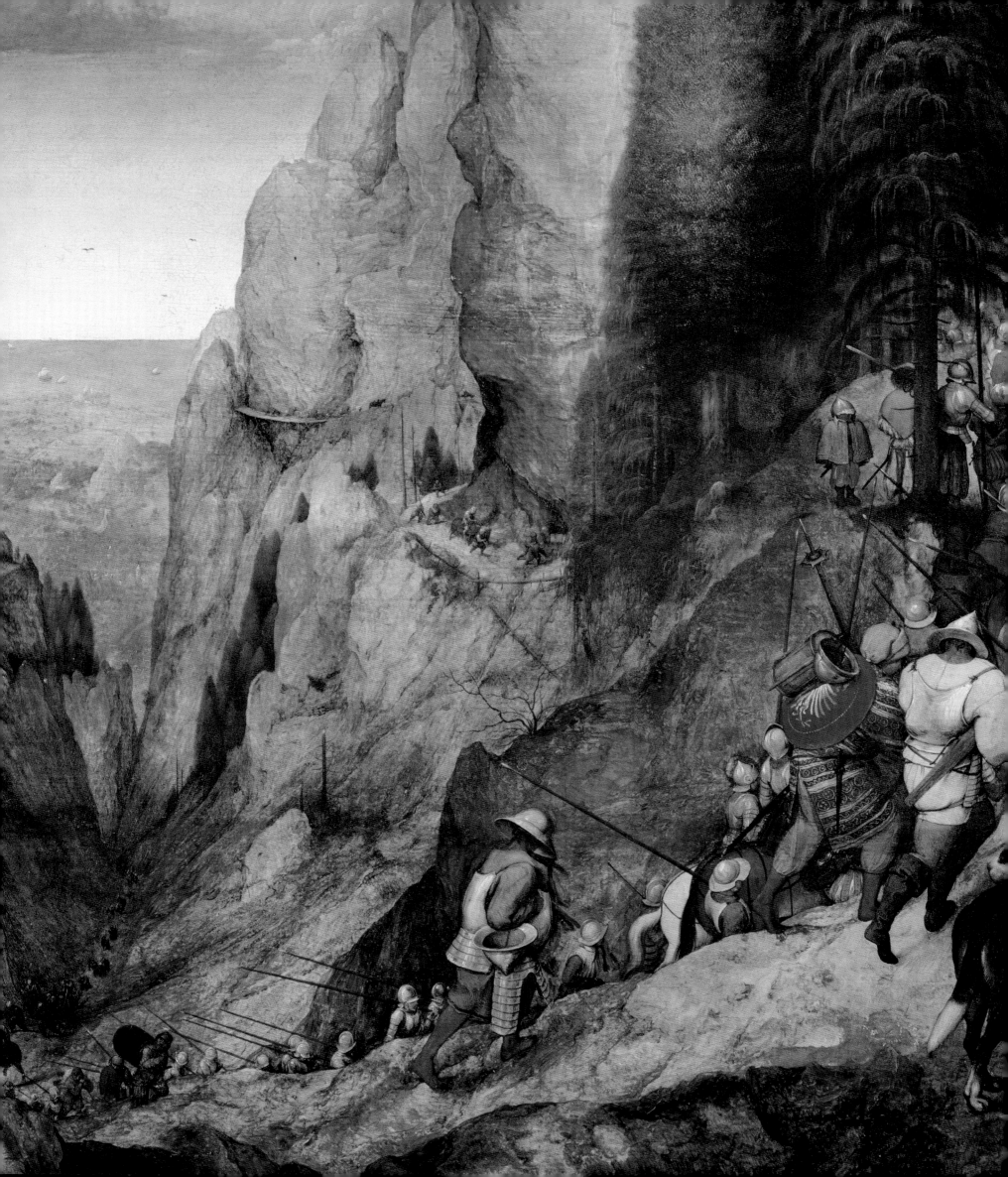

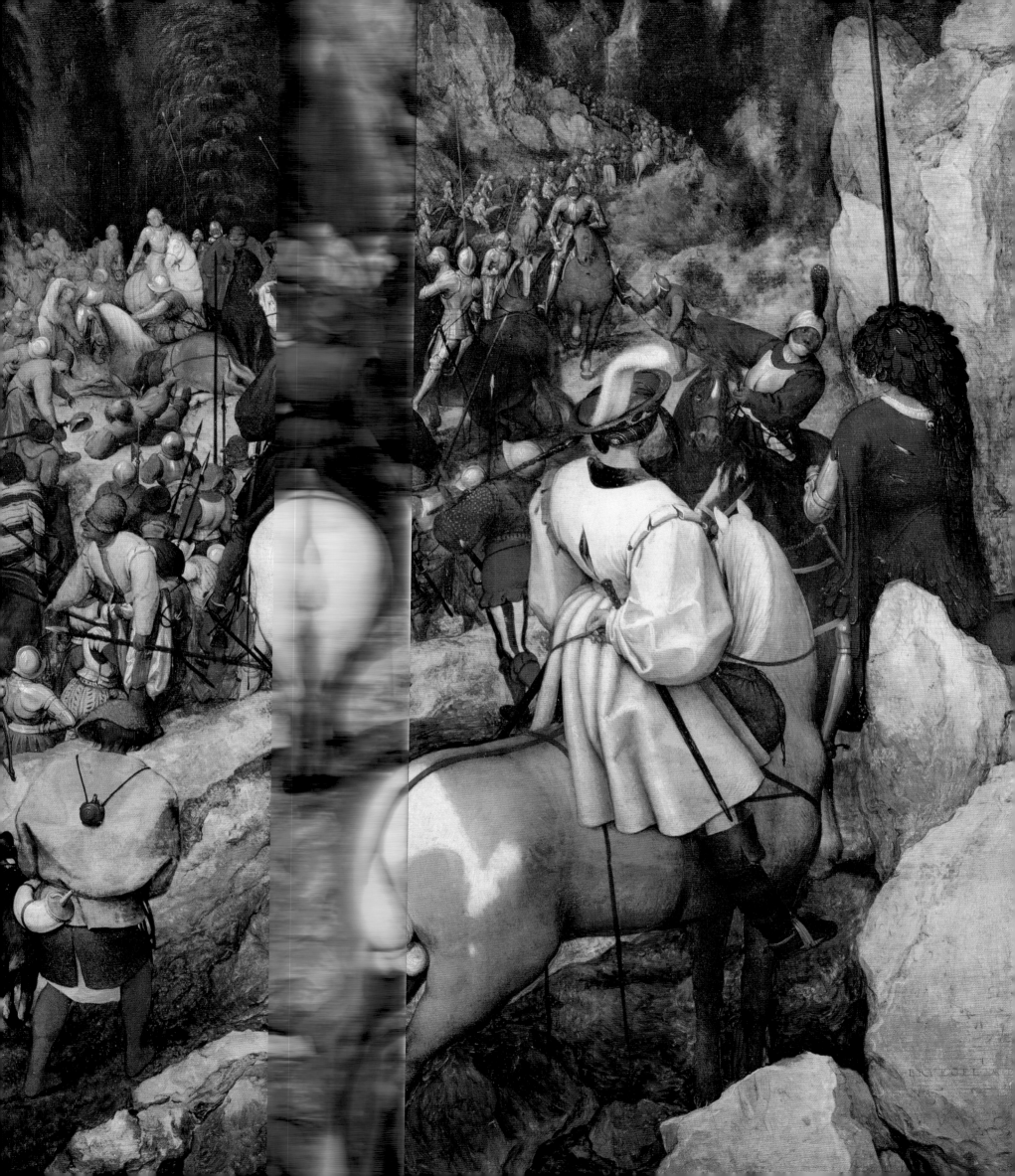

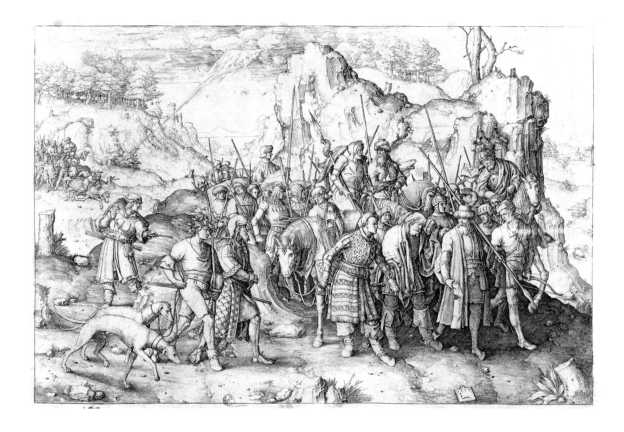

voice of Jesus as he fell to the ground. In Bruegel's painting that light can be found, above and to the left of the evergreens, angled to intercept the prone figure of Saul. His soldiers respond to his accident but do not seem to grasp the significance of the event. In the denouement the temporarily blinded Saul, who will change his name to Paul, would be led on to Damascus by his own men.

This is the subject at the center of an earlier representation of the subject, the engraving (plate 239) by Lucas van Leyden. In that work, across an expansive landscape, the main scene in the foreground before a steep cliff shows the blinded and bewildered Paul on foot within the cohort of his soldiers, some mounted, most on foot. Lucas includes some exotic costumes with turbans but also a number of contemporary fashions, for example, the armor of cavalry or the slashed uniforms of infantry. One of the soldiers behind Paul is leading his horse by the reins. But in the left middle ground a second narrative reveals the preceding moment,[28] when at the head of the army Saul's horse stumbles, as if struck by a lightning bolt from a dark cloud above the scene in the top center of the print. The narrative manipulation of forcing the viewer to discover the main theme of a pictorial composition is an established pattern in Lucas van Leyden's engraved work, and Bruegel also employed this pictorial strategy in his earlier works, such as *The Fall of Icarus* or *The Census at Bethlehem* (plates 110, 230).[29] We can readily assume that some of Bruegel's inspiration came from the celebrated earlier Dutch graphic artist (d. 1533).

Like the Tower of Babel theme, the conversion of Paul, a literal fall from a horse, the very marker of chivalric honor, constituted an image of the punishment of pride.[30] Certainly this message, a sudden divine rebuke and a transformation from pride to its opposite, humility, was a commonplace in sermon literature on this event. The long tradition of this New Testament image did not mean that it had to have particular contemporary significance; however, in conjunction with the timing of the year 1567 and the arrival of Alba after his own trip through the Alps, surely the idea of punishing pride and suggesting the importance of personal recognition, even revelation, for a potential persecutor would have been relevant for the representative of perceived tyranny, Alba. But once more, as with the *Massacre of the Innocents* (plate 235), the use of a biblical scene could have provided the artist with plausible denial if he were to be challenged or charged—like so many who were soon subjected to charges by the Council of Troubles after 1567—with criticism of Alba and his authority. It should

239 *(above)*
Lucas van Leyden
Conversion of St. Paul, 1509
Engraving, 11 1/16 × 16 in.
(28.1 × 40.7 cm)
Galleria degli Uffizi, Gabinetto
Disegni e Stampi, Florence

240 *(opposite)*
Pieter Bruegel
Tower of Babel (small version)
Oil on panel, 23 3/8 × 29 1/8 in.
(59.9 × 74.6 cm)
Museum Boijmans Van Beuningen,
Rotterdam

Such an army would have resembled the Spanish forces brought to the Netherlands by the duke of Alba in 1567, the very year of this painting.[27] Ten thousand strong, they left Spain in April of 1567, and Alba led his army northward in June on what became known as "the Spanish road," across the Alps of Italy through Piedmont and Savoy before arriving in Brussels on August 22. The purpose of this indirect route was to avoid the regional influence of Calvin's Geneva while en route to the Netherlands. No viewer of Bruegel's painting could have failed to associate with Alba both the Alpine imagery and the presentation of soldiers in contemporary armor and uniforms.

However, this picture remains a religious subject, and the main figure has to be discovered at the foot of the towering evergreen trees near the center of the composition. Clad in blue and surrounded by a circle of observers, foreshortened on the ground as he lies before the horse from which he has just fallen, lies the figure of St. Paul (Acts 9:1–8). In his role as Saul, persecutor of Christians, the future Paul was on a journey to Damascus to round up the religious and convey them to Jerusalem for punishment at the hands of the high priest. According to the Gospels, a light shone on him, and he heard the

243, 244 (opposite, pages 290–91)
Pieter Bruegel
Triumph of Death
Detail, full view
Oil on panel, 45⅝ × 63⅛ in.
(117 × 162 cm)
Museo Nacional del Prado, Madrid

the Council of State. Egmont had worked on religious compromise at the direction of the regent, even making a personal visit to Philip II in Madrid early in 1565.[39] Thus Bruegel certainly did not have to advocate radical change of either religion or politics to be a conscientious protester about the breakdown of religious consensus and increasingly against draconian Spanish policies, especially after the advent of Alba.

Thus the Rotterdam *Tower of Babel* retains a profound air of ambiguity. First, it celebrates a remarkable and seemingly autonomous creation of a unique, if ultimately doomed, construction. Yet at the same time it is clearly "in vain" in every respect—an impossible, doomed project that results from human vainglory—not the obsessive command of a single megalomaniac but rather the project of an entire region, perhaps of all humanity. Bruegel might even have visualized this conjunction of an unbroken, pre-Reformation Church in an undestroyed tower as an image with precarious, unstable nostalgia. As usual, the artist does not proclaim a clear message, but instead leaves the thoughtful viewer with an undetermined conclusion.

Also ambiguously Bruegel produced one other undated painting, a large work that is not explicitly religious but certainly remains rooted in spiritual issues: the *Triumph of Death* (plates 155, 220, 243–247).[40] Scholarly consensus usually places it around the time of Bruegel's most explicitly Bosch-based subjects in 1562: *Mad Meg* and *Fall of the Rebel Angels* (plates 143, 146). But even a casual glance reveals the completely different tone of this unrelieved bleak and dismal picture from those lighthearted, witty works. Of course, such a difference could still be contemporary with those creations; however, even the forms of the *Triumph of Death* more closely resemble works produced after 1565. Its grimness as well as its layout and handling of paint perhaps most closely resemble another undated but later work: *Massacre of the Innocents* (plate 235). It is especially difficult to pinpoint dates for Bruegel paintings during the 1560s on the basis of stylistic traits. Most pictures present high horizons and widely distributed figure groups, painted with visible brushwork (especially in the distinctive blue-green costumes), across a vast tilted space, and this picture certainly conforms to those habits. But in this work, Bruegel narrows the range of his palette to portray the scorched earth in a harmony of brown tones, and he largely abandons the spots of bright color to be found in his crowded works earlier in the decade. Moreover, the tall, slender figure types, reserved for holy figures in 1564 images (*Christ Carrying the Cross*, *Adoration of the Magi*,

plates 8, 200), now dominate the setting, something that was not yet evident in the Months series of 1565 but does seem to be a predilection of the painter in 1566 (the *Baptist*, *Census*, and *Massacre* pictures, plates 224, 230, 235). While such arguments cannot be conclusive, it is important with each undated picture to give fresh examination to its place in Bruegel's oeuvre, instead of accepting old assumptions—here, that the artist simply indulged in a Boschian phase only in and around the year 1562. Of course, from the time of his earliest prints, Bruegel had maintained a continuous dialogue with the heritage of Bosch.

In fact the only explicitly Boschian element of the *Triumph of Death* appears in the center of the picture: an almost overlooked dark cube that seems to be the entrance to Hell itself. Silhouetted against flames that erupt from its center, dark demons with bat wings, flying insects and ravens, or animate toads clamber around its sides. This section of the painting most completely resembles the silhouetted monsters before the fires in *Mad Meg* (plate 143), but it also serves to underscore the differences in mood and tone between the two paintings.

Just in front of this Boschian center the skeletal figure of Death appears, wielding a scythe, atop a skeletal nag, the "pale horse" of the Apocalypse (Revelation 6:8). Indeed, Walter Gibson memorably described the *Triumph of Death* as a "secular apocalypse."[41] But this image does not represent the end of the world, when the dead will be resurrected and judged by a returning Christ in heaven (although a few skeletons are emerging without flesh from graves in the central distance before the open water). Rather, this scene sets up mortal combat between the living and the dead in a devastated landscape. Ships are sinking before the smoke-filled horizon, and instruments of torture and execution—gallows and wheels as in Bruegel's *Justice* engraving design (plates 169, 170)—top the hillsides. Skeletons abound across this wasteland—the implacable, irresistible army of death that overwhelms all of humanity, truly the Triumph of Death.

Rather than Bosch, Bruegel here engages with the vast late medieval heritage of visual culture about death, including the Dance of Death depictions in cemeteries and churchyards across Europe.[42] Perhaps the most famous recent and accessible instance is Hans Holbein the Younger's printed woodcut cycle *The Dance of Death* (published in Lyons 1538 but designed in 1525, plates 248–251).[43] Peter Parshall notes that these images were produced at the beginning of a new, intense, sectarian

245, 246 *(right, opposite)*
Pieter Bruegel
Triumph of Death
Details of plate 244
(upper right, gallows and wheels
of torture; upper left, foreground,
the king and the cardinal)

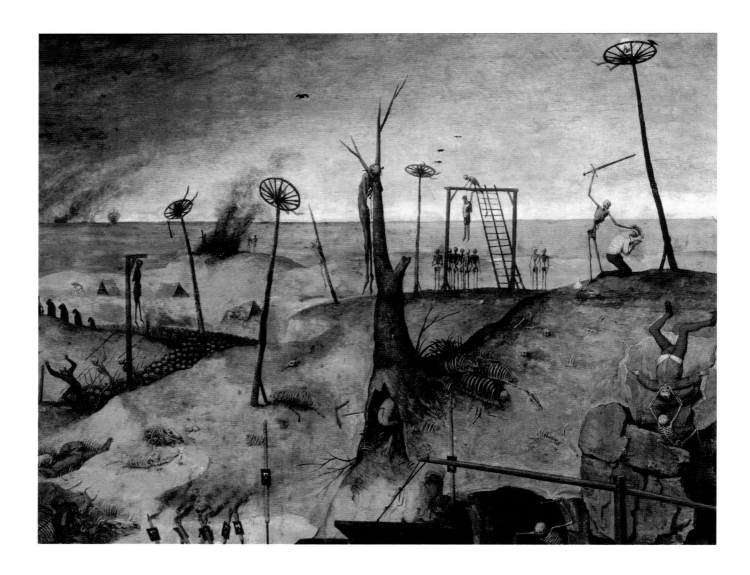

period of "ideology" in European history, the era that would erupt into religious wars. What Holbein's intricate little woodcuts (fifty-one in number) provide is a sequence of separate, active encounters between skeletons and individuals of every station in life as well as both sexes. Close comparison of individual vignettes in Bruegel's Madrid painting shows inventive adaptation of Holbein's dramatic scenes. The king in the lower left corner is forced by a skeletal companion to behold an hourglass that indicates his time is running out (plate 246); Holbein shows a skeleton dressed as a court fool and holding an hourglass as he assails the queen with her ladies-in-waiting (plate 247). A similar skeleton in fool's motley appears with a court lady behind the table at the right (plate 249). Bruegel likewise shows skeletal mirror images of many of his victims, for example the cardinal next to the king in the left foreground, whose

nemesis also wears a red hat; Holbein's cardinal has Death grabbing for his hat (plate 246). Next to the table in the lower right corner, Death accompanies the song of a courtly couple, just as Holbein shows a fashionably dressed pair striding to the rhythms of a skeletal drum (plate 251). Meanwhile, in front of the table Bruegel shows a young nobleman standing to draw his sword, while another brightly dressed fool attempts to hide under that table, even as a masked skeleton pours out the wine from its cooler and disrupts the games of cards and backgammon. Certainly like Bruegel, Holbein features a couple of scenes with professional soldiers fighting in vain against Death, just as combat figures in Bruegel, whether infantry in uniforms or knights in armor, stand up to oppose the skeletal onslaught. Bruegel also introduces some new figures across the foreground near the center: a pilgrim whose throat is being cut as well

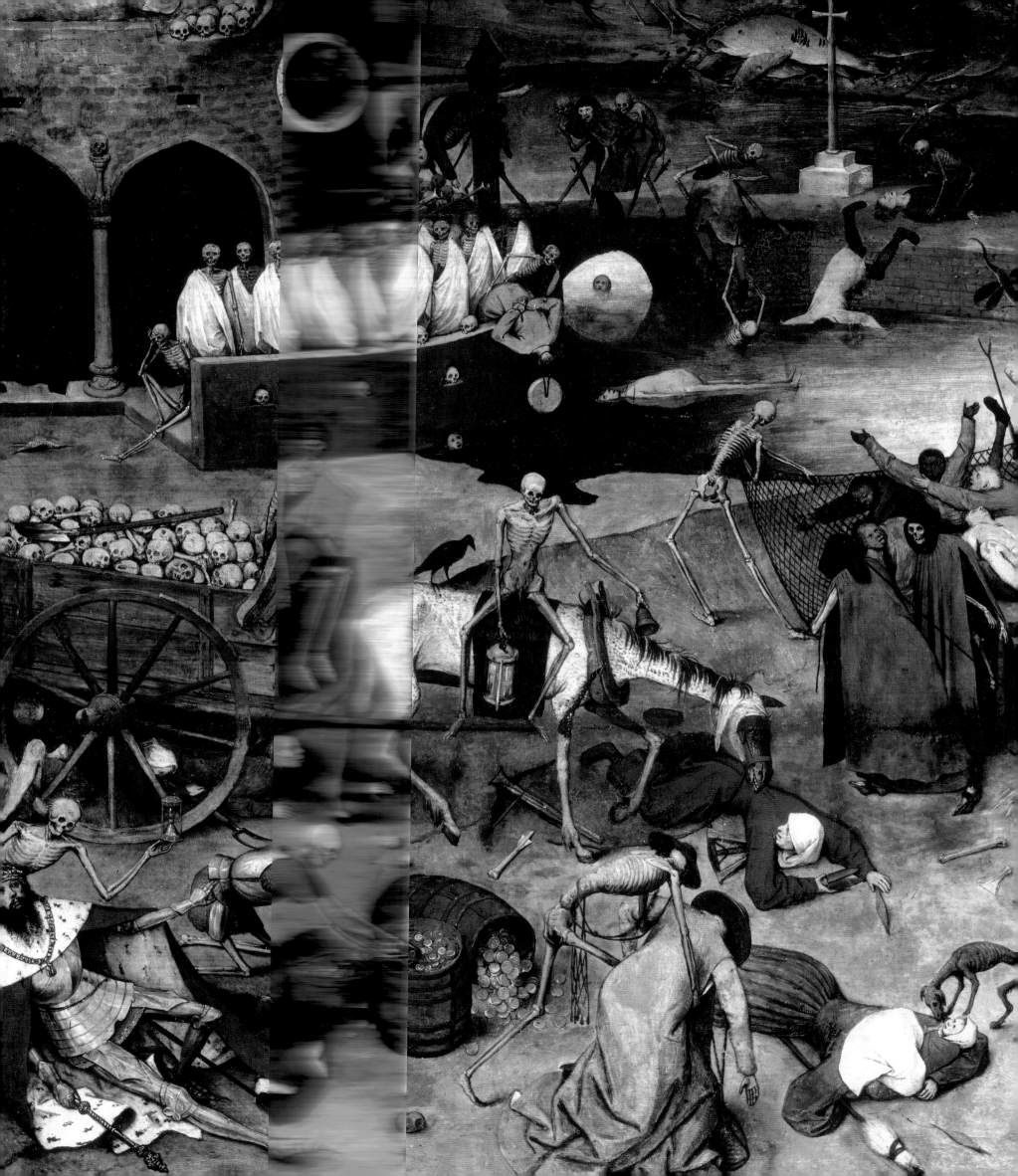

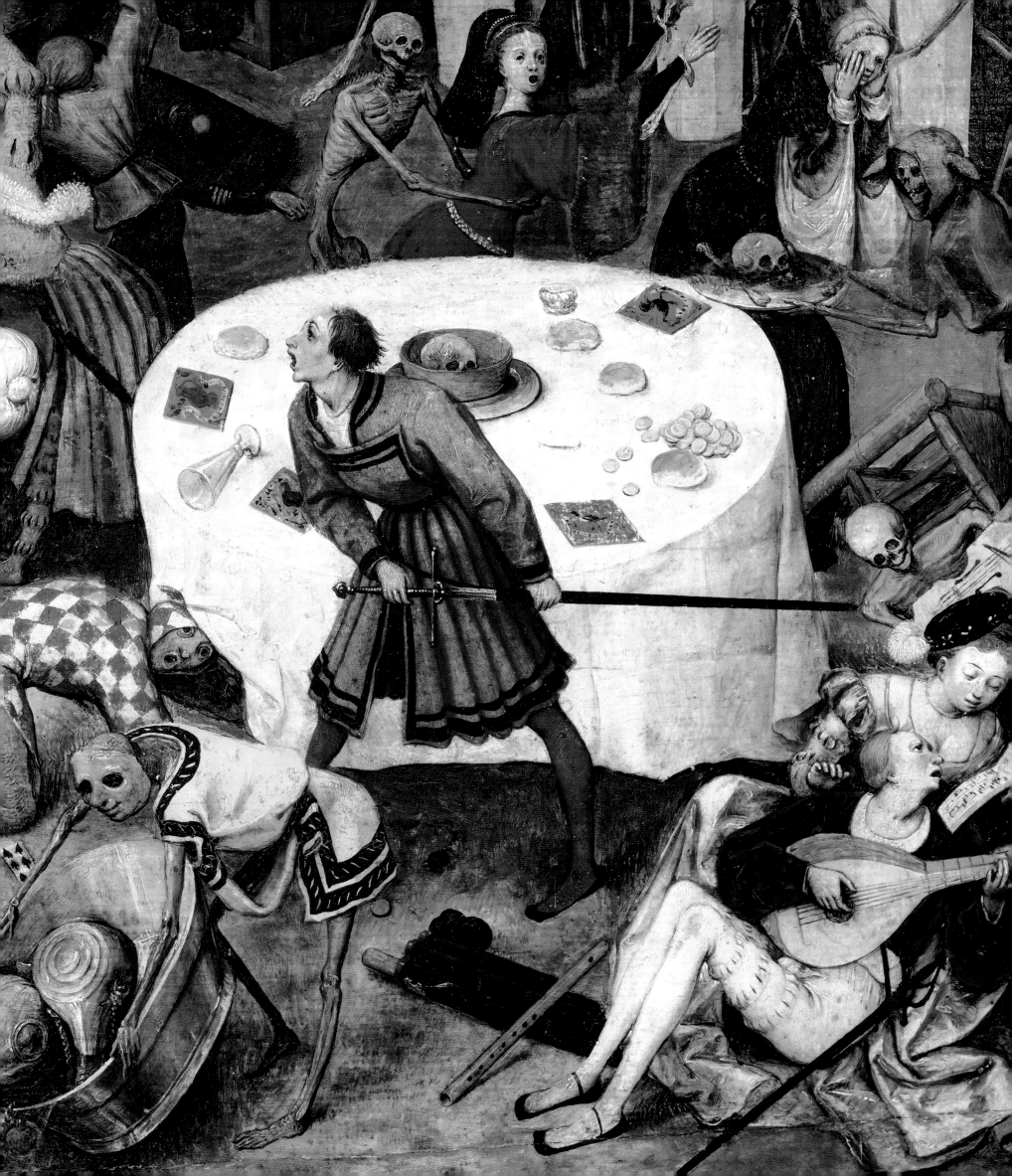

as a woman who is spinning, only t___
abruptly cut behind her in a transacti___
mundane echo of the Three Fates fro___
ogy by Keith Moxey.[44]

Fear of damnation and of sudde___
motivated numerous depictions of t___
medieval imagery, including the Da___
theme of the Three Living and Th___
representation of decaying bodies in___
contrast, Holbein's woodcuts and B___
Death interrupt the very activities t___
ished by each of the individuals, chie___
money in the case of the king or yo___
case of the amorous couple. Unlike___
between the quick and the dead, the___
give their adversaries occasion to rep___
to mend their ways. Instead, like the___
fruits and flowers in Dutch and Flem___
teenth century, their very preciousn___
sience of life provides the poignan___
permanent representation in paint.[4]___
does not still human life in order to___
he stills it suddenly and thereby und___
gility and impermanence. Here su___
this life rather than the promise or i___

Most striking about the *Triumph* ___
violence and the sheer mass of Deat___
spare no one. Here, too, Holbein's ___
provided inspiration, especially the___
skeletons, which corresponds to E___
beside the pond at the left center as___
skeleton atop the large coffinlike tr___
the right. Their violence against th___
edent in the luxurious manuscript ___
Clovio, a Croatian painter in Rome___
prominent Farnese family and was w___
(see chapter 2) from his time in Ital___

But the real innovation of the *Tr*___
military discipline of the skeletal ar___
in tight formation behind a phalan___
coffin lids—in the right middle d___
emerge from a cave behind the gia___
of almost numberless skulls in tig___
not the nonthreatening conflict be___
so evident in the works usually da___
ironic conquest over devils by *Ma*___
the inevitable victory by the angels___
Angels (plate 146). Instead it is th___
tary conquest, already represented ___
the countless armored fighters in ___

247 *(opposite)*
Pieter Bruegel
Triumph of Death
Detail of plate 244
(lower right, showing Death,
a fool, and courtesans)

248–249 *(top)*; 250–251 *(above)*
Hans Holbein the Younger
Excerpts from *The Dance of Death:*
Death and the Cardinal, Death
and the Queen, Death and the Knight,
Death and the Courtly Couple
Woodcuts, 1¾ × 2½ in.
(6.5 × 4.8 cm) each
Musée du Louvre,
Collection Rothschild, Paris

Pieter Brueghel the Younger made a copy of this work in color (plate 256), probably based upon a posthumous engraving of 1579 by Pieter Perret. The copy is at once easier to read but also alters the effects of the grisaille: by eliminating the carefully calibrated shadows that serve to highlight the principals, it reduces the need for close looking to discern both the apostles and the retreating figures. Pieter the Younger's stiffer, stouter figures make clear how much these larger figures, at once more slender and solemn in their movements, extend Bruegel's achievements of 1564 from the holy figures of the foreground of *Christ Carrying the Cross* (plate 8) as well as the *Adoration of the Magi* (plate 200) and the other images seen in this chapter. But they contrast with his earlier religious works, such as the *Fall of the Rebel Angels* (plate 146) or the drawing of the *Resurrection* (plate 210). Some scholars (Grossmann, Gibson) have credited this more dignified presentation of large-scale figures and gestures to a renewed influence of Italian painting, but without any suggestion of why Bruegel, who had been to Italy a decade earlier, would suddenly take up Italian models for his figures.[55] In any case, the greater dignity and gravity of these figures does seem to be part of a shift in his religious art toward the monumental.

One other major religious grisaille was produced by Bruegel around this time, but it is undated: *The Death of the Virgin* (plate 257). This work was engraved posthumously (but not reversed) by Philips Galle (1574) for its owner, the distinguished Antwerp geographer Abraham Ortelius, producer of the first atlas, the *Theatrum orbis terrarum* of 1570 and numerous later editions.[56]

The source for this story lies outside the Bible, chiefly in the legends recorded in the thirteenth-century *Golden Legend* of Jacobus da Voragine.[57] Chapter 119 ("The Assumption of the Blessed Virgin Mary") recounts the later life of the Virgin, based in part upon an apocryphal Gospel of St. John.[58] By this account first John and then the other apostles were miraculously transported to Mary's house to be present for her death, though it also speaks of the advent of Christ and angels to receive her soul, not depicted by Bruegel.

Imagery of the Death of the Virgin is relatively rare, although several famous scenes were made by fifteenth-century Flemish masters, such as Hugo van der Goes (Bruges, Groeninge Museum), and the theme inspired two splendid early prints: a late-fifteenth-century engraving by Martin Schongauer of Colmar (plate 258) and a woodcut by Albrecht Dürer (plate 259) from his cycle of the Life of the Virgin.[59] All these works share with Bruegel's grisaille the steeply foreshortened position of

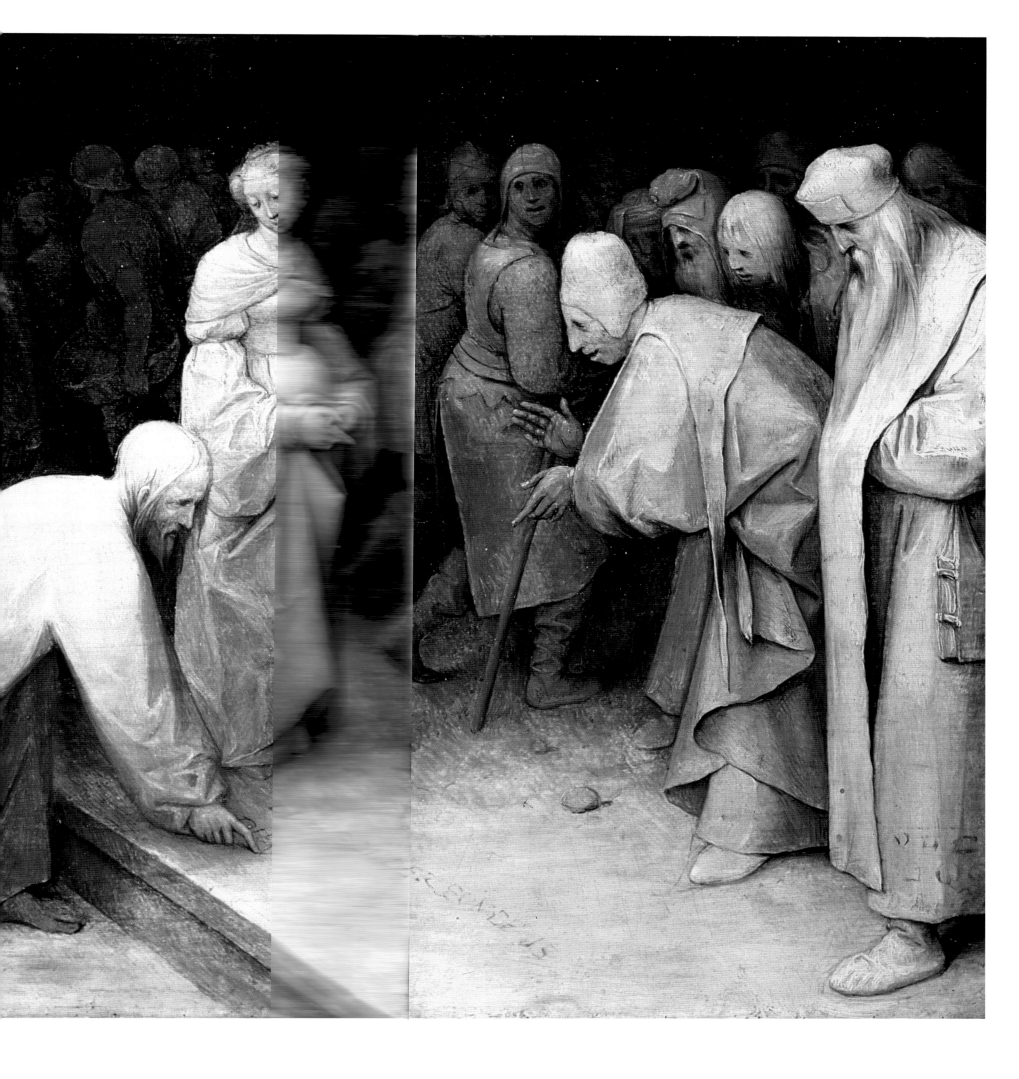

256
Pieter Brueghel the Younger
*Christ and the Woman Taken
in Adultery*
Oil on panel, 11 × 15⅞ in.
(28.1 × 40.6 cm)
Philadelphia Museum of Art,
John G. Johnson Collection

Mary's deathbed in an ordinary—and contemporary—domestic setting, filled with homely furniture and utensils, plus the presence of a densely packed cluster of the twelve apostles by her bedside, one of whom holds the candle above her to administer the sacrament of last rites (Extreme Unction). In Hugo's painting the foremost apostle, St. Peter, holds the candle while dressed in priestly robes (alb, dalmatic, and stole); in the prints it is the youthful, beardless St. John who stands close to her and helps the Virgin to support the candle in her hand, with Peter right behind, holding a book.[60] Bruegel has thoughtfully incorporated both elements into his painting: St. Peter in a cope with a trefoil clasp is bestowing the candle to the upright figure of the Virgin (a feature in Dürer), while the prominent figure of St. John sits isolated, sleeping in a chair by the fireplace at the left edge of the picture. Walter Melion aptly notes that the pose of John echoes the eternal sleep of the Virgin—even down to the clasped hands—as ordained by Christ, who linked the two from the cross in John 19:26–27.[61]

Since Peter, the first head of the church, here administers the ultimate sacrament, backed by the processional cross (common to both prints), it is reasonable to infer that Bruegel shows a clear adherence to the traditional faith in this grisaille.

However, Bruegel has also included forty figures, including several women, one of whom prominently adjusts the pillow of the Virgin. This populace is closer to a gathering of all saints, an inclusion of the entire community of the faithful, as in the earthly scene by Jan van Eyck's renowned Ghent Altarpiece, based on the vision in Revelation (7:9–10) where besides apostles, patriarchs, martyrs, confessors, and virgins assemble to adore the Sacred Lamb.[62] Voragine does note that Jesus arrived with angels as well as these other figures, but he is nowhere to be seen in the Bruegel image. As with the *Triumph of Death*, Bruegel here omits the supernatural; only the Virgin is marked off as holier through her glowing halo. None of the additional figures can even be clearly identified. Whereas the dying Virgin was shown

as youthful and beautiful in both Hug[...] here she appears as distinctly aged, i[...] agine's calculation that she was sevent[...] Her distinctive glow, even while red[...] of Christ and the angels in Hugo's ea[...] accent against the darkness for Brue[...] tured well in the graphic syntax of Ph[...] ing. Even the reaffirmation of the Vi[...] an extra-biblical text for the topic o[...] Bruegel's careful adherence to pictor[...] dition at this stage of his career (w[...] with the decrees on sacred images at t[...] in December of 1563, calling for re-af[...] of the Virgin and of the saints in Ca[...] If we attempt to assign a date for the[...] the closest comparisons seem to be [...] religious figural narratives of 1564: [...] *Magi* (plate 200) and the religious fi[...] *rying the Cross* (plate 8).

Much has been made of the Bru[...]

Ortelius, who owned the picture and can be held responsible for the inscription on the print after it. However, those religious sentiments of the inscription are platitudes about the joy and sorrow of the Virgin's death as a model for Christian faithful ("the joyful gestures and features of sorrow of the righteous").[64] We already know Ortelius from his paean of praise on behalf of Bruegel in his own *album amicorum* of 1574 (see chapter 2). But his heterodox private religious beliefs, associated with the secret "Family of Love," are often assumed by scholars (especially Grossmann) to have been shared by the artist.[65] Of course, even as friends, Ortelius and Bruegel need not have shared religious ideas, especially of such a controversial and private a nature; moreover, to have revealed them in any way would have been truly dangerous, even before the Council of Troubles, but certainly after 1567, when so many suspected individuals fled to Cologne or other points of exile. If he was a member of the Family of Love, Bruegel kept his secret so well that we cannot now detect it with the available

257
Pieter Bruegel
Death of the Virgin, c. 1565
Oil on panel, 14 × 21½ in.
(36 × 55 cm)
Upton House, National Trust,
Banbury

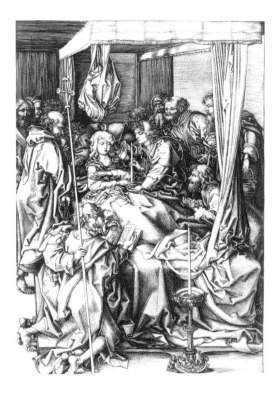

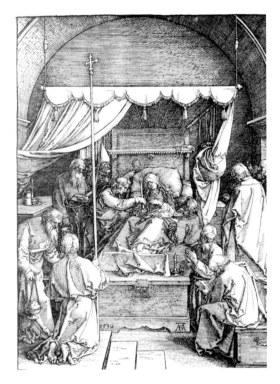

documentation, even by his seemingly close association with the prolific correspondent Abraham Ortelius. What the two men almost certainly did share was anxiety about their increasingly dangerous, sectarian times. As Ortelius candidly declared to his cousin Emmanuel van Metern (13 December 1567, during the onset of Alba's repression):

> We live in a very disordered time, which we have little hope of seeing very soon improved, as I fear that it will receive a greater shock, so that the patient will soon be entirely prostrate, being threatened with so many and varied illnesses, as the Catholic evil, the Gueux [Revolt] fever, and the Huguenot [Calvinist] dysentery, mixed with other vexations. . . . All this we have deserved through our sins; for we are motivated by pride and ambition; every one wishes to be called, but not to be good; every one wishes to teach others, but not to humble himself; to know much and to do little, to dominate others, but not to bow under God's hand. May He be merciful to us, and grant us to see our faults.[66]

258 *(above, left)*
Martin Schongauer
Death of the Virgin, c. 1470
Engraving, 9⅞ × 6½ in.
(25.2 × 16.6 cm)
Musée Condé, Chantilly

259 *(above, right)*
Albrecht Dürer
Death of the Virgin from
Life of the Virgin, 1510
Woodcut, 11⅞ × 8⅛ in.
(29 × 20.6 cm)
Musée du Louvre,
Collection Rothschild, Paris

260 *(opposite)*
Pieter Bruegel
Death of the Virgin, c. 1565
Detail of plate 257

As Bruegel's *Death of the Virgin* suggests, it would surely be too extreme to characterize the artist as a crypto-Calvinist, despite his clear reference to contemporary occurrences, such as hedge preaching in his *Preaching of St. John the Baptist*. Yet some Bruegel images also suggest the artist's nostalgia for a unified Church or his plea for humility (*Census at Bethlehem*) or toleration and forgiveness (*Christ and the Woman in Adultery*) rather than confrontation. Certainly he seems to give increasingly explicit suggestions about his patriotic discomfort with foreign rule through the regent and her advisers, first Granvelle and later the hated Duke of Alba (*Massacre of the Innocents, Conversion of St. Paul*). Seen now in the context of his overall oeuvre, his *Christ Carrying the Cross* or *Adoration of the Magi*, both of 1564, already epitomize the importance of true piety and recognizing the holy figures, even when humble or hidden, while also turning away from conflict and persecution on religious grounds.

9

PEASANT
LABOR AND
LEISURE

At the end of the 1550s, the ▨▨▨▨ ▨▨▨▨ ▨▨▨ he was working on his Sev▨▨▨ ▨▨▨▨ ▨▨▨ of prints for Cock as well ▨▨ ▨▨▨ ▨▨▨▨▨▨ independent paintings of both *Car*▨▨▨ ▨▨▨ *Len*▨ ▨ well as *Netherlandish Proverbs*, Brueg▨▨ ▨▨▨ ▨▨▨▨▨ his first images of what would becom▨ ▨▨▨ ▨▨▨▨▨▨ most familiar subject: peasant festivit▨▨▨ ▨▨ ▨▨▨▨ designs for a pair of prints, only one ▨▨▨▨▨ ▨▨▨ ▨▨▨▨ presenting a kermis (kirk-mass), a once ▨▨▨▨▨▨▨▨▨▨ celebration. As with most such event▨ ▨▨▨▨ ▨▨ ▨▨▨▨▨ St. Patrick's day for Irish-Americans, ▨▨▨ ▨▨▨▨▨ ▨▨▨ itself soon became inevitably overshad▨▨▨▨ ▨▨ ▨▨▨ ▨▨▨ rural contests and entertainments of t▨▨ ▨▨▨▨▨▨▨ ▨▨ ▨ well as by the delights—dancing, dri▨▨▨▨ ▨▨▨ ▨▨▨▨ ing—freely permitted on a unique ann▨▨▨ ▨▨▨▨▨▨

For Hieronymus Cock, Bruegel m▨▨▨ ▨ ▨▨▨▨▨ ▨▨ *Saint George Kermis* (plate 263, origi▨▨▨ ▨▨▨▨▨▨ ▨▨▨ which was etched by the same collab▨▨▨▨▨▨▨ ▨▨▨ ▨▨ already worked with him on the Larg▨ ▨▨▨▨▨▨▨▨ ▨▨ chapter 4), although the brothers D▨▨▨▨▨▨ ▨▨ ▨▨ sign the print.[1] As an image, this w▨▨ ▨▨▨▨ ▨▨▨▨ resembles Bruegel's 1559 painting the *Combat between Carnival and Lent* (plate 176). Its space contains the same parish church in the top center and tavern at the right, and its elevated viewpoint and high horizon permit a panoramic horizontal survey of the full setting. Within that space, figures are small in scale, even in the foreground.

The specifics of the saint and his holiday are evident from several details. A procession with banners and litters with saint statues approach the church entrance. Above the tavern entrance in the right corner an enormous triangular banner shows St. George, standing full length in his customary contemporary role, dressed in armor and holding a longbow as the patron saint of those soldiers. In the center of the print, the most famous legend of the saint is acted out before the church, as St. George rides in on horseback to rescue a maiden from a dragon (on wheels). In the upper left distance at the horizon the holiday is celebrated through the annual archery contest of the longbowmen, who shoot their arrows into the air to knock down a popinjay target from

261 *(pages 306–307)*
Pieter Bruegel
The Grain Harvest, 1565
Detail of plate 278

262 *(opposite)*
Pieter Bruegel
Wedding Dance, 1566
Detail of plate 288

263 *(below)*
Jan and Lucas Duetecum,
after Pieter Bruegel
St. George Kermis, c. 1559
Etching and engraving,
13 × 20⅜ in. (33.2 × 52.3 cm)
Rijksmuseum, Amsterdam

atop a windmill. Another holiday fea[...] drama performance, staged in the op[...] another small tavern to the right of th[...] The stage is elevated upon empty ba[...] formance also utilizes a "watcher," [...] above its screen, just as represented fo[...] in the background of Bruegel's 1560 [...] 173, 174).[2] Special market stalls have [...] the churchyard.

But other activities seem entirely f[...] sure-seeking. One unifying motif is c[...] out the setting tankards and croc[...] widely, but most of the drinking take[...] foreground table at the tavern. In th[...] some fights have already broken out, [...] influence of alcohol. Several boister[...] under way: in the center of the print [...] uniforms performs a formal sword da[...] outside the tavern in the lower righ[...] of men and women stride forward in[...] dance to the music of a pair of bagpi[...] rous couples have already paired off, [...] beneath the tree at left center near [...] couple sitting on the covered wago[...] ground. Similar to the figures in *Chil*[...] 195) the left corner shows one group [...] of an unidentified game with balls an[...] the foreground center one child is ri[...] and a quartet of adolescents or nimb[...] acrobatic pile. The link between chi[...] assumed by many interpreters for *C*[...] literally embodied in the foreground[...] costume with a basket over his shoul[...] of small children who cling to his co[...] tugs at the youngest and smallest chil[...]

Throughout the village, this world[...] instinct, in spite of its religious holida[...] ing, dancing, fighting, loving—all o[...] and passion—tend to lead revelers [...] Deadly Sins, especially lust, gluttony[...] than toward the Seven Virtues. Yet as [...] paintings of *Carnival and Lent* (plate [...] *Games*, Bruegel still takes some clo[...] country life on holiday. He notes the [...] and the church celebrations of proce[...] re-enactment. He notes the distinctiv[...] dance and a game of balls and hoop[...] ment a viewer might draw, it is not ob[...] is making any harsh moral judgment h[...] ars have claimed; he also attempts t[...]

behavior and customs, but not in any fully disinterested fashion. It is equally clear, especially with the included fool and the children, that the artist uses his elevated composition to construct a comprehensive view of peasant behavior, which he observes as a simpler, more natural, more instinctual form of human living, especially in contrast to his own urbanity.

Whether the tale is true or merely plausible, Bruegel's careful observation of peasant life might have been based on actual experience in the countryside near Antwerp. According to Karel van Mander in his 1604 *Schilderboek*, together with his friend, merchant Hans Frankert, Bruegel

often went out into the country to see the peasants at their fairs and weddings. Disguised as peasants, they brought gifts like the other guests, claiming relationship or kinship with the bride or groom. Here Bruegel delighted in observing the droll behavior of the peasants, how they ate, drank, danced, capered, or made love, all of which he was well able to reproduce cleverly and pleasantly in water color or oils, being equally skilled in both processes. He represented the peasants, men and women, of the [Kempen] and elsewhere naturally, as they really were, betraying their boorishness in the way they walked, danced, stood still, or moved.[3]

From this posthumous understanding of his art and its roots came the common subsequent designation of the artist as "Peasant Bruegel." Of course, this avowed interest in the peasant—especially the festive peasant—as a subject does not settle the question of Bruegel's potentially shifting attitude toward these country people (see below). However, next to the dancers in the foreground a pair of better dressed, standing figures observe the festivities; one of them points at the revelers but also looks out of the print at the observer, as if to invite the same kind of detached scrutiny of this unfolding kermis.

Like the etching by Frans Hogenberg of *Carnival and Lent* (plate 185), published in Antwerp by Bartholomeus de Mompere, the Bruegel's other early peasant print, the *Kermis at Hoboken* (original drawing, plate 264) was also engraved for de Mompere by Hogenberg, whose monogram appears on a barrelhead at the lower left corner.[4] Since this is the lone print that Bruegel did with someone other than Cock, and since it so closely resembles the *St. George Kermis*, his reason for this unique moment of disloyalty probably resulted

264
Pieter Bruegel
Kermis at Hoboken, 1559
Pen and brown ink, contours
indented for transfer,
10⅜ × 15⅜ in. (26.5 × 39.4 cm)
Courtauld Institute, London,
Lee Collection (Mielke 44)

peasants at kermis or wedding celebrations be seen as readily sympathetic, since the audience for these works were obviously urban bourgeoisie. In terms of the social background of this subject, kermis celebrations themselves, with drinking and all the other excesses, persisted among the populace despite attempts to rein them in by urban authorities in both Nuremberg and Antwerp.

Bruegel's return to the peasant subject also occurred in a pair of prints made for Cock in 1563: *The Thin Kitchen* and *The Fat Kitchen* (original drawings lost; plates 270, 271). In essence, these antithetical images reprise the allegorical personifications of *Carnival and Lent*.[19] One of them also shows a foreground child with an empty pot on his head like the infants in the *Alchemist* (1558; plate 61). In the *Thin Kitchen* an obese peasant hurries out the door of a crowded hovel, laid out much like Aertsen's Antwerp painted hearth, where he has stumbled onto the emaciated large family who live there. From their mantel hang bulbs and dried fish, austere Lenten foods, and they also eat mussels and turnips. However, this humble fare seems to be the necessary result of poverty rather than the voluntary austerity of Lent. Even their dog, nursing scrawny pups under the table, forages among the mussel shells for food. The caption, both in Dutch and French, speaks in the voice of the fat man: "Where the thin man stirs the pot, meager fare is offered. Thus I'll gladly take myself off to the fat kitchen."

In contrast to the generosity of the thin family, the corpulent family of the *Fat Kitchen* expels from its midst a thin man, who is ready to entertain with his bagpipe. Not only are their children fat, but even their dogs and cat are equally rotund. Their hut, laid out in the opposite direction, shows sausages on the mantel and a crowded cluster of hams hanging from the ceiling. Suckling pigs sit on the table and on a spit in the fire next to a grill with sausages; multiple kettles are already cooking. This family and its habits are so obviously and comically excessive that there can be no mistaking this image for having any documentary value whatsoever. Once more the voice of the fat man speaks (in Dutch and French): "Go away thin man, no matter how hungry you are. This is the fat kitchen, and you won't be served." Unlike *Carnival and Lent*, these essentially contrasting lifestyles are not seasonal nor even complementary, except in reversing each other as compositions and situations, thin versus fat. Yet Bruegel seems to have no more compassion or fascination with the thin poor than he does with the obscenely fat. Significantly, Bruegel now sets up his contrasts of behavior strictly in the grotesquely distorted forms of alien figures, peasants, even as he

removes their behavior from the circumstances of holiday license.

Yet the very next time that Bruegel made any image of peasants, he produced a series of panel paintings, *The Months*, showing them in vast landscape settings while busy laboring in fields and pastures.[20] In this case, for this considerable project, we know the patron: Nicolaes Jongelinck, someone we have already met earlier as the recent client of several important Bruegel religious works—*Christ Carrying the Cross* (plate 8) and the large *Tower of Babel* (plate 215)—as well as a number of series from Frans Floris, including the Labors of Hercules (also engraved by Cornelis Cort for Cock) and the Seven Liberal Arts.[21] By the time Bruegel produced these panels, he had already moved to Brussels, but clearly his connection to a major taste-maker in Antwerp remained strong; moreover, Jongelinck was quite well connected with the court at Brussels. His own wealth came from a royal appointment, collector of the lucrative Zeeland toll, and his brother Jacques Jongelinck was a major sculptor, who completed the major gilt bronze tomb in Bruges for Charles the Bold. Jacques also made portrait medals for leading court figures, such as Cardinal Antoine Perrenot de Granvelle (plate 223), principal minister for regent Margaret of Parma and himself a patron of Bruegel (*Flight into Egypt*, plate 207).[22] The impressive collection of Nicolaes Jongelinck, who died in 1570, is known because of an inventory of his goods, made later in the decade as security for a loan to a friend on the wine excise.[23] His large and fashionable house, really an exurban villa, was built in a new district developed just outside the new walls of Antwerp after mid-century, and it clearly had room for large-scale painted series.[24] Buchanan has suggested that the peasant subjects would have been appropriate for a dining room decoration in the large house of Jongelinck. His patronage can also be compared to other documented collections with court connections; notably, the inventory of Jean Noirot, former master of the mint at Antwerp and another bankrupt, featured five Bruegel pictures, of which four—a winter landscape and two peasant kermis scenes—were located in the "small back dining room."[25]

The theme of the Labors of the Months traditionally was closely associated with the imagery for calendar cycles in late medieval manuscripts, such as the Limbourg Brothers' renowned *Tres Riches Heures* for Jean, duke of Berry (c. 1415).[26] In addition, we have already seen Bruegel relying on calendar images, particularly from the early sixteenth-century Ghent-Bruges School of manuscripts, for his 1560 painting of *Children's Games*

Comme
Uiue

Daer magherman die pot roert is een arm ghas terije
dus Loop ick nae de uette Cueken met herten blije

miûe
Cuisine

Vuech magherman uan hier hæ hongherich ghij siet
Tis hier al uette Cueken ghi yn dye hier niet

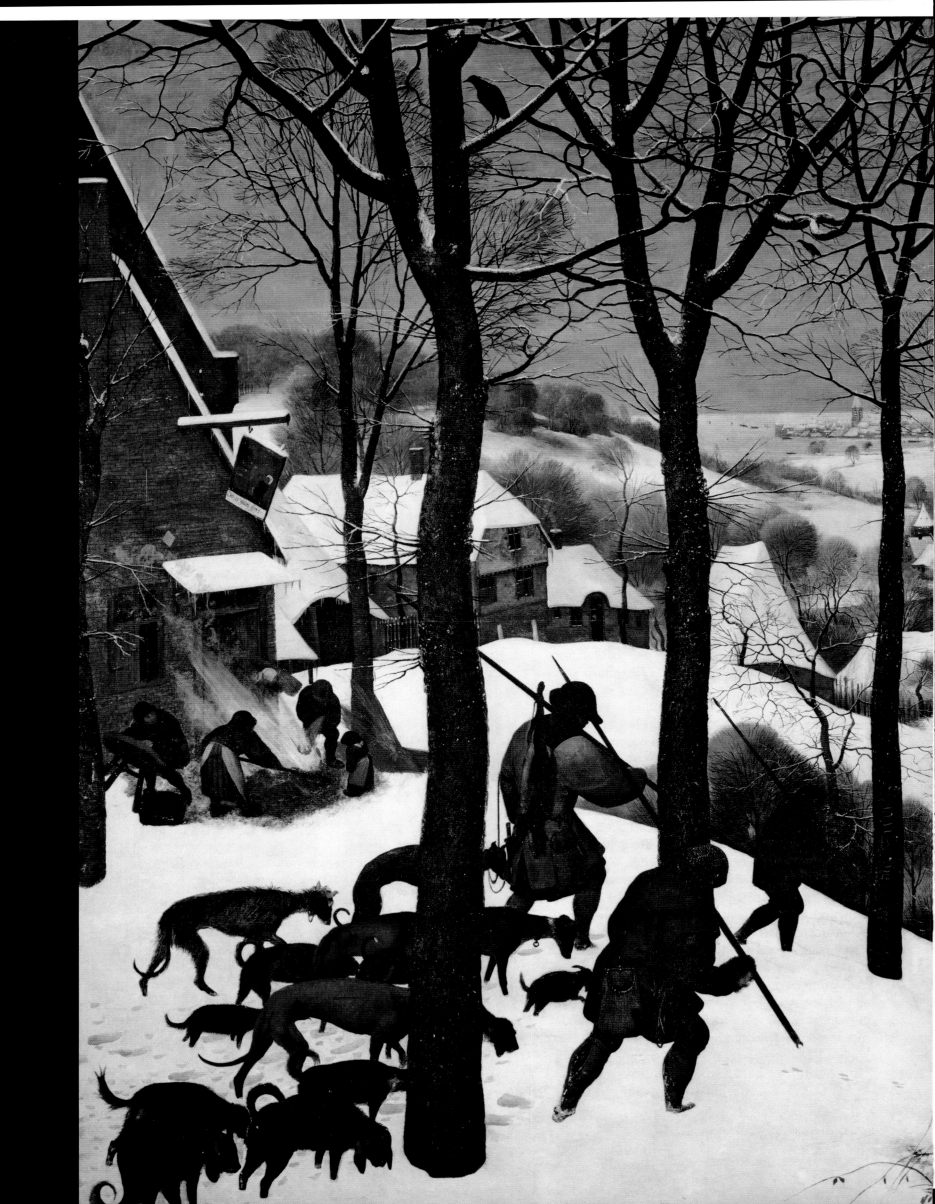

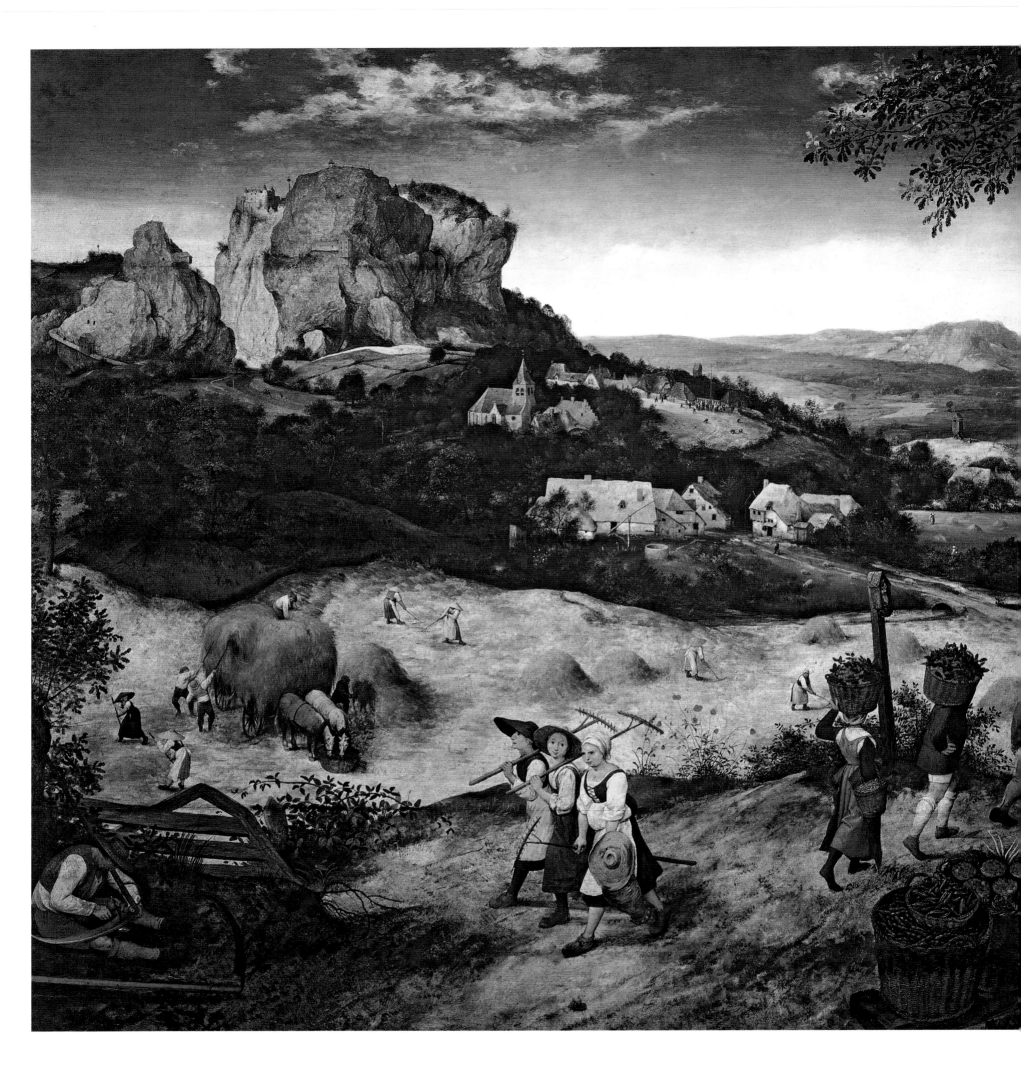

completely with the baskets they are carrying, so that these hard-working peasants become completely identified with the productive landscape and its bounty.

Numerous scholars in assessing Bruegel's peasants have stressed the kind of pride in the peasantry and their husbandry for the land and its produce. As noted above for *The Fall of Icarus* (plate 110), the laboring peasant himself served a symbol of virtuous diligence and industriousness.[36] More emphatically, some authors of the period praised the peasant as a class worthy of esteem; for example, as Carroll and Gibson have noted, Erasmus himself in his *Adagia* (see chapter 6) praises the peasants of his homeland.[37] For example, in his adage attacking usurers and their greed ("To exact tribute from the dead"), Erasmus makes a favorable contrast with peasants in passing, praising "the husbandman, the most innocent kind of man and the most essential to a community . . ."[38] In a more extended fashion, Erasmus praises the peasants of his homeland in the adage "a Batavian ear":

> . . . no race is more humane or generous and less wild or fierce. By nature they are straightforward, free of treachery and deceit, prone to no serious vices, although they are somewhat too fond of pleasure, particularly feasting. The reason for this, I think, is the marvelous abundance of everything that customarily stimulates the pursuit of pleasure. This abundance comes partly . . . from the natural fertility of the region itself, since it is everywhere intersected by navigable rivers that are well stocked with fish and abounds in rich pastures.[39]

Peasants offered an alternative behavior and set of values to the urban merchants, who formed such an ongoing concern in commercial Antwerp (see chapter 2), what Erasmus called in his earlier adage "this sordid class of merchants who use tricks and falsehoods, fraud and misrepresentation, in pursuit of profit from any source." These more favorable views cannot be assigned to Bruegel either, but Jongelinck's patronizing, seigniorial outlook toward the peasants suggests a benevolent, mildly amused, if socially superior viewpoint toward them, very much in the same spirit as the luxury manuscript calendar pages.

The next harvest scene, *The Grain Harvest* (plate 278) reinforces this overall outlook through its forms.[40] First, it immerses the peasants within a landscape, which links up well with the *The Hay Harvest*—responding to that bluish horizon with a purple-grayish haze of its own. Its

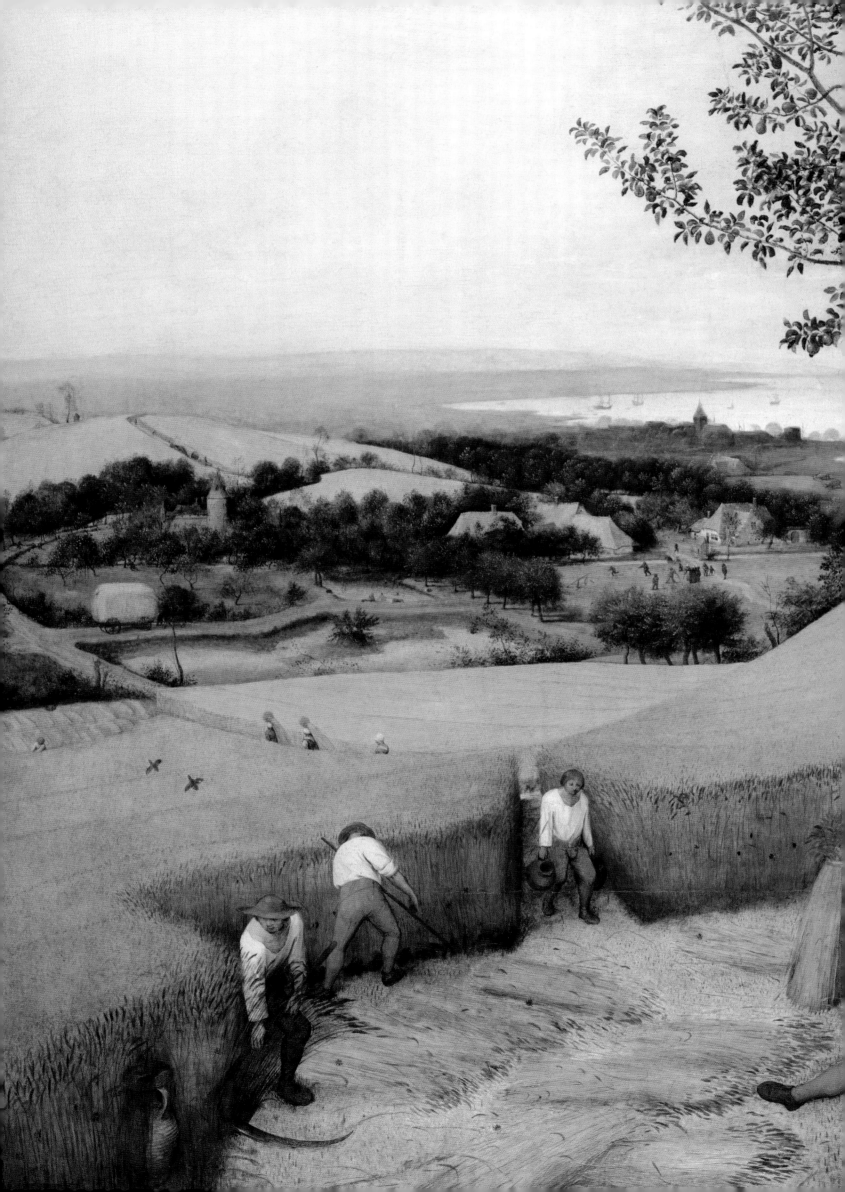

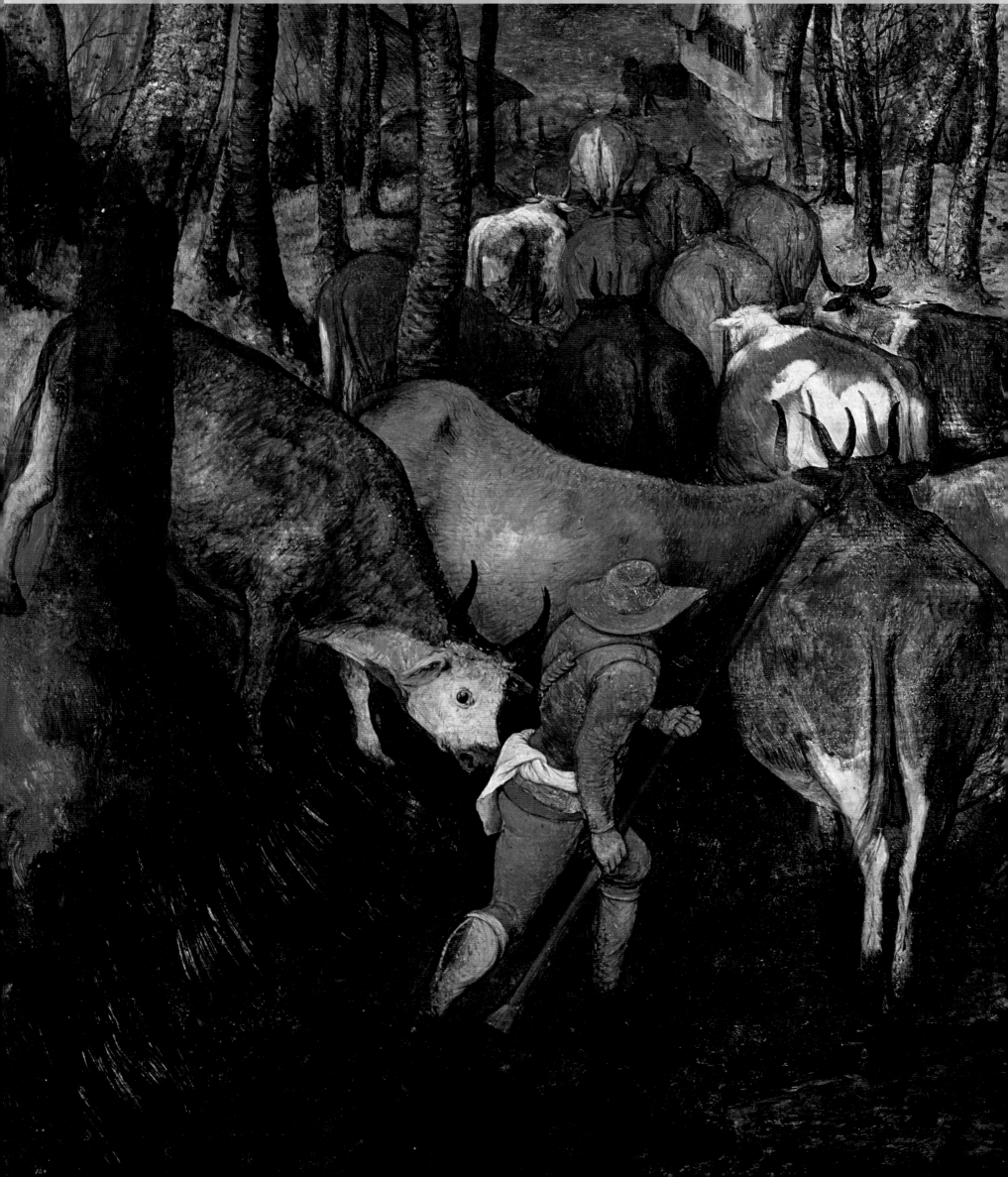

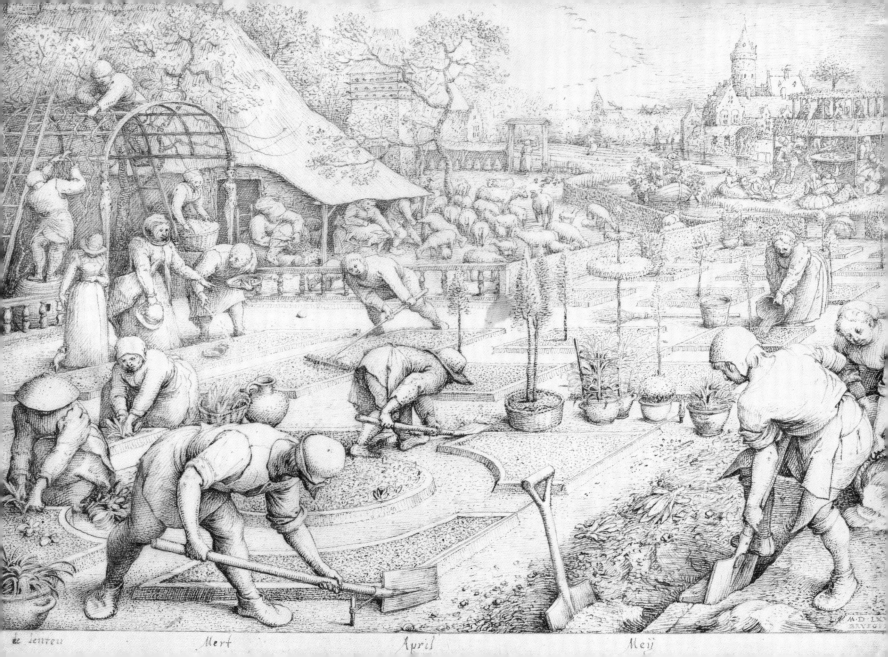

de lentreu Mert April Meÿ

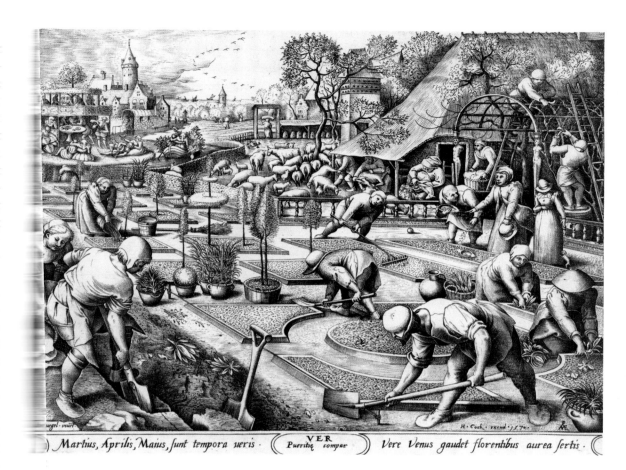

) Martius, Aprilis, Maius, sunt tempora ueris . (**VER** Pueritiæ compar) Vere Venus gaudet florentibus aurea sertis . (

and/or hawking and courting (especi... with music or in a love garden), ratl... ant activities. If peasants do appear, ... sheep to pasture or begin to plant. Of c... might well have enjoyed imagining hi... a leisured nobleman; however, in ligh... all of his other pictures in the Month... peasants (or hunters) who work fo... seems more likely that he would have o... sized land and labor. Thus sheep-shea... and sowing—or, alternatively, some ... hunting on horseback, counterpart to ... *the Snow*—might have formed the then... ing image.

In 1565 Bruegel created a *Spring* dra... 283), the start of a four-part set of desig... sons cycle for Hieronymus Cock, whic... pleted posthumously in 1570 by Hans ... for the final two seasons (see below). ... drawing, Bruegel offers almost every a... with the season that then began the yea... ish reckoning. In the foreground, he ... but of a formal garden, not open fiel... itself offers early documentation of the a... defined early Netherlandish gardens: i... metric shapes, later identified by the F... *terre*, each of them punctuated with a tr...

Like the peasants in *The Grain Har*... round laborers stoop over in their worl... insert shrubs into geometrically borde... tions. They are instructed by a standin... woman, whose status is unclear but w... sesses a mastery of gardening and en... dence of the estate owner, if she is not t... is accompanied by a well-dressed youn... with a tiny lap dog beside her and is flank... side by a fawning retainer, who listens ... instructions. Behind the garden layout ... does take place in an enclosure; in the ba... beehives and dovecotes add to the pi... bandry. In effect, the labors of the month... front to back in this print, from the plan... through sheep-shearing and beekeepin... May's background aristocratic pleasures ... tance, enacted before an elaborate cast... villa.[45]

The Vienna drawing distance include... complete with its customary couples, ... and added green brush, lolling on a back... like the calendar image in Bening's Da...

...yond the water a two-tiered love garden is populated ...th amorous couples drinking wine and listening to ...usic. The inscription on the print emphasizes the par-...ls between the first of four seasons and the first of the ...es of humanity, youth, "Spring, similar to childhood." ...oreover, a Latin couplet invokes the Children of the ...anets tradition, specifically Venus, which influences ...ers: "In spring, golden Venus rejoices in garlands of ...ooming flowers."

...Bruegel would only continue his designs for the Four ...asons for Cock in 1568, when he completed *Summer* ...ate 284), a variation on the *The Grain Harvest* (plate ...) but with much more dominant, large peasant fig-...s, seen from close up.[46] Indeed, Bruegel has dramati-...y designed the large foreground scythe to extend out ...he lower frame of the picture, a feature also picked ... in the engraving. As in the *The Hay Harvest* (plate ...), many of these peasants are seen from behind or ...h their faces obscured by hats, jugs, or baskets, as if ...r very anonymity, linked to their labors, comprised ... essence of their collective identity. As we shall see

282 (*opposite*)

Pieter Bruegel

Spring, 1565

Pen and brown ink, 8⅝ × 11¼ in.

(22 × 29 cm)

Albertina, Vienna (Mielke 64)

283 (*above*)

Pieter van der Heyden,

after Pieter Bruegel

Spring, 1570

Engraving, 8⅝ × 11⅛ in.

(22.2 × 28.6 cm)

The Metropolitan Museum

of Art, New York; Harris Brisbane

Dick Fund

(chapter 10), such monumental proportions for these peasants marked a departure for the artist in his last few years, providing a heroic presence for peasants, which some scholars have compared to Italian Renaissance models. Yet in the context of the *Summer* drawing, Bruegel has retained most of the action and setting of *The Grain Harvest*: scything and gathering wheat as well as harvesting of fruits from trees in the middle distance on a hillside backed by a village with a parish church. The heat of the season, which is conveyed by swimmers and background summer games in the New York painting, is emphasized in this design by a brilliant sun in the upper corner above the distant vista and by the massive jug hoisted in the foreground by the thirsty man with the projecting scythe. Like the *Spring* engraving, *Summer* also carries inscriptions that associate the season with the Ages of Humanity: "Summer, image of youth." But this image also celebrates the land and its productivity: "Hot summer brings bounteous harvests to the fields."

The remaining two images of the Four Seasons for Cock were produced by after the death of Bruegel in 1569, following designs by Hans Bol of Mechelen (1534–93).[47] *Autumn* and *Winter* both appeared in 1570 together with the two Seasons prints after Bruegel. Their content continues to convey the expected activities of each season. *Autumn* features a foreground image at a cottage, where the fatted livestock is slaughtered at the end of the feeding season; in the middle distance wine is being produced, pressed and put into barrels. In the far distance, wood is cut down and gathered for winter warmth. This season is inscribed as the "type of manliness" (*virilitatis typus*), equivalent to maturity, a fertile time that "gives grapes heavy with wine." *Winter* completes the series as the counterpart of old age and the time of enforced leisure for those who work the land, "when the strength of winter binds flowing waves into ice." Thus it features ice-skating with the mixing of classes on frozen ponds before an expensive villa as well as festive carousing in a country inn. Since the month of February is also included among the winter months, the left background shows initial staking vines and pruning trees, as in *The Dark Day*.

For the most part, Bruegel's drawings up to the period of the Months had been either designs for prints or independent landscape compositions. But his interest in peasants for their own sakes also found expression in a pair of single-figure drawings that do not reappear in either prints or extant paintings. A mark of their authenticity and lasting influence is the fact that they were copied in a tighter hand, close to the painter's

own son, Jan Brueghel, at the turn of the seventeenth century. The first of these depicts a *Gooseherd* (plate 286), viewed at full-length and in profile.[48] As noted by Mielke, this drawing does reappear within a group of proverbs in painted roundels, six copies made after presumed Bruegel original designs by his other son, Pieter Bruegel the Younger, who not only made copies (with backgrounds) after the *Twelve Proverbs* (1558) but also made colored copies after the *Spring* and *Summer* prints as well as the *Fall* and *Winter* drawings by Bol.[49] From the copy (plate 286) we can readily conclude that this Shepherd is truly a Gooseherd, and also that his meaning stems from his role, which illustrates in close-up a version of one of the many sayings already included in the *Netherlandish Proverbs* (plate 186, no. 71). In the upper right background of the painting, this figure embodies one conundrum about how the world works, "Who knows why geese go barefoot?" We cannot know whether Bruegel ever completed a now lost roundel of his own with this same figure, but he also includes a similar gooseherd in the (damaged) central background of his 1568 canvas, *The Blind Leading the Blind* (plate 305), as a contrast to his eponymous large foreground figures.

The other large single-figure drawing, albeit damaged and rubbed, represents a bagpiper (Mielke 58).[50] We have already seen bagpipes in Aertsen peasant scenes and Bruegel kermis celebrations alike, most recently the *Fat Kitchen* (plate 271), with similar round figures in the cottage. As noted earlier, the bagpipe was the instrument *par excellence* of peasants in the country, assembled out of the readily available basics of an animal bladder and a simple wooden flute with bored holes.[51] Bruegel's drawing cleverly matches the puffed cheeks (lost by the copyist) of this peasant on his stool with both the swollen bag of his instrument and the stocky, rounded shape of his body. No painted version of this figure exists, even in copies; however, bagpipers come to play an increasingly prominent role in Bruegel's important late paintings of peasants at leisure.

The first of these is a large *Wedding Dance* (plate 288).[52] A pair of pipers stand in the lower right corner, within a tilted space whose high horizon reaches almost to the top of the image, filled to the top with a crowd of energetic dancers. These figures display the large scale and round shapes of Bruegel's late peasant images, such as *Summer* (plate 285), and their bright colors, especially reds, make the viewer's eye dance across the full surface. The faces of these figures closely resemble the simple ovals and comic-book features already seen in *The Hay Harvest* and *The Grain Harvest* from 1565 (plates 277,

Harvest and *The Grain Harvest* from ▓▓▓▓▓▓ (▓▓▓
278), again provoking amusement as ▓▓▓▓▓▓▓▓▓
social distance from these figures, who ▓▓▓▓▓▓▓▓▓▓
different as physiques.

This presentation, especially of p▓▓▓▓▓▓▓▓▓
rather than engaged in productive la▓▓▓▓▓▓▓▓▓▓
raises the crucial question of Bruegel'▓▓▓▓▓▓▓
his subjects—whether he is laughing ▓▓▓▓▓▓▓▓▓
pathetically or laughing at them with ▓▓▓▓▓▓▓▓▓
social condescension.[53] The evidence ▓▓▓▓▓▓▓
verbal, is rich but complex and contr▓▓▓▓▓▓▓▓
with the picture itself, Alpers (followi▓▓▓▓▓▓
of Pamela Larson) has itemized seve▓▓▓▓▓▓▓
village practices, which surely resulte▓▓▓▓▓▓▓
observation on the part of the artist ▓▓▓▓▓▓▓▓
visits to countryside celebrations.[54] T▓▓▓▓▓▓
changing leaves show that this is a ce▓▓▓▓▓▓
autumn, a time of plenty, following the▓▓▓▓

Not only the use of bagpipes for ▓▓▓▓▓▓▓▓▓
also the custom of producing long ta▓▓▓▓▓▓▓▓
out earthen trenches for legs and feet ▓▓▓▓▓▓▓
custom. Moreover, as both Gibson an▓▓▓▓▓▓▓
the background table with a cloth of ▓▓▓▓▓▓▓
pended crown was reserved for the bri▓▓▓▓▓▓
posed to sit immobile, surrounded by ▓▓▓▓▓▓▓
waited upon like a queen for a day.[55] I▓▓▓▓▓▓
ture, however, she is visible in her blac▓▓▓▓▓▓
dem as a very active member in the lin▓▓▓▓▓▓
with an older man, perhaps her father ▓▓▓▓▓▓
law. This could be read as a breach of d▓▓▓▓▓▓
surely both drinking and dancing—a▓▓▓▓▓▓▓
the couple kissing publicly near the b▓▓▓▓▓▓
permitted on this special occasion (p▓▓▓▓▓▓
Even the prominent and controversial ▓▓▓▓▓▓
painted out by a former owner), worn ▓▓▓▓▓▓▓
piper and the foreground dancers, were ▓▓▓▓▓▓
country fashion as well as a clothing i▓▓▓▓▓▓
the more dashing infantry costume of s▓▓▓▓▓▓
soldiers, although they have been seen b▓▓▓▓▓▓

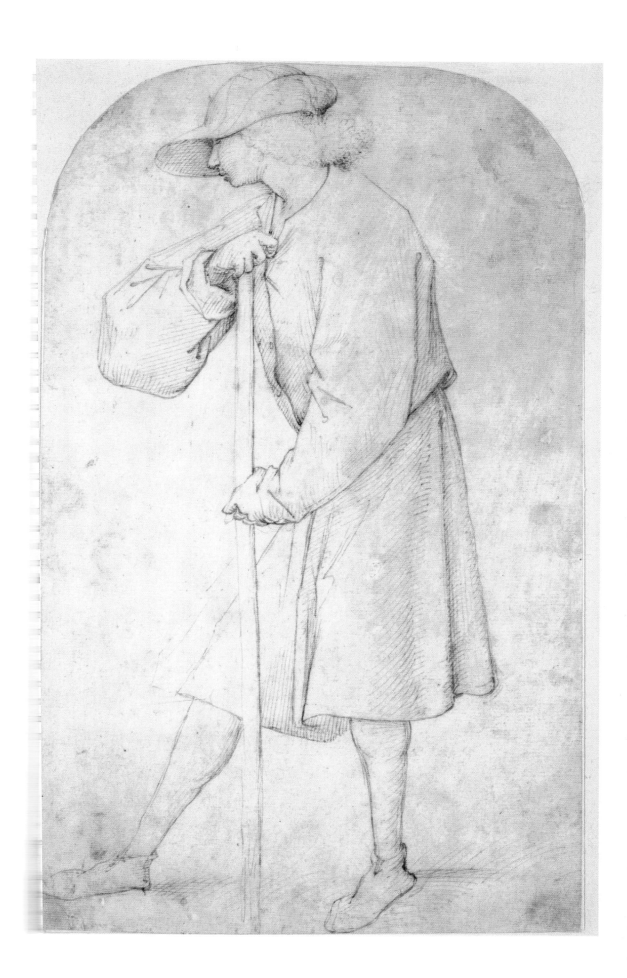

286 *(opposite)*

Pieter Brueghel the Younger

Gooseherd, 1594 or 1599

Oil on canvas, 6⅝ × 6⅝ in.

(17 × 17 cm)

Koninklijk Museum voor

Schone Kunsten, Antwerp

287 *(right)*

Pieter Brue▓▓▓

Gooseherd

Pen and yel▓▓▓▓

9⅝ × 5¾ i▓▓▓

Staatliche ▓▓▓▓

Dresden (N▓▓▓

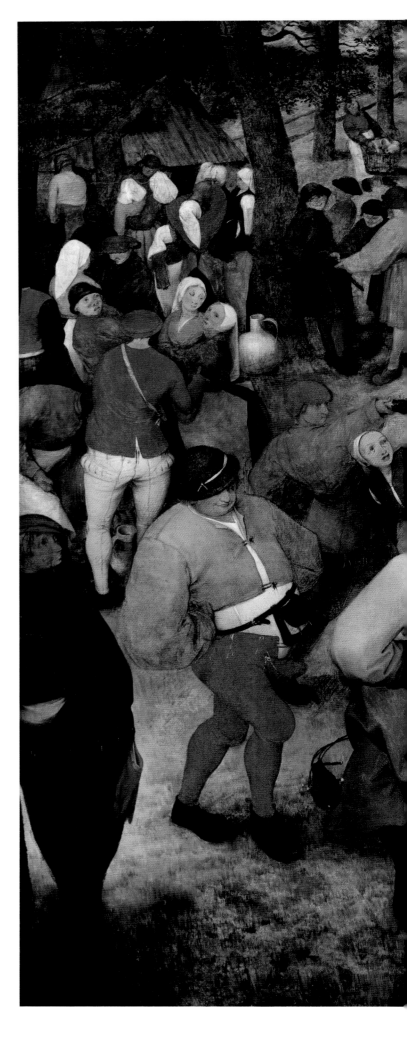

as evidence of Bruegel's visible marking of peasants as sexually promiscuous.[56]

Another image of peasant country wedding festivities outdoors was etched prior to the Detroit painting by Peter van der Borcht, again for Bartholomeus de Mompere (plate 289). [57] While surely not something to be taken at face value for documentation, it does show a centrally placed placid bride wearing her diadem in front of her cloth of honor. She is receiving practical gifts for a country wife: stools, pots, a churn, even a child's potty stool right in front of her, and all are being recorded at the corner of her table by a professional scribe. Wheat fields, not yet fully mowed, are visible in the upper left, balanced at right by preparations of porridge in a large cauldron outside an inn. On axis with the bride are both bagpiper and large tuns of wine or beer for the celebration. A few cripples and beggars stand outside the background inn, seeking a meal from the festivity. Certainly some elements here do betray excess, particularly the vomiting woman in the lower right corner or the figure defecating at the edge of the wheat field; however, this etching still shows more restraint than its models in Beham and other German print images, and it also seems to inject some local, Flemish flavor into the event.

A cruder related print with the same subject, whose design is ascribed to Van der Borcht but was published after 1600, has a full inscription in French, followed by Dutch under a Latin title that reads, "How the marriageable peasant is presented with his wife":

> This is how the villager treats his darling wife,
> She is clad simply in a bridal gown.
> The guest drinks, curses, and empties onto the
> table
> Money, chairs, and cooking pots and stools.
> Peasant weddings are a gaudy spectacle,
> The motto is: give freely and present the bride
> with gifts
> Of money and fine things, be they men or women,
> And the worse the food, the better the drinking.[58]

Of course, these inscriptions were added, in this case to a Van der Borcht print rather than to the Bruegel, and at least a generation later. But they do suggest a flavor of what an urban visitor to a country wedding might have thought about what he observed and how he felt compelled to supply a serious gift, as attested in Van Mander's biography about Bruegel's own visits to country weddings. Indeed, this commentary echoes Van Mander's description of what Bruegel encountered:

"the droll behavior of the peasants, how they ate, drank, danced, capered, or made love."

For the significance of the Detroit painting, we can also examine Bruegel's engraved design of a similar theme, *Peasant Wedding Dance*, which was engraved by Pieter van der Heyden but printed posthumously by Cock's widow with just the name of the firm rather than Cock himself.[59] No drawing survives, and the numerous painted copies by Pieter Brueghel the Younger might just as easily derive from the print itself as from any drawing or lost painting; moreover, there is no difference between a drawing or a print as a source for a colored painting.[60]

Here the bride stays in her appointed place, seated immobile in front of her cloth of honor and under a suspended crown, flanked by matrons. Guests in the background approach from both sides with domestic wedding gifts of all kinds, which reach the very top of the print; the plate before her holds coins. All of the gifts, including a crib, are duly noted by a scribe at the corner of the table, who is seen from behind, but nowhere is the groom to be seen. Large, round peasants,

resembling those in the Detroit panel or in the *Summer* drawing, dance with their codpieces across the foreground to the music of two bagpipers against a tree at the left edge. Several couples along the right side of the print are openly kissing. In their midst a calm, standing observer looks on, smiling, in dress that suggests his identity as a scholar. The added inscription makes the festive tone clear and seems to be the voice of the speaker/observer, detached from the activity of the event:

Keep it up musicians and make it last,
So long as the flute and drum play.
Liz will pluckily move her rump
Because her wedding day is not every day.
Tricky Dicks are doing fancy steps,
I'm listening to the fife and you've missed a beat.
Our bride has given up dancing.
Which, by the way, is for the best, because she's
 full and sweet [i.e. pregnant].

Not every day is a wedding day, just as a kermis comes but once a year. Of course, a pregnant bride (note the crib) is also a "dirty bride," the object of mockery and satire in coarse plays, as seen already in Bruegel's *Carnival and Lent* as well as his later isolated designs for prints. But this image itself still does not so openly castigate vulgarity or excess as do the Van der Borcht images or the German woodcut precedents of Sebald Beham in Nuremberg.

Bruegel's country festivity images culminate in his large undated painting, *Peasant Kermis* (plate 291).[61] Here the subject stands closer to the theme and representation of Sebald Beham's raucous woodcuts, and the gesture of the figures at table on the left almost literally repeat the earlier small-scale tavern scene in *The St. George Kermis*. However, especially compared to the two 1559 kermis prints, Bruegel's viewpoint is here positioned at its very lowest, below the eye level of even the seated figures. Prominent in the left foreground is the familiar bagpiper, cheeks puffed like the Bruegel drawing as he sets the tune for heavy-footed dancers who enter from the right edge. All are large, thick figures with an ungraceful, ponderous movement and coarse features that recall Albrecht Dürer's 1514 engraving of a *Peasant Couple Dancing* (plate 290).[62] Such images of dancing peasants, particularly as an engraved series of images of couples, became a specialty of Dürer followers, especially Sebald Beham. But even the dance steps,

so evident in the Detroit painting, a[...] figures overlap one another in the Vie[...]

At the center amidst the dancers i[...] stands another fool in motley, ges[...] another index of general folly like [...] prints.[64] This fool is paired with a [...] urban visitor, whose contrasting stare [...] his disapproval. This pairing of fool [...] the trio seen from the back at the c[...] *and Lent*, but there the two parties s[...] in opposite directions, whereas this [...] stand and stare at the festivity—and [...] course, they also represent the oppos[...] mis celebration: the sober saint's day [...] annual festivity that it arouses, a tensic[...] by Aertsen in his *Return from the Proce*[...]

Many of the same elements already [...] prints are repeated here along a row, [...] red banner atop the tavern at left, fea[...] Mary and a military saint (George or [...] as the steeple of the parish church ab[...] the right distance; however, due to t[...] point, they both play a much reduce[...] identify the cause of the celebration [...] it. Indeed, none of those basic churc[...] whether processions or morality plays [...] here, although along the same horizon[...] the Madonna and Child is affixed to th[...] right together with a floral offering, p[...] by the attentive pious viewer as the l[...] ment hidden among the dominant bo[...]

What dominates the energetic festi[...] is the life outside the tavern at the fa[...] doorway one man holds a crock high [...] him another man, seen from the back [...] ing against the wall. Another large figu[...] piper holds a large crock on his kne[...] musician. Behind the bagpiper one [...] with delightful cartoon-like profiles [...] front of them another woman in a wh[...] steal a kiss from one of the drinkers a[...] ing him at the table two other men, [...] well into their cups, reach out in a sq[...] of discord certainly stands closer to t[...] Sebald Beham's woodcuts, and in th[...] tavern below the banner a woman a[...] outstretched arms. (It is not clear [...] to draw him in, perhaps for erotic dal[...] he seeks to draw her out in order t[...]

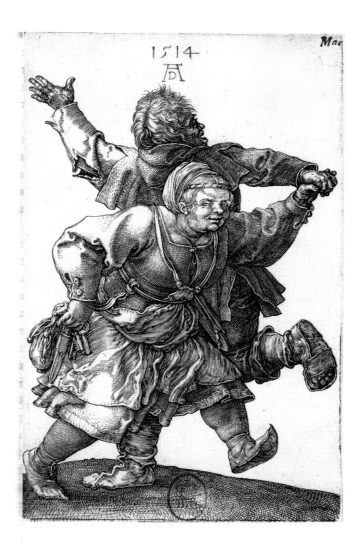

290
Albrecht Dürer
Peasant Couple Dancing, 1514
Engraving
Bibliothèque Nationale
de France, Paris

291 (*pages 344–45*)
Pieter Bruegel
Peasant Kermis
Oil on panel, 44½ × 64 in.
(114 × 164 cm)
Kunsthistorisches Museum,
Vienna

Their gestures are echoed, much as in Bruegel's large paintings, such as *Children's Games*, in the right foreground as a small female figure, carrying a coin purse at her side like an adult, instructs a smaller, younger girl (who wears a bell).

Certainly the *Peasant Kermis* can be defined as an image of excess, indulged in without the control imposed by participation of city visitors or outside witnesses (except for the small, dark figure beside the fool in the center, and he conspicuously disapproves). This kermis remains little inflected—or moderated—by the ostensible saint's day, proclaimed on the red banner, which provides the occasion for celebration. Yet in comparison to the earlier Bruegel images of kermis in prints of nearly a decade earlier, it now takes place with the viewer immersed in the action rather than overlooking it omnisciently from a great height. There is danger in

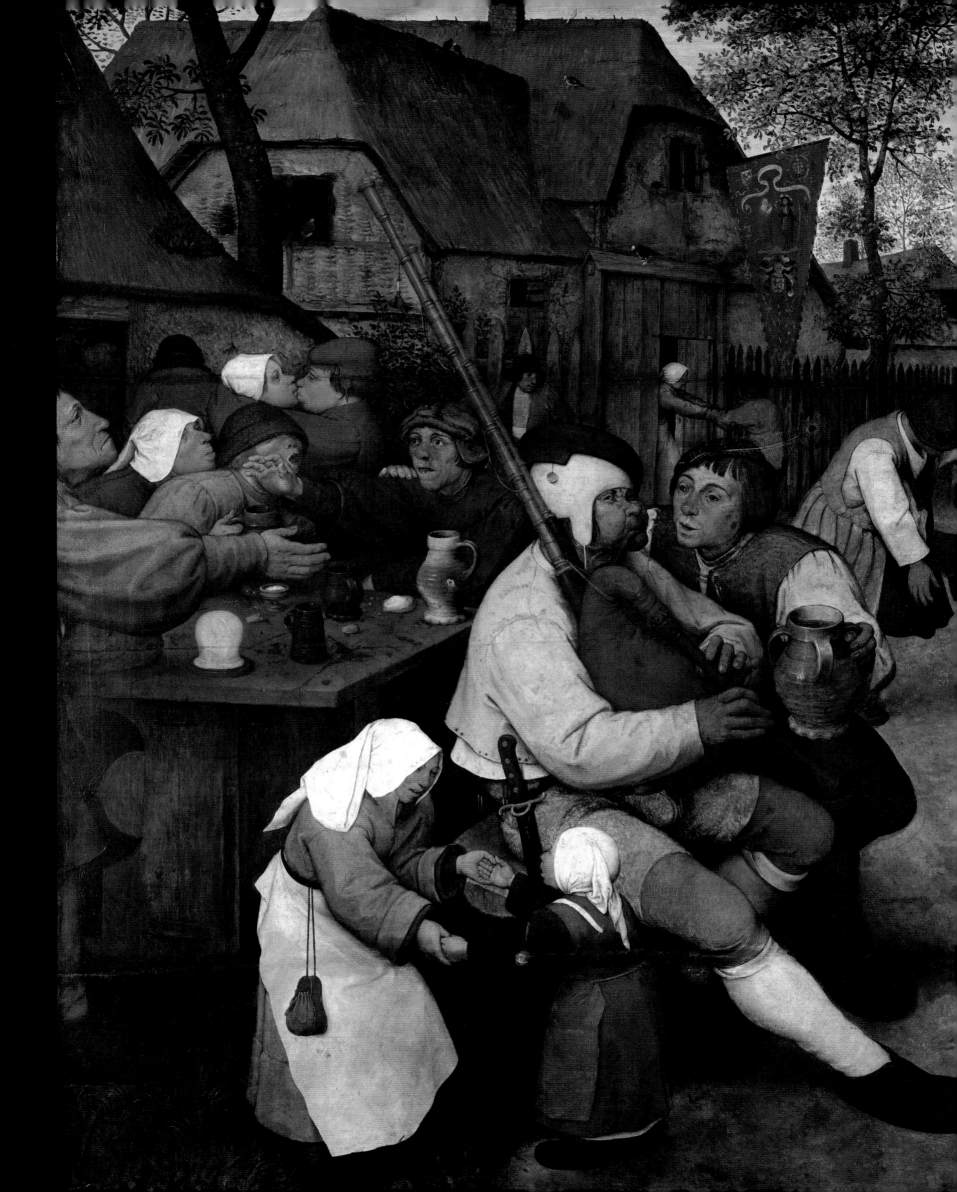

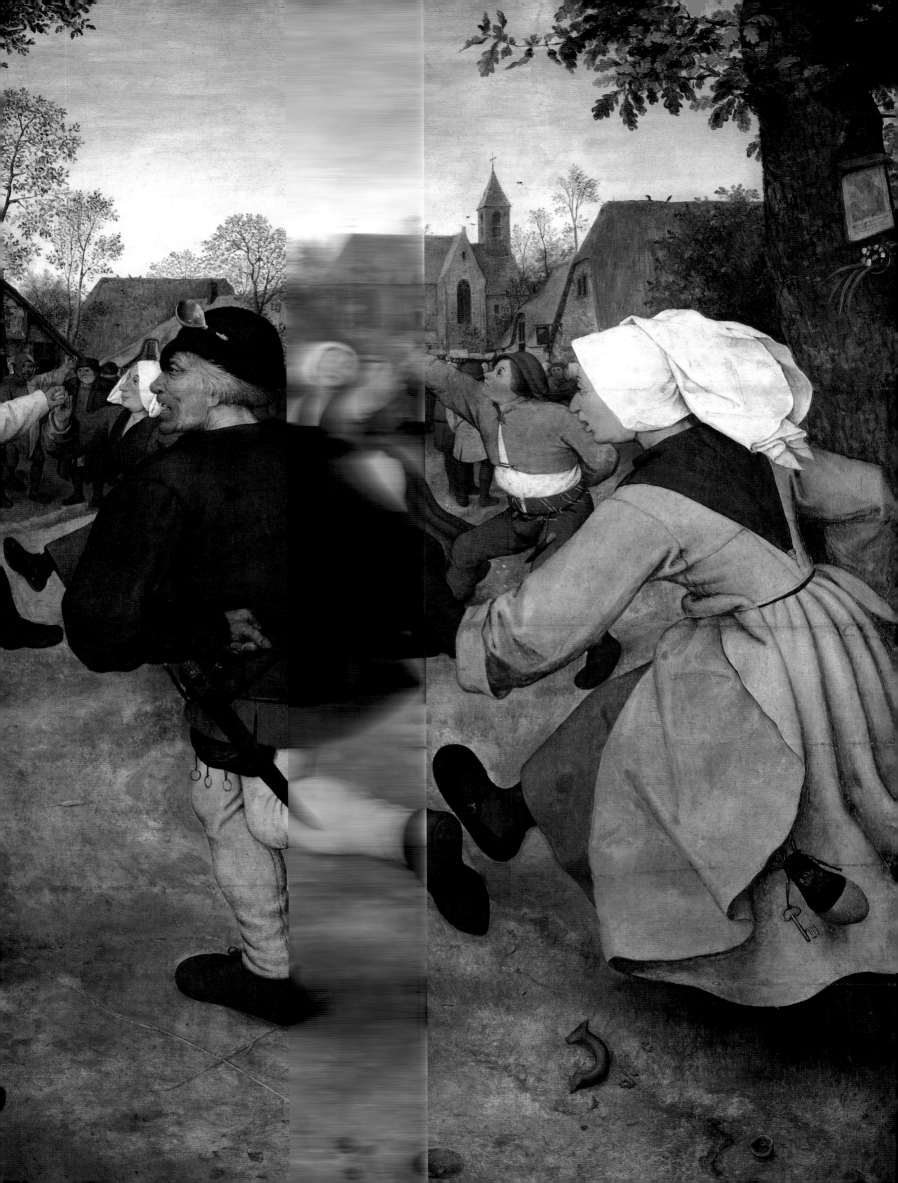

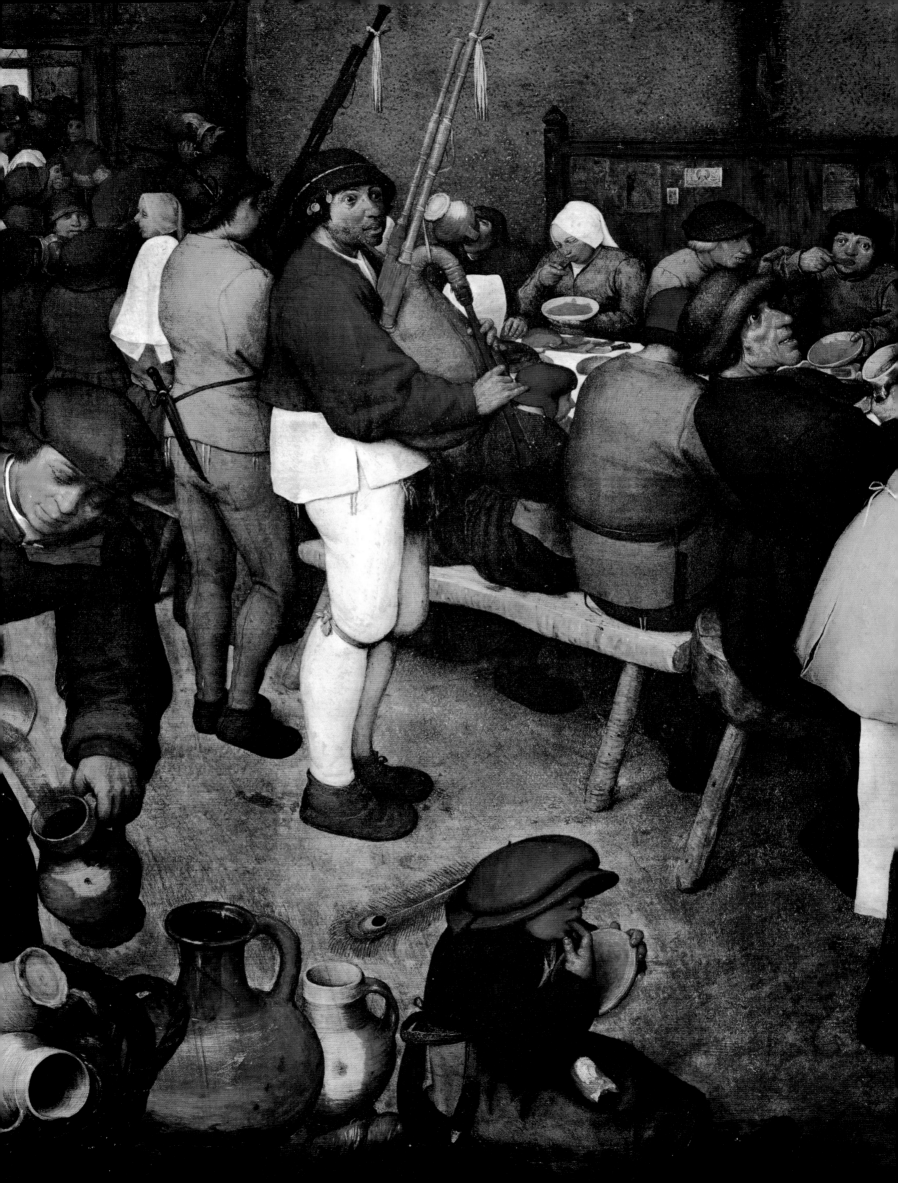

31

(if not necessarily documentary) paintings, including several works by Jan Brueghel showing his patrons, archdukes Albert and Isabella, at a peasant wedding feast, if somewhat detached from it (Prado, Madrid).[74] These several examples reinforce the suggestion that such imagery was not intended by Bruegel merely to show examples of negative behavior and excess by simpler or more primitive peoples. He certainly does not minimize or eradicate social distinctions; indeed these differences are as clearly evident in the *Peasant Wedding Feast* as they are in the later images of Albert and Isabella. But here he does show peasant customs as well as peasant costumes and portrays their simpler behavior (and simple features) with bemused attention.[75] This image utilizes none of the harsh caricature that was so evident in the *Thin Kitchen* and *Fat Kitchen* prints. In this respect, compared to the heritage of German woodcuts or the coarser Flemish tradition of Aertsen or Van der Borcht, Bruegel's peasant images convey their obvious humor with some human dignity.

A lost work by Bruegel reinforces this outlook towards peasant weddings: *Wedding Procession* (plates 295, 296), copied carefully by Jan Brueghel and formerly even attributed to Pieter himself.[76] That work shows both parties to the wedding and their parents following a pair of bagpipers in solemn parades, divided according to gender, along the edge of a village towards a parish church at the left horizon. The feast itself is already being prepared in large kettles within the distant village at the right horizon. The bride proceeds solemnly, serene in her dark dress and diadem, but she is flanked by a pair of youths and followed by matrons, presumably the two mothers of the wedding party. Now, however, the groom is visible, framed between trees in his own dark jacket with a bright red hat with a little circlet on top, as he solemnly leads the rest of the group. Right behind the groom come the two fathers, which suggests that the two men closest to the bride in the *Peasant Wedding Feast* could also comprise the fathers of bride and groom, respectively (particularly the one in his own separate chair under the last sheaf, though Demus considers him a notary, like the scribes who write down gifts in the printed versions of wedding celebrations).

This composition, neglected because its Bruegel original is missing, clearly shows how much respectful attention to peasant custom and conduct—albeit with genuine fascination for its alien difference—was bestowed by the artist on his subject. As noted above, such pictures (when documented) often hung in dining rooms or social spaces in the homes of their prosperous urban collectors, such as Noirot.[77] Thus, the differences of peasant life and customs as well as their reassuring productivity, which contributed to a regional prosperity, would surely have intrigued these patrons.

One final lost Bruegel image, probably a grisaille, consistently and handsomely copied by Jan, engages the town/country connection directly: *The Visit to the Farmhouse* (plates 297, 298).[78] This peasant cottage, dominated by a giant kettle in its center, offers a more spatially complex setting—with multiple doorways, a stair, and a ceiling—than the *Thin Kitchen* engraving of 1563. Its taller figures with small heads as well as its grisaille technique recall *Christ and the Woman Caught in Adultery* (plate 255) of 1565 or the *Spring* design of the same year (plate 282). Thus this original image presumably was produced earlier than the *Peasant Kermis* and *Peasant Wedding Feast.* Here two main figures occasion the scene, the seigneur and his wife at right, who are dressed in their traveling clothes as they condescend to make a visit on site to their tenant farmers. They have arrived with gifts, perhaps (even as godparents) to celebrate a recent birth, the infant with mother and crib with milk soup at lower left. The affluent wife seems to bestow coins to the young child who stands before her, and the lord of the manor has brought a wrapped food gift, probably a sugarloaf, for the peasant head of household. A giant kettle suggests that preparations for the meal extend well beyond the visible figures to the wider village, so this event might well be part of a general birth celebration with the entire community.

At the same time, the elements of peasant daily life are represented in well-observed details: two niddy-noddy thread holders for weaving, with wound fiber tied and resting on the bench top beside them; a backpack on the bench below for hauling, shearing scissors on the foreground child's chair; a butter churn in use at the center rear. A seated peasant on the bench seems to be using a wooden spoon to press smooth the edges and surface of a metal pan. The bench itself is ornamented with pasted devotional woodcuts, well worn. Two dogs are visible: one a lapdog in the crib, the other a larger hunting hound begging at the rear table. That table has the same kinds of bowls of porridge and large loaves of bread as the *Peasant Wedding Feast*, and a shaped mound of butter in the center like the *Peasant Kermis*. Clearly it is set with enough places for a big group.

Such an image certainly dismisses any encompassing view of Bruegel peasant images as sardonic negative images of excessive, even sinful behavior—the prevailing view of an earlier generation, epitomized by Grossmann

and Stridbeck. Moreover, in showing [...] their own setting, still busy with prep[...] ing butter, cooking) and tool repair (th[...] image shows peasant domestic labor [...] ration for a celebratory festivity. Mo[...] position embodies contacts between [...] country and their lords, Bruegel's pre[...] whether residing in country estates o[...] itself. Though he does not discuss thi[...] picture epitomizes one view of the a[...] Kaveler, who discusses the *Peasant* [...] "an icon of a coherent social structure [...] vision of community . . . a notion o[...] qualities proper to one's region."[79]

Despite such well-observed deta[...] image of hard-working peasants, lik[...] stereotype, an urban view—but not [...] nition of incivility and immoderatio[...]

[...]iew of peasants is what prosperous, contented patrons [...] Jongelinck, Noirot, Vezelar) would want to imagine [...]bout their own country, particularly in their suburban [...]omes and estates.[80] Additionally, as Gibson makes [...]lear, this is the very period in which the representation [...]f village settings—as well as country estates—formed [...]he subject of series of engravings, the Small Landscapes (plates 67–68) issued by Cock in both 1559 and 1561 after drawings by a masterful, if anonymous, contemporary of Bruegel.[81]

Gibson, Kaveler, and Carroll have all pointed to the degree of imagined rural productivity as the backbone of national identity and prosperity, which informed public presentations by the *rederijkers* in Antwerp.[82] When Antwerp hosted the dramatic competition among rhetoricians' chambers of regional cities in 1561 and posed the question for their responses, "Which occupation is most useful and honorable and yet little esteemed?"

295, 296 *(below and pages 354–55)*
Jan Brueghel, after Pieter Bruegel
Wedding Procession
Full view and detail
Distemper on panel, 24 × 44⅝ in.
(61.5 × 114.5 cm)
Musée Communal (Broodhuis),
Brussels

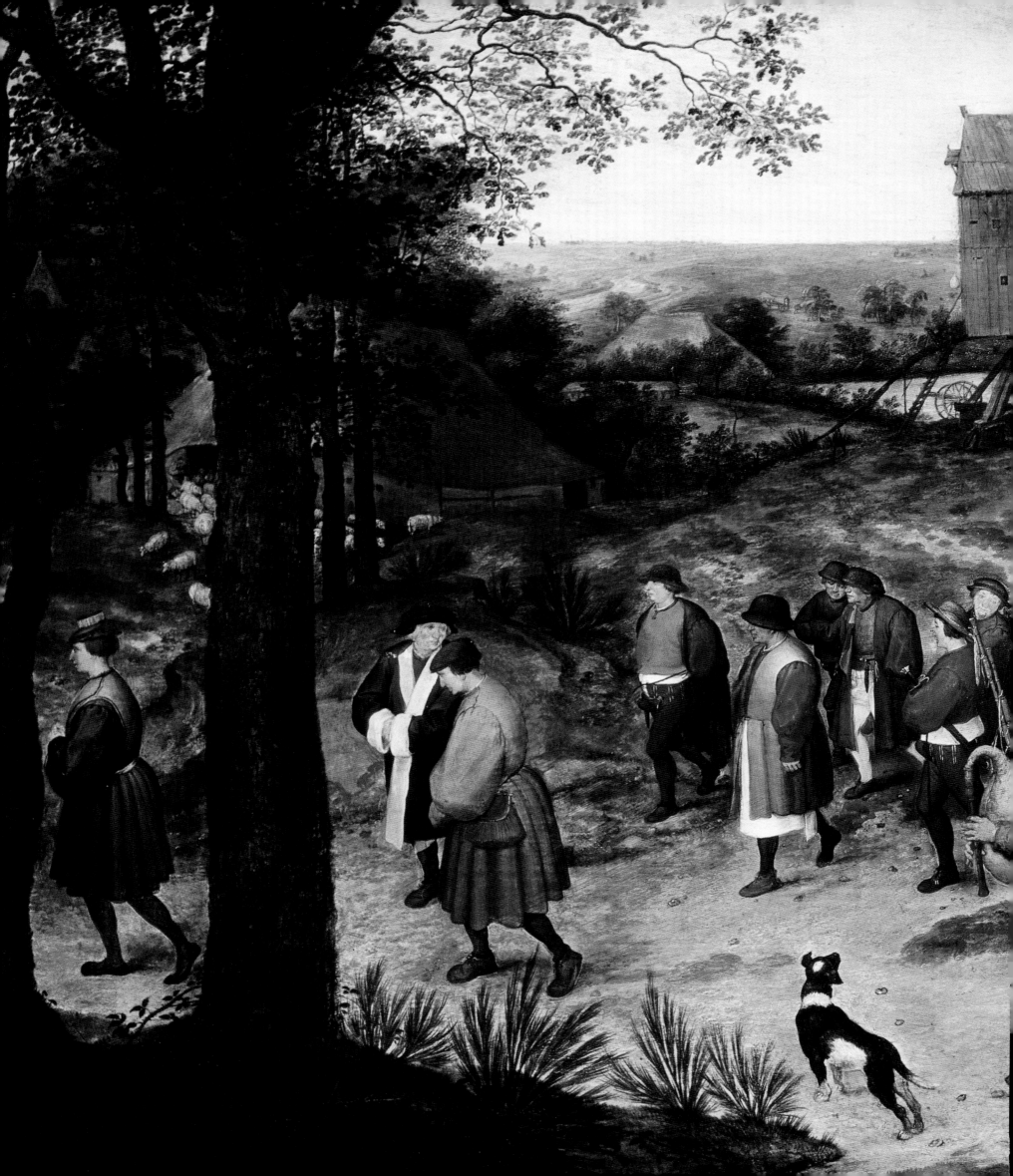

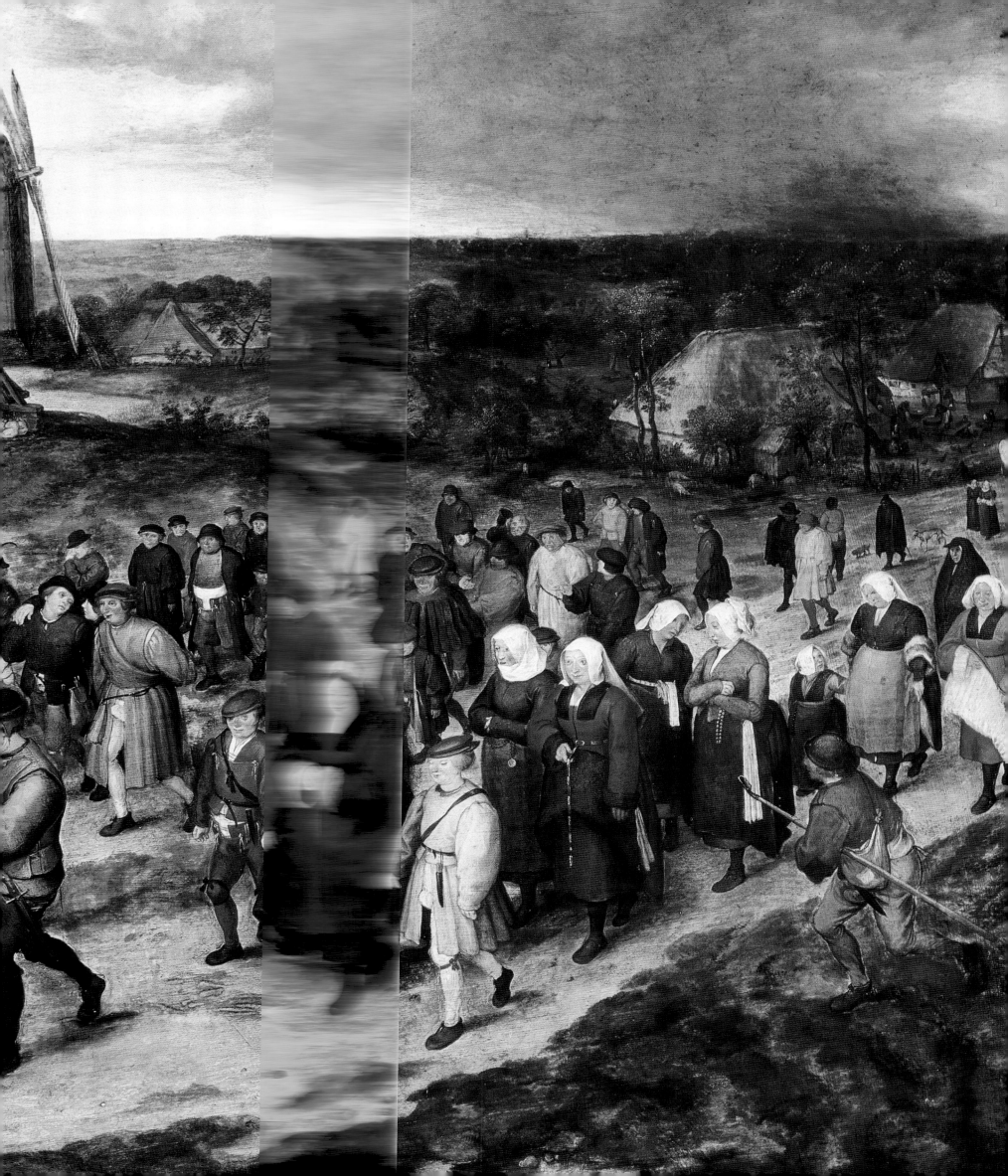

the unanimous answer was "agriculture." Mere rhetoric, perhaps, but certainly the kind of conventional thinking by Bruegel's fellow guild members. Already in Antwerp's published *Song-Book* of 1544, praise for the peasant in Dutch—not Latin—as "the noble landsman" (*edelen Landtman*) takes the following form in verse:

He is virtuous in his customs.
Therefore I must praise him,
For with his sweaty limbs he feeds
Nations, provinces, fortresses, and cities.
The good landsman, inspired by every virtue,
Serves loyally without coercion.
He plows, he delves, he hacks, he digs,
While many a nobleman lies on his soft bed
Without giving the farmer a thought or reflecting
On how he nourishes and comforts us.
Popes, kings, princes, counts:
For them to live, he must slave.[83]

In effect, this view holds that the peasant is the loyal servant of the nation as a whole. Gibson also notes that a 1559 procession in Antwerp, expressly celebrating the blessings of peace in the wake of the Treaty of Cateau-Cambrésis, featured a float showing peasants eating and drinking as the embodiment of peace and productivity, with the title, "We make good cheer." This benign outlook often resulted in the presence of the urban or noble visitors to peasant kermis and wedding festivities, and, although a later pictorial development by Jan Brueghel, even culminated in the imagery of Albert and Isabella, present (if isolated) amidst the festive folk of their harmonious "country."

Confirmation of this view emerges from departing from the single-minded focus on Bruegel in this chapter. We can discern the wider climate in which he operated within a series of prints that we have briefly met above: Maarten van Heemskerck's 1564 *Vicissitudes of Human Affairs*.[84] That cycle provides a recurring theme of how time shapes and reshapes the long-run fortunes of nations. Its more general relevance for Antwerp and the contemporary Bruegel environment stems from the fact that its eight allegorical floats of personifications reprises a program actually performed in the city for its annual Circumcision Procession (June 1, 1561). The message remains basic, and it seems very much to have been shared by Bruegel, whose consistent discomfort with soldiers and warfare we have repeatedly noted in the pages above. In sequence, the floats declare how Time, charioteer of the World, unleashes inevitable movement that

297
Pieter Bruegel (?)
Visit to a Farmhouse,
original c. 1565
Oil on panel, 11⅛ × 16⅝ in.
(28.5 × 42.7 cm)
Collection Lugt, Institut
Néerlandais, Paris

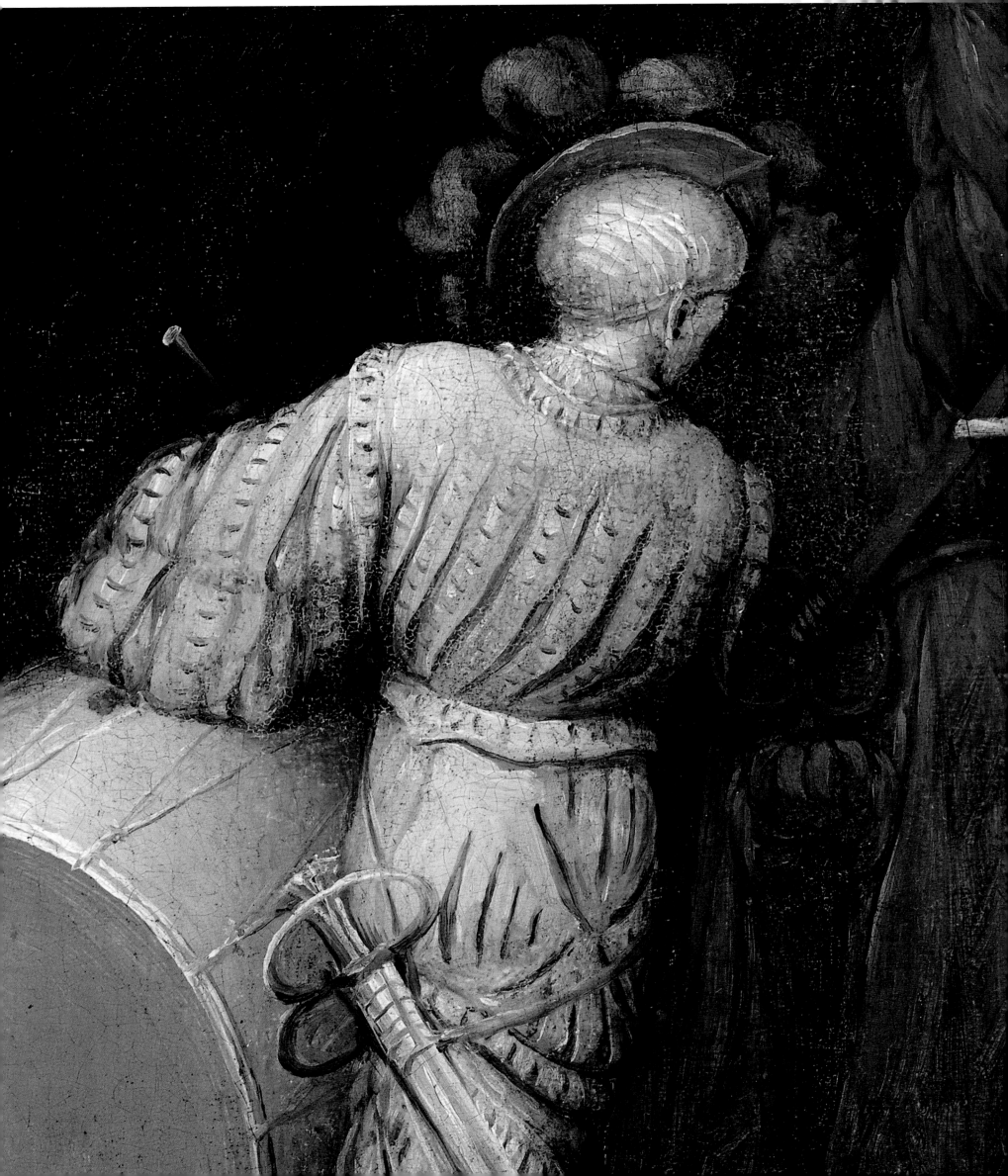

10

SOCIAL STRESSES
AND STRAINS

The last couple of years of [illegible] career were beset by the early [illegible] Revolt, marked by the ster[illegible] "Wonder Year" of 1566 on behalf of [illegible] by the duke of Alba—harsh repressi[illegible] 1567, known as the Council of Trou[illegible] same year, at the very time when he [illegible] ing to explore peasant subjects in hi[illegible] produced a folk fantasy picture [illegible] known in Dutch as the Land of Coc[illegible] *land,* "Lazy-Luscious Land" (plate 3[illegible] engraved posthumously by Pieter va[illegible] an added inscription (plate 301) in [illegible] made after a full-color Bruegel pain[illegible] of his drawing designs.[3] Its text cl[illegible] the painting: "The lazy and glutton[illegible] and clerks / get there and taste all fo[illegible] dens are sausages, the houses are ta[illegible] chickens fly around already roasted[illegible]

The Land of Cockaigne present[illegible] of gluttony and guzzling, of b[illegible] obtained without work or effort. [illegible] more massively rotund, reclinin[illegible] this painting comprises univers[illegible] indeed, these three main figures a[illegible] the medieval structure of society [illegible] orders": those who pray (the cle[illegible] fur-lined robe with the book, ink[illegible] scribe), those who fight (the sold[illegible] lying on his battlefield lance), a[illegible] the fields (a bulky peasant, lying [illegible] In his presentation of pure fant[illegible] factual, for once Bruegel does [illegible] ironic image, a world-upside-[illegible] lie to those readings of his am[illegible] (chapter 6) as unquestionably i[illegible]

The idea of "Lazy-Lusciou[illegible] many cultures, including Ame[illegible] (famously recorded by Burl Ive[illegible] of a "bum" of the "Big Rock Ca[illegible] a close equivalent.[6] Once mo[illegible] precedent in the sixteenth cent[illegible] lais, in the fourth book of *P*[illegible] Island, an island of Carnival, [illegible] of the Chitterlings; furtherm[illegible] soon composed a fantasy voya[illegible] Panurge, Pantagruel's proté[illegible] Nuremberg also composed a[illegible] land of Schlaraffenland, in 153[illegible] the main features of available[illegible]

this theme appeared in 1546 and doubtless helped to shape Bruegel's conceptions.

Even a cursory inspection of Bruegel's image lays out the character of the place. In the foreground center between the peasant and the scholar a hard-boiled egg with legs, a vestige of Boschian fantasy, is walking with its top cracked open and a knife ready for eating its contents. In similar fashion, a roast chicken is lying down on a plate above the scholar; just behind, a roast pig walks past with a knife affixed to its skin and a wedge already cut out from its back. For a glutton to gain admission to Lazy-Luscious Land, the texts tell us, he must tunnel his way into it by eating through the mountainous barrier of buckwheat porridge, which Bruegel shows in the upper right as a dense purple-gray mass; out through a hole in the porridge tumbles a peasant newcomer with a spoon. In contrast to simpler, peasant fare (cf. the soups and bread of the *Visit to a Farmhouse,* plates 297, 298), the foods in this fantasy land are all carnivalesque: rich, fatty meats; cheeses; pies; even a pancake cactus at the right edge and a sausage fence in the rear. The pies will slide off the roof (unlike the pies vainly sought by an archer in *Netherlandish Proverbs*), and other foods or

299 (pages 360–61)
Pieter Bruegel (?)
Three Soldiers, 1568
Detail of plate 315

300 (opposite)
Pieter Bruegel
The Peasant and the Bird-Nester, 1568
Detail of plate 304

301 (below)
Pieter van der Heyden,
after Pieter Bruegel
Lazy-Luscious Land, after 1570
Engraving, 8⅛ × 10¾ in.
(20.9 × 27.7 cm)
The Metropolitan Museum
of Art, New York, Harris Brisbane
Dick Fund

Die dâr lay en lacker fyt bår crifman oft clercken Die tuynen fyn worsten die huyfen met vlayen
die gheraekt daer en fmaeckt clâr van als fonder werken cappuynen en kieckens t vluchter al ghebruyen

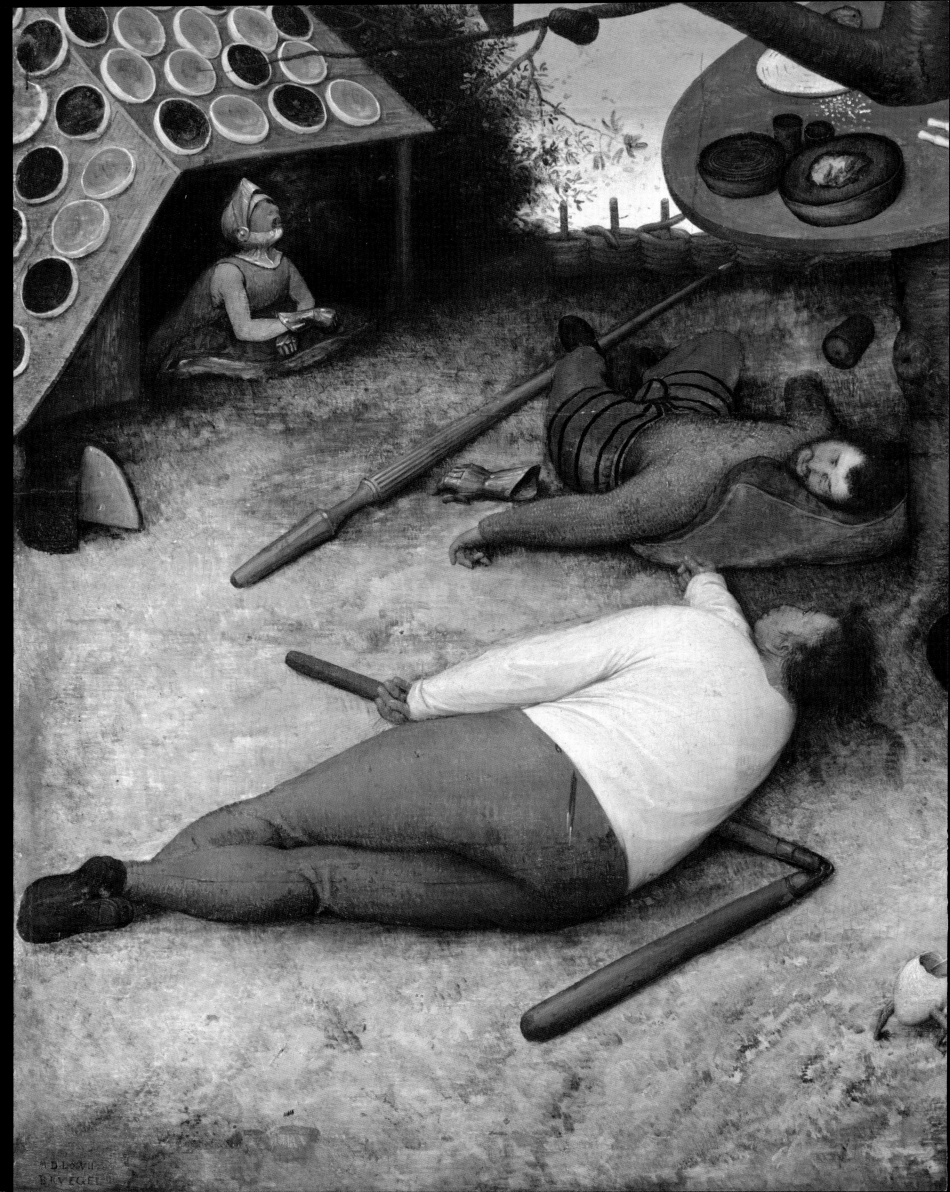

We have already seen the dignity and virtue attached to the diligence of laboring peasants, both in the *Fall of Icarus* (plate 110; a picture, we recall, that might date later, perhaps in the early 1560s, rather than from the early date usually assigned to it) and in the 1565 series of the Months (see chapter 9). As in those works, this image too presents steady and patient productivity; these ponderous peasants work closely with nature and understand the dangers to which they are exposed. They wear heavy protective garb, including wicker masks, rendering them even more fully anonymous than the harvesting figures in Bruegel's *Summer* drawing (plate 285). Their body movements are deliberate as they proceed to gather honey from the beehives.

These careful actions of the beekeepers contrast utterly with the remaining figure, also anonymous: a peasant who clings precariously to the branch of the tree at the top right of the print. He has climbed up to grab a bird's nest for its eggs. The significance of his behavior is given by the proverb, written in Dutch into the ground at the lower left corner: "He who knows where the nest is has the knowledge / he who robs it has the nest." In this drawing Bruegel returns to his fascination with popular culture, already seen in *Netherlandish Proverbs* (plate 186), and also as a source of *Lazy-Luscious Land*. The proverb that informs the Berlin *Beekeepers* also appeared in a major proverb collection compiled at that moment in Antwerp by François Goedthals.[14]

In effect, these two types of peasants form polar opposites, like the contrasting pair of the proverb, but both are trying to derive real sustenance from nature—the beekeepers through careful husbandry, the nest robber through sudden, risky seizure. Both can be said to "have the nest," though the tree-climber with his bird's eggs could never hope to withstand a swarm of bees. One could readily compare the daring of the nest-robber to the flight of Icarus, with the same potential for a tragic fall; in contrast, by carefully working with nature's elements, the beekeepers recall productive work done by plowman, shepherd, angler, and even sailors in the *Icarus* painting (plate 110).

The Berlin *Beekeepers* must be interpreted in conjunction with a large-scale 1568 painting of the same proverb: *The Peasant and the Bird-Nester* (plates 300, 304).[15] This image injects a third term, a working background farm, into the equation, and in presentation it features a single dominant, large, striding peasant within its vertical format. He has one of Bruegel's silliest moon faces, grinning and wide-eyed, facing the viewer as he points over his shoulder. The object of his smug, self-satisfied smile is

another nest-thief, whose grasp of the branch in the tree at top left seems even more precarious than in the Berlin drawing; his bright brown hat is falling off his head, and he seems to be hanging upside down, on the verge of losing his grip and falling along with it. But the stout, land-bound peasant fails to observe his own predicament: so eager is he to point out the folly of others that he is about to stride into a stream that runs across the lower edge of the painting. At his feet the brambles and iris both suggest suffering, perhaps even death.[16] Thus Bruegel presents peasants in an isolated forest context as physical embodiments of folly, both active and passive or complacent.[17] The smug striding peasant is headed for a fall just as surely as his rival up the tree, but both figures are contrasted with working farmers, who know their place and how to work productively with nature. The message of the proverb suggests that activity, rather than mere principle or abstract knowledge, gets results.[18]

This is precisely the meaning of the proverb enacted in several later versions of the scene by Bruegel's follower in the next generation, David Vinckboons (*Bird-Nester*, 1606).[19] In this print, the mocking peasants who point to the tree-climber with the nest are so distracted that they get their pocket picked by a ragged beggar—a daring theft directed at fellow humans. Yet the right side of the etching features a pointed contrast of more settled peasant life as husbandry: a mother nurses her baby; a child fondles his dog; and two large baskets beside them hold both chickens (or captured birds) and eggs, produced the more conventional way and retrieved more safely with a long fork, on top of the baskets.

In Bruegel's *Peasant and Bird-Nester*, another well-tended farm, like the setting of the *Beekeepers*, is depicted in full but in miniature, as a small element at the bright, green area, firmly and stably planted upon the right horizon. The farm features a pair of buildings with space for both horses and chickens (whose eggs are regular and do not require anyone to climb a tree). A pair of tiny figures sit quietly on the ground under the distant tree: a seated father with a stick is instructing a child, just as the proverbial print of 1556, *Big Fish Eat Little Fish* (see plate 68) included a father pointing out the lessons of a proverb to his son. Of course, this message also has biblical analogues, notably a parable of Jesus (Matthew 7:2–3), "For with what judgment you judge, you will be judged . . . And why do you look at the speck in your brother's eye, but do not consider the plank in your own eye?"

Numerous commentators have observed the mass and presence of the striding peasant in the Vienna painting, even comparing him to Michelangelo's own late figures,

for example, in his 1541 *Last Judgment* fresco in the Sistine Chapel, or else some of the twisting figures of the Sistine ceiling, plus several standing figures in the later Pauline Chapel.[20] Most recently, this argument has been revived by Todd Richardson to argue that Bruegel made use of Raphael and Leonardo models as well, chiefly to provide the same kind of dignity and seriousness in pictorial terms, for the local pictorial vernacular. Such pictorial models could rival the heroic Roman-based bodies of both Frans Floris and Maarten van Heemskerck (see chapter 2). In the same fashion, contemporary poets in French or Dutch tried to rival the dominant cultural prestige of classical Latin.[21]

Whether or not this is the case, or could have been expected to have been recognized by a discerning viewer, Bruegel does use the powerful stature of a foolish peasant, a large figure who directly confronts the viewer, to present a visual paradox—a commanding presence at full scale and in vertical format, suggesting a serious religious or history picture, yet used instead to embody a popular proverb, representing a socially humble subject.[22] This visual irony of contradictory form and content already underlies the entire fantasy presented by *Lazy-Luscious Land*, and in the *Bird-Nester* its dominant negative examples are only truly undermined and revealed through the obscure detail of the distant farm. In contrast to Richardson's assertion of a positive kind of vernacular seriousness, these pictures require analysis of the seeming conflict between their negative themes and their assertive presentation—the burden on the viewer from the artist has even intensified.

This same process of discovery of seriousness within an everyday theme can be compared to the discovery of the religious figures and core meanings within the village setting of Bruegel's later religious pictures, for example, *Census at Bethlehem* (plate 230) or within the mountainous landscape of *The Conversion of Paul* (plate 237). Certainly Bruegel's elevation of peasant subjects to large-scale, independent subjects suitable for paintings (see chapter 9) was already a major innovation in itself from earlier print models; moreover, the degree to which Bruegel can be interpreted to have had sympathy for, or even nostalgia for, the life of the peasant in the local countryside certainly reinforces the point that Richardson makes about the artist's innovations within Flemish painting. Just because these two dominant figures present negative examples need not mean that the other peasant subjects, even of festivity (*Peasant Kermis; Peasant Wedding Feast*) should be understood as vices or as negative examples.

However, in *The Peasant and the [Bird-Nester]* [Bruegel] has seemingly provided the inverse [...] tures—a full moral universe, convey[...] large peasant figures rather than rec[...] humble yet holy figures located amid[...] basic message remains in both kinds [...] cially the late works: humility and c[...] literally incarnate in the figure of [...] *Adoration of the Magi*, plate 200), bu[...] laboring peasant on the land (comp[...] *Peasant and the Bird-Nester*) provid[...] path in a world filled with both [...] (Indeed, the risks run by the nest ro[...] as analogous to long-distance comm[...]

Bruegel produced a pair of canva[...] ferent medium of distemper, in th[...] One of them, *The Blind Leading t[...]* remains one of his most famous [...] should be noted that this image is g[...] ticularly in its center, so in order to [...] position, one must consult a care[...] attributed to Jan Brueghel, plate 3[...] course, derives from a one-line par[...] in its brevity, by Jesus (Matthew 1[...] a variant in Romans 2:19): "if the [...] both will fall into a ditch." Bruegel [...] this image at the upper right horiz[...] *ish Proverbs* (plates 186, 187), whe[...] blind men appears in near-silhoue[...]

This same subject had already [...] teenth-century engravings: a sm[...] Matsys (plate 307) shows a row [...] to the right and toppling, like th[...] chain reaction; in addition, a larg[...] made for Hieronymus Cock by [...] after "Hieronymus Bosch invent[...] of those prints share with Brueg[...] of vagabonds as well as the begga[...] the hurdy-gurdy, a set of strings, [...] a rotating wheel, turned by a cra[...] musical training or talent to play.[...] the hurdy-gurdy is in the lower ri[...] the leader into the ditch. Above t[...] ure Bruegel has placed a promine[...] seen along the ditch of the *Bir[...]* noting (spiritual) blindness and [...] His naturalistic emphasis exten[...] with clinical attention to the var[...] course, the cluster of mutually d[...] could be compared to the group [...]

but of course, they are idlers and vagrants, not diligent workers.

But what sets Bruegel's image apart from his models is his inclusion of an extensive background—much more legible in the Paris copy—that contrasts utterly with the tragedy of the foreground. Steeply thatched roofs and a parish church comprise a typical Flemish village. The authenticity of its prominent central parish church has been reaffirmed by local observers; Marijnissen even claims that it still exists at Pede-Sainte-Anne, near Brussels.[28] Even more striking is the difference between the steep slope, down which the beggars march, from upper left to lower right, versus the stable horizon of the background village within the overall horizontal landscape format. Its vertical steeple, a counterpoint to the horizon, is emphasized all the more by appearing at the gap where the second figure in line has begun to fall and opens a space in front of the groping third figure and his stick. Whereas the costumes of the blind are rendered in cool blues and violets in a narrow range of color, the background village is presented with the bright golds and greens of summer, like Bruegel's imagery in his *The Hay Harvest* (plate 277).

305 *(below)*
Jan Brueghel, after Pieter Bruegel
The Blind Leading the Blind, 1568
Oil on panel, 46½ × 66 in.
(118 × 168 cm)
Musée du Louvre, Paris

306 *(pages 372–373)*
Pieter Bruegel
The Blind Leading the Blind, 1568
Distemper on canvas, 33½ × 60⅞ in.
(86 × 156 cm)
Museo Capodimonte, Naples

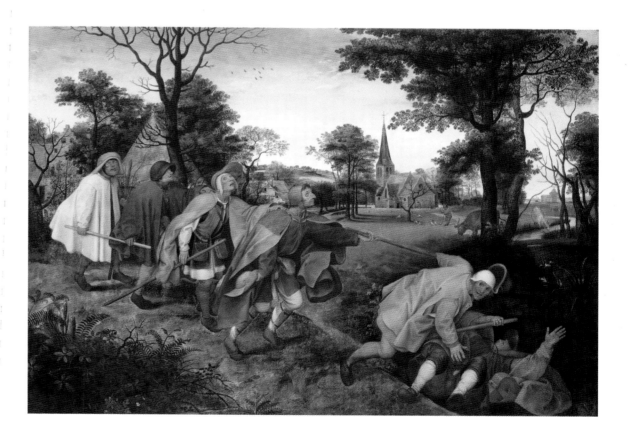

307

Cornelis Massys

Parable of the Blind Men,

c. 1544–46

Engraving, 1¾ × 3⅛ in.

(4.5 × 7.9 cm)

Bibliothèque Royale de

Belgique, Brussels

Careful inspection of the Naples original will reveal the remnants of a brown cow next to the ditch and under the tree, just above the second falling figure. The Paris copy not only confirms the presence of that cow but also shows a second, white cow on the other side of the tree, leaning over the ditch to sip the water. Its precarious stretch downward and its color seem to echo the danger and the fall of the blind beggars, just as the venturesome sheep beside the sea and near the ship suggest the dangers leading to *The Fall of Icarus* (see plate 110). More importantly, the Paris copy reveals a major figure next to the first cow (and just beneath the rear of the church). Completely effaced from the Naples canvas, a goose herder, similar to the Bruegel drawing of a few years earlier, stands in solitary profile with his flock. Just as with the horizontal stability of the farm in the *Peasant and the Bird-Nester*, this goose herder stands peacefully in his pastoral role within the village green. This juxtaposition is not unprecedented: such a figure had already appeared near the three blind men in *Netherlandish Proverbs* to embody the proverb of "who knows why the geese go barefoot?" That proverb poses the mystery of why things in the world operate as they do, even as it suggests a receptivity and acceptance of one's lot and the order of things.

The presence of such a herdsman, particularly in conjunction with a parable of Jesus, recalls a pair of lost late works by Bruegel, known from copies, which were discussed earlier: *The Good Shepherd* and *The Hireling Shepherd* (plates 253, 254). Like these other late images, both lost works feature large-scale figures in expansive landscapes and use peasant labors as images of self-sacrifice or self-interest, respectively. The stocky figure of the *Hireling Shepherd* is as massive as the peasants in either *Lazy-Luscious Land* or *The Peasant and the Bird-Nester*. Moreover, we now note that he is a wanderer in his own right, showing the edge of a hurdy-gurdy under his right arm, to suggest that he is little more responsible than the blind beggars of *The Blind Leading the Blind*.[29] Unlike the festive peasants in kermis images or wedding scenes, and unlike even virtuous working peasants in landscapes of the Months, these two scenes add the figure of an attacking wolf, a tangible element of genuine danger—a situation that we shall see in several other late Bruegel images. Yet in making use of parables (here John 10, also the explicit subject of his 1565 engraving *The Good Shepherd*), such works also carry a religious charge, a combination that Bruegel had employed going back to his earliest dated painting, *The Parable of the Sower* (plate 109) and his *Wise and Foolish Virgins* engraving (plate 77), both populated by country people.

But in his later years parables facilitated this fusion of his two principal thematic interests: the human content of religious figures and the moral significance of the simpler country life of peasants. Like the contrast between the wise and foolish virgins, one shepherd abandons his responsibilities, while the other remains steadfast in his duty, even in the presence of danger. Indeed, the parable declares explicitly that the shepherd is the figure for Jesus himself, pastor of his flock, who defends them against "thieves and robbers" who would steal, and kill, and destroy. The charge of this parable is to gather in even those sheep not of the fold, to make "one flock and one shepherd." In an era of increasing sectarianism between Calvinists and traditional Catholics, religious tension became entangled with the assertion of local privileges and rights against distant Spanish rule. By using the parables, which are already religiously sanctioned metaphors but still require interpretation, Bruegel could produce religious images that did not have to be placed in a church setting, site of iconoclastic destruction in 1566 (chapter 8). Moreover, through the use of familiar and commonplace parables, common to both Catholic and Calvinist Bibles, he could leave his own sympathies inexplicit, so that either *The Blind Leading the Blind* or *Good Shepherd* could be framed by the sympathies of each

viewer, to define what Grossm[...] are blind to true religion."[30] [...] spiritual out-group for these im[...] remains elusive—even more am[...] attitude, whether straightforwa[...] stirred debate about the meani[...] of the Virtues (chapter 6).

While *The Blind Leading the B[lind ...]* gious painting by Bruegel, a po[...] *grims to Emmaus*, engraved by [...] signature) for the Cock worksh[...] self and dated 1571, close to his [...] another explicitly religious stor[...] large figures.[31] It bears an ins[...] reference (Luke 24) and a La[...] you think it worthy to assume[...] grim in order to confirm our [...]" In effect, it provides a perfect c[...] *Leading the Blind*: in the print[...] Christ himself, represent the fa[...] share the same travel garb. As [...] this religious scene is still a situ[...] temporary, since even his own [...] the presence of the risen Christ[...] are dining together in the inn [...] would continue to have a dee[...] of true, spiritual seeing down [...] brandt.[32] In Bruegel's image t[...] occurred; while the viewer can [...] around the head of Jesus, his [...] so they still remain spiritually[...] Bruegel had treated this subjec[...] Large Landscape engravings (p[...] that earlier print series emphas[...] small figures; however, even in[...] of Christ in the center is subtly[...] the drawing design and the en[...] viewer to discover. Characterist[...] his earlier and later works, as [...] *Blind*, the omniscient and pa[...] small figures in a large setting[...] scale figures, seen from belo[...] however, show the setting sun [...] both the traditional associatio[...] sun and to imply that later the[...] the still of the night and the fo[...]

The other Bruegel canvas [...] (plate 308) does not depict a [...] an inscription underneath, p[...] by a contemporary hand, wh[...]

voice and the purpose of its eponymous recluse in his dark robes: "Because the world is so untrue/ Thus I go off, filled with rue." Its circular frame recalls the earlier embodiments of *Twelve Proverbs*, which suggested both universal significance as well as a decorative emphasis, frequently used for peasant themes (plate 193; see also Bosch's *Peddler*, plate 12).[34] This is also the circular shape of the bull's-eye mirror, which could capture the full span of a space, further suggesting an encompassing vision; indeed, many late medieval comprehensive treatises were known as "mirrors," such as the Mirror of Princes literature or the *Mirror of Human Salvation*.[35] It should be noted that another selection of a dozen images, possibly based on Bruegel originals, whether paintings or drawings, were engraved as roundels with inscriptions by the professional printmaker, Jan Wierix.[36] The *Misanthrope* print of that series closely related in its roundel composition and components to the Naples canvas, has a Dutch inscription with much the same sense: "He wears mourning because the world is unfaithful, most people behave without rhyme or reason. Few now live as one should live. People rob, grab, and everyone is full of deceit."[37]

Such a suggestion of comprehensiveness emerges from the three terms of this painting, which, like the *Peasant and Bird-Nester*, uses three figures to embody contrasts of behavior. The dark hermit, dressed like a monk and clasping his hands prayerfully, professes to be withdrawing from the world, covered in the color of mourning, and indeed he does head for a wilderness locale in the trees at the left. Yet he is exposed as a hypocrite, who has hidden a coin purse (strangely shaped like a heart) under his robes, which is revealed by a stealthy pickpocket who prepares to snip and steal it. That shoeless beggar is presented as an allegorical figure, immured in a transparent globe to represent the world's poverty and need as well as its cruel survival instinct. This is the very world on which the pious hypocrite uncharitably turns his back. We have seen this kind of figure before: at the bottom center of *Netherlandish Proverbs*, a taller beggar, equally ragged and wearing a splint for his crippled leg, must stoop to make his way through the world, a similar glass orb. There in a visual dialectic he is contrasted instead with a different adjacent figure, the rich, well-dressed young man who "has the world on his thumb." Yet the Misanthrope will suffer more than the loss of his purse; he is so self-absorbed in his meditations that he fails to notice—like the pointing Peasant who misses the water's edge beneath his feet—the sharp metal man-traps that stand directly in his own path.

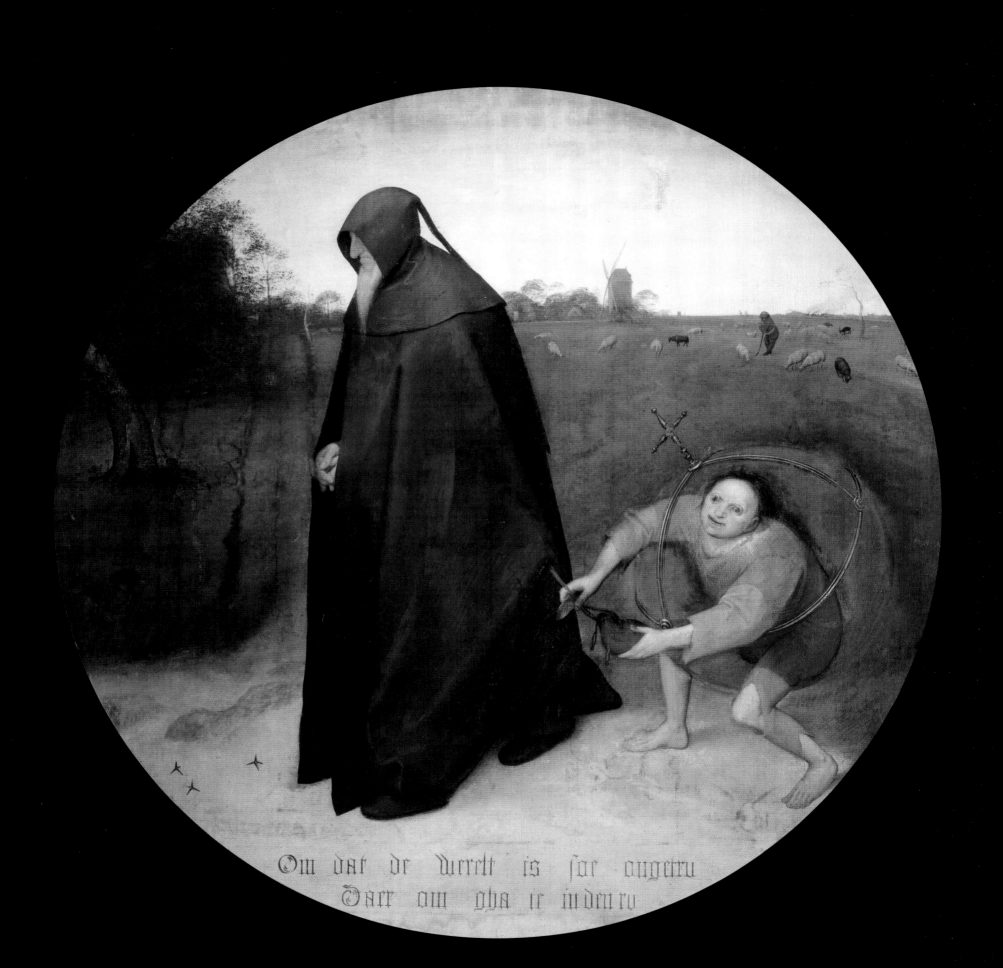

Om dat de werrelt is soe ongetru
Daer om gha ic in deru

If neither of these two foreground figures can be taken as models of Christian virtue, there still remains a third, distant figure just below the horizon. Standing and tending his flocks, another stoic shepherd offers a diligent alternative, like the gooseherd in the *Blind Leading the Blind* or the farmers in a similar position in *The Peasant and the Bird-Nester*. This landscape too, is an open, almost unbroken field, laid out like the background of the lost *Hireling Shepherd*. A windmill at the horizon not only conforms in its radial symmetry to the shape of the canvas as well as the globe, but also suggests the cycle of the seasons and the harmony of working with nature's forces. Yet even at this level of the picture, not everything can be harmonious: a ribbon of red name, located just to the right of the shepherd at the farthest distance on the horizon, signals additional, still unknown danger that could threaten even his own.

At the same time as the two canvases, Bruegel also produced a tiny panel, *The Beggars*. In effect, this image also practices what we saw in *The Blind Leading the Blind*, where an element was excerpted and enlarged from *Netherlandish Proverbs*. Also like the assumed print images of *The Dirty Bride* and *The Feast of the Wild Man*, excerpted from his 1559 *Carnival and Lent*, Bruegel here has made a picture out of the parade of lepers who are begging for their sustenance on Copper Monday, following Epiphany or Twelfth Night. In contrast, however, to the basic festive character of the processions and related street plays in the urban setting at the left side of *Carnival and Lent*, this small Louvre panel focuses a glaring spotlight on a trio of often-mounted, grotesque faces with coarse features as well as broken and crippled bodies, assisted with makeshift splints and crutches. Bare walls that enclose this space evoke more claustrophobia than the spacious streets of the large painting of *Carnival and Lent*. Because the noblemen protesting Spanish tyranny in their revolt proudly adopted the contemptuous designation given to their petitions and called themselves "the beggars," some scholars have wanted to see Bruegel making an allegorical statement here about the nascent Dutch Revolt (see chapter 8), though whether it would be positive or negative must remain moot, since any viewpoint informing this picture is highly questionable.

The distinctive dress worn by these lepers clearly points to their festive annual moment, through the paper crowns associated with the Epiphany season. Instead of clappers, carried in *Carnival and Lent*, one of them wears bells to announce their coming. Foxtails, worn so conspicuously by these cripples and already seen in

Carnival and Lent, served as markers of lepers; certainly the animal was widely associated in late medieval animal lore with slyness and deceit, and beggars themselves were often considered malingerers, fakes, or rogues.[41] Also visible with these beggars, the woman who collects alms for them wears her own distinctive conical hat and broad cape.

A contemporary hostile outlook toward beggars and cripples is evident from a pair of design drawings one of which (plate 310), less finely executed, was published posthumously as a Cock print, attributed to "Bosch" (see chapter 3) by inscription.[42] Its text takes a clearly pejorative outlook, especially toward the leader of the beggars, the Cripple Bishop: "All who like to live on the blue [the color of deceit, for example, "blue cloak"] sack of deceit / Almost all go as cripples [but] on both sides / Thus the Cripple Bishop has many servants / Who avoid the straight and narrow path to make a fat living." In both of these related drawings we see ragged figures with crutches and splints, some with hurdy gurdies or lutes, many wearing the traveling cloaks of both pilgrims and vagabonds. But these drawings still display an underlying quality of humor for these small-scale figures (admittedly at the expense of the disabled), which accords well with *Carnival and Lent* or the early kermis prints, both 1559. Only the inscription on the Cock print shows the same harshness as the Paris *Beggars*, which is composed with the same close-up focus and lowered viewpoint of the other late works. By the time of Bruegel's late period, a harsher judgment of these figures as idlers and social outcasts overwhelms any suggestion of humor or distance.[43]

On the reverse of the Paris *Beggars* a short, yet learned Latin inscription praises the artist in terms akin to the humanist tropes used posthumously by Abraham Ortelius (see chapter 2): "What was lacking in our nature, is lacking in art. So great was the talent given to this painter. Here Nature, expressed in painted figures, seen through these cripples, is surprised to see that Bruegel is her equal."[44] It also exclaims in colloquial Dutch, surely with irony: "O cripples, may your affairs prosper!" Taken in combination, this direct address as well as the praise of the painter for his naturalism—rather than for some transcendent ideal of beauty—suggest the same kind of engagement with the beggars as in the Cock print, but now with enhanced attention to their appearances. This naturalistic emphasis clearly emerges through the broken bodies and awkward postures of the beggars but also in their distinctive, if coarse, features. We have seen Bruegel introducing such heads within his religious and

308 *(opposite)*
Pieter Bruegel
The Misanthrope, 1568
Distemper on canvas, 33½ × 33⅛ in.
(86 × 85 cm)
Museo Capodimonte, Naples

309 *(pages 378-379)*
Pieter Bruegel
The Beggars, 1568
Oil on panel, 7¼ × 8⅜ in.
(18.5 × 21.5 cm)
Musée du Louvre, Paris

BRVEGEL · M·D·LXVIII·

310 (below)
Attributed to Hieronymus Bosch
Beggars and Cripples
Pen and brown ink, 11⅛ × 8⅛ in.
(28.5 × 20.8 cm)
Albertina, Vienna

311 (opposite)
Pieter Bruegel
Head of a Peasant Woman, c. 1568
Oil on panel, 8⅝ × 7 in.
(22 × 18 cm)
Bayerische Staatsgemäldesamm-
lungen, Alte Pinakothek, Munich

peasant scenes, going back to his 1564 London *Adoration of the Magi* (see plates 199, 200).

Indeed, several small individual panels of isolated heads with distinctive facial features, chiefly of peasants, have been preserved and ascribed to Bruegel; in addition, several other works are known only from copies. Such heads are known as *tronies*, or study heads, and some other artists paint them for reuse, to reappear in larger compositions.[45] We have already seen Frans Floris using a similar *tronie*, *Sea God* (plate 29) for his 1561 *Feast of the Sea Gods* (plate 28), as part of his workshop method. The most persuasive head attributed to Bruegel, although unsigned and undated, is the *Head of a Peasant Woman* (plate 311), whose close-up profile features and monochrome but subtly brushed costume stand close to works like *The Blind Leading the Blind* or *The Peasant and the Bird-Nester*, both of 1568. Her features also closely resemble the female dancer at the right edge of the undated *Peasant Kermis* (plate 291), though she was not expressly reutilized there.[46]

In fact, the Rubens inventory of 1640 mentions "small heads" by Bruegel on panel; one of them, a *Yawning Peasant* (plate 313) is preserved.[47] Although its attribution has been contested between Pieter the Elder and Pieter the Younger, more scholars favor seeing it as a copy (a seventeenth-century engraving in reverse after this yawning face was also produced by Lucas Vorsterman, one of Rubens's principal printmakers). Moreover, there might once have been other Bruegel study heads. A series of etched character heads akin to these two Bruegel *tronies*, thirty-six pairs, were produced by the Duetecum brothers, those Cock printmaker associates responsible for the Large Landscapes (chapter 4), but those heads lack ascription to any artist; when they were reprinted in the seventeenth century, Bruegel was credited as "inventor," though no single head matches any figures in the extant Bruegel paintings.[48] That attribution also shows how much of this peasant genre and related character heads had come to be associated with Bruegel by the next century.

Such character heads and attribution questions surround another important painting, seemingly signed and dated by Bruegel: *The Peasants' Distress* (plate 312).[49] As for authenticity, the high quality of execution of this work makes it the strongest of the several well-preserved paintings that are still doubted at times as originals. However, this picture does at least raise the question of workshop participation, in part because its inconsistent execution (like the *Good Shepherd*, plate 253), in part because some of the figures in the image repeat gestures

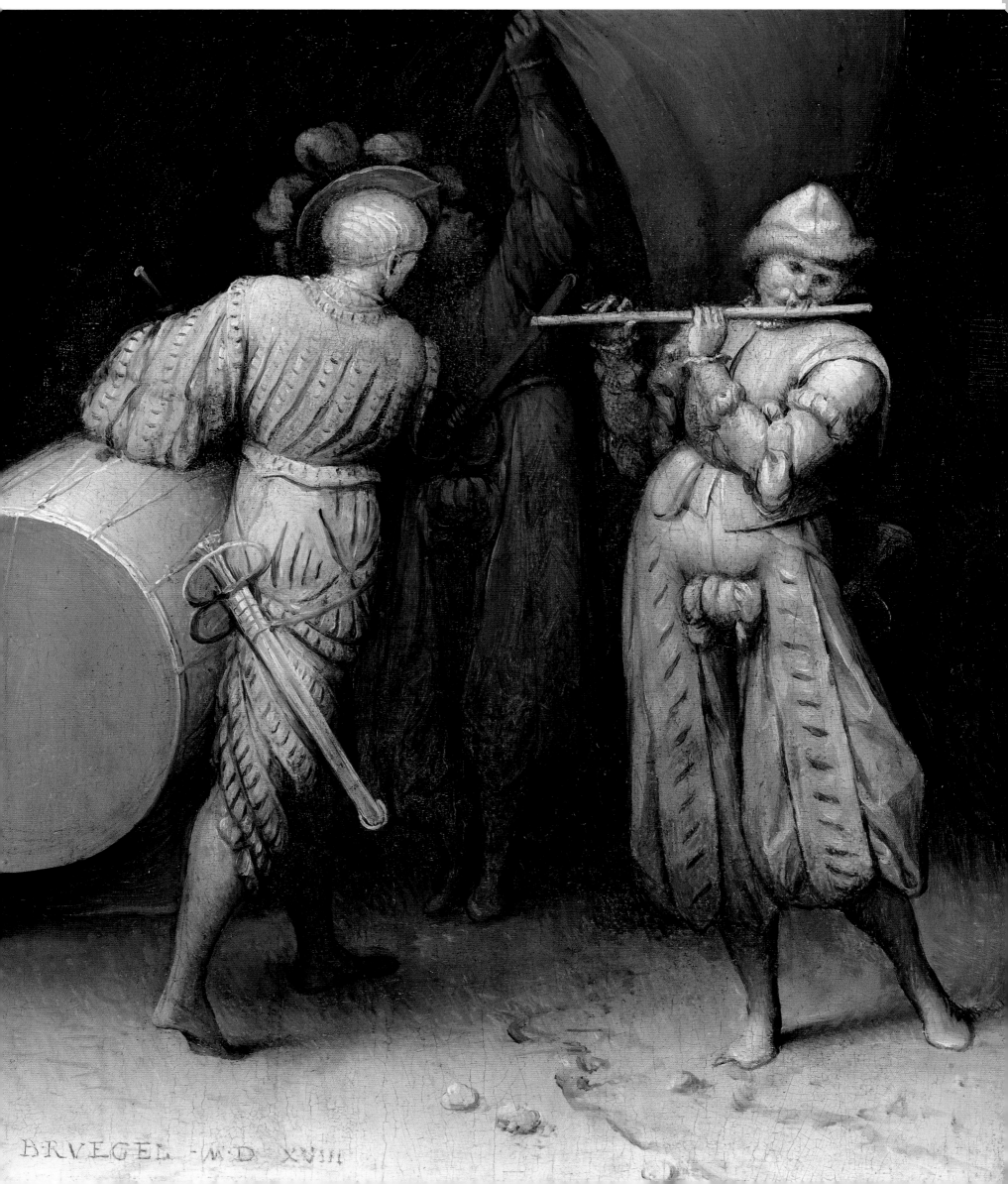

BRVEGEL · M·D· XVIII

the Gallows (plate 317), provide[...]r work as well as suggesting th[...]or discord.[62] Relatively small in i[...]e fullest command of atmospher[...]s works and has been linked to[...]est in calendar page miniature[...]t work by Simon Bening (see c[...]or the Months). Still composed [...]tional structure that Bruegel f[...]e Landscapes in the middle 1550s[...]*Magpie on the Gallows* features sma[...]t figures who punctuate the spac[...]d pair who gesture toward the h[...]t in the lower left corner. Their [...]ta opens into a distant river va[...]ndly, tall flanking trees frame [...]ill declines in step-like drop-offs[...]t, verdant, hazy distance.

Yet in this case, any sense o[...]ely disturbed in the center foreg[...]cal presence of a prominent gallo[...]agpie perches atop that structur[...]ge of the hill on the right stand[...]the Large Landscape engraving [...]In the lower right corner a wa[...]ing with nature and cyclical proc[...]the horizon of the *Misanthrope* [...]of the gallows presents a marke[...]om the hillside village emerges [...]easant figures. Included amon[...]pers play for a lively dance by a[...]ing (in bright colors on the part[...]ight under the shadow of the g[...]seen from above, still looks like a[...]kermis prints or a miniaturize[...]troit *Wedding Dance* (plate 288).

During this late period [...]produced one other peasant i[...]lost, which suggests that he trea[...]ly as hardy laborers or harmless [...]tims of brigands, but rather as [...]tous creatures of passion. His *I*[...]only from a seventeenth-centur[...]) by Lucas Vorsterman, Ruben[...](who also produced another eng[...], and from several painted copi[...]ger.[63] This subject has been ig[...]uegel scholars, in part because i[...]rman copy seems to be based on[...]lso in part because it dispels the[...]otion

315 *(opposite)*
Pieter Bruegel (?)
Three Soldiers, 1568
Oil on panel, 7⅞ × 6⅞ in.
(20.32 × 17.78 cm)
Frick Collection, New York

316 *(left)*
Hendrick Goltzius (1558–1617)
Standard-Bearer, 1587
Engraving
Toledo Museum of Art

in Bruegel's oeuvre of a harmless peasantry, only given to quarrels under the influence of drink, as in the case of the *Peasant Kermis*, where figures at the table outside the tavern shows signs of a budding conflict. The print calls Bruegel the "Apelles" of his age and serves as a tribute to the reputation he enjoyed in the early seventeenth century, though of course the subject is vulgar and the large figures are distorted by their rage.[65] This brawl is the result of a game of cards, now scattered all over the ground, and presumably of heavy drinking, since a large, empty keg stands in the lower corner. These large, round peasants are seen close-up and at eye level in their aggression, just as in the *Peasant Kermis* painting for festivity or the 1568 *Summer* drawing for labor (plate 284). These fighting peasants, however, are wielding peasant harvest tools as weapons: a flail and a pitchfork, even under restraint. Women, still in the same white linen caps, are also involved; one of them holds a drinking crock, but the other one attempts to intervene as peacemaker. Just as in the *Magpie* picture, the site in the background is a country village (with some small dancers in the painted

copies), though there is no sign of a special occasion or event like a wedding. This image readily and clearly conveys the negative view of peasants, drunk as beasts and given both to fighting (as well as flirting) as a result.

Also very much a part of the *The Magpie on the Gallows*, although easily overlooked in the shadows of the lower left corner, a final peasant figure is defecating beneath the same threatening gallows. This detail has drawn scholarly commentary, relating it to a Dutch proverb, "to shit on the gallows," already pictured in the upper right corner on the horizon of *Netherlandish Proverbs* (plates 186, 187). Of course, this assertion of natural body processes along with the manifest lack of politesse belong to the very essence of peasant life, conceived as the antipode to urban, civilized living. But at the same time, this act can be taken as a public disrespect for authority, represented by the punitive justice of the gallows, as in Bruegel's own *Justice* scene (plate 171). Contrasting to the gallows and linked to the cycles of nature in the watermill, the neighboring cross marks the place of a burial and suggests death as part of inevitable, but normal processes, like the seasons (or even like the detail of the corpse in the bushes before the path of the plowman in *The Fall of Icarus*, plate 110). Of course, the same cross could also be seen in the opposite manner, as a tomb resulting from harsh punishment by authorities, so this ambiguity ripples still more widely through the painting.

Bruegel's remarkable detachment from what could easily be a strongly editorial position echoes the interpretive difficulty—and the scholarly range of readings—from his Virtues prints series of 1559. It would be easy to choose to see him aligning against the authority of the gallows—either with the disdain of shitting peasant in the corner or with indifference of the celebrating peasant dancers peasants. Or one could take the vantage point of a civilized urbanite and see frivolity and folly in the peasant festivity itself (particularly when faced with the potential threat of judicial punishment) or baseness in their boorish body functions. Although most modern scholars want to view Bruegel as a Flemish patriot, siding with the natives in the countryside against their absentee landlords in Spain, this could easily be a modern viewpoint projected onto the picture.[66] The peasants' lack of respect for, or fear of, the authority represented by the gallows certainly could be viewed negatively, especially with Bruegel's loose association in Brussels with those who govern.

But the artist did keep this picture in his family. Karel van Mander's 1604 biography maintains that this particular picture was bequeathed by the painter to his wife:

II

BRUEGEL'S LEGACY

The several copies afte▨▨▨▨▨▨▨▨▨▨ *The Painter and His Clien*▨▨▨▨▨▨▨▨ ▨e continuing popularity▨▨▨▨▨▨▨▨ ▨ork and of the artist himself well ▨▨▨▨▨▨▨▨. Certainly it is fair to state that▨▨▨▨▨▨ ▨e to assume the same status as B▨▨▨▨▨▨▨ himself in his early career, na▨▨▨▨▨▨▨▨▨ tinctive and clearly recognizabl▨▨▨▨▨▨▨ themes that could be adapted▨▨▨▨▨▨▨▨t commercial success. Whereas ▨▨▨▨▨▨▨▨ of *Big Fish Eat Little Fish* had a▨▨▨▨▨▨ engraving in the form of an i▨▨▨▨▨▨▨s Bos," soon after Bruegel's own ▨▨▨▨▨▨▨ of landscape drawings appear▨▨▨▨▨▨▨s name. One of the principal tas▨▨▨▨▨▨g the past generation has been to ▨▨▨▨▨▨l forgeries, as well as deceptive ▨▨▨▨▨▨ ative adaptations from the mo▨▨▨▨▨▨y in the field of independent dra▨▨▨▨▨

Outright forgeries are fairly▨▨▨▨▨▨ lowers, but a cluster of landscap▨▨▨▨▨▨▨ 45) has now been convincingly ▨▨▨▨▨▨▨r

Flemish artist, Jacob Savery (c. 1565–1603) on the basis of a pair of similar drawings that he signed and dated.[1] For the most part, these works feature drawings of rocky mountain settings, sometimes punctuated with small castles or villages and occasional tiny figures progressing slowly through narrow passes. Most of these drawings are signed in block letters and dated between the years 1559 and 1562; previously they were regarded as the latest dated authentic Bruegel landscape drawings, and they do simulate the flickering effects of Bruegel's disciplined grammar of ink strokes.[2]

A representative image, larger in size and falsely signed and dated 1562, incorporates many of the main motifs of this series of convincing forgeries (plate 325). It includes, at the right side, small-scale figures who make their way up a steep mountain road with towering mountains behind them at the horizon. Across a river stands a small fortified castle at the foot of high cliffs. The careful draftsmanship comprises fine flecks applied consistently and delicately to evoke atmosphere as well as substances, but it lacks both the variety and energy of Bruegel's own technique, despite building upon his

323 *(pages 398–399)*
Joos de Momper(?)
Storm at Sea
Detail of plate 347

324 *(opposite)*
Peter Paul Rubens (1577–1640)
The Kermis, c. 1635
Detail of plate 344

325 *(below)*
Jacob Savery, (c. 1565–1603)
Rocky Landscape with Castle and River, 1562
Drawing, 7½ × 12¼ in.
(19.2 × 31 cm)
Graphische Sammlung,
Munich (Mielke A42)

330
Lucas van Valckenborch
Forest with Angler, 1590
Oil on panel, 18⅜ × 21⅞ in.
(47 × 56 cm)
Kunsthistorisches Museum, Vienna

peasants, ranging from a pig herder and two anglers to a group of walking peasants (one of them lame) with a little girl. While no single Bruegel model can be found, this Lucas van Valckenborch work conveys all of his earlier sentiment about the productive countryside and the harmony of Flemish peasants with local nature (though the cow has overturned her milk pail). It offers a nostalgic image of peace in a period of political disruption. The foreground zone includes carefully observed vegetation and presents a lowered horizon with tall trees, whose leaves extend well beyond the top of the frame. Meanwhile, the background construction juxtaposes a dark, closed distance at the end of a pathway on the left against an open vista at right, dominated by greens, with tall, slender trees dissolved in brighter light. Like several of Bruegel's late paintings (see chapter 10), a small vil-

lage and church steeple occupy the distant horizon at right, here seen across a pond.

One further Lucas van Valckenborch painting, a mature work of a *Forest with an Angler* (plate 330), now forms a true forest landscape, surely indebted to Bruegel's *Stream with Angler* drawing (plate 92). Moreover, this small painting also seems to grasp the purpose of Bruegel's independent landscape drawings, produced for their own sake as compositional exercises of convincing settings.[19] We note the compositional harmony of a tall tree, whose bough stretches across from the left side and echoes the rounded hill that rises on the right. But this remains an unpretentious work, filled with naturalistic details, particularly the foreground marsh grasses and the roots of the tree in the left corner, with little artifice of framing or recession. Even more than in Bruegel's forest drawings, *Forest with Angler* abandons

any inclination to make a dist░░░░░░░░░░░░te visual focus, though a hunt ap░░░░░░░░░░░░d. Only a few points of dappled l░░░░░░░░░░░ in miniature at the horizon, pro░░░░░░░░░░░n-templation of the dense darkn░░░░░░░░░░░ of the forest. Next to a hunter, s░░░░░░░░░░ he lower left corner, the one brig░░░░░░░░░░e, the well-dressed courtly angl░░░░░░░░░░░e-ground, whose face and white░░░░░░░░░░st

the darkness. He looks almost like a saint in private con-templation but shows full appreciation of his surround-ings. In addition, the angler, probably a self-portrait, turns to look out at the viewer, as if wishing to share his sportsman's personal delight in his activity and in the secluded site. Hunting and fishing also are noble pre-rogatives, which identify this landscape as a game pre-serve, something alluded to only marginally by Bruegel in his eponymous *Hunters in the Snow* (plate 275), but

331
Jan Brueghel (1568–1625)
Temptation of Christ, 1595
Drawing, 8 × 11 in. (20.8 × 28.1 cm)
Institut Néerlandais, Collection Frits Lugt, Paris

much more familiar to the later courtly role of Lucas van Valckenborch (see below for his *Seasons*).[20]

Among the most enthusiastic Bruegel followers, his son Jan Brueghel composed his own youthful *Temptation of Christ* (plate 331), near the end of his Italian stay. That image not only reprises and thickens the forest setting to fill the entire sheet but also retains the Gospel subject added by Cock for the 1554 etching.[21] This drawing already reveals the younger Brueghel's predilection for composing in tonal layers and contrasts, which he develops fully in his panel paintings during the following decade.

For example, his vertical *Forest Landscape* (plate 333) carefully prepares a study for a setting, to be filled in with figures, as in the case of his own later, painted *Temptation of Christ* (plate 332).[22] The study shows how much Jan derived from his father's imagery of thick forest, populated only with animals, though he makes subtle adjustments in his painted version. Jan manipulates color contrasts against the darker depths to emphasize foreground tree trunks and leaves. Animals here are quite small and only emerge upon closer inspection. The soft blue atmosphere of the distant mountains, visible through a gap at the left edge goes back to the color formula for distance of the sixteenth-century Flemish world landscape, exemplified in Pieter Bruegel's painted works by *The Hay Harvest* (plate 277). Many of these same qualities recur in the *Temptation* painting, but this work goes further in the distinctive direction of Jan's mature tonal harmonies, emphasizing richer blues and greens as well as successive layers of dark and light.[23] Artificial in comparison to Lucas van Valckenborch, Jan Brueghel seems to provide landscape primarily as a setting for his religious figures like his older Dutch contemporary, another Amsterdam émigré, Gillis van Coninxloo (1544–1606/7).[24]

As noted above (chapter 9), Bruegel can also be credited with the basic invention of the winter landscape, especially with skating scenes on the ice[25]—whether in a print design like the *Ice Skating before the Gate of St. George* (plate 44), in paintings such as the background of his *Hunters in the Snow*, or in his separate panel of *Winter Landscapes with Skaters* (plate 275), a work that was frequently copied by Pieter the Younger over the course of his long career.[26] We have also seen Bol completing the series of the Seasons for Cock with an engraved *Winter* (plate 276), featuring skaters across the entire foreground. Bruegel also buried the Epiphany within a Flemish village during a heavy snowstorm in his *Adoration of the Magi in the Snow* (plate 206).

332 *(above)*
Jan Brueghel
Forest Landscape with Temptation of Christ, c. 1605–10
Oil on panel, 24⅛ × 16⅛ in.
(62 × 41.5 cm)
Kunsthistorisches Museum, Vienna

333 *(opposite)*
Jan Brueghel
Forest Landscape, c. 1605
Oil on panel, 33⅞ × 12½ in.
(40 × 32 cm)
Kunsthistorisches Museum, Vienna

thematically reprises but physically reverses the main activities featured in Bruegel's own print design (plate 282) and possibly builds upon his missing image of Spring from the Months. In the tradition of calendar images of the month of May, it shows courtly couples in luxurious dress strolling through wildflowers and enjoying a picnic outdoors. They linger on the heights in the right corner, whence their view over formal gardens includes other small aristocratic figures, as the distance features the royal palace in Brussels,[28] before which a joust is under way. While Valkenborch's *Summer* (1585; Vienna) quite closely reprises Bruegel's *The Grain Harvest* (plates 261, 278) for July or August, his *Autumn* (1585; Vienna) once more mixes nobles with peasants at the wine harvest, an event usually associated with October.[29]

Dutch artists of the early seventeenth century also built upon the solid foundations of winter scenes established by Bruegel. Some artists, notably Hendrick Avercamp (1585/86–1634), specialized in this subgenre; in Avercamp's case almost exclusively on ice skaters.[30] More subtly, although not strictly a Bruegel invention, the institution of representing the seasons as a series of paintings and prints, detached from the realm of manuscript illumination, soon became a staple of visual imagery.[31] Perhaps closest to the model of Bruegel is the etched *Winter* (1617) from a series by Jan van de Velde II of Haarlem (c. 1593–1641), who also produced a twelve-print series of the Months in 1618.[32] As noted above, it too emphasizes an emphatically low horizon, visible at left, but also many other distinctive Bruegel features: the spindly, curving trees at right as well as the village with church tower and distant windmill. But Van de Velde even adopts Bruegel's earlier compositional structure from his *Wooded Region* (plate 104) from the Large Landscapes series.

A painting that deftly fuses the skater imagery with decorative use of Bruegel-inspired trees and compositional layout is *Winter* (plate 337) by the Middelburg artist Adriaen van de Venne (1589–1662).[33] Its prominent inclusion of well-dressed upper classes (as well as a background castle) and its emphasis on recreational activities instead of labors extend the tone of Lucas van Valckenborch's Seasons series; however, these works are now executed on an intimate scale for close examination of their artistic virtuosity, like the panels and coppers by Jan Brueghel.

Such upper-class imagery only serves to underscore how much Bruegel himself has always been associated with imagery of peasants in nature as an object

334
Lucas van Valckenborch
Winter/January, 1586
(detail)
Oil on canvas, 45⅝ × 77¼ in.
(117 × 198 cm)
Kunsthistorisches Museum, Vienna

All of these pictorial elements combine in Lucas van Valckenborch's *Winter* (1586; plate 334), part of a large-scale canvas series in emulation of Bruegel's *Months* (chapter 9).[27] Like Bruegel's compositions, this painting features a high panorama to an elevated horizon, viewed from a corner ledge, in this case at the lower left. Unlike *The Hunters in the Snow*, this image only looks across a village street and shows no distant peaks. Here peasants scurry home with firewood and provisions in the midst of a thick snowstorm, whose flakes fill the full viewing surface and intervene between the eye of the viewer and the scene in the background, as first conveyed in Bruegel's *Adoration of the Magi in the Snow* (plate 206); however, this village street also contains several aristocratic figures, seated in sleds on runners drawn by horses. This mixture of classes, already seen in Bruegel festive peasant settings (as well as later works by his son Jan for the ruling archdukes; chapter 9) recurs repeatedly in Valckenborch's *Seasons* and links his imagery even closer to the tradition of Flemish illuminated calendar pages than Bruegel's.

Especially Valckenborch's *Spring* (plates 335, 336)

335, 336
Lucas van Valckenborch
Spring/May, 1587
Full view and detail
Oil on canvas, 45¼ × 77¼ in.
(116 × 198 cm)
Kunsthistorisches Museum, Vienna

337
Adriaen van de Venne (1589–1662)
Winter from Four Seasons, 1617
Oil on panel, 6½ × 9 in.
(64 × 91 cm)
Worcester Art Museum
Charlotte E .W. Buffington Fund

of pictorial interest, especially in painting. We saw (in chapter 9) that Bruegel was by no means the first or only one of his contemporaries to focus on peasant subjects, even in painting (Pieter Aertsen), and that his interest emerged only after a prolific prior generation of German printmakers had already focused on such figures.[34] Yet from Van Mander's 1604 biography onward, Bruegel became the touchstone in Netherlandish painting for peasant subjects, particularly for his depictions of their festivity (sometimes relocated into tavern settings by his Dutch and Flemish successors).[35]

Hence it is hardly surprising that a group of nearly eighty sheets of figure drawings, primarily of peasants, laid down in brown ink (often over chalk) with delicate linework characteristic of Bruegel (compare the *Goose-herd*, plate 287), were readily attributed to the artist until only a generation ago. Known as the *naer het leven* (made "after life") drawings, these works were often considered studies made on site, compiled for later use—even annotated with specific inscriptions about color for costumes.[36] Their subjects chiefly comprised picturesque and exotic but also typical figures featured in Bruegel paintings: peasants, beggars, gypsies, soldiers.

Thus the elimination of this entire drawing group

from Bruegel's oeuvre in 19___ ___ ___ ___ of a
bombshell, when their reattri___ ___ ___ sly
advanced by two young sch___ ___ ___ and
Frans van Leeuwen; their da___ ___ ___ on
general consensus (excepting___ ___ ___ con-
sidered a Bruegel original si___ ___ ___ In
fact, the handwriting itself an___ ___ ___-
ing became criteria of judgm___ ___ ___ he
convincing reassignment of t___ ___ ___ ry
(1578–1639), as did the discov___ ___ ___ th
costume expressly stemming f___ ___ ___ av-
ery worked at the imperial cou___ ___ ___ a-
sional specific relationship to ___ ___ ___ as
not coincidental, but now inst___ ___ ___ i-
nary studies from life by Brueg___ ___ ___ of
these works are taken to be car___ ___ ___'s
existing repertoire of figures, s___ ___ ___ s
of individuals within his crow___ ___ ___ k
spectator from within *Christ C___* ___ ___).
Yet most of the drawings do s___ ___ ___l
notebook of unusual figure ty___ ___ ___d
from observations—even in th___ ___ ___d
of sketchbook for humans and ___ ___ ___d
an unusual practice.[39] These fig___ ___ ___s,
ants, should be compared to Sa___ ___ ___-
ful, close-up studies of trees a___ ___ ___n
Alps.[40] What is not clear is wh___ ___ ___
these works to be mistaken fo___ ___ ___
the forgeries of his older broth___ ___ ___
extreme, to be understood as a ___ ___ ___
very least, this close and symp___ ___ ___
ant life, even animals, from life ___ ___ ___
next logical step in a process of s___ ___ ___
"from life."[41]

A striking example of the Save___ ___ ___
Two Bohemian Peasants (plate 338___ ___ ___
and the phrase "naer het leven,"___ ___ ___
fully linked to a figure in anothe___ ___ ___
pendent drawing *Four Peasants u___ ___ ___
This pair shows stout bodies, se___ ___ ___
pulled over eyes) and from behi___ ___ ___
later peasant figures, for example___ ___ ___
of 1568 (plate 284). But their dis___ ___ ___
other costume details reveal thei___ ___ ___
rather than Flanders and rule out___ ___ ___

Of course, the life of peasant___ ___ ___
influential legacy of Bruegel to___ ___ ___
of artists. A spectacular drawing___ ___ ___
(plate 339) that extends the spati___ ___ ___
kermis prints of 1559 (plate 263) ___ ___ ___

Vinckboons, another émigré artist (1576–1630/33) from
Mechelen who moved via Antwerp to Amsterdam.[43] We
have already met Vinckboons through his drawing that
reworked Bruegel's *Peasant and Bird-Nester* for an etch-
ing of 1606; this drawing, too, like many Vinckboons
designs, was engraved by a professional printmaker-
publisher, Nicholas de Bruyn. Compared to Bruegel,
the crowd is even larger and more densely packed into
an open square, flanked at left with a tavern and framed
at right by an undulating tree in silhouette. Unusually,
in the center of Vinckboons's setting stands an ornate
and tall castlelike building, probably a town hall like
some extant fifteenth-century Flemish examples (Lou-
vain, Oudenarde, Bruges).[44] Among the tiny figure
groups many of the same activities have been adopted
from Bruegel: eating and drinking at table, fighting and
dancing to bagpipes, children playing acrobatic games,
and well dressed city visitors standing and observing
everything. The middle ground is filled with the stalls

338
Roeland Savery (1576–1639)
Two Bohemian Peasants, c. 1605–10
Pen and brown ink and black chalk;
framing lines in brown ink, 5 15/16 ×
7 3/8 in. (15.1 × 18.8 cm)
Cleveland Museum of Art,
Purchase from the J. H. Wade Fund

339
David Vinckboons (1576–1630/33)
Village Kermis, 1602
Drawing
Statens Museum for Kunst,
Copenhagen

of a festival market as well as an outdoor comic stage performance. In the far right distance at the horizon, another archery contest takes place above a windmill. Using tinted washes to organize his space, Vinckboons, like Jan Brueghel, alternates bright and shadowy layers in depth. This drawing compels the same careful inspection and admiration of virtuoso handiwork in the control of such numerous figures crowded together within a vast, yet well articulated, open-air arena. It should be noted as well that Vinckboons, in a kind of inversion of social condescension toward peasants as subjects, also designed a number of equally encompassing views of castle gardens devoted to representing festivities of the rich, such as his contemporary *Feast in the Glade*.[45]

Also like Bruegel, Vinckboons produced some images of peasant festivity with a lower point of view. His *Village Kermis* (1603; Morgan Library and Museum, New York) clearly an independent, finished drawing, is articulated

with applied washes to provide strong shadows and silhouettes as well as added colors for the costumes of the dancing figures.[46] Its later painted complement offers an even more inclusive and populous setting for his Dresden *Village Kermis* (plate 340).[47] In that work the viewpoint is slightly elevated, which still provides a measure of viewer detachment, like Bruegel's kermis prints of 1559. Typical of Vinckboons, the village panorama is punctuated by richly articulated trees and foliage. The varied activities remain the same, but now they emphasize more social distance and a harsher tone toward peasant excesses than in Bruegel. Such an outlook is confirmed by an inscription added to a Vinckboons print, which clearly expresses a critical outlook toward peasants at celebrations.[48] Details in the painting expressly underscore peasant misbehavior, and there is no longer any sign of religious events other than the banner of the saint (St. George or Sebastian) hanging in the right foreground

above a tavern. While the bac[...]ures, crowded around market [...] door performance, cruel by n[...] "tug the goose," in which the ne[...] grabbed at by passing horseme[...] cessfully throttles the animal.[49] [...] picture starts in center foregrou[...] of small figures in bright costu[...] To their right the tavern hosts [...] drinkers and flirting couples ur[...] ner of the saint, as in Bruegel's n[...] corner a child has dropped his tr[...] decorum. Opposite at left a sma[...] in which patrons are departing [...] is already vomiting in the left c[...] on the other end of the boat in [...] woman pointing, like the two fig[...] in a boat in *Big Fish Eat Little* [...]

instruction—or warning—about the ways of the world. Behind that boat a ragged beggar with a hurdy-gurdy stops at the door of a ramshackle inn, and other beggars cluster there. Thus Vinckboons includes something of the social variety of *Carnival and Lent* in his later Dresden *Kermis*, but all of the festive figures in the painting are presented as the butt of his sharp social criticism of their misbehavior.

Shortly afterwards Vinckboons also produced a small panel isolating a principal beggar motif: *Blind Hurdy-Gurdy Player* (plate 341), one of several such images by him, which emulate the harsh naturalism already seen in Bruegel's 1568 *Beggars* (plate 309).[50] In that work within another village, seen at eye-level, the dark-clad central figure, led by a small dog, is not a subject of pathos, as modern viewers might view the handicapped, but rather an object of scorn and mirth, followed by jeering children. Leafless trees show that the climate verges on

340
David Vinckboons
Village Kermis, 1603
Oil on panel, 20¼ × 35⅝ in.
(52 × 91.5 cm)
Staatliche Kunstsammlungen,
Gemäldegalerie Alte Meister,
Dresden

341
David Vinckboons
Blind Hurdy-Gurdy Player,
c. 1606–10
Oil on panel, 13⅛ × 24⅜ in.
(33.8 × 62.5 cm)
Rijksmuseum, Amsterdam

winter, and the pig slaughter in the doorway at right is another sign of the changing season, as in *The Hunters in the Snow* (plate 275).

The biography of Vinckboons, like those of Jacob Savery or Hans Bol, exemplifies the disruptions suffered by artists in the political turmoil of the Dutch Revolt, particularly around the 1585 fall of Antwerp to Spanish forces led by Alessandro Farnese.[51] After that time, the resulting religious reaction, intolerant to Protestant creeds, resulted in the emigration of a number of artists to the Northern Netherlands, particularly to Amsterdam, but also to Middelburg near Antwerp.[52] Both Bol and Vinckboons were raised in Mechelen and then moved to Antwerp, not only because of greater economic opportunity but also for safety, because rebellious Mechelen was sacked by Alba in 1572 during the "second Revolt." Jacob and Roeland Savery were born in Kortrijk, but Jacob trained with Bol in Antwerp in the early 1580s. In 1584 Bol departed for Amsterdam, followed by Jacob's move to Haarlem in 1585, then Amsterdam, in 1589, where Roeland joined him. The younger Vinckboons, born in Mechelen only in 1576, also moved with his father first to Antwerp in 1580, and after 1586 to Amsterdam.

With this profound dislocation and with their elective affinity for the Dutch Revolt, we can readily understand

a particular sympathy among these artists for peasant suffering as a symbol of national trauma. The cruelty of soldiers had already shaped Bruegel's staging of a religious depiction, the *Massacre of the Innocents* (plate 235), a work that was copied carefully in many versions during the next generation; but he (and/or his workshop) also initiated this subject as a non-religious theme with his 1567 signed *Peasants' Distress* (see plate 312).[53] Once more Vinckboons too became an active formulator of this theme in both prints and paintings; indeed, he designed a series on this theme consisting of four images, concentrating on large figures crowded in a limited setting at eye level. Engraved (1610) by one of Rubens's favored engravers, Boetius à Bolswert, the quartet of prints follow a sequence of events (anticipating Jacques Callot's 1633 *Miseries of War* etchings). They carry the following titles: *Forced Entry* (where the soldier with halberd kicking down the door of the peasant hut repeats the posture shared in Bruegel's *Massacre* and *Peasant's Distress*); *The Peasant Tyrannized* in his own home; *Peasant Joy*, *The Expulsion*, a revenge scene; and finally, Reconciliation between Peasants and Soldiers under a tree outside a tavern.[54] Both Fishman and Lammertse emphasize the connections between Vinckboons and the literary circles of the *rederijkers*, whose plays also engage the theme of exploitation of peasants by occupying soldiers.[55]

Moreover, Jacob and R[...] also made images—drawings and pain[...] of [...] Distress, particularly through pa[...] views of villages being plundered; for examp[...] Jacob Savery's *Village Plundered by Cavalry* (plate 34[...] [...]ed village view of Valckenborch'[...] winter snowfall or Vinckboons's festive summ[...] into a scene of looting and pillage, where live[...]ck is being herded and staples are being appropriated[...] the tavern (whose sign ironically bears a crown) a[...] onto wagons.[56] This delicately tinted indep[...] drawing features carefully delineated small figu[...] delicate leafless tram[...]ing tree boughs, and a diagona[...] view into distance from the lower right corner—transf[...] Bruegel's country idyll into turmoil.

Not only painters from the [...] Netherlands depicted the Peasants' Distre[...] a versatile Antwerp painter, known as a specialist i[...] scenes as well as a member (after 1626 captain) of the local militia guild, Sebastian Vrancx (1573–1647) [...] showed peasants victimized by cavalry un[...] [...]. His solo pictures often employ an old-fashioned [...] horizon to show his conflicts unfolding across spac[...] Vrancx also collaborated with other Antwerp artis[...] providing figures for Jan Brueghel and others.[58] In [...] such collaboration, *Attack on a Convoy* (plate 342), [...] created during the temporary truce of the Dut[...] [...]. Jan painted the setting, again empl[...] an open expanse, flanked by forest, with the th[...] color formula—to move from bright and varied c[...] in the foreground to a green middle ground to a lu[...] blue-white atmospheric distance at the high hor[...]. This image essentially updates Bruegel's 1567 *Peas[...] [...] by showing smaller victims, figures systemat[...] reduced in scale as the eye gazes farther into distan[...] Vrancx's figures fully retain the earlier violence, [...] into costumes of peasants immediately d[...] the [...] to scenes of physical cruelty dispensed either [...] mounted cavalry or armed infantry. As in Bruegel's [...] disperses on the *Gallows* (plate 317), a tall roadside cr[...] appears in the right middle distance, and on closer inspection a gallows with bodies still on it—appears i[...] the left distance, just before the blue horizon zone.

Bruegel's long-term influence on Flemish painting—besides the adaptations of his ide[...] son Jan into the next generation—can still be felt [...] the work of Antwerp's greatest painter, Pe[...] Paul Rubens (1577–1640).[59] A less well-known compo[...] by Rubens survives in an initial ink sketch (Lu[...] Collection, Institut Néerlandais, Paris) but also elabo[...] into an engraving

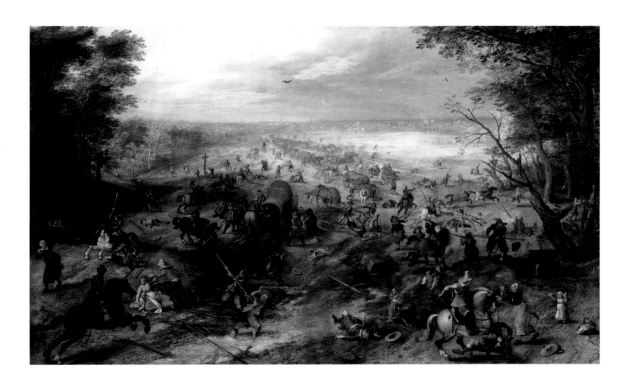

342 *(above)*
Jan Brueghel and Sebastian Vrancx
(1573–1647)
Attack on a Convoy, c. 1612
Oil on panel, 21⅝ × 33⅛ in. (55.5 × 85 cm)
Kunsthistorisches Museum, Vienna

343 *(below)*
Jacob Savery
Village Plundered by Cavalry,
before 1602
Drawing, 14¾ × 20½ in. (37.6 × 52.4 cm)
British Museum, London

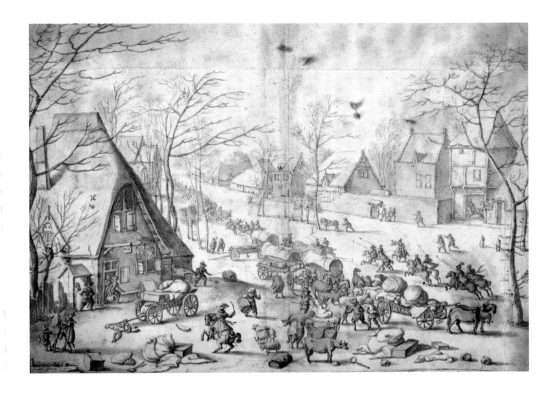

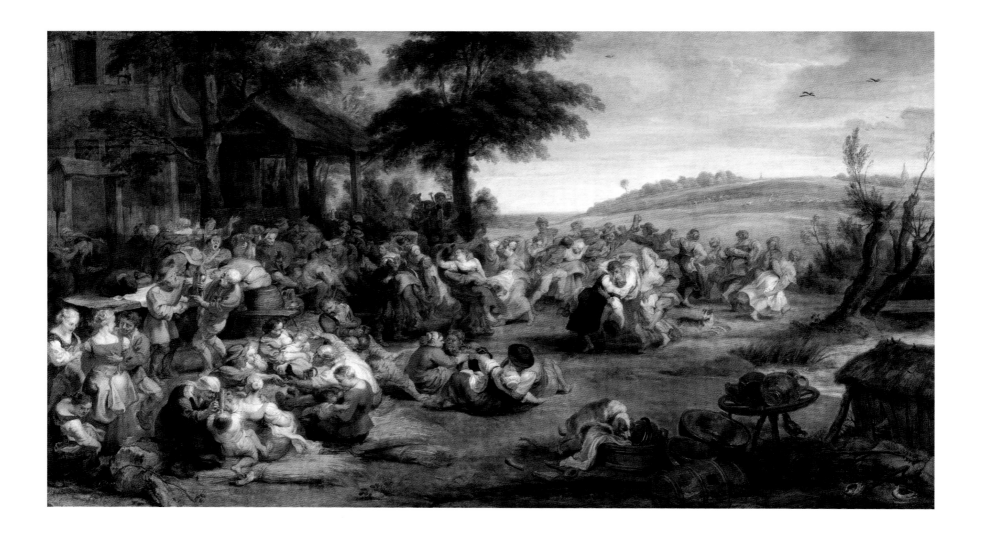

by Frans van den Wyngaerde after a lost late painting, shows *Soldiers Carousing*.[60] In fact, this is a Peasants' Distress image, painted in Rubens's retirement by an artist patently nostalgic for an era of peace after his frustrating diplomatic career spent with international royalty in the attempt to secure truces or even wider peace within the Thirty Years' War. Like Vinckboons's images of the peasants beset in their cottage by billeted troops as well as reconciled to their enemies at an outdoor tavern in the denouement of conflict, Rubens shows a crowded table in a village, but now its customers are soldiers, dressed in the old-fashioned slit "Swiss" costumes of the previous century. These soldiers strong-arm their unwilling peasant "hosts," not only for food and drink but also for their women, whom they freely embrace. In the center of the composition, slumping at table while he hoists a glass of wine, one of those infantrymen (*Landsknechten*) looks out at the viewer while he rests his enormous

battle-sword on his shoulder.[61] But behind him a pair of his comrades-in-arms scowl and threaten the peasants with halberd and sword, showing that violence lurks just below the surface even in this traditionally festive setting.

Rubens in the 1630s, newly remarried and retired to a country estate (purchased in 1635), Het Steen near Antwerp, repeatedly strove to recapture an image of peace and prosperity, which he recognized in the kermis scenes and landscapes by Pieter Bruegel. For decades, Rubens had painted in the classicizing international style for Counter-Reformation Catholic churches, and he adopted subjects of mythology or allegory for ruling kings. During his final years, however, Rubens began "painting in Flemish," as Svetlana Alpers aptly describes his final Indian summer of creativity.[62]

Perhaps his most obvious homage to Bruegel's legacy and reaffirmation of his delight in his Flemish

countrymen is Rubens's ow_____ (____.4), which has sometimes been c_____ ____ cele- bration. No banner singles it_____ _____ no church is visible except at the _____ ____ _____ but neither does any dark-clad bri_____ _____ ____ its panoramic expanse. Inste____ ___ ____ of the unmatched energy of Rub_____ ____ ____ ___ dance in the right middle zon_____ __ ____ _le outdoor table by a tavern on t_____ _____ _re range across all forms of phys_____ _____ __ng a left foreground scene where____ ___ _____ __ __n- kard to a young child (embo_____ ___ _____ _____ "as the old pipe, so the youn___ ____ __ _____ __h- ion, Rubens stresses eroticism___ ____ ____ ___ is crowded scenes at eye level, _____ __ ____ ____g explicitly indecorous physical e_____ _____ _____ nursing, pissing (in the lower___ ____ ___ _____l cases of drunken stupor on the____ _____ ____ _____ ants become a spectacle in thei_____ ____ ___ ___- tant from their urban or nobl_____ _____ _____ __ painter himself, in both roles). ___ _____ _____ __ the depicted mingling of nobl__ __ ____ ____ peasants at festive occasions, as _____ __ ___ ___ for the archdukes Albert and Isa_____ ___ ____

Rubens, in short, raises all o_ ___ _____ questions surrounding Bruegel_ ____ __ _____ whether they are negative role ____ __ _____ folly, or even sin, or else simpl__ ___ ____ ____ offering a positive, primal altern____ __ ____ ___ complexities? Clearly Rubens de___ ____ __ ___ viewpoints. Thrice knighted an_ _____ __ _ __ that Nicolaes Jongelinck could ____ ____ __ __ ___ artist-diplomat also clearly stoo_ ____ ___ ____ above Flemish peasants than Bru___ ___ __ ___ inevitable condescension in thi ____ __ __ tive peasants. But it is equally un_____ ___ ____ the great artist of the body and ____ __ ____ (especially in his late work), als_ ___ __ ___ vitality and energy of these peas___ ___ ____ ___ abides especially in their dance, v___ ___ __ ___ subject of his preparatory ink dra___ ___ ____ British Museum), with its them_ ___ ____ ___ twirling dancing couple. Rubens a____ ____ __ ___ decorous, isolated version of a P____ ____ ___ Madrid), with intricate compositi___ ____ __ __ nified grace of the couples, includi__ ___ ____ suggesting the classical god of wi__ ___ ___ __ freely translated the exuberance o_ ___ ____ to the actions of mythological saty___ ____ __ __ contemporary *Feast of Venus* (c. 16___ ___ ____

Museum, Vienna). So Rubens here maintains a kind of physical empathy for the earthiness of these peasants, who are almost literally equated with the land that Rubens in country retirement proudly called home.

Those very freedoms and seemingly timeless pleasures of peasants within the fullness of nature—beautifully realized by Rubens on the right horizon of the painting with a green expanse to hills and sky—still remained threatened by the devastation of war more than two generations after the death of Bruegel. At the same moment Rubens was clearly revealing his own personal anxiety about his region through a learned, elaborate decorative program that he designed for the triumphal entry of a Spanish regent, the Cardinal-Infante Ferdinand, brother of King Philip IV of Spain, into Antwerp in April of 1635.[63] There Rubens used classical rhetoric to signal the sad plight of Antwerp by showing the departure of Mercury (plate 242), god of Commerce, from the city; he also showed the opening of the Temple of Janus, Roman symbol for a state of war.[64] Thus—especially when seen against his own, contrasting image of the Peasants' Distress, the lost *Soldiers Carousing*—it is plausible to see Rubens's return to imagery of peasant festivity as nostalgia for a lost halcyon period of local prosperity and peace. Bruegel imagery has become the seed pearl for Rubens's later Flemish nostalgia.

Rubens also emulated the Bruegel legacy in his own later attention, relatively rare for the artist, to landscape, especially with a Flemish appearance.[65] After his move to Het Steen, he returned to Bruegel imagery for his own version of the Large Landscapes or Months. Consensus has emerged toward the theory that two grand Rubens panels of similar size, *Landscape with Chateau Het Steen* (plate 345) and *Landscape with Rainbow* (plate 346), were once joined in a single great panorama. The *Het Steen* image not only features the chateau framed by trees at the left edge and peasant carters in the lower left corner, but it also is laid out according Bruegel's earlier compositional structure, which follows the gaze of a hunter with rifle to a diagonal recession toward the right. The setting slopes down in a series of gentle hills, marked by lines of trees, toward the horizon at the middle of the panel on the right. This picture also retains the Flemish three-color landscape convention of world landscapes from the previous century, as it recedes with tones ranging from browns to green to a thin line of blue distance.[66] But like Rubens's *Kermis*, *Landscape with Het Steen* is laid out within a strong horizontal format, reinforcing its effect of panoramic breadth.

That same proportional breadth is shared by *Landscape*

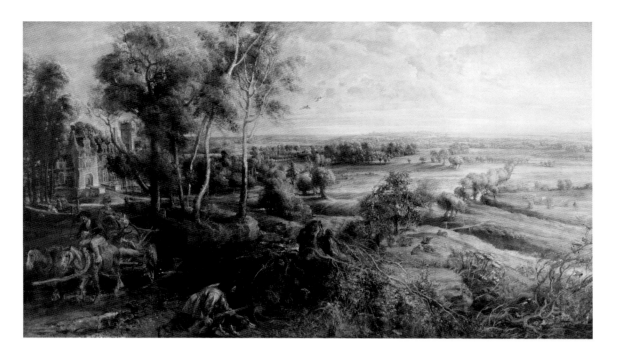

with Rainbow, which joins neatly at its horizon and presents a complementary recession from the right corner forest along a stream filled with ducks to the open, shared left horizon halfway up. However, *Landscape with Rainbow* looks more self-contained, because from the left corner a second orthogonal is created by the inward facing hay wagon that recedes into depth along a line of grain and a pitted mud road. Yet even here a kind of balance pertains between the works: the peasant cart in *Het Steen* moves out of the image at the left, whereas the hay wagon in *Rainbow* moves into the picture space at the left.

The contents of these two landscapes are revealing. *Het Steen* presents not only the estate manor home but also seigniorial activities: a foreground hunter stalks birds in the brambles of the center foreground, as a small cluster of well-dressed spectators stands in the shadows of the trees near the building facade. Near the join of the two figures at the right edge a tiny group of milkmaids complements the foreground carters with their calf and creates an overlap of husbandry with the field activities in the *Landscape with Rainbow*. That work's agrarian emphasis forms a fitting complement to the *Steen* estate management center, so while it is unlikely that Rubens imagined a cycle of multiple images like Bruegel's (or Valckenborch's) Months, these two summer landscapes deftly balance each other. Moreover, the evident sunrise in *Het Steen* ends with the return of some workers from the fields and a visibly advanced hay harvest beneath the *Rainbow*.

In relation to Bruegel, the *Rainbow* presents one more direct homage by Rubens. As noted, it includes both hay harvest and the promise of grain harvest soon, combining Bruegel's two complementary images from the Months. The trio of peasant figures, two women and one man, who stride out of the landscape against the movement of the hay wagon in the foreground center, echoes the trio of young women with rakes in the same location within 1565 *The Hay Harvest* (plate 277) and thus suggests that somehow Rubens knew that exact image or a copy after it.[67] In the foreground center Rubens includes a herdsman with a large cluster of cows, productive farm animals that he had studied in drawings and featured in several earlier images of farms, just as Bruegel's 1565 *Return of the Herd* had first emphasized the importance of cows in painting of the Low Countries.[68] All of the brightly colored peasants in these pendant paintings are sturdy, stout, and strong, suggesting their own positive link to the productivity of the land itself.

Concerning man and nature, one last topic of lasting

345 *(top)*
Peter Paul Rubens
Landscape with Chateau Het Steen,
probably 1636
Oil on panel, 51⅛ × 89⅜ in.
(131.2 × 229.2 cm)
National Gallery, London

346 *(above)*
Peter Paul Rubens
Landscape with Rainbow, c. 1636
Oil on panel, 52⅞ × 91⅝ in.
(135.6 × 235 cm)
Wallace Collection, London

influence may be attributed ████████████ ████ine
painting, including images ████████████ ██s.[69]
Bruegel's chief contributio███████████████ ██ his
eleven prints of ships and o██████████████le,
besides his painted *View of* ████████████bu-
tion disputed) and *The Fall o*███████████ his
major role in formulating thi██████████████lly
credited, except by specialist█████████████g,
formerly considered an auth████████████████ an
unfinished last work), but n███████████████er
imitation, features just such a ███████████████m-
pest: *Storm at Sea* (plate 347).███████████████m
unfolds on vast open water w█████████████ty
skyline, marked after a clearin████████████ a
church tower. Such a harbor d████████████al
in several Bruegel images, fro███████████ip
in his *Dutch Hulk* engraving. █████████████s
and skyline also form the prin████████████is
drawing of the *Stormy River Sc*███████████e
43). In the *Storm at Sea* the co██████████████ of
the massive, curving waves, w███████████████-
sels, resists any sense of visual ████████████or
the horizon, to set up what Go█████████████-
solvable tensions between hop█████████████d
death, calm and storm."

The subject of *Storm at Sea*, e███████████-
mann, concerns the threat pos████████████y
by the storm itself but also by t███████████t
looms beside it.[72] Yet in an act ███████████e
is easily distracted by a barrel, ██████████████
the ship, which then is left free ██████████████
port—and by allegorical extens████████████
church. But the picture's genera████████████
passing danger to not just one ███████████
be equally appropriate for a con████████████
even a potential political referen███████████
the image was painted) to the ██████████████
Dutch Revolt—the more so bec████████████
of shipping to both the comme██████████████
being of the Netherlands.

As Goedde makes clear, desp██████████████
creation of the Vienna panel afte███████████
Bruegel, the artist surely still sta██████████████
no definite model survives by his█████████████
addition to the Vienna *Storm at* █████████████
sions of seastorms were painted b████████████
ghel already during his time in Ita█████████████
Landscape with the Sacrifice of Jon█████████
the Sea of Galilee (1595; Ambrosia█████████████
both painter and printmaker Piet█████████████

careful study of ships and the sea into the pictorial reper-
toire, whether as part of some biblical or mythic subject
or as an independent picture, in fair weather or foul.[74]
The same kind of subtle cues also led Jan Brueghel and
others to develop the subgenre of forest landscapes out
of a few Bruegel models (see above). In addition, the
same kind of full-scale development of a new type of
painted landscape occurred when Jan developed river-
sides from his father's drawing oeuvre into a subgenre
of painted settings.

One other painted work has been relegated to the
limbo of uncertain attribution: a multifigure *Adoration
of the Magi* on canvas (plate 349); however, its ultimate
originality as a Pieter Bruegel design is surely confirmed
by a host of close copies after it by both Pieter the
Younger and Jan Brueghel (plates 349, 350).[75] Its canvas
support and distemper medium were a specialty of the
city of Mechelen (compare Hans Bol, above) and par-
ticularly of Bruegel's eventual mother-in-law, the wife
of his master, Pieter Coecke van Aelst, Mayken Verhulst
(see chapter 2), so, if accepted as authentic, this image is
usually dated early in the artist's career as a painter. How-
ever, if not assumed to be early because of the medium,
the tall, slender figures of the image and their crowding

347
Joos de Momper (?) (1564–1635)
(formerly attributed to Pieter
Bruegel)
Storm at Sea
Oil on panel, 27¾ × 37⅞ in.
(71 × 97 cm)
Kunsthistorisches Museum,
Vienna

suggests comparison with other religious works of the early 1560s (see chapter 7) in both paintings and prints.

Seen from an elevated point of view with a high horizon, it features a central stable, behind which can be surveyed exotic animals—several camels and an elephant as well as many horses—plus a crowd of slender, small-scale, full-length figures in imagined Middle Eastern dress (including gypsies below the elephant). The holy figures appear at the lower center of the image: Mary and the Christ Child, marked with small haloes, are seated under the projecting thatch, receiving the kneeling homage of the oldest magus like enthroned royalty. Joseph stands alone in the shadows, directly behind them, hat in hand. The kneeling black magus is overlapped behind the corner supporting post of the stable.

As usual, Pieter the Younger makes literal copies after his famous father (e.g. plate 348 after plate 206), whereas Jan Brueghel adapts, combines, and creates a new composition. His *Adoration of the Magi* (plate 350) moves around many of the figures from the canvas and even includes others merged out of other Bruegel scenes. For example, the conversing St. Joseph and his companion,

348 *(left)*
Pieter Brueghel the Younger
Adoration of the Magi (after plate 206)
Oil on panel, 14 × 21⅞ in.
(36 × 56 cm)
Musées Royaux des Beaux-Arts
de Belgique, Brussels

349 *(below)*
Pieter Brueghel the Younger
Adoration of the Magi in the Snow, 1595
Oil on canvas, 48 × 62¾ in.
(123.2 × 161 cm)
Philadelphia Museum of Art;
The Bloomfield Moore Collection

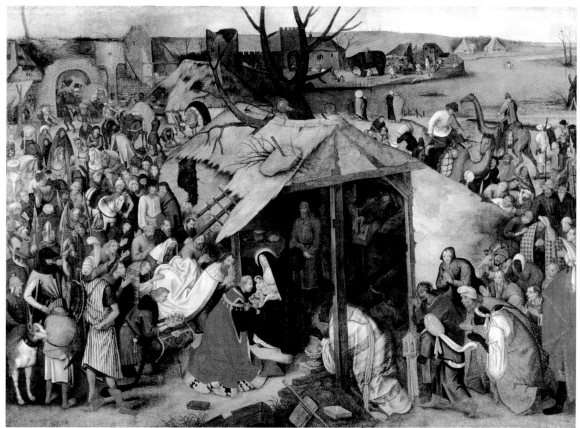

350
Jan Brueghel
Adoration of the Magi, 1598
Oil on copper, 12⅞ × 18¾ in.
(33 × 48 cm)
Kunsthistorisches Museum, Vienna

as well as all three magi figures and their armed retinue come from the elder Bruegel's 1564 London *Adoration* (plate 200). The *Gooseherd* figure from the Dresden drawing (plate 287) appears together with a bagpiper on the right edge of the stable. Additionally, although stripped of any ominous overtones, turbaned figures who peer out of the window and door behind the holy figures seem to stem from the original (or one of the many copies) of Bosch's Madrid *Adoration of the Magi* (plate 204).[76] The ass in the stable has been eliminated, though it is common to both the Brussels canvas and the copies by Peter the Younger; however, the large mastiff in the lower left corner is shared by all three artists. In effect, the sheer density of the converging crowd offers a testimony to the holy figures as the spiritual center of

the earth, located in Jan's version below the glowing star of Bethlehem in the sky above the stable.

For the most part, Bruegel's religious pictures did not find immediate followers except with his sons, although Valkenborch held a special fascination for the *Tower of Babel*, of which he made repeated versions, beginning with the small panel in Munich (plate 241), which omits the figure group around Nimrod like Bruegel's own smaller Rotterdam panel. We have already seen that several religious works by Bruegel were literally copied by Jan, such as the *Preaching of John the Baptist* (versions in both Basel and Munich, 1598; plate 225), and Jan also made an adaptation of that composition, rendering it as a *Sermon on the Mount* (plate 351) in virtuoso miniature scale on copper.[77] As was the case with his modification

of the *Adoration of the Magi* ca[...] figures, wearing bright costume[...] ishly contemporary, crowd toge[...] forest landscape. Several of the [...] pest painting were retained, inclu[...] and the foreground gypsy fortun[...] others have been added, such as [...] right. As befits Jan's own image[...] ing peasant festivities, here he in[...] temporary upper-class urban visi[...] the three-color construction, Jan[...] of Jerusalem as a coastal town in [...] the right. In this case, finding Chr[...] tion of John the Baptist becomes [...] just beyond a foreground shadow[...]

Because of what the subject of John the Baptist Preaching implied about prophetic utterance and adherence to the Gospels, it enjoyed considerable afterlife, among painters at the turn of the century in both the Catholic South as well as the Protestant North Netherlands. Abraham Bloemart of Utrecht, a Catholic (c. 1595–1600; Rijksmuseum, Amsterdam), plus Cornelis van Haarlem (1602; National Gallery, London), and David Vinckboons in Amsterdam (c. 1610; Rijksmuseum) all produced Dutch versions of the subject, always adapted to the stylistic predilections of individual artist.[78]

One of many other Jan dialogues with the works of his father consisted of his own variations on the lost, multifigure *Crucifixion*, seen above in the (presumably more literal) copy by Pieter the Younger (see plate 219).

351
Jan Brueghel
Sermon on the Mount, 1598
Oil on copper, 10⅜ × 14⅜ in.
(26.7 × 36.8 cm)
J. Paul Getty Museum, Los Angeles

352

Jan Brueghel

Crucifixion, c. 1595

Oil on copper, 10⅛ × 13⅝ in.

(26 × 35 cm)

Kunsthistorisches Museum, Vienna

One of Jan's early masterworks, from the same crucial moment of 1598—the year after his admission to the Antwerp guild—his Munich *Crucifixion* (variant in Vienna; plate 352) also incorporates elements from the prior great Pieter Bruegel Gospel panorama, *Christ Carrying the Cross* (plate 8), such as the swooning Virgin amid holy figures on a foreground hill at left (and even horse skulls of a horse on the corner hillsides).[79] Jan still makes respectful use of Peter the Elder (combined with exposure to a major multifigure *Calvary* drawing by Albrecht Dürer, a model for the three crosses), which indicates his continuity with the ongoing Netherlandish tradition, just as we saw Pieter Bruegel himself doing relative to his predecessors, all the way back to Rogier van der Weyden but also making careful use of the Calvary scenes from the previous generation (see chapter 1). Yet Jan has reduced the scale of his father's model and adapted his medium, his forms, and the content of his religious work to the mentality of his own turn-of-the-century era, dominated by wealthy, often noble, collectors. Their fascination for colorful, miniature details within a vast, masterful landscape calls for a balance between painterly virtuosity by a visibly innovative artist and his adaptation of recognizable picture types.

It has seldom been noted that [illegible] *Suicide of Saul* (plate 213) also fou[illegible] work, a *Battle of Hebrews Against A*[illegible] This work, as often is the case w[illegible] adapts the pictorial model of his fa[illegible] Amalekites, perennial hostile enem[illegible] already been used as the instrumer[illegible] ment of the first king of Israel, Sa[illegible] which was expressly captioned wit[illegible] cal citation in order to avoid confu[illegible] earlier or later biblical battles, even [illegible] esis.[80] Jan, in fact, chooses an ear[illegible] the history of the Hebrews, uncapt[illegible] through the praying figure on the [illegible]

hillside at the upper right. There above the battle, as with Pieter's Saul, the leader of the Hebrews, Moses, raises his hands in prayer, surrounded by two stalwart companions, Aaron and Hur, on either side. Thus this scene is identified as the moment at the battle of Rephidim (Exodus 17:8–16) before the epiphany on Mount Sinai, when Moses maintains divine support in the battle as long as his own arms are upraised, in this case aided with human support from his lieutenants. Thus in the end the Hebrews, led by Joshua, defeat their mortal enemies through the agency of human leadership, so they are supported rather than abandoned by God during the heat of this battle. Jan Brueghel has revised his father's model (with its own possible contemporary

353
Jan Brueghel
Battle of Hebrews against Amalekites;
after 1602
Dresden, Gemäldegalerie

politico-religious charge) into a positive image of religious generalship, a topic all the more meaningful within the intensified, ongoing strife of the Dutch Revolt.

As a final example of Jan's dialogue with his father's religious compositions, his own large panel, *Harbor Scene with Christ Preaching* (plate 354), might initially seem utterly different from any precedent.[81] As we have come to expect from Jan Brueghel, this is an impressively expansive landscape setting, framed by a tall, dark forest at the left and seen from an elevated viewpoint along a shoreline to a horizon with distant blue mountains. At first glance the crowded figure scene that dominates the image from the foreground into the harbor at the middle distance includes mixed social groups (still including gypsies and turbaned Asians in the background crowd), dressed in their varied costumes, but especially prominent are a pair of ladies in colorful, full-length dresses, surrounded by dark-suited gentlemen. The action in front of the ladies seems to focus around a fish market, featuring foreground distribution of the catch, rendered with all of the meticulously precise naturalism for which Jan Brueghel would become renowned.[82]

But as with some of the compositions by Pieter the Elder, an attentive viewer will eventually discover—off center and in the distance—a religious subject for the picture (compare *Census at Bethlehem*, *Conversion of Paul*; plates 230, 237). In Jan's Munich panel a crowd turns toward the preaching figure of Christ, a tiny figure with a tinier halo, who stands with apostles in one of the larger boats near the center of the image. In fact, this moment has been identified as Christ's conversion of his first apostles while a "fisher of men" (Mark 1:16–20; Luke 5), but this could also be the shoreline moment along the Sea of Galilee of his very first parable (Matthew 13:3–8), already included, but hidden, near the right edge of Pieter the Elder's earliest dated painting, *The Parable of the Sower* (plate 109). Both events are possible, since each occurs beside the Sea of Galilee, and one of the miracles enacted there consists of Christ's production of a multitude of fishes (Luke 5:1–10). However, the scene depicted could be identified as the calling of the first apostles (a scene more clearly presented in the near background of another Jan Brueghel landscape with the miraculous draft of fishes in the foreground, the Dresden *Calling of Peter and Andrew*, 1608). If so, those prominently featured fashionable nobles who do not face Christ might be exhorted by the painter to turn and heed the words of his sermon ("Repent, and believe

Jan Brueghel and Peter Paul Rubens
Allegory of Sight, 1617
Oil on panel, 25¼ × 42¾ in.
(64.7 × 109.5 cm)
Museo Nacional del Prado, Madrid

in the gospel," Mark 1:15). What is important to note in this exquisite and complex panel in Munich is how much, despite initial discrepancies, both its composition and its viewing process of sudden spiritual discovery still owe to Pieter Bruegel the Elder.

Thus Pieter Bruegel did leave a lasting legacy in his forms and favorite themes, but also not least in the achievements of his two painter sons, Peter the Younger (1554–1637/38) and Jan Brueghel (1568–1625). Jan, in particular, was celebrated as one of the most distinguished and rewarded painters of the early seventeenth century, a court painter for the archdukes in Brussels and producer of some of the most expensive paintings of the day. Thus his own character, apart from the father he never really knew personally, deserves valedictory attention at the end of this volume. Peter the Younger was certainly what might be called a "second Bruegel," as his father had earlier been called a "second Bosch", the more so since he made his entire career out of "slavish" copies after the compositions of his father, whether known from prints or from original drawings and paintings.[83]

Jan Brueghel, in contrast, was more distinctly original and recognizable in his own continuation of the world landscapes and other subgenres (forest scenes, riversides) of his father as stages for both peasant and religious subjects. He also continued to imitate, but he freely adapted, not just the models of Pieter the Elder, but also the glowing fire landscapes against dark backgrounds that derived ultimately from Bosch himself, whether in religious scenes, such as Bosch's own favorite, the Temptation of St. Anthony, or else in a variety of mythological representations of Hades, such as the visit of Aeneas.[84] Jan also came to be known for his numerous other innovative contributions to Flemish art: meticulous floral still lifes; mythologies; and allegories (especially of the Four Elements and Five Senses), often enhanced with small-scale naturalistic details. He was also noted for his frequent and careful collaborations with other painters, including Joos de Momper, Sebastian Vrancx, and his close friend Rubens (who painted a portrait of Jan's family and later became one of his executors in 1626) but also especially (before the return of Rubens to Antwerp in 1608) Hendrick van Balen.[85]

Whereas Peter Bruegel thematized his profession of painter in an independent drawing, *The Painter and His Client* (plate 321), where the discontents of an uncertain market and an imperceptive client discourage invention, Jan Brueghel's representation of the purpose of art, in turn, focuses on art within a large royal collection and on the sense of *Sight* (plate 355).[86] This painting marks

an ambitious collaboration [between Jan Brueghel] and Peter Paul Rubens, the resul[t of a major commission] by the archdukes Albert and I[sabella—whose court] oth artists served—of a large-sc[ale canvas of the] Five Senses. *Sight* is located in a [gallery/cabinet of curiosi]ties, or Kunst- and Wunderk[ammer ... and even the chan]delier features the double-[headed eagle of the Holy] Roman Empire and their Ha[bsburg crowns. Por]traits of the archdukes, adapt[ed from Rubens originals], are featured prominently o[n the table at left, behind] the Venus-like allegorical figu[re of Sight ...]he gazes on a small painting de[picting Jesus Healing the] Blind Man (John 9:1–7, Ma[...]ne of true seeing in both the ph[ysical and spiritual senses]. Various instruments of sight a[nd the foundation of obser]vational science surround th[e main figure: telescope], microscope, sextants. Maps [of terrestrial spaces and] celestial knowledge (astrolabe[s] ...[fla]nk the figures. On the opposite, right corner of the [painting stands another] large Rubens-Brueghel collab[oration, the Madonna in] *a Flower Garland* (with a live par[rot ... of the Madonna], on top).[89] It overlaps an und[erneath painting ... bu]t doubtless with a religious sub[ject ... even the revelation] of angelic hosts in the corne[r ... vision ... and] a green curtain provides a worl[d ... of physical] revelation.[90]

Other solo paintings by the a[rtist figure prominentl]y in this diverse and representat[ive collection. Rubens's] *Tiger and Lion Hunt* (on the [wall ... Drunken Silenus/] *Bacchanal* on the floor; Bruegh[el's flower arrangement nex]t to the winged Genius figure. T[his latter image is gazed] at by an attentive monkey with[spectacles, because art] is the "ape of nature," but is al[so capable of mimicking] visual illusion at the physical, a[nimal level of the floor].

(aligned with indulgent mythic figures of Silenus as well as a corner still-life dominated by wine grapes).[91] The scale of both spaces, including the background garden at left and gallery at right, point to a princely palace as the site of this rich collection, which also includes both classical busts and small copies after Renaissance sculptures, arrayed beneath the *Hunt* (as ever, a uniquely princely activity and pictorial subject; see above, note 20).[92] Above the doorway to the garden hangs a copy after a "conjugal allegory" by Titian, a harmony of Mars with Venus, which would speak to the marital love of the archdukes.[93]

While some intricacies of this collaboration remain to be worked out, *Allegory of Sight* reveals much about both Jan Brueghel and his audience in 1617. His learned subjects, made for sophisticated and discerning clients, often the archdukes of Flanders themselves, were fully as diverse and sophisticated as the collections they amassed, and Jan meticulous technique combined with his complex subjects to make his images prized collectors' items. He served as collaborator, not with engravers on inexpensive prints like his father, but instead with other painters of the highest social standing, including his fellow court artist, Rubens. Their collaborative works were esteemed as even greater than the sum of their parts. Indeed, as noted, Jan Brueghel, especially when he collaborated with Rubens, can be seen as reuniting the disparate and competing styles of art-making in Pieter Bruegel's mid-sixteenth-century Antwerp. While maintaining his own profitable, large local workshop in Antwerp, Jan's paintings successfully reached admiring noble patrons across the span of Europe—from Milan to Prague, from Brussels to Madrid, to adorn princely collections in the new era of the *Kunstkammer*.

CONCLUSIONS

For someone who wa[...] in his own day for intro[...] Flemish painting, B[...] consistently aroused diverse [...] interpretations concerning hi[...] tions. This study has not utili[...] odology or documentation bu[...] to examine each authentic w[...] attributions and some lost wo[...] The artist's presentations and [...] consistent, however.

How then to assess the achie[...] the Elder? First, one needs to i[...] Bruegel—like all artists—bega[...] foundations of his predecessor[...] gious works, particularly *Chris*[...] also the London *Adoration of th*[...] *Death of the Virgin*, depend c[...] visual tradition, extending bac[...] tury but also adopted with va[...] sixteenth-century painters and p[...]

Of course, the works that led [...] ond Bosch" often stand close to [...] cessive Bosch imitators earlier i[...] Bosch study (chapter 5) empha[...] despite the continuity of subj[...] hermit saints), one can just as e[...] ences of tone and valence inser[...] Bruegel often added a smile and[...]

the demons and mitigated the ultimate horror conveyed by Bosch himself—in his early prints projects (especially the Seven Vices) as well as in his several paintings. The lone exception (and here it is claimed to be later in date as well as fundamentally nihilistic in mood) is the *Triumph of Death*.

Moreover, Bruegel added innumerable figures to his Gospel scenes, who sometimes threaten to overwhelm the clarity of the visual heritage and force the viewer to make out what subject is being depicted. This challenge simply to identify the content of a religious scene distinguishes Bruegel from most of his predecessors, but it informs many of his Gospel subjects, even to the point of making the recognition of holy figures within a landscape and a crowd of ordinary figures into an epiphany in its own right. Even this challenging process is not unprecedented; it can be found anticipated in prints and paintings by Lucas van Leyden as well as hybrid works by Pieter Aertsen or Joachim Beuckelaer, which combine kitchen or market scenes with background Gospel narratives. Bruegel created many images where that very process of discernment seems to be the main point of the image: *Adoration of the Magi in the Snow*, *Census at Bethlehem*, *Sermon of St. John the Baptist*, and *Conversion of Paul*. All these works require a viewer to discover that the depicted scene even contains religious protagonists, which reinforces a theology of humility and immanence. In similar fashion, Bruegel restages several of his Gospel events in modern, Flemish, snow-bound villages,

356 *(opposite)*
Pieter Bruegel
Massacre of the Innocents
Detail of plate 236

suitable presentation used t[...] of a subject. Thus when Brueg[...] as nearly indistinguishable fron[...]ag- ers in snowy villages or open[...]eir inherent humanity, indeed th[...]he Incarnation of Jesus in a hum[...] as a pilgrim to Emmaus after his[...]n, to the near-invisibility of St.[...]he ground itself, even at the mo[...]g conversion. Not to mention[...]ty of the tragic Icarus, brought l[...]r- invisibility as he crashes pathet[...]e- gel's lone mythic painting. N[...] be further from the preternatural[...]d for the holy figures or classica[...]d Heemskerck in their contemp[...]al subjects. For this reason, Brue[...]o the humble mode of presenting[...]i- tual subjects, as told in Christ's[...]i- bly local landscape settings to pl[...]l ordinary figures from the first p[...] *able of the Sower* to the *Blind Le[...]*.

One final truth about Brueg[...]y became just as successful as Bo[...] in making his mark in art histor[...]d what the modern marketing w[...]- nizable "brand." The name Bru[...] series of favorite forms, such as l[...] cal figures and faces of peasants.[...] use of either landscapes or peas[...] for painting, while not invented[...] adopted by him and then trans[...] his two painter sons, Jan Brueg[...] the Younger, as well as to futur[...] teenth-century Flanders and H[...] Younger was a repetitive imitat[...] las and pictorial models, Jan w[...] distinctive presentations, using[...] finely painted, small-scale figure[...] emulated a number of his father's[...] same time, Jan also greatly expa[...] repertoire of favorite subjects, wh[...] later Antwerp practitioners of in[...] notably Rubens, as if to reconcile[...] previous century that had open[...] Bruegel and Floris or Heemskerc[...]

Pieter Bruegel finally develope[...] ture of forms and themes that bot[...] engage the viewer. Already in h[...] but especially in his paintings of t[...]

hybrid imagery made out of all his major components. In the *Fall of Icarus*—even if the original does not sur- vive, the invention remains quintessential Pieter Brue- gel—landscapes with large peasants must been "seen through" to discern the tiny clue of feathers and feet that identify the true subject as Ovidian myth. In so many of his religious subjects, the holy figures are imbedded amid ordinary villagers or soldiers who surround them—only the percipient viewer will even find, let alone recognize, the holy family in the stable or the snow of a village or see St. Paul cast to the ground behind large, colorfully uniformed equestrian soldiers. Moreover, pictures using the quoted words of Christ as the subjects for pictures can literally embody parables, almost as if in disguise, in the figures of sowers, shepherds, or blind beggars in local landscapes. Spiritual insight must transcend physi- cal sight for these pictures to convey their ultimate sig- nificance and religious message, just like the parables themselves.

Less expressly religious, Bruegel's Seven Virtues prints also localize moral actions within plausibly realized, if artificially constructed, familiar and worldly settings. Bruegel even uses popular vernacular proverbs and say- ings as if he were emulating the example of Christ to cre- ate new paintings, as if acting out the Latin proverb, *vox populi vox dei*.[1] He makes his own full-scale, parable-like pictures, independent of formal religion, contrasting the behaviors of large figures, such as *The Peasant and the Bird-Nester* or *The Misanthrope*. Often a background vil- lage church steeple suffices to suggest basic country faith, unruffled by the winds of political or religious conflict and doctrinal controversy. Thus for Pieter Bruegel, reli- gious images pose as country scenes, whereas country scenes may contain great spiritual truths.

Such complex pictures, in short, demand careful scru- tiny, even of small or background details. One of the artist's ultimate paintings in every sense, *The Magpie on the Gallows* clearly engages with primal issues (by means of their implied opposition): life and death, power and religion, nature and culture, country and city. Sorting out those issues and their complex possible relationships remains a puzzle for the viewer, but these important readings only emerge through careful inspection—of Bruegel's most masterful and luminous world landscape layout and of his final image of festive peasants and their rural village. With such beauty and charm as the visual stimulus, even for profound ideas, Bruegel remains perennially fascinating—and best approached directly through extended and repeated contemplation of his pictures, the real purpose of this book.

357 *(opposite)*
Pieter Bruegel
Children's Games, 1560
Detail of plate 195

NOTES

CHAPTER 1. GOD IN THE DETAILS:
CHRIST CARRYING THE CROSS (1564)

1. The most attentive examinations of the figures in the setting, particularly in their separate groups, are given by Reindert Falkenburg, "Pieter Bruegels *Kruisdraging*: een proeve van 'close reading,'" *Oud Holland* 107 (1993), 17–33; Joseph F. Gregory, *Contemporization as Polemical Device in Pieter Bruegel's Biblical Narratives* (London, 2005). Many of the observations that follow derive from their insightful analyses. See also Michael Francis Gibson, *The Mill and the Cross: Pieter Bruegel's "Way to Calvary"* (Lausanne, 2000).

2. Mark Tucker, "Rogier van der Weyden's Philadelphia *Crucifixion*," *Burlington Magazine* 139 (1997), 676–83.

3. For the swooning Virgin underneath the cross, animated by an echoing compassion that echoes the suffering of her Son, see Otto von Simson, "*Compassio* and *Co-redemptio* in Roger van der Weyden's *Descent from the Cross*," *Art Bulletin* 35 (1953), 9–16; Falkenburg, "The Decorum of Grief: Notes on the Representation of Mary at the Cross in Late Medieval Netherlandish Literature and Painting," M. Terttu Knapas and A. Ringbom, eds., *Icon to Cartoon: A Tribute to Sixten Ringbom* (Studies in Art History by the Society for Art History in Finland 16) (Helsinki, 1995), 65–89. Emphasizing the more normal location of this *Stabat Mater* emotional response under the cross, Jürgen Müller, *Das Paradox als Bildform: Studien zur Ikonologie Pieter Bruegels d.Ä.* (Munich, 1999), 136–41, highlights that in Bruegel's Vienna painting the holy figures mark the presence of an "invisible cross," which needs to be sensed and internalized by the pious beholder.

4. Shirley Neilsen Blum, *Early Netherlandish Triptychs* (Berkeley, 1969), 49–58; more generally, Blum, "Symbolic Invention in the Art of Rogier van der Weyden," *Konsthistorisk Tidskrift* 46 (1977), 103–22. The larger issue of grisailles is addressed through a case study in R. Preimesberger, "Zu Jan van Eycks Diptychon in der Sammlung Thyssen-Bornemisza," *Zeitschrift für Kunstgeschichte* 60 (1991), 459–89; see also Paul Philippot, "Les Grisailles et les 'degrés de realité' de l'image dans la peinture flamande des XVe et XVIe siècles," *Bulletin Musées Royaux des Beaux Arts de Belgique* 15 (1966), 225–42.

5. An image of *Christ Carrying the Cross* in a round frame, one of a series of Passion engravings from 1509 (Bartsch 64) by Lucas van Leyden, isolates the holy figures in a hillside at the lower left as the Way to Calvary unfolds in the distance behind them.

6. For this modeling of proper conduct by holy figures in biblical representations as examples to pious beholders of religious paintings and manuscripts, F. O. Büttner, *Imitatio pietatis: Motive der christlichen Ikonographie als Modelle zur Verähnlichung* (Berlin, 1983), esp. 89–105 on the Virgin and her companions during the Passion.

7. Müller, *Paradox als Bildform*, 136–42, esp. 140–41, comments on the fact that these holy figures exemplify the "cross within us" as laid out by Erasmus in his *Enchiridion militis christiani* (Handbook of the Christian Knight, 1503).

8. For the full Crucifixion, including discussion of the good *vs.* bad thieves, Mitchell Merback, *The Thief, the Cross, and the Wheel: Pain and the Spectacle of Punishment in Medieval and Renaissance Europe* (Chicago, 1999), esp. 218–65.

9. Merback, ibid., 222–30, emphasizes the role of Franciscans in setting up the contrast between good (Dysmas) and bad thieves as moral exempla, particularly concerning Church discipline of confession and penance.

10. In full Crucifixion narratives often the bad thief is depicted falling into the hands of a devil, or else the figure is shown in anguished contortion on the cross. Correspondingly, the good thief either is accompanied by an angel or appears more tranquil and stoical in enduring his torment.

11. Renilde Vervoort, "The Pestilent Toad: The Significance of the Toad in the Works of Bosch," Jos Koldeweij, Bernard Vermet, with Barbera van Kooij, eds., *Hieronymus Bosch: New Insights into His Life and Work* (Rotterdam, 2001), 145–51, fig 15.7, noting the overlapping associations with Jews and sorcery. For representations of Jews and of Judas, Ruth Mellinkoff, *Outcasts: Signs of Otherness in Northern European*

Art of the Late Middle Ages (Berkeley, 1993), esp. part 1 for costume.

12. Falkenburg, "*Kruisdraging*," 29–30; Gregory refers instead to an apocryphal Secret Passion, which features either the dragging of Christ himself through the brook of Kidron or else casting Jesus into a pool of filth outside the gates of Jerusalem; cf. James Marrow, *Passion Iconography in Northern European Art of the Late Middle Ages and Early Renaissance* (Kortrijk, 1979), 95–170. The Asa episode was invoked by Luther as part of his criticism of idolatry and was illustrated (no. 212) in the Luther Bible.

13. Ingvar Bergström, "The Iconological Origins of *Spes* by Peter Breughel the Elder," *Nederlands Kunsthistorisch Jaarboek* 7 (1956), 53–63.

14. Gregory sees an allusion here to the legend of the giant St. Christopher, who bore the Christ Child on his back and was granted revelation and then conversion after his epiphany; see Larry Silver, "Christ-Bearer: Dürer, Luther, and St. Christopher," *Essays in Northern European Art Presented to Egbert Haverkamp-Begemann* (Doornspijk, 1983), 239–44; see also Müller, *Paradox als Bildform*, 136–42, esp. 138.

15. This hypocrisy is well discussed by Müller, ibid., esp. 137, citing the contrast between internal and external religiosity as defined by Erasmus in his *Enchiridion militis christiani* (1503). See also Gustav Stridbeck, *Bruegelstudien* (Stockholm, 1956), 250: "the key for the moral lesson of the representation at hand, namely the indifference of man in the face of the suffering of Christ, which is a picture of that hypocrisy that takes the place of true religiosity with most people. The main content, therefore, is the contrast between the sufferings of Christ and the indifference of mankind."

16. Gertrud Schiller, *Iconography of Christian Art* II. *The Passion of Christ*, trans. Janet Seligman (Greenwich, Conn., 1972), 78–82. For Simon of Cyrene, who empathetically takes up the cross with Jesus, as the prototype of the individual pious Christian, see Büttner, 56–62.

17. Spiritual blindness is the overall theme of this picture according to Falkenburg, "*Kruisdraging*," 17–33; see also Falkenburg, "Marginal Motifs in Early Flemish Landscape Painting," Norman Muller, Betsy Rosasco, and James Marrow, eds., *Herri met de Bles: Studies and Explorations of the World Landscape Tradition* (Turnhout, 1998), 153–70, esp. 166–67 for the Vienna *Way to Calvary*.

18. The identification of the Bosch figures as a Peddler was first made by Konrad Renger, "Versuch einer neuen Deutung von Hieronymus Boschs Rotterdamer Tondo," *Oud Holland* 84 (1969), 67–76.

19. An interpretation opposite to this contrast is provided by Robert Genaille, "La Montée au Calvaire de Bruegel l'Ancien," *Jaarboek van het Koninklijk Museum voor Schone Kunsten Antwerpen* (1979), 143–96, esp. 173–87; he assumes that Bruegel's later sympathy for the peasant (see chapter 9) should carry over to this presentation of a religious subject, even though the peasant mode is a sharp contrast to the tall and slender representation of the holy figures in the manner of van der Weyden.

20. The first to propose a self-portrait for this bearded figure was Michael Auner, "Pieter Bruegel–Umrisse eines Lebensbildes," *Jahrbuch der kunsthistorischen Sammlungen in Wien* 52 (1956), 107–8.

21. Heinrich Gerhard Franz, *Niederländische Landschaftsmalerei im Zeitalter des Manierismus* (Graz, 1969); Walter Gibson, "*Mirror of the Earth*": *The World Landscape in Sixteenth-Century Flemish Painting* (Princeton, 1989).

22. Carol Krinsky, "Representations of the Temple of Jerusalem before 1500," *Journal of the Warburg and Courtauld Institutes* 133 (1970), 1–19; Helen Rosenau, *Vision of the Temple: The Image of the Temple of Jerusalem in Judaism and Christianity* (London, 1979); Yona Pinson, "The Iconography of the Temple in Northern Renaissance Art," *Assaph: Studies in Art History* (1996), 147–74.

23. See Erwin Panofsky, *Hercules am Scheidewege* (Leipzig-Berlin, 1930) as well as his discussion of the *paysage moralisée* relative to Dürer's *Hercules* engraving (c. 1500); see Panofsky, *Albrecht Dürer*, 73–76; also Werner Busch, "Lucas van Leydens 'Grosse Hagar' und die augustinische Typologie-auffassung der Vorreformation," *Zeitschrift für Kunst-*

geschichte 45 (1982), 97–129, for Lucas's engraving of a *paysage moralisée* in his early engraving, *Expulsion of Hagar*. More generally Falkenburg, *Joachim Patinir: Landscape as an Image of the Pilgrimage of Life* (Amsterdam-Philadelphia, 1988).

24. W. Gibson, "Mirror of the Earth," 68–69; W. Gibson, "Bosch's Boy with a Whirligig: Some Iconographical Speculations," *Simiolus* 8 (1975–76), 9–15. A different interpretation is James Smith Pierce, "The Windmill on the Road to Calvary," *New Lugano Review* 11–12 (1976), 48–55, which argues for the Eucharistic significance more specifically.

25. W. Gibson, "Mirror of the Earth," 69, no. 84. See also the allegorical interpretations of Jacob van Ruisdael's windmills, itemized (somewhat disapprovingly) by Seymour Slive, *Jacob van Ruisdael*, exh. cat. (Cambridge, Mass., 1982), 114–16, no. 39, through emblems of the seventeenth century, e.g., Zacharias Heyns (1625): "The letter killeth, but the spirit giveth life."

26. Discussing the title pages of Albrecht Dürer's 1511 Passion woodcut series, Panofsky, *Albrecht Dürer*, 138–39; David Hotchkiss Price, *Albrecht Dürer's Renaissance* (Ann Arbor, 2003), 126, 181.

27. For the drawing, Fritz Koreny, *Early Netherlandish Drawings from Jan van Eyck to Hieronymus Bosch*, exh. cat. (Antwerp, 2002), 15–16, 56–60, no. 10 (there ascribed to a follower of Dirc Bouts after a work by a Van Eyck follower). The painting is discussed by Friedrich Winkler, "Die Wiener Kreuztragung," *Nederlands Kunsthistorisch Jaarboek* 9 (1958), 83–108; see also Hans Belting and Dagmar Eichberger, *Jan van Eyck als Erzähler* (Worms, 1983), 116–28.

28. Hartmut Krohm and Jan Nicolaisen, *Martin Schongauer Druckgraphik*, exh. cat. (Berlin, 1991), 91–93, no. 9.

29. Falkenburg, "*Kruisdraging*," plates 9–12; Genaille, "Montée," 143–96.

30. Falkenburg, "Antithetical Iconography in Early Netherlandish Landscape Painting," *Bruegel and Netherlandish Landscape Painting*, exh. cat. (Tokyo, 1990), 25–33.

31. W. Gibson, "Mirror of the Earth," 26–33; Gibson, "The Man with the Little Owl: The Legacy of Herri Bles," Muller, Rosasco, and Marrow, eds., *Herri met de Bles*, 131–42; for the numerous *Way to Calvary* by Herri met de Bles, Luc Serck, "La Montée au Calvaire dans l'Oeuvre d' Henri Bles: Création et composition," ibid., 51–72; more generally on the artist, see also *Autor de Henri Bles*, exh. cat. (Namur, 2000).

32. Serck, ibid., 51, aptly compares this sequence of small scenes to the encompassing reenactment of the *Passion* by Hans Memling for Tommaso Portinari in Bruges (1470–71; Galleria Sabauda, Turin); Dirk de Vos, *Memling* (Antwerp, 1994), 105–9, no. 11.

33. W. Gibson, "Mirror of the Earth," 23–26; Dietrich Schubert, *Die Gemälde des Braunschweiger Monogrammisten* (Cologne, 1970). The name picture in Herzog-Anton-Ulrich-Museum, Braunschweig (Brunswick), depicts the *Feeding of the Five Thousand*. On the still-open question of whether the Brunswick Master should be equated with Jan van Amstel, see Schubert, ibid.; Genaille, "L'oeuvre de Jan van Amstel, le Monogrammiste de Brunswick," *Bulletin Musées Royaux des Beaux-Arts de Belgique* 23–29 (1974–80), 65–96. A dissertation on this important artist was just completed by Matthias Ubl for the University of Frankfurt.

34. W. Gibson, "Mirror of the Earth," 24, notes that this more topographical image of Jerusalem probably derives from a woodcut by Herman Beerntz. van Borculo (1538), based on a drawing on site by Dutch painter Jan van Scorel, who visited the city as a pilgrim in 1520–21. See also J. A. L. de Meyere, *Jan van Scorel 1495–1562* (Utrecht, 1981), 10–11, 17–18.

35. Paul Vandenbroeck, "Nieuw materiall voor de studie van het Hooiwagen-motief," (1984), 39–65; Vandenbroeck, "Jheronimus Bosch' 'Hooiwagen': enkele bijkomende gegevens," *Jaarboek van het Koninklijk Museum voor Schone Kunsten Antwerpen* (1987), 107–42; W. Gibson, *Figures of Speech Picturing Proverbs in Renaissance Netherlands* (Berkeley, 2010), 39–79.

36. Keith Moxey, "Reflections on Some Unusual Subjects in the Work of Pieter Aertsen," *Jahrbuch der Berliner Museen* 18 (1976), 57–83; Genaille, "Montée," 167–70; more generally Genaille, "Pieter Aertsen, précurseur de l'art rubénien," *Jaarboeck Koninklijk Museum voor Schone Kunsten Antwerpen*

(1977), 7–96, esp. 33, no. 15 (Berlin), ▓▓▓▓
The lost Berlin painting was dated 1▓▓▓▓
the Antwerp painting is undated.

37. Genaille, "Montée," 170–73, plates 17▓▓
ture, signed with monogram and da▓▓▓
Jack Kilgore, New York; I am most g▓▓▓▓
for the image and research on the pr▓▓▓
tant painting.

38. Carl van de Velde, "The Labours of ▓
Series of Paintings by Frans Floris," ▓▓
107 (1965), 114–23; Iain Buchanan, "▓
Niclaes Jongelinck: I. 'Bacchus and t▓
Jongelinck," Burlington Magazine 132 ▓
Buchanan, "The Collection of Niclae▓
The 'Months' by Pieter Bruegel the E▓▓
Magazine 132 (1990), 541–50.

39. On Nicolaes and Jacques Jongelinck, ▓
Kaveler, Pieter Bruegel: Parables of Or▓
(Cambridge, 1999), 34–35, esp. 51, 54.

40. Van de Velde, "Labours of Hercules," ▓

41. On Passion imagery and literature, se▓
Passion Iconography; for a precedent of ▓
relation to meditations, Falkenburg, ▓
on art and devotional literature of the ▓
Jeffrey Hamburger and Anne-Marie ▓
Mind's Eye: Art and Theological Argum▓
(Princeton, 2006), esp. Thomas Lente▓
Can See . . .': Rituals of Gazing in the ▓
360–73; also Herbert Kessler, "Turnin▓
eval Art and the Dynamics of Contem▓
the Meditations on the Life of Christ, se▓
by Isa Ragusa and Rosalie Colie (Prin▓

CHAPTER 2.
BRUEGEL IN ANTWERP

1. Jan van der Stock, Antwerp, Story of a ▓
Century, exh. cat. (Antwerp, 1993); Le▓
Golden Age (Antwerp, 1973).

2. For the wider European context of An▓
dominance, Fernand Braudel, The Whe▓
York, 1982); see also Braudel, The Persp▓
(New York, 1984), esp. 143–57.

3. Herman van der Wee, The Growth of the▓
the European Economy (The Hague, 19▓
Jan Materne, "Antwerp as a World Mar▓
and Seventeenth Centuries," in van der ▓

4. Philip Vermeylen, Painting for the Mark▓
of Art in Antwerp's Golden Age (Turnho▓
Ewing, "Marketing Art in Antwerp, 14▓
Pand," Art Bulletin 72 (1970), 558–84.

5. Van der Stock, Printing Images in Antw▓
1998); Timothy Riggs, Hieronymus Cock▓
York, 1977). A similar industrialization ▓
tion of decorative arts in Antwerp; see S▓
28–29.

6. Karel van Mander, "Life of Joachim Pati▓
and Hieronymus Cock," Schilderboek (16▓

7. Guicciardini, Descrittione di . . . tutti I Pa▓
1567), 99D (Description of All the Low C▓

8. Hans-Joachim Raupp, Untersuchungen z▓
und Künstlerdarstellung in den Niederlan▓
hundert (Hildesheim, 1984), 18–23; Walt▓
the Netherlandish Canon: Karel van Mand▓
(Chicago, 1991), 143–45; for early apprec▓
by his contemporaries, see also 173–82. F▓
of texts, see J. Puraye, ed. and trans., Les ▓
célèbres des Pays-Bas (Liège, 1956).

9. English translation by Fritz Grossmann, ▓
Edition of the Paintings, rev. ed. (London▓
the translation of the Van Mander biogr▓
modern biography, 10–22. See also Nadir▓
"The Elusive Life of Pieter Bruegel the E▓
Pieter Bruegel the Elder: Drawings and Pri▓
York, 2001), 3–11; Manfred Sellink, Brueg▓
Paintings, Drawings, and Prints (Ghent, 2▓
features the Van Mander text 286–89.

An ingenious argument, based on a 1606 engraved portrait
of Jan Brueghel, son of Pieter, deduces from the inscribed
age that Pieter was the same age when he died and would
thus have been born around 1526/27; Jan Baptist Bedaux and
A. van Gool, "Bruegel's Birthyear: Motive of an Ars/Natura
Transmutation?" Simiolus 7 (1974), 133–56.

Thomas Campbell, Tapestry in the Renaissance: Art and Mag-
nificence, exh. cat. (New York, 2002), 379–85; Georges Marl-
ier, La Renaissance flamande: Pierre Coecke d'Alost (Brussels,
1966).

Adolf Monballieu, "Pieter Bruegel en het altar van de
Mechelse Handschoenmakers (1551)," Handelingen van de
Koninklijk Kring voor Oudheidkunde, Letteren en Kunst van
Mechelen 68 (1964), 92–110; Roger Marijnissen, Bruegel
(Antwerp, 1988), 11.

Orenstein, Drawings and Prints, 96–97, no. 8.

A. E. Popham, "Pieter Bruegel and Abraham Ortelius," Burl-
ington Magazine 59 (1931), 188; Armin Zweite, Marten de Vos
als Maler (Berlin, 1980), esp. 21, cites the same letter from
Scipio Fabianus of 1561 about "Martinus Vulpi" and "Petro
Bruochl."

Charles de Tolnay, Pierre Bruegel l'Ancien (Brussels, 1935), 61,
n. 11. On Clovio, Elena Calvillo, "'Il Gran Miniatore' at the
Court of Cardinal Alessandro Farnese," Stephen Campbell,
ed., Artists at Court: Image-Making and Identity, 1300–1550
(Boston, 2004), 163–75; Maria Cionini-Visani and Grgo
Gamulin, Giorgio Giulio Clovio: Miniaturist of the Renaissance
(New York, 1980). A facsimile of the Farnese Hours was
published by Webster Smith (New York, 1976). Clovio
helped to sponsor the younger El Greco, who portrayed
him on a panel showing his manuscript masterpiece (1570;
signed Domenikos Theotokopoulous; Naples, Museo
Capodimonte).

Tolnay, "Newly Discovered Miniatures by Pieter Bruegel the
Elder," Burlington Magazine 107 (1965), 110–14, attributed
several miniatures to Bruegel, based upon this documented
association with the miniaturist Clovio, including the item
in Clovio's inventory, "a small inventory painted half by him-
self and half by Pieter Bruegel." Tolnay further attributed
Clovio miniatures to Bruegel in later articles: "A New Minia-
ture by Pieter Bruegel," Burlington Magazine 120 (1978),
3–97; "Further Miniatures by Pieter Bruegel the Elder,"
Burlington Magazine 122 (1980), 616–23. Besides the Farnese
Hours (c. 1535–39), he identified parts of Clovio's Towneley
Lectionary (1550s; New York Public Library ms 91); see also
Jonathan Alexander, The Painted Page: Italian Painted Book
Illumination, 1450–1550 (London-New York, 1994), 248–52,
▓ 134.

de Vier Winden: De prentuitgeverij van Hieronymus Cock,
▓▓. cat. (Rotterdam, 1988); Riggs, Hieronymus Cock, Print-
▓ker and Publisher (New York, 1977); Lydia De Pauw-
▓ Veen, Jerome Cock, éditeur d'estampes et graveur 1507?–1570,
▓▓. cat. (Brussels, 1970). Cock's model from publishing
▓▓ts might also have come from Rome, where first Anto-
▓ Salamanca and later Antonio Lafreri, whose firms later
▓ged, were both early print publishers before midcentury;
▓ Christopher Witcombe, Print Publishing in Sixteenth-
▓tury Rome (London-Turnhout, 2008).

▓ Ghisi, Suzanne Boorsch, The Engravings of Giorgio Ghisi,
▓▓. cat. (New York, 1985); for Lombard, Godelieve Den-
▓▓e, Lambert Lombard (Antwerp, 1990), esp. 313–15 for the
▓▓ts (Cock publisher: nos. 3, 5–7, 10, 13–22, 24, 26, 31, 33,
▓y of them dated, between 1551–57 and one as late as 1563).

▓▓gs, "Bruegel and His Publisher," Otto von Simson and
▓thias Winner, eds., Bruegel und seine Welt (Berlin, 1979),
▓–73.

▓y Silver, "Second Bosch: Family Resemblance and the
▓keting of Art in the Sixteenth-Century Low Countries,"
▓rlands Kunsthistorisch Jaarboek 50 (1999), 31–56.

▓ghel-Brueghel: Flämische Malerei um 1600, exh. cat.
▓▓na, 1998); Klaus Ertz, Pieter Breughel der Jüngere 1564–
▓38 (Lingen, 2000); Peter van den Brink, Bruegel Enter-
▓▓, exh. cat. (Maastricht-Brussels, 2001).

▓ham Ortelius (1527–1598): Cartographe et humaniste, exh.
▓ Antwerp-Brussels, 1998).

▓▓ably the strongest claim for Bruegel's intellectual attain-
▓▓▓, based on his link to Ortelius is given by Margaret Sul-

livan, Bruegel's Peasants: Art and Audience in the Northern
Renaissance (Cambridge, 1994), 5–38: "The circle of men
associated with Bruegel are humanists, specifically 'humanist
Christians'" (8–9); see also Justus Müller-Hofstede, "Zur
Interpretation von Bruegels Landschaft. Ästhetischer Land-
schaftsbegriff und Stoische Weltbetrachtung," Von Simson
and Winner, Bruegel und seine Welt, 73–142.

24. Krista de Jonge and Gustaaf Janssens, eds., Les Granvelle
et les Anciens Pays-Bas: Liber doctori Mauricio Van Durme
dedicatus (Louvain, 2000); M. Piquard, "Le Cardinal de
Granvelle, les Artistes et les Ecrivains, d'après les documents
de Besançon," Revue Belge d'Archéologie et d'Histoire de l'Art 17
(1947), 133–47. Many of Granvelle's works were removed
during the sack of Mechelen in 1572, part of the early years
of the Dutch Revolt (see chapter 8).

25. Buchanan, "The Collection of Niclaes Jongelinck: The
'Months' by Pieter Bruegel the Elder," Burlington Magazine
132 (1990), 541–50; Van de Velde, "The Labours of Hercules,
a Lost Series of Paintings by Frans Floris," Burlington Maga-
zine 107 (1965), 114–23.

26. Van de Velde, "Labours of Hercules"; Sellink, Cornelis Cort,
exh. cat. (Rotterdam, 1994), 75–97, nos. 22–32 (Hercules);
123–36, nos. 42–48 (Seven Liberal Arts).

27. Ethan Matt Kaveler, Pieter Bruegel: Parables of Order and
Enterprise (Cambridge, 1999), 34–35, figs. 14a–b; 51, noting
that Jongelinck executed the gilded bronze effigy on the
tomb of Charles the Bold of Burgundy in Bruges, Church
of Our Lady.

28. Kaveler, Bruegel: Parables of Order, 51–54; W. Gibson, Pieter
Bruegel and the Art of Laughter (Berkeley, 2006), 67–76; Luc
Smolderen, "Tableaux de Jérôme Bosch, de Pierre Bruegel
l'ancien et de Frans Floris disperses en vente publique à la
monnaie d'Anvers en 1572," Revue belge d'Archéologie et
d'Histoire de l'Art 64 1995), 33–41.

29. Marten de Vos also painted a group portrait of the board
members of the Brabant mint in 1584 (Antwerp, Rock-
oxhuis). See Zweite, 303–4, no. 83; Michel Jennes, "Een
schilderij van Maarten de Vos voor de rechtbank van de
Brabantse Munters," Jaarboek Koninklijk Museum Antwerpen
(1978), 43–52; J. de Ridder, "De vierschaar van de Brabantse
munt te Antwerpen: Een gerechtigheidstafereel door
Maarten de Vos," Jaarboek Koninklijk Museum Antwerpen
(1984), 219–52.

30. Orenstein, Drawings and Prints, 196–200, nos. 79–80;
for de Mompere within the print production of Antwerp,
Van der Stock, Printing Images in Antwerp (Rotterdam,
1998), 113–14, 406 (document 56).

31. Svetlana Alpers, "Bruegel's Festive Peasants," Simiolus 6
(1972/73), 163–76.

32. Grossmann, Paintings, 9; for the Calumny drawing (Lon-
don, British Museum), Orenstein, Drawings and Prints,
234–36, no. 104.

33. Marijnissen and Ruyffelaere, Bruegel, 12, noting that the
epitaph in its lateral chapel was restored in 1676 by a descen-
dant, David Teniers III.

34. In addition to the references in note 2, see Sellink, Cort,
147–52, nos. 53–54.

35. Jean Puraye, ed., Album amicorum Abraham Ortelius
(Amsterdam, 1969); Melion, Netherlandish Canon, 173–79.
On the phenomenon of the album amicorum, see M.A.E.
Nickson, Early Autograph Albums (London, 1970); K. Tho-
massen, ed., "Alba amicorum": Vijf eeuwen vriendschap op
papier gezet; Het "album amicorum" en het poëziealbum in de
Nederlanden (Maarsen, 1990). For discussion of Rembrandt's
drawing contribution to this tradition, Nicola Courtright,
"Origins and Meanings of Rembrandt's Late Drawing Style,"
Art Bulletin 78 (1996), 487–94.

36. Jan Muylle, "Pieter Bruegel en Abraham Ortelius: Bijdrage
tot de literaire receptie van Pieter Bruegels werk," Archivum
Artis Lovaniense: Bijdragen tot de geschiedenis van de Kunst
der Nederlanden: Opgedragen aan Prof. Em. Dr. J. K. Steppe,
ed. Maurits Smeyers (Louvain, 1981), 319–37; Mark Meadow,
"Bruegel's Procession to Calvary, Aemulatio and the Space
of Vernacular Style," Nederlands Kunsthistorisch Jaarboek 47
(1996), 192–96, with translation.

37. As Meadow points out (ibid., 193, n. 46), Lampsonius employed this same trope for his verses in praise of the fifteenth-century Louvain artist Dieric Bouts.

38. In landscapes momentary phenomena of disturbance: rainbows, squall lines of rain, or lightning strikes; see Falkenburg, "'Schilderachtig weer' bij Jan van Goyen," Christiaan Vogelaar, *Jan van Goyen*, exh. cat. (Leiden, 1996), 60–69, esp. 62–65; see in particular 114, no. 28 (c. 1643), *Ships in a Lightning Storm* (Leiden), whose entry mentions how Van Mander's treatise of 1604, *Grondt der vry schilder-const* (fol. 35, vv. 12–13) singles out Apelles for admiration of his ability to represent the impossible appearances in nature.

39. Melion, *Netherlandish Canon*, 178, cites several Bruegel works that minimize the heroism in this fashion, most notably *The Fall of Icarus* (see plates 110, 112), but also *Christ Carrying the Cross* (see plate 8).

40. Ibid., passim.

41. Ibid., 179; Bedaux and van Gool, "Bruegel's Birthyear," 133–56. On Sadeler, Dorothy Limouze, "Aegidius Sadeler (1570–1629): Drawings, Prints, and the Development of an Art Theoretical Attitude," *Prag um 1600: Beiträge zur Kunst und Kultur am Hofe Rudolfs II* (Freren, 1988), 183–92, esp. 187, fig. 8.

42. Meadow, "Bruegel's *Procession to Calvary*," 181–83; see also David Freedberg, "Allusion and Topicality in the Work of Pieter Bruegel: The Implications of a Forgotten Polemic," *The Prints of Pieter Bruegel the Elder*, exh. cat. (Tokyo, 1989), 53–65.

43. Larry Silver, "*Figure nude, historie et poesie*: Jan Gossaert and the Renaissance Nude in the Netherlands," *Nederland Kunsthistorisch Jaarboek* (1986), 1–40; this term, *poesie*, is also used to discuss the mythological works of Titian, produced in pairs, for King Philip II in Spain during the period of Bruegel's own artistic activity (c. 1550–62); see David Rosand, "*Ut pictor poeta*: Meaning in Titian's *Poesie*," *New Literary History* 3 (1971–72), 527–46; Rona Goffen, *Titian's Women* (New Haven, 1997), 9, 242–73.

44. Momus, companion of Envy, notably criticized the Olympian gods, though he could only find fault with the footwear of the goddess of beauty, Venus. He also advocated that humanity be fashioned with a see-through breast so that nothing of the heart could remain concealed. Bruegel's contemporary from Haarlem, Maarten van Heemskerck (see chapter 3 for prints after Heemskerck by Cock) painted a large panel of this subject, *Momus Criticizing the Creations of the Gods* (1561; Gemäldegalerie, Berlin); Ilja Veldman, "A Painter and a Humanist: Heemskerck and Hadrianus Junius," in Veldman, ed., *Maarten van Heemskerck and Dutch Humanism of the Sixteenth Century* (Amsterdam, 1977), 101–3; Rainald Grosshans, *Maerten van Heemskerck: Die Gemälde* (Berlin, 1980), 231–35, no. 93.

45. Van de Velde, *Frans Floris* (Brussels, 1975), 61–63, 67, 276–778, no. 137.

46. Mentioned in Van Mander's *Wtlegging*, book 11, fol. 94. Eric Jan Sluijter, "De 'Heydensche Fabulen' in de Noordnederlandse schilderkunst circa 1590–1670," Ph.D. diss. (Leiden University, 1986), 198–210, plates 2–14; see Abraham Bloemart's oil sketch (c. 1595; The Hague) and several other versions in Joanaeth Spicer and Lynn Federle Orr, *Masters of Light: Dutch Painters in Utrecht during the Golden Age*, exh. cat. (San Francisco–Baltimore, 1997), 270–73, no. 46. Another noteworthy example is the large 1593 canvas by Cornelis Cornelisz. van Haarlem (Frans Hals Museum, Haarlem).

47. Van de Velde, *Floris*, 56–58, 209–13, no. 62; J. Vervaet, "Catalogus van de altaarstukken en ambachten uit de Onze-Lieve-Vrouwekerk van Antwerpen en bewaard in het Koninklijk Museum," *Jaarboek Koninklijk Museum Antwerpen* (1976), 197–98, 207–8; Ria Fabri and Nico van Hout, eds., *From Quinten Metsijs to Peter Paul Rubens*, exh. cat. (Antwerp, 2009), 99–102, no. 3.

48. Leontine Buijnsters-Smets, *Jan Massys* (Zwolle, 1995); V. Scaff, "Ioannes Quintini Massiis Pingebat," *Mélanges d'archéologie et d'histoire de l'art offerts au Professeur Jacques Lavalleye* (Louvain, 1970), 259–79; Larry Silver, *Quinten Massys* (Totowa, N.J., 1984). For overlap between these family members, Edouard de Callatay, "Cornelis Massys

paysagiste, collaborateur de son père et son frère et auteur de l'album Errera," *Bulletin Musées Royaux des Beaux Arts de Belgique* 14 (1965), 49–71; Burton Dunbar, "The Question of Cornelis Massys' Landscape Collaboration with Quinten and Jan Massys," *Jaarboek Koninklijk Museum Antwerpen* (1979), 125–41.

49. Buijnsters-Smets, 191–93, no. 34. For the subject, Julius Held, "Flora, Goddess and Courtesan," Millard Meiss, ed., *De Artibus opuscula XL: Essays in Honor of Erwin Panofsky* (New York, 1961), 201–18, esp. 216; for Titian's *Flora* (Uffizi, Florence), Goffen, *Titian's Women* 72–75, describing the courtesan as "a woman of indisputable beauty but perhaps dubious morality."

50. Buijnsters-Smets, nos. 16, 36, 53/a. For the theme in general, Alison Stewart, *Unequal Love* (New York, 1977); the Quinten Massys original of the composition (Washington, National Gallery) in Larry Silver, "The Ill-Matched Pair of Quinten Massys," *Studies in the History of Art* 6 (1974), 105–23.

51. Buijnsters-Smets, nos. 29, 39, 44, 47, 50/a, 54.

52. Ibid., nos. 30, 37/a, 46, 49. For this theme, see Renger, "Alte Liebe, gleich und ungleich, zu einem satirischen Bildthema bei Jan Massys," Görel Cavalli-Björkman, *Netherlandish Mannerism* (Stockholm, 1985), 35–46.

53. The latest discussion of the London Massys is in Lorne Campbell et al., *Renaissance Faces Van Eyck to Titian*, exh. cat. (London, 2008), 228–31, no. 70, citing Erasmus's *Praise of Folly*: "old women who . . . look like corpses . . . They go around . . . still in heat . . . longing for a mate." The New York pendant, no. 71, was reunited for this exhibition.

54. Emanuel Winternitz, "Bagpipes and Hurdy-Gurdies in their Social Setting," *Musical Instruments and Their Symbolism in Western Art* (New Haven, 1979), 66–85.

55. Renger, "Alte Liebe," 38–39. Renger also points to the lone herring on the table as a possible reference to a folk saying, "Hij heft den haring afgekaakt" (he has gutted the herring), which suggests impotence and failure at love. And he further underscores the associations of the bagpipe with male genitals, where an empty instrument is also akin to an empty purse as well as an empty pipe.

56. For Jan van Amstel's contributions to the presentation of religious subjects in landscape, W. Gibson, "*Mirror of the Earth*," 23–26; Giorgio Faggin, "Jan van Amstel," *Paragone* n.s. 15, no. 175 (1964), 43–51; Dietrich Schubert, *Die Gemälde des Braunschweiger Monogrammist* (Cologne, 1970). One problem with the identification is that the figure of "Jan van Anestelle" was inscribed in Antwerp as a member of the painters guild in 1528 but he died in 1535, and no certain works by him are known.

57. For military dress and conduct, Larry Silver, "The Landsknecht: Summer Soldier and Sunshine Patriot," James Clifton and Leslie Scattone, *The Plains of Mars: European War Prints, 1500–1825*, exh. cat. (Houston, 2009), 16–29; Matthias Rogg, *Landsknechte und Reisläufer: Bilder vom Soldaten* (Paderborn, 2002); for seventeenth-century Dutch gatherings of soldiers, Jochai Rosen, "The Dutch Guardroom Scene of the Golden Age: A Definition," *Artibus et Historiae* 17 (2006), 151–74.

58. Aertsen has not been the subject of a modern monograph, but a special issue of the *Nederlands Kunsthistorisch Jaarboek* 40 (1989) was devoted to his work; moreover, some of his unusual subjects have been well discussed: Moxey, "Reflections on Some Unusual Subjects in the Work of Pieter Aertsen," *Jahrbuch der Berliner Museen* 18 (1976), 57–83.

59. Elizabeth Alice Honig, *Painting and the Market in Early Modern Antwerp* (New Haven, 1998), 39–43; Jan Emmens, "Eins aber ist nötig. Zu Inhalt und Bedeutung von Markt- und Küchenstücken des sechzehnten Jahrhunderts," *Album amicorum J. G. van Gelder* (The Hague, 1973), 93–101, remains the classic interpretation of the contrast. See also Larry Silver, *Peasant Scenes and Landscapes* (Philadelphia, 2006), 87–102.

60. For Martin Luther, this Gospel episode epitomized the contrast between Old Testament Law and New Testament Grace, based upon the doctrine of unmerited divine redemption through faith alone; his associate Lucas Cranach frequently realized images of Christ and the Adulterous

Woman. See Carl Christensen, *Art and the Reformation in Germany* (Athens, Ohio, 1979), 130–34.

61. Honig, 53–81; on the erotic overtones of the market scenes by both Aertsen and Beuckelaer, particularly in the phallic shapes of vegetables, esp. 58–59; also Kaveler, "Erotische elementen in de markttaferelen van Beuckelaer, Aertsen en hun tijdgenoten," *Joachim Beuckelaer*, exh. cat. (Ghent, 1986), 18–26.

62. Honig, 68–70, on links to theater; Meadow, "Aertsen's *Christ in the Home of Martha and Mary*, Serlio's Architecture and the Meaning of Location," Jelle Koopmans, Meadow, Kees Meerhoff, and Marijke Spies, eds., *Rhetoric-Rhétoriqueurs-Rederijkers* (Amsterdam, 1995), 175–96.

63. A related triptych of Gospel images concerning the sea was commissioned from Peter Pourbus by the Bruges guild of fishmongers (1576; Brussels), also featuring the calling of Peter and Andrew to be "fishers of men" (Matthew 4:18–22; Luke 5:1–11) and the Tribute Money (Matthew 17:24–27); see Philippot, "Le 'Retable des Poissoniers' des Musées Royaux, oeuvre de Pierre Pourbus," *Bulletin Musées Royaux des Beaux-Arts de Belgique* (1973), 73–84.

64. Orenstein, *Drawings and Prints*, 212–18, nos. 89–94; see also Larry Silver, "Pieter Bruegel in the Capital of Capitalism," *Nederlands Kunsthistorisch Jaarboek* 47 (1996), 126–30; for the tradition, Irene de Groot and Robert Vorstman, *Sailing Ships: Prints by Dutch Masters from the Sixteenth to the Nineteenth Century* (Maarsen, 1980); *Het rijk van Neptunus*, exh. cat. (Rotterdam, 1996), 1–5, citing a 1568 account notice by book publisher Christopher Plantin that he had received "all ten ships from Cock."

65. Frans Smekens, "Het Schip bij Pieter Bruegel de Oude: een authenticiteits-criterium?" *Jaarboek Koniklijk Museum voor Schone Kunsten Antwerpen* (1961), 5–57; Richard Unger, "Marine Paintings and the History of Shipbuilding," David Freedberg and Jan de Vries, eds. *Art in History, History in Art: Studies in Seventeenth-Century Dutch Culture* (Santa Monica, Cal., 1991), 75–93.

66. Orenstein, *Drawings and Prints*, 204–7, no. 85. Although Cornelis van Dalem, also known as a painter in Antwerp, is credited as the publisher on the print itself, he more likely served as the financial backer of the project. Cock's name appears on the second state, bearing the same date, 1561.

67. Ger Luijten and A.W.F.M. Meij, *From Pisanello to Cézanne: Master Drawings from the Museum Boymans van Beuningen*, exh. cat. (Rotterdam, 1990), 60–62, no. 17.

68. The drawing, usually dated c. 1560, probably because of its correspondence with the two-sheet print, provides a finely delineated topography of Reggio Calabria. Its accents in wash were almost certainly added later. Orenstein, *Drawings and Prints*, 204, no. 84; both works Sellink, *Bruegel*, 156–57, nos. 97–98. The Doria painting, neither signed nor dated, is usually regarded as the Bay of Naples. It is challenged as a Bruegel original, in part because of its condition problems by Sellink, *Bruegel*, 275, no. X7, where it is included among the problem paintings on account of "stiff brush-strokes and poorly executed background as well as the mechanically rendered sea and the lack of a convincing sense of depth."

69. Kees Zandvliet, *The Dutch Encounter with Asia 1600–1950*, exh. cat. (Amsterdam, 2002); C. R. Boxer, *The Dutch Seaborne Empire 1600–1800* (London, 1973); see also Harold Cook, *Matters of Exchange: Commerce, Medicine, and Science in the Dutch Golden Age* (New Haven, 2007).

70. Dated c. 1559 by Sellink, *Bruegel*, 133, no. 79. The standard catalogue of Bruegel drawings is Hans Mielke, *Pieter Bruegel: Die Zeichnungen* (Turnhout, 1996); drawings will be referred to by their Mielke numbers from this catalogue. Mielke 61, no. 52, suggests an allegorical significance to the opposition of the ships to this unsettled weather, reinforced by the presence of an added island of punishment with gallows and wheel, which did not actually exist in the Scheldt River.

71. Initialed "F.H." at the bottom right of the print. Orenstein, *Drawings and Prints*, 174–76, nos. 62–63, noting a pentimento on the drawing of a column from the gateway that is still visible through the covering of the wagon; Eddy de Jongh and Ger Luijten, *Mirror of Everyday Life: Genreprints in the Netherlands 1550–1700*, exh. cat. (Amsterdam, 1997), 49–53, no. 2; also Margaret Carroll, *Painting and Politics*

in Northern Europe: Van Eyck, Bruegel [...]
Contemporaries (University Park, Penn[...]
the early seventeenth century a restrik[...]
of this print from the original plate ha[...]
that misdate the print: "Porta S. Geor[...]
repeated with an inscription at the bo[...]
drew this and depicted it from life [aa[...]
introduces the additional moral warni[...]
periness of Human Life" as a theme o[...]
is no evidence that this was the purpo[...]
(see below, chapter 9).

72. Of course, skating scenes would becor[...]
artists, particularly Hendrick Avercam[...]
teenth century, for whom see Ger Luij[...]
Golden Age: Northern Netherlandish Ar[...]
(Amsterdam, 1993), 299, 634–38, nos. [...]
van Straaten, Koud tot op het bot: De ver[...]
in de zestiende en zeventiende eeuw in de [...]
Hague, 1977); Ariane van Suchtelen, [...]
Time: The Dutch Winter Landscape in th[...]
(The Hague, 2001); Pieter Roelofs, ed.[...]
Master of the Ice Scene, exh. cat. (Amster[...]

73. De Jongh and Luijten, Mirror of Everyd[...]
noting that the orientation of the city sl[...]
than reversed in printing; Raupp, Baue[...]
und Entwicklung des bäuerlichen Genres i[...]
niederländischen Kunst ca. 1470–1570 (Nic[...]
fig. 234. For later topographic imagery [...]
in seventeenth-century Dutch paintings[...]
van Lakeveld, ed., The Dutch Cityscape i[...]
its Sources, exh. cat. (Amsterdam-Toront[...]
Suchtelen and Arthur Wheelock, Jr., Du[...]
Golden Age, exh. cat. (The Hague-Washi[...]

74. Antwerp's adoption of Renaissance arch[...]
temporary festival structures, particular[...]
permanent buildings in W. Kuyper, The [...]
Renaissance Architecture into the Netherla[...]
esp. 13–18 for the imperial gate featured i[...]
destroyed in 1865, when the city demolis[...]
defensive walls.

75. Carroll, Painting and Politics, 69–73; Hug[...]
en kapitalisme te Antwerpen in de 16de eeuw[...]
198–205. On changes in warfare in the six[...]
particularly artillery and the bastion, Geo[...]
Military Revolution (Cambridge, 1988), 6[...]
Renaissance Fortification: Art or Engineeri[...]
Simon Pepper and Nicholas Adams, Fire[...]
tions: Military Architecture and Siege Warf[...]
Century Siena (Chicago, 1986), esp. 3–31.

76. The columns signified the Pillars of Herc[...]
beyond which the emperor sought to pres[...]
signified; Earl Rosenthal, "The Invention[...]
Device of Emperor Charles V at the Cour[...]
Flanders in 1516," Journal of the Warburg a[...]
tutes 36 (1973), 198–230.

77. Carroll, Painting and Politics, 66–69; Mea[...]
Civic Identity in Philip II's 1549 Antwerp [...]
Nederlands Kunsthistorisch Jaarboek 49 (199[...]

78. Van der Stock, ed., Antwerp: Story of a Met[...]
(Antwerp, 1993), 273–74, no. 129, recounti[...]
del, built in 1567, was demolished in 1577. T[...]
a revolt of the occupying troops began the [...]
year, 1576. See Peter Arnade, Beggars, Icono[...]
Patriots: The Political Culture of the Dutch R[...]
2008), 191–98, 264–72; also Guido Marnef[...]
Age of Reformation (Baltimore, 1996).

79. Carroll, Painting and Politics, 70–71, also n[...]
of current warfare might have dampened th[...]
Antwerp citizens for their walls—especially[...]
taken against cities that refused to surrende[...]
notably the recent sack of St. Quentin in Fr[...]
imperial troops, of which Cock issued an et[...]
However, this very victory was achieved by [...]
were defending Antwerp (the very reason fo[...]
and that signal victory led soon to the impo[...]
with France at Cateau-Cambrésis, so it is po[...]
significance of that conflict opposite to wha[...]

[...]oly, Urbanisme; Charlotte Houghton, "A Topical Reference
[t]o Urban Controversy in Pieter Aertsen's 'Meat Stall,'" Burl-
ington Magazine 143 (2001), 158–60; Houghton, "This Was
Tomorrow: Pieter Aertsen's Meat Stall as Contemporary
Art," Art Bulletin 86 (2004), 277–300.
[S]oly, "Fortificaties, belastingen, en corruptie te Antwerpen
[i]n het midden van de 16de eeuw," Bijdragen tot de Geschie-
[d]enis 53 (1970), 191–210; Monballieu, "P. Bruegels 'Schaatsen-
[r]ijden bij de St.-Jorispoort te Antwerpen,' de betekenis van
[h]et jaartal 1553 en een archiefstuk," Jaarboek Koninklijk
[M]useum Antwerpen (1981), 17–30, whose historically contin-
[g]ent argument uses the false seventeenth-century date on the
[s]econd state of the print (see above, n. 71), though he does
[r]aise important questions about corruption and controversy
[s]urrounding the project of the city walls.
[O]renstein, Drawings and Prints, 166–70, nos. 58–59; Bret
[R]othstein, "The Problem with Looking at Pieter Bruegel's
Elck," Art History 26 (2003), 165–73, with bibliography.
[N]oted by Riggs, "Bruegel and His Publisher," 166–67.
[T]he theme of "Everyman" formed a recurrent subject in
[bo]th public festivals and allegorical plays, sinnekens, staged
[in] Antwerp and other Netherlandish urban chambers of
[rh]etoric (rederijkers). The English late-medieval morality
[pla]y "Everyman" probably derives from an earlier Dutch-
[la]nguage version; see John Watkins, "The Allegorical The-
[atr]e: Moralities, Interludes, and Protestant Drama," in
[Dav]id Wallace, ed., The Cambridge History of Medieval Eng-
[lish] Literature (Cambridge, 1999), 767–74; for the Nether-
[lan]dish tradition, W.M.H. Hummelen, De sinnekens in het
[rede]rijkersdrama (Groningen, 1959). More generally on the
artist, W. Gibson, "Artists and Rederijkers in the Age of
Bruegel," Art Bulletin 63 (1981), 426–46, esp. 438–40;
A. M. Ramakers, "Bruegel en rederijkers," Nederlands
Kunsthistorisch Jaarboek 47 (1996), 81–105.
[Rot]hstein, "Bruegel's Elck"; Greta Calman, "The Picture of
[No]body," Journal of the Warburg and Courtauld Institutes 23
[(19]60), 60–64; Müller, Das Paradox als Bildform: Studien zur
[Ik]onologie Pieter Bruegels d.Ä. (Munich, 1999), 56–76.
[Ore]nstein, Drawings and Prints, 170–72, nos. 60–61; Mat-
[thia]s Winner, "Zu Bruegels Alchimist," in Von Simson and
[Win]ner, Pieter Bruegel und seine Welt, 193–202, invoking
[classi]cal precedents, including Petrarch and Sebastian Brant's
[Ship] of Fools (1494).
[Pam]ela Smith, The Business of Alchemy (Princeton, 1997);
[Rich]ard Westfall, "Newton and Alchemy," Brian Vickers,
[ed.,]Occult and Scientific Mentalities in the Renaissance (Cam-
[brid]ge, 1984), 315–35.
[Law]rence Principe and Lloyd DeWitt, Transmutations:
[Alche]my in Art (Philadelphia, 2002); Wayne Franits, Dutch
[Seven]teenth-Century Genre Painting (New Haven, 2004),
[...]42; Rüdiger Klessmann, Die Sprache der Bilder, exh. cat.
[Brau]nschweig, 1979), 150–53, no. 35. Adriaen van Ostade's
[The]Alchemist (London, National Gallery) contains the
[inscri]ption in Latin, "you lose your time and effort."
[...]stein, Drawings and Prints, 253–54, no. 115; Kaveler,
[Pict]orial Satire, Ironic Inversion, and Ideological Conflict:
[Brueg]el's Battle Between the Piggy-Banks and Strong Boxes,"
[Neder]lands Kunsthistorisch Jaarboeck 47 (1996), 155–79.
[...]stein, Drawings and Prints, 219–21, no. 95.
[...]Silver, Hieronymus Bosch (New York, 2006), 252–60.
[...]Koslow, "Frans Hals Fisherboys: Exemplars of Idle-
[ness,]" Art Bulletin 57 (1975), 418–32.
[...]Janson, Apes and Ape Lore in the Middle Ages and the
[Renais]sance (London, 1952), esp. 216–25; Michel Weemans,
[...]i met de Bles's Sleeping Peddler: An Exegetical and
[Anthr]opomorphic Landscape," Art Bulletin 88 (2006), 459–
[...]o makes the larger claim that Bles's landscape hides a
[demo]nic face in its features, suggesting that the depicted
[...]is a deceptive, diabolical realm of appearances and dis-
[tortio]ns, "vanitas and illusory vision." (469) This construc-
[tion o]f the setting does not carry over into Bruegel's print of
[the sam]e subject, but it has been suggested by Falkenburg
[that su]ch landscapes of deception and false seeing dominate
[nume]rous Bosch and Bles works, and possibly even
[...]unsuspected Bruegel settings, including The Months.
[...m]ost recently, Reindert Falkenburg, "The Devil is in
[...Det]ail: Ways of Seeing Joachim Patinir's 'World Land-

scapes,'" Alejandro Vergara, ed., Patinir, exh. cat. (Madrid,
2007), 61–79. For the animal notion of apes in contrast to
the divine, note also the chained ape in Albrecht Dürer's
engraving Madonna of the Monkey (c. 1498).

94. Bruegel designs led to posthumous proverb prints about
peddlers. One of the prints from "Twelve Flemish Proverbs,"
engraved in Antwerp by Jan Wierix, declares, "Every peddler
praises his own wares," while the contents of the box also
present jews' harps, penny-whistles, and nets. Next to the
peddler is an obese peasant figure who tells the huckster to
go away and praise his wares to the blind and the deaf.
Another engraving from the same series, The Carefree Ped-
dler, bears an inscription that predicts a bad end: "He who
fraudulently fills his peddler's tray and thus thinks he will
gain riches; indeed, he in the end lodges with the poor and
sitting next to his bride scratches his head." Next to a seated
immobile bride in the print stands a distraught and restless
peddler, with his hands raised alongside his head.

95. Sullivan, "Peter Bruegel the Elder's Two Monkeys: A New
Interpretation," Art Bulletin 63 (1981), 114–26.

96. In Bruegel's 1559 Netherlandish Proverbs (Berlin; see plate
187), a woman watches a stork fly over, which signals that
she is slothful and wasting time; Meadow, Pieter Bruegel the
Elder's Netherlandish Proverbs and the Practice of Rhetoric
(Zwolle, 2002), 38 n. 41.

CHAPTER 3.
HIERONYMUS COCK, BRUEGEL'S PRINTMAKER

1. Still definitive is Riggs, Hieronymus Cock: Printmaker and
Publisher (New York, 1977); see also De Pauw-De Veen,
Hieronymus Cock, prentuitgever en graveur 1507–1570, exh. cat.
(Brussels, 1970); In de Vier Winden, exh. cat. (Rotterdam,
1988). For Bruegel prints, Orenstein, Pieter Bruegel the Elder:
Drawings and Prints, exh. cat. (New York, 2001).

2. Colin Clair, Christopher Plantin (London, 1960); Leon Voet,
The Golden Compasses (London, 1969–72), 2 vols.

3. Lisa Pon, Raphael, Dürer, and Marcantonio Raimondi
(New Haven, 2004); Michael Bury, The Print in Italy,
exh. cat. (London, 2001), esp. 68–80, 121–35; Christopher
Witcombe, Print Publishing in Sixteenth-Century Rome
(London-Turnhout, 2008).

4. Suzanne Boorsch, The Engravings of Giorgio Ghisi, exh. cat.
(New York, 1985); Sellink, Cornelis Cort, exh. cat. (Rotter-
dam, 1994).

5. Specifically, eight dedications of Cock publications between
1551 and 1562 were directed at Granvelle; Riggs, Cock, 48.

6. Pon, Raphael, Dürer, and Raimondi, 16–17, 43–48, is the most
authoritative recent discussion on privilege in Italy in the
early sixteenth century.

7. Christian Hülsen and Hermann Egger, Die römischen
Skizzenbücher von Marten van Heemskerck, 2 vols. (Berlin,
1913–16); Kunst voor de Beeldenstorm, exh. cat. (Amsterdam,
1986), 220–24, nos. 101–5; Arthur Di Furia, "Heemskerck's
Rome: Memory, Antiquity, and the Berlin Sketchbooks,"
Ph.D. diss. (University of Delaware, 2008).

8. Riggs, Cock, 34–35, 273, nos. 38–50. Inscribed, "many kinds
of landscapes [lantschappen], with fine histories arranged
therein, from the Old and New Testaments, and several
merry mythologies [Poeteryen], very useful for painters and
other art-lovers [liefhebbers der consten; i.e., connoisseurs]."

9. Lambert Lombard et son temps, exh. cat. (Liège, 1986); Den-
haene, Lambert Lombard (Antwerp, 1990), esp. 313–15 for
engravings after designs by Lombard.

10. This suggestion of classical authenticity would only be sur-
passed in the following century by Nicolas Poussin in his
Eucharist from the Sacraments series of paintings made for
his friend Cassiano del Pozzo (1634; coll. Duke of Rutland,
Belvoir Castle); for discussion see Elizabeth Cropper and
Charles Dempsey, Friendship and the Love of Painting (Prince-
ton, 1996), 112–16, plate 3, showing the three couches of the
triclinium; for prints from the Raphael circle as sources for
Lombard's classicism, Madeleine Viljoen, "False Antiquities
in the Age of Raphael," Print Quarterly 21 (2004), 244–45.

11. Indispensible is Van de Velde, Frans Floris (1519/20–1570):
Leven en Werk (Brussels, 1975). A Harvard dissertation was
recently completed by Edwin Wouk.

12. Larry Silver, "Graven Images: Reproductive Engravings as Visual Models," in Riggs and Silver, *Graven Images: Professional Printmakers in Antwerp and Haarlem, 1540–1640,* exh. cat. (Evanston, 1993), 1–45, esp. 8–12.

13. W. Kuyper, *The Triumphant Entry of Renaissance Architecture into the Netherlands: The Joyeuse Entrée of Philip of Spain into Antwerp in 1549* (Alphen aan den Rijn, 1994), 6–78, esp. 49–56; Meadow, "Ritual and Civic Identity in Philip II's 1549 Antwerp *Blijde Inkomst,*" *Nederlands Kunsthistorisch Jaarboek* 49 (1998), 37–67. Kuyper translates the inscription on the Floris etching, addressing the young prince, and sets the triumphal tone of the event: "This victory, O happy one, is promised thee by the Fates, O great Austrian race, O thrice greatest offspring."

14. Van de Velde, *Floris,* 218–27, nos. 69–78; Van de Velde, "The Labours of Hercules, A Lost Series of Paintings by Frans Floris," *Burlington Magazine* 107 (1965), 114–23.

15. For this series, Van de Velde, *Floris,* 239–46, nos. 93–99; Van de Velde, "Painters and Patrons in Antwerp in the Sixteenth and Seventeenth Centuries," Hans Vlieghe, Arnout Balis, and Carl van de Velde eds., *Concept, Design and Execution in Flemish Painting (1550–1700)* (Turnhout, 2000), 29–37; Sellink, *Cort,* 123–136, nos. 42–48.

16. On early print collecting, Peter Parshall, "Art and the Theater of Knowledge: The Origin of Print Collecting in Northern Europe," *Harvard University Art Museum Bulletin* 2: 3 (1994), 7–35; also Veldman, *Images for the Eye and Soul: Function and Meaning in Netherlandish Prints (1450–1650)* (Leiden, 2006).

17. Riggs, *Cock,* 140–49, fig. 125; Henk Nalis, *The Van Doetecum Family: The New Hollstein Dutch and Flemish Etchings, Engravings, and Woodcuts 1450–1700* (Rotterdam, 1998).

18. Boorsch, *Ghisi,* 71–74, no. 14.

19. Veldman, *Leerrijke reeksen,* exh. cat. (Haarlem, 1986); Veldman, *Images for Eye and Soul;* Silver, "Graven Images," 12–17.

20. *Kunst voor de Beeldenstorm,* 262–63, no. 144.

21. Ibid., 267–68, no. 148.

22. For example, under *Arithmetica,* the inscription identifies the knowledge embodied by the female personification as she who reveals the secrets of numbers, "Non dubiis per me numeris rite omnia constant."

23. Bart Rosier, "The Victories of Charles V: A Series of Prints by Maarten van Heemskerck, 1555–56," *Simiolus* 20 (1990/91), 24–38. The popularity of the series was reaffirmed through successive editions, seven in total, between 1556 and 1640, including reissues in fairly quick order in 1558 and 1563.

24. The caption reads: "Here pope, the king of France, and the Dukes of Saxony, Hesse, and Cleves, concede to the keen eagle, before whom Suleiman flees distraught." Rosier, "Victories of Charles V," 25–26, n. 9.

25. Earl Rosenthal, "The Invention of the Columnar Device of Emperor Charles V at the Court of Burgundy in Flanders in 1516," *Journal of the Warburg and Courtauld Institutes* 36 (1973), 198–230.

26. Rosier, "Victories of Charles V," 24, n. 4, translates the Latin dedication thus: "The chief of the many victories of the divine Charles V, supreme emperor. To the Great Philip, son of the divine Charles V, and King of Spain . . . father of the fatherland, and our most benevolent prince, Hieronymus Cock, printer and painter, of his own accord publishes these images of paternal triumphs, the chief among very many, entrusted to imperishable prints and to the immortal fame of that inviolable majesty, dedicating them with the deepest sentiments of humility and respect. 1556. Printed at Antwerp . . . With the royal privilege for six years."

27. Veldman, "Dirck Volkertsz. Coornhert and Heemskerck's Allegories," in Veldman, ed., *Maarten van Heemskerck and Dutch Humanism in the Sixteenth Century* (Amsterdam, 1977), 55–93.

28. Hans-Martin Kaulbach and Reinhart Schleier, *Der Welt Lauf: Allegorische Graphikserien des Manierismus,* exh. cat. (Stuttgart, 1997). Specifically for Heemskerck series: Four Seasons (1563), Seven Planets, Four Temperaments, Nine Worthies, and Eight Wonders of the World (including the Colosseum as the final construction), Veldman, *Leerrijke reeksen,* 68–107, nos. 8–12.

29. Riggs, *Cock,* 100–111.

30. Upon his own independent publishing in 1582 Hendrik Goltzius of Haarlem recognized Galle with an engraved portrait on behalf of one of his own protégés; see Huigen Leeflang and Ger Luijten, *Hendrick Goltzius (1558–1617),* exh. cat. (Amsterdam, 2003), 15–16, fig. 6. On Galle, Sellink and Marjolein Leesberg, *Philips Galle* (Rotterdam, 2001). Coornhert left professional engraving to open his own book publishing house, where he could publish his own religious tracts, the achievement for which he is best known to history; H. Bonger, *Leven en werk van Dirk Volkertsz. Coornhert* (Amsterdam, 1978), 13–14, 28–32.

31. This change, not yet closely analyzed by scholars, might be as much an evolution as a sharp alteration; it is easiest to observe in the largest Heemskerck drawings collection in Statens Museum for Kunst, Copenhagen: Jan Garff, *Tegninger af Maerten van Heemskerck* (Copenhagen, 1971); see also Riggs, "Graven Images: A Guide to the Exhibition," in Riggs and Silver, *Graven Images,* 106, ascribing the shift more to the exposure of Heemskerck to the model of Ghisi's engravings and the Cock workshop in general, beginning with the 1556 series, *Victories of Charles V.*

32. Veldman, *Heemskerck and Dutch Humanism,* 133–41; Sheila Williams and Jean Jacquot, "Ommegangs anversois du temps de Bruegel et de van Heemskerck," Jaquot ed., *Les fêtes de la Renaissance. II Fêtes et ceremonies au temps de Charles Quint* (Paris, 1960), 359–88.

33. Veldman, *Heemskerck and Dutch Humanism,* 137, n. 2.

34. For Old Testament visual narratives, Peter van der Coelen, *Patriarchs, Angels and Prophets: The Old Testament in Netherlandish Printmaking from Lucas van Leyden to Rembrandt,* exh. cat. (Amsterdam, 1996), esp. 13–15, calculating that out of 599 prints by the artist, 423 are biblical, out of which 278 are Old Testament figures. See also Eleanor Saunders, *Old Testament Subjects in the Prints of Maarten van Heemskerck:* "Al seen claere speigele der tegenwoordige tijden" (Ann Arbor, 1984; diss. Yale University, 1978). For an example of an assemblage into an album of Heemskerck religious themes by a seventeenth-century collector, see the "Heemskerck Album" of 245 prints (Rijksmuseum, Amsterdam); A. de Bruin, F. van Daalen, J. P. Filedt-Kok, I. van Leeuwen, and I. M. Veldman, "Conservatie, restauratie en onderzoek van een zestiende-eeuws prentenboek: het *Heemskerck-album,*" *Bulletin van het Rijksmuseum* 38 (1990), 173–214.

35. Veronika Thum, *Die Zehn Gebote für die ungelehrten Leut': Der Dekalog in der Graphik des späten Mittelalters und der frühen Neuzeit* (Munich-Berlin, 2006), 134–36, 224.

36. Freedberg, "Art and Iconoclasm, 1525–1580: The Case of the Northern Netherlands," *Kunst voor de Beeldenstorm,* exh. cat. (Amsterdam, 1986), 69–84, figs. 12–17; more broadly, Freedberg, "The Problem of Images in Northern Europe and Its Repercussions in the Netherlands," *Hafnia* (1976), 25–45; Freedberg, *Iconoclasm and Painting in the Netherlandish, 1566–1609* (New York, 1988); for Heemskerck in particular, Saunders, "A Commentary on Iconoclasm in Several Print Series by Maarten van Heemskerck," *Simiolus* 10 (1978–79), 59–83. For general historical background Arnade, *Beggars, Iconoclasts, and Civic Patriots: The Political Culture of the Dutch Revolt* (Ithaca, N.Y., 2008), 125–65.

37. Freedberg, "Art and Iconoclasm," 79–80; for Haarlem, whose iconoclasm occurred in May, 1578, Saunders, "A Commentary on Iconoclasm," 80–81; Mia Mochizuki, *The Netherlandish Image after Iconoclasm, 1566–1672* (Aldershot, 2008), 105.

38. Van der Coelen, *Patriarchs, Angels and Prophets,* 14–19; Mielke, "Antwerpener Graphik in der 2. Hälfte des 16. Jahrhunderts. Der Thesaurus veteris et novi Testamenti des Gerard de Jode (1585) und seine Künstler," *Zeitschrift für Kunstgeschichte* 38 (1975), 29–83; Melion, "Bible Illustration in the Sixteenth-Century Low Countries," in James Clifton and Walter Melion, *Scripture for the Eyes: Bible Illustration in Netherlandish Prints of the Sixteenth Century,* exh. cat. (New York, 2009), 14–106; for the images after Heemskerck of Daniel and the Golden Calf, 185–90, nos. 46–47. Many of the Heemskerck series included these later, more uncommon narratives that included destruction of idols, yet they were placed in an overtly Catholic publication: histories of Dinah and Shechem, Judah and Tamar, the Ten Commandments, Joash and Athaliah, Josiah, the Fiery Furnace, Jonah, and Daniel, Bel, and the Dragon.

39. Nicole Dacos, *La découverte de la Domus Aurea et la formation des grotesques à la Renaissance* (London, 1969); for a useful pictorial catalogue of ornament prints, Marijnke de Jong and Irene de Groot, *Ornamentprenten in het Rijksprentenkabinet* I (Amsterdam, 1998).

40. Sune Schéle, *Cornelis Bos: A Study of the Origins of the Netherlands Grotesque* (Stockholm, 1965), to be supplemented by Van der Coelen, "Cornelis Bos—Where Did He Go? Some New Discoveries and Hypotheses about a Sixteenth-Century Engraver and Publisher," *Simiolus* 23 (1995), 119–46; Hans Devisscher, ed., *Cornelis Floris 1514–1575* (Brussels, 1996), esp. 36–69.

41. Rebecca Zorach, *Blood, Milk, Ink, Gold: Abundance and Excess in the French Renaissance* (Chicago, 2005), 142–58; Henri Zerner, *Renaissance Art in France* (Paris, 2003), 132–39.

42. Heiner Borggrefe, Thomas Fusenig, and Barbara Uppenkamp, *Hans Vredeman de Vries und die Renaissance im Norden* (Munich, 2002); for the prints see Peter Fuhring, *Hans Vredeman de Vries,* 2 vols. (Rotterdam, 1997); now see Christopher Heuer, *The City Rehearsed: Object, Architecture, and Print in the Worlds of Hans Vredeman de Vries* (London, 2009).

43. Frank Kernodle, *From Art to Theater* (Chicago, 1944), 176–86; on Serlio and the Netherlandish pictures of Pieter Aertsen and Joachim Beuckelaer, Moxey, *Aertsen, Beuckelaer, and Secular Painting in the Reformation* (New York, 1977), 41–43, 72–76.

44. Since Cock's wife's name was Volcxken Diericx, that motto with his surname in it also contains a pun upon her Christian name.

45. *In de Vier Winden,* 11.

46. Vandenbroeck, "Bubo significans, 1: Die Eule als Sinnbild der Schlechtigkeit und Torheit, vor allem in der niederländischen und deutschen Bilddarstellung und bei Jheronimus Bosch," *Jaarboek Koninklijk Museum voor Schone Kunsten Antwerpen* (1985), 19–136.

47. Herman Pleij, *Het gilde van de Blauwe Schuit: Literatuur, volksfeest en burgermoraal in de late middeleeuwen* (Amsterdam, 1983), esp. 187–235.

48. Later Dutch images of boaters with music are discussed by H. Rodney Nevitt, Jr., *Art and the Culture of Love in Seventeenth-Century Holland* (Cambridge, 2003), esp. 50–196–205, 216 (on Rembrandt's 1645 etching *The Omval*).

49. Examples include works by Simon Bening, a sixteenth-century illuminator from Ghent, whose calendar pages surely influenced Bruegel: "Da Costa Hours" (c. 1515; Morgan Library, New York, M. 399, fol. 6v); "Hennessy Hours" (c. 1530; Bibliothèque Royale, Brussels, ms. II, 158), fol. 5v; Calendar leaves (Victoria and Albert Museum, London, Salting ms. 2538, inv. E. 4575–1910); see also Antwerp, Mayer van den Bergh Breviary, fol. 3v. See Thomas Kren and Scot McKendrick, *Illuminating the Renaissance,* exh. cat. (Los Angeles, 2003), 324–29, 450–51, 467–70, 483–84, nos. 92, 140, 150, 159.

50. As translated in *Jheronimus Bosch,* exh. cat. ('s-Hertogenbosch, 1967), 216–17, no. 98: "Flat-Breeches being here both player and steersman, / The birds take him for an owl, / And though his company may frolic and sweat / They will be called the passengers in the Blue Boat."

51. See a related picture by Peeter Balten, *St. Martin's Day* (Koninklijk Museum, Antwerp), discussed by Vandenbroeck, *Beeld van de Andere Vertoog over het zelf,* exh. cat. (Antwerp, 1987), 212, no. 81, fig. 135. A related fragment in Vienna (no. 2691) is sometimes considered a copy after (the right one-third of) a Bruegel original, which has now been rediscovered, a canvas dated to the later 1560s and now in the Prado Museum, Madrid; *Flämische Malerei von Eyck bis Bruegel* (Vienna, 1981), 123–26. For copies of this entire composition, Klaus Ertz, *Pieter Bruegel der Jüngere* (Lingen, 1997), 466–69, nos. A452–53. See also chapter 9.

52. Author's translation: "The good St. Martin is depicted here / Among all these cripples, vile, poor scum / Now they fight

one another for loot, this evil commo▓▓▓▓▓▓▓▓
mantle instead of coin."

53. Emanuel Winternitz, *Musical Instrum▓▓▓▓ ism in Western Art* (New Haven, 1979▓▓▓▓ ment shows up in images of beggars i▓▓▓▓ by Jacques Bellange and George de la▓▓▓▓ Even more, in later Dutch paintings, ▓▓▓▓ Vinckboons, *The Blind Hurdy-Gurdy ▓▓▓▓* Amsterdam), or Adriaen van de Venn▓▓▓ associated with the blind; see Edward▓▓▓ Peter Grijp, *Music and Painting in the ▓▓▓* (The Hague, 1994), 306–11, no. 43.
54. For the bagpipe as a peasant instrumen▓▓ instrument of folly, Winternitz, *Music▓▓▓*.
55. On fools in Netherlandish art, see Van▓▓ *of Erasmus*, exh. cat. (Rotterdam, 2008▓▓ *The Fool's Journey. A Myth of Obsession i▓▓ Art* (Turnhout, 2008); Vandenbroeck,▓▓ 40–60; Larry Silver, *The Paintings of Q▓▓* (Oxford, 1984), 146–48.
56. Fullest discussion (in a vain attempt to ▓▓ to Bruegel himself) by Reinhard Liess,▓▓ schaften Pieter Bruegels d. Ä. im Lichte▓▓ *Kunsthistorisches Jahrbuch Graz* 15–16 (1▓▓ 17 (1981), 35–150; 18 (1982), 79–164; Egb▓▓ Begemann, "Joos van Liere," Otto von ▓▓ Winner, *Pieter Bruegel und seine Welt* (B▓▓ for the state of the attribution issue, Or▓▓ *and Prints*, 289–99, nos. 135–44.
57. This significance is discussed at length ▓▓ ence of the *Small Landscapes* by W. Gibs▓▓ *The Rustic Landscape from Bruegel to Rui▓▓* 2000), esp. 1–26.
58. W. Gibson, *Pleasant Places*, 27–49.
59. Freedberg, *Dutch Landscape Prints* (Lon▓▓ 28–31.
60. Orenstein, *Drawings and Prints*, 108–10,▓▓
61. The sixteenth-century history of the *Ga▓▓ Delights* remains somewhat murky befor▓▓ the Netherlands and ends up in the roya▓▓ Philip II of Spain. We know that the wo▓▓ of Nassau in Brussels, where it was recor▓▓ of a visitor, Antonio de Beatis, and it was▓▓ at the end of 1567 before it was confiscate▓▓ Orange by the Duke of Alba in 1568. In b▓▓ after Bosch paintings were produced for ▓▓ in Brussels by 1566, and several painted c▓▓ center panel were produced (Budapest). ▓▓ "High Stakes in Brussels, 1567. *The Garde▓▓* as the Crux of the Conflict between Willi▓▓ the Duke of Alva," in Jos Koldeweij, Bern▓▓ *Hieronymus Bosch: New Insights into His L▓▓* terdam, 2001), 87–90. For the utensils in ▓▓ closely derived from everyday objects, inc▓▓ and table knife; Hans Janssen, "Everyday ▓▓ Paintings of Hieronymus Bosch," ibid., 17▓▓
62. Sullivan, "Bruegel's Proverbs: Art and Au▓▓ Northern Renaissance," *Art Bulletin* 73 (19▓▓ 441–44; W. Gibson, *Figures of Speech. Pict▓▓ Renaissance Netherlands* (Berkeley, 2010).
63. Orenstein, *Drawings and Prints*, 142–44, r▓▓ that many of the lines have been reinforced▓▓ strengthen them for the engraver to follow▓▓
64. Riggs, "Bruegel and his Publisher," in Von▓▓ ner, *Pieter und seine Welt*, 168–73, noting th▓▓ medium of *The Festival of the Fools* is more ▓▓ mine. The spatial complexity of the compo▓▓ the large scale of a painting, and there is a u▓▓ shading which does not suggest Bruegel's p▓▓ other hand, the subject and composition . ▓▓ similar work is probably the print *The Witc▓▓* which dates from 1559 and is almost certain▓▓ made for the print."
65. Larry Silver, *Quinten Massys*, 147, citing a re▓▓ "The Stone Hidden under the Exposed Lu▓▓ anthology compiled in Antwerp (1524) by J▓▓ no. 89; Vandenbroeck, *Jheronimus Bosch tus▓▓*

tadscultuur (Berchem, 1987), esp. 312–18; more generally, W. Gibson, "Artists and *Rederijkers* in the Age of Bruegel," *Art Bulletin* 63 (1981), 426–46.

Orenstein, *Drawings and Prints*, 251–52, no. 114, suggests that the posthumous printing of the engraving suggests the van der Heyden was working from an unfinished drawing in the painter's legacy and that he lacked the usual collaborative supervision in translating drawing into print.

In a set of twelve circular engravings of proverbs in Dutch and French after Bruegel designs (Jan Wierix, engraver), one of the images links the (drinking) fool who sits atop a broken egg with his *marot* inside it. The inscription warns against excessive drinking. W. Gibson, *Figures of Speech*, 97–98.

▓inson, "The Water Mill in Brueghel's *Witch of Malleghem* ▓559) or Incurable Folly," *Source* (1993), 30–33, explains this image of the mill as a literal depiction of a folk proverb, "to ▓o to the mill" as a phrase meaning "to go crazy."

▓oxey, "Pieter Bruegel and *The Feast of Fools*," *Art Bulletin* ▓. (1982), 640–46. The inscription is lengthy: "You *sotte-bollen* [numbskulls], who are plagued with foolishness, / Come to the green if you want to go bowling, Although one has lost his honor and another his money, / the world values the greatest *sottebollen*. / *Sottebollen* are found in all nations, / Even if they do not wear a fool's cap on their heads. / They have such grace in dancing that their foolish heads spin like tops. / The filthiest *sottebollen* shit everything away, / There are those who take others by the nose. / Some sell Jew's harps and the others spectacles / With which they deceive many nitwits. / Yet there are *sottebollen* who behave them-selves wisely, / And taste the true sense of 't *Sottebollen* [lawnballing] / Because they [who] enjoy folly in them-selves / Shall best hit the pin with their *sotte-bollen*." Todd ▓hardson, "To See Yourself within It: Pieter Bruegel the ▓er's *Festival of Fools*," Falkenburg, Melion, and Richard-▓n, eds., *Image and Imagination of the Religious Self in Late ▓dieval and Early Modern Europe* (Turnhout, 2007), ▓–305.

▓j, *Blauwe Schuit*, 22–27; R. Marijnissen, "De Eed van ▓ester Oom. Een voorbild van Brabantse Jokkernij uit ▓egels tijd," in Von Simson and Winner, *Bruegel und seine ▓t*, 51–61; more generally, E. K. Chambers, *The Medieval ▓e* (Oxford, 1903), 1: 274–335; Enid Welsford, *The Fool: ▓ Social and Literary History* (Garden City, N.Y., 1961), ▓–219.

▓hardson, "Pieter Bruegel the Elder: Art Discourse in ▓ Sixteenth-Century Netherlands," Ph.D. diss. (University ▓ ▓eiden, 2008), 143–73, esp. 156–61. I am grateful to ▓. Richardson for sharing his work with me prior to ▓ublication.

▓ foreground instruments include a flute and a Jew's harp, ▓h is referred to in the inscription and also featured as ▓ery within the proverbs in roundels after Bruegel, ▓ved posthumously by Jan Wierix, under the heading ▓ry Peddler Praises his Own Wares" (also known in the ▓ture as "The Dishonest Merchant"). There the open ▓el of the traveling salesman features both flutes and ▓ harps, but a fat man beside him is unimpressed and ▓him to sell his trinkets to the deaf and the blind. In the ▓ground musical ensemble a hurdy-gurdy also appears.

▓ardson, "Art Discourse," 161–64; on the reprint of *Til ▓spiegel* in the Netherlands, Paul Vriesema, "Eulenspiegel-▓ke in niederländischer Sprache van c. 1520 bis 1830," ▓rendo 32: 4 (2002), 3–59.

▓ort, 1524, no. 165, *Alle sotten en draghen gheen bellen*. ▓ in Silver, *Quinten Massys*, 146.

▓se of the consensus opinion that Galle engraved this ▓ it can be dated between 1560 and 1563, when Galle ▓d his own rival shop to the Quatre Vents.

▓berg, "Allusions and Topicality in the Work of Pieter ▓el: The Implications of a Forgotten Polemic," in *The ▓ of Pieter Bruegel the Elder*, exh. cat. (Tokyo, 1989), ▓ Meadow, "Bruegel's *Procession to Calvary*, Aemulatio ▓e Space of Vernacular Style," *Nederlands Kunsthistorisch ▓k* 47 (1996), 181–205.

▓n and translation by J. Puraye (Liège, 1956); Melion, ▓andish Canon*, 143–45, plates 87–98; Raupp, *Untersu-▓n zu Künstlerbildnis und Künstlerdarstellung in den*

Niederlanden im 17. Jahrhundert (Hildesheim-Zurich, 1984), 18–23, plates 1–9.

CHAPTER 4.
BRUEGEL AS LANDSCAPE ARCHITECT

1. On the Large Landscapes, Orenstein, *Pieter Bruegel the Elder: Drawings and Prints*, exh. cat. (New York, 2001), 120–36, nos. 22–35.
2. Martin Royalton-Kisch, "Pieter Bruegel as a Draftsman: The Changing Image," in Orenstein, *Drawings and Prints*, 13–26; Mielke, *Pieter Bruegel: Die Zeichnungen* (Turnhout, 1996), with discussion of landscapes, 5–24.
3. Larry Silver, *Peasant Scenes and Landscapes* (Philadelphia, 2006), 26–52, esp. 27 n. 1 for the Dürer quote; on Patinir, Alejandro Vergara, *Patinir*, exh. cat. (Madrid, 2007).
4. An Zwollo, "De Landschapstekeningen van Cornelis Mas-sys," *Nederlands Kunsthistorisch Jaarboek* 16 (1965), 43–65; the principal landscape developments of the early sixteenth century are charted by W. Gibson, *"Mirror of the Earth": The World Landscape in Sixteenth-Century Flemish Painting* (Princeton, 1989), esp. 21–22 for Cornelis Matsys.
5. Bernard Aikema and Beverly Brown, *Renaissance Venice and the North*, exh. cat. (Venice, 1999).
6. Jane Martineau and Charles Hope, eds., *The Genius of Venice 1500–1600*, exh. cat. (London, 1983), 337, no. P38; David Rosand and Michelangelo Muraro, *Titian and the Venetian Woodcut*, exh. cat. (Washington, 1976), no. 25.
7. Rosand, "Giorgione, Venice, and the Pastoral Vision," Robert Cafritz, Lawrence Gowing, and David Rosand, *Places of Delight: The Pastoral Landscape*, exh. cat. (Washington, 1988), 21–81, esp. 38, no. 33, fig. 23, for the Uffizi drawing; Konrad Oberhuber, "Le Message de Giorgione et du jeune Titien dessinateurs," *Le Siècle de Titien*, exh. cat. (Paris, 1993), 432–50.
8. Rosand, "Giorgione, Venice, and the Pastoral Vision," 21–81; esp. 60, no. 22, fig. 54; the Titian drawing that modeled this image is in the Louvre (inv. no. 5573; no. 18, fig. 56); Rosand and Muraro, *Titian and the Woodcut*, 60–62, no. 28; *Le Siècle de Titien*, exh. cat. (Paris, 1993), 562–63, nos. 209–10.
9. Patinir had featured a number of Jerome figures in his land-scapes; Vergara, *Patinir*, 278–341, nos. 18–26; on the icono-graphy of Jerome in the wilderness, Herbert Friedmann, *A Bestiary for Saint Jerome* (Washington, 1980), 48–100.
10. Inv. 1323; W. Roger Rearick, "Titien: la fortune du dessina-teur," *Le Siècle de Titien*, 553–58, fig. 2.
11. *Pieter Bruegel d. Ä. als Zeichner*, exh. cat. (Berlin, 1975), 43–47, nos. 41–46; for the next drawing and its copies see also 47–48, nos. 47–49.
12. Mielke, *Zeichnungen*, 16–17; see also *Landscape with Exotic Animals* (Cambridge, Mass., Fogg Art Museum), inscribed "[Br]uegel inven[it] 1554," but attributed to Jan Brueghel after Pieter the Elder, c. 1600, in Orenstein, *Drawings and Prints*, 264–65, no. 119. This work contains an elephant and a camel as well as several monkeys underneath a towering old tree. A similar drawing copy (Paris, Lugt Collection, Institut Néerlandais, ibid., fig. 113) shows bears, deer, and other wild animals.
13. Katherine Crawford Luber, *Albrecht Dürer and the Venetian Renaissance* (Cambridge, 2005); Panofsky, *The Life and Art of Albrecht Dürer* (Princeton, 1955), 118–19.
14. Orenstein, *Drawings and Prints*, 106–8, no. 14, fig. 80.
15. Two prints in the series, *Country Market* (Nundinae Rustico-rum) and *Rest on the Flight into Egypt* (Fuga Deiparae in Aegyptum) resemble the other etchings and seem to employ Bruegel landscape formulas, and they even feature the ascrip-tion to Bruegel as "inventor"; however, their weakness of overall design and presentation of figures has led some schol-ars to be skeptical of their authenticity of attribution. After all, Cock certainly was willing to practice deception in attrib-uting many of his print designs to "Bosch" (chapter 3). See Orenstein, *Drawings and Prints*, 120–35, nos. 22–34, noting 134, no. 34, that the *Country Market* print survives in a unique first state that omits the name of Bruegel. Orenstein faults this composition for "its tiny, insubstantial figures, clumps of land, and spindly trees," and she notes of the fig-ures in *Flight into Egypt* that the "thin, insubstantial figures

must have been invented by someone other than Bruegel, probably the etchers themselves." (133).

16. Vergara, *Patinir*, 321, 358, nos. 23, 29; Robert Koch, "La Sainte-Baume in Flemish Landscape Painting of the Sixteenth Century," *Gazette des Beaux-Arts* 66 (1965), 273–82.

17. Parshall, "Lucas van Leyden's Narrative Style," *Nederlands Kunsthistorisch Jaarboek* 84 (1978), 185–237, esp. 224–29.

18. Orenstein, *Drawings and Prints*, 116–17, no. 20. Despite some dispute about the date of the drawing, she assigns it to the period of the Large Landscapes rather than earlier or later. She cites the larger size of the figures and explicitly compares the landscape layout to the *Way to Emmaus* drawing, but she claims that the regularity of the drawing presents a technique that Bruegel would adopt for prints at a slightly later date. As noted above, n. 15, the eventual print with this same subject included in the Large Landscapes series was probably designed by an artist other than Bruegel, but it was deliberately meant to look like his work and the rest of the prints in the series.

19. See Falkenburg, *Joachim Patinir: Landscape as an Image of the Pilgrimage of Life* (Amsterdam, 1988), 65, 78–85, 94–96; also 97–103, discussing the Madrid *Rest on the Flight* by Patinir.

20. Since the image is one of quiet and relaxation—*dolce far niente* in the manner of pastoral—the Latin title seems to be a misnomer: it should read Solitudo, i.e., "solitude" rather than Solicitudo, "care."

21. Orenstein, *Drawings and Prints*, 274–76, no. 125; the discussion of this Master of the Mountain Landscapes with bibliography is 266–76, nos. 120–25. Mielke, who was one of the early converts to reattributing this oeuvre, accepts the London drawings as no. 25; Mielke, *Zeichnungen*, 44–45, no. 25; for the Master of the Mountain Landscapes, whom Mielke tentatively identifies with Roelant Savery, 74–80, nos. A1–20. Ironically, now the most beloved Alpine scenes of earlier Bruegel scholarship are the works, truly a consistent and handsome ensemble, which are reassigned to this master. His London drawing of *Rustic Cares* is described by Orenstein as "more precise and measured than is typical of Bruegel," characterized by "fine, sharp, controlled line work" without the "spring and movement" of the accepted landscape drawings (274). Black chalk underdrawings seem to be a consistent preliminary working process for this master.

22. Larry Silver, "The Importance of Being Bruegel: The Posthumous Survival of the Art of Pieter Bruegel the Elder," in Orenstein, *Drawings and Prints*, 74; Luijten et al., *Dawn of the Golden Age*, exh. cat. (Amsterdam, 1993), 658–60, no. 330.4; more generally, Freedberg, *Dutch Landscape Prints* (London, 1980), esp. 32–38.

23. Orenstein, *Drawings and Prints*, 118–19, no. 21. A copy of this work in the British Museum, probably by Jan Brueghel, confirms the presence a Pieter Bruegel original (though possibly a lost work) as well as a second image, *River Landscape with Village* (Mielke, *Zeichnungen*, no. 28); *Pieter Bruegel d. Ä. als Zeichner*, 54–56, nos. 59–60; a third image, a variant also in the Louvre, was considered authentic by Mielke (*River Landscape with Angler*; Mielke, *Zeichnungen*, no. 29, and a copy of that work, also by Jan Brueghel and in the Louvre, is dated 1556).

24. *Breughel-Breughel*, exh. cat. (Antwerp, 1998), 177–79, no. 54, fig. 54c.

25. Christopher White, "'The Rabbit Hunters' by Pieter Bruegel the Elder," Von Simson and Winner, *Bruegel und seine Welt*, 187–91.

26. Orenstein, *Drawings and Prints*, 200–202, no. 81. For the experimentation made by nonspecialist printmakers, usually known for their paintings and for their work with collaborators who made engravings after their designs, see Michael Cole and Madeleine Viljoen, *The Early Modern Painter-Etcher*, exh. cat. (University Park, Pa., 2006), where the Bruegel *Rabbit Hunt* appears, 95–96, no. 8; also for the general phenomenon, see Michael Cole and Larry Silver, "Fluid Boundaries: Formations of the Painter-Etcher," 5–35.

27. For the hunting weapons, see the Triumphal Procession of Emperor Maximilian I; Stanley Appelbaum, ed., *The Triumph of Maximilian I* (New York, 1964), no. 14; see also the drawings for Maximilian hunts by Jörg Breu the Elder (Munich, Graphische Sammlung), especially the *Bear Hunt*,

c. 1516; Larry Silver, *Marketing Maximilian* (Princeton, 2008), 179, fig. 70.

28. Sullivan, "Proverbs and Process in Bruegel's 'Rabbit Hunt,'" *Burlington Magazine* 145 (2003), 30–35.

29. Note especially the Berlin Sketchbook (101 extant sheets) and the Errera Sketchbook (Brussels, Musées Royaux des Beaux-Arts, 84 sheets): Franz, *Niederländische Landschaftsmalerei im Zeitalter des Manierismus* (Graz, 1969), 68–77; see *Pieter Bruegel d. Ä. als Zeichner*, 134–35, no. 180 (Berlin Sketchbook); 135–37, no. 181 (Errera Sketchbook); also Christopher Wood, "The Errera Sketchbook and the Landscape Drawing on Grounded Paper," Norman Muller, Betsy Rosasco, and James Marrow, eds., *Herri met de Bles* (Princeton, 1998), 101–16.

30. Christian Vöhringer, *Pieter Bruegels d. Ä. Landschaft mit pflügendem Bauern und Ikarussturz* (Munich, 2002) has the fullest discussion with bibliography. In the most recent catalogue of the works of Bruegel, this picture is placed among the "problematic attributions" by Manfred Sellink, *Bruegel* (New York, 2007), 271, no. X3; also a "contested attribution" according to R. H. Marijnissen, *Bruegel* (Antwerp, 2003), 378–79. Recent study of the canvas suggests that the oldest original portions of that support date closer to 1600; M.J.Y. Van Strydonck et al., "Radiocarbon Dating of Canvas Paintings: Two Case Studies," *Studies in Conservation* 43 (1998), 209–14. Doubts about the authenticity of the Brussels canvas have been articulated most recently by Dominique Allart, "La chute d'Icare des Musées Royaux des Beaux-Arts de Belgique à Bruxelles," J. P. Duchesne et al. eds., *Mélanges Pierre Colman (Art and Fact* 15) (Liège, 1996), 104–7. For the Ovid translation in English, see Rolfe Humphries, *Ovid Metamorphoses* (Bloomington, 1955), 187–90, ll. 184–272.

31. Vöhringer, *Bruegels Ikarussturz*; Lyckle de Vries, "Bruegel's *Fall of Icarus*: Ovid or Solomon?" *Simiolus* 30 (2003), 5–18; Karl Kilinski, "Bruegel on Icarus: Inversions of the Fall," *Zeitschrift für Kunstgeschichte* 67 (2004), 91–114; Beat Wyss, "Der Dolch am linken Bildrand: zur Interpretation von Pieter Bruegels Landschaft mit dem Sturtz des Ikarus," *Zeitschrift für Kunstgeschichte* 51 (1988), 222–42; Kaveler, "The *Fall of Icarus* and the Natural Order," *Pieter Bruegel: Parables of Order and Enterprise* (Cambridge, 1999), 57–76, reading the picture as "a myth of early modern Europe opposed to one of antiquity."

32. De Vries, "Ovid or Solomon?" 7 n. 15, citing A. Henkel and A. Schöne, *Emblemata* (Stuttgart, 1978), col. 775, and also pointing out how Daedalus defies normal human limitations imposed by nature, as he "turned his thinking / Toward unknown arts, changing the laws of nature." (Translation of Rolfe Humphries, VIII, 188–89). Also on Sambucus (1564, 77), Kaveler, "Pieter Bruegel's *Fall of Icarus* and the Noble Peasant," *Jaarboek Koninklijk Museum Antwerpen* (1986), 97, fig. 9.

33. The sculptor was Artus Quellinus; Katherine Fremantle, *The Baroque Town Hall of Amsterdam* (Utrecht, 1959), 73; Simon Schama, *The Embarrassment of Riches* (Berkeley, 1987), 343, fig. 156. The opposite figure of Icarus was Arion, saved from drowning by a dolphin that was charmed by his singing with a harp, and this mythic figure appears in marble outside the neighboring bureau in Amsterdam, the Insurance Office. Among several of the several engravings of ships for Cock, Bruegel added landscapes with mythical figures: one engraving features *Three Caravels in a Rising Squall with Arion on a Dolphin*, another includes *Daedalus and Icarus in the Sky above an Armed Three-Master*.

34. Quoted by Kaveler, "Bruegel's *Fall of Icarus* and the Noble Peasant," 83–98, esp. 90, n. 20: "We should also remark with respect to this flight how ambition or desire for great things, if bridled by reason and wisdom, does not climb beyond her compass or boundaries, more than is proper, or than merit and dignity call for." (Van Mander, *Wtleggingh*, 1604, 71).

35. Alpers, *The Decoration of the Torre de la Parada* (Corpus Rubenianum Ludwig Burchard IX) (London, 1971), 223–25, no. 33; the final canvas is in the Prado, Madrid. On Bernard Salomon's woodcuts of 1557, ibid., 80–86. The mythographic tradition of Icarus in the sixteenth century is more widely examined by Vöhringer, Bruegels, *Ikarussturz*, 80–104.

36. Ovid, trans. Humphries, VIII, 256–59. Best discussion of the partridge is Vöhringer, Bruegels, *Ikarussturz*, 34–35, 169–71.

37. Tolnay, "Sutiden zu den Gemälden Pieter Bruegel d. Ä.," *Jahrbuch der kunsthistorischen Sammlungen in Wien* n.s. 8 (1934), 110: "Es bleibt kein Pflug stehen um eines Menschens willen der stirbt."

38. Kenneth Lindsay and Bernard Huppé, "Meaning and Method in Bruegel's Painting," *Journal of Aesthetics and Art Criticism* 14 (1956), 383; Kaveler, *Bruegel: Parables of Order*, 71.

39. Ibid., 96–97: "Weapons of any kind are antithetical to the peasant's natural role, and the dagger in Bruegel's *Fall of Icarus* suggests a similar threat to social stability." See also Wyss, "Der Dolch," 224 n. 5, who calls this dagger a "usual peasant weapon."

40. The original drawing, dated 1559, is in Berlin, Kupferstichkabinett. Vöhringer, Bruegels, *Ikarussturz*, 159–62; Kaveler, "Bruegel's *Fall of Icarus*;" Robert Baldwin, "Peasant Imagery and Bruegels 'Fall of Icarus,'" *Konsthistorisk Tidskrift* 55 (1986), 101–14, stressing the association of the plowman with the personification of Diligence in contemporary Netherlandish prints. More generally, see Veldman, "Images of Labor and Diligence in Sixteenth-Century Netherlandish Prints: The Work Ethic Rooted in Civic Morality or Protestantism?" *Simiolus* 21 (1992), 227–64.

41. For the iconography of the image, Bergström, "The Iconological Origins of 'Spes' by Pieter Bruegel the Elder," *Nederlands Kunsthistorisch Jaarboek* 7 (1956), 53–63.

42. Joz. de Coo, *Museum Mayer van den Bergh Catalogus I* (Antwerp, 1966), 178–79, tek. 809, fig. 47. Another Bol panel of the subject, a small roundel dated 1567, is in Museum Damme, Maerlant; see Franz, *Niederländische Landschaftsmalerei*, fig. 307; Kaveler, *Bruegel: Parables of Order*, fig. 29. Van Mander's biography of Bol in the 1604 *Schilderboek* mentions another Icarus painting in tempera on canvas, now lost, belonging to Jan van Mander in Ghent. See also the *Icarus* in Stockholm, Nationalmuseum, attributed to Joos de Momper, which includes both Daedalus and Icarus; Görel Cavalli-Björkman, *Dutch and Flemish Paintings I, c. 1400–c. 1600* (Stockholm, 1986), 90–91, no. 42.

CHAPTER 5. "SECOND BOSCH": BRUEGEL ADAPTS A TRADITION

1. Melion, *Shaping the Netherlandish Canon: Karel van Mander's Schilder-Boeck* (Chicago, 1991), 143–72, figs. 86–98 (Bruegel at fig. 88); see the edition by J. Puraye, ed., *Dominique Lampson: Les effigies des peintres célebres des Pays-Bays* (Liège, 1956).

2. Translation by Fritz Grossmann, *Bruegel: The Paintings*, rev. ed. (London, 1966), 9.

3. Larry Silver, "Second Bosch: Family Resemblance and the Marketing of Art," *Nederlands Kunsthistorisch Jaarboek* 50 (1999), 31–56, esp. 55 n. 32; Henry Luttik-huizen, ed., *The Humor and Wit of Pieter Bruegel the Elder*, exh. cat. (Grand Rapids, 2010).

4. Orenstein, *Pieter Bruegel the Elder: Drawings and Prints*, exh. cat. (New York, 2001), 137–39, nos. 36–37. For Bosch's *St. Anthony Triptych* (Lisbon), Larry Silver, *Hieronymus Bosch* (New York, 2006), 220–34.

5. Gert Unverfehrt, *Hieronymus Bosch: Die Rezeption seiner Kunst im frühen 16. Jahrhundert* (Berlin, 1980), 181–82, 185–86, 280, no. 123, fig. 135.

6. W. Gibson, "Invented in Hell: Bosch's Tree-Man," Julien Chapuis, ed., *Invention: Northern Renaissance Studies in Honor of Molly Faries* (Turnhout, 2008), 163–73.

7. On the tribulations of St. Anthony, Charles Cuttler, "The Lisbon *Temptation of Saint Anthony* by Jerome Bosch," *Art Bulletin* 39 (1957), 109–26; Jean Michel Massing, "Schongauer's 'Tribulations of St. Anthony': Its Iconography and Influence on German Art," *Print Quarterly* 1 (1984), 220–36.

8. "Many are the afflictions of the righteous; but the Lord delivereth him out of them all." (Psalm 34:19), Andrée Hayum, *The Isenheim Altarpiece: God's Medicine and the Painter's Vision* (Princeton, 1989).

9. Orenstein, *Drawings and Prints*, 163–65, nos. 56–57.

10. For Netherlandish paintings of the Last Judgment, Craig Harbison, *The Last Judgment in Sixteenth Century Northern Europe: A Study of the Relation Between Art and the Reforma-*

tion (New York, 1976); Emile Mâle, [...] gious Art in France of the Thirteenth Ce[...] 1958), 379–80, noting that the reason [...] of Hell is its association with the mo[...] in the book of Job (41), interpreted as [...] Binski, *Medieval Death* (Ithaca, N.Y., [...] Christine Göttler, *Last Things. Art an[...] tion in the Age of Reform* (Turnhout, 2c[...] survival of the Mouth of Hell as a hide[...] pomorphic landscapes by both Bosch [...] is discussed by Weemans, "Herri met [...] dler: An Exegetical and Anthropomor[...] *Bulletin* 88 (2006), 459–81; Falkenburg[...] Detail: Ways of Seeing Joachim Patini[...] scapes," Alejandro Vergara, ed., *Patini[...] 2007), 61–79.

11. Kaulbach and Schleier, eds., *"Der Welt[...] Graphikserien des Manierismus*, exh. cat[...] Larry Silver, "Graven Images: Reprodu[...] Visual Models," in Timothy Riggs and [...] *Images: The Rise of Professional Printma[...] Haarlem, 1540–1640*, exh. cat. (Evansto[...] 8–12.

12. Orenstein, *Drawings and Prints*, 144–6c[...] Nina Serebrennikov, "Pieter Bruegel the[...] tues' and 'Vices,'" Ph.D. diss. (Universit[...] 1986). I am most grateful to my valued c[...] of her dissertation. A tapestry series of t[...] tion by Bruegel's purported master, Piet[...] showed the Seven Vices (1544; drawing [...] Staedel, dated 1537; Campbell, *Tapestry[...]* exh. cat. (New York, 2002), 381410–16, [...] Bauer and Jan-Karel Steppe, *Tapisserien[...] nach Entwurfen von Pieter Coecke van Aels[...]* Halbturn, 1981). For the tradition, Adolf[...] *Allegories of the Virtues and Vices in Medie[...]* 1989); Morton Bloomfield, *The Seven De[...]* Lansing, 1952). Virtues; Genevieve Souc[...] of the Seven Virtues': Reconstruction of [...] (c. 1520–1535)," *Acts of the Tapestry Symposi[...]* 1979), 103–53.

13. Amidst many late medieval associations [...] gories of sins, German prints could have [...] source for Bruegel; see, for example, the [...] by Aldegrever (1552, B. 127), which shows[...] of arms with a toad. Gisela Luther, *Heinr[...]* (Münster, 1982), 48.

14. In America bachelor parties on the last nig[...] ding are called "stag parties."

15. Silver, *Bosch*, 21–79.

16. Natalie Z. Davis, "The Reasons of Misrule[...] ture in Early Modern France* (Stanford, 197[...]

17. For the information on Latin sources, Ser[...] xvii, citing assistance from Josef Ijsewijn [...] University of Louvain for assistance with [...] *Avarice*.

18. Moxey, "The Criticism of Avarice in Sixtee[...] Netherlandish Painting," Görel Cavalli-Björ[...] *landish Mannerism* (Stockholm, 1985), 21–3[...]

19. Lester K. Little, "Pride Goes before Avaric[...] and the Vices in Latin Christendom," *Amer[...] Review* 76 (Feb. 1971), 16–49.

20. Quis metus, aut pudor est unquam propera[...]

21. Orenstein, *Drawings and Prints*, 158–60, no[...]

22. *In de Vier Winden*, exh. cat. (Rotterdam, 19[...]

23. Ora tument ira, nigrescunt sanguine venae. [...] phrase is almost identical: "Anger swells the[...] ters the spirit, and blackens the blood."

24. Orenstein, *Drawings and Prints*, 150–51, nos[...]

25. The Catholic Church was compared to a be[...] because of its structure of hierarchy and aut[...] Sybesma, "The Reception of Bruegel's Beek[...] of Choice," *Art Bulletin* 73 (1991), 467–73.

26. Orenstein, *Drawings and Prints*, 148–49, no[...] Latin inscription reads, "Drunkenness and [...] be shunned." The Flemish, "Shun drunkenn[...] for excess makes man forget God and himse[...]"

[...]bid., 156–57, nos. 52–53. The Latin reads: "Sluggishness [...]breaks strength, long idleness [breaks] the nerves." The [...]Flemish: "Sloth makes [man] powerless and dries out the [...]nerves until man is good for nothing."

[...]ts Latin inscription: "Envy is a monster to be feared, and a [...]most severe plague." Its Flemish: "Envy is an eternal death [...]nd a terrible plague, a beast which devours itself with false [...]roubles."

[...]or hidden images of the mouth of Hell within normal out-[...]ard appearances in Bosch as well as his sixteenth-century [...]ccessors, Falkenburg, *Devil in the Detail*; Falkenburg also [...]as a full-scale study of Bosch's *Garden of Delights Triptych* in [...]ress, which he generously shared with me in addition to [...]r ongoing dialogue.

[...]urkeys are documented as imported in Europe by 1511, [...]mported through Seville for King Ferdinand of Spain, and [...]name was "peacock of the Indies" (*pavo de las Indias*). The [...]ench equivalent, "cock of India" (*coq d'Inde*; Italian *gallo [...]India*), now shortened to *dinde*, was documented as in the [...]ssession of Marguerite de Navarre by 1534. A German [...]ariant, *Kalekutisch hu[h]n*, or cock of Calicut, in southern [...]dia, gave rise to the modern Dutch word for turkey, *kal-[...]n*. Sabine Eiche, *Presenting the Turkey* (Florence, 2004); [...]e Lotte Möller, "Der indianische Hahn in Europa," in *Art [...]Ape of Nature* (New York, 1981), 313–40. A turkey [...]ears in the 1604 engraving of the Fall of Man in a set [...]ix prints after Abraham Bloemart, executed by Jan [...]nredam, where it has been interpreted as "pride goes [...]ore the fall." *Het Aards Paradijs*, exh. cat. (Antwerp, 1982), [...]31, no. 79. The bird also appears in early printed natural [...]ories, such as Conrad Gesner (1555), and among groups [...]nimals in Eden scenes, Noah's ark, or other narratives, [...]example, Frans Boels, *Orpheus among the Animals* (1587; [...]ate collection; ibid., 104–5, no. 38). Giambologna pro-[...]d a life-sized bronze *Turkey* for the grotto of Cosimo [...]Medici in the 1560s.

[...]er, *Bosch*, 317.

[...]cy Corwin, "The Fire Landscape: Its Sources and its [...]elopment from Bosch Through Jan Brueghel I," Ph.D. [...](University of Washington, 1976).

[...]n Mellinkoff, "Riding Backwards: Theme of Humilia-[...]and Symbol of Evil," *Viator* 4 (1973), 153–76. For the [...]k-procession, or charivari, Natalie Davis, *Society and [...]ure* (as in n. 16).

[...]Gibson, *Pieter Bruegel and the Art of Laughter* (Berkeley, [...]), 28–38, noting (33) that celebrated publisher Christo-[...]Plantin used a similar term for this very set of the Seven [...]ly Sins in 1558 when he dispatched them to Paris, calling [...]the "seven sins, drolleries" (*7 pechez drolleries*). He also [...](34, n. 17) an etymological link between the English [...]"droll" and the figure of a "troll," so establishing a pos-[...]connection between the demonic and the entertaining.

[...]ail Bakhtin, *Rabelais and His World* (Cambridge, Mass., [...]Peter Stallybrass and Allon White, *The Politics and Poet-[...]Transgression* (Ithaca, N.Y., 1986), 27–66.

[...]nal drawing lost; Orenstein, *Drawings and Prints*, [...], no. 55; K. G. Boon, "*Patientia* dans les graveurs de [...]orme aux Pays-Bas," *Revue de l'art* 56 (1982), 7–24. The [...]"Patientia est malorum quae aut inferuntur, aut acci-[...]cum aequanimitate perlatio."

[...]ra Swain, *Fools and Folly during the Middle Ages and [...]naissance* (New York, 1932); Jan Op de Beeck, *De Zotte [...]rs: Moraalridders van het Pinseel rond Bosch, Bruegel en [...]er*, exh. cat. (Mechelen, 2003); Korine Hazelzet, *Ver-[...]Werelden: Exempla contraria in de Nederlandse beeldende [...]*Leiden, 2007); Van der Coelen, "Praise of Folly," [...]*of Erasmus*, exh. cat. (Rotterdam, 2008), 213–29.

[...]ein, *Drawings and Prints*, 188–89, nos. 74–75.

[...]*Religious Art in France: The Late Middle Ages: A Study [...]eval Iconography and its Sources*, trans. Marthiel Mat-[...]Princeton, 1986), 285–317, esp. 290.

[...]m vincere, iracundiam cohibere, caeteraq[ue] vitia et, [...]s / cohibere, vera fortitudo est.

[...]ein, *Drawings and Prints*, 210–12, nos. 87–88. The ink [...]cribed the date on the drawing differs in color and [...]n doubted as authentic by some scholars.

42. M. R. James, *The Apocryphal New Testament* (Oxford, 1924), 117–42.

43. Ann Kartsonis, *Anastasis: The Making of an Image* (Princeton, 1986); for the general iconography, Op de Beeck, *De Zotte Schilders*, 76–79.

44. Jane Martineau, ed., *Mantegna*, exh. cat. (London-New York, 1992), 258–72, nos. 65–71, which shows variants on this subject as well as a Giovanni Bellini version and an engraving after Mantegna, 263–66, no. 67.

45. Orenstein, *Drawings and Prints*, 221–24, nos. 96–97.

46. The date is somewhat abraded and has also been read as 1562. Rogier van Schoute, Hélène Verougstraete, "La *Dulle Griet* et le *Triomphe de la Mort* de Pierre Bruegel: Observations d'ordre technologique," in Verougstraete and van Schoute, eds., *Le dessin sous-jacent dans la peinture* 10 (1995), 7–12; W. Gibson, "The Devil's Nemesis: Griet and Her Sisters," *Bruegel and the Art of Laughter*, 124–44; W. Gibson, "Pieter Bruegel, *Dulle Griet* and Sexist Politics in the Sixteenth Century," Otto von Simson and Matthias Winner, eds., Pieter *Bruegel und seine Welt* (Berlin, 1979), 9–15; Sullivan, "Madness and Folly: Pieter Bruegel the Elder's *Dulle Griet*," *Art Bulletin* 59 (1977), 55–66. Most recently Louise Milne, *Carnivals and Dreams: Pieter Bruegel and the History of the Imagination* (London, 2007), 159–317, a highly interpretive study.

47. Fol. 233, quoted by W. Gibson, *Bruegel and the Art of Laughter*, 126; see edition of Van Mander by Hessel, *The Lives of the Illustrious Netherlandish and German Painters* (Doornspijk, 1994–99), I, 192–93.

48. *The Canterbury Tales*, "The Squire's Tale," 602; W. Gibson, *Bruegel and the Art of Laughter*, 141.

49. A similar argument was advanced by Sullivan, "Griet," 64, recalling the legendary giant Druon Antigon, who once inhabited the region and was a figure evoked in Antwerp civic pageantry.

50. Jan Grauls, *Volkstaal en volksleven in het werk van Pieter Bruegel* (Antwerp, 1957), 6–76, esp. 28. The origin of this figure surely lies in the figure of St. Margaret, whose attribute, a dragon, indicates her victory, like Jonah's, over a monster. Often the saint is depicted with the dragon on a leash, like Bruegel's *Fortitude*, or else under her feet. For her legend, see William Granger Ryan, trans., Jacobus de Voragine, *The Golden Legend* (Princeton, 1993), II, 232–33.

51. W. Gibson, *Bruegel and the Art of Laughter*, 127 n. 7, citing Grauls, 39. On artillery in early modern warfare in Europe, J. R. Hale, *War and Society in Renaissance Europe, 1450–1620* (Baltimore, 1985), 46–49, noting the name "Mad Margaret" among various other nicknames for the ordnance. "Mons Meg" was already noted for its size as a siege weapon by 1479 but was no longer useful by 1501.

52. W. Gibson, *Bruegel and the Art of Laughter*, 127.

53. Hezelzet, *Verkeerde Werelden*, esp. 165–81, also plates 4, 144; Wilma van Engeldrop Gastelaars, "Ic sal U smitten op uwen tant: Geweld tussen man en vrouw in laatmiddel-eeuwse kluchten," Ph.D. diss. (Amsterdam, 1984); more generally Lène Dresen-Coenders, "De omgekeerde wereld: tot lering en vermaak," *Helse en hemelse vrouwen: schrikbeelden en voorbeelden van de vrouw in de christelijke cultuur* (1400–1600), M. L. Caron, ed., exh. cat. (Utrecht, 1988), 73–84, esp. 76. The classic study is Natalie Zemon Davis, "Women on Top," *Society and Culture*, 124–51.

54. Moxey, *Peasants, Warriors, and Wives: Popular Imagery in the Reformation* (Chicago, 1989), 101–26, 156 n. 11: quoting a verse "Be master in your house / If your wife wears the pants / She'll be your scourge and your curse." Also W. Gibson, "Some Flemish Popular Prints from Hieronymus Cock and his Contemporaries," *Art Bulletin* 60 (1978), 677–79. From the generation before Bruegel, Cornelis Matsys produced an engraving (1539) on the Battle for the Trousers; W. Gibson, "Dulle Griet," 11–12; Van der Stock, *Cornelis Matsys 1510/11–1556/57*, exh. cat. (Brussels, 1985), 34, no. 26 (illustrated in W. Gibson, "Dulle Griet," fig. 5). Now W. Gibson, *Figures of Speech*, 118–41.

55. Hazelzet, *Verkeerde werelden*, 26–27, fig. 4. A German term for this man is *Pantoffelheld*, or "slippers hero"; see a later roundel print, engraved by Harmen Muller. For the Liefrinck image, *Tussen heks en heilige: Het vrouwenbeeld op de*

drempel van de moderne tijd, 15de/16de eeuw (Nijmegen, 1985), 180, no. 44. The Flemish text reads in translation: "'Tis no wonder that the world is perverse [*verdraeyt*] / And that the hen no crows above the cock / Because nobody is satisfied with his own / The man scorns man's work almost completely / And enhances the work of his wife."

56. Larry Silver, "Jheronimus Bosch and the Origins of Evil," *Journal of the Historians of Netherlandish Art* 1 (2009); Pinson, "Fall of the Angels and Creation of Eve in Bosch's Eden: Meaning and Iconographical Sources," Maurits Smeyers and Bert Cardon eds., *Flanders in a European Perspective: Manuscript Illumination around 1400 in Flanders and Abroad* (Louvain, 1995), 693–707; Luther Link, *The Devil* (New York: Abrams, 1996), esp. 22–30; Karl-August Wirth, "Engelsturz," *Reallexikon zur deutschen Kunstgeschichte* (Stuttgart: Metzler, 1937ff) vol. 5, cols. 621–74 (1960).

57. Silver, "Jheronimus Bosch and the Origins of Evil."

58. Ria Fabri and Nico Van Hout, eds., *From Quinten Metsijs to Peter Paul Rubens*, exh. cat. (Antwerp, 2009), 99–102, no. 3.

59. Maurice McNamee, *Vested Angels: Eucharistic Allusions in Early Netherlandish Paintings* (Louvain, 1998), esp. 181–200 for Last Judgments.

60. Emanuel Winternitz, *Musical Instruments and Their Symbolism in Western Art* (New Haven, 1979), 66–86; Edwin Buijsen and Louis Peter Grijp, *Music and Painting in the Golden Age*, exh. cat. (The Hague, 1994), 306–10, no. 43. The use of hurdy-gurdies by seventeenth-century Dutch artists, such as David Vinckboons and Adriaen van de Venne, and French artists, such as Jacques Bellange and George de la Tour, shows them in the hands of blind beggars.

61. This instrument appears among the other items laid upon the shelves in Hans Holbein's 1533 *The Ambassadors* (London, National Gallery) as well as in his 1528 portrait of the astronomer, *Nicolaus Kratzer* (Paris, Louvre); see John North, *The Ambassadors' Secret: Holbein and the World of the Renaissance* (London-New York, 2002), 99–108.

62. Voragine, *Golden Legend*, 3–10, esp. 4.

63. Orenstein, *Drawings and Prints*, 230–31, no. 101, noting that there is a second state in which the priestly vestment, a stole with the cross, worn by a witch in the lower right corner, is replaced by a more innocuous linear symbol that avoids overt anticlericalism.

64. *Tussen heks en heilige*, 188–89, nos. 60–61; Claudia Swan, *Art, Science, and Witchcraft in Early Modern Holland: Jacques de Gheyn II (1565–1629)* (Cambridge, 2005), 123–36, 144–51, 175–76. In general for representation of flying witches, especially in German prints, Charles Zika, "Fears of Flying: Representations of Witchcraft and Sexuality in Sixteenth-Century Germany," *Exorcising Our Demons: Magic, Witchcraft and Visual Culture in Early Modern Europe* (Leiden, 2003), 237–687; Sigrid Schade, *Schadenzauber und die Magie des Körpers: Hexenbilder der frühen Neuzeit* (Worms, 1983); Linda Hults, *The Witch as Muse. Art, Gender, and Power in Early Modern Europe* (Philadelphia, 2005).

65. According to Vervoort, an elephant named Emmanuel arrived in Antwerp in 1563; Vervoort, "De heilige, de heks en de tovenaar; verklaring van de Bruegel-prent: De legendarische ontmoeting tussen Sint Jacob en de tovenaar Hermogenes," *Millenium* 16 (2002), 99–113, cited by Sellink, *Bruegel* (Ghent, 2007), 199.

66. Orenstein, *Drawings and Prints*, 232–34, nos. 102–3.

67. Montague Rhodes James, *The Apocryphal New Testament* (Oxford, 1975; first ed. 1924), 331–32 (Acts of Peter), 470: "Hasten thy grace, O Lord, and let him fall from the height and be disabled." William Granger Ryan, trans. *The Golden Legend* (Princeton, 1993), I, 341–44.

68. Arnade, *Beggars, Iconoclasts, and Civic Patriots: The Political Culture of the Dutch Revolt* (Ithaca, N.Y., 2008), 63–74; Marnef, *Antwerp in the Age of the Reformation: Underground Protestantism in a Commercial Metropolis, 1550–1577* (Baltimore, 1996).

69. Jacques Le Goff, *The Birth of Purgatory* (Chicago, 1981); Paul Binski, *Medieval Death* (Ithaca, N.Y., 1996), 181–99; Christine Göttler, *Last Things* (Turnhout, 2010), esp. 31–69, 103.

CHAPTER 6. PARABLES, PROVERBS, PASTIMES

1. Charles de Tolnay, *The Drawings of Peter Bruegel* (London, 1952; orig. ed. 1925), 26–28; Carl Gustav Stridbeck, *Bruegelstudien* (Stockholm, 1956), 126–70; Irving Zupnick, "Appearance and Reality in Bruegel's Virtues," *Actes du XXIIe Congrès Internationale de histoire de l'art* (Budapest, 1969), I, 745–53. Also Jan van Gelder and Jan Borms, *Brueghel's zeven deugden en zeven hoofdzonden* (Amsterdam-Antwerp, 1939); Serebrennikov, "Pieter Bruegel the Elder's Series of 'Virtues' and 'Vices,'" Ph.D. diss. (University of North Carolina, 1986), 129–255. For general images of the fifteenth-century allegories of the Virtues, Emile Mâle, *Religious Art in France: The Late Middle Ages: A Study of Medieval Iconography and its Sources* (Princeton, 1986), 285–301; Rosemond Tuve, "Notes on the Virtues and Vices," *Journal of the Warburg and Courtauld Institutes* 24 (1963), 264–303.

2. Nadine Orenstein, *Pieter Bruegel the Elder: Drawings and Prints*, exh. cat. (New York, 2001), 180–81, nos. 66–67.

3. Larry Silver and Henry Luttikhuizen, "The Quality of Mercy: Sixteenth-Century Dutch Depictions of Charity," *Studies in Iconography* 29 (2008), 216–48.

4. Ria Fabri and Nico Van Hout, eds., *From Quinten Metsijs to Peter Paul Rubens*, exh. cat. (Antwerp, 2009), 87–93, no. 2.

5. Miri Rubin, *Corpus Christi: The Eucharist in Late Medieval Culture* (Cambridge, 1991), esp. 310–12; T. H. White, *The Bestiary* (New York, 1960), 132–33.

6. Orenstein, *Drawings and Prints*, 182–83, nos. 68–69.

7. Eddy de Jongh, *Tot Lering en vermaak*, exh. cat. (Amsterdam, 1976), 116–19, no. 24 (Barent Fabritius, Rotterdam, 165[2]); Kenneth Craig, "Rembrandt and the Slaughtered Ox," *Journal of the Warburg and Courtauld Institutes* 46 (1983), 235–39, points to an association of the scene with Christ's own sacrifice and the fatted calf of the Prodigal Son parable; see also Rembrandt's etching of a sleeping *Hog* (1643), where one child plays with the pig's bladder of an earlier slaughter and another strokes the family pet, even as their father gathers his axe prior to its next use; Linda Stone-Ferrier, *Dutch Prints of Daily Life*, exh. cat. (Lawrence, Kans., 1983), 178–80, no. 49.

8. Orenstein, *Drawings and Prints*, 184–85, nos. 70–71.

9. I. Bergström, "The Iconological Origins of *Spes* by Pieter Bruegel the Elder," *Nederlands Kunsthistorisch Jaarboek* 7 (1956), 53–63: "Hofft es gang glücklich von handen / In wasser vund in füres nodt"; Serebrennikov, 166–68 also mentions a print of *Hope* by Hans Sebald Beham that shows a melancholic prisoner in the stocks before the praying personification. She also cites a 1520/35 *Triumph of Hope* tapestry with the allegory on a ship amidst shipwrecks with a phoenix attribute and biblical prisoners, Menasseh (2 Kings 21) and Daniel as well as the three Hebrews in the fiery furnace. Though she does not cite any discussion, see the tapestry series, *Triumphs of the Seven Virtues*, Brussels c. 1535, Anna Bennett, *Five Centuries of Tapestry from the Fine Arts Museum of San Francisco*, exh. cat. (San Francisco, 1976), 93–101 (a version of this weaving is in Pittsburgh, Carnegie Institute, fig. 48).

10. Dirk De Vos, *Rogier van der Weyden* (New York, 1999), 217–25. The heraldic arms of Jean Chevrot (d. 1460), the patron, and of his bishopric, Tournai, appear in the spandrels. The date of the work is disputed, and the presence of workshop assistance in the figures of the wings is evident, as well as later replacements of heads with inserted portraits by another hand. De Vos overturns an earlier consensus of seeing the work as c. 1445 or later; surely the demands of the enormous *Beaune Altarpiece* (1443–51) would have compromised the output of the van der Weyden studio, but this work also shows the taller, slenderer figure types and faces of that newer phase and surely lies somewhat later than his proposed 1440–45 period, even if still difficult to date with precision.

11. Stridbeck, *Bruegelstudien*, 132–43.

12. Bonnie Noble, *Lucas Cranach the Elder: Art and Devotion of the German Reformation* (Landham, Md., 2009); Joseph Koerner, *The Reformation of the Image* (Chicago, 2004), esp. 252–81; Carl Christensen, *Art and the Reformation in Germany* (Athens, Ohio, 1979), esp. 61–65, 160–63.

13. Bob Scribner, *For the Sake of Simple Folk: Popular Propaganda for the German Reformation* (Oxford, 1994), esp. 17–22; Martin Warnke, *Cranachs Luther* (Frankfurt, 1984), esp. 32–34.

14. Gertrude Schiller, "The 'Arma Christi' and Man of Sorrows," *Iconography of Christian Art* (Greenwich, Conn., 1972), II, 184–96; Rudolf Berliner, "Arma Christi," *Münchner Jahrbuch der bildenden Kunst* 6 (1955), 35–116; Robert Suckale, "Arma Christi: Überlegungen zur Zeichenhaftigkeit mittelalterlicher Andachtsbilder," *Städel-Jahrbuch* 6 (1977), 177–208.

15. Peter Parshall, "The Art of Memory and the Passion," *Art Bulletin* 81 (1999), 456–72, esp. 464.

16. Miri Rubin, *Corpus Christi*, esp. 302–16.

17. For general history, Edward Peters, *Torture* (Philadelphia, 1996); Christoph Hinckeldey, *Criminal Justice Through the Ages* (Rothenburg, 1993), esp. 174–79, by Friedrich Merzbacher on judicial torture; for the period, Richard van Dülmen, *Theatre of Horror: Crime and Punishment in Early Modern Germany* (Cambridge, 1990).

18. Mitchell Merback, *The Thief, the Cross and the Wheel: Pain and the Spectacle of Punishment in Medieval and Renaissance Europe* (Chicago, 1999), esp. 126–57 for public punishments, 158–97 on the wheel as a specific instrument of torture.

19. Ibid., 136.

20. Ibid., 150–57; for a comparative contemporary instance in Italy, Samuel Edgerton, Jr., *Pictures and Punishment: Art and Criminal Prosecution during the Florentine Renaissance* (Ithaca, N.Y., 1985); see also Freedberg, "The Representations of Martyrdoms during the Early Counter-Reformation in Antwerp," *Burlington Magazine* 118 (1976), 425–33.

21. *Hooghe Vierschare des Hertoghs van Brabant*, as noted in the first printed edition of the Antwerp city laws and ordinances, *Rechten ende Costumen* (Plantin, 1582); acute observation of Serebrennikov, 154 n. 42.

22. Serebrennikov, 156–58. I am also grateful to Rebecca Parker Brienen for sharing with me her unpublished master's paper on Damhouder and the illustrations to his treatise.

23. Diana Norman, "'Love Justice, You Who Judge the Earth': The Paintings of the Sala dei Nove in the Palazzo Pubblico, Siena," Norman, ed., *Siena, Florence and Padua: Art, Society and Religion 1280–1400* (New Haven, 1995), 145–67, esp. 147–49; see also Quentin Skinner, "Ambrogio Lorenzetti: the Artist as Political Philosopher," *Proceedings of the British Academy* 72 (1986), 1–56; the classic study, emphasizing ancient ideas of justice is Nicolai Rubinstein, "Political Ideas in Sienese Art: the Frescoes by Ambrogio Lorenzetti and Taddeo di Bartolo in the Palazzo Pubblico," *Journal of the Warburg and Courtauld Institutes* 21 (1958), 179–207.

24. On the ruler's right: Peace (reclining), Fortitude, and Prudence. To his left: Magnanimity, Temperance, and another figure of Justice.

25. Orenstein, *Drawings and Prints*, 190–91, nos. 76–77; Ger Luijten and A.W.F.M. Meij, *From Pisanello to Cézanne: Master Drawings from the Museum Boijmans van Beuningen*, exh. cat. (Rotterdam, 1990), 63–65, no. 18.

26. Dieter Blume, *Regenten des Himmels: astrologische Bilder in Mittelalter und Renaissance* (Berlin, 2000), esp. 158–94; Kaulbach and Schleier, eds., *"Der Welt Lauf": Allegorische Graphikserien des Manierismus*, exh. cat. (Stuttgart, 1997); Veldman, "De macht van de planeten over het mensdom in prenten naar Maarten de Vos," *Bulletin van het Rijksmuseum* 31 (1983), 21–53.

27. For the astronomy, Edward Grant, *Planets, Stars, and Orbs: The Medieval Cosmos 1200–1687* (Cambridge, 1994), esp. 569–617.

28. Kaulbach and Schleier, *"Der Welt Lauf,"* 80–92, nos. 16–18; Veldman, *Leerijke reeksen van Maarten van Heemskerck*, exh. cat. (Haarlem, 1986), 73–81, no. 41; Veldman, "Seasons, Planets and Temperaments in the Work of Maarten van Heemskerck: Cosmo-Astrological Allegory in Sixteenth-Century Netherlandish Prints," 11 (1980), 163–74.

29. Ibid., 167–69, esp. fig. 32; Giulia Bartrum, *German Renaissance Prints 1490–1550* (London, 1995), 115–17, no. 109.

30. Larry Silver, "Power and Pelf: A New-Found *Old Man* by Massys," *Simiolus* 9 (1977), 63–92; Moxey, "The Criticism of Avarice in Sixteenth-Century Netherlandish Painting," Görel Cavalli-Björkman, ed. *Netherlandish Mannerism* (Stockholm, 1986), 21–34.

31. The origin of the mechanical arts arose ⬛ codification of Hugh of St. Victor in ⬛ Benjamin Rifkin, *The Book of Trades: J* ⬛ *Sachs* (New York, 1973), xiv–xix; Davi ⬛ *ment of Sense* (Cambridge, 1987), 235– ⬛

32. J. J. Mak, "De Wachter in het rederijk ⬛ leiding van de toneelvertooning op B ⬛ *Oud Holland* 64 (1949), 162–72; W. G ⬛ *Rederijkers* in the Age of Bruegel," *Art* ⬛ plus fine discussion of Temperance an ⬛ Ramakers, "Bruegel en de rederijkers. ⬛ literatuur in de zestiende eeuw," *Neder* ⬛ *Jaarboek* 47 (1996) 81–105, esp. 89.

33. W. Gibson, "Artists and *Rederijkers*"; ⬛ Mak, *De Rederijkers* (Amsterdam, 194 ⬛

34. Consuelo Dutschke, "Liturgical Manu ⬛ ed., *Leaves of Gold: Manuscript Illumin* ⬛ *Collections*, exh. cat. (Philadelphia, 200 ⬛

35. Ernst Robert Curtius, *European Litera* ⬛ *Middle Ages* (New York, 1953), 36–78; ⬛ about the position of painting in relati ⬛ Michael Baxandall, *Giotto and the Orat* ⬛ Francis Ames-Lewis, *The Intellectual L* ⬛ *sance Artist* (New Haven, 2000).

36. First observed in print by Jane ten Brin ⬛ Bruegel the Elder and the Matter of Ita ⬛ *Journal* 23 (1992), 205–34.

37. Sellink, *Cornelis Cort*, exh. cat. (Rotter ⬛ nos. 42–48; the Floris paintings date c ⬛

38. Wayne Booth, *The Rhetoric of Fiction* (C ⬛ 300–308, going on to observe, "Our pl ⬛ of pride in our own knowledge . . . an ⬛ with the silent author who, also knowi ⬛ ated the trap for . . . those readers who ⬛ allusion. I notice, of course, only those ⬛ prepared to notice, and I am therefore ⬛ irony as something that gives *me* [italic ⬛ ble." Also Booth, *The Rhetoric of Irony* (⬛

39. Serebrennikov, 142–43 n.21, citing Eras ⬛ Method of Copia," *De duplici copia verb* ⬛ sixteenth-century *locus classicus* of this d ⬛ *communis*. See also Terence Cave, *The C* ⬛ *Problems of Writing in the French Renais* ⬛ Rebecca Bushnell, *A Culture of Teachin* ⬛ *Humanism in Theory and Practice* (Ithac ⬛ 43; Ann Moss, *Printed Commonplace-B* ⬛ *ing of Renaissance Thought* (Oxford, 199 ⬛

40. Lynn White, Jr., "The Iconography of ⬛ Virtuousness of Technology," Theodore ⬛ Seigel, eds., *Action and Conviction in Ea* ⬛ *Essays in Memory of E. H. Harbison* (Prin ⬛ 219, esp. 217; cited by W. Gibson, "Artis ⬛ 444. More broadly, Alfred Crosby, *The* ⬛ *Quantification and Western Society, 1250–* ⬛ 1997); Timothy Reiss, *Knowledge, Disco* ⬛ *in Early Modern Europe: The Rise of Aest* ⬛ (Cambridge, 1997).

41. Barbara Benedict, *Curiosity: A Cultural* ⬛ *ern Inquiry* (Chicago, 2001); Klaus Krü ⬛ *Welterfahrung und ästhetische Neugierde* ⬛ *früher Neuzeit* (Göttingen, 2002); R.J.V ⬛ der Marr, eds., *Curiosity and Wonder fro* ⬛ *the Enlightenment* (Aldershot, 2006).

42. On the related skill of marketplace judg ⬛ responding to the painting of market su ⬛ with background Gospel scenes of eithe ⬛ Adulterous Woman or Christ Presented ⬛ painted by both Pieter Aertsen and Joac ⬛ Elizabeth Honig, *Painting and the Mark* ⬛ *Antwerp* (New Haven, 1998), 53–99.

43. Out of a vast literature on emblems, two ⬛ bring out the basic dialectic between im ⬛ Rosalie Colie, *The Resources of Kind: Gen* ⬛ *Renaissance* (Berkeley, 1973), 36–67; Mar ⬛ *Seventeenth-Century Imagery* (Rome, 196 ⬛ is Arthur Henkel and Albrecht Schöne, ⬛

⬛ *uch zur Sinnbildkunst des XVI. und XVII. Jahrhunderts* ⬛ Stuttgart, 1976).

⬛ This sensible point is made by Serebrennikov, 207–8 n. 135, ⬛ iting Julius von Schlosser, "Giusto's Fresken in Padua und ⬛ ie Vorläufer der Stanza della Segnatura," *Jahrbuch der kun-* ⬛ *historischen Sammlungen des allerhöchsten Kaiserhauses* 17 ⬛ 1896), 13–100, where bas reliefs associate *homo faber* with the ⬛ even planets, seven virtues, seven sacraments, and seven lib- ⬛ ral arts; see also Curtius, *European Literature and the Latin* ⬛ *Middle Ages*. Arguably Bruegel's outlook would harmonize ⬛ ith the emphasis on justice and religion along with poetry, ⬛ athematics, and philosophy in Raphael's Stanza della Seg- ⬛ atura program, despite its emphatic humanist interest in ⬛ he ancient world.

⬛ V. Gibson, "Artists and *Rederijkers*," 444 n. 125, citing E. van ⬛ utenboer, *Volksfeesten en rederijkers te Mechelen (1400–1600)* ⬛ Ghent, 1962), 155.

⬛ arroll, "Breaking Bonds: Marriage and Community in ⬛ ruegel's *Netherlandish Proverbs* and *Carnival and Lent*," in ⬛ *ainting and Politics in Northern Europe* (University Park, ⬛ enn., 2008), 50–63; Ethan Matt Kaveler, *Pieter Bruegel:* ⬛ *arables of Order and Enterprise* (Cambridge, 1999), 111–48; ⬛ lexander Wied, *Bruegel: Il Carnevale e la Quaresima* ⬛ Milan, 1996); Klaus Demus, Friderike Klauner, Karl Schütz, ⬛ *lämische Malerei von Eyck bis Bruegel* (Vienna, 1981), 61–68; ⬛ arl Gustaf Stridbeck, "'Combat Between Carnival and ⬛ ent' by Pieter Bruegel the Elder. An Allegorical Picture of ⬛ e Sixteenth Century," *Journal of the Warburg and Courtauld* ⬛ *stitutes* 19 (1956), 96–109.

⬛ or the beehive as a church symbol, see Sybesma, "The ⬛ eception of Bruegel's Bee-keepers: A Matter of Choice," ⬛ *rt Bulletin* 73 (1991), 467–73.

⬛ or charivari, Natalie Zemon Davis, "The Reasons of ⬛ isrule," *Society and Culture in Modern France* (Stanford, ⬛ 75), 97–123; Paul Vandenbroeck, *Jheronimus Bosch: Tussen* ⬛ *lksleven en stadscultuur* (Berchem, 1987), esp. 250–80; for ⬛ e *rommelpot*, Judith Leyster, *A Dutch Master and Her World*, ⬛ h. cat. (Worcester, 1993), 356–61, no. 40; Eddy de Jongh ⬛ d Ger Luijten, *Mirror of Everyday Life: Genreprints in the* ⬛ *etherlands 1550–1700*, exh. cat. (Amsterdam, 1997), 229–32, ⬛ o. 45, discussing an engraving after Cornelis Saftleven, ⬛ *ildren with a Rommelpot and Top* (1633), and explaining the ⬛ *mmelpot* as a Carnival instrument but neglecting the top, ⬛ hich appears on the Lent side of Bruegel's picture; more ⬛ nerally, Charles de Mooij, *Vastenavond-Carnaval: Feesten* ⬛ *n de omgekeerde wereld*, exh. cat. ('s-Hertogenbosch, 1992); ⬛ muel Kinser, *Rabelais's Carnival* (Berkeley, 1990); Peter ⬛ rke, "The World of Carnival," *Popular Culture in Early* ⬛ *odern Europe* (New York, 1978). 178–204.

⬛ erman Pleij, *Het gilde van de Blauwe Schuit: Literatuur,* ⬛ *ksfeest en burgermoraal in de late middeleeuwen*, 2nd ed. ⬛ msterdam, 1983).

⬛ renstein, *Drawings and Prints*, 246–48, nos. 111–12. The ⬛ cription on the engraving is derived from Vergil (*Bucolica* ⬛ II, 26): "Mopsus marries Nisa, what may not we lovers ⬛ pe for?"

⬛ mus et al., *Flämische Malerei*, 62–64; C. Gaignebet, "Le ⬛ mbat de Carnaval et de Carême de P. Bruegel," *Annales:* ⬛ *onomies, Sociétés, Civilisations* 27 (1972), 313–45; Elke Schutt- ⬛ m, *Pieter Bruegels d. Ä "Kampf des Karnevals gegen die* ⬛ *t" als Quelle volkskundlicher Forschung* (Frankfurt, 1983). ⬛ da Stone-Ferrier, *Dutch Prints of Daily Life*, exh. cat. ⬛ wrence, Kans., 1983), 68, 120–22, no. 26, discussing Claes ⬛ sz. Visscher, *Leper Procession*, etching, 1608 and identify- ⬛ the saw-millers' guild emblem, the *Janneman*, on the ⬛ f.

⬛ s Twelfth Night custom is represented in seventeenth- ⬛ tury images by Jacob Jordaens (Brussels, Kassel, St. ⬛ ersburg, Vienna) and Jan Steen (Kassel, Buckingham ⬛ ce, Woburn Abbey).

⬛ hard Bernheimer, *Wild Men in the Middle Ages* (Cam- ⬛ dge, Mass., 1952), 52–56; Timothy Husband, *The Wild* ⬛ n, exh. cat. (New York, 1980), 156–57, no. 42. Bruegel's ⬛ ge has been identified with a more specific tale of broth- ⬛ separated at birth, one of them becoming a wild man, ⬛ on and Valentine; Bernheimer, 17–20; this story of tamed

⬛ instincts would also be appropriate for the transition between Carnival and Lent.

55. Orenstein, *Drawings and Prints*, 214–42, no. 108.

56. Demus et al., *Flämische Malerei*, 64; Marijnissen, *Bruegel* (Antwerp, 2003), 146.

57. Good discussion with summary of earlier views in Kaveler, *Bruegel: Parables of Order*, 145–48.

58. De Mooij, *Vastenavond*, 109–10, nos. 45–46; Kaveler, *Bruegel: Parables of Order*, 146–47.

59. De Mooij, *Vastenavond*, 110–11, no. 47.

60. Carroll, *Painting and Politics*, 28–46; Meadow, *Pieter Bruegel the Elder's* Netherlandish Proverbs *and the Practice of Rhetoric* (Zwolle, 2002); a fine analysis of the painting, with a chart of the proverbs contained in it, in Marijnissen, *Bruegel*, 133–45.

61. Meadow, *Pieter Bruegel the Elder's* Netherlandish Proverbs, 99–101, 132–35, published by Bartholomeus de Mompere, Cock's rival, who published a single Bruegel engraving, *The Kermis at Hoboken*, possibly engraved by Hogenberg; Carroll, *Painting and Politics*, 34, notes that 39 proverbs in Bruegel's image overlap with the total of 43 in Hogenberg (Meadow, *Bruegel's* Netherlandish Proverbs, 101, cites 37); see also Louis Lebeer, "De Blauwe Huyck," *Gentse Bijdragen tot de Kunstgeschiedenis* 6 (1939–40), 161–229, esp. 180–86; R. W. Brednich, "Die holländischen-flamischen Sprichwort-bilderbogen vom Typus 'De blauwe huyck,'" *Miscellanea Prof. em. Dr. K. C. Peeters* (Antwerp, 1975), 120–31.

62. Meadow, *Pieter Bruegel the Elder's* Netherlandish Proverbs, 133; his translation of the subtitle reads "the world's oddities [*abvisen*] is more beseeming."

63. Yoko Mori, "'She Hangs the Blue Cloak over her Husband.' The world of Human Follies in Proverbial Art," Wolfgang Mieder, ed., *The Netherlandish Proverbs: An International Symposium on the Pieter Brueg(h)els* (Burlington, Vt., 2004), 71–101; for the Ill-Matched Pair theme, Alison Stewart, *Unequal Couples* (New York, 1977). The model was set by prints by the anonymous Master of the Amsterdam Cabinet in the late fifteenth century. Usually this couple is presented through a lustful old man with a cunning young harlot; this kind of "trophy wife" usually appears in imagery with the sexes reversed and the older spouse a woman with a promi-nent bag of money. The subject in both kinds was a perennial favorite in Germany; Bodo Brinkmann, *Cranach*, exh. cat. (London, 2008), 308–13, nos. 91–95; the most celebrated example in the Netherlands is by Quinten Massys (Washing-ton, National Gallery); Lawrence Silver, "The *Ill-Matched Pair* by Quinten Massys," *Studies in the History of Art* 6 (1974), 104–24.

64. Larry Silver, *The Paintings of Quinten Massys* (Totowa, N.J., 1984), 134–60; Pieter van der Coelen, *Images of Erasmus*, exh. cat. (Rotterdam, 2008), 213–28; on literature, Barbara Kön-neker, *Wesen und Wandlung der Narrenidee im Zeitalter des Humanismus* (Wiesbaden, 1966); Joel Lefebvre, *Les fols et la folie* (Paris, 1968); Geraldine Thompson, *Under Pretext of Praise: Satiric Mode in Erasmus' Fiction* (Toronto, 1973); M. Screech, *Ecstasy and the Praise of Folly* (London, 1980); Her-man Pleij, *De eeuw van de zotheid: Over de nar als maatschap-pelijk houvast in de vroeg moderne tijd* (Amsterdam, 2007).

65. Meadow, *Bruegel's* Netherlandish Proverbs, 33, also notes that the man's cap is atop the column rather than on his own head, which on one level points to the Dutch word for a column capital (literally "capstone," *kapsteen*) but also underscores the complete identification of the man with the structure of the church. For the descriptions to the key to the painting, listed on page 219 of this text, I have also used Alan Dundes and Claudia Stibbe, *The Art of Mixing Metaphors: A Folkloristic Interpretation of the Netherlandish Proverbs by Pieter Bruegel the Elder* (Helsinki, 1981); and Marijnissen, *Bruegel*.

66. Ibid., 49, 51, fig. 24, also notes that the man wears only a single shoe, for "no shoe fits his foot," meaning that he is never satisfied and usually offers only negative advice. David Kunzle, "'Belling the Cat'–'Butting the Wall,'" Mieder, *Netherlandish Proverbs*, 144–53, shows further interpretive layers that can be adduced for these unmarked but complex images. He argues that the breastplate armor on the man at the wall signals his role as a soldier, but that

he still has peasant clothing on ("Are you a warrior or a peasant?"). His recklessness or quickness to anger might well be signaled by his knife ("not only cooks carry long knives"). From copies he observes that there might have been a bandage on his leg to show the injuries inflicted in combat ("young soldier, old beggar"), and he reads the differences in footwear as another indication of beggary by the veteran.

67. Meadow, *Bruegel's* Netherlandish Proverbs, 49–50, fig. 25, noting that the unlucky black dog between them (like the black cat of modern superstition) reinforces the notion of their malicious gossip.

68. Ibid., 40 n. 52, notes that such obeisance could be prudent self-protection rather than overt hypocrisy.

69. This Dürer nude, c. 1498, clearly plays upon the Northern European suspicion of sexuality and its close association with witchcraft, often defined as sex by a female with a demon, most directly discussed by Dyan Elliott, *Fallen Bodies: Pollution, Sexuality, and Demonology in the Middle Ages* (Philadelphia, 1999); Walter Stephens, *Demon Lovers. Witchcraft, Sex, and the Crisis of Belief* (Chicago, 2002); for the visual tradition, Sigrid Schade, *Schadenzauber und die Magie des Körpers: Hexenbilder der frühen Neuzeit* (Worms, 1983); Bodo Brinkmann, *Witches' Lust and the Fall of Man: The Strange Fantasies of Hans Baldung Grien*, exh. cat. (Frankfurt, 2007).

70. Medieval legends of Vergil, who figured him as a magician, also told the Power of Women tale about his being deceived in a nocturnal lift upstairs in a basket to visit his paramour, who hung him out to dry, humiliating him. This scene was represented twice (woodcut, engraving, 1525) by Lucas van Leyden. Susan L. Smith, *The Power of Women* (Philadelphia, 1995), 156–69; Domenico Comparetti, *Vergil in the Middle Ages*, 1895 (Hamden, Conn.; 1966); John Spargo, *Virgil the Necromancer* (Cambridge, Mass., 1914).

71. Kunzle, "Bruegel's Proverb Painting and the World Upside Down," *Art Bulletin* 59 (1977), 197–202; Stridbeck, "Die verkehrte Welt," *Bruegelstudien*, 172–84; Carroll, *Painting and Politics,* esp. 46–50, interprets the image as a dystopia, an allegory of "a misgoverned polity."

72. Meadow, *Bruegel's* Netherlandish Proverbs, 60–61, suggests that the man running behind the pigs might be taking advantage of the situation, like an opportunistic or good businessman, "who knows well what he drives who has pigs before him." However, he also notes that he runs "as if his ass were on fire," which of course is what Bruegel shows literally, so this does not look like a business opportunity.

73. Ibid., 12–13, gives the fullest analysis of this activity, noting that to "seek an axe" usually means to seek an excuse.

74. Ibid., 32–33.

75. Carroll, *Painting and Politics,* 53, noting that the saying "he drags the block" normally refers to hopeless love or useless work; the former seems improbable here, and the peasant status of the figure seems pertinent.

76. Meadow, *Bruegel's* Netherlandish Proverbs, 36 n. 39.

77. Ibid., 157.

78. Sellink, *Bruegel* (Ghent, 2007), 123 no. 72; Jozef de Coo, *Museum Mayer van den Bergh*, 3rd ed. (Antwerp, 1978), 40–46, no. 339: *Haec perhibent vitae gestu ridenda faceto / consilia et mores ingeniose notant*; de Coo, "Twaalf spreuken op borden van Pieter Bruegel de Oude," *Bulletin Musées Royaux des Beaux-Arts de Belgique* 14 (1965), 83–104. Claudia Goldstein in her Ph.D. dissertation, "Keeping up Appearances: The Social Significance of Domestic Decorations in Antwerp, 1542–1600" (Columbia University, 2003), has noted that similar plates on round panels comprised a pictorial type, usually devoted to themes of proverbs, Labors of the Months, and riddles. I am grateful to Dr. Goldstein for sharing her thoughts prior to their publication; see also Goldstein, "Artifacts of Domestic Life: Bruegel's Paintings in the Flemish Home," *Nederlands Kunsthistorisch Jaarboek* 51 (2000), 173–93. She claims that the inscriptions of the Antwerp *Twelve Proverbs* was added when they were assembled into the single panel a century after their creation.

79. Renger, *Lockere Gesellschaft: Zur Ikonographie des Verlorenen Sohnes und von Wirtshausszenen in der niederländischen Malerei* (Berlin, 1970).

80. Auctioned at Christie's, London, on 10 July 2002, no. 37; Sellink, *Bruegel*, 112, no. 62; Roger van Schoute and Hélène Veroutstraete, "A Painted Roundel by Pieter Bruegel the Elder," *Burlington Magazine* 142 (2000), 140–46. X-rays reveal an indistinct signature and date of 1557. The diameter measures 20 cm. As an early work, its evident weakness can be explained by youthful inexperience.

81. Claudia Goldsmith has claimed the same in "Keeping up Appearances," but the point has been systematically argued by H.D.L. Vervliet, "De 'Twaalf Spreek-woorden' van het Museum Mayer van den Bergh: een onderzoek naar de datum van ontstaan van de onderschriften," *Jaarboek Koninklijk Museum Antwerpen* (1954–60), 73–81.

82. Meadow, *Bruegel's* Netherlandish Proverbs, 56–81 for sources; on the notebook system of commonplaces, 83–97.

83. George Boas, *Vox Populi: Essays in the History of an Idea* (Baltimore, 1969), traces the history of the proverb, *Vox populi vox dei* ("the voice of the people is the voice of God") from its medieval origins (Alcuin, c. 798), which curiously combines a Latin phrase to celebrate the wisdom of "the people."

84. Desiderius Erasmus, *Adagiorum chiliades*, in *Collected Works of Erasmus* (Toronto, 1982); Margaret Mann Philipps, *The Adages of Erasmus* (Cambridge, 1964); William Barker, ed., *The Adages of Erasmus* (Toronto, 2001).

85. M. A. Screech, *Rabelais* (London, 1979) is a good introduction to the author's learning. See also Natalie Davis, "Proverbial Wisdom and Popular Errors," *Society and Culture*, 227–45.

86. Edition of Symon Andriessoon, *Duytsche Adagia ofte Spreecwoorden*, ed. Mark Meadow and Anneke Fleurken (Hilversum, 2003). The basic survey of Dutch proverb collecting is W.H.D. Suingar, *Erasmus over Nederlandsche spreekwoorden* (Utrecht, 1873).

87. The standard modern reference in the later nineteenth century was assembled by P. J. Harrebomée, *Spreekwoordenboek der nederlandsche taal* (Utrecht, 1858–70), but see the relevance of Dutch proverbs for Bruegel's work by folklorist Grauls, *Volkstaal en volksleven in het werk van Pieter Bruegel* (Antwerp, 1957); also Mieder, *Netherlandish Proverbs*, a series of essays on Bruegel's individual proverbs. For Hieronymus Bosch and proverbs, Vandenbroeck, *Jheronimus Bosch*, esp. 207–46.

88. Dundes and Stibbe, *The Art of Mixing Metaphors*. An instance of their interpretation of imagery in the Berlin painting is their association, p. 39, of the eye and the scissors with quickness of sight, either as a wink or a snip. They also compile a list of 115 phrases, some twenty of which were new to the discussion, in contrast to Grauls's and Marijnissen's list of fewer than ninety.

89. Laid out articulately by my esteemed colleague, Roger Abrahams, *Everyday Life: A Poetics of Vernacular Practice* (Philadelphia, 2005), esp. "Genres," 52–69; also Alan Dundes, "On the Structure of the Proverb," *Proverbium* 15 (1975), 961–73. See also works by Mieder, *Handbook on the Proverb* (Westport, Conn., 2004); Mieder and Dundes, *The Wisdom of Many: Essays on the Proverb* (New York, 1981); W. Gibson, *Figures of Speech*, passim.

90. Fundamental studies: W. Gibson, "Artists and *Rederijkers*"; Moxey, "Pieter Bruegel and Popular Culture," Freedberg, ed., *The Prints of Pieter Bruegel the Elder*, exh. cat. (Tokyo, 1986), 42–52; Ramakers, "Bruegel en de rederijkers. Schilderkunst en literatuur in de zestiende eeuw," *Nederlands Kunsthistorisch Jaarboek* 47 (1996), 81–105. Moxey alone argues for Bruegel's class participation in the suppression of popular culture in the sixteenth century, including satires on carnival. This urban view—and understanding imagery as creating social meaning—will color the interpretation of peasantry as a theme in Bruegel's art (see chapter 9).

91. Demus et al., *Flämische Malerei*, 68–72; Sandra Hindman, "Pieter Bruegel's *Children's Games*, Folly and Chance," *Art Bulletin* 63 (1981), 447–75; Edward Snow, "'Meaning' in *Children's Games*: On the Limitations of the Iconographic Approach to Bruegel," *Representations* 1 (1983), 27–60; Snow, *Inside Bruegel: The Play of Images in Children's Games* (New York, 1997), emphasizing a visceral empathy by the artist with the human figure in this work and the rest of his oeuvre. Hindman's article, 469–72, surveys the earlier literature and the varied identifications of the games.

92. Heiner Borggrefe, ed., *Hans Vredeman de Vries und die Renaissance im Norden*, exh. cat. (Lemgo-Antwerp, 2002).

93. Hindman, "Pieter Bruegel's *Children's Games*," 453–54, noting that such bonfires were often sponsored by civic authorities and staged near a city hall.

94. Stridbeck, *Bruegelstudien*, 185–91; see also W. Gibson, *Bruegel* (New York, 1977), 85–88, who invokes the imagery of a *rederijker* verse, published in the Antwerp anthology of Jan van Doesborch (1530), which compares the folly of humanity to games of children.

95. On the Ages, Elizabeth Sears, *The Ages of Man: Medieval Interpretations of the Life Cycle* (Princeton, 1986).

96. Craig Thompson, ed., *The Colloquies of Erasmus* (Chicago, 1965), 432–41; Snow, *Inside Bruegel,* 156–58, notes that throwing "Venus" was the ancient form of victory, so he infers that fulfilling desire remains the goal in Bruegel's scene and argues that these serious players are stand-ins for the Fates of classical myth. In the process he falls prey to the interpretative schemas that he otherwise forswears for a more phenomenological experience of the painting (and all of Bruegel's works).

97. Ibid., 97–104.

98. This contention clearly contests the importance assigned by Hindman, "Pieter Bruegel's *Children's Games*," to the imitation of wedding in a procession and to the game of blind man's buff, which she reads as a childish version of the folly and chance involved in marriage.

99. The classic article on imagination as a source of representation is Ernst Gombrich, "Meditations on a Hobby Horse," *Meditations on a Hobby Horse* (London, 1963), 1–11; of course the importance of equestrian skills needs no brief for the early modern period, but see Walter Liedtke, *The Royal Horse and Rider* (New York, 1989).

100. Malcolm Vale, *War and Chivalry* (London, 1981), 152–54; James Clifton and Leslie Scattone, *The Plains of Mars*, exh. cat. (Houston, 2009), 65–69, nos. 9–10.

101. Identified by Hindman, "Pieter Bruegel's *Children's Games*," 469, fig. 31.

102. Ibid., 455–58, 473–74, appendix 2.

103. Thomas Kren and Scott McKendrick, *Illuminating the Renaissance: The Triumph of Flemish Manuscript Painting in Europe*, exh. cat. (Los Angeles, 2003), 412–87; for the Mayer van den Bergh breviary in particular, Maurits Smeyers and Jan van der Stock, *Flemish Illuminated Manuscripts 1475–1550* (Ghent, 1996).

104. Hindman, "Pieter Bruegel's *Children's Games*," 461–62, plates 20–21.

105. Ibid., 462–63, fig. 23, there called *Infancy*; De Jongh and Luijten, *Mirror of Everyday Life*, 90–94, no. 11; Christiaan Schuckman, *Maarten de Vos* (Rotterdam, 1996); Christiaan Schuckman, et al., Hollstein's *Dutch and Flemish Etchings, Engravings, and Woodcuts c. 1450–1700* (Amsterdam, 1949), 44: 290, no. 1466.

106. Stridbeck, *Bruegelstudien*, 185–91, figs. 49–52; for example, Roemer Visscher's boy with the hoop (Hindman, "Pieter Bruegel's *Children's Games*," fig. 24), with the caption, "it is better to stand still." On seventeenth-century attitudes toward children, Simon Schama, *The Embarrassment of Riches: An Interpretation of Dutch Culture in the Golden Age* (New York, 1987), 481–561, esp. 497–516, with the Roemer Visscher emblem at fig. 250, noting that for Roemer Visscher the hoops signified futility, whereas for Jacob Cats they symbolized cycles, predictability, and the revolution of the heavens.

107. The Silenus of Alcibiades, an image used by Rabelais in his preface to *Gargantua*, appears earlier in Erasmus's *Praise of Folly* and, importantly, as a major touchstone in his *Adages* shortly afterwards (1515); William Baxter, *Adages*, 3.3.1, 241–68; Margaret Mann Phillips, 74–96. It refers to a figure ugly on the outside but beautiful when opened, and for Erasmus both the humble figure of Christ and the Gospels have this same dual identity. Rabelais uses this figure for his own text.

108. Translation by Hindman, "Pieter Br... Games," 466, n. 136, fig. 28, plus the ... engraving from Cats's 1622 *Houwelij...* *Embarrassment of Riches*, 499 for text...

109. Jordaens: Antwerp, 1638; Ottawa, Be... Paris; Steen: Berlin, The Hague, Am...

110. The classic study is Norbert Elias, *Th...* (New York, 1978), 53–59, 70–84, 89–9...

111. Principal texts include besides Scham... *Riches*: Philippe Ariès, *Centuries of Ch...* 1962); Mary Durantini, *Studies in the ... the Child in Seventeenth-Century Dutch ...* 1982), esp. 177–296; Lawrence Stone, *... Marriage in England 1500–1800* (New ... Louis Flandrin, *Families in Former Ti... hold, and Sexuality* (Cambridge, 1979) ... and Rudi Ekkart, *Pride and Joy: Childr... Netherlands 1500–1700*, exh. cat. (Haarle... ography; Steven Ozment, *Ancestors: T... Old Europe* (Cambridge, Mass., 2001), ... dren's play, which expressly contradict...

112. In addition to the images of children a... group portraits in Bedaux and Ekkart, ... Heemskerck's family of five (Kassel) or... of thirteen (1561; Museum Wuyts-van ... Caroly, Lier); see also Eddy de Jongh, ... *en trouw*, exh. cat. (Amsterdam, 1986).

113. This stylistic trait of Bruegel is at its pe... of large paintings and has been well an... Sedlmayr, "Bruegel's *Macchia*" (1934), i... Wood, ed. *The Vienna School Reader: Po... cal Method in the 1930s* (New York, 2000 ... he interprets this stylistic choice as an in... of the individual, a distinctly modern se... comically by the artist.

CHAPTER 7. RELIGION AND TRAD... ANTWERP, EARLY 1560S

1. Color symbolism of the holy figures is a... however, the association of blue with th... well established after the twelfth century ... reau, *Blue: The History of a Color* (Princet... For mourning, particularly in conjunction ... see also the association of blue with the c... symbolic of the Virgin's sorrows, in Rob... Symbolism in the *Portinari Altarpiece*," *A...* (1964), 70–77.

2. A tradition of Mary's lap as the Throne of ... Christ on her lap is examined by Ilene Fo... *of Wisdom: Wood Sculptures of the Madonn... France* (Princeton, 1972).

3. John Pope-Hennessy, *Italian High Renais... Sculpture*, 2nd ed. (London, 1970), 305–6; ... 1506, a purchase of the Mouscron family ... This work was seen and described by Albr...

4. For the tradition of the three magi as repr... corners of the known globe, especially in t... of Antwerp, see Dan Ewing, "Magi and M... Force behind the Antwerp Mannerists' Ad... *Jaarboek Koninklijk Museum voor Schone Ku...* (2004–2005), 275–99; also Larry Silver, *Th... Quinten Massys* (Oxford, 1984), 91–94. For ... Milan *Adoration Triptych*, see *ExtravagAnt!... Chapter of Antwerp Painting 1500–1530*, exh. c... 2005), 64–66, no. 21.

5. For other *Adorations*, see ibid., nos. 17, 22, ... see also the replicas and exports by Joos van ... lyzed by John Hand, *Joos van Cleve* (New H... nos. 16–18, 61, 69, 74.

6. Paul Kaplan, *The Rise of the Black Magus in ...* (Ann Arbor, 1985); also *Die Heiligen Drei K... lung und Verehrung*, exh. cat. (Cologne, 198... Koerner, "The Epiphany of the Black Magu... *Image of the Black in Western Art. III.1. From ... covery" to the Age of Abolition* (Cambridge, 2c...

7. Dirk De Vos, *Hans Memling: The Complete ...* 1994), 112–14, no. 13 (Prado; dated 1470–72):

Triptych, dated 1479 (Bruges, St. Janshospital; ibid., 158–61, no. 32) repeats the Prado composition at a smaller scale. Memling also included a prominent black magus among ...is many Infancy scenes in a Munich panorama, *Advent and Triumph of Christ* (ibid., 173–79, no. 38, dated to 1480). For ...ugo, Walter Vanbeselaere, "Pieter Bruegel en Hugo van ...er Goes," *Gentsche Bijdragen tot de kunstgeschiedenis* 10 ...944), 221–32; Elisabeth Dhanens, *Hugo van der Goes* ...Ghent, 1998), x; for the problems of dating Hugo's works, ...p. the *Monforte Altarpiece*, Jochen Sander, *Hugo van der Goes: Stilentwicklung und Chronologie* (Mainz, 1992), 31–33, ...9–34, proposing an earlier dating, just after c. 1470, for ...e work.

...arry Silver, *Hieronymus Bosch* (New York, 2006), 164–76, ...th vast literature; the new, more precise dating is given ...X. Duquenne, "La famille Scheyfve et Jérôme Bosch," *...ntermédiaire des Généalogistes* 59, no. 349 (2004), 1–19, ...o also reveals the commissioning agent to be an Antwerp ...aper. Cited by Catherine Reynolds, "Patinir and Depic-...ns of Landscape in the Netherlands," Alejandro Vergara, ..., *Patinir*, exh. cat. (Madrid, 2007), 97, n. 2.

...e presence of this variety of gems points to the lively ...bal sea trade of Antwerp, for sapphires came out of Sri ...nka and the Indian Ocean, whereas emeralds more charac-...sticly stem from Spanish America. Rubies are Asian ...es, today chiefly exported from Burma, but in the six-...th century they would have come to Antwerp from ...th Asia, either Sri Lanka (Ceylon) or else Goa or Cochin, ...ling outposts of the Portuguese in the Indian Ocean. ...eralds, then as now, originate largely from South Amer-...particularly Colombia, and were transported up to ...werp via Seville or Cadiz (though they could come from ...a as well through Portuguese networks). That both of ...e gems are present in the painting shows the vast expanse ...ntwerp's trading reach, abetted by the city's Portuguese ...ell as Spanish import market. The sapphire also has a ...alese origin in this period, first overland through Arab ...Jewish middlemen but recently reinforced by the new ...uguese connections after 1505. If there were not already ...ng implications of wealth from the costumes, coins, and ...of the magi, then the presence of such jewels would ...rm this association. See Donald Lach, *Asia in the ...ng of Europe* II. *A Century of Wonder* (Chicago, 1970), ...2, 117, mentioning the Affaitadi family of Italian ...hants in Antwerp; also A.J.R. Russell-Wood, *The ...guese Empire, 1415–1808* (Baltimore, 1998), 103, 127; ...Parry, *The Age of Reconnaissance* (Berkeley, 1981), 41. ..., *Bosch*, 21–78, with bibliography.

...de Vervoort, "The Pestilent Toad. The Significance of ...oad in the Works of Bosch," Jos Koldeweij, Bernard ...t, eds., with Barbara van Kooij, *Hieronymus Bosch: ...nsights into His Life and Work* (Ghent, 2001), 145–51. ...Pinson, "Bruegel's 1564 *Adoration*: Hidden Meaning of ...the Figure of the Old King," *Artibus et Historiae* 30 ..., 109–28; Pinson, "Connotations of Sin and Heresy in ...gure of the Black King in Some Northern Renaissance ...tions," *Artibus et Historiae* 34 (1996), 159–75. Her prin-...ems of attention in the London *Adoration* are the fig-...n the hem of the oldest magus and the gift of the black ... Her views are seconded by Müller, "Abandonnez ...les formes d'images.' Remarques sur l'iconographie ...nne de Pieter Bruegel l'Ancien," Roland Recht, ed., *De ...nce de l'image: les artistes du Nord face à la Réforme ...*2002), 167–95, esp. 184–90.

...ages of turbans, associated with Islam and evil in ...for example, his Frankfurt *Ecce Homo*, see Silver, ...47–48. Spectacles usually signal shortsightedness ...re general kind, as if a measure of moral shortcom-...the *Spectacle Seller*, ascribed to Jacob Cornelisz. van ...en, Groningen Museum (illustrated in Max J. ...nder, *Early Netherlandish Painting* XII (Leiden-..., 1975), 119, no. 288, plate 152. Also see other works ...r Bruegel the Elder, for example, *Elck* (1558; British ...n, London); commentary by Müller, in Nadine ...n, *Pieter Bruegel the Elder: Drawings and Prints*, ... (New York, 2001), 169. In similar fashion, eye-...t next to the ass who reads sheet music in *The Ass*

at School (1556; Staatliche Museen, Berlin) in ibid., 142–44, no. 40.

14. Wolfgang Stechow, *Pieter Bruegel the Elder* (New York, [1969]), 88; this tradition was represented in an Alsatian panel of the early fifteenth century (Strasbourg, Musée des Beaux-Arts), where an angel speaks to the waking Joseph, as well as a small Rembrandt oil panel (1645; Berlin, B. 569), where he appears in the darkness of a dream to the sleeping Joseph with Mary indoors. For this theme, Schiller, *Iconography of Christian Art* (Greenwich, Conn., 1971) I, 56–57. Müller, ibid., 186, suggests that this image of Joseph shows him using his hat to cover his genitals as a sign of his "inno-cence" of the begetting of Jesus. One of the fuller sources of this legend of Joseph's doubt is the apocryphal Book of James ("Protoevangelium"), Chapters 13–14; see Montague Rhodes James, *The Apocryphal New Testament* (Oxford, 1975; first ed. 1924), 44.

15. Schiller, *Iconography*, I, 60–61, cites Origen's interpretation of the verse of Isaiah 1:3: "The ox knoweth his owner, and the ass his master's crib: but Israel doth not know, my people doth not consider." In this reading the ass explicitly symbol-izes the Jews, who either did not recognize Christ or rejected him outright.

16. E. M. Butler, *The Myth of the Magus* (Cambridge, 1993; orig. ed. 1948), esp. 66: "The downfall of the magus when antiq-uity waned was directly due to the appearance of Christ." Certainly the black magician as adversary of Christian truth is vividly represented by the story of Simon Magus and his defiance of St. Peter, told in the thirteenth-century *Golden Legend* of Jacobus de Voragine; see William Granger Ryan, trans. *The Golden Legend* (Princeton, 1993) II, 325–29. Bruegel even illustrated a related narrative in a pair of linked prints at this same time: *St. James and the Magician Hermogenes* (1565); see Orenstein, *Drawings and Prints*, 230–34, nos. 101–4.

17. Leo Steinberg, *The Sexuality of Christ in Renaissance Art and in Modern Oblivion* (New York, 1983), with the London *Ado-ration* expressly discussed on p. 67 as part of the "humana-tion" of God: "The action starting from lower left involves the Magus' stare, the Child's crotch and smile, the Virgin's bounteous bosom, the respectful hat of St. Joseph, and the whispered confidence in his ear." Steinberg clearly sees this painting as less fraught with danger or disbelief, "This is, after all, a happy occasion."

18. For Massys and Erasmus, Silver, *Massys*, esp. 117–33; for the quotation, John Dolan, ed., *The Essential Erasmus* (New York, 1964), 68, 51. Müller, ibid., invokes Erasmus as a for-mative thinker for the visual arts in the sixteenth-century Netherlands, though he does not specifically tie his thought to the London *Adoration*; see also Müller, *Das Paradox als Bildform: Studien zur Ikonologie Pieter Bruegels d.A.* (Munich, 1999).

19. Formerly dated 1567 but redated from careful technical examination by Dominique Allart, "Did Peter Bruegel the Younger See His Father's Paintings? Some Methodological and Critical Reflections," Peter van den Brink, ed., *Brueghel Enterprises*, exh. cat. (Maastricht-Brussels, 2001–2002), 52.

20. As noted by Allart and van den Brink, ibid., 149–59, the Winterthur *Adoration* has been copied more times than any other religious image by Bruegel; some 36 versions are known, of which about 25 are attributed to Pieter Bruegel the Younger. Sellink, *Bruegel*, 190, no. 126.

21. Vergara, *Patinir*, 170–75, no. 3, signed. The significance of the theme as one of wandering in the world is given by Falkenburg, *Joachim Patinir: Landscape as an Image of the Pilgrimage of Life* (Amsterdam-Philadelphia, 1988).

22. Identified by Robert Koch, *Joachim Patinir* (Princeton, 1968), 24, n. 19. James, *Apocryphal New Testament*, 75.

23. Craig Harline, *Miracles at the Jesus Oak* (New York, 2003), esp. 11–15, discussing statues of the Virgin that appeared in a tree, usually an oak, where miracles occurred; Zirka Filipczak, "Trees Growing in the Wilderness and Statues of Miracle-Working Madonnas," Jaynie Anderson, ed., *Crossing Cultures: Conflict, Migration and Convergence* (Melbourne, 2009), 413–18. Among documented cult shrines of the Virgin in Flanders associated with trees: Our Lady of the Holy Oak in Oirschot, Our Lady of the Lime Tree at Osterwijk, Our

Lady of the Oak at Meerveldhoven, Our Lady of the Little Stock at Antwerp, Our Lady of the Cherry Tree at Edelaere, Our Lady of Grace at Scheut. On tree shrines in the Low Countries generally, see Jean Chalon, *Les arbres fétiches de la Belgique* (Antwerp, 1912). On Antwerp see L. Philippen, *Le cult`tre Dame 't Stocxken en Anvers, 1474–1580* (Antwerp, 1925). For similar shrines in Germany, see Albrecht Altdorfer imagery, as discussed by Christopher Wood, *Albrecht Altdorfer and the Origins of Landscape* (Chicago, 1993), 181–90, noting the presence of such *Bildstöcke* at crossroads and their visible presence on the outside wings of Bosch's *Haywain Triptych* (Madrid, Prado) or even in the landscape setting of Bruegel's Prague *Haymaking* (1565). Such images risked the practice of idolatry and reminded reformers, including Luther and Zwingli, of pagan idols.

24. For the role of the column as the marker of pagan idolatry, Michael Camille, *The Gothic Idol* (Cambridge, 1989), esp. 1–9, discussing medieval images of the Flight and idols, 197–203 for the image on the column, with the potent substitution of replacing pagan idols with Christian images, including the Virgin and Child.

25. Ibid., 221, fig. 117 (ms 43–1954, fol. 3v).

26. On Bruegel's paintings at Granvelle's palace in Brussels see: A.-J. Wauters, "Pierre Bruegel et Cardinal Granvelle," *Académie Royale de Belgique, Bulletins de la classe des lettres et des sciences morales et politiques de la classe des Beaux-Arts* (1914): 87–90. On Granvelle's patronage of the arts and letters, see Maurice Piquard, "Le Cardinal Granvelle, les artistes et les écrivains," *Revue belge d'archéologie et d'histoire de l'art* 17 (1947–48): 133–47; W. Gibson, *Bruegel and the Art of Laughter* (Berkeley, 2006), 73–74. As pointed out by Ethan Matt Kaveler, *Pieter Bruegel: Parables of Order and Enterprise* (Cambridge, 1999), 30, Granvelle's mention of the *Flight into Egypt* appears at a time when he tries to recover his paintings collection for his later palace at Besancon. Additionally, this painting was in the collection of Peter Paul Rubens and is mentioned in his estate inventory of 1640: "A Landschap with the flight into Egipt by old Brugel." Jeffrey Muller, *Rubens: The Artist as Collector* (Princeton, 1989), 21, 128, no. 191. For portraits of Granvelle by the Spanish court artist, Antonis Mor of Utrecht, now see Joanna Woodall, "Patronage and Portrayal: Antoine Perrenot de Granvelle's Relationship with Antonis Mor," Krista de Jonge and Gustaaf Janssens, *Les Granvelle et les Anciens Pays-Bas* (Louvain, 2000), 245–77.

27. For fifteenth-century Netherlandish drawing, Fritz Koreny, *Early Netherlandish Drawings from Van Eyck to Bosch*, exh. cat. (Antwerp, 2002); also William Robinson and Martha Wolff, "The Function of Drawings in the Netherlands in the Sixteenth Century," John Hand et al., *The Age of Bruegel*, exh. cat. (Washington, 1986), 25–40, esp. 34–37.

28. Grossmann, "Bruegel's 'Woman Taken in Adultery' and other Grisailles," *Burlington Magazine* 94 (1952), 218–29.

29. J. R. Hale, *Artists and Warfare in the Renaissance* (New Haven, 1990), esp. 169–99.

30. Ibid., 192–99, fig. 244; Larry Silver, "Germanic Patriotism in the Age of Dürer," Dagmar Eichberger and Charles Zika, eds., *Dürer and His Culture* (Cambridge, 1998), 59, with further references.

31. Grossmann, *Pieter Bruegel: Complete Edition of the Paintings*, rev. ed. (London, 1966), 193–94. The note at the end of Dante's verse makes reference to David's lament upon hearing the news of Saul's suicide (II Samuel 1:17–21), where the new young king (1:21) curses the mountains of Gilboa. See also Erich Auerbach, "Saul's Pride," *MLN* 64 (1949), 267–69.

32. Peter Arnade, *Beggars, Iconoclasts, and Civic Patriots: The Political Culture of the Dutch Revolt* (Ithaca, N.Y., 2008).

33. Margaret Carroll, *Painting and Politics in Northern Europe* (University Park, Penn., 2008), 31–32, 84–85; Stephen Mansbach, "Pieter Bruegel's Towers of Babel," *Zeitschrift für Kunstgeschichte* 45 (1982), 43–56; Henk van Nierop, "The Nobles and the Revolt," Graham Darby, ed. *The Origins and Development of the Dutch Revolt* (London, 2001), 48–66. Marnef, *Antwerp in the Age of Reformation*, trans. J. C. Grayson (Baltimore, 1996).

34. Most recently Carroll, *Painting and Politics*, 75–87, with bibliography.

35. *Josephus with an English Translation*. Loeb Classical Library, vol. 4, trans. H.St.J. Thackeray (Cambridge, Mass., 1958–65), 1: 4, 2–3, cited by Carroll, *Painting and Politics*, 211, n. 59.

36. Saint Augustine, *The City of God*, trans. Marcus Dods (Chicago, 1952), 425–26.

37. Christine Armstrong, *The Moralizing Prints of Cornelis Anthonisz* (Princeton, 1990), 105–14; *Kunst voor de Beeldenstorm*, exh. cat. (Amsterdam, 1986), 281, no. 157.

38. Thomas Kren and Scot McKendrick, *Illuminating the Renaissance*, exh. cat. (Los Angeles, 2003), 420–22, no. 126, with bibliography.

39. Helmut Minkowski, *Aus dem Nebel der Vergangenheit steigt der Turm zu Babel* (Berlin, 1960), esp. 48, 68; Stefaan Grieten, "De iconografie van de Toren van Babel bij Pieter Bruegel: traditie, vernieuwing en navolging," *Jaarboek Koninklijk Museum Antwerpen* (1988), 97–136, esp. 106, fig. 4.

40. Ilja Veldman, *Maarten van Heemskerck and Dutch Humanism in the Sixteenth Century* (Maarsen, 1977), 133–41, esp. fig. 87; Veldman, *Leerrijke reeksen van Maarten van Heemskerck*, exh. cat. (Haarlem, 1986), 50–51, no. 6.3. Following in the train of Pride is Envy.

41. H. Arthur Klein, "Pieter Bruegel the Elder as a Guide to Sixteenth-Century Technology," *Scientific American* 238/3 (March 1978), 134–37.

42. Timothy Riggs, *Hieronymus Cock: Printmaker and Publisher* (New York, 1977), 30, 129–30, 256–59, nos. 2–11; *In de Vier Winden*, exh. cat. (Rotterdam, 1988), 32–33, nos. 15–16.

43. For Heemskerck drawings, recorded in Rome 1532–36, now see Arthur di Furia, "Heemskerck's Rome: Memory, Antiquity, and the Berlin Sketchbooks," Ph.D. diss. (University of Delaware, 2008), esp. chapter 3.2.3. See also *Kunst voor de Beeldenstorm*, 267–68, no. 148; Josua Bruyn, "Oude en nieuwe elementen in de 16 deeeuwse voorstellingswereld," *Bulletin van het Rijksmuseum* 35 (1987), esp. 143–51.

44. Larry Silver, "Pieter Bruegel and the Capital of Capitalism," *Nederlands Kunsthistorisch Jaarboek* 47 (1996), 125–53, esp. 135–36.

45. Jozef Duverger, "Cornelis Floris en het Stadhuis te Antwerpen," *Gentsche Bijdragen tot de Kunstgeschiedenis* 7 (1941), 37–72; Holm Bevers, *Das Rathaus von Antwerpen (1561–1565)* (Hildesheim, 1985), esp. 41–81 on the allegorical program conveying Antwerp anxiety about restraint of local trade due to increasing centralization of the Netherlands under Spanish rule. This local pleading to the monarch would continue well into the next century, expressed in the Joyous Entries of each successive regent; see Elizabeth McGrath, "Rubens's Arch of the Mint," *Journal of the Warburg and Courtauld Institutes* 37 (1974), 191–217.

46. Arnade, *Beggards, Iconoclasts, and Civic Patriots*, 251–54. Carroll, *Painting and Politics*, 31–32, 66–72, points to the increasing tensions regarding imperial taxes levied on Antwerp by their Spanish rulers for foreign wars, embodied in the Emperor's Gate at the city entrance after 1545.

47. W. Kuyper, *The Triumphant Entry of Renaissance Architecture into the Netherlands* (Leiden, 1994), 66–67; for the Antwerp City Hall, 151–73; Mark Meadow, "Ritual and Civic Identity in Philip II's 1549 Antwerp *Blijde Incompst*," *Nederlands Kunsthistorisch Jaarboek* 49 (1998), 56–58.

48. *Breughel-Brueghel*, exh. cat. (Antwerp, 1998), 63–69, nos. 13–15, featuring a signed Pieter the Younger *Calvary* of 1617 (Budapest, Szépmüvészeti Museum), a work where Joos de Momper the Younger has been seen as a collaborator for the landscape) as well as a Jan Brueghel of 1595 (Vienna, Kunsthistorisches Museum), which utilizes but varies many of the same figure groups. For the Philadelphia panel, closely related to the Budapest image, Peter Sutton, *Northern European Paintings in the Philadelphia Museum of Art* (Philadelphia, 1990), 44–46, no. 15.

49. Van den Brink, *Brueghel Enterprises*, 50, document 23; see also 48, doc. 5 (coll. Archduke Ernst, Brussels 1595); doc. 18 (coll. Maria Bruegel, daughter of Pieter the Younger, Brussels, 1627). In general, Klaus Ertz, *Pieter Brueghel der Jüngere* (Lingen, 2000), 414–38.

50. Ellen Jacobowitz and Stephanie Stepanek, *The Prints of Lucas van Leyden and His Contemporaries*, exh. cat. (Philadelphia, 1983), 161–63, no. 56–58; Elisabeth Roth, *Der volkreiche*

Kalvarienberg in Literatur und Kunst des Spätmittelalters (Berlin, 1958); Mitchell Merback, *The Thief, the Cross and the Wheel* (Chicago, 1998).

51. Samuel Edgerton, *Pictures and Punishment: Art and Criminal Prosecution during the Florentine Renaissance* (Ithaca, N.Y., 1985), 165–67; Merback, ibid., 148, 264, citing the Roman confraternity of San Giovanni Decollato, charged with the spiritual care of prisoners, who visited the condemned in their cells but also followed him to the scaffold as *confortatori* with images. Sutton, *Northern European Paintings*, mistakes the plaque as the Decalogue.

52. This is the considered argument by Carroll, *Painting and Politics*, 83–84, 214, no. 105, noting the remonstrances to Margaret of Parma from both city officials and local nobles in 1562–63.

53. Van den Brink, *Brueghel Enterprises*, 48, doc. 1 (21 February 1566, new style).

54. For Jacques Jongelinck's medals of Granvelle, Kaveler, *Bruegel: Parables of Order*, fig. 14; for his (attributed) court sculpture of Philip II, Lorne Campbell et al., *Renaissance Faces*, exh. cat. (London, 2008), 274–75, no. 91, comparing this royal likeness to the secure bust of the court figure, *duke of Alba* (1571; New York, Frick Collection).

CHAPTER 8.
RELIGIOUS IMAGERY IN A TIME OF TROUBLES

1. Literature on the Dutch Revolt is now massive, but a classic touchstone is Peter Geyl, *The Revolt of the Netherlands 1555–1609* (London, 1932). More recently Geoffrey Parker, *The Dutch Revolt* (Ithaca, N.Y., 1977); Jonathan Israel, *The Dutch Republic: Its Rise, Greatness, and Fall* (Oxford, 1995); Anton van der Lem, *De opstand in de Nederlanden (1555–1609)* (Utrecht, 1995); and Peter Arnade, *Beggars, Iconoclasts, and Civic Patriots: The Political Culture of the Dutch Revolt* (Ithaca, N.Y., 2008). Very useful essays in Graham Darby ed., *The Origins and Development of the Dutch Revolt* (London, 2001). On Antonis Mor, Joanna Woodall, *Anthonis Mor: Art and Authority* (Zwolle, 2007), esp. 137–41, 157–61, 402–9.

2. Andrew Pettegree, "Religion and the Revolt," in Darby, *Origins and Development of the Dutch Revolt*, 67–83; Guido Marnet, *Antwerp in the Age of the Reformation* (Baltimore, 1996); Phyllis Mack Crew, *Calvinist Preaching and Iconoclasm in the Netherlands 1544–1569* (Cambridge, 1978). More generally, Philip Benedict, *Christ's Churches Purely Reformed: A Social History of Calvinism* (New Haven, 2002), 173–201.

3. Charles Cuttler, "Exotics in Fifteenth Century Art: Comments on Oriental and Gypsy Costume," Frans Vanwijngaerden ed., *Liber amicorum Herman Liebaers* (Brussels, 1984), 419–34; Erwin Pokorny, "The Gypsies and their Impact on Fifteenth-Century Western European Iconography," Jaynie Anderson ed., *Crossing Cultures* (Melbourne, 2009), 623–27; on Cornelis van Dalem, Grossmann, "Cornelis van Dalem Re-Examined," *Burlington Magazine* 96 (1954), 42–51.

4. Alejandro Vergara, *Patinir*, exh. cat. (Madrid, 2007), 342–57, nos. 27–28 (Philadelphia, Brussels), as well as the background of his *Baptism* (Vienna), 216–25, no. 11. On met de Bles, Alan Chong, "Cleveland's *Landscape with John the Baptist* by Herri Bles: A Landscape with Figures or Figures in a Landscape?" Norman Land, Betsy Rosasco, and James Marrow, eds., *Herri met de Bles: Studies and Explorations of the World Landscape Tradition* (Turnhout, 1998), 85–94; W. Gibson, "Herri met de Bles: Landscape with St. John the Baptist Preaching," *Bulletin of the Cleveland Museum of Art* 55 (1968), 78–87. More generally see W. Gibson, *"Mirror of the Earth": The World Landscape in Sixteenth-Century Flemish Painting* (Princeton, 1989). Other notable *Preaching of St. John the Baptist* pictures by met de Bles are in Vienna (Kunsthistorisches Museum) and Dresden (Gemäldegalerie).

5. Vergara, *Patinir*, 347, plate 8 notes that, like Bruegel, the left bank of the river in Philadelphia originally held an image of the Baptism in miniature, but it was repainted. The scene is still clearly visible, signaled by a tiny dove of the Holy Spirit, in the Brussels version, which seems to be a workshop(?) replica of nearly equal merit.

6. These preparations for winter are am[...] that exemplify *Prudence* in Bruegel's c[...] print in the Virtues series for Cock (1[...] Royaux), where salting meat for stora[...] for warmth are central activities.

7. Reindert Falkenburg, *Joachim Patini[...] of the Pilgrimage of Life* (Amsterdam, [...] Kahren Jones Hellerstedt, "The Blin[...] in Netherlandish Paintings," *Simiolus* [...]

8. *Breughel-Breughel: Een Vlaamse schilde[...] cat. (Antwerp, 1998), 294–98, nos. 97[...] Brink ed., *Brueghel Enterprises*, exh. ca[...] 2001), 80–124, 134–48, nos. 1–13, the t[...]

9. Van den Brink, *Brueghel Enterprises*, 1[...]

10. Literature on Calvinism and the arts i[...] sources for various Protestant views o[...] in Carlos Eire, *War against the Idols* (C[...] esp. 195–233; Sergiusz Michalski, *The [...] Visual Arts* (London, 1993); Philip Be[...] a Culture? Remarks on Calvinism and [...] Corby Finney ed., *Seeing beyond the W[...] Calvinist Tradition* (Grand Rapids, 199[...] cifically on Calvinism in the Netherlan[...] on Haarlem, Mia Mochizuki, *The Neth[...] Iconoclasm 1566–1672* (Aldershot, 2008).

11. John Calvin, *Institutes of the Christian [...]* (Philadelphia, 1930), I, 98.

12. Arnade, *Beggars, Iconoclasts, and Civic [...]* bibliography; Marnef, *Antwerp in the A[...]* J. Scheerder, *De Beeldenstorm* (Bossum, [...] *Iconoclasm and Painting in the Revolt of [...] 1609* (New York, 1988); Freedberg, "De[...] storm, De Noordelijke Nede[...] *de Beeldenstorm*, exh. cat. (Amsterdam, [...]

13. J. F. Heijbroek, *Geschiedenis in Beeld*, ex[...] 2000) 68; James Tanis and Daniel Hors[...] exh. cat. (Bryn Mawr, 1993), esp. 40–41[...] in translation: "After a little preaching /[...] gion, / The breaking of images commer[...] statue standing. / Cowl, monstrance, go[...] And all else that was at hand, / All was b[...] / As many people soon learned."

14. For the earlier splendor of a major chur[...] suffered during iconoclasm (although l[...] example of Haarlem St. Bavo's as discus[...] *Netherlandish Image after Iconoclasm*, esp[...] least one contemporary account (by a C[...] violence by soldiers, including their mu[...] generally, Jeremy Dupertuis Bangs, *Chu[...] ture in the Low Countries before 1566* (Kirk[...] esp. 7–19, with discussion of Leiden's Pie[...]

15. Cynthia Hahn, "'Joseph Will Perfect, M[...] Jesus Save Thee': The Holy Family as M[...] the Mérode Triptych," *Art Bulletin* 68 (19[...] widely on St. Joseph: Carolyn Wilson, *S[...] *Renaissance Society and Art* (Philadelphia[...]

16. Freedberg, *Iconoclasm and Painting in th[...] Chapter 7, esp. 198–248; J. Vervaet, "Cat[...] altaarstukken van gilden en ambachten u[...] Vrouwekerk van Antwerpen en bewaard [...] Museum," *Jaarboek Koninklijk Museum* (1[...] Concerning Pieter Aertsen, who left Antv[...] dam in 1556, the destruction of his altarpi[...] ing the high altar of Amsterdam's Nieuw[...] particularly bemoaned by Van Mander in [...] *boek* as "a tragic loss to art through ravin[...] 244r), and the same author relates the ang[...] himself at these losses: "Pieter was freque[...] the works which he had intended to leave [...] posterity were thus brought to nothing." [...] and translated by Freedberg, *Kunst voor de[...] n. 138, 141.

17. Arnade, *Beggars, Iconoclasts, and Civic Patr[...]* that the iconoclastic riots centered entirely [...] Our Lady in Antwerp.

For Alba, subject of two biographies (William Maltby, Berkeley, 1983; Henry Kamen, New Haven, 2004), see now Arnade, *Beggars, Iconoclasts, and Civic Patriots*, 166–211. Arnade, *Beggars, Iconoclasts, and Civic Patriots*, 182–83, provides the exact tally: 8,568 people tried for heresy or treason or both, 1,083 actually executed, 20 banished.

The most recent assertion of Habsburg criticism on the part of Bruegel is Kunzle, *From Criminal to Courtier: The Soldier [i]n Netherlandish Art 1550–1672* (Leiden, 2002), 103–12; Stanley [F]erber, "Pieter Bruegel and the Duke of Alba," *Renaissance News* 19 (1966), 205–19.

[K]unzle, *From Criminal to Courtier*, 35–62, discusses the Massacre of the Innocents theme; for other Alva period images, [3]4–56; for later depredations of peasants, 167–86, 257–356; [a]lso Jane Fishman, *Boerenverdriet* (New York, 1982).

[D]esmond Shawe-Taylor and Jennifer Scott, *Bruegel to [R]ubens*, exh. cat. (London, 2007), 88–91, no. 14; Lorne [C]ampbell, *The Early Flemish Pictures in the Collection of her [M]ajesty* (Cambridge, 1985), 13–19, no. 9.

[W]oodall, *Anthonis Mor*, 173–80, plate 59; this portrait, however, dates to 1549, making it the image of a man almost [t]wenty years younger.

[T]he accuracy of the armor, which would be anachronistic [i]n any case, is attested by Kunzle, *From Criminal to Courtier*, [6], citing H. Bartlett Wells, "Arms in Bruegel's Slaughter [of] the Innocents," *Journal of the Arms and Armor Society* 4 (1964), 199.

[M]aurice Vale, *War and Chivalry* (London, 1981); Maurice [K]een ed., *Medieval Warfare: A History* (Oxford, 1999), esp. [A]ndrew Ayton, "Arms, Armour, and Horses," 186–208. [La]rry Silver, "Shining Armor: Emperor Maximilian, Chivalry, and War," Pia Cuneo ed., *Artful Armies, Beautiful Battles* [Le]iden, 2001), 61–86.

[Par]ker, *The Army of Flanders and the Spanish Road 1567–1659* [rev]. ed. (Cambridge, 1990); Parker, *The Grand Strategy of [Ph]ilip II* (New Haven, 1998), 115–46.

[Mar]shall, "Lucas van Leyden's Narrative Style," *Nederlands [Ku]nsthistorisch Jaarboek* 29 (1978), 185–237, esp. 221–24.

[W]ell articulated in Kenneth Lindsay and Bernard Huppé, [M]eaning and Method in Brueghel's Painting," *Journal of [Aes]thetics and Art Criticism* 14 (1956), 376–86, esp. 381 for [Con]version of St. Paul.

[Er]nst Dobschütz, "Die Bekehrung des Paulus," *Repertorium [für] Kunstwissenschaft* 50 (1929), 87–111; citing this article Par[sha]ll, "Lucas van Leyden's Narrative Style," 223, notes that [the] earliest equestrian examples of Saul's conversion derived [fro]m scenes depicting the battle between Virtues and Vices [in] Prudentius's Latin allegory, *Psychomachia*. For Pruden[ce] and Pride's association with a horse, Emile Mâle, *The [Goth]ic Image* (New York, 1958), 98–130, esp. 99.

[Law]rence Silver, "The Sin of Moses: Comments on the [Earl]y Reformation in a Late Painting by Lucas van Leyden," [Art] *Bulletin* 55 (1973), 401–9, esp. 407–9; Elise Lawton [Smi]th, *The Paintings of Lucas van Leyden* (Columbia, Mo., [1992]), 64–66, 72–74, 106–9, no. 11. Lawton Smith also notes [that] here Lucas includes gypsy costumes for these early [He]brews, and she ascribes meaning both to their literal [Egy]ptian reference but also to the associated loose living [of] this ethnic group. The reference to I Kings is another [re]lation of the Lord to Elijah on Mount Horeb (another [nam]e for Sinai) with the mystic length of forty days, like [Chris]t's own Temptation in the wilderness (Matthew 4:1–11; [Mar]k 1:12–13, Luke 4:1–13).

[Falke]nburg, *Patinir*, 78–82, 91–96, 101–2. This allegorical [imag]ery already appears in Albrecht Dürer's engraving of *[Hercu]les* (B.73), where the hero assists Virtue in her battle [agains]t before a *paysage moralisée*; an image of the "castle of [virtu]e" atop a hill in the left background, in contrast to the [valle]y of pleasure at the right horizon.

[Alexa]nder Wied, "Lucas van Valckenborch," *Jahrbuch der [kunst]historischen Sammlungen in Wien* 67 (1971), 141, 192, [...]; Wied, *Lucas und Marten van Valkenborch* (Freren, [198]1), 31, 33–34, 90, no. 6; Konrad Renger and Claudia [Denk], *Flämische Malerei des Barock in der Alten Pinakothek* [Mun]ich-Cologne, 2002), 492–96.

[Edwar]d Snow, "The Language of Contradiction in Bruegel's [Tower] *of Babel*," RES 5 (1983), 41–48, notes the contradiction

in the Vienna Tower between the built-up and the carved-down components of the structure. He interprets the reference to the Colosseum as ancient greatness brought low by history, citing Protestant identification of Catholic Rome as a second Babylon. But he also highlights Bruegel's positive enthusiasm for depicting the process of construction, all the more emphatic in the unambiguous build-up of the Tower in Rotterdam, as if the creativity of the builders is akin to the creativity of the artist himself: "the spectacle it poses as a nearly completed *successful* project" (p. 46) In this respect the positive side of the Tower can also be aligned with Mansbach's claim that the Rotterdam building in its collective enterprise is like a reconstitution of the prelapsarian innocence of humanity, still communicating in the primal language before being struck down by divine confusion of tongues; Stephen Mansbach, "Pieter Bruegel's Towers of Babel," *Zeitschrift für Kunstgeschichte* 45 (1982), 43–56.

35. On the seaport and the farming villages as the site of earthly materialism, see Falkenburg, *Patinir*, 91–96, 101–2; Larry Silver, "Pieter Bruegel in the Capital of Capitalism," *Nederlands Kunsthistorisch Jaarboek* (1997), 135–36.

36. Elizabeth McGrath, "Rubens *Arch of the Mint*," *Journal of the Warburg and Courtauld Institutes* 37 (1974), 191–217; for the wider context of the Triumphal Entry of Cardinal-Infante Ferdinand into Antwerp, see also Julius Held, *The Oil Sketches of Peter Paul Rubens* (Princeton, 1980), 219–47, esp. 240–45, nos. 162–64; John Rupert Martin, *The Decorations for the Pompa Introitus Ferdinandi. Corpus Rubenianum Ludwig Buchard Part XVI* (London, 1972), esp. 178–203, nos. 46–51. The program was devised by Caspar Gevartius, the Antwerp city secretary.

37. Johann-Christian Klamt, "Anmerkungen zu Pieter Bruegels Babel-Darstellungen," Otto von Simson and Matthias Winner, eds., *Pieter Bruegel und seine Welt* (Berlin, 1979), 43–49, esp. 45–47.

38. Renger and Denk, *Flämische Malerei des Barock*, 494.

39. Arnade, *Beggars, Iconoclasts, and Civic Patriots*, 184–85; for the Madrid visit of Egmont, Parker, *Dutch Revolt*, 64–65.

40. Larry Silver, "Ungrateful Dead: Bruegel's *Triumph of Death* Re-Examined," David Areford and Nina Rowe eds., *Excavating the Medieval Image* (Aldershot, 2004), 267–78.

41. W. Gibson, "Bruegel's *Triumph of Death*: A Secular Apocalypse," W. Gibson, *Pieter Bruegel the Elder: Two Studies* (Lawrence, Kans., 1991), 53–86, comparing the devastation and torments in this painting to Bosch's *Last Judgment Triptych* (Vienna, Akademie). W. Gibson, the most thorough student of this painting, is also the only author to note the isolated Boschian center within the *Triumph of Death*, observing that "The structure is oddly unsubstantial and the gestures of the devils curiously ineffectual, for they have no part in the torment of the living . . . as if even the forces of Hell could not compete with the armies of the dead." (p. 56) W. Gibson also notes the presence of a strong Triumph of Death tradition in Italy, notably in the Pisa Campo Santo (destroyed in World War II), a work possibly known to Bruegel from his trip to Italy; for this image see Liliane Guerry, *Le theme du "Triomphe du Mort" dans la peinture italienne* (Paris, 1950), 122–61. However, the Pisa mural shows flying angels of death swooping above the mortals, so its resemblance to Bruegel is general and thematic rather than particular.

42. Philippe Ariès, *The Hour of Our Death* (New York, 1981), 140–312; Jean Delumeau, *Sin and Fear* (New York, 1990); Paul Binski, *Medieval Death* (Ithaca, N.Y., 1996); more specifically on the Dance of Death, James M. Clark, *The Dance of Death in the Middle Ages and Renaissance* (Glasgow, 1950); A. Tenenti, *La Vie et la mort à tavers l'art du XVe siècle* (Paris, 1952); now Elina Gertsman, *The Dance of Death in the Middle Ages. Image, Text, Performance* (Turnhout, 2010).

43. Parshall, "Hans Holbein's *Pictures of Death*," Mark Roskill and John Hand eds., *Hans Holbein: Paintings, Prints, and Reception* (Washington, 2001), 83–95, with bibliography.

44. Moxey, "The Fates and Pieter Bruegel's Triumph of Death," *Oud Holland* 87 (1973), 49–51.

45. Binski, *Medieval Death*, esp. 29–50, 123–63; Kathleen Cohen, *Metamorphosis of a Death Symbol: The Transi Tomb in the Late Middle Ages and the Renaissance* (Berkeley, 1973).

46. Celeste Brusati, "Stilled Lives: Self-Portraiture and Self-Reflection in Seventeenth-Century Netherlandish Still-Life Painting," *Simiolus* 20 (1990/91), 168–82, pointing out against the normal claims that still-life only embodies the concept of *Vanitas*, instead the permanence and virtuosity of the painter's art can "still" and preserve that very life. More generally Paul Taylor, *Dutch Flower Painting 1600–1720* (New Haven, 1995).

47. Clovio's estate (1578) mentions four works by Bruegel, including a *Tower of Babel* on ivory; all are lost; Fritz Grossmann, *Bruegel: Complete Edition of the Paintings* rev. ed. (London, 1966), 16–17. W. Gibson, 69, plate 68, mentions Clovio's *Farnese Hours* (New York, Morgan Library). See Webster Smith, *The Farnese Hours* (New York, 1976); on Clovio, Elena Calvillo, "'Il Gran Miniatore' at the Court of Cardinal Alessandro Farnese," Stephen Campbell ed., *Artists at Court: Image-Making and Identity 1300–1550* (Boston, 2004), 163–75.

48. Vale, *War and Chivalry*, 146–64; Brian Downing, *The Military Revolution and Political Change* (Princeton, 1992), 56–83; William McNeill, *The Pursuit of Power* (Chicago, 1982), 94, stressing also the importance of drill as a fundamental Dutch contribution to military preparations at the end of the sixteenth century, 117–39.

49. Parker, *Dutch Revolt*, 108–10. The decisive Battle of Jemmingen was won by the Spanish on 21 July. Alba smelted the cannons captured at Jemmingen to have an over-life-sized bronze sculpture made of himself by Jacques Jongelinck and showing him conquering heresy and rebellion; Arnade, *Beggards, Iconoclasts, and Civic Patriots*, 198–200; Luc Smolderen, *La Statue du duc d'Albe par Jacques Jonghelinck (1571)* (Brussels, 1972).

50. Silver, *Hieronymus Bosch* (New York, 2006), 164–77, plates 129–30; Lotte Brand Philip, "The Prado *Epiphany* by Jerome Bosch," *Art Bulletin* 35 (1953), 267–93.

51. Grossmann's 3rd edition, *Pieter Bruegel: Complete Edition of the Paintings* (London, 1973), 201–2; the most recent word on the image by Philippe and Françoise Roberts-Jones, *Bruegel une dynastie de peintres*, exh. cat. (Brussels, 1980), 58, no. 6, who assign the work to Jan Bruegel. The work was first published by Gustav Glück, "Über einige Landschaftsgemälde Peter Bruegels des Älteren," *Jahrbuch der Kunsthistorischen Sammlungen in Wien* n.s. 9 (1935), 164–65, as Pieter the Younger after a lost Pieter Bruegel the Elder.

52. Bruegel's discomfort makes a curious parallel with Albrecht Dürer's celebrated gift in 1526 to the Nuremberg City Council of his *Four Holy Men* (Munich, Alte Pinakothek), a work that was accompanied by inscriptions (in Luther's German translation of the New Testament) from the four depicted saints: Paul, Peter, John, and Mark. A general warning was appended: "All worldly rulers in these dangerous times should give good heed that they receive not human misguidance for the Word of God, for God will have nothing added to his Word nor taken away from it." See Fedja Anzelewsky, *Dürer His Art and Life* (New York, 1980), 224–30, plates 228–29; also Kurt Martin, *Albrecht Dürer: Die Vier Apostel* (Stuttgart, 1963). Here the false prophets could equally well be on either extreme from the Lutheran Reform, whether Catholics or radical Protestants.

53. Summarized by Arnade, *Beggars, Iconoclasts, and Civic Patriots*, 54–66.

54. Grossmann, "Bruegel's 'Woman Taken in Adultery' and Other Grisailles," *Burlington Magazine* 94 (1952), 218–29.

55. Grossmann, "Bruegel's Grisailles," 224; W. Gibson, *Bruegel* (New York, 1977), 134–40.

56. *Abraham Ortelius (1527–1598)*, exh. cat. (Antwerp-Brussels, 1998); Renée Boumans, "The Religious Views of Abraham Ortelius," *Journal of Warburg and Courtauld Institutes* 17 (1954), 374–77.

57. The fullest discussion of the narrative and content of the grisaille is Walter Melion, "*Ego enim quasi obdormivi*: Salvation and Blessed Sleep in Philips Galle's *Death of the Virgin* after Pieter Bruegel," *Nederlands Kunsthistorisch Jaarboek* 47 (1996), 14–52; I would also like to cite the fine work by Lamar Lentz, "*The Dormition of the Virgin* and the Religious Views of Pieter Bruegel the Elder and Abraham Ortelius,"

unpublished M.A. thesis, University of Texas, 1991, and to thank the author for sharing it with me.

58. Jacobus de Voragine, *The Golden Legend*, trans. William Granger Ryan (Princeton, 1993), 2.78–80.

59. Zsuzsa Urbach, "Notes on Bruegel's Archaism, His Relation to Early Netherlandish Painting and Other Sources," *Acta Historiae Artium* 24 (1978), 237–45. For a lost horizontal *Death of the Virgin* by Hugo van der Goes, preserved in copies in Berlin, Prague, and London, see Max J. Friedländer, *Early Netherlandish Painting* IV (Leiden, 1969), 41, no. 25, plate 38. Joos van Cleve was formerly known as the Master of the Death of the Virgin after two celebrated paintings, now in Cologne and Munich; John Hand, *Joos van Cleve* (New Haven, 2004), 9, 24–30, 69–70, nos. 7, 47.

60. Maurice McNamee, *Vested Angels* (Louvain, 1998), appendix A, "Liturgical Vestments and Accouterments," 209–27.

61. In similar fashion, Mary experiences a compassion upon the death of her son, vividly represented by her faint and echo of his posture in Rogier van der Weyden's *Descent from the Cross* (Madrid, Prado); Otto von Simson, "'Compassio' and 'Co-Redemptio' in Roger van der Weyden's 'Descent from the Cross,'" *Art Bulletin* 35 (1953), 9–16.

62. For the Ghent Altarpiece, Elizabeth Dhanens, *Van Eyck: The Ghent Altarpiece* (New York, 1973), esp. 56–62; Grossmann, *Complete Paintings*, 196.

63. Elizabeth Gilmore Holt, *A Documentary History of Art* (New York, 1958), 63–64; Melion, "Galle's *Death of the Virgin*," discusses the image in relation to Catholic Counter-Reformation literature on the Virgin and her death by Petrus Canisius (1577) and Jesuit meditational tets by Franciscus Costerus (1588) and Hieronymus Natalis (1595).

64. Nadine Orenstein, *Pieter Bruegel the Elder: Drawings and Prints*, exh. cat. (New York, 2001), 258–61, no. 117, noting documentary acknowledgment by friends of Ortelius, both Dirck Volckertsz. Coornhert (1578) and Benito Arias Montano (1590) for their receipt of the print as a gesture of friendship with Ortelius. Another inscription on the print makes explicit that Ortelius had the print made "on behalf of himself and his friends" (*sibi et amicis*).

65. Grossmann, "Bruegel's Grisailles," 226, citing Popham, "Bruegel and Ortelius," *Burlington Magazine* 59 (1931), 184–88; Boumans, "Religious Views of Ortelius." For the wider heterodox network, see especially Alastair Hamilton, *The Family of Love* (Cambridge, 1981); Hamilton, "The Family of Love in Antwerp," *Bijdragen tot de Geschiedenis* 70 (1987), 87–96; Perez Zagorin, *Ways of Lying* (Cambridge, Mass., 1990), esp. 1771–30 for the *Family of Love*. It should be noted, however, that Coornhert, grateful recipient in 1578 of one of Ortelius's prints, recoiled from the *Family of Love* and its leader Hendrik Niclaes, and he wrote in the next year an accusation against his spiritual leadership in his *Little Glass of Unrighteousness* (1579), a direct reproach to Niclaes's *Mirror of Righteousness* (*Spiegel der gherechticheyt*); see Gerrit Voogt, *Constraint on Trial: Dirck Volckertsz. Coornhert and Religious Freedom* (Kirksville, Mo., 2000), 134–35.

66. Quoted by Grossmann, "Bruegel's Grisailles," 226, n. 37, from J. A. Hessels's edition of Ortelius's letters (1887), no. 23.

CHAPTER 9. PEASANT LABOR AND LEISURE

1. Nadine Orenstein, *Pieter Bruegel the Elder: Drawings and Prints*, exh. cat. (New York, 2001), 196–97, no. 79.

2. J. J. Mak, "De Wachter in het Rederijkersdrama naar aanleiding van de toneelvertooning op Bruegel's Temperantia," *Oud Holland* 64 (1949), 162–72.

3. Translation by Fritz Grossmann, *Bruegel: Complete Edition of the Paintings* (London, 1966), 7.

4. Orenstein, *Drawings and Prints*, 198–200, no. 80. De Mompere's name sits in the right edge of the inscription; Eddy de Jongh and Ger Luijten, *Mirror of Everyday Life: Genreprints in the Netherlands 1550–1700*, exh. cat. (Amsterdam, 1997), 44–48, no. 1.

5. For Sebastian as the patron saint of crossbowmen's or longbowmen's militia guilds in the Netherlands, Egbert Haverkamp-Begemann, *Rembrandt: The Nightwatch* (Princeton, 1982), 39. Frans Hals's two militia guilds in Haarlem were dedicated to St. Hadrian and St. George, respectively;

see in general M. Carasso-Kok and J. Levy-van Halm, eds., *Schutters in Holland*, exh. cat. (Haarlem, 1988), esp. 22.

6. As noted by Orenstein, *Drawings and Prints*, 198, both the pigs and the man were removed from a newly identified second state, possibly as indecorous or potentially liable as anticlerical.

7. Norbert Elias, *The History of Manners* (New York, 1978), esp. 129–43; more generally on the scandalous, base bodily emphasis of these kermis and carnival scenes, Peter Stallybrass and Allon White, *The Politics and Poetics of Transgression* (Ithaca, N.Y., 1986), 27–66. Seminal texts include the works of Erasmus, such as his colloquy "The Profane Feast" (1518) or his treatise "On Civility in Boys" (1530). See chapter 6.

8. For the thoughtful revision of the last word of the caption as "chewing" in the sense of overeating, see W. Gibson, "Festive Peasants before Bruegel: Three Case Studies," *Simiolus* 31 (2004–2005), 294–95 n. 13, citing Susan Gilchrist.

9. Adolf Monballieu, "De 'Kermis van Hoboken' bij P. Bruegel, J. Grimmer, en G. Mostaert," *Jaarboek Koninklijk Museum voor Schone Kunsten Antwerpen* (1974), 139–69; Monballieu, "Nog eens Hoboken bij Bruegel en tijdgenoten," ibid. (1987), 185–206; W. Gibson, *Pieter Bruegel and the Art of Laughter* (Berkeley 2006), 81–84.

10. Translation in De Jongh and Luijten, *Mirror of Everyday Life*, 47, fig. 3.

11. Mielke, "Radierer um Bruegel," Otto von Simson and Matthias Winner, eds., *Pieter Bruegel und seine Welt* (Berlin, 1979), 63–65, fig. 2.

12. On earlier imagery of peasants in general, Hans Joachim Raupp, *Bauernsatiren: Entstehung und Entwicklung des bäuerlichen Genres in der deutschen und niederländischen Kunst ca. 1470–1570* (Niederzier, 1986), 214–22 (Aertsen); 223–44 (Bruegel); 245–51 ("Group van der Borcht"). No monograph fully examines Pieter Aertsen yet; however, see the special issue of the *Nederlands Kunsthistorisch Jaarboek* 40 (1989); *Kunst voor de Beeldenstorm*, exh. cat. (Amsterdam, 1986), 342–47.

13. Keith Moxey, *Pieter Aertsen, Joachim Beuckelaer, and the Rise of Secular Painting in the Context of the Reformation* (New York, 1977), 67–71. See a related painting, *Village Fair* (1563; St. Petersburg, Hermitage), by Joachim Beuckelaer, Aertsen's nephew and follower; Raupp, *Bauernsatiren*, fig. 199, where the religious procession is absent and flirtatious eroticism predominates, particularly for the well-dressed visitors.

14. One card shows a fool, the other a stag, associated with lust.

15. Last of the peasant pictures by Aertsen features the ultimate Carnival fare, *Peasant Company with Pancakes* (1560; Museum Boijmans van Beuningen, Rotterdam); *Kunst voor de Beeldenstorm*, 346–47, no. 228; however, this work presents the peasants as more earnest in their preparations, with surprisingly dour expressions.

16. Raupp, *Bauernsatiren*, esp. 1134–94; Alison Stewart, *Before Bruegel: Sebald Beham and the Origins of Peasant Festival Imagery* (Aldershot, 2008), esp. 59–135; Moxey, *Peasants, Warriors, and Wives: Popular Imagery in the Reformation* (Chicago, 1989), 35–66.

17. Stewart, 75–78, fig. 2.4.

18. Stewart, 85–86; Moxey, 63–65.

19. A similar contrast between fat and thin heads in a single painting, formerly held to be a Bruegel but now omitted from his oeuvre, is the Copenhagen *Fight Between Carnival and Lent*; see Max J. Friedländer, *Early Netherlandish Painting*. XIV. *Pieter Bruegel* (Leyden, 1976), 46, no. 49. A reprise of these two prints was painted in two panels by the young Jan Steen, c. 1650; Perry Chapman, Wouter Kloek, and Arthur Wheelock, Jr., *Jan Steen, Painter and Storyteller*, exh. cat. (Washington, 1996), 103–8, nos. 2–3 (the latter image of *The Lean Kitchen* is in Ottawa, National Gallery of Canada).

20. Among Bruegel's most studied paintings, with vast bibliography: Inge Herold, *Pieter Bruegel: Die Jahreszeiten* (Munich, 2002); Vöhringer, *Pieter Bruegels d. Ä. Landschaft mit pflügendem Bauern und Ikarussturz* (Munich, 2002); W. Gibson, *"Mirror of the Earth": The World Landscape in Sixteenth-Century Flemish Painting* (Princeton, 1989), 70–75; Hans van Miegroet, "'The Twelve Months' Reconsidered. How a Drawing by Pieter Stevens Clarifies a Bruegel Enigma," *Simiolus* 16 (1986), 29–35; Demus et al., *Flämische*

Malerei (Vienna, 1981), 86–94; Fritz [...]
bilder Pieter Bruegels d. Ä (Vienna, 19[...]

21. Ethan Matt Kaveler, *Pieter Bruegel: [...]*
Enterprise (Cambridge, 1999), 35, 51–[...]
Collection of Niclaes Jongelinck: II. [...]
Bruegel the Elder," *Burlington Maga[...]*
Carl van de Velde, "The Labours of [...]
of Paintings by Frans Floris," *Burling[...]*
(1965), 114–23; also Van de Velde, "Pa[...]
Antwerp in the Sixteenth and Sevente[...]
Vlieghe, Arnout Balis, and Carl van d[...]
Design and Execution in Flemish Paint[...]
hout, 2000), 29–37.

22. For Jacques Jongelinck, Kaveler, *Bru[...]*
34–35, 50, figs. 13–14 (Granvelle), 23 ([...]
Bruegel's merchant friend and fellow [...]
festivals).

23. See also Buchanan, "The Collection o[...]
I. 'Bacchus and the Planets' by Jacque[...]
ton Magazine 132 (1990), 102–13.

24. Van de Velde, "Hercules," 117, nn. 21–2[...]
chased in 1547 by Thomas Jongelinck, [...]
and sold it to his brother Nicolaes in N[...]

25. Goldstein, "Artifacts of Domestic Life[...]
the Flemish Home," *Nederlandish Kun[...]*
(2000), 173–93, esp. 180; W. Gibson, *B[...]*
Laughter, 67–68.

26. Vöhringer, 57–79, 133–55; Herold, *Jahr[...]*
Smeyers, "Het jaar rond: Kalendar mi[...]
handschriften," Yvette Bruijnen and Pa[...]
Vier Jaargetijden in de kunst van de Ned[...]
exh. cat. ('s-Hertogenbosch, 2002), 37–[...]
Time Sanctified: The Book of Hours in M[...]
exh. cat. (Baltimore, 1988), 45–54; Will[...]
darminiaturen der Stündenbücher (Mur[...]
pensable for the medieval tradition, J. [...]
Labors of the Months in Antique and Me[...]
of the Twelfth Century (New York, 1938)[...]
Hourihane, ed., *Time in the Medieval W[...]*
the Months and Signs of the Zodiac in the[...]
(University Park, Penn., 2007).

27. Sandra Hindman, "Pieter Bruegel's Ch[...]
and Chance," *Art Bulletin* 63 (1981), 455–[...]

28. Vöhringer, 54–56; Buchanan, 549–50; T[...]
Scot McKendrick, *Illuminating the Ren[...]*
of Flemish Manuscript Painting in Europ[...]
Angeles, 2003), 447–86; Kren, "Simon [...]
Development of Landscape in Flemish [...]
tion," Thomas Kren and Johannes Rath[...]
ing Calendar: Clm 23638a Bayerische Staa[...]
1988), 204–73; Thomas Kren, "Landscap[...]
Reintegrated Book of Hours Illuminate[...]
Michelle Brown and Scot McKendrick, [...]
Book: Makers and Interpreters (London, [...]

29. Buchanan, 'Months', 541–43; Demus et [...]
86–88, tracing the documented history o[...]
the Months was presented to Archduke [...]
Netherlands from 1593 to 1595, there wer[...]
together at his death and posthumous in[...]
of Twelve Months of the year by Bruegel[...]
these works were inventoried in the coll[...]
regent (1646–56), Archduke Leopold Wi[...]
return to Vienna (1659), only five works [...]

30. Kren and McKendrick, 450–51, fig. 140a[...]
New York, Morgan Library, ms M399, fc[...]
(*Hennessy Hours*; Brussels, Bibliothèque[...]

31. Linda and George Bauer, "The 'Winter L[...]
Skaters and Bird Trap' by Piter Bruegel t[...]
tin 66 (1984), 145–50. This image is one o[...]
often copied works, usually at the same s[...]
son Pieter the Younger; see Peter van den[...]
Enterprises, exh. cat. (Maastricht-Brussels[...]
72, which notes 127 versions of this comp[...]

32. Published by Johannes Galle; Orenstein, [...]
Prints, 175–76, fig. 90; also Eddy de Jongh[...]
Mirror of Everyday Life, 51–52, fig. 5, misda[...]

print to 1553 but crediting the artist, which the original print
by Cock failed to do.

W.A. Baillie-Grohman, *Sport in Art*, 2nd ed. (London, 1920);
Raimond van Marle, *Iconographie de l'art profane au Moyen
Age et à la Renaissance* (The Hague, 1931), 197–278; Francis
Klingender, *Animals in Art and Thought to the End of the
Middle Ages* (Cambridge, Mass., 1971), 447–76; a retrospec-
tive discussion of earlier art history as background to the
analysis of Rubens hunts by Arnout Balis, *Hunting Scenes:
Corpus Rubenianum Ludwig Burchard*, vol. 18.2 (London,
1986), 50–69; overview by Thomas Allsen, *The Royal Hunt
in Eurasian History* (Philadelphia, 2006).

See, for example, the Habsburg hunting tapestries, known as
the "Chasses de Maximilien," designed by Bernart van Orley;
Campbell, *Tapestry in the Renaissance: Art and Magnificence*,
exh. cat. (New York, 2002), 329–38, nos. 37–40; Arnout Balis
et al., *Les Chasses de Maximilien* (Paris, 1993). For important
earlier cycles, Margaret Freeman, *The Unicorn Tapestries*
(New York, 1976); George Wingfield Digby, *The Devonshire
Hunting Tapestries* (London, 1971).

W. Gibson, *"Mirror of the Earth"*.

Kaveler, "Pieter Bruegel's 'Fall of Icarus' and the Noble Peas-
ant," *Jaarboek Koninklijk Museum Antwerpen* (1986), 83–98;
Robert Baldwin, "Peasant Imagery and Bruegel's 'Fall of
Icarus," *Konsthistorisk Tidskrift* 55 (1986), 101–14; Veldman,
"Images of Labor and Diligence in Sixteenth-Century Neth-
erlandish Prints: The Work Ethic Rooted in Civic Morality
or Protestantism?" *Simiolus* 21 (1992), 227–64.

Carroll, "Peasant Festivity and Political Identity in the Six-
teenth Century," *Art History* 10 (1987), 295–309; W. Gibson,
"Bruegel and the Peasants: A Problem of Interpretation," in
Pieter Bruegel the Elder: Two Studies (Lawrence, Kans., 1991),
1–52, esp. 17–26; Gibson, "Festive Peasants before Bruegel,"
5–9.

William Baker, ed. *The Adages of Erasmus* (Toronto, 2001),
20 (no. I, ix, 12).

Ibid., 373 (no. IV, vi, 35).

Maryan Ainsworth and Keith Christensen, eds., *From Van
Eyck to Bruegel. Early Netherlandish Painting in the Metropoli-
tan Museum of Art*, exh. cat. (New York, 1998), 386–91, no.
2.

Sandra Hindman, "Bruegel's *Children's Games*," 474, in the
Golf Book (London, British Library, Add. ms 24098), fol. 25v.

Spicer, "De Koe voor d'aerde statt': The Origins of the
Dutch Cattle Piece," Ann-Marie Logan ed., *Essays in North-
ern European Art Presented to Egbert Haverkamp-Begemann on
his 60th Birthday* (Doornspijk, 1983), 251–56; C. Boschma et
al. *Meesterlijk vee: Nederlandse veeschilders 1600–1900*, exh. cat.
(Dordrecht, 1988). See in particular for Jan van de Velde's
etching, *The White Cow* (1622), analysis by Freedberg, *Dutch
Landscape Prints* (London, 1980), 35: "The world of Horace's
happy countryman, the shepherd of the *Eclogues* and the
peaceful farmer of the *Georgics* has been transplanted to the
Netherlands." He notes the couplets on van de Velde's *Sum-
mer*, "Summer's heat is here; the diligent farmer seeks shade
beneath the trees, and the fat cows wander over the grass.
The rustic maid milks the sheep and softens their foaming
udders; she makes cheese, and stores the honey of the bees
in overflowing pots."

Orenstein, *Drawings and Prints*, 236–37, nos. 106–7.

Virginia Tuttle Clayton, *Gardens on Paper, Prints and Draw-
ings 1200–1900*, exh. cat. (Washington, 1990), 44–47, an inno-
vation often associated in the Netherlands with Hans
Vredeman de Vries (1526–1606), painter-designer who also
published a garden design book, *Hortorum Viridariorumque
[...]*; see Erik de Jong, "A Garden Book Made for Emperor
Rudolf II in 1593: Hans Puechfeldner's *Nützliches Künst-
lich der Gartnereij*," in Therese O'Malley and Amy Myers,
*The Art of Natural History. Illustrated Treatises and Botanical
Paintings, 1400–1850* (Washington, 2008), 187–203; Peter
Fuhring, ed., *De wereld is een tuin: Hans Vredeman de Vries en
de tuinkunst van de Renaissance* (Ghent, 2002); for later gar-
dens in Holland, De Jong, *Nature and Art: Dutch Garden
and Landscape Architecture, 1650–1740* (Philadelphia, 2000).
Karen Jones Hellerstedt, *Gardens of Earthly Delight,
Sixteenth- and Seventeenth-Century Netherlandish Gardens*,
exh. cat. (Pittsburgh, 1986), 8–9, no. 1; Yvette Bruijnen and

Paul Huys Janssen, *De Vier Jaargetijden in de kunst van de
Nederlanden 1500–1750*, exh. cat. ('s-Hertogenbosch, 2002),
122–23, no. 17.

46. Orenstein, *Drawings and Prints*, 243–45, nos. 109–10. In this
entry, Michiel Plomp offers a unique interpretation of the
print by noting that one of the figures, with wooly hair, in
the line of harvesters is turned toward the viewer and mow-
ing "against the grain" (literally), i.e., "with a disorderly
character." Moreover, he characterizes the hair itself as sug-
gesting "a passionate, stubborn nature." While this figure
does stand apart from his peers, he is hardly a dominant
character in the scene, and this overinterpretation typifies the
kinds of deep readings given to Bruegel scenes, particularly
of peasants. However, this entry is particularly interesting
for its use of Dutch phrases as interpretive keys to Bruegel
visual concepts, especially with a comical intention.

47. A scholarly monograph on Bol is still lacking; best discus-
sion of his graphic work and his relationship to Bruegel
is given by Franz, *Niederländische Landschaftsmalerei im
Zeitalter des Manierismus* (Graz, 1969), 182–97; Franz, "Hans
Bol als Landschaftszeichner," *Kunsthistorisches Jahrbuch Graz*
I (1965), 19–68.

48. John Oliver Hand et al., *The Age of Bruegel*, exh. cat. (Wash-
ington, 1986), 103–4, no. 30; Mielke, *Pieter Bruegel: Die
Zeichnungen* (Turnhout, 1996), 63, no. 57. The copy is in
Albertina, Vienna, inv. 7865; see *Pieter Bruegel d. Ä. als Zeich-
ner*, exh. cat. (Berlin, 1975), 79, no. 92, entry by Mielke.

49. Klaus Ertz, ed., *Breughel-Brueghel: Een Vlaamse schilders-
familie rond 1600*, exh. cat. (Antwerp, 1998), 327–31, nos.
110–15, esp. no. 114 for the *Gooseherd*, permitting its clear
identification and understanding. For the *Twelve Proverbs*,
319–23, nos. 106–8; for the images after the Four Seasons
prints of 1570, 355–66, nos. 126–29.

50. Orenstein, *Drawings and Prints*, 225–27, nos. 98–99; the copy
is in New York, Metropolitan Museum, 1975.131.172.

51. W. Gibson, *Bruegel and the Art of Laughter*, 90–94; Emanuel
Winternitz, *Musical Instruments and Their Symbolism in West-
ern Art* (New Haven, 1979), 66–85. See the lines in Sebastian
Brant's *Ship of Fools* (Basel, 1494), contrasting the bagpipe
with lute and harp, instruments of the angels: "If bagpipes
you enjoy and prize / And harps and lutes you would
despise, / You ride a fool's sled, are unwise" (chapter 54;
"Of Impatience of Punishment," translated by Edwin Zey-
del, New York, 1944, 186). For Flemish bagpipes, Hubert
Boone, *Le Cornemuse* (Brussels, 1983).

52. Ernst Scheyer, "The *Wedding Dance* by Pieter Bruegel the
Elder in the Detroit Institute of Arts: Its Relations and Deri-
vations," *Art Quarterly* 28 (1965), 167–93; Alpers, "Bruegel's
Festive Peasants," *Simiolus* 6 (1972–73), 163–76; W. Gibson,
"Bruegel and the Peasants," esp. 35–37.

53. W. Gibson, "Bruegel and the Peasants," summarizes the con-
tentious debate between Alpers and Miedema on this sub-
ject, which to a certain extent reprises the interpretations of
Sebald Beham peasant images (see above, n. 16), debated by
Alison Stewart as "popular entertainment" versus Keith
Moxey as "repressive humor." The literature has grown
large, but these are the major contributions: (popular
entertainment) Alpers, "Bruegel's Festive Peasants";
Alpers, "Realism as a Comic Mode. Low-Life Painting
Seen Through Bredero's Eyes," *Simiolus* 8 (1975/76), 115–44;
Alpers, "Taking Pictures Seriously. A Reply to Hessel
Miedema," *Simiolus* 10 (1978/79), 46–50; Carroll, "Peasant
Festivity"; W. Gibson, "Bruegel and the Peasants"; W.
Gibson, "Rustic Revels," in *Bruegel and the Art of Laughter*,
77–105; (repressive humor) Miedema, "Realism and Comic
Mode: The Peasant," *Simiolus* 9 (1977), 205–19; Miedema,
"Feestende boeren—lachende dorpers," *Bulletin van het
Rijksmuseum* 29 (1981), 191–213; Vandenbroeck, "Verbeeck's
Peasant Weddings. A Study in Iconography and Social Func-
tion," *Simiolus* 14 (1984), 79–124; Raupp, *Bauernsatiren*, esp.
223–44, 271–321; Sullivan, *Bruegel's Peasants: Art and Audi-
ence in the Northern Renaissance* (Cambridge, 1994), who
sees these works as produced for a learned audience and
informed by classical satire.

54. Alpers, "Bruegel's Festive Peasants," 167 n. 15.

55. Scheyer, "The *Wedding Dance*," 175, 188; Alpers, "Bruegel's
Festive Peasants," 168; W. Gibson, "Some Notes on Pieter

Bruegel the Elder's *Peasant Wedding Feast,*" *Art Quarterly* 28 (1965), 194–208, concluding then that these late Bruegel peasant scenes conformed to the prevailing interpretation of social condemnation of peasant excesses.

56. Clifton and Scattone, *The Plains of Mars: European War Prints, 1500–1825,* exh. cat. (Houston, 2009), esp. nos. 3–7, 9–11; Grace Vicary, "Visual Art as Social Data: The Renaissance Codpiece," *Cultural Anthropology* 4 (1989), 3–25; Jeffery Persels, "Bragueta humanistica, or Humanism's Codpiece," *Sixteenth Century Journal* 28 (1997), 79–99.

57. Raupp, *Bauernsatiren,* 248–51, figs. 235–36; Miedema, "Realism and Comic Mode," 212–13, n. 38.

58. Ibid.

59. Orenstein, *Drawings and Prints,* 248–50, no. 113; De Jongh and Luijten, *Mirror of Everyday Life,* 54–57, no. 3. Orenstein sensitively notes that the patchy shading of the engraving differs from the usual, more linear collaboration by the two men, so that there is a good chance that the model for the print was a lost smaller painting, possibly already by a Bruegel imitator, who did not so effectively convey movement or even hats on heads.

60. The earliest painted copy by Pieter the Younger (Walters Art Museum, Baltimore), is dated 1607, and dated examples extend to 1624; *Brueghel-Breughel* (Essen 1997), 125–29, no. 20, with comparisons; see also a related work, modified and placed in a wider landscape, by Jan Brueghel, ibid., 122–24, no. 19. Some of the roughly three dozen copies reverse the direction of the print, but others do not, so even if the source was a Bruegel graphic rather than a painting, it could have been either a drawing or the engraved print.

61. Kaveler, *Bruegel: Parables of Order,* 184–211; W. Gibson, *Bruegel and the Art of Laughter,* esp. 68–72, 100–102; Demus et al., *Flämische Malerei,* 115–18; most recently Richardson, "Pieter Bruegel the Elder: Art Discourse in the Sixteenth-Century Netherlands," Ph.D. diss. (Leiden University, 2008), esp. 106–29. I am most grateful to Prof. Richardson for sharing his work with me prior to publication.

62. This print also has a pendant engraving, *The Bagpiper* (1514), and while Bruegel certainly does not literally copy either work (for example, his bagpiper is bearded), nonetheless his ponderous, coarse peasant figures stand closer to the monumentality of the Dürer precedent than to almost any other imagery. Giulia Bartrum, *Albrecht Dürer and His Legacy,* exh. cat. (London, 2002), 193, nos. 136–37. On the dancing peasant, Raupp, *Bauernsatiren,* 165–94, with attention to Sebald Beham small engravings in the wake of Dürer, particularly a series of twelve months and twelve dancing couples to depict a *Peasant Festival* (1546), 189, fig. 171; on dance in general, also Kaveler, *Bruegel: Parables of Order,* 196–200. Now John Block Friedman, *Brueghel's Heavy Dancers. Transgressive Clothing, Class, and Culture in the Late Middle Ages* (Syracuse, 2010).

63. Sullivan, *Bruegel's Peasants,* 62, and Richardson, "Art Discourse," 118, acutely observe that the tiny broken handle of a pot in the lower right corner probably refers to the loss of virginity or even promiscuity of the woman who enters the dance just above it; it also contrasts utterly with the painted woodcut attached to the tree above her and the church steeple at the horizon. For a vaginal association with a crock in a contemporary picture, see the Vienna Jan Massys *Merry Company* (1564; plate 32). Under the feet of her male partner a pair of hay stalks form the sign of the cross, as if to show the opposite pole, genuine countryside religious celebration, perhaps being trampled; see Richardson, "Art Discourse," 119–20; Demus et al., *Flämische Malerei,* 117, points to the seasonal aspects of hay as post-harvest remnants.

64. Kaveler, *Bruegel: Parables of Order,* 200–209; on folly more generally, Pinson, *The Fools' Journey: A Myth of Obsession in Northern Renaissance Art* (Turnhout, 2009); Van der Coelen, "Praise of Folly," *Images of Erasmus,* exh. cat. (Rotterdam, 2008), 213–29.

65. Alpers, "Realism as a Comic Mode," 124 n. 39, notes this phrase on a Van Mander kermis drawing of a tipsy couple (1588; Amsterdam, Rijksmuseum).

66. For a similar principle of seeing through worldly distractions to religious significance, Falkenburg, "Marginal Motifs in Early Flemish Landscape Paintings," Norman Muller, Betsy

Rosasco, and James Marrow, eds., *Herri met de Bles: Studies and Explorations of the World Landscape Tradition* (Princeton, 1998), 153–69; Falkenburg, "The Devil is in the Detail: Ways of Seeing Joachim Patinir's 'World Landscapes,'" Alejandro Vergara, *Patinir,* exh. cat. (Madrid, 2007), 61–79.

67. See a variant by Peeter Balten, *St. Martin's Day* (Antwerp, Koninklijk Museum), discussed by Paul Vandenbroeck, *Beeld van de Andere Vertoog over het zelf,* exh. cat. (Antwerp, 1987), 212, no. 81, fig. 135. A related fragment in Vienna (no. 2691) also provides a copy after (the right one-third of) the Bruegel original; *Flämische Malerei von Eyck bis Bruegel* (Vienna, 1981), 123–26. For images of the entire composition, Klaus Ertz, *Pieter Bruegel der Jüngere* (Lingen, 1997), 466–69, nos. A452–53. A reversed engraved copy by N. Guérard, attributed to Jan Brueghel, appears in the Bastelaer catalogue (no. 214).

68. Diane Wolfthal, *The Beginnings of Netherlandish Canvas Painting: 1400–1530* (Cambridge, 1989); Lawrence Silver, "The Sin of Moses": Comments on the Early Reformation in a Late Painting by Lucas van Leyden," *Art Bulletin* 55 (1973), 401–9.

69. Kaveler, *"Bruegel: Parables of Order,"* 149–83; W. Gibson, "Bruegel and the Peasants," esp. 37–43; Demus et al., *Flämische Malerei,* 110–15; Richardson, "Art Discourse," 78–105.

70. W. Gibson, *Bruegel and the Art of Laughter,* esp. 88–105, 119–23.

71. Alpers, "Bruegel's Festive Peasants," 167 n. 14, citing the research of Dr. Sidra Stich.

72. Hans Sedlmayr, "Bruegel's *Macchia*" (1934), in Christopher Wood, ed., *The Vienna School Reader* (New York, 2000), 323–76.

73. Kaveler, *Pieter Bruegel: Parables of Order,* 164–68.

74. W. Gibson, *Bruegel and the Art of Laughter,* 152–53, fig. 84; W. Gibson, "Bruegel and the Peasants," 41; Alpers, "Bruegel's Festive Peasants," 169–71. Also Cordula Schumann, "Court, City and Countryside: Jan Brueghel's Peasant Weddings as Images of Social Unity under Archducal Sovereignty," Werner Thomas and Luc Duerloo, eds., *Albert and Isabella 1598–1621: Essays* (Turnhout, 1998), 151–61, noting that one pair of images, *Wedding Banquet Presided by the Archdukes* and *Wedding Procession,* was recorded already in 1613 and another pair of pendants, *Peasant Dance in Front of the Archdukes* and *Wedding Dance,* was signed and dated 1623. For entries, *Albert and Isabella: Catalogue,* 195–97, nos. 271–72; *Brueghel-Breughel* (Essen), 254–56, nos. 73–74 (1623).

75. On the specificity of the peasant costumes, see Kaveler, *Bruegel: Parables of Order,* 172–77, comparing the fashions in the image to costume books, particularly Abraham de Bruyn (Antwerp, 1581). For costume books, Elizabeth Rodini and Elissa Weaver, eds., *A Well-Fashioned Image: Clothing and Costume in European Art 1500–1850,* exh. cat. (Chicago, 2002).

76. Sellink (Ghent, 2007), *Bruegel,* 273, no. X5; *Brueghel-Breughel* (Essen), 121–22, no. 18, n. 1, fig. 1. The work was also copied in slightly simpler form but consistent composition by Pieter Breughel the Younger, who also produced variant, simplified pendant compositions of the processions of the bride and the groom, respectively (for example, Kansas City, Nelson Gallery; Scheyer, "The *Wedding Dance,*" figs. 6–7).

77. Richardson, "Art Discourse," 65–80, evokes the Platonic heritage of the symposium, or *convivium,* reprised in Erasmus's celebrated colloquies, such as "Godly Feast," "Poetic Feast," and "Profane Feast," as well as "A Lesson in Manners." This table talk became a pastime of such educated and sophisticated collectors before their images of Bruegel's own festive meals of peasants. This point has been made by Margaret Sullivan, *Bruegel's Peasants,* esp. 30–36, and is discussed by W. Gibson, *Bruegel and the Art of Laughter,* 106–19. See also Michel Jeanneret, *A Feast of Words: Banquets and Table Talk in the Renaissance* (Chicago, 1991), esp. 40–45 on civility and table manners, 176–85 for the Erasmus discussions; Craig Thompson, ed., *The Colloquies of Erasmus* (Chicago, 1965).

78. *Breughel-Breughel* (Essen), 116–20, nos. 15–17; Sellink, *Bruegel,* 274, no. X6; Demus et al., *Flämische Malerei,* 126–28. The original was probably a grisaille, since two versions survive in gray tones, one in Paris (Fondation Custodia), some-

times still regarded as the Pieter the Elder original, the other in Antwerp (Koninklijk Museum, no. 645), attributed to Jan, c. 1597. Jan the Younger in 1627 also speaks of "a black-and-white foster-father [*voesterheer*] of my father," surely referring to a grisaille by his father, Jan the Elder. Ertz, *Pieter Bruegel der Jüngere,* 474–86, nos. A462–88.

79. Kaveler, *Pieter Bruegel: Parables of Order,* 183; though he does not discuss this image of the *Visit to a Farmhouse,* Kaveler, 182–83, following Sullivan, *Bruegel's Peasants,* 91–95, perceptively notes the presence of children in peasant festivities by Netherlandish artists, for example, in the foreground of Bruegel's *Peasant Kermis,* in contrast to their German models.

80. See the thoughtful remarks on Rubens and farming, making use of that artist's great learning and undoubted familiarity with Horace's praise of the farmer, *beatus ille* ("blessed is he"), by Lisa Vergara, *Rubens and the Poetics of Landscape* (New Haven, 1982), 72–98, 154–91, esp. 158–60 for Horace's Second Epode.

81. W. Gibson, *Pleasant Places: The Rustic Landscape from Bruegel to Ruisdael* (Berkeley, 2000), esp. 1–26; on country estates, W. Gibson, "Bruegel and the Peasants," 26, fig. 17.

82. W. Gibson, *Bruegel and the Art of Laughter,* 67–69, 77–105; W. Gibson, "Bruegel and the Peasants," 23–31; Carroll, "Peasant Festivity," 295–97, 314 n. 111.

83. *Ibid.,* 297 n. 67; see also Veldman, "Images of Labor."

84. Engraved by Cornelis Cort. Kaulbach and Schleier, "*Der Welt Lauf*" *Allegorische Graphikserien des Manierismus,* exh. cat. (Stuttgart, 1997), 151–56, no. 40, reprised with greater emphasis on figures in a later cycle by Marten de Vos, engraved by Philips Galle, ibid., 156–59, no. 41; Veldman, *Maarten van Heemskerck and Dutch Humanism of the Sixteenth Century* (Amsterdam, 1977), 133–41; Sheila Williams and Jean Jacquot, "Ommegangs anversois du temps de Bruegel et de van Heemskerck," *Les fêtes de la Renaissance* II (Paris, 1960), 359–88.

85. In similar fashion, Erasmus declared in one of the longest and most heartfelt of his Adages of 1515, *Dulce bellum inexpertis* (War is sweet for those who have not tried it); William Barker, *The Adages of Erasmus* (Toronto, 2001), 317–56 (IV, I, 1); Margaret Mann Phillipos, *Erasmus on His Times* (Cambridge, 1967), 99–101, 107–39; see also 34–72 for Erasmus's disregard in the Adages for both money and power. As noted by Williams and Jacquot, 386–88, Erasmus may have revived the ancient adage that underlies Heemskerck's print cycle, *Omnium rerum vicissitudo est* (I, vii, 63).

CHAPTER 10. SOCIAL STRESSES AND STRAINS

1. Arnade, "Alba as Avenger and Usurper of Royal Authority," *Beggars, Iconoclasts, and Civic Patriots: The Political Culture of the Dutch Revolt* (Ithaca, N.Y., 2008), 166–211.

2. Louis Lebeer, "Le pays de Cocagne," *Bulletin Musées Royaux des Beaux-Arts de Belgique* (1955), 199–214; Ross Frank, "An Interpretation of *Land of Cockaigne* (1567) by Pieter Bruegel the Elder," *Sixteenth Century Journal* 22 (1991), 299–329, reading the picture as a "critical, humanist, political commentary leveled at the participants in the First Revolt"; on the fantasy, including several late medieval texts, Herman Pleij, *Dreaming of Cockaigne: Medieval Fantasies of the Perfect Life* (New York, 2006), including discussion of the name, 391–402.

3. Orenstein, *Pieter Bruegel the Elder: Drawings and Prints,* exh. cat. (New York, 2001), 255–57, no. 116. Of course, the grisaille of *The Death of the Virgin* (see plates 257, 260) was also engraved posthumously, and it is possible that the posthumous *Wedding Dance* derived from a lost painting (no drawing survives in any case), which was copied by Pieter the Younger, albeit possibly from the print itself (see plate 288). See Timothy Riggs, "Bruegel and his Publisher," Otto von Simson and Matthias Winner, eds., *Pieter Bruegel und seine Welt* (Berlin, 1979), 165–73, esp. 168, 173.

4. Georges Duby, *The Three Orders: Feudal Society Imagined* (Chicago, 1980); Giles Constable, "The Orders of Society," *Three Studies in Medieval Religious and Social Thought* (Cambridge, 1995), 249–360.

5. Wayne Booth, *A Rhetoric of Irony* (Ch[...] the indices, including a clear counter[...] presentation, which signal irony in li[...]

6. Wallace Stegner, *The Big Rock Candy [...]* 1943).

7. Pleij, *Dreaming of Cockaigne*, 289–90 [...] gruel of 1538; on Hans Sachs, *Schlara[...]* the Rabelais epigone, also Marijnisse[...] 1971), 62–63, n. 91, with descriptions [...] in chapters 18–28.

8. For the winter of 1564–65, Kaveler, *B[...] and Enterprise* (Cambridge, 1999), 21[...] of Cockaigne, 100–17, argues that actu[...] severe or prevalent than one might su[...] eval literature, which instead fostered[...]

9. Veldman, "Images of Labor and Dilig[...] Century Netherlandish Prints: The W[...] Civic Morality or Protestantism?" *Sim[...]

10. Ibid., 235–38, figs. 11–12, plus discussi[...] road to poverty and want," 239–49, n[...] of *The Idler's Punishment*, figs. 18–20.

11. For Adam and Eve as the foundation[...] sion, Pleij, *Dreaming of Cockaigne*, 6–[...]

12. Ibid., 294.

13. Orenstein, *Drawings and Prints*, 238–[...] *Bruegel: Parables of Order*, 233–54; als[...] Reception of Bruegel's Beekeepers: A[...] *Art Bulletin* 73 (1991), 467–73, who re[...] allegory of the Church (cf. Bruegel's *F[...]* her head), whose honey has been robb[...] oclasm of August, 1566. The date is ins[...] its final numerals, so whether this is a[...] the year of the closely related *Summer[...]* see plate 284), must remain moot.

14. On Bruegel and proverbs, Meadow, *P[...] Netherlandish Proverbs and the Practi[...]* 2002); Grauls, *Volkstaal en volksleven i[...] Bruegel* (Antwerp, 1957), esp. 160–74 o[...] though he interprets this proverb in te[...] "faint heart ne'er won fair maid."

15. Richardson, "Pieter Bruegel the Elder[...] Sixteenth-Century Netherlands," Ph.D[...] versity of Leiden, 2008), 130–42; Thor[...] Bruegel d. Ä.: der Bauer, der Vogeldie[...] *Münchner Jahrbuch der bildende Kunst [...]* Pierre Vinken and Lucy Schlüter, "Piet[...] en de mens die de dood tegenmoet tre[...] *Kunsthistorisch Jaarboek* 47 (1996), 54–7[...] et al., *Flämische Malerei von Eyck bis Br[...]* 107–10.

16. The iris, or "sword lily" served as a sym[...] sorrow in fifteenth-century Netherlan[...] ings, in part surely because of its dark c[...] Koch, "Flower Symbolism in the Porti[...] *Bulletin* 46 (1964), 70–77; Mirella Levi[...] *den of the Renaissance* (Florence, 1977)[...] both the brambles and iris with death ([...] soul), Vinken and Schlüter, 60–67, note[...] included in Hugo van der Goes's *Adam[...]* where the flower covers Eve's genitals.[...] Mary is understood as the "new Eve," b[...] of suffering, even death, is appropriate[...] kind in Eden. The iris appears at anothe[...] quence of blindness in Bruegel's 1568 *Bl[...] Blind* (see plate 306).

17. As Kaveler, *Bruegel: Parables of Order*, 2[...] Sebastian Brant's *Ship of Fools* (orig. ed.[...] shows a woodcut (chapter 36) of a fool[...] with a bird's nest in his hand, with the t[...] unwisely often falls hard." Richardson,[...] endorses with approval the ironic invers[...] ler, whose consistent Erasmian interpre[...] posits the artist as an ironist, in this cas[...] gested sense of danger and safety to ind[...] ant rather than the bird-nester; Müller,[...] *Bildform: Studienzur Ikonologie Pieter Br[...]* 1999), 82–89. In the case of the painting[...]

the working farm undermines this interpretation by providing a normative and preferable alternative.
Kjell Boström, "Das Sprichwort vom Vogelnest," *Konsthistorisk Tidskrift* 18 (1949), 77–98, who also reads symbolic meaning into the plants.

Eddy de Jongh and Ger Luijten, *Mirror of Everyday Life: Genreprints in the Netherlands 1550–1700*, exh. cat. (Amsterdam, 1997), 108–10, no. 16: Hessel Gerritsz (?) after David Vinckboons, *Bird Nest*, etching, 1606, where the proverb, monogram, and date appear in the lower left corner of the print; see also fig. 1, for a preliminary drawing of the scene, Brussels, Bibliothèque Royale; also Luijten et al., *Dawn of the Golden Age*, 614–15, no. 286.
Tolnay, "Bruegel et l'Italie," *Les Arts plastiques* (1951), 121–30; Stridbeck, *Bruegelstudien* (Stockholm, 1956), 266–89.
Richardson, "Art Discourse," 134–37, links the *Bird-Nester* to Leonardo's *John the Baptist* (Paris, Louvre); elsewhere, 85–86, he compares (especially for compositions) the *Peasant Wedding Feast* to Raphael's *Entombment* and, 107–8, the *Peasant Kermis* to Titian's *Bacchanal of the Andrians*. For the argument about the vernacular as a rival to the classical, see 27–60, invoking the cultural parallel of the Pléiade poets in France and the Dutch verses of Lucas de Heere (esp. 54–56; but see chapter 2 for his verse attacks on a Bruegel-like painter for pictorial coarseness), using a combination of classicizing principles with the local language.
This visual paradox has been brilliantly delineated by Falkenburg in several articles on "paradoxical *encomium*," principally about Aertsen, such figures as his *Cook* (1559; Brussels): Falkenburg, "Pieter Aertsen, Rhyparographer," Jelle Koopmans et al., eds., *Rhetoric-Rhétoriqueurs-Rederijkers* (Amsterdam, 1995), 197–217; Falkenburg, "Pieter Aertsen's *Alter Marktverkäufer*: Imitatio artis als Paradox," Müller, *Imitatio [...] Formen künstlerischer Aneignug in der Frühen Neuzeit* (Munich, 2006).
Kaveler, *Bruegel: Parables of Order*, 240–41, emphasizes the bees and their hive as models for social order: human harmony in concerted action and division of labor. In fact, the natural hierarchy of bees could be compared to the three orders, discussed above for *Lazy-Luscious Land*. He discusses the alternative interpretations of the image, which praise the nest-robber for his pains ("no pain, no gain"), 246–49.
This combination of distemper (a kind of watercolor with the medium of glue size) and canvas seems to have held the distinction of separate medium in Netherlandish art, a topic currently being investigated in a dissertation at Harvard by Odilia Bonnebakker. She pointed out in a 2008 lecture that such canvases did not have a ground besides glue, so that texture and less blended brushwork were both visible and prized qualities in such works; moreover, because there was no added varnish, the surface retained a matte finish and could not be altered. For a survey of early canvases from the region, Diane Wolfthal, *The Beginnings of Netherlandish Canvas Painting: 1400–1530* (Cambridge, 1989); for a prominent example by an earlier Dutch painter, Lucas van Leyden, *Moses Striking the Rock* (1527; Boston Museum of Fine Arts), see Lawrence Silver, "The *Sin of Moses*: Comments on the Early Reformation in a Late Painting by Lucas van Leyden," *Art Bulletin* 55 (1973), 401–9.
Sellink, *Bruegel* (Ghent, 2007), 252–53, no. 165; Roger Marijnissen, *Bruegel* (Antwerp, 2003), 365–68; Hans Sedlmayr, "Der Sturz der Blinden. Paradigma einer Strukturanalyse," *Epochen und Werke* I. (Vienna-Munich, 1959), [...]–56. For the Paris copy, Édouard Michel, *Catalogue raisonné des peintures: Peinture flamandes du XVe et du XVIe [siè]cle* (Paris, 1953), as "attributed to Brueghel de Velours" [Jan] Brueghel), 52–54, inv. No. RF.829.
[Pau]l Lafond, *The Prints of Hieronymus Bosch*, ed. Susan [Koslow?]christ (San Francisco, 2002), 81–83, no. 16.
[Em]manuel Winternitz, *Musical Instruments and Their Symbolism in Western Art* (New Haven, 1979), 66–85; David Vinckboons, whose *Bird-Nester* drawings and etchings we saw above, also produced a painting of a *Blind Hurdy-Gurdy Player* (Rijksmuseum, Amsterdam; see plate 11.16{ }).
Kahren Jones Hellerstedt, "A Traditional Motif in Rembrandt's Etchings: The Hurdy-Gurdy Player," *Oud Holland* 95 (1981), 16–50.

28. Marijnissen, *Bruegel*, 365.

29. Stridbeck, *Bruegelstudien*, 256, misidentifies the pack of the shepherd as a bagpipe, but the point remains the same, since both were instruments associated with folly; yet the hurdy-gurdy was more the music of choice for beggars, blind and otherwise, whereas the bagpipe was obviously the country instrument of peasants and might have been more aptly employed during his leisure by a shepherd in the countryside. Stridbeck also notes that the hireling wears one hat while carrying another, a sign of duplicity.

30. This point about the fraught historical circumstances of Bruegel's work and religious painting more generally in the wake of Iconoclasm was emphasized best by Freedberg, *Iconoclasm and Painting in the Revolt of the Netherlands, 1566–1609* (New York, 1988); Freedberg, "Art and Iconoclasm, 1525–1580—The Case of the Northern Netherlands," in *Kunst voor de Beeldenstorm*, exh. cat. (Amsterdam, 1986), 69–84; Freedberg, "The Hidden God; Image and Interdiction in the Netherlands in the Sixteenth Century," *Art History* 5 (1982), 133–53.

31. Sellink, *Bruegel*, 266, no. 174; Louis Lebeer, *Catalogue raisonné des estampes de Pierre Bruegel l'ancien* (Brussels, 1969), 184–88, no. 85.

32. Shelley Perlove and Larry Silver, *Rembrandt's Faith: Church and Temple in the Dutch Golden Age* (University Park, Penn., 2009), 311–21.

33. Panofsky, "Albrecht Dürer and Classical Antiquity," *Meaning in the Visual Arts* (New York, 1955), 256–65.

34. Sellink, *Bruegel*, 250–51, no. 164. For roundels in association with peasant scenes, see also the medallion of *The Drunk Cast into the Pigsty* (1557); ibid., 112–13, nos. 62–63; Roger van Schoute and Hélène Verougstraete, "A Painted Roundel by Pieter Bruegel the Elder," *Burlington Magazine* 142 (2000), 140–46.

35. Herbert Grabes, *Mutable Glass: Mirror Images in Titles and Texts of the Middle Ages and the English Renaissance* (Cambridge, 1982); Lucien Dällenbach, *Mirror in the Text* (Chicago, 1989); for mirror imagery in art, Heinrich Schwarz, "The Mirror in Art," *Art Quarterly* 15 (1952), 96–118; Schwarz, "The Mirror of the Artist and the Mirror of the Devout," *Studies in the History of Art Dedicated to William Suida* (London, 1959), 90–105; Gustav Hartlaub, *Zauber des Spiegels* (Munich, 1951).

36. Rejected as Bruegel designs by Orenstein, *Pieter Bruegel: The New Hollstein Dutch and Flemish Etchings, Engravings and Woodcuts* (Ouderkerk aan de Ijssel, 2006), nos. A8–18; fullest discussion in Lebeer, *Catalogue raisonné des estampes*, 155–69, nos. 65–76. A similar roundel, signed by Jan Wierix and dated 1568, and published uniquely by Martin Peeters instead of Cock, was made at the same size after the small roundel, *The Drunk Cast into the Pigsty* (Sellink, *Bruegel*, 112–13, nos. 62–63) and bears the added inscription: "If all the world despise the poor / You shall live in a sty like a pig," and "Destined to live in a sty, spurned like a pig / The fate I endure today may be yours tomorrow." Wierix also became one of the leading printmakers of the Catholic Reformation illustrated books, such as the annotated Gospel images of Nadal, for which see Melion, *The Meditative Art: Studies in the Northern Devotional Print* (Philadelphia, 2009); more centrally see Clifton and Melion, *Scripture for the Eyes: Bible Illustration in Netherlandish Prints of the Sixteenth Century*, exh. cat. (New York, 2009).

37. Also part of the same series is a pair of blind beggars, depicting *The Blind Leading the Blind*, with a Dutch inscription: "Walk carefully at all times, be faithful, trust nobody but God in all things. For if a blind man leads another, one sees that they both fall together into the ditch." Other components of these twelve roundels lack clear ties to Bruegel designs, but have French distichs within and Flemish quatrains around the circle. These include: (a) *The Quarrelsome Housewife*, where a servant fails to obey her mistress in a domestic interior (French: "a woman who nags without reason doesn't do anything but make trouble at home"); (b) *The Man with the Moneybag and His Flatterers*, where a human giant dispenses coins from a large bag, while smaller sycophants crawl up his open rear end (French: "One does not know how to enter as one would like the hole of the one

who can give"); (c) *The Misanthrope Robbed by the World*; (d) *The Music of the Rich is Always Pleasant, even if Played on a Jawbone*, in which a rich man literally plays a jawbone while behind him another man plays a trumpet in a pillory (cf. *Netherlandish Proverbs*), meaning that he has acquired his wealth illegally (French: "He who has the means to receive plays well on the jawbone"); (e) *Every Peddler Praises His Own Wares*, with the same trinkets—cheap mouth instruments—as the *Peddler Robbed by Monkeys* (1562; see plate plate 49), as a fat man looks over at the peddler (French: A. Here are the nets, trumpets and flutes. Such wares you never had. B. Go away, peddler, go away from here, and take your goods somewhere else."); (f) *He Begs in Vain at the Door of the Deaf Man*, with two monks waiting outside (French: "We now beg in vain because we should at the door of a deaf person"); (g) *The Archer Who Shoots All His Arrows*, with a crossbow at a doorsill (cf. *Netherlandish Proverbs*; French: "He who gives often and has no joy of it dispatches one arrow after the other"); (h) *Two Blind Men Leading Each Other Will Fall into the Ditch* (Flemish only) (i) *A Fool Hatches a Big Empty Egg*, with a fool drinking atop a giant, cracked eggshell (Flemish only); (j) *The Carefree Peddler*, with a seated bride alongside an anguished peddler of rings (Flemish only); (k) *The Hay Runs after the Horse*, a social inversion in which women chase after men for marriage, a scene in the background (Flemish only); (l) *He Warms Himself at a Burning House* (cf. *Netherlandish Proverbs*; Flemish only). W. Gibson, *Figures of Speech. Picturing Proverbs in Renaissance Netherlandish* (Berkeley, 2010), 80–117.

38. Sellink, *Bruegel*, 254, no. 166; Marijnissen, *Bruegel*, 354–58.

39. See remarks above, chapter 6, concerning the church calendar events imbedded in *Carnival and Lent*; also especially see Linda Stone-Ferrier, *Dutch Prints of Daily Life*, exh. cat. (Lawrence, Kans., 1983), 120–22, no. 29, discussing Claes Jansz Fisscher, *Leper Procession,* etching, 1608.

40. S. J. Gudlaugsson, "Wat heeft Pieter Bruegel met zijn 'bedelaars' bedoeld?" *Mededelingen van het Rijksbureau voor Kunsthistorische Documentatie* 2 (1947), 32–35. This is particularly true of Magdi Tóth-Ubbens, *Verloren beelden van mieserabele bedelaars* (Ghent, 1987), who also notes about Copper Monday, that "the outcasts of society were the first to celebrate the New Year and to herald the public festivities of the Carnival period . . . The special status of lepers, exiled to a sort of no-man's land, made them eminently suited to the topsy-turvy world of these festivals, where they and their like served as a warning to the healthy, virtuous faithful." (106) On the "Beggars," Peter Arnade, *Beggars, Iconoclasts, and Civic Patriots*, 80–84, 170–73.

41. For beggar images, the basic study is Lucinda Reinold, "The Representation of the Beggar as Rogue in Dutch Seventeenth-Century Art," Ph.D. diss. (University of California, Berkeley, 1981); Paul Vandenbroeck, *Beeld van de andere, vertoog over het zelf*, exh. cat. (Antwerp, 1987), 117–26; also Lawrence Silver, "Of Beggars: Lucas van Leyden and Sebastian Brant," *Journal of the Warburg and Courtauld Institutes* 39 (1976), 253–57; Larry Silver and Henry Luttikhuizen, "The Quality of Mercy: Sixteenth-Century Dutch Depictions of Charity," *Studies in Iconography* 29 (2008), 216–48. On the fox, especially the Reynaert tradition, Raymond van Uytven, *De papegaai van de paus: Mens en dier in de Middeleeuwen* (Louvain, 200), 93–100; T. H. White, *The Bestiary* (New York, 1954), 53–54, "He is a fraudulent and ingenious animal." See also Donald Francis Klingender, *Animals in Art and Thought to the End of the Middle Ages* (London, 1971), 366–68, 387–88, 417; good survey of fox tail references in De Pauw-De Veen, "Das Brüsseler Blatt mit Bettlern und Krüppeln: Bosch oder Bruegel," Von Simson and Winner, *Bruegel und seine Welt*, 155–57.

42. De Pauw-De Veen, Ibid., 149–58; Vandenbroeck, *Jheronimus Bosch: Tussen volksleven en stadscultuur* (Berchem, 1987), esp. 58–62; K. G. Boon et al., *Jheronimus Bosch*, exh. cat. ('s-Hertogenbosch, 1967), 162–65, 218–19, nos. 49–50, 101. Grossmann, "New Light on Bruegel I: Documents and Additions to the Oeuvre," *Burlington Magazine* 101 (1959), 345, says of the Brussels drawing, the superior of the two, which has an added signature and date of 1558: "Though this is not a signature it correctly indicates the artist and

approximate date . . ." as he compares it to *Carnival and Lent* in figure types. The most sage assessment is that of Erwin Pokorny, who also sees the Brussels drawing as the superior work, but situates both images somewhere between the oeuvres of Bosch and Bruegel. I am grateful to Prof. Pokorny for numerous conversations on both artists.

43. Larry Silver, "Peter Bruegel in the Capital of Capitalism," *Nederlands Kunsthistorisch Jaarboek* 47 (1996), 138–43.

44. Muylle, "Pieter Bruegel en Abraham Ortelius: Bijdrage tot de literaire receptie van Pieter Bruegels werk," *Archivum Artis Lovaniense: Bijdragen tot de geschiedenis van de kunst der Nederlanden opgedragen aan Prof. Em. Dr. J. K. Steppe* (Louvain, 1981), 319–37, esp. 335; Meadow, "Bruegel's *Procession to Calvary*, Aemulatio and the Space of Vernacular Style," *Nederlands Kunsthistorisch Jaarboek* 47 (1996), 192–96 for the *Album amicorum* of Ortelius.

45. Muylle, "Tronies toegeschreven aan Pieter Bruegel. Fysionomie en expressie," *De zeventiende eeuw* 17 (2001), 174–204, 18 (2002), 115–48; Konrad Oberhuber, "Pieter Bruegel und die Radierungsserie der Bauernköpfe," Von Simson and Winner, *Bruegel und seine Welt,* 143–47. On tronies in Dutch painting tradition of the seventeenth century, Lyckle de Vries, "Tronies and Other Single Figures in Netherlandish Painting," *Leids Kunsthistorisch Jaarboek* 8 (1989), 185–202; Dagmar Hirschfelder, *Tronie und Porträt in der niederländischen Malerei des 17. Jahrhunderts* (Berlin, 2008). On Rembrandt, Jaap van der Veen, "Faces from Life: *Tronies* and Portraits in Rembrandt's Painted Oeuvre," Albert Blankert, *Rembrandt: A Genius and His Impact*, exh. cat. (Melbourne, 1998), 69–73. Rubens also made *tronies*; see the pair of heads of old men in *Rubens: A Master in the Making*, exh. cat. (London, 2005), 186–87, nos. 85–86.

46. Sellink, *Bruegel*, 257, no. 168, there dated c. 1568; also W. Gibson, *Bruegel and the Art of Laughter*, 56–57.

47. Ibid., 57–59, n. 91; Jeffrey Muller, *Rubens: The Artist as Collector* (Princeton, 1989), 129–30, nos. 195–199. Concerning the Brussels *Yawning Peasant*, W. Gibson believes it to be an original by Pieter the Elder, whereas Muller inclines to see a copy by Pieter the Younger; *Breughel-Brueghel*, exh. cat., Essen, 1998, 366–71, no. 117, not only considers it a work of Pieter the Younger but also identifies the figure as a "sick man" rather than a yawner; this is the opinion of Klaus Ertz, *Pieter Brueghel der Jüngere (1564–1637/38)* (Lingen, 1988/2000), 953–62. Sellink, *Bruegel*, 272, no. X4, considers it among "problematic attributions." Gibson also cites the dissertation by Goldstein (Columbia, 2003), 205, which identifies an inventory entry within the Antwerp collection of Michiel van der Heyden of "a person with a big open mouth" as a *Yawner* like the Brussels painting. For the Vorsterman engraving, inscribed "Pieter Bruegel pinxit," Lebeer, *Catalogue raisonné des estampes*, 194, no. 90; Orenstein, *Bruegel: New Hollstein*, no. A22.

48. Gibson, *Bruegel and the Art of Laughter*, 59–60; Oberhuber, "Radierungsserie"; Henk Nalis, *The Van Doetecum Brothers: The New Hollstein Dutch and Flemish Etchings, Engravings and Woodcuts* (Rotterdam, 1998), II, 148–68, nos. 341–76. A pair of heads in the Fogg Art Museum, Harvard University, in Oberhuber, ibid. figs. 9–10, do match up more closely with heads in the 1564 *Way to Calvary* (see plate 17); for the man's head, wearing a soldier's fashionable hat, another version exists: Montpellier, Musée Fabre, with a "P.B." monogram; see *Breughel-Brueghel*, 366–71, no. 119; see also Gaston van Camp, "Pierre Bruegel a-t-il peint une série des Sept Péchés capitaux?" *Revue belge d'Archéologie et de l'Histoire de l'Art* 23 (1954), 217–23; Sullivan, *Bruegel's Peasants: Art and Audience in the Northern Renaissance* (Cambridge, 1994), 84, plates 7–9.

49. Sten Karling, "*The Attack* by Pieter Bruegel the Elder in the Collection of the Stockholm University," *Konsthistorisk Tidskrift* 45 (1976), 1–18; W. Gibson, "Bruegel and the Peasants," 43–44; endorsed by Grossmann in *Bruegel: Une dynastie des peintres*, exh. cat. (Brussels, 1980), 59, no. 7; listed by Sellink, *Bruegel*, 276, no. X8, among the "problematic attributions" and contested by Genaille, 'L'Attaque de paysans,' Est-elle une oeuvre de Pierre Bruegel l'Ancien?" *Bulletin Musées Royaux des Beaux-Arts de Belgique* (1981–84), 63–80. This work also has been viewed as a copy after Pieter the Elder by

Pieter the Younger, especially by Klaus Ertz, *Pieter Bruegel der Jüngere*, 775–86, 792–94.

50. While this subject is rare before Bruegel in the visual arts, a similar countryside robbery by vagabond soldiers of fortune appears on the *Peddler* wing, the exterior of Hieronymus Bosch's *Haywain Triptych* (Madrid and Escorial); see Larry Silver, *Hieronymus Bosch* (New York, 2006), 261, fig. 197.

51. Jane Fishman, *Boerenverdriet: Violence Between Peasants and Soldiers in Early Modern Netherlandish Art* (New York, 1982); Kunzle, *From Criminal to Courtier: The Soldier in Netherlandish Art 1550–1672* (Leiden, 2002), esp. 102–12.

52. Sullivan, "Proverbs and Process in Bruegel's 'Rabbit Hunt,'" *Burlington Magazine* 145 (2003), 30–35.

53. Orenstein, *Drawings and Prints*, 131, no. 31.

54. Larry Silver, "Ungrateful Dead: Bruegel's *Triumph of Death* Re-Examined," David Areford and Nina Rowe, eds., *Excavating the Medieval Image: Manuscripts, Artists, Audiences: Essays in Honor of Sandra Hindman* (Aldershot, 2004), 265–78; Carroll, *Painting and Politics in Northern Europe* (University Park, 2008), 40–42, notes the absurdity of military figures in *Netherlandish Proverbs* (1559; see plate 6.24{ }), as they "bell the cat" while "armed to the teeth" and "beat their heads against a wall" but also selfishly—and destructively—"warm their hands by the fire of a neighbor's house."

55. Almost undiscussed by scholars; Sellink, *Bruegel*, 260, no. 170, accepts the work as genuine.

56. Malcolm Vale, *War and Chivalry* (London, 1981), 147–54; for imagery of soldiers in earlier German prints, Moxey, *Peasants, Warriors, and Wives: Popular Imagery in the Reformation* (Chicago, 1989), 67–80: note the crucial role of the ensign, as described in verses by Hans Sachs of Nuremberg on woodcuts of a military procession by Erhard Schoen, which also clusters fife and drums near the banner: "I have been appointed standard-bearer, / Chosen from the noisy ranks. / Whoever sees the flag flying / Believes that his side can still win / And is thus encouraged to carry on the battle / And to fight with all his might. / Therefore I wave my flag / Since it is worth my life and limbs. / I will not retreat a step; / Because of this I must be given triple pay by a powerful lord / Who goes to war for honor and renown." (71) See also Clifton and Scattone, *The Plains of Mars: European War Prints, 1500–1825*, exh. cat. (Houston, 2009), 62–69, with separate prints from Germany and the Netherlands representing standard bearers (nos. 6–7) and fife and drum corps (nos. 9–10).

57. Larry Silver, "The Landsknecht: Summer Soldier and Sunshine Patriot," Clifton and Scattone, ibid., 16–29; Matthias Rogg, *Landsknechte und Reisläufer: Bilder vom Soldaten* (Paderborn, 2002). On codpieces, Clifton and Scattone, *Plains of Mars*, 69–70, no. 11 (Franz Brun, *A Gunner*, 1559); Grace Vicary, "Visual Art as Social Data: The Renaissance Codpiece," *Cultural Anthropology* 4 (1989), 3–25.

58. The shadowy face of the ensign, whose *Landsknecht* hat is adorned with prominent feathers, might share a Bruegel model with the lost *Head of a Soldier*, preserved in copies in the Fogg Museum, Harvard as well as the Fabre Museum, Montpellier (see *Breughel-Brueghel*, exh. cat. [Essen, 1998], 366–71, no. 119).

59. Huigen Leeflang and Ger Luijten, *Hendrick Goltzius (1558–1617)*, exh. cat. (Amsterdam, 2003), 78–79, no. 26. The Latin inscription echoes Hans Sachs's German verses on Erhard Schoen's woodcut (see above, n. 54): "I, the standard-bearer, ensure steadfastness of mind and of heart: as long as I stand, the line holds, if I flee, it flees also."

60. Arnade, *Beggars, Iconoclasts, and Civic Patriots*, 181–91; the execution was on 5 June 1568, and the heads of the noble prisoners were dishonored by being placed on pikes on the scaffold. This infuriated their peer, William of Orange, who would take up the military and political leadership of the Dutch Revolt.

61. For Callot, Clifton and Scattone, *Plains of Mars*, 110–21, no. 30; Diane Wolfthal, "Jacques Callot's Miseries of War," *Art Bulletin* 59 (1977), 222–33; more generally, Kunzle, *From Criminal to Courtier*. Diane Russell, *Jacques Callot: Prints and Related Drawings*, exh. cat. (Washington, 1975), translates the text on *Plundering a Large Farmhouse*: "Here are the fine exploits of these inhuman hearts. They ravage every-

where. Nothing escapes their hands. ▮▮▮▮
to gain gold, another encourages his ▮▮▮▮
a thousand heinous crimes, and all w▮▮▮▮
commit theft, kidnapping, murder, a▮▮▮▮

62. Sellink, *Bruegel*, 255–56, no. 167; Kave▮▮
Order, 217–33; Thomas Kren and Sco▮▮▮
nating the Renaissance: The Triumph o▮▮
Painting in Europe, exh. cat. (Los Ang▮▮
no. 165; Genaille, "La pie sur le gibet,"▮▮
entre les Pays-Bas et l'Italie à la Renaiss▮
Susanne Sulzberger (Brussels-Rome, ▮▮
Brumble, "Peter Bruegel the Elder: T▮▮▮
scape," *Art Quarterly* n.s. 2 (1979), 125▮▮

63. For the print, Lebeer, *Catalogue raiso*▮▮
no. 89. For the paintings by Pieter the▮▮▮
Brueghel, exh. cat. (Essen, 1997), 406–▮▮
Galerie, Prague).

64. The drawing was almost certainly ow▮▮▮
his own painted copy is recorded in h▮▮▮
sions, taken at his death in 1640: no. ▮▮
paysans faict après un dessein du vieu▮▮
Rubens: Artist as Collector, 120; howev▮▮
in der Graphik, exh. cat. (Göttingen, ▮
claims that the Vorsterman print does▮▮
Rubens copy. Vorsterman's work carr▮▮▮
Brueghel, who presumably owned th▮▮▮
death in 1625 (Jan often collaborated ▮▮
Woollett and Ariane van Suchtelen, *R*▮
A Working Friendship, exh. cat. [Los A▮
generally, See Kristin Belkin, *Corpus* ▮
Burchard, Part XXVI: Copies and Adap▮
sance and Later Artists: German and N▮
(Turnhout, 2009), which appeared to ▮▮
in this volume.

65. J. B. Bedaux and A. van Gool, "Brueg▮▮
of an Ars/Natura Transmutation," *Sim*▮

66. Kaveler, *Bruegel: Parables of Order*, 22▮
the range of modern responses: "Toln▮▮
detected an expression of constant and▮▮
folly, set against the grandeur of natu▮▮
however, discerned a political allusion ▮
Spanish domination' or a 'challenge to▮▮
sion.' Grossmann, too, asked if the da▮▮
'gesture of defiance' and noted 'an air ▮
seems to belie the somber meaning of ▮
has more recently suggested that the c▮▮
ants indicates 'the felicity of [Bruegel's▮
whole, threatened by war and ruin,' an▮
'a plea for peace in a country that was ▮
the brink of war.' Alpers, silent on the ▮
reading, doubts that the dance repres▮▮
ing death but rather perhaps some pea▮
strating the continuity of life."

67. Kaveler, *Bruegel: Parables of Order*, 22▮

68. In the *Two Monkeys*, the interpretation ▮
(chapter 2) saw the birds as storks, the▮
construed as a form of laziness for a hu▮
case, too, the contrast of the energetic▮
against the sitting magpie suggests a s▮▮
ever, if the birds in either case are hero▮
understanding would be pertinent. I h▮
to ascertain the sixteenth-century Flen▮
herons, nor any proverbs using them ▮▮
Bruegel's attention to bird life in his s▮
it appears already in the Large Landsca▮
of his work deserves closer scrutiny.

69. Orenstein, *Drawings and Prints*, 234–3▮
"Bruegel en de rederijkers. Schilderku▮
zestiende eeuw," *Nederlands Kunsthisto*▮
(1996), 81–94; *Pieter Bruegel d. Ä. als Z*▮
lin, 1975), 83–85, no. 98; Christopher V▮
the Elder: Two New Drawings," *Burli*▮
(1959), 336–41; for the theme in genera▮
Calumny of Apelles: A Study in the Hum▮
Haven, 1981); Jean-Michel Massing, *L*▮
son iconographie: Du texte à l'image (Str▮

Cast, *Calumny of Apelles*, 32–54 for Florence; for Melanch-
thon, ibid., 94–96. Albrecht Dürer also created a *Calumny of
Apelles*, both in a drawing (1522; Albertina, Vienna, W. 922)
and in a mural for the Nuremberg City Hall after 1521; ibid.,
▮9–120, figs. 27–28. For the currency of this subject in near-
contemporary prints, independent of Bruegel, created by
printmakers who had worked for Cock, see Giorgio Ghisi
after Luca Penni, 1560, and Cornelis Cort after Federico
Zuccaro, 1569 (Cast, *Calumny of Apelles*, 84–86, 126–33, figs.
▮5, 31); see also Suzanne Boorsch, *The Engravings of Giorgio
Ghisi*, exh. cat. (New York, 1985), 110–13, no. 27; Sellink,
Cornelis Cort, exh. cat. (Rotterdam, 1994), 200–205, no. 68.
Ramakers, "Rederijkers," 90–94; Thierry Boucquey,
▮Bruegel, intertexte fou de la farce: choréographie de 'La
Fête des Fous," *Word and Image* 5 (1989), 252–59.
The humility of Truth and her closeness to the earth have
▮een related to Psalm 85:11, "Truth shall spring out of the
▮arth, and righteousness shall look down from heaven." For
▮he heritage of naked Truth as allegory, revealed by Time,
▮ritz Saxl, "Veritas Filia Temporis," Raymond Klibansky
▮nd H. J. Paton, *Essays in Philosophy and History Presented
▮o Ernst Cassirer* (Oxford, 1936), 197–222; D. J. Gordon,
▮Veritas Filia Temporis," *Journal of the Warburg Institute* 3
▮1939–40), 228–40; Winner, "Bernini's 'Verità,'" *Munuscula
▮iscipulorum: Kunsthistorische Studien H. Kauffmann zum 70.
Geburtstag* (Berlin, 1970), 393–413.
Meadow, "Bruegel's *Procession to Calvary*," 181–82; Freedberg,
▮Allusion and Topicality in the Work of Pieter Bruegel: The
▮mplications of a Forgotten Polemic," Freedberg, ed., *The
Prints of Pieter Bruegel the Elder*, exh. cat. (Tokyo, 1989), 53–65.
A letter from Antwerp art dealer Fourchoudt in 1670 men-
▮ions a Bruegel painting, *De Calomnia*; Glück, "Peter
▮ruegel the Elder and Classical Antiquity," *Art Quarterly* 6
▮1943), 167–87, esp. 167, 178–79.
▮opham, "Pieter Bruegel and Abraham Ortelius," *Burlington
Magazine* 59 (1931), 184–88; Muylle, "Pieter Bruegel en Abra-
▮am Ortelius," *Archivum Artis Lovaniense*, 319–37; Melion,
▮haping the Netherlandish Canon: Karel van Mander's* Schil-
▮er-Boeck (Chicago, 1991), 173–82; Meadow, "Bruegel's *Pro-
▮ssion to Calvary*," 192–96.
▮he strongest advocate of the humanist Bruegel is Margaret
▮ullivan, *Bruegel's Peasants*; see also for the Erasmian
▮ruegel, Müller, *Das als Bildform Paradox*.
▮amakers, "rederijkers," esp. 83–94 for the *Calumny of
▮pelles*; Larry Silver, *The Paintings of Quinten Massys*
▮Totowa, N.J., 1984), 105–60 for connections between Eras-
▮us, the *rederikers*, and Antwerp art; W. Gibson, "Artists
▮nd *Rederijkers* in the Age of Bruegel," *Art Bulletin* 63 (1981),
▮26–46; for the wider influence of Erasmus, Van der Coelen,
▮mages of Erasmus*, exh. cat. (Rotterdam, 2008).
▮eldman, *Maarten van Heemskerck and Dutch Humanism of
▮he Sixteenth Century* (Maarsen, 1977), esp. 124–41; for the
▮ntwerp circumstances and the program, Sheila Williams
▮nd Jacques Jacquot, "Ommegangs anversois due temps du
▮ruegel et de van Heemskerck," Jacquot ed., *Les fêtes de la
▮enaissance II* (Paris, 1960), 359–88.
▮ sophisticated literary historical assessment of Netherland-
▮sh culture as a mixture between high and low, even on the
▮evel of street art and its subjects, is given by Pleij, "Urban
▮lites in Search of a Culture: The Brussels Snow Festival
▮f 1511," *New Literary History* 21 (1990), 629–47; Pleij, *De
▮eeuwpoppen van 1511: Stadscultuur in de late middeleeuwen*
▮Amsterdam, 1988); also Pleij, "Restyling 'Wisdom,' Remod-
▮ling the Nobility, and Caricaturing the Peasant: Urban
▮iterature in the Late Medieval Low Countries," *Journal of
▮nterdisciplinary History* 32 (2002), 689–704.
▮ellink, *Bruegel*, 222.
▮bid., 267, no. 175; Lebeer, *Catalogue raisonné des estampes*,
▮88–90, no. 87; Müller, *Das Paradox als Bildform*, 172–78.
▮erner Weisbach, *Trionfi* (Berlin, 1919); Prince d'Essling
▮nd Eugene Münz, *Pétrarch, ses etudes d'art, son influence
▮ur les artistes, ses portraits et ceux de Laure, l'illustration de ses
▮rits* (Paris, 1902). For a Netherlandish comparison, Heem-
▮kerck's 1559 engraved *Triumph of Patience*, see Veldman,
▮eemskerck and Dutch Humanism*, 62–70 for Heemskerck's
▮ycle of Petrarcan *Trionfi*, engraved by Philips Galle (drawing
▮esigns dated 1565); see Veldman, *Leerrijke reeksen van*

Maarten van Heemskerck, exh. cat. (Haarlem, 1986), 58–66,
no. 7.

83. Veldman, *Heemsckerck and Dutch Humanism*, 133–40; Veld-
man, *Leerrijke reeksen*, 47–57, no. 6. The preliminary drawing
(1563) by Heemskerck is in Copenhagen, Statens Museum.
The Dutch text of the 1561 Antwerp procession reads simply:
"War brings great poverty in every land / And strips the com-
mon folk of gold and goods in hand" (Oorloghe brenct in
allen landen Armoede groot,/ En maect tgemeyn volck van
ghelt en goede bloot).

84. Erwin Panofsky, "Father Time," *Studies in Iconology: Human-
istic Themes in the Art of the Renaissance* (New York, 1962),
69–93.

85. Orenstein, *Drawings and Prints*, 228–30, no. 100, *Pieter
Bruegel d.Ä. als Zeichner*, 80–82, no. 95, which points out that
the gaping client is derived from a Bosch figure with specta-
cles, a pickpocket figure behind the crowd that witnesses the
tricks of the *Conjurer*; see Larry Silver, *Hieronymus Bosch*,
plate 220.

86. Winner, "Zu Bruegels 'Alchimist,'" Von Simson and Winner,
Pieter Bruegel und seine Welt, 193–202, esp. 202 for the link to
this drawing.

87. Raymond Klibansky, Erwin Panofksy, and Fritz Saxl, *Saturn
and Melancholy* (Cambridge, 1964).

88. For an example of the romantic projections onto the painter,
Otto Benesch, curator at the Albertina, who worked continu-
ally with this drawing, is representative; Benesch, *The Art of
the Renaissance in Northern Europe* (London, 1965), 108: "the
fanaticism, the inward wrath of the creative artist, who, for-
getting the world around him, has to follow his inward urge
and complete his work even at the cost of hardship of life . . .
the creative furore of the artist."

89. Mielke, *Pieter Bruegel: Die Zeichnungen* (Turnhout, 1996),
no. 60a–d; for Rubens (no. 60d), Michael Jaffé, "Rubens
and Bruegel," Von Simson and Winner, *Pieter Bruegel und
seine Welt*, 37–42, esp. 41–42 n. 19, fig. 17. See also Belkin,
*Corpus Rubenianum, Part XXVI: German and Netherlandish
Artists* (Turnhout, 2009).

CHAPTER 11. BRUEGEL'S LEGACY

1. Nadine Orenstein, *Pieter Bruegel the Elder: Drawings and
Prints*, exh. cat. (New York, 2001), 276–81, nos. 126–29;
Hans Mielke, *Pieter Bruegel: Die Zeichnungen* (Turnhout,
1996), 80–85. Mielke discerningly first identified the prob-
lems of attribution with this entire group in his review of a
1980 Paris exhibition, *Master Drawings* 23–24 (1986), 76–81,
and that reexamination unleashed a chain reaction of recon-
siderations of the Bruegel landscape corpus. For the signed,
authentic Jacob Savery drawings in the Morgan Library,
New York and in the Lugt Collection, Institut Néerlandais,
Paris, see John Hand et al., *The Age of Bruegel*, exh. cat.
(Washington, 1986), 251–53, 258–59, nos. 97, 100, juxtaposed
there with one of these "Bruegel" fakes from Berlin, *Land-
scape with Castle*, of "1561." For the artist, An Zwollo, "Jacob
Savery, Nachfolger von Pieter Bruegel und Hans Bol," Von
Simson and Winner, *Bruegel und seine Welt* (Berlin, 1979),
203–13; Jan Briels, *Vlaamse schilders en de dageraad van Hol-
lands Gouden Eeuw* (Antwerp, 1997), 376–77.

2. Ludwig Münz, *Bruegel Drawings* (London, 1961), 18–19, 211–
14, nos. 27–50, groups them together as the "Small Land-
scapes" and credits them as his "most delicate and most
resolved in light and colour," although he notes that a few
individual sheets had been doubted as authentic by previous
scholars. He also ascribes some of their distinctive character,
a "picturesque dreamworld," as a psychological escape by
the artist during years of personal crisis, which led him to
emphasize the transitory quality in such motifs as ruins,
boulders, and picturesque weathered rocks.

3. Parshall, "Art and the Theater of Knowledge: The Origins of
Print Collecting in Northern Europe," *Harvard University
Art Museums Bulletin* (1994), 7–36; for a pioneering print
collection of the early sixteenth century, Mark McDonald,
The Print Collection of Ferdinand Columbus (1488–1539) (Lon-
don, 2004); later print collecting in the Low Countries, Van
der Coelen, *Prints in the Golden Age: From Art to Shelf Paper*,
exh. cat. (Rotterdam, 2006); for changes in the status of
drawings, William Robinson and Martha Wolff, "The Func-

tion of Drawings in the Netherlands in the Sixteenth Century," *Age of Bruegel*, 25–40, esp. 34–39. Bosch might have been one of the first artists in the Low Countries to produce self-consciously independent drawings for collectors.

4. Larry Silver, *Hieronymus Bosch* (New York, 2006), 279–80; Koreny, *Early Netherlandish Drawings from Jan van Eyck to Hieronymus Bosch* (Antwerp, 2002), 164–72, 185–87, nos. 40, 45.

5. Orenstein, *Drawings and Prints*, 266–76, nos. 120–25; Mielke, *Zeichnungen,* 74–80, nos. A1–A20. One work still disputed, the landscape setting for *Solicitudo Rustica* in reverse of the direction of the Cock print (London, British Museum), Mielke, *Zeichnungen*, 25, is also included as authentic in this study (see plate 326); yet the drawing is regarded as a work of the Master of the Mountain Landscapes on account of its "more precised and measured draftsmanship . . . fine, sharp, controlled line work" by Orenstein, *Drawings and Prints*, 274–76, no. 125. Later watermarks, no sooner than the mid-1580s, well after the death of Bruegel, formed a major piece of evidence for the Morgan drawing and others in the group.

6. Briels, 377–79; Thomas DaCosta Kaufmann, *The School of Prague* (Chicago, 1988), 228–48; *Roelant Savery in seiner Zeit (1576–1639)*, exh. cat. (Cologne-Utrecht, 1985); Kurt Müllenmeister, *Roelant Savery* (Freren, 1988); an unpublished catalogue of Savery drawings was completed in the dissertation by Joaneath Spicer (Yale University), 1979. For a later, dated Roeland Savery drawing in the manner of Bruegel but more broadly, if regularly, delineated is his inscribed 1605 mountain with an inserted background view of the Prague Cathedral (Berlin): *Pieter Bruegel d. Ä. als Zeichner*, exh. cat. (Berlin, 1975), 164, no. 244.

7. Spicer, "Roelandt Savery and the 'Discovery' of the Alpine Waterfall," *Rudolf II and Prague*, exh. cat. (Prague, 1997), 146–56.

8. Kaufmann, *School of Prague*, 280–85; *Pieter Bruegel d. Ä. als Zeichner*, exh. cat. (Berlin, 1975), 169–71, no. 259–63; An Zwollo, "Pieter Stevens, ein vergessener Maler des Rudolfinischen Kreises," *Jahrbuch der Kunsthistorischen Sammlungen in Wien* 64 (1968), 119–80.

9. Eliška Fučíková, "Prague Castle under Rudolf II, His Predecessors and Successors," *Rudolf II and Prague*, 38–39; also Terez Gerszi, "Landscapes and City Views of Prague," ibid., 130–39, for Roeland Savery and Stevens in relation to Bruegel landscapes; also Gerszi, "Bruegels Nachwirkung auf die niederländischen Landschaftsmaler um 1600," *Oud Holland* 90 (1976), 212–21. For the Vienna collection, Wilfried Seipel, *Pieter Bruegel the Elder at the Kunsthistorisches Museum in Vienna* (Milan, 1999).

10. *Age of Bruegel*, 93–94, no. 25; Orenstein, *Drawings and Prints*, 268–69, no. 120; for the state of research before the exclusion from Bruegel's oeuvre, Felice Stampfle, *Netherlandish Drawings of the Fifteenth and Sixteenth Centuries . . . in the Pierpont Morgan Library* (New York, 1991), 24–26, no. 43.

11. A closely related drawing at Bowdoin College Museum, Brunswick, Maine (Orenstein, *Drawings and Prints*, 270–71, no. 121; Mielke, *Zeichnungen, no.* A10), is inscribed in the same ink "Waltersspurg," whereas Otto Benesch called the location of the Morgan drawing Burg Jorgenberg and the village of Ruis. For the links between the Bowdoin drawing, a drawing at the Fogg Art Museum, Harvard University (Mielke, *Zeichnungen*, no. A9), and the Morgan drawing, see Konrad Oberhuber, "Bruegel's Early Landscape Drawing," *Master Drawings* 19 (1981), 146–56, who dates the works even earlier than their conventional placement in Bruegel's oeuvre back in Antwerp in 1553–54; he argues instead that they were part of his trip down to Italy and thus produced either in fall, 1551, or spring, 1552, "when he first encountered the Alps." Such argumentation by a distinguished drawings connoisseur shows the esteem accorded to the Morgan drawing as an authentic Bruegel until the last decade.

12. The Dresden sketch is Mielke, *Zeichnungen, no.* A2; the Chatsworth sheets, Mielke A13, 15. Orenstein, *Drawings and Prints*, 272–73, no. 123 (Mielke A13).

13. *Age of Bruegel*, 167–68, no. 59; Stampfle, 42, no. 68; Huigen Leeflang and Ger Luijten, *Hendrick Goltzius (1558–1617)*, exh. cat. (Amsterdam, 2003), 203–15, 223–27, nos. 75, 80–81; see

also a comparable 1594 drawing (Haarlem, Teylers Musem), ibid., 186–87, no. 67. For the goals of Goltzius as assimilator of previous artistic manners, Melion, "Karel van Mander's *Life of Goltzius*. Defining the Paradigm of Protean Virtuosity in Haarlem around 1600," *Studies in the History of Art* 27 (1989), 113–33.

14. Heinrich Gerhard Franz, "Hans Bol als Landschaftszeichner," *Jahrbuch des Kunsthistorisches Instituts Graz* 1 (1965), 19–67; Franz, *Niederländische Landschaftsmalerei im Zeitalter des Manierismus* (Graz, 1969), 182–97.

15. Arnade, *Beggars, Iconoclasts, and Civic Patriots: The Political Culture of the Dutch Revolt* (Ithaca, N.Y., 2008), 312–27. A posthumous commemorative portrait of *Hans Bol* (1593) was engraved by Hendrik Goltzius; see Leeflang and Luijten, 162–63, no. 54.

16. For city views, Luijten et al., *Dawn of the Golden Age*, biography 301; 518–20, no. 196, dated 1589. Note also that Jacob Savery made a trio of drawings, falsely ascribed to Bruegel, 1562, of the Amsterdam city walls; ibid., 520–21, no. 197. See also Ariane van Suchtelen and Arthur Wheelock, Jr., *Dutch Cityscapes of the Golden Age*, exh. cat. (The Hague-Washington, 2008): 40–41, plate 26, Bol, *Tournament on the Hofvijver in The Hague*, 1586 (Dresden); 96–99, no. 13, Bol, *View of Amsterdam*. For courtly miniatures, still understudied for Bol, see *Boar Hunt* (1588, Residenz, Munich) or the hunting mythology, *Landscape with Venus and Adonis* (1589; Getty Museum, Los Angeles).

17. H. G. Franz, "De boslandschappen van Gillis van Coninxloo en hun voorbeelden," *Bulletin Musées Royaux des Beaux-Arts de Belgique* 14 (1963), 66–85; Ulrike Hanschke, *Die flämische Waldlandschaft* (Worms, 1988); Hans Devissscher, "Die Entstehung der Waldlandschaft in den Niederlanden," *Von Bruegel bis Rubens*, exh. cat. (Cologne, 1992), 191–202; on Jan Brueghel and forest landscapes, Klaus Ertz, *Jan Brueghel der Ältere (1568–1625): Die Gemälde* (Cologne, 1979), 192–211.

18. Franz, *Landschaftsmalerei*, 198–208; Alexander Wied, *Lucas and Marten van Valckenborch* (Freren, 1990).

19. Allan Ellenius, "The Concept of Nature in a Painting by Lucas van Valckenborch," Görel Cavalli-Björkman, ed., *Netherlandish Mannerism* (Stockholm, 1985), 109–16; Franz, *Landschaftsmalerei*, 207–8.

20. Ellenius, 112–13, discusses early modern views of fishing as a pastime. W. A. Baillie-Grohman, *Sport in Art*, 2nd ed. (London, 1920); Raimond van Marle, *Iconographie de l'art profane au Moyen Age et à la Renaissance* (The Hague, 1931), 197–278; Francis Klingender, *Animals in Art and Thought to the End of the Middle Ages* (Cambridge, Mass., 1971), 468–76; a retrospective discussion of earlier art history as background to the analysis of Rubens hunts by Arnout Balis, *Hunting Scenes: Corpus Rubenianum Ludwig Burchard*, vol. 18.2 (London, 1986), 50–69; impressive general overview by Thomas Allsen, *The Royal Hunt in Eurasian History* (Philadelphia, 2006).

21. Engraved in reverse by Aegidius Sadeler; *Dessins Flamands du dix-septième siècle*, exh. cat. (London-Paris, 1972), 19–20, no. 13; *Breughel-Breughel*, exh. cat. (Essen, 1998), 436–37, no. 151. For a related earlier image of a swamp forest landscape (1593; Museum Boijmans van Beuningen, Rotterdam), made in Milan by Jan, ibid., 434–35, no. 150. For the subject of saints in landscapes by Jan Brueghel, now see Leopoldine van Hogendorp Prosperetti, *Landscape and Philosophy in the Art of Jan Brueghel the Elder (1568–1625)* (Aldershot, 2009), 172–87.

22. *Breughel-Breughel*, 508–12, nos. 194–95.

23. Several commentators have stressed the influence of later sixteenth-century Italian landscape models, which Jan would have seen in Rome, particularly Girolamo Muziano, whose vertical format works of saints in retreat were also available in engravings by Cornelis Cort; see Sellink, *Cornelis Cort*, exh. cat. (Rotterdam, 1994), 176–82, nos. 61–67; for the Muziano drawing of St. Onuphrius (Lugt Collection, Paris), *Pieter Bruegel d. Ä. als Zeichner*, 150–51, no. 206.

24. Franz, *Landschaftsmalerei*, 270–88; Franz, "Boslandschappen"; also Paul Huys Janssen, "Gillis van Coninxloo en het boslandschap," *Panorama op de wereld: Het landschap van Bosch tot Rubens*, exh. cat. ('s-Hertogenbosch, 2001), 134–46, nos. 43–54.

25. Van Straaten, *Koud tot op het bot: De verbeelding van de winter in de zestiende en zeventiende eeuw in de Nederlanden* (The Hague, 1977); Van Suchtelen, *Holland Frozen in Time: The Dutch Winter Landscape in the Golden Age*, exh. cat. (The Hague, 2001).

26. For Pieter the Younger's copies after both *Adoration of the Magi in the Snow* and *Winter Landscape with Skaters*, see Peter van den Brink, *Bruegel Enterprises*, exh. cat. (Maastricht-Brussels, 2001), 149–72, nos. II–III; *Breughel-Breughel*, 378–84, nos. 122–23 for copies after Bol's *Winter* and the *Winter Landscape with Skaters*; Klaus Ertz, *Pieter Brueghel der Jüngere (1564–1637/38)* (Lingen, 1988/2000), 299–305, 537–75.

27. Wied, *Valckenborch*, no. 51. In fact seven Valckenborch canvases survive, five in Vienna and two in Brno (late spring and late fall, with the return of the herd like Bruegel, so this series was likely to have been designated by months rather than seasons. What we call *Winter* probably is December or January; *Summer* is July or August.

28. While the relationship between the city and its river is freely adapted, the distinctive skyline tower of the Brussels City Hall below the palace hill is easily discerned. A careful earlier view of the two structures (also including a joust) was produced for the ruling dukes by court artist Bernart van Orley as the first image, *Departure for the Hunt*, of his tapestry series designs (c. 1528–30); see Campbell, *Tapestry in the Renaissance: Art and Magnificence*, exh. cat. (New York, 2002), 329–31, nos. 37–38; for the fullest study, Krista de Jonge, "Het paleis op de Coudenberg te Brussel in de vijftiende eeuw: De verdwenen hertogelijke residenties in de Zuidelijke Nederlanden in een nieuw licht geplaats," *Belgisch Tijdschrift voor oudheidkunde en kunstgeschiedenis* 60 (1991), 5–38.

29. Franz, *Landschaftsmalerei*, 205–7, plates 250–51; Wied, *Valckenborch* nos. 47, 49.

30. Luijten et al., *Dawn of the Golden Age*, 299, 634–38, nos. 305–8.

31. Yvette Bruijnen and Paul Huys Janssen, *De vier jaargetijden in de kunst van de Nederlanden 1500–1750*, exh. cat. ('s-Hertogenbosch-Louvain, 2002); Kaulbach and Schleier, *"Der Welt Lauf": Allegorische Graphikserien des Manierismus*, exh. cat. (Stuttgart, 1997), 116–33.

32. Luijten et al., *Dawn of the Golden Age*, 320, 658–60, no. 330; see also Four Seasons intaglio prints after David Vinckboons (1617–18), ibid., 657–58, no. 329. For van de Velde's 1618 series, *Vier jaargetijden*, 142–45, nos. 60–71.

33. Luijten et al., *Dawn of the Golden Age*, 321, 655–57, no. 328. The series is divided; both *Spring* and *Summer* are in the Getty Museum, Los Angeles, while *Autumn* is in a private collection.

34. Raupp, *Bauernsatiren* (Niederzier, 1986); Moxey, *Peasants, Warriors, and Wives* (Chicago, 1989); Alison Stewart, *Before Bruegel* (Aldershot, 2008).

35. Renger, *Adriaen Brouwer und das niederländische Bauerngenre 1600–1660* (Munich, 1986).

36. Ludwig Münz, *The Drawings of Pieter Bruegel* (London, 1961), 21–26, 214–24, nos. 51–125, provides the consensus view prior to 1970; he includes the *Gooseherd* in the group, as no. 90. One other work in the group, *Four Men Standing in Conversation*, no. 89, is still retained by most current scholars; see Sellink, *Bruegel* (Ghent, 2006), 219, no. 144 (Mielke, *Zeichnungen, no.* 59). The *Bagpipe Player*, was discovered after publication of Münz's corpus and judged authentic and independent of the *naer het leven* group. That group has been entirely removed—without mention—from Mielke's definitive revaluation of Bruegel drawings (Turnhout, 1996).

37. Orenstein, *Drawings and Prints*, 282–88, nos. 130–34; Spicer, "The 'Naer het Leven' Drawings: By Pieter Bruegel or Roelandt Savery?" *Master Drawings* 8 (1970), 3–30; Frans van Leeuwen, "Iets over het handschrift van de 'naer het leven'-tekenaar," *Oud Holland* 85 (1970), 25–32; van Leeuwen, "Figuurstudies van 'P. Bruegel," *Simiolus* 5 (1971), 139–49. A heated controversy over priority of discovery ensued, particularly in Holland, exacerbated by vehement contemporary Dutch opposition to America's unpopular Vietnam war; summarized in Orenstein, *Drawings and Prints*, 288, notes 12–14.

38. This is particularly noteworthy for so⬛⬛ figures, particularly the soldiers and ⬛⬛ of rabbis (Frankfurt, Staedel; Münz ⬛⬛ Star of David and Jewish Culture in I⬛⬛ Reflected in Drawings of Roelandt S⬛⬛ Vianen," *Journal of the Walters Art Ga⬛⬛*

39. Kaufmann, *Drawings from the Holy R⬛⬛* exh. cat. (Princeton, 1982), 3–30, the sixt⬛ Savery, 164–71, nos. 60–63: "as in Van⬛ term *near het leven* to describe Brueg⬛ gel's peasant scenes can still be regarde⬛ Savery's in that they possess the stamp⬛ something taken from reality" (168).

40. *Age of Bruegel*, 260–62, no. 101.

41. For the importance of the concept of ⬛ cially in nature studies, during the sixt⬛ shall, "Imago contrafacta: Images and ⬛ Renaissance," *Art History* 16 (1993), 55⬛ "*Ad vivum, naer het leven*, from the life⬛ Mode of Representation," *Word and I⬛*

42. *Age of Bruegel*, 265–66, no. 103; Kaufm⬛ *Empire*, 168–69, no. 62, noting the imp⬛ subjects in imperial Prague art; see als⬛ *lecherlich*': Low-life Painting in Rudolf⬛ *1600: Beiträge zur Kunst und Kultur an⬛* (Freren, 1988), 33–38.

43. Luijten et al., *Dawn of the Golden Age*, ⬛ 287; *Pieter Bruegel d. Ä. als Zeichner*, 17⬛ Wegner and H. Peé, "Die Zeichnunge⬛ boons," *Münchner Jahrbuch der bildena⬛* 35–128, esp. 63–64, no. 16.

44. A.L.J. van de Walle, *Gotische Kunst in l⬛* Munich, 1972), esp. 46–54 (towers).

45. *Age of Bruegel*, 301–2, no. 119 with both⬛ collection, U.S.) and print; for the role⬛ establishing the new genre of sybaritic⬛ "merry companies," Nevitt, *Art and th⬛ Seventeenth-Century Holland* (Cambri⬛ Elmer Kolfin, *The Young Gentry at Pla⬛ landish Scenes of Merry Companies 1610–⬛* esp. 103–4.

46. *Age of Bruegel*, 299–300, no. 118; Stamp⬛ Wegner and Peé, 65–66, no. 18.

47. *De uitvinding van het landschap, Van Pa⬛ 1650*, exh. cat. (Antwerp, 2004), 224–25⬛

48. Miedema, "Realism and Comic Mode⬛ *lus* 9 (1977), 205–19, esp. 212: "See these⬛ these minions of Bacchus. / One eats, c⬛ brim, the other / vomits on the groun⬛ dances lustily, the other yells and / war⬛ the while health and money are ebbing⬛

49. Identified by Wayne Franits, *Dutch Sev⬛ Genre Painting* (New Haven, 2004), 55⬛ 1562 etching (with the name of Bartho⬛ in the second state) focused around thi⬛ rad Oberhuber, *Zwischen Renaissance u⬛ alter von Bruegel und Bellange*, exh. cat⬛ no. 78, plate 16; in this case the contest⬛ for the hanging goose from a moving b⬛ than from horseback.

50. Jonathan Bikker, *Dutch Paintings of the⬛ in the Rijksmuseum Amsterdam: I—Artis⬛ and 1600* (New Haven, 2007), 403–4, n⬛

51. Friso Lammertse, "David Vinckboons⬛ en tekenaar in Amsterdam," *Het Kunstb⬛ Vingboons* (Amsterdam, 1989), 13–43.

52. Briels, *Vlaamse schilders*, esp. biographie⬛ "A Turning-Point in the History of Dut⬛ et al., *Dawn of the Golden Age*, 112–121; ⬛ Importance of Being Bruegel: The Post⬛ the Art of Pieter Bruegel the Elder," Or⬛ *Prints*, 67–84.

53. Briels, *Vlaamse schilders*, 159–62; Jane F⬛ *verdriet: Violence Between Peasants and S⬛ Netherlands Art* (Ann Arbor, 1982); Ku⬛ *Courtier: The Soldier in Netherlandish A⬛*

⬛sp. 285–92; also for Massacre of the Innocents as a theme, ⬛03–18, 219–26, 232–34.

⬛Fishman, 31–45, plates 14–19, with discussion of the inscrip⬛ions; Kunzle, 288–92 (see plate 341). The final painting (Ber⬛n) is dated 1608; preliminary drawing (Amsterdam, ⬛Rijksprentenkabinet) in *Netherlandish Drawings circa 1600 in ⬛e Rijksmuseum* (The Hague, 1987), 160–61, no. 96. A pen⬛ant pair of paintings (Amsterdam, Rijksmuseum) from the ⬛orkshop of Vinckboons after c. 1619, show *The Peasant's ⬛isfortune* and *The Peasant's Pleasure*; Bikker, 406–7, nos. ⬛15–16.

⬛ammertse, 26–32; Fishman 34–38, notes also, 33, how ⬛e caption on the final print of the series, Reconciliation, ⬛xpressly mentions the Truce of 1609 (ended in 1621); "Look ⬛ow how the Truce turns everything upside down—the cruel ⬛oldier sits down with the peasant."

⬛unzle, 285–86, plates 11.1–2, also shows a pair of Roeland ⬛avery *Plundering a Village* paintings: Kortrijk (Courtrai), ⬛tedelijk Museum, 1604; Douai, Musée de la Chartreuse, ⬛505. Vinckboons also has drawing sheets in Frankfurt, both ⬛ the Staedel Kunstinstitut and the Städtische Galerie. A ⬛rint designed by Vinckboons and engraved by Johannes ⬛an Londerseel, c. 1610, shows a *Landscape with Travelers ⬛ttacked by a Gang of Robbers* (see Silver, "Importance of ⬛eing Bruegel," 75, plate 76).

⬛unzle, 292–308.

⬛rueghel-Breughel, 518–20, no. 198; Joost vander Auwera, ⬛ebastiaen Vrancx (1573–1647) en zijn samenwerking met ⬛n I Brueghel (1568–1625)," *Jaarboek Koninklijk Museum ⬛or Schone Kunsten Antwerpen* (1981), 135–50; for various ⬛n Brueghel collaborations, see also Woollett and Van ⬛achtelen, *Rubens and Brueghel: A Working Friendship*, ⬛h. cat. (Los Angeles, 2006); Klaus Ertz, *Jan Brueghel der ⬛ltere: Die Gemälde*, 470–508, esp. 505–8 for Vrancx and Jan ⬛rueghel.

⬛n the general question of Rubens's politics, especially in ⬛gard to war, asserting a revisionist argument in favor of ⬛s propaganda role in a war machine, Kunzle, 393–438; also ⬛cently Kristin Belkin, *Rubens* (London, 1998), esp. 269–⬛0, for the later, pacifist phase of the artist's career.

⬛shman, 45–61, plates 21–24; Anne-Marie Logan, *Peter Paul ⬛ubens: The Drawings*, exh. cat. (New York, 2005), 302–5, no. ⬛3, there dated c. 1638 and associated with an entry in the ⬛40 estate inventory: "A troop of Swiss who force peasants ⬛ give them money and set the table, on canvas." Jeffrey ⬛uller, *Rubens: The Artist as Collector* (Princeton, 1989), ⬛3, no. 90. Copies of the painting survive in Munich and ⬛udapest.

⬛ubens's sources for such distinctive period costume surely ⬛rive from sixteenth-century drawings and prints by both ⬛viss and German artists; see Larry Silver, "The Lands⬛echt: Summer Soldier and Sunshine Patriot," Clifton and ⬛attone, *The Plains of Mars: European War Prints, 1500–1825*, ⬛h. cat. (Houston, 2009), 16–29; Matthias Rogg, *Lands⬛echte und Reisläufer: Bilder vom Soldaten* (Paderborn, ⬛02).

⬛pers, *The Making of Rubens* (New Haven, 1995), 4–64; ⬛gan, *Rubens: Drawings*, 280–83, no. 103, for the careful ⬛gure studies sheet (London, British Museum) prior to the ⬛ouvre *Kermis*; also notable during this period is the inde⬛ndent chalk drawing, finished with gouache and water⬛lor, *A Sermon in a Village Church*, c. 1633–35 (New York, ⬛etropolitan Museum), ibid., 290–91, no. 107: "the subject ⬛atter, although religious, seems to be very personal, per⬛ps family-oriented."

⬛hn Martin, *The Decorations of the Pompa Introitus Ferdi⬛ndi: Corpus Rubenianum Ludwig Burchard XVI* (London, ⬛72); Elizabeth McGrath, "Rubens's Arch of the Mint," ⬛urnal of the Warburg and Courtauld Institutes* 37 (1974), ⬛1–217; McGrath, "Le Déclin d'Anvers et les decorations de ⬛bens pour L'Entrée du Prince Ferdinand en 1635," Jean ⬛cquot and Elie Konigson, eds. *Les Fêtes de la Renaissance ⬛II* (Paris, 1975), 173–86.

⬛pers, *The Making of Rubens*, 29, notes that on the scene ⬛ the arch with the Departure of Mercury, the figure of ⬛omus, god of revelry, appears on the positive side of the ⬛corations, alongside Abundance and Wealth and opposite

allegories of Poverty and Industry. Other Rubens allegories might be cited: his 1632–33 oil sketch for Whitehall Ceiling, commissioned by King Charles I, in which the felicity of the reign of James I is signaled by *Peace Embracing Plenty* (New Haven, Mellon Art Center), the latter holding a cornucopia of abundance; and his 1629–30 *Allegory of Peace* (London, National Gallery), where a satyr, accompanied by Bacchic dancers presents a cornucopia to a seated figure of Peace in the image of Venus.

65. Christopher Brown, *Making and Meaning: Rubens's Land-scapes* (London, 1998), esp. 59–74; Lisa Vergara, *Rubens and the Poetics of Landscape* (New Haven, 1982), esp. 99–135, with a good discussion of classical pastoral and the *beatus ille* heritage of Horace and its positive outlook towards the peasant, 136–53. Both works remained in Rubens's own collection, inventoried in his 1640 estate as "A great landscape after the life [*au naturel*; note: =*naer het leven*] with little figures in it upon a board" [*Steen*] and "A great landscape where it rains with little cows in it"; Muller, *Artist as Collector*, 119, nos. 135–36.

66. W. Gibson, *"Mirror of the Earth": the World Landscape in Sixteenth-Century Flemish Painting* (Princeton, 1989), esp. 83–84 for Rubens.

67. Jan Brueghel also featured a trio of young peasant women with rakes in the foreground of his own expansive riverside landscape with forest, preserved in two versions (Basel; Aschaffenburg, 1602); *Brueghel-Breughel*, 157–58, no. 33; this image in turn provides a variation on Pieter the Elder's drawing of the *Pilgrims to Emmaus*.

68. Vergara, 72–98.

69. Margarita Russell, *Visions of the Sea: Hendrick C. Vroom and the Origins of Dutch Marine Painting* (Leiden, 1983); George Keyes, *Mirror of Empire: Dutch Marine Art of the Seventeenth Century*, exh. cat. (Minneapolis, 19); Jeroen Giltaij, *Praise of Ships and the Sea*, exh. cat. (Rotterdam, 1996); for tempests in particular, Lawrence Goedde, *Tempest and Shipwreck in Dutch and Flemish Art* (University Park, Penn., 1989), who fully appreciates the influence of Bruegel on this subject genre, 63–76.

70. De Groot and Vorstman, eds., *Sailing Ships: Prints by the Dutch Masters from the Sixteenth to the Nineteenth Century* (New York, 1980); *Het rijk van Neptunus*, exh. cat. (Rotterdam, 1997).

71. Demus et al., *Flämische Malerei* (Vienna, 1981), 128–38; Goedde, *Tempest and Shipwreck* 70–76, 222–23, no. 70; Klaus Ertz, *Josse de Mompere der Jüngere (1564–1635)* (Freren, 1986), 365–90; a damaging bit of evidence against its authenticity is dendrochronology, whose analysis of the panel asserts that the tree was felled at the earliest between 1575–85. A related work in Stockholm, *Shipwreck of the Greek Fleet on the Voyage Home from Troy*, is also currently attributed to Momper; Cavalli-Björkman, *Dutch and Flemish Paintings I* (c. 1400– c. 1600) (Stockholm, 1986), 88–89, no. 41; see also Kjell Boström, "Är 'Stormen' verkligen en Bruegel," *Konsthistorisk Tidskrift* 20 (1951), 1–19; Boström, "Joos de Momper och det tidiga marin-måleriet I Antwerpen," ibid. 23 (1954), 45–66.

72. Grossmann, *Bruegel: The Paintings*, 2nd ed. (London, 1966), 204–5, no. 155, citing the interpretation of Ludwig Burchard, based upon Zedler's *Universal-Lexikon (1732–50)*: "if the whale plays with the barrel that has been thrown to him and gives the ship time to escape, then he represents the man who misses the true good for the sake of futile trifles." This same metaphor was later re-used in English literature by Jonathan Swift in his *Tale of the Tub* (published 1704), which was a response to the threatened Ship of State by another "whale," Thomas Hobbes's *Leviathan*. Marijnissen, *Bruegel* (Antwerp, 2003), 381, mentions this mariners' trick as recorded in two sixteenth-century printed accounts of voyages: *Tvoyage van Mher Joos van Ghistele* (Ghent, 1557) and *De wonderlycke Historie vande Noordersche Landen* (Antwerp, 1572), and he notes that the painting might also contain a veiled political allegory.

73. *Brueghel-Breughel*, 148–50, no. 30; signed, on copper (*Sea-storm*; private collection); 196–98, no. 49, signed and dated, on copper (*Jonah*; German private collection); Ertz, *Jan Brueghel*, 108–14.

74. While not discussed at length here, the range of Huys's prints after Bruegel designs contains the following titles that go beyond the depicted ships in them: *Armed Three-Masted Ship off a Coast, with the Fall of Daedalus and Icarus* (Orenstein, *Drawings and Prints*, 212, no. 89; Lebeer, *Catalogue raisonné des estampes*, 116, no. 44); *Three Caravels in a Rising Gale, with Arion on a Dolphin in the Foreground* (Orenstein, *Drawings and Prints*, 212, no. 90; Lebeer, *Catalogue raisonné des estampes*, 118, no. 48); *Two Galleys Following an Armed Three-Masted Ship, with the Fall of Phaëton* (Lebeer, *Catalogue raisonné des estampes,* 118, no. 49).

75. In the most recent publications of Bruegel's oeuvre by both Manfred Sellink (2006) and Roger Marijnissen (2003), the Brussels canvas, gravely damaged like most canvases, including Bruegel's two works in Naples (see plate 173); see Diane Wolfthal, *The Beginnings of Netherlandish Canvas Painting: 1400–1530* (Cambridge, 1989). For the copies by Bruegel's painter sons, *Brueghel-Breughel*, 76–87, 500–502, nos. 1–5, 189, where (based on a paper by Stephen Kostyshyn) the Brussels canvas is posited by Klaus Ertz as possibly a work by a contemporary of Pieter the Elder, Pieter Baltens. Ertz also assigns the date as later than 1616 on the basis of the EV letters in the signature; also Klaus Ertz, *Pieter Brueghel der Jüngere*, 306–9, 318–20. The Philadelphia panel by Pieter the Younger is also catalogued by Peter Sutton, *Northern European Paintings in the Philadelphia Museum of Art* (Philadelphia, 1990), 41–43, no. 14, also showing a detailed drawing, dated 1595, by Peter the Younger.

76. Larry Silver, *Bosch*, 164–77.

77. Woollett and Van Suchtelen, *Rubens and Bruegel*, 186–91, no. 25; Arianne Faber Kolb, *Jan Brueghel the Elder: The Entry of the Animals into Noah's Ark* (Los Angeles, 2005), 40–41; Ertz, *Jan Brueghel*, 429–32. Jan would have seen the original by his father (or a copy of it) in the collection of the archdukes when he returned from Italy; this image is recorded in the inventory of Archduchess Isabella after her death in 1633. Dominique Allart, "Did Pieter Brueghel the Younger See His Father's Paintings?" Van den Brink, *Bruegel Enterprises*, 50, document 20.

78. (Bloemart) Henk van Os et al., *Netherlandish Art in the Rijksmuseum 1400–1600* (Amsterdam, 2000), 222, no. 96; (Cornelis) Neil MacLaren and Christopher Brown, *The Dutch School 1600–1900: National Gallery Catalogues* (London, 1991), 85–86, no. 6643; (Vinckboons), Bikker, 405, no. 314.

79. Renger, *Flämische Malerei des Barock in der Alten Pinakothek* (Munich, 2002), 90–91, no. 823. An earlier Jan *Crucifixion* (Vienna, c. 1595) shows some figures, such as the foreground soldiers casting lots of the robe of Christ, more close-up; *Brueghel-Breughel*, 104–5, no. 12. During his brief visit to Prague in 1604, Jan also made a literal replica of that elaborate Albrecht Dürer drawing (Uffizi, Florence, W. 317) as a multifigure *Crucifixion*, copied literally but also transposed into a colorful painting on copper (1604; Uffizi, Florence); Larry Silver, "Translating Dürer into Dutch," Julien Chapuis, ed., *Invention: Northern Renaissance Studies in Honor of Molly Faries* (Turnhout, 2008), 208–23; also Ertz, *Jan Brueghel*, 433–39.

80. After Amalek massacred Hebrew stragglers (Deuteronomy 25:17–19), Israel was commanded to destroy all remnants of that tribe, which is why Saul's clemency towards them (I Samuel 15:9) incurred divine wrath and led to Saul's loss and suicide. Other references for Amalekites, descended from Esau (Genesis 36:12) and thus fraternally hostile to Jacob, see Numbers 24:20, where Balaam prophesies that "Amalek was the first of the nations, but in the end he shall come to destruction." King David pursued the Amalekites after the death of Saul (I Chronicles 4:43). See also Ertz, *Jan Brueghel*, 463–67, on battles in Jan's work.

81. Renger, *Flämische Malerei*, 85–87, no. 187.

82. Pieter Aertsen and his nephew Joachim Beuckelaer established the pictorial genre of the fish market in Antwerp art, where it enjoyed a long afterlife, extending to collaborations between animal and still-life specialists, such as Frans Snyders, and figure painters, such as Cornelis de Vos. See Elizabeth Honig, *Painting and the Market in Early Modern Antwerp* (New Haven, 1998), for fish, esp. 82–99, 121–23 for the Brueghel panel in Munich, 151–67, 175–76, also noting, 122, that the two ladies are dressed in Venetian gowns. She notes perceptively about the comprehensive survey within the crowd: "Humanity is catalogued here in all its variety, including both the social spectrum—beggars and burghers, abbots and aristocrats—and the geographical one, with turbaned easterners, Venetian noblewomen, and Flemish housewives and merchants. On Bruegel as a master painter of, and cataloguer of, animals of the world, Faber Kolb, *Noah's Ark*.

83. Allart, "Did Pieter Brueghel the Younger See His Father's Paintings?", 46–57.

84. Larry Silver, *Bosch*, 391–97; Ertz, *Jan Brueghel*, 116–36.

85. Woollett and Van Suchtelen, *Rubens and Bruegel*, also discusses other collaborations, esp. 44–127, nos. 1–13 for Rubens, 140–65, nos. 17–21 for van Balen, 166ff; Honig, *Painting and the Market*, 177–212 on collaborations and Antwerp connoisseurship. For Jan's celebration of the rarity of the flowers in his pictures to precious jewels and for his prices, see Alan Chong and Wouter Kloek, *Still-Life Paintings from the Netherlands 1550–1720*, exh. cat. (Cleveland, 1999), 28–30, 110–13, no. 3: "Because of the expense and rarity of many cultivated plants, floral bouquets were unusual, and it is evident from Brueghel's comments that in both their natural and painted forms they were considered rare and delicate items, on a par with gold, gems, exotic shells, and fragile porcelain." Also John Loughman, "The Market for Netherlandish Still-Lifes, 1600–1720," 88–91. The Rubens portrait of Jan Bruegel, his second wife, Catharina van Marienbergh, and his family (Courtauld Institute, London) dates slightly earlier, c. 1612–13; Hans Vlieghe, *Portraits. Corpus Rubenianum Ludwig Burchard XIX.11* (London, 1987), 60–62, no. 79.

86. Woollett and Van Suchtelen, *Rubens and Bruegel,* 90–99, no. 8. The fullest study of this *Sight* image is Justus Müller-Hofstede, "'Non Saturatur Oculus Visu': Zur 'Allegorie des Gesichts' von Peter Paul Rubens und Jan Brueghel d.Ä.," in Herman Vekeman and Müller-Hofstede, eds., *Wort und Bild in der Niederländischen Kunst und Literatur des sechzehnten und siebzehnten Jahrhunderts* (Erstadt, 1984), 243–89, with the early history of the cycle, which seems to have been a gift to Duke Wolfgang Wilhelm of Pfalz-Neuburg before coming back to Spain in 1636 with Cardinal-Infante Ferdinand; for the larger context of both gallery pictures and collecting, Victor Stoichita, *The Self-Aware Image*, esp. 81–83, 127–34. A study of the full cycle is Barbara Welzel, *Der Hof als Kosmos sinnlicher Erfahrung: Der Fünfsinne-Zyklus von Jan Brueghel d. Ä. und Peter Paul Rubens als Bild der erzherzoglichen Sammlungen Isabellas und Albrechts* (Marburg, 1997); Ertz, *Jan Brueghel*, 328–62; see also 363–89 for allegories of the Four Seasons.

87. Arthur MacGregor, *Curiosity and Enlightenment: Collectors and Collections from the Sixteenth to the Nineteenth Century* (New Haven, 2007); Oliver Impey and MacGregor, *The Origins of Museums: The Cabinet of Curiosities in Sixteenth- and Seventeenth-Century Europe* (Oxford, 1985).

88. Links between the beauty of Venus and Vision: Eric Jan Sluijter, "Venus, Visus and Pictura," *Seductress of Sight: Studies in Dutch Art of the Golden Age* (Zwolle, 2000), 87–159. The allegory is defined by Müller-Hofstede from her diadem as Juno Optica, atop Rubens's title page for an optical treatise by Franciscus Aguilonius (1613); for Rubens's illustrations of Aguilonius, Martin Kemp, *The Science of Art* (New Haven, 1990), 99–104, plate 194. Juno's attribute, a peacock, appears above the allegory in the background garden space.

89. Woollett and Van Suchtelen, *Rubens and Bruegel*, 116–21, no. 12; Stoichita, *The Self-Aware Image*, 76–81; Freedberg, "The Origins and Rise of the Flemish Madonnas in Flower Garlands," *Münchner Jahrbuch der bildende Kunst* 32 (1981), 115–50.

90. On curtains, real and simulated for religious paintings, Wolfgang Kemp, *Rembrandt, Die Heilige Familie oder die Kunst, einen Vorhang zu lüften* (Frankfurt, 1986).

91. Aside from any possible reference to Bruegel's *Two Monkeys* (1562; see plate 52), apes and art appear in several gallery paintings as satirical figures, Stoichita, *The Self-Aware Image*, 82–83, 127–28. The monkey would also be the antithesis of the "intelligent" speaking parrot. For the Rubens Silenus images, Lisa Rosenthal, *Gender, Politics, and Allegory in the Art of Rubens* (Cambridge, 2005), 101–3, plate 33; Alpers, *The Making of Rubens*, 101–57, esp. plate 88. The still life is probably the work of specialist Frans Snyders, who also collaborated with Rubens; Woollett and Van Suchtelen, 166–85, nos. 22–24.

92. Jeffrey Muller, "Private Collections in the Spanish Netherlands: Ownership and Display of Paintings in Domestic Interiors," Peter Sutton, *The Age of Rubens*, exh. cat. (Boston, 1994), 194–205; for Rubens's own space to house his collection of ancient sculpture, Muller, "Rubens's Museum of Antique Sculpture: An Introduction," *Art Bulletin* 59 (1977), 571–82.

93. The iconography is complex and disputed; see Panofsky, *Studies in Titian Mostly Iconographic* (New York, 1969), on love and beauty, as well as faith, 127–38; *Le siècle de Titien*, exh. cat. (Paris, 1993), 518–20, no. 163.

CONCLUSIONS

1. George Boas, *Vox populi: Essays in the History of an Idea* (Baltimore, 1969). The cover of the softcover edition features Bruegel's *Wedding Dance* (1566; Detroit Institute of Arts).

INDEX OF NAMES

Reference numbers in italics refer to plate

Aertsen, Pieter, 11, 26, 28–30, 31, 33, 48, 4...
 348, 352, 412, 433, 434; *20, 35, 266, 267, ...*
Aesop, 220, 225
Agricola, Johannes, 230
Alba, Duke of, 253, 276–277, 280, 284, 288...
 416, 435
Albert and Isabella, Archdukes, 268, 349, ...
Alberti, Leon Battista, 390
Alexander the Great, 43, 252
Alps, 103, 284, 286, 403
Altdorfer, Albrecht, 252
Amsterdam, 416
Andriessoon, Symon, 230
Anthonisz., Cornelis, 253, 256; *214*
Antwerp, 11–12, 24, 26, 37, 41–42, 44, 45, ...
 62, 65, 69, 95, 147, 163, 166, 199, 231, 2...
 276, 287, 312, 327, 353, 357, 404, 416, 4...
Antwerp City Hall, 259–260
Apelles, 43
Arias Montano, Benito, 435
Augustine, Saint, 253, 259
Aux Quatre Vents, 79, 139, 206, 435
Avercamp, Hendrick, 410

Babylon, 259
Baltens, Pieter, 38
Barroci, 69
Basrode, 121
Batavia, 51
Beer, Jan de, 242; *202*
Bega, Cornelis, 60
Beham, Sebald, 315, 340, 342, 343
Bening, Simon, 233, 320, 324, 330; *273, 27...*
Berghes, Robert de, 71
Berry, Jean, duke of, 316, 324
Beuckelaer, Joachim, 11, 30–31, 33, 45, 48, ...
Bloemaert, Abraham, 425
Bol, Hans, 134, 335, 336, 404–405, 408, 4...
Bolswert, Boetius à, 416
Bos, Cornelis, 76
Bosch, Hieronymus, 12, 20, 24, 33, 37, 41, ...
 139, 151, 156, 157, 159, 160, 166, 167, 169
 241, 243, 245, 250, 288, 297, 401, 404, ...
 11, 12, 62, 136, 149, 151, 184, 204, 310
Botticelli, Sandro, 391
Bouts, Dieric, *212*
Brabant, 37, 47, 199
Brabo, 47, 260
Breda, 37
Brederode, Henri de, 385
Breu the Elder, Jörg, 252
Britto, Giovanni, 97
Bronzino, Agnolo di Cosimo, called, 73
Bruegel, Pieter (the Elder), life, 33, 37–44
 311, 388, 390
Bruegel, Pieter (the Elder), works, *1, 2, 5–*
 45, 48, 51, 65, 68, 70, 78, 79, 82, 84, 85, 86, 8...
 95, 100, 103, 106, 107, 108, 109, 110, 111, 113,
 128, 129, 132, 133, 135, 138, 139, 142, 143, 14...
 156, 157, 159, 162, 163, 167, 169, 170, 171, 173,
 181, 183, 186, 187, 188, 189, 190, 191, 192, 19...
 199, 200, 206, 207, 210, 213, 215, 220, 221, 2...
 240, 243, 244, 245, 246, 247, 253, 255, 257, 2...
 274, 275, 276, 277, 278, 280, 281, 282, 284, 2...
 297, 299, 300, 302, 303, 304, 306, 308, 309, 31...
 320, 321, 356, 357
Brueghel, Jan, 11, 42, 100, 125, 268, 336, 3...
 408, 410, 417, 419, 421, 423–431, 437; ...
 331, 332, 333, 342, 350, 351, 352, 353, 354, 355
Brueghel, Pieter the Younger, 11, 41, 42, 4...
 336, 342, 380, 397, 408, 421, 423–424, ...
 256, 286, 348, 349
Brueghel (city), 37
Bruges, 413
Brussels, 41–42, 65, 249, 261

...n, Nicolas de, 234, 413
...elius, Arnoldus, 260
...ni di Pellezuoli, Donato, 57

...ot, Jacques, 385, 416
...in, John, 265, 274–275
...pagnola, Domenico, 96, 126; *83*
...pin, Robert, 268, 276; *233*
..., Jacob, 234
...llus, 45
...les V, 57, 73–74
...io, Giulio, 38, 295; *252*
...s, Hieronymus, 11, 12, 37, 38, 40–42, 44, 50, 51, 56, 59, 69–91,
 ...5, 112, 125, 139, 142, 151, 157, 159, 160, 203, 206, 215, 231, 233,
 ...49, 250, 258, 309, 316, 321, 335, 342, 353, 371, 375, 377, 393, 397,
 ...01, 404, 408, 434, 435; *54, 56, 66*
...s, Matthijs, 69–70, 82, 83; *53, 55*
...cke, Mayken, 41
...cke van Aelst, Pieter, 37–38, 76, 95, 421
...aert, Hans, 71
...osseum (Rome), 258
...rnhert, Dirk Volckertsz., 73–74, 435
..., Cornelis, 41, 42, 69, 72, 74, 75, 91, 203, 316, 393
...ach, Lucas, 194

...Costa Hours, 320, 335
...nhouder, Josse de, 199
...d, Gerard, 242
...jcx, Volcxken, 41
...tecum, Jan and Lucas, 72–73, 76, 112, 125, 309, 380; *26, 52, 60,*
 ...3, 96, 98, 101, 102, 104, 263, 314
...r, Albrecht, 33, 46, 70, 95, 109, 160, 167, 220, 300, 342, 402,
 ...04, 426; *141, 150, 259, 290*

...ont, count of, 265, 277, 287–288
...mus, 47, 125, 215, 229, 231, 234, 245, 327, 330, 392, 435
...apius, 43
...ompos, 42–43

...ily of Love, 435
...ese, Alessandro, 38, 416
...inand, Archduke, 287
...inand, Cardinal-Infante, 419
...eris, Bartholomeus, 260
...s, Cornelis, 76
...s, Frans, 11, 33, 41, 44–46, 48, 71–73, 74, 76, 90, 95, 139, 167,
 ...72, 203, 276, 316, 370, 380, 391, 392, 435, 437; *28, 29, 30, 57*
...ck, Sebastian, 230
...ckert, Hans, 42, 311
...ius, Pieter, 233

..., Philips, 41, 73, 74, 75, 89, 160, 183, 249, 250, 296, 300, 303,
 ...66, 375, 393; *47, 77, 160, 161, 164, 166, 174, 211, 319*
..., Théodore, *23*
...nt, 276
...si, Giorgio, 40, 69, 70, 73, 90, 203
...vanni da Bologna, 287
...kendon, Albrecht, 315
...dthals, François, 230, 368
...zius, Hendrick, 385, 403–404; *316, 327*
...saert, Jan, 44
...velle. *See* Perrenot de Granvelle
...mani, Domenico, 256
...bbendonk, 349
...cciardini, Lodovico, 37, 41, 44, 57, 139

...re, Lucas de, 44, 46, 392
...nessy Hours, 320
...oken, 312, 349
...enberg, Frans, 215, 220, 225, 275–276, 277, 311; *185, 232*
...bein the Younger, Hans, 288, 292, 295; *248–251*
...enbout, Gerard, 256
...nes, count of, 265, 277, 385
...s, Frans, 50, 51, 56; *38, 39, 40, 44*

...ella, archduke. *See* Albert and Isabella, Archdukes
..., 90, 95

Jerusalem, 30, 31, 260
Jode, Gerard de, 76, 234
Jongelinck, Jacques, 33, 42, 261, 316, 320
Jongelinck, Nicolaes, 33, 41–42, 45, 72, 203, 261, 316, 324, 327,
 335, 392, 435
Jordaens, Jacob, 234
Josephus, 253
Juvenal, 148

Kies, Simon Iansz., 72

Lactantius, 157
Lafreri, Antonio, 69
La Marck, Erard de, 71
Lampsonius, Domenicus or Dominique Lampson, 37, 41, 43, 91,
 139, 157
Leonardo da Vinci, 370
Liefrinck, Hans, 167; *145*
Limbourg brothers, 316
Lombard, Lambert, 40, 70–71, 90, 95
Lorenzetti, Ambrogio, *172*
Louvain, 413
Lucas van Leyden, 113, 202, 260, 284, 286, 404, 433; *75, 97, 239*
Lucian, 390–391
Ludolph of Saxony, 33
Luther, Martin, 194

Mandyn, Jan, *119*
Mantegna, Andrea, 160
Margaret of Austria, 57
Margaret of Parma, 249, 253, 261, 265, 277
Massys, Cornelis, 46, 95, 100, 126, 274, 371, 402, 434; *80, 231, 307*
Massys, Jan, 46–48; *31, 32*
Massys, Quinten, 46, 47, 95, 280; *205*
Master of James IV of Scotland, 256; *216*
Master of the Brunswick Monogram, 26, 28, 48–49; *34*
Master of the Mountain Landscapes, 120, 402; *326*
Master of the Small Landscapes, 82, 402; *67*
Matthias, archduke, 405
Maurits Nassau, prince of Orange, 76
Mechelen, 38, 57, 405, 416, 421
Melanchthon, Philip, 391
Memling, Hans, 242
Messina, 51
Met de Bles, Herri, 26–28, 31, 33, 60, 96, 270, 434; *16, 17, 228*
Michelangelo, 46, 69, 72, 73, 167, 370; *201*
Middelburg, 416
Mompere, Bartholomeus de, 42, 311, 313, 340
Momper the Younger, Joos de, 260, 430; *323, 347*
Mor, Anthonis, *222, 223, 234*
Moses, 427
Muller, Harmen Jansz., 74–75, 203
Muziano, Girolamo, 69

Netherlands, 11, 82, 199, 253, 277, 321, 330
Newton, Isaac, 59
Noirot, Jean, 42, 316, 352, 435
Nuremberg, 315

Ortelius, Abraham, 38, 41, 42–43, 46, 231, 300, 303–304, 392, 435
Oudenarde, 413
Ovid, 131, 134, 148, 393

Patinir, Joachim, 24, 26, 82, 95, 103, 113, 118, 119, 126, 245, 259,
 270, 274, 277, 286, 324, 434; *208, 227*
Paul, Saint, 183, 284
Pencz, Georg, 203
Perrenot de Granvelle, Antoine, 41–42, 69, 74, 76, 249, 261, 265,
 276, 297, 304, 316, 435
Perret, Pieter, 300
Peters, Maarten, 260
Petrarch, 393
Philip II of Spain, 33, 41, 57, 72, 74, 253, 265, 276, 277, 288, 312,
 434
Philip IV of Spain, 133, 419
Plantin, Christopher, 69, 435

Pliny the Elder, 43–44, 390
Postel, Christian Guillaume, 435

Rabelais, François, 157, 229–230, 231, 363
Raimondi, Marcantonio, 69, 72
Raphael, 69, 70, 72, 203, 370
Reggio di Calabria, 51
Rome, 33, 40, 69, 71, 76, 100, 103, 258
Rubens, Peter Paul, 12, 287, 380, 396, 417–420, 437; *112, 242, 324, 344, 345, 346, 355*
Rudolf II, Emperor, 44, 59, 163, 280–281, 402

Sachs, Hans, 315, 363
Sadeler, Aegidius, 44; *27*
St. Quentin, 57
Salamanca, Antonio, 69
Salamanca, Francesco, 69
Salomon, Bernard, 133
Sambucus, Johann, 133
Savery, Jacob, 401, 403, 404, 413, 416–417; *325, 343*
Savery, Roelandt, 402, 413, 416–417; *338*
Schäufelein, Hans, 252
Schetz, Balthazar, 312, 349
Schetz, Gaspar, 349
Schetz, Melchior, 349
Schoen, Erhard, 315
Schongauer, Martin, 25–26, 33, 300, 303; *15, 258*
Serlio, Sebastiano, 50, 76
Siena, 200
Sint Jans, Geertgen tot, 242
Spranger, Bartholomeus, 44
Steen, Jan, 234

Stevens, Peter, 402
Stradanus, 233

Teniers, David, 60
Timanthes, 43
Titian, 38, 69, 96, 97, 126, 431

Van Amsel, Jan, 28, 48, *18, 19*
Van Balen, Hendrick, 430
Van Coninxloo, Gillis, 408
Van Dalem, Cornelis, 268; *226*
Van den Berghe, Jan, 24
Van den Wyngaerde, Frans, 418
Van der Borcht, Pieter, 57, 340, 342, 352; *265, 289*
Van der Goes, Hugo, 241, 242, 245, 300, 303; *203*
Van der Heyden, Pieter, 41, 77, 79, 83, 86, 139, 209, 342, 363, 371; *46, 49, 50, 61, 64, 69, 71, 72, 76, 117, 121, 123, 125, 127, 130, 131, 134, 137, 140, 152, 154, 270, 271, 283, 285, 301*
Van der Weyden, Rogier, 17, 24, 31, 33, 169, 194, 245, 435; *7, 165, 168*
Van de Velde, Jan, 121, 330
Van de Velde II, Jan, 410
Van de Venne, Adriaen, 234, 410; *337*
Van Eyck, Jan, 24–25, 33, 139, 302; *13, 14*
Van Haarlem, Cornelis, 425
Van Heemskerck, Maarten, 69, 73–76, 90, 95, 203, 258, 357–358, 366, 370, 391, 392, 393, 435, 437; *58, 59*
Van Hemessen, Jan, 48, 314; *33, 73*
Van Hooren, Melchisedech, 260; *218*
Van Leyden. *See* Lucas van Leyden
Van Liere, Joos, 79

Van Mander, Karel, 37, 42, 48, 103, 133, 157, 163, 261, 280, 311, 340, 349, 388, 393, 402, 404, 412
Van Meckenem, Israhel, 166, 233
Van Metern, Emmanuel, 304
Van Orley, Bernard, *158*
Van Reymerswaele, Marinus, *126*
Van Schoonbeke, Gilbert, 57, 59
Van Scorel, Jan, 217
Van Valckenborch, Lucas, 245, 286, 287, 405–408, 410, 424; *241, 329, 330, 334, 335, 336*
Van Valckenborch, Marten, 405
Vasari, Giorgio, 157
Venice, 38, 69, 96, 97, 109
Verhulst, Mayken, 37, 38, 421
Vinckboons, David, 370, 413–416, 425; *339, 340, 341*
Visscher, Claes Jansz, 82
Visscher, Roemer, 234
Vogtherr, Heinrich, 190
Voragine, Jacobus da, 300, 302–303
Vorsterman, Lucas, 380, 387
Vos, Marten de, 38, 76, 234
Vrancx, Sebastien, 417, 430; *342*
Vredeman de Vries, Hans, 76, 231
Vriendt, Cornelis Floris de, 260

Warnersen, Peter, 230
Wierix, Jan, 37, 42, 90–91, 375; *24, 74*
William of Orange, 265, 277, 296

Zuccaro, Federico, 69

INDEX OF WORKS

Works attributed to "Bruegel" are by Pieter Bruegel the Elder. Reference numbers in *italics* refer to plates.

Adoration of the Magi, Bruegel, 241, 250, 271, 276, 296, 297, 300, 303, 371, 380, 384, 424; *199, 200*
Adoration of the Magi, Hieronymus Bosch, 242, 297, 424; *204*
Adoration of the Magi, Jan Brueghel, 421, 423; *350*
Adoration of the Magi, Jan de Beer, 242; *202*
Adoration of the Magi, Pieter Brueghel the Younger, 421; *349*
Adoration of the Magi, Quinten Massys, 244; *205*
Adoration of the Magi in the Snow, Bruegel, 56, 245, 271, 321, 408, 410, 423; *206*
Adoration of the Magi in the Snow, Pieter Brueghel the Younger, 42, 423; *348*
Alchemist, The, Bruegel, 59, 173, 392; *48*
Alchemist, The, Philips Galle, after Pieter Bruegel, 59, 392; *47, 322*
Allegory of Sight, Jan Brueghel and Peter Paul Rubens, 430; *355*
Alpine Landscape, Bruegel, 103; *89*
Anger, Bruegel, 148; *128*
Anger, Pieter van der Heyden, after Pieter Bruegel, 148; *127*
Antoine Perrenot, called Granvelle, Antonis Mor, 265, 316; *223*
Antwerp City Hall, Melchisedech van Hooren, *218*
Apollo and Daphne, Hieronymus Cock, after Matthijs Cock, 70, 83; *56*
Apollo and Daphne, Matthijs Cock, 70; *53, 55*
Archangel Michael Fighting the Dragon, Albrecht Dürer, 167; *150*
Arithmetic, Frans Floris, 72; *57*
Armed Three-Master Anchored near a City, Frans Huys, after Pieter Bruegel, 50; *39*
Arrival of the Holy Family in Bethlehem, Cornelis Matsys, 274; *231*
Ascent of the Blessed, facing *Earthly Paradise,* Hieronymus Bosch, 169; *151*
Ass at School, The, Bruegel, 86; *70*

Ass at School, The, Peter van der Heyden, after Pieter Bruegel, 86; *71*
Attack on a Convoy, Jan Brueghel and Sebastian Vrancx, 417; *342*
August, Simon Bening, 330; *279*
Avarice, Bruegel, 60, 147; *124*
Avarice, Pieter van der Heyden, after Pieter Bruegel, *125*

Basrode, Bruegel, 121; *106*
Battle of Hebrews against Amalekites, Jan Brueghel, 427; *353*
Beekeepers, The, Bruegel, 366; *303*
Beggars, The, Bruegel, 79, 212, 377, 415; *309*
Beggars and Cripples, attributed to Hieronymus Bosch, 377; *310*
Belgian Wagon, Jan and Lucas Duetecum, after Pieter Bruegel, 118, 130; *101*
Big Fish Eat Little Fish, Bruegel, 41, 83, 139, 148, 314, 353, 370, 415; *68*
Big Fish Eat Little Fish, Peter van der Heyden, after Pieter Bruegel, 41, 83; *69*
Blind Hurdy-Gurdy Player, David Vinckboons, 415; *341*
Blind Leading the Blind, Peter van der Heyden, after "Hieronymus Bosch," 79, 371; *64*
Blind Leading the Blind, The, Bruegel, 226, 348, 371, 390, 405; *306*
Blind Leading the Blind, The, Jan Brueghel (?) after Pieter Bruegel, 42, 79, 126, 226, 336, 348, 371, 405; *305*
Blue Boat, Peter van der Heyden, after "Hieronymus Bosch," 77, 316; *61*

Calumny of Apelles, The, Bruegel, 42, 390, 396; *318, 320*
Census at Bethlehem, Bruegel, 42, 118, 245, 249, 271, 280, 284, 288, 348, 370, 390, 428; *229, 230*
Charity, Bruegel, 183, 195, 206, 312; *157, 159*
Charity, Philips Galle, after Pieter Bruegel, *160*

Chevrot Altarpiece (*Seven Sacraments* triptych), Rogier van der Weyden, 194; *165, 168*
Children's Games, Bruegel, 62, 209, 214, 231, 311, 320; *195, 196, 197, 357*
Christ and the Adulterous Woman, Pieter Aertsen, 49; *35*
Christ and the Woman Caught in Adultery, Bruegel, 297, 352, 385, 390, 392, 396; *255*
Christ and the Woman Taken in Adultery, Pieter Brueghel the Younger, 250, 300; *256*
Christ Carrying the Cross, after Jan van Eyck, Budapest, 25; *13*
Christ Carrying the Cross, after Jan van Eyck, Vienna, 25; *14*
Christ Carrying the Cross, Bruegel, 17, 20, 23, 31, 41, 106, 241, 261, 270, 277, 280, 300, 303, 316, 384, 390, 413, 426; *5–6, 8, 9*
Christ Carrying the Cross, Herri met de Bles, 27; *16*
Christ Carrying the Cross, Hieronymus Bosch, Madrid, 20, 23; *11*
Christ Carrying the Cross, Hieronymus Bosch, Vienna, *10*
Christ Carrying the Cross, Joachim Beuckelaer, *21*
Christ Carrying the Cross, Martin Schongauer, 25; *15*
Christ Carrying the Cross, Master of the Brunswick Monogram (Jan van Amstel?), 28; *19*
Christ in Limbo, Albrecht Dürer, 160, 163; *141*
Christ in Limbo, Bruegel, 160, 169, 174, 177; *139*
Christ in Limbo, Pieter van der Heyden, after Pieter Bruegel, 160; *140*
Christ's Entry into Jerusalem, Master of the Brunswick Monogram (Jan van Amstel?), 28; *18*
Combat between Carnival and Lent, Bruegel, 79, 209, 212, 231, 309, 311, 315, 377; *156, 175, 176, 177, 178, 180, 181, 183*
Combat between Carnival and Lent, follower of Hieronymus Bosch, 215; *184*
Combat between Carnival and Lent, Frans Hogenberg, 215, 311; *185*

Combat between Money-Boxes and Piggy-B... Heyden, after Pieter Bruegel, 60, 147...
Conversion of St. Paul, Bruegel, 113, 280, 2... 237, 238
Conversion of St. Paul, Lucas van Leyden, ...
Crucifixion, Jan Brueghel, 352
Crucifixion, Pieter Brueghel the Younger...
Crucifixion, Rogier van der Weyden, 17; ...

Dance of Death, The (four excerpts from)... Younger, 288, 292; 248–251
Dance of the Magdalene, Lucas van Leyde...
Dance of the Peasants, from Peasant Kerm...
Dark Day, The, Bruegel, 43, 320; 272, 274
Death of the Virgin, Bruegel, 41, 250, 300...
Death of the Virgin, Martin Schongauer, ...
Death of the Virgin from Life of the Virgin,...
Dirty Bride, The, Bruegel, 209, 214; 179
Duke of Alba, Antonis Mor, 276, 280; 234
Dulle Griet ("Mad Meg"), Bruegel, 41, 16... 116, 142, 143
Dutch Hulk and a Boeier, Frans Huys, aft...

Earthly Paradise, Bosch. See Ascent of the ...
Egg Dance, The, Pieter Aertsen, 314, 348...
Everyman, Pieter van der Heyden, after ... 225; 46
Everyman (Elck), Bruegel, 59, 183, 225, 2...

Faith, Bruegel, 194, 206, 268; 167
Faith, Philips Galle, after Pieter Bruege...
Fall of Icarus, Bruegel, 126–134, 271, 284... 110, 113
Fall of Icarus, copy by Jan Brueghel (?),... 130; 111
Fall of Icarus, Hans Bol, 134, 404; 114
Fall of Icarus, Peter Paul Rubens, 133; 11
Fall of the Magician Hermogenes, The, B...
Fall of the Magician Hermogenes, The, P... after Pieter Bruegel, 174; 154
Fall of the Rebel Angels, Hieronymus Bo...
Fall of the Rebel Angels, The, Bruegel, 41... 146, 147, 148
Farnese Hours, Giulio Clovio, 38, 295; 2
Fat Kitchen, The, Pieter van der Heyde... 316, 366; 271
Feast of the Sea Gods, Frans Floris, 44, 5...
February, Simon Bening, 273
Festival of Fools, Peter van der Heyden, ... 86, 88, 225; 76
Flight into Egypt, Bruegel, 41, 118, 245, ...
Flight into Egypt, from Speculum huma...
Flight into Egypt, Joachim Patinir, 245, ...
Flora, Jan Massys, 46; 31
Forest Landscape, Jan Brueghel, 408; 33
Forest Landscape with Temptation of Ch...
Forest Landscape with View of Ocean, B...
Forest with Angler, Lucas van Valcken...
Forest with Bears, Bruegel, 106, 404; 9
Fortitude, Bruegel, 159, 174, 183; 138
Four Seasons, Adriaen van de Venne. S...

Gluttony, Bruegel, 151; 132
Gluttony, Pieter van der Heyden, 151; ...
Good Government, The, Ambrogio Lor...
Good Shepherd, Pieter Brueghel the Yo... Bruegel, 297, 374, 380; 253
Gooseherd, Bruegel, 396, 412, 424; 287
Gooseherd, Pieter Brueghel the Young...
Grain Harvest, The, Bruegel, 327, 335, ...

Harbor Scene with Christ Preaching, J...
Hay Harvest, The, Bruegel, 131, 324, 3...
Harvesters, The. See Grain Harvest, T...
Head of a Peasant Woman, Bruegel, 3...
Head of a Yawning Peasant, Pieter Br... Brueghel the Younger, 380; 313

...Feeler (Hennentaster), Hans Liefrinck, 167, 220; 145
...ling Shepherd, copy after Pieter Bruegel, 297, 374, 384; 254
...e, Bruegel, 21, 134, 189, 190, 195; 163
...e, Philips Galle, after Pieter Bruegel, 189; 164
...ters in the Snow, Bruegel, 100, 131, 320, 407, 408, 416; 2, 275
...t of the Wild Man, The, anonymous, after Pieter Bruegel, ...212; 182

...kating before the Gate of St. George, Frans Huys, after Pieter Bruegel, 56, 125, 321, 408; 44
...oclasm, Frans Hogenberg, 275; 232

...ph and Potiphar's Wife, Maarten van Heemskerck, 59
...ice, Bruegel, 20, 195, 206, 288, 384, 388; 169, 170, 171

...mis, The, Peter Paul Rubens, 419; 324, 344
...mis at Hoboken, Bruegel, 42, 311; 264

...dscape, Cornelis Matsys, 95, 401, 402; 80
...dscape with Bears, Bruegel, 41, 82, 96, 109, 112, 114, 404; 65
...dscape with Castle, Hans Bol, 404; 328
...dscape with Chateau Het Steen, Peter Paul Rubens, 419; 345
...dscape with Fortified City, Bruegel, 106; 90
...dscape with Gypsy Family, Cornelis van Dalem, 268; 226
...dscape with Parable of the Sower, Bruegel, 41, 126, 131, 134, 270, 374, 428; 78, 109
...dscape with Penitent Magdalene, Jan and Lucas Duetecum, after Pieter Bruegel, 113, 130; 96
...dscape with Rabbit Hunt, Bruegel, Paris, 125; 108
...dscape with Rabbit Hunt, Bruegel, private collection, 12, 41, 125, 131, 384; 107
...ndscape with Rainbow, Peter Paul Rubens, 419; 346
...dscape with St. Jerome, Bruegel, 100, 106, 113, 130; 86
...dscape with Wooded Slope, Domenico Campagnola (after Titian?), 97; 83
...rge Alpine Landscape, Bruegel, 112; 95
...st Judgment, The, Bruegel, 142; 120
...st Judgment, The, Hieronymus Bosch, 167; 136
...st Judgment, The, Hieronymus Bosch, with The Fall of the Rebel Angels, 167; 149
...st Judgment, The, Pieter van der Heyden, after Pieter Bruegel, 157; 121
...st Judgment triptych, Bernart van Orley, 183; 158
...zy-Luscious Land, Bruegel, 225, 363; 302
...zy-Luscious Land, Pieter van der Heyden, after Pieter Bruegel, 249, 363; 301
...fe of the Virgin, Albrecht Dürer. See Death of the Virgin
...ust, Pieter van der Heyden, after Pieter Bruegel, 145; 123
...ust (Luxuria), Bruegel, 145; 122

...ad Meg. See Dulle Griet ("Mad Meg")
...adonna and Child, Michelangelo, 241; 201
...agpie on the Gallows, The, Bruegel, 42, 387, 417; 317
...argaret of Parma, Antonis Mor, 265; 222
...arket Scene with Ecce Homo, Joachim Beuckelaer, 49; 36
...assacre of the Innocents, Bruegel, 42, 284, 288, 296, 384, 416; 235, 356
...assacre of the Innocents, copy after Pieter Bruegel, 245, 277, 280; 236
...eadow with Trees, Lucas van Valckenborch, 405; 329
...erode Altarpiece, Robert Campin, 276; 233
...erry Company, Jan Massys, 47; 32
...iraculous Draft of Fishes, Joachim Beuckelaer, 50; 37
...isanthrope, The, Bruegel, 348, 375, 384, 387; 308
...oneychanger and His Wife, Marinus van Reymerswaele, 147; 126
...onforte Altarpiece, Hugo van der Goes, 242; 203
...ountain Coastal Landscape, Hendrick Goltzius, 403; 327
...ountain Landscape with River and Travelers, Bruegel, 103, 120; 88
...ountain Landscape with River, Village, and Castle, Master of Mountain Landscapes, 402; 326
...ule Caravan on a Hillside, Bruegel, 103, 112; 87

Naval Battle in the Straits of Messina, Frans Huys, after Pieter Bruegel, 51; 40
Netherlandish Proverbs, Bruegel, 86, 125, 126, 131, 166, 209, 215, 220, 231, 336, 368, 371, 388; 144, 186, 187, 188, 189, 190, 191, 192

Operation of the Stone of Folly, Jan van Hemessen, 86; 73

Painter and His Client, The, Bruegel, 392, 394, 401, 430; 321
Parable of the Blind Men, Cornelis Massys, 371; 307
Parable of the Wise and Foolish Virgins, Philips Galle, after Pieter Bruegel, 89, 374; 77
Pastoral Landscape, Bruegel, 97, 103; 85
Patience, Pieter van der Heyden, after Pieter Bruegel, 157, 177, 183; 137
Peasant and the Bird-Nester, The, Bruegel, 368; 300, 304
Peasant Brawl, Bruegel, 387
Peasant Couple Dancing, Albrecht Dürer, 342; 290
Peasant Feast, Pieter Aertsen, 314; 267
Peasant Kermis, Bruegel, 342, 380; 1, 291
Peasant Kermis, Pieter van der Borcht, 313; 265
Peasants by the Hearth, Pieter Aertsen, 314; 269
Peasants' Distress, Pieter Bruegel (?) and workshop, 12, 380, 385, 416; 312
Peasant Wedding Feast, Bruegel, 339, 348; 292, 293
Peasant Wedding Feast, Pieter van der Borcht, 340, 348; 289
Peddler, Hieronymus Bosch, 23, 60, 315, 375; 12
Peddler Robbed by Monkeys, Pieter van der Heyden, after Pieter Bruegel, 60, 88, 166; 49
Pilgrims to Emmaus, Hieronymus Bosch, 130, 375, 434
Portrait of Bruegel, Aegidius Sadeler, 44; 27
Portrait of Hieronymus Cock, from Domenicus Lampsonius, Pictorum aliquot celebrium Germaniae inferioris effigies, Jan Wierix, after unknown artist, 91; 74
Portrait of Peter Bruegel, from Domenicus Lampsonius, Pictorum aliquot celebrium Germaniae inferiores effigies, Jan Wierix, 91, 139, 349; 24
Portrait of Pieter Bruegel, Theodore Galle, 23
Preaching of St. John the Baptist, Bruegel, 126, 265, 288, 348; 221, 224
Preaching of St. John the Baptist, Herri met de Bles, 270; 228
Preaching of St. John the Baptist, Jan Brueghel, 268, 424; 225
Preaching of St. John the Baptist, Joachim Patinir, 270; 227
Pride, Bruegel, 45, 148; 129
Pride, Pieter van der Heyden, after Pieter Bruegel, 148; 130
Prudence, Bruegel, 189, 194, 206; 162
Prudence, Philips Galle, after Pieter Bruegel, 189; 161

Quack Dentist, workshop of Lucas van Leyden, 86; 75

Rest on the Flight into Egypt, Bruegel, 118; 100
Resurrection, Bruegel, 163, 249, 300; 210
Resurrection, Dieric Bouts, 250; 212
Resurrection, Philips Galle, after Pieter Bruegel, 163, 169, 249; 211
Return from the Procession, Bruegel, 313, 343; 266
Return of the Herd, Bruegel, 330; 280, 281
Ripa Grande, Bruegel, 38, 100; 25, 84
River Landscape, Jan Brueghel, 125; 105
River Valley in a Hilly Landscape, Bruegel, 109; 93
Rocky Landscape with Castle and River, Jacob Savery, 401; 325
Rustic Solitude or Rustic Care (Solicitudo Rustica), Jan and Lucas Duetecum, after Pieter Bruegel, 118, 125, 387; 102

St. George Kermis, Jan and Lucas Duetecum, after Pieter Bruegel, 42, 309, 413; 263
St. James and the Magician Hermogenes, Pieter van der Heyden, after Pieter Bruegel, 173; 152
St. Martin in a Boat, Jan and Lucas Duetecum, after "Hieronymus Bosch," 79, 348; 52, 63
St. Michael with the Dragon of the Apocalypse, Frans Floris, 45, 167; 30
Sea God, Frans Floris, 380; 29
Self-Portrait before the Colosseum, Maarten van Heemskerck, 73, 258; 58
Sermon on the Mount, Jan Brueghel, 424; 351
Seven Sacraments, Rogier van der Weyden. See Chevrot Altarpiece
Ship of Fools, Hieronymus Bosch, 77; 62
Sloth, Bruegel, 151, 225; 133, 135
Sloth, Pieter van der Heyden, after Pieter Bruegel, 151; 134
Soldiers at Rest, Jan and Lucas Duetecum, after Pieter Bruegel, 384; 314